Art in an Age of Revolution, 1750–1800

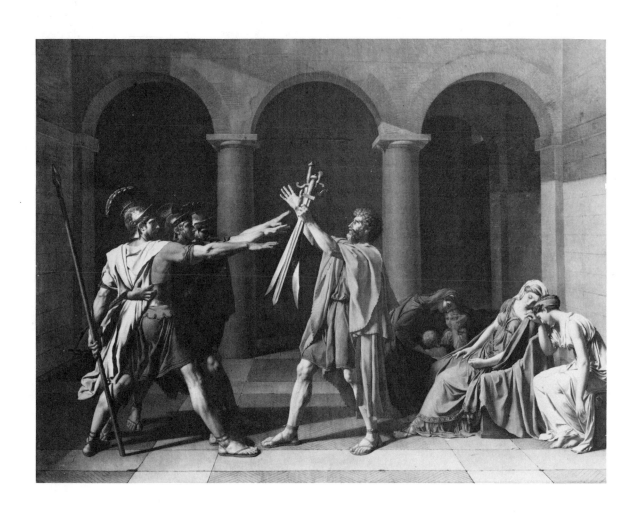

A SOCIAL HISTORY OF MODERN ART
Volume 1

Art in an Age of
Revolution
1750–1800

Albert Boime

The University of Chicago Press
Chicago and London

This volume has been supported in part by a gift
from Joey and Toby Tanenbaum in honor of
Albert Boime's contribution to nineteenth-century
art history, and by a grant from the Martin Foun-
dation. The author is grateful to them and to the
Guggenheim Foundation for a fellowship in 1984–
1985 that enabled him to advance the social history
of modern art as well as to UCLA's Committee on
Research for continuing grants to complete the
project. Publication of this book also has been aid-
ed by a grant from the Millard Meiss Publication
Fund of the College Art Association. MM

The University of Chicago Press, Chicago 60637
The University of Chicago Press, Ltd., London

Library of Congress Cataloging-in-Publication Data

Boime, Albert.
 Art in an age of revolution, 1750–1800.

 (A social history of modern art ; v. 1)
 Includes index.
 1. Art and revolutions. 2. Neoclassicism (Art)
3. Art, Modern—17th-18th centuries. I. Title.
II. Series.
N6425.N4B6 1987 709'.03'3 87-5944
ISBN 0-226-06332-1 (cloth); 0-226-06334-8 (paper)

To Myra

Contents

Illustrations

Preface

This book is the first in a series devoted to the social history of art in the modern epoch. It deals with the art of the revolutionary age 1750–1800, particularly documenting the repercussions of what Eric Hobsbawm called the "dual revolution"—the French Revolution of 1789 and the early English Industrial Revolution—upon the artists of this period.[1] This twin upheaval had far-reaching effects on the pattern of human existence, the consequences of which no one living in the period could have escaped. It in turn set into motion political, social, and technical revolutions which determined to a large extent the configuration of the modern world. My aim is to catch the scope of these consequences through an intensive analysis of the artists and their works.

During the period covered by this book, Western Europe began the transformation—a pace that would accelerate in the next half century—from a semi-feudal, agrarian economy into an urban-industrial society. This profound transformation holds the key to an understanding of cultural developments in the period, and any attempt to circumvent it seriously distorts the history of art. While traditional art history has generally isolated its subject, treating it as an almost autonomous phenomenon, the social history of art seeks to set the artist and the work of art into a broad historical and economic context in order to ground it upon the fundamental facts of material life. This approach will be used here. It rejects the traditional focus on the idea of "masters" and "masterpieces" in their role as instruments of the art market, but it presents the familiar artists and works as inseparable from the historical context.

The imagery of this period visually records the way in

which people of a certain status perceived, accepted, or rejected the social, political, and cultural changes of their time. A study of this imagery also makes clear how it was possible for talented people to earn their living by depicting in concrete form these various attitudes. The epoch witnessed the emergence of a powerful middle-class society, and in consequence art shifted from being primarily a luxury product for an aristocracy to a status symbol for the middle class and became subjugated to a market-dominated economy. Artists now concentrated on highly individualized and original approaches to promote their "product" and establish a trademark appropriate to the more faceless audience for their work. Art continued to serve as the emblem of good taste, as the means of aggrandizing the patron, and as an active agent for advancing official ideology. Even when under the pressure of a growing democratic consciousness it purported to speak for "the people," it nevertheless betrayed the attitudes of the dominant class toward the less privileged.

Art in an Age of Revolution, 1750–1800 makes a distinct leap in art history studies by moving beyond stylistic divisions and viewing developments in terms of major historical epochs. Neoclassicism and early romanticism are seen in their historical setting, and the burden of having to define these labels in a circular argument and in violent contradiction to the actual examples—a common pitfall of most broad surveys—is thus eliminated. Painters of opposing viewpoints are not considered in isolation and in necessary conflict but are measured together within the collective thinking of their time. As a result, surprising similarities emerge and oft-repeated antitheses dissolve under the microscope of history.

A work of art is the result of thousands of decisions made by the artist under the pressure of a community in which he or she participates, and this involves the mediating network of art patrons, critics, dealers, and art historians. These decisions are reached in the context of a cherished value system based on the economic and political interests of privileged social groups. Clarification of the social role of art is therefore vital if we are to understand the historical meaning of nineteenth-century art: the formalistic and stylistic assumptions previously imposed on this art by art historians—examined without reference to the framework of this social reality for so long—have only recently been challenged and need a broadly based perspective to authenticate or disprove them.

This is not the place to embark on a definition of art; but I accept as a given the structuralist notion that visual art—no matter how seemingly spontaneous or contrived—is essentially a language of signs that transmits ideas. These are ideas about reality held concurrently in the larger social realm which shaped the artist's particular world view and in turn is reinforced, reinvigorated, and disseminated by the visual agent. This would include art that attempts to shut out or deny the intolerable reality that is history. The task I have set for myself is to uncover these ideas and provide a reasonable basis for assigning a determinate place to modern art.

Art neither has its own autonomous internal development nor is it universal and "timeless." Who really knows whether Salieri's music might not some day be considered as significant as Mozart's? In the subsequent volumes in this series increasing attention will be given to the "Salieris" of the art world, the so-called mediocrities who have been ranked according to what only can be considered an arbitrary and even capricious standard. By this same standard women and minority artists have been neglected, and influential popular painters like Norman Rockwell and Chesley Bonestell are relegated to "inferior" status. Once we accept the simple fact that the work of art is produced by a human being who has been socialized by family, school, religion, and the media, then it can take its place in the larger range of human production and be seen as a reciprocating device in the social mechanism, caught up in and determining the dynamics of change itself. Why do we demand less of a Pollock in this sense than of a neolithic pot? My dream would be to culminate a book on twentieth-century art with an analysis of my ex–next-door neighbor in Binghamton, New York—a retired electrician who painted in his garage. His life and work would tell us more about ourselves than a library full of traditional art criticism.

I do not want to make this sound too simple. While insisting on the connection between art and social life, I also recognize that the intervention of the personal and original contributions of individual artists gives this connection a special twist not always obvious at first glance. Like Kool-Aid, the connection may be several stages removed from reality, overlaid with a sequence of distortions based on presumptions and inferences from these presumptions. Indeed, human consciousness never comes into contact with existence directly but is filtered

through these successive overlays of the surrounding world.

A work of art, like the unfoldment of a single day or the life of an individual, includes the history of the world and of civilization. But just as each day is experienced from the unique perspective of each individual, so this book attempts to grasp the particular perspective of a particular social group of skilled professionals known as "artists." I will concentrate as much as possible on their everyday existence from the dual standpoint of their productivity and their illusions or ideals. In getting at the layers of obfuscation known as "ideology," I hope to gain a fuller comprehension of the implacable process of history.

Ideologies are modes of understanding and interpretations (religious or philosophical) of the world plus a certain amount of illusion we call "culture,"[2] a process of production of ideas, a source of ideologically motivated actions and activities. Creative activity is one form of this cultural production: it signifies "spiritual" creations (including social time and space) and the actual making of things. It also signifies the self-production of a "human being" as part of a historical process and includes the production of social relations. Finally, taken in its widest sense, creative activity embraces reproduction, not only biological but the material reproduction of the tools of production and of works of art. Artistic production is comprised within the general economic structure of society and serves to disguise and vindicate the society's basic character.

In this attempt to determine the conjunction of "reality" and "ideology," we shall have to keep in mind that these two terms are relative and at the same time dialectically interlocked.[3] Ideology here shall be used in three senses, but most often as a system of related beliefs, values, and images characteristic of a particular class and more or less distorted from "reality." This distortion is governed by the material interests, conscious or unconscious, of those who subscribe to it insofar as they desire to maintain or advance their position over and against other competing social groups. Ideology will also refer on occasion to a system of illusory beliefs—false ideas or false consciousness—which can be contrasted with true or scientific knowledge, and finally to the conscious, deliberate process concerned with the production of ideas we generally call "propaganda." In the first two senses of the term, the beliefs are held in common by one's peers and are accepted

as the norm; in the last sense persons and institutions manipulate ideas to win the confidence of certain groups and negate the impact of the ideas and aspirations of other groups with conflicting interests. Finally, the concept of ideology presupposes the vision of a comprehensible social totality that can function as a yardstick to measure the false visions working to maintain relations of dominance.

This may suggest that I am in possession of a genuine or true explanation of the whole from which I see particular ideological visions deviating. While no one can make such a claim, it is possible to tell history in a more authentic form in comparison with which other stories may be seen to be wanting and perverse. There probably is no ultimate, knowable "reality," but there is a totality of human history congruent with human intelligence, and these are conceivable only as aspects of an identical reality. If we can never know *the* reality, given the prevalence of ideology and illusion we can certainly discover what it is *not*. As we are confined to the inside of the totality and determined by it, we have to keep telling truer stories to expose the falsehoods foisted upon us by those who reproduce and maintain the relations of dominance. History is akin to mythmaking and storytelling which give people a sense of place and identity and help them manage the painful contradictions of "reality." But telling the totality has been the prerogative of a privileged segment of society: those who are exploited need their narrative to resist their imprisonment within one or another structure of false reality.

My work has been influenced by a generation of art historians schooled under fire in the sixties—T. J. Clark, Carol Duncan, Nicos Hadjinicolaou, among others—who have advanced art historical studies by carefully grounding cultural productions in historical specificities, observing the mutual dependence of art objects with other cultural activity of predominantly social, political, moral, religious, or scientific forms in which they are both an effect and a force. Their studies, however, involved mainly sharply defined and relatively short chronological epochs, while the present work seeks to catch some of the sweep of Arnold Hauser's seminal *Social History of Art*, which was nevertheless flawed by its inevitable overgeneralizations and lack of regard for individual artists and their works. Hauser's use of the term "social history" meant something quite different than it does now; he dealt with the broad movements of institutions and ideas, while the social

historian of today tries to enter into the everyday life of the past and thus get beyond the privileged strata of society whose social predominance insured the preservation of their records for posterity. At the same time, Hauser used it in a specifically radical way, while contemporary social history is gradually becoming inflated by maximum historical detail and minimum concern for its political content.[4]

Art is generally produced by middle-class individuals who control sufficient resources to work full time at it, or are supported by patrons or institutions possessing the required resources. Since they must please their patrons, artists tend to project the aspirations and ideals of the dominant class. Uneducated laborers are too busy trying to survive to "make art." When they did leave records of their perceptions they did so for immediate use and personal applications. Most often, they produced handicrafted objects like furniture or store signs which are now paraded in museums as anonymous "folk art." If their illiteracy or lack of leisure time prevented the recording of ideas and thoughts in documents, these handicrafted items (except for songs and oral records) constitute the real heritage of the underclasses. But because they did not work to satisfy patrons—that is, people whose records have come down to us—they have been systematically ignored and their work undervalued in relation to "high" art. I would prefer to substitute for terms like "high" and "low" art the notion of the *utile* and the *inutile* to characterize these different forms of artistic production. Such terms would apply to the technical function of objects, while preserving their ideological applications.

In the period under question, ranging from mid-eighteenth to mid-nineteenth century, painting in particular offers a record of the profound changes wrought upon society by the progress of the middle classes and their attempt to consolidate their gains while fending off the aristocracy and the working classes. Although this art must inevitably yield an incomplete portrait of the social reality, it still affords us significant glimpses of it. In the process of studying art history through social history we will also perceive a visual record of social relations and daily life as diversely experienced by members of each class, race, and sex. The forms of social life depicted in each work analyzed will be compared with the historical accounts, which are themselves checked against multiple—often contradictory and confused—perspectives.

This book gives priority to the political interpretation of works of art and takes as its point of departure Marx's central idea of class conflict. Every scholar who wants to write about ordinary people in everyday life owes a tremendous debt to Marx. Marxism is one of the rare methodologies that looks at life from the point of view of the oppressed. My next-door neighbor in Binghamton would never consider himself "oppressed," but my dream to locate him squarely in the domain of social history could never have been even considered without the precedent of Marx. The basic questions that I ask of my material and the value I place on my writing and teaching is directly related to it. I want to make sense of artistic achievement in a total human context and seek a more authentic image of those whose suppression left scant place for them in visual productions.

This is where I am presently at on the intellectual grid. I know that I occupy some precisely mapped-out and safe terrain that is ultimately contained, if not actually regulated, by one bureaucracy or another. But I also believe that history is a comprehensible process, the knowledge of which forms consciousness and a sense of expanding possibilities. It would be naive of me to lay claim to a thorough understanding of the various mediations, stages, epochs, and ideologies standing between reality and cultural production. Neither do I wish to privilege my voice over another's, but rather I want my narrative set against the one that has been foisted upon me ever since I can remember and which I know to be patently false. I hope with this work to take a step in the direction of creating a sense of conviction that we can tear away the vest of illusion that keeps us imprisoned in the Bastille of History.

Albert Boime

Los Angeles
March 1985

Acknowledgments

The idea for this series grew out of my Art 54, Modern Art Survey, course that I have taught at UCLA since the fall of 1977. It owes a tremendous debt to the probing questions of undergraduates and graduate teaching assistants whose support of the course has greatly enriched our program. Their relentless demands for a text to fit the lectures set me to launching this project.

Many people throughout the world have contributed to the realization of Volume 1, and were I to list them all the acknowledgments would consume several pages. Though I regret omitting a single name I hope they know that I cherish their salutary criticisms, friendly advice, help in typing and translation, generous efforts to obtain for me photographic and bibliographical material—and, finally, the labors and even gentle prompting of the editorial staff of the University of Chicago Press who brought the book to its ultimate realization.

I am also grateful to the Guggenheim Foundation for a fellowship in 1984–1985 that enabled me to advance significantly the social history of modern art, to UCLA's Committee on Research for continuing grants to complete the project, and to Joey and Toby Tanenbaum and the Martin Foundation for subsidies to help keep the book at an affordable price.

Art in an Age of Revolution, 1750–1800

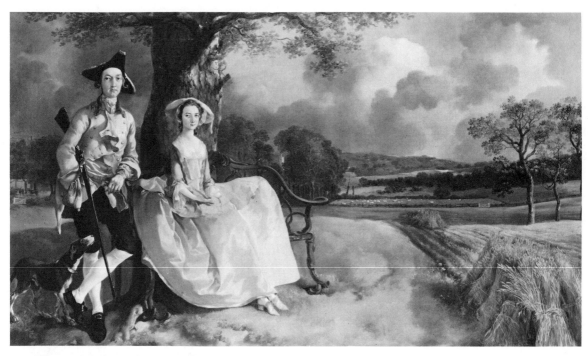

1.1 Thomas Gainsborough, *Portrait of Robert
and Mary Andrews*, c. 1748–1749. Courtesy of
the Trustees, The National Gallery, London.

1 Prerevolutionary Conditions (c. 1750–1789)

The two revolutions—the political French and the industrial English—and the social transformations they brought about represent a great divide in human history. They radically altered thinking and feeling forever after. No survey of any cultural institution of the period can omit the way it was affected by these events. No one living then could have escaped their all-pervasive impact.

This chapter sets out some of the general conditions prevailing in the prerevolutionary epoch, focusing on France and England. These conditions naturally reflected a world in flux, soon to be subjected to the upheavals caused by the dual revolution. One major catalyst, the Seven Years' War, particularly accelerated the revolutionary process, and we shall examine it in a separate chapter. Through a representative sample of the artists, we shall attempt to show here how art signified the contradictions of life during the prerevolutionary period. The metaphor for these contradictions is the proverbial coin: on one side, there are the elegant town houses, rolling estates, new wealth, refined taste, and the fascination for the exotic, and on the other, the worst destitution and hardship imaginable, alcoholism, starvation, disease, and the brutalizing slave trade, all of which constituted the real foundation for old luxury and new wealth.

The Western world just prior to the dual revolution was overwhelmingly rural. The worst poverty in the countryside was found among landless wage laborers, rural domestic workers, and those who inhabited infertile land. Generally, the peasantry could expect little but hardship and undernourishment; they had to deal with periodic widespread harvest failure, epidemics, and the plague. The provincial town still belonged essentially to

the economy and society of the countryside and lived for the most part off the peasantry. Its professional and middle classes dealt in corn and cattle, processed farm products; they supplied the lawyers and notaries who handled the affairs of noble estates or land-holding communities and the merchant-entrepreneurs who put out and collected for and from the rural spinners and weavers. Artisans and shopkeepers catered to the peasantry or the townspeople.

The agrarian problem was therefore the fundamental one in the eighteenth century, and it may be most clearly seen in the relation between those who cultivated the land and those who owned it, those who produced its wealth and those who accumulated it. The European economic complex still depended upon a quasi-feudal structure with the typical peasant as serf, committing a large portion of the week to labor on the noble's land, or providing its equivalent in other duties. This unfreedom was in many ways indistinguishable from chattel slavery in the colonies—the other major institution essential to the European economy. The characteristic landlord was a titled aristocrat or country squire who owned and cultivated large estates and exploited the peasantry.

The real picture of the countryside, however, is not often directly expressed in art; art was produced for wealthy patrons who wanted images of order, stability, comfort, and charm which would rationalize and legitimize their sphere of control. We can observe this function of art in a famous work by the English painter Thomas Gainsborough, the portrait of *Robert and Mary Andrews* (fig. 1.1). It depicts a young squire and his wife, newly married, he standing with his hunting rifle and she seated on an iron seat beneath a sturdy tree. Beyond them and off to the right stretches their fertile farmland, with special emphasis on the neatly gathered sheaves and the stubble of the wheatfield to their right. Gainsborough deliberately located the couple at the far left of the painting in order to allow a glimpse of the magnitude of their land, that is, the proprietary claim that grants them gentrified status. There is even a hint that the sense of property extends to the wife as well: in an unfinished passage she holds in her lap a dead pheasant just shot by her husband, symbolizing that she, too, has been snared in the "chase." The enclosed areas of the estate, including the fenced-off livestock, demonstrate that Andrews exploited advanced agricultural techniques like the new crop-rota-

tion schemes. Here Gainsborough gives us a picture of the rural world as a place of peace and leisure, of wealth and the capacity to apply it to efficient and modern ends.

There is no suggestion in this panoramic view of how all the order and prosperity was achieved; no sign of how the work was carried out in actuality. Judging from their dress and comportment it is clear that neither Robert nor Mary Andrews participated in the work process. The question is, then, who tilled the fields? While we see all the effects of labor, there is no evidence of labor. It is as if the carefully cultivated fields and well-groomed livestock were cared for by some mysterious force emanating from the Andrews. In fact, the Andrews lived off the fruits of the invisible tenant farmers and hired landless laborers, but they need not be represented: what the artist emphasizes is the ability of the protagonists to command the process of labor itself. Indeed, with the advance of the enclosure movement, which diminished the number of farms and increased their average size in favor of the big landowners, a large segment of the rural population was forced to leave the country to live in the towns. Rural society, once known for a long ladder of ranks and degrees of wealth, now became more sharply divided into employers and laborers—the latter occupying the lowest rungs of the social ladder.

Unquestionably, Gainsborough identified his interests with those of his upper-class patrons: his father had been a prosperous woolen merchant in Sudbury which he eventually represented in Parliament.[1] Thomas had even higher pretensions and behaved like a "gentleman." He studied with the French engraver Hubert-François Bourguignon Gravelot and the English portraitist Francis Hayman, both admired in polite society. He made his way painting portraits of fashionable types, capturing their rank through opulent costumes and graceful poses. His list of sitters reads like a "who's who" of English nobility.

In 1755 Gainsborough painted a pair of landscapes to decorate the country seat of the duke of Bedford, one of England's great landed and innovative aristocrats who literally ran an army of tenant farmers, laborers, servants, and gamekeepers.[2] One of the pictures is entitled *Landscape with a Woodcutter Courting a Milkmaid* (fig. 1.2). In this instance the artist actually represents rural laborers, but their existence is shown to be almost as idyllic as that of the Andrews. The focal point of the composition

1.2 Thomas Gainsborough, *Landscape with a Woodcutter Courting a Milkmaid,* 1755. By kind permission of the Marquess of Tavistock and the Trustees of the Bedford Estates, Woburn Abbey.

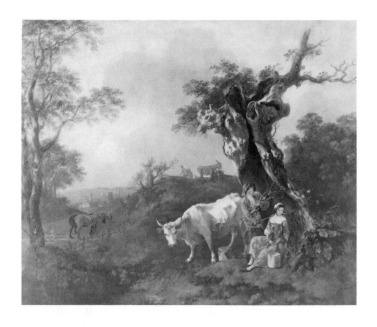

is the foreground pair of woodcutter and milkmaid who momentarily pause in their respective tasks to indulge in a harmless flirtation. At the same time, we see in the middleground a virtuous ploughman who plies his craft with single-minded devotion. This would seem to provide a kind of moral contrast with the idleness of the couple. As in the Andrews portrait, the male stands and the female sits in front of a large tree trunk. But whereas in the former leisure is shown to be a permanent way of life, in the latter it is but a momentary pause in the labor process. This is pictorially demonstrated by the fact that the milkmaid's cow forms part of a pictorial movement with the ploughman and his horses, conveying a kind of cyclical process in which work is the driving force. Yet none of the work appears toilsome: the ploughman is presented in the distance, and his action is neutralized by a pair of trees which cuts him off from the plough and all but obscures his relationship to it. Gainsborough thus creates the mythologized world of "Merrie Ole England," a contented land where all work together (but not too arduously) and reap the fruits of their common industry. In actuality, the poor knew little respite from drudgery. But Andrews and the duke of Bedford assumed it to be only "natural" that artists depict an idealized image of rural life to conceal the realities of material existence in the countryside, that real leisure was exclu-

1.3　Giacomo Ceruti, *Old Man Leaning on a Spade*, c. 1760. Collection L. Bonzi, Milan. Courtesy Alinari/Art Resource, New York.

sively reserved for them and implied total freedom from having to work for a living.

A more authentic picture of eighteenth-century rural life comes through in the work of the North Italian painter Giacomo Ceruti, *Old Man Leaning on a Spade* (fig. 1.3).[3] Ceruti, who was active through the middle of the century, rejected the idealized projection of the countryside, and for this he has suffered profound neglect. Known as "Il Pitocchetto," or "The Beggar," he came from Brescia and began his career in the typical way of executing portraits of the feudal aristocracy in Lombardy. In Milan he made contact with progressive intellectual circles inspired by the thinkers of the French Enlightenment. He then turned for his subjects to the poor—peasant laborers, beggars, lost waifs, laundresses, and handicapped persons from the most neglected sectors of society. How he earned his living doing these pictures remains a mystery, nor do we know the audience for which he must have painted.[4] It is possible that they were commissioned by a state official who wanted studies of the "lower orders" for bureaucratic records, or they were done to satisfy the perverse taste of a decadent aristocracy. For what is remarkable in these works is their absence of sentimentality and their straightforward depiction. The peasant laborer in our example is exhausted from fatigue, his clothing in tatters, his face weatherbeaten and prematurely aged. Unlike Gainsborough, Ceruti presents the image of a suffering human being whose weary body takes respite from numbness due to prolonged and relentless physical exertion. Ceruti composes the picture in the conventional triangle but with a somewhat unstable base. The body is barely supported as it tilts forward on the handle of the tool which itself contacts the ground only at the point of the implement. The effect of this work is to project the provisional status of the serf against the Renaissance use of the triangular motif which emphasized permanence and monumentality.

Ceruti's peasant gazes directly at the viewer, a device he also employs in his depiction of children (fig. 1.4). But they neither ask for condescending pity nor do they entertain; they regard the spectator with self-understanding. Not only in the portrayal of adults but also in the presentation of children do artists transmit the material and ideological concerns of their epoch. Ceruti frequently shows youngsters doing menial tasks or begging—in a time that has come down as the great age for images of

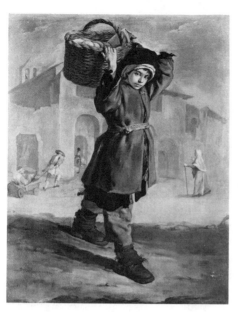

1.4 Giacomo Ceruti, *The Young Porter*, c. 1750. Pinacoteca di Brera, Milan. Courtesy Alinari/Art Resource, New York.

children. Locke's notion of the newborn mind as a *tabula rasa* gave rise to fresh consideration of learning and social status. Children born to noble families are at the same level as children born to laboring families; lack of opportunity and privilege prevents the latter from achieving their potential. This is caricatured in Fielding's *Tom Jones* (1749), where despite the fact that the highborn foundling is treated as an ordinary lowborn, in the "right" home of Squire Allworthy he attains his "rightful" position in society. Rousseau's *Emile* (1762), another novel that advances heretical views on childrearing (although quite conservative on the status of women), similarly reflects the interest in children stimulated by the increasing attacks on the privileges of caste. It is in this period that we get the modern definition of childhood as a specific age, distinct from adulthood, of the child as the tender, innocent being who merits special coddling. In medieval society the idea of childhood as a distinct category did not exist; in the puritanical seventeenth century the child is perceived mainly as a delicate creature who needs to be protected from malevolent forces and reformed; in the eighteenth century the child comes to occupy symbolically a central place in the family. This is seen in Lord Chesterfield's obsessive *Letters to His Son* (1774) on how to succeed in society.

Many artists in this period become adept at catching the "cute" character of the child and depicting it in a modern sense, with its specialized garb and playful curiosity. While most images of children in art and literature of the period that have come down to us show youngsters in well-to-do surroundings, Ceruti is again exceptional in revealing the child of the poor. Rural children were expected to be self-supporting by the time they were six years old to relieve the strain on the family budget. Since in agrarian communities there was little for them to do outside of haymaking and harvest, children resorted to beggary in the towns and cities. Here visitors could expect to be besieged by hordes of children trying every trick of the trade. For poor children there was no age of innocence, only one of survival in the world of the underprivileged. Worse yet, there was barely any escape from one's social position; no way that parents could guarantee that their children would ever do any better. Significantly, several heroes of Fielding and, later, of Dickens, while identified with the working classes, ultimately prove to be the children of well-placed families.

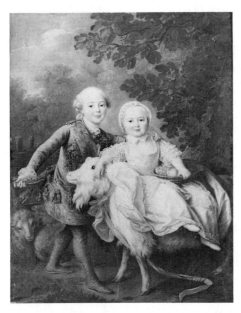

1.5 François-Hubert Drouais, *The Comte d'Artois and His Sister, Madame Clotilde*, 1763. Musée du Louvre, Paris.

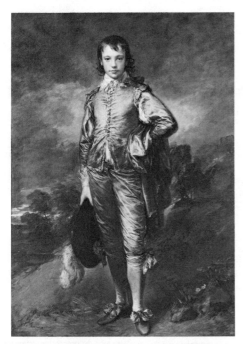

1.6 Thomas Gainsborough, *Blue Boy*, c. 1770. Reproduced by permission of The Huntington Library, San Marino, California.

As in art, literary depictions of children were full of contradictions depending on the writer's background and aspirations. The English poet-artist William Blake, like Ceruti, expressed the flipside of the coin—especially in his *Songs of Innocence* and *Songs of Experience*. One of Blake's most poignant poems is the *Chimney Sweeper*, the subject of which was a familiar sight in London. Very young children were particularly open to exploitation in this trade since they could climb up the narrow chimneys, but the job also deformed their bodies and discolored their skin.

The children of the most privileged classes are shown in different trappings and communicate another set of meanings. The French academician François-Hubert Drouais was a favorite painter at the court of Louis XV for his portrayal of children. In 1763 he executed the portraits of two of the royal children, the future Charles X, young brother of Louis XVI, and his sister, the future Queen of Sardinia (fig. 1.5). It is clear from Drouais's treatment that *ancien régime* culture, with its emphasis on surface charm, bodily gestures, and costume as an indication of one's social rank, extended to children as well. The portrait represents the etiquette of court youngsters who emulate adults in their contrived poses, costly wardrobe, and even in their enactment of pastoral fantasies. The young girl is dressed as a shepherdess; she holds a basket of fruit and rides on the back of a goat. It was a commonplace form of leisure for courtiers to play as rural folk, a kind of gracious "slumming" in which homage was paid to a simpler way of life. At the same time, there was no recognition of the real hardships of this life, and the ritual was enacted in the context of the actual freedom of this class from the need to exert any physical labor to survive.

Another example of the representation of privileged children is Gainsborough's well-known *Blue Boy* (fig. 1.6). A model of aristocratic refinement and poise, the sitter was actually the son of a wealthy Soho hardware merchant who was a close friend of the painter.[5] The growth in the demand for iron pots in both the domestic and foreign markets made the ironmongers one of the symbols of the rising bourgeoisie. The elder ironmonger died in 1768, and Gainsborough's subject is the heir to the family business which he ran until 1796. The youth, Jonathan Buttall, wears the seventeenth-century "cavalier" fashion, a form of "fancy dress" lifted from Van

Dyck's portraits which supplied the English upper classes with their idea of aristocratic elegance. Gainsborough exploited all his talents to impart to this child of an upwardly mobile middle-class family the aristocratic ideal. Yet, at the same time, this youth projects the confidence and poise of a group that would wrest power from the aristocracy with the onset of the Industrial Revolution.

The status of women in this period was also in flux. All working-class women in the eighteenth century were expected to work to support themselves when single and contribute to the family income when married. They had three possibilities: (1) unmarried women could do domestic service; (2) wives performed domestic industry central to the family economy, including spinning wool or cotton and lacemaking; (3) rural women carried loads. Domestic industry was essentially for women at home; they could perform their tasks while the baby lay in the cradle or the children played. But changes were taking place that posed an immediate threat to this situation—at least as far as spinning was concerned. Distribution of the raw material and collection of the finished product entailed an elaborate network of itinerant merchants, with the result being a rather irregular and inconvenient process. It is not surprising that spinning was the first process to undergo industrial change and adversely affect

1.7 Giacomo Ceruti, *Laundress*, c. 1750. Pinacoteca Civica, Brescia.

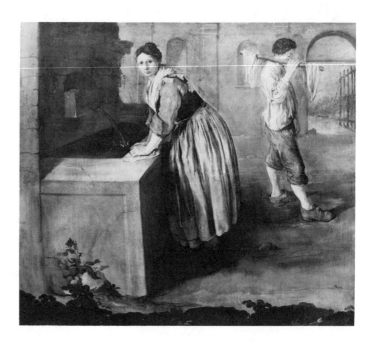

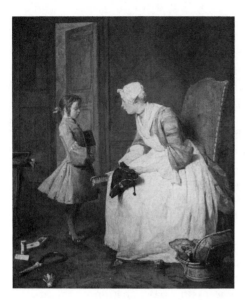

1.8 Jean-Baptiste-Siméon Chardin, *Governess*, 1738. The National Gallery of Canada, Ottawa.

the family economy. The family was undermined as the basic unit of production when the spinner was taken out of the house and the married woman could not work at the factory.

In the countryside, the commonest form of female labor was load carrying; the hillside terraces of Spain, France, and Italy were kept watered by thousands of women who daily made the steep ascent with buckets carried on their heads. Women also carried soil, coal, vegetables, and refuse. Perhaps at the other extreme of the female work force was the governess, who usually came from a middle-class background but worked for families in foreign countries where the change of status could be rationalized in terms of the cultural change.

Representations of women are often an indicator of an artist's class status or aspirations. Ceruti portrays his concern for laboring women in works like his *Laundress* (fig. 1.7), depicting a common type of manual work of the most exhausting kind. The French painter Jean-Baptiste-Siméon Chardin showed a painting of a *Governess* at the Salon of 1739 (the academy's official exhibition) which was acquired by the banker Despuechs and passed soon afterward into the collection of Prince Jozef-Wenzel of Liechtenstein (Fig. 1.8). Chardin painted still lifes and interiors of a middle-class type which appealed to the well-to-do members of this group and to aristocrats who identified themselves with the appearances of sobriety as against the profusion and license of courtly life. Even foreign rulers like Frederick the Great, Queen Louisa Ulrica of Sweden, and the Prince of Liechtenstein purchased Chardins as a sign of their "enlightened" attitude. Here in the ambience of a prosperous but unostentatious home the governess admonishes her young ward on the way to school in the virtues of neatness and orderliness. The boy, dressed in this instance like a miniature adult, listens with eyes lowered but in full understanding of the message. In the foreground, Chardin draws attention to the contrast between the clutter of his toys and the neat organization of the governess's working tools. But she holds a cleaning brush, and he a book: the governess is essentially a household servant (and surrogate mother) whose role is to indoctrinate children with a seriousness of purpose. She is there to promote their advancement, reflecting the middle-class aspiration to political as well as economic power based on merit rather than birth. Understandably, Chardin's work became increasingly popu-

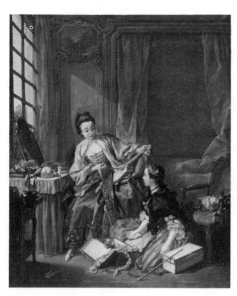

1.9 François Boucher, *Modiste*, 1746. Nationalmuseum, Stockholm.

lar after mid-century, when the morality and life-style he glorified projected the growing assertiveness of the rising bourgeoisie.

Chardin's opposite—a confrontation established in their own lifetime—was François Boucher, the First Painter to the King. He personified the taste of the ruling class in his manifold role as painter, decorator, and applied artist. Boucher's close connection with the court made him subject to attack by the same Enlightenment critics who denounced his patrons for their profligacy. His *Modiste* of 1746 is more than an observation of an aristocratic pretension; it conveys clearly in its love of rich textures, warm colors, and full-bodied painting the pleasures that made life irresistible for the privileged few (fig. 1.9). An elegant woman who has just had her hair done sifts through a wide assortment of ribbons presented to her by a milliner who kneels at the woman's feet in eager expectation. The main preoccupation of the aristocratic client is trying to decide which of the ribbons to wear. It is no coincidence that the world of high fashion found its perfect apologist in Boucher; his father had been a Parisian lace designer who worked for the luxury trade.[6] The successful artisan and the successful artist of the *ancien régime* worked for the same clientele that flaunted its wealth as a sign of privileged status.

In the contrast between the works of Chardin and Boucher we observe an important law of the artistic jungle in this period. Artists, dependent on patronage, could not insult their masters and had to paint for them images that please and incarnate their values. In the case of painters born in our period, the majority came from the skilled artisanate or the middle classes, and success required their dependence on the dominant elite. But their own desire for self-advancement generally needed little ideological prompting. Few children of the peasantry could be inculcated with such a desire since their outlook was basically fatalistic. Thus it is vital to consider the class origins and class aspirations of artists to historically position their art.

For, in fact, histories of art, depending on the period in which they appear and the bias of their authors, tend to select and manipulate the visual evidence to suit this or that theory of artistic change. Since they are not concerned with history, emphasis is placed on "classic" works that support and demonstrate a theory of style. Thus we often get imbalanced or partial views of partic-

ular artists and observe only one aspect of their work. The eighteenth century is a perfect example of this, as we generally see paraded erotic themes of Boucher and his disciple Fragonard which fit the preconceived ideal of the *ancien régime*. The way out of this quagmire is to consider the audience for which the artist worked. In this period, the court in France assumed the position of a parasitical body in France, stripped of actual power as a result of Louis XIV's desire to centralize his government and trade the power of the landed nobility for social and economic privileges at Versailles. On the other hand, the middle classes progressively acquired material power, although they remained blocked from key political and official positions. Since the time of Louis XIV the middle class made gains at the expense of the nobility, who constituted an obstacle to their social progress in the eighteenth century. The growth of the middle class provided the dynamic for change during the period and constituted a critical audience for art: it was this group, comprising merchant, professional, rich artisan, and even well-to-do peasant that felt hampered by the restrictions and privileges of the aristocratic class structure.

An understanding of the art of the period requires at least a general idea of the artist's patronage, whether he painted declamatory eulogies or heroic scenes from French history for the court, erotic charades for the nobility, or homely scenes for the sober middle class. These currents were not, however, exclusive or independent; on the contrary, they frequently fused and influenced one another.

The art of eighteenth-century France was in general closely linked to the luxury trade, whose center was still the court. The traditional label for this art, "rococo" (from the French *rocaille* or "pebble" and *coquille* or "shell"), suggests a world of sensuous objects, things in miniature, ornamental decoration, and the intimate interiors of the aristocrats and upper middle classes who abandoned the court of Versailles after the death of Louis XIV (1715) for the pleasures of Paris society. When we use the term "objets d'art," we are essentially invoking the mania of collectors in this period for things of value to display indicating refinement and erudition—and this included natural objects like shells or geological specimens.[7] French industry in the period was still largely confined to handicrafted luxury goods; it was only toward the end of the century that the Industrial Revolu-

tion and the advances of applied science began to be felt in France.

The institution of fine arts servicing the court and the higher nobility was the Académie Royale des Beaux-Arts. Its authoritative position made it a major influence on almost all art production of the period. While comprising both honorary and pedagogic functions, it also served as a crediting body whose imprimatur guaranteed a career in the arts. To win the Grand Prix de Rome and return to become an *agréé* of the academy meant that one was privileged to exhibit at the official Salons (biannual from 1748 to 1795), where important patrons could be introduced to the latest works.

The official exhibition, founded in 1667, was held ceremoniously from 1725 in the *Salon carré* (literally the *square* gallery) of the Louvre. It was tremendously popular with the educated public and often attracted a solid segment of the popular classes as well. But though the contemporary critics referred to the occasional shop girl, clerk, and artisan, their references to "society" had a much narrower application than they do today. Society prior to the Revolution was defined in terms of the elite—a definition carried over to more recent times in the "society pages" of the local newspapers. The various social groups of the *ancien régime* were divided by special showings and previews, and in particular by the exhibition catalogs, or *livrets*, which were beyond the financial reach of the nonnoble, nonprofessional, and nonmercantile groups. The critics who reviewed the exhibitions keyed their discussions to those who could afford the *livrets*, since their reviews were often published in pamphlet form and meant an additional expense.[8]

Elsewhere, too, academies of art and regular exhibitions under royal sponsorship proliferated during the eighteenth century, attesting to their high priority as selectors and advertisers of enlightened rule and acceptable culture. In this way they came increasingly to administer to overtly propagandistic ends. The Royal Academy in England was founded in 1768 under the patronage of George III, partly to outshine his rival Louis XV across the Channel, whom he defeated in the Seven Years' War. Academies directed and shaped art production through their indoctrination of a younger generation, through their support of certain stylistic categories, their preference for certain subject matter, and their rewards for artists who conformed most readily to these constraints.

The French academy came under the jurisdiction of the directeur (later surintendant) des bâtiments who answered directly to the king himself. Surintendants generally had noble status and profoundly affected the taste of their time, controlling the dispensation of royal commissions, choosing administrators at Paris and at the branch at Rome (where the Prix de Rome winners lodged), and advising important collectors. The surintendant clearly influenced the choice of membership in the academy as well, and also recommended to the king those artists who could be designated First Painter to the King.

Naturally, academy members had the highest social prestige in the artistic community, and most of them have come down through history in one way or another. The long training leading to membership was divided into three essential stages: the *Grand Prix*, the *agrément*, and the *réception à l'académie*. The *Grand Prix*—later known as the Prix de Rome—was a traveling fellowship that made it possible for a talented disciple to live at the branch of the academy located in Rome and directed by an eminent painter chosen by the surintendant. After mid-century, the pensioners at Rome were required to send back to Paris regularly specific types of work as proofs of progress. After returning from Rome, students had to be approved by their seniors by submitting one of their works to the assembled academicians. Women were not eligible for the *Grand Prix*, but they (as well as males who failed to win the prize) could join the academy in a minor category. The highest prestige, however, attached itself to the *Grand Prix* winners who epitomized the pinnacle of the academy's hierarchy of modes, the history painter. The hierarchy of modes represented the academy's ranking of subject matter, with history painting (sacred or profane) at the top and still life and landscape at the bottom. After being *agréé*, the candidates were required to present a *morceau de réception* (reception piece) on a given subject usually within a year's time. The subject of the reception piece designated the *agréé*'s place within the hierarchy: history painter, portraitist, genre, painter of still lifes, landscapist.

The status of the painter depended upon his or her category, with history painting meriting royal distinction. The subjects of these paintings were most often selected from biblical, mythological, and ancient history, but they also included themes glorifying the king and depicting significant events of his reign.[9] Since the king justi-

1.10 François Boucher, *Rising of the Sun*, 1753. Reproduced by permission of the Trustees of the Wallace Collection, London.

1.11 François Boucher, *Setting of the Sun*, 1753. Reproduced by permission of the Trustees of the Wallace Collection, London.

fied his position through mythological, religious, and historical allusions to his exalted ancestry, it may be seen that the hierarchy of modes was oriented around the royal ideal. Thus the privileged painters were those whose repertoire tended to exalt the king and the meaning of kingship in various contexts. Not surprising, those who fell into this category were also those who became *Premier Peintre* and Officers of the Academy. First Painters to the King were invariably ennobled and held all the "honors, authorities, powers, pre-eminences, prerogatives, privileges, franchises and liberties that pertain to the office."

There was within the structure of the academy itself a social hierarchy consisting of *agréés*, *académiciens*, and *officiers*. They roughly approximated the class structure in society, with the last group a privileged body analogous to the aristocracy: it received preferential treatment in the Salons and made all the administrative decisions. Even their places at an assembly were distinguished by richly upholstered armchairs as opposed to the wooden benches of the academicians.

An example of a model academician was Boucher: he won the *Grand Prix* in 1724, became *agréé* upon his return from Italy in 1731, and three years later was received as a history painter. He was a virtuoso performer, ultimately standing at the center of the decorations and remodelings of the royal residences at Versailles and Fountainebleau, decorating the townhouses (*hôtels*) of the upper classes, creating sets for the opera, executing cartoons for the Gobelins Tapestry Works and designs for ceramics and interior furnishings. Indeed, the profuse expenditure on buildings, fetes, ornamentation, and works of art associated with Boucher was in good measure responsible for the antiluxury arguments and accusations of corruption directed at the court. His virtuosity and facility complemented all too well the court's taste; it found in him their perfect apologist, and he was designated *Premier Peintre du Roi* in 1765.

While Boucher's approach softened the classical style admired by Louis XIV and made it more decorative, the ideological implications of his work remained the same. Boucher's two designs for the Gobelins Tapestry Works, the *Rising* and the *Setting of the Sun*, indicate how mythological history painting served the royal house (figs. 1.10, 1.11). These were later commissioned by Madame de Pompadour, the favorite mistress of Louis XV, to deco-

1.12 François Boucher, *Madame de Pompadour (Jeanne-Antoinette Poisson)*, 1758. Courtesy of the Board of Trustees of the Victoria and Albert Museum.

rate her recently completed country house, Bellevue, a gift of the king. Her features are clearly discernible in the head of the nymph who comes forward from a crowd of courtiers in the *Rising of the Sun* to greet Apollo.[10] The radiant god is the flattering persona for Louis XV himself, a royal allusion made popular by the identification of Louis XIV—"The Sun King"—with the mythological deity. In the *Setting of the Sun* Apollo now reaches out to the nymph, as if he has chosen her from the crowd of attendants.

Boucher, like all history painters who had proven himself, could be called upon to execute a variety of commissions, including portraits, landscapes, and genre themes. His success was intimately tied to the patronage of the marquise de Pompadour (Jeanne-Antoinette Poisson) who greatly influenced the contemporary taste and helped make Versailles the art capital of Europe. Her mother's lover, Lenormand de Tournehem, and her brother, the marquis de Marigny, served successively as directeurs des bâtiments. While she became the focus of the dissatisfaction with courtly extravagance, she was hardly the frivolous concubine history has made her out to be. She supported the founding of the royal porcelain factory at Sèvres and participated in the running of the Gobelins workshops. Her favorite painter was Boucher, and it is easy to see why in his portrait of her seated in the garden at Versailles (fig. 1.12). He shows her acting out the Enlightenment demand to check the imperatives of reason and intellect with the promptings of nature. She pauses in her reading of a musical piece (she was a talented musician) to listen to the song of a bird on a nearby branch. Boucher's portrait is an ingenious stratagem, making the spectator presuppose her intellectual attainments presently abandoned to momentary impulse; the whole paradox of Rousseau's critique of culture is that his own capacity to criticize the overrefinement of modern society springs directly from that culture. The nostalgia for a person in a state of nature reflects a highly self-conscious and sophisticated viewpoint. Boucher's portrait rings false in the convenient moss-covered rock on which the manuscripts repose and the stagelike backdrop. This is not a "state of nature" but an artificial environment privately owned. It is not surprising to learn that Boucher possessed precious collections of blue butterflies and brilliantly colored stones.

Boucher idealizes Pompadour in the form of a porce-

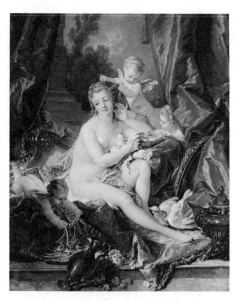

1.13 François Boucher, *The Toilet of Venus*, 1751. The Metropolitan Museum of Art, New York. Bequest of William K. Vanderbilt, 1920 (20.155.9).

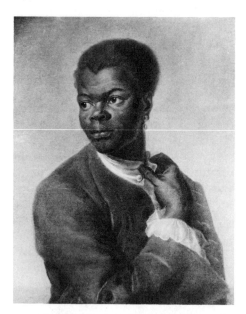

1.14 Maurice Quentin de Latour, *Portrait of a Black Servant*, 1741. Musée des Beaux-Arts, Geneva.

lain doll and pays conspicuous attention to the ample silken costume, reflections of an opulence also contradicting the overt message of the picture. Among the decorations Pompadour commissioned from the painter for her residence at Bellevue were a set of pictures for a luxurious bathroom. This group probably included *The Toilet of Venus* of 1751 (fig. 1.13)—painted the same year in which appeared William Hogarth's *Gin Lane* and volume 1 of Diderot's *Encyclopédie*. While it is clearly a decorative panel, the dazzling surface technique, sensuous textures, and profusion of precious objects that seem to spill over at the boundaries typify Boucher's work. Since we know that Venus was modeled after the Pompadour, it would seem that the surrounding luxury in the picture is the visual equivalent of her actual wealth. Boucher's painting is both a mirror of the fortune and status of its possessor and an object of luxury itself. The glittering array of satins and silks make us forget the slave trade on which it was based as well as the striking silk workers of Lyons—the center of the European industry—who were ruthlessly suppressed in a 1744 uprising.

The mark of the privileged classes and those of the middle class able to emulate them was to live "nobly"—to live in magnificently furnished town houses, to provide custom for artists and the manufacturers of such luxuries as silk, porcelain, silverware, and mirrors, and to be the main consumers of the colonial imports which (combined with the slave trade) brought prosperity to the shipowners and merchants of towns like Bordeaux and Lyons. Despite the wars, inflation, and periodic famines, the years 1730–1778 were a time of relative agricultural prosperity, with the result that for nobles and middle class alike land was an attractive form of investment. Yet the poor peasants remained poor: they shouldered the tax burden while the surplus profits from agriculture went to the landowners and rich bourgeoisie. Among those who profited most were the farmers-general,★ a group of powerful financiers who often collected the rents and feudal dues for the large proprietors. The Pompadour's uncle and protector, Lenormand de Tournehem, began his career as a farmer-general, and it seems inevitable that she and Boucher, the son of a Parisian *maître-peintre* and lace designer employed in the luxury

★ The privilege of tax collecting was literally "farmed out" to this group.

1.15 Nicolas Lancret, *Escaped Bird*. Courtesy Museum of Fine Arts, Boston.

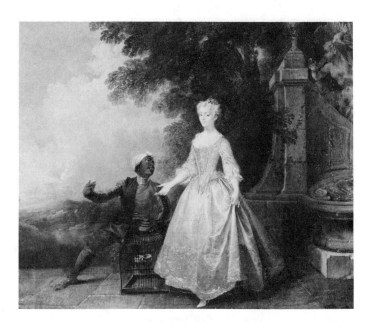

trade, should come together under the aegis of the rococo.

In addition to the peasantry at home, colonization and the institutionalization of slavery abroad provided the foundation for eighteenth-century wealth and culture. Commodities like sugar and tobacco were produced by slave labor and exchanged in the world market. Black people appear regularly as servants in the imagery of the period: the black servants in Nicolas Largilierre's *Portrait of Princess Rakoczi* (National Gallery, London), Maurice Quentin de Latour's *Portrait of a Black Servant* (fig. 1.14), and Nicolas Lancret's *Escaped Bird* (fig. 1.15) are depicted in luxurious environments as exotic objects. While black people in Europe suffered less hardship than the plantation slaves in the colonies and trading stations, they were often flamboyantly costumed and paraded as a sign of luxury much as any other prized possession. What is essential to realize is that the shimmering surface technique and sensuous color that we often observe in the aristocratic art of the period represents the painters' involvement in the contemporary culture and the extent to which they were attuned to courtly ostentation and surface display.

The wealthy merchants, bankers, doctors, and tax farmers now began to rival the aristocratic collectors; at first they emulated the aristocracy in manners and art but

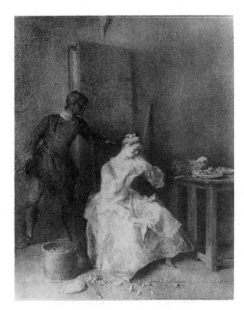

1.16 Nicolas Lancret, *The Black Servant and the Cook*.

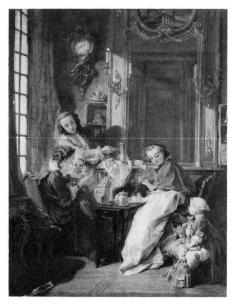

1.17 François Boucher, *The Breakfast*, 1739. Musée du Louvre, Paris.

gradually imposed their own taste. Lancret's *The Black Servant and the Cook* shows the kitchen of a middle-class home, with less emphasis on refinement than on the condescending view of two servants caught unawares in a playfully erotic situation (fig. 1.16). No longer accessory to their wealthy employer, servants—black and/or white—can be shown on their own so long as they are confined to their "native habitat." Lancret was himself a wealthy person who employed servants and also invested in the chartered trading companies that constituted a vital part of the *ancien régime colonial*.[11]

The examples of Boucher and Pompadour reveal the contradictions of their class in seeking both the wealth denoting status and the Enlightenment ideals which, among other things, advised better fiscal management of the nation's resources. But Boucher painted for more than one audience—his work could embody middle-class values at times. The earlier *Breakfast* of 1739 is a genre picture of the interior of a middle-class apartment with its paneling, brackets, and rococo clock (fig. 1.17). An idealized image of family harmony and modest bourgeois living, it focuses on the children both thematically (all eyes are turned to them) and formally (the diagonal leading from father to the child at the right). It is in this period that the middle-class family begins organizing itself around the child and raises the wall of private life between itself and society. The family cuts itself off from the world to better control the development of the child and encourage its aspirations. The middle-class family forged its identity by withdrawing from the promiscuity imposed by the old sociability and uniting its various members by feeling, habit, and their way of life.

On the shelf at the left is a seated Chinese figurine called a *Pu-tai*. This figure was identified symbolically with domestic bliss, but more important its presence here attests to the period's taste for Chinese artifacts. A great vogue existed in the eighteenth century for original works of the Far East as well as European copies and derivations known as *chinoiserie*. The relatively high cost of the originals encouraged domestic imitations which often resulted in hybridized conceptions, as in the case of Boucher's fantastic series of designs for cartoons executed by the Beauvais Tapestry Factory (fig. 1.18).[12] One set was made for Mme. de Pompadour, three for Louis XV, and still another for the Chinese emperor. The taste for luxury and exoticism stimulated a riot of fantasies in

1.18 François Boucher, Chinoiserie design for cartoon executed by the Beauvais Tapestry Factory. Museum Boymans-van Beuningen, Rotterdam.

the oriental mode, and while chinoiserie dated from the previous century it was never as prevalent as in the mid-eighteenth century. The popular taste for Chinese porcelain emerges in this period (still retained in the English term "china" for porcelain), and even the first Chinese restaurants make their appearance at this time.

Beneath the obvious affinity of the rococo style with chinoiserie, its sinous designs, light tints, and love of the miniature, there were more basic explanations for the vogue. Chinese porcelain became one of the most valuable items of Eastern trade in addition to tea and silk, and as part of the luxury trade was a sign of social prestige. On another level, there was now considerable philosophic interest in Chinese culture and government. The Jesuit missionaries who tried to convert the Chinese in the seventeenth century became engrossed in the study of Confucius; in 1687 they published a French translation of his works at Paris and gave glowing accounts of the Chinese Empire which they claimed to be a model of wise government. Many Enlightenment leaders—despite their inconsistent views on the question—admired the Chinese bureaucracy for making appointments on the basis of merit and not privilege, on talent and not on birth, and praised the traditional Chinese respect for parental authority. Voltaire emphasized the superiority of Chinese ethics over Catholicism, while Rousseau's followers could find in the *Tao Te Ching* of Lao Tzu the critique of civilization as decadent and the desire to restore primitive conditions.

François Quesnay, Mme. de Pompadour's physician and a physiocrat (a group that espoused the idea that land

was the source of all wealth, thus rationalizing in economic terms the pastoral fantasy),[13] shared Pompadour's enthusiasm for Chinese art and culture. When in 1750 Jesuit missionaries to China returned with a native scholar named Ko, Quesnay and Pompadour had him attached to the court where he remained for thirteen years. The three even persuaded Louis XV to follow the Chinese emperor's example of guiding the plough at the opening of the 1756 spring tilling. Quesnay, who later became known as the "Confucius of Europe," rated Chinese philosophy above the Greek, celebrated the Chinese state for educating its people and for basing itself on science and natural law, and even proposed a scheme of a graduated income tax designed after a Chinese model. Ultimately, Quesnay, who wrote for the *Encyclopédie*, wanted reform of the French monarchy along Chinese lines, and many members of the court who thought it in their best interests to project an enlightened attitude supported his position. Chinoiserie thus propagandized for the dominant culture by seemingly signifying a rethinking of social and political priorities.

Jean-Baptiste-Siméon Chardin, a member of the Academy in "lower standing" than Boucher, was identified with ideals of the progressive middle class.[14] Yet he, too, cannot be isolated from the dominant social network and shows the commercial implications of chinoiserie. His *A Lady Taking Her Tea*, for example, seems to epitomize in its quiet sanctity a middle-class domestic ideal (fig. 1.19).

1.19 Jean-Baptiste-Siméon Chardin, *A Lady Taking Her Tea*, 1736. Hunterian Art Gallery, University of Glasgow.

The uncluttered composition, harmonious design of the vertical of the woman's body and horizontal established by her right arm and the table top, the slowly rising steam, and the pleasant smile on her face create a sense of self-satisfaction and repose. In this period, European diets began to be affected by the growing import of tea from the East and made profitable the commercial ventures of the English East India Company and the French Compagnie des Indes in which Lancret invested. The eighteenth century was a great age of tea drinking, especially in England. Tea reached Europe from China chiefly in Dutch vessels, to be auctioned at the great ports. It was in an attempt to compete with the Dutch that tea growing in India was undertaken. It is perhaps no coincidence that an English collector purchased Chardin's work and that the association of tea with the commercial exploitation of overseas colonies would become so close that a crucial step toward the American Revolution came over the collection of a tax on tea. The event that ever after was called the "Boston Tea Party" was prepared in 1773 by the ladies of Edenton when they solemnly swore "not to conform to the pernicious custome of drinking tea." The seemingly trivial subject of Chardin thus becomes meaningful in terms of eighteenth-century commerce and class status: tea had not trickled down to the popular classes, but it was available to the middle classes.

Generally, Chardin's interiors and still lifes are models of simplicity, order, and domestic bliss, constituting the static worldview of a self-confident segment of the middle class. Yet it is essentially conservative and follows the artist's own life-style which he in turn inherited from his father, a royal cabinetmaker who specialized in billiard tables. Throughout his life, Chardin maintained close connections with the court. He received both official commissions from its members and independent commissions from affluent bankers and merchants. Chardin's carefully worked surface, passion for domestic objects, and modest themes reflect the thrifty and practical-minded French artisan sure of success within the current social structure. The middle-class ethos of hard work and dedication to *métier*—a term referring to both craftsmanship in particular and vocation in general—is at the bottom of Chardin's worldview and his professional activity. Ultimately, he attained membership in the Académie Royale and was appointed its treasurer in 1755. His loyalty to the academy was never questioned: he kept its accounts

1.20 Jean-Baptiste-Siméon Chardin, *The Card Castle*, c. 1737. Musée du Louvre, Paris.

1.21 Jean-Baptiste-Siméon Chardin, *The House of Cards*, c. 1737. National Gallery of Art, Washington, D.C., Andrew W. Mellon Collection.

in good order, cataloged its library, and organized its Salons (the exhibitions of the academicians' work opened to the public). While this may seem surprising in view of the fact that Chardin was discriminated against by the academy because of his type of subject matter, he himself accepted, apparently without public criticism, its hierarchy of subject modes.

Chardin's career undoubtedly suffered from the fact that the genre of history painting was inaccessible to him. Late in life, his request for a royal pension was refused by Pierre, then Premier Peintre due Roi, on the grounds that his type of art did not entail the expenses and time of his colleagues practicing history painting. Yet it seems clear that Chardin accepted this kind of discrimination because he accepted his social status in the hierarchical regime. This is revealed partly in his imagery: the confrontation of two versions of children building card castles indicate social distinctions and degrees of success (figs. 1.20, 1.21). While both engage in trivial amusements the aristocratic child, symbolized by the Knave of Hearts facing the viewer from the open drawer of the table, is tidy and builds an effective structure, while his less fortunate counterpart is somewhat disheveled and less efficient. By virtue of fronting the spectator with the open drawer, Chardin further enforces a distance that adds to the aristocratic child's exclusivistic space.[15] In his still lifes, Chardin often establishes a hierarchy among the various things represented, with objects of refinement like a porcelain or polished metallic container dominating all the rest (figs. 1.22, 1.23).

At the same time, his pictures of children project a moralizing approach consonant with the painter's class position. In other examples of this type, Chardin depicts youths spinning tops or blowing bubbles—traditional symbols of the transience of human existence (figs. 1.24, 1.25). The boy with the top (pointing to a life of limited duration) ignores his books and writing lesson, while the bubble blower (bubbles refer to the idea of *vanitas* or ephemeral world) indulges in an idle pastime. Appropriately, just as he criticizes idleness, he celebrates the useful labor of the *Kitchen Maid* and the *Kitchen Boy* (both in the Hunterian Museum, Glasgow) and the *Draftsman* (National Museum, Stockholm). Diligence is a virtue to emulate, although especially gratifying when practiced by the laboring classes.

Chardin's genre scenes (scenes of everyday life) and

1.22 Jean-Baptiste-Siméon Chardin, *Still-Life with Bowl of Plums and Delftware Pitcher*, c. 1760. The Phillips Collection, Washington, D.C.

still lifes point to progressive influences in contemporary French life and culture. The advanced ideas then circulating in French society derive largely from those countries where the middle class had developed most rapidly, England and Holland. Now predominantly Protestant, both countries enjoyed effective mercantile economies supported by powerful navies, with England ahead in its development of industrial potential. France looked into both as culture models in one form or another: from the Dutch it assimilated the taste for genre and still-life im-

1.23 Jean-Baptiste-Siméon Chardin, *Bronze Goblet and Fruit*, c. 1760. Courtesy Museum of Fine Arts, Boston.

agery, and from the English it borrowed the philosophic and moral concepts that stimulated their Enlightenment.

The art we now identify with middle-class taste—that is, the modes held inferior by the academy—had had a complete development in Holland during the previous century. Progressive French people looked to Holland, in general, out of admiration for its commercial supremacy and because it associated its culture with civil liberty. When the system of religious toleration set by Henri IV was ended by the Revocation of the Edict of Nantes in 1685, French Protestants in large numbers sought refuge in England and the Low Countries. In Holland they developed powerful French publishing houses, and Amsterdam became, and remained until the Revolution, an important center for the dissemination of liberal French ideas. One of the outstanding French Protestants in Holland was Pierre Bayle, a pivotal figure in the early Enlightenment. His major work, *Dictionnaire historique et critique* (1697), one of the most popular books in the eighteenth century, attacked religious persecution, mocked established ecclesiastical authority, pointed out the limits of both the rational and theological arguments for the existence of God, and popularized the philosophies of Hobbes and Spinoza. Following the precedent established by people like Bayle, it became customary for French political dissi-

1.24 Jean-Baptiste-Siméon Chardin, *Child Spinning Top*, Salon of 1738. Musée du Louvre, Paris.

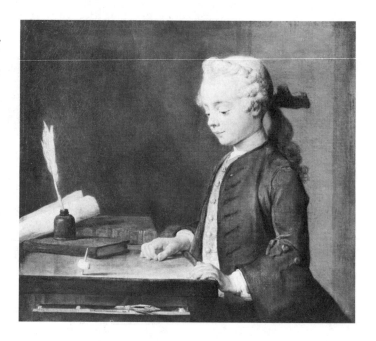

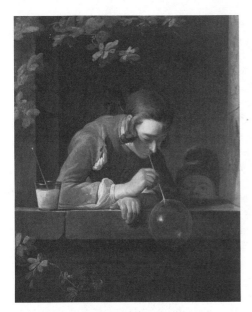

1.25 Jean-Baptiste-Siméon Chardin, *Soap Bubbles*, exhibited 1734. National Gallery of Art, Washington, D.C. Gift of Mrs. John W. Simpson.

dents—even as late as the nineteenth century—to seek refuge in Holland. Thus it may be claimed that the taste for Chardin implied a taste for Dutch culture and its democratic associations. While Chardin's art was no call to arms, he and his independent and official patrons supported rational approaches to government and greater opportunities for the middle class.

England represented an even richer and more fertile source of ideas. Locke's *Essay Concerning the Human Understanding* (1690), which refuted the Cartesian doctrine of innate ideas, insisted that all ideas were rooted in experience. In 1700 it was translated in its entirety by Pierre Coste, an exiled Huguenot living in London, and numerous French editions appeared. In addition to Locke, Newton—popularized in France by Voltaire—was another dominant source of inspiration for the nascent Enlightenment. He personified in common with Locke the experimental or inductive method. Out of the questioning mentality—furthered along by the deist movement which believed in the rational accessibility of a simple monotheism, rejected revelation, disparaged ceremonial rites, and stressed morality over faith—sprang the Enlightenment ideal. France and England became the two main centers of fresh thought, and to a point were interdependent. Voltaire, Montesquieu, Rousseau, and Diderot visited England and drew largely on this experience. The year 1734 witnessed the publication of Pope's *Essay on Man* and Voltaire's *Lettres philosophiques*; the latter was written after the author's return from England and celebrated English religious toleration, the balances of constitutional monarchy, the science of Newton, and the epistomology of Locke.

England's cultural hegemony grew out of its middle-class stabilization and its industrial and commercial power. During the course of the eighteenth century, the French market was slowly engulfed by English production. The commercial treaties enacted between the two countries at the end of the Seven Years' War in 1763 further undermined the French luxury trade and resulted in an influx of cheap English products. England and everything English became a kind of vogue, including its theoretical economics, materialist philosophy, and new literary forms. The English novel, both in the satirical mode of Swift and Fielding and the sentimental mode of Richardson, had an overwhelming impact on French thought: *Tom Jones*, *Jonathan Wild*, *Pamela*, and *Clarissa Harlowe*

were all translated and often illustrated by French engravers. The middle-class dramas of Sheridan and Goldsmith became the prototype of French *drame bourgeois*.

The English painter who incarnates the social and philosophical outlook of his society in this period is William Hogarth (1697–1764).[16] He is exceptional in revealing the views and tastes of a broad cross-section of his society, since he aimed not only at the aristocracy but also at the well-to-do middle class and the general public. Hogarth emerges in a time when English trade dominated the mercantile nations and the middle class constituted a major force that had continually grown in power since the Revolution of 1688. He expresses the confidence of this class in his work, daring to wage a campaign against the aristocratic taste for continental—especially Italian and Flemish—art and aligning himself with Swift and Fielding. Hogarth's favorite device had more in common with the literary tradition than the visual; he designed series of narrative paintings and prints after the originals that follow a character through a sequence of social events like chapters in a book or scenes in a play. Hogarth innovated a novel form of history painting, which in many ways parodied the French tradition. While he insisted on a moralizing content, he considered himself a "Comic History Painter"—a combination he hoped would "entertain and improve the mind." In this way, Hogarth asserted a new form of painting in competition with the stuffy continental examples and thereby hoped to expand his chances for financial success.

Hogarth made no bones about his commercial interests and ultimately achieved financial success with his art. His father had had similar ambitions but fared less successfully; he was a schoolmaster and sometime entrepreneur who published textbooks and opened a coffeehouse for intellectuals. The coffeehouse failed, he was thrown into debtors' prison, and his later difficulties with booksellers and publishers made his son resolve to be more astute in commercial dealings. Hogarth appealed to a wider audience by denouncing art academies, connoisseurs, and art collectors—indeed, the entire cultural establishment—introduced caricature in "history painting," and emulated the satirists in attacking marriage, church, prison, and poorhouse. As in the case of Chardin, he looked to Dutch genre pictures (although for different purposes) as a model for his approach. Trained as an engraver and commercial artist, Hogarth also tried to expand the audi-

1.26 William Hogarth, "Orgy in the Rose Tavern," scene from *The Rake's Progress*, 1735. By courtesy of the Trustees of Sir John Soane's Museum.

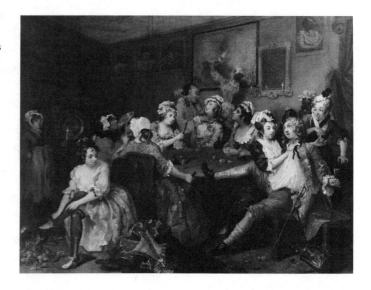

ence for art by translating his paintings into prints and choosing subjects related to popular plays and novels.

Hogarth's series *The Rake's Progress* (1733–1735), consisting of eight scenes, exemplifies the moralizing mentality of the age. Tom Rakewell, who comes into a modest inheritance, typifies the middle-class person bent on emulating the tastes and fashions of the aristocracy and ultimately falls from his authentic class position to incarceration in Bedlam. Themes of social climbing and the decadence and evils of social institutions pervade Hogarth's work: one scene in the series depicts an orgy in the Rose Tavern, Drury Lane under the aegis of portraits of various Roman Emperors (fig. 1.26). Almost everything in the room is broken, and a woman in the background sets fire to a map of the world on the wall. In the same period that Hogarth executed these works, Montesquieu published his *Considérations sur les causes de la grandeur des romains et de leur décadence* (1734), which foreshadowed Gibbon's *Decline and Fall of the Roman Empire* (1776). The social and political changes of the time pushed thought to contemplate the possible decline and fall of contemporary states—a fear projected on the most celebrated historical case study of decadence.

Hogarth's famous series, *Marriage à la Mode* (1743–1745), comprising six scenes, treats the ambiguity of social status, degeneracy of the aristocratic line, and the evils of contracted marriage. Scene 1 shows a merchant selling his daughter to a lord in exchange for a title,

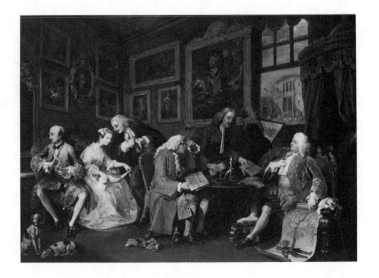

1.27 William Hogarth, "The Marriage Contract,"scene 1 from *Marriage à la Mode*, 1743–1745. Courtesy of the Trustees, The National Gallery, London.

while the lord sells his son in order to pay off debts and continue the art patronage he has always enjoyed (fig. 1.27). The aristocrats are shown suffering from gout and venereal disease, while the middle-class persons are shown indifferent to all except entrance into high society. There is also an attack on the whole institution of marriage, symbolized by the unhappy dogs chained together in the foreground. Hogarth compulsively filled his compositions with detail as if to give his audience their money's worth, but at the same time each motif is a specific emblem within the overall narrative. For examples, most of the paintings on the wall depict scenes of cruelty and martyrdom, while the unfinished mansion in the background refers to the degeneracy of the lord's line.

Hogarth also expressly ridicules the mania for art collecting in this series; throughout there is a clutter of meaningless bric-a-brac which not only equates artistic and moral corruption but also mocks the pretensions and aspirations to culture. Scene 4 depicts the countess and the assembly of types representing her fantasy: hairdressers, fashionable ladies, eunuch singers, and black servants (fig. 1.28). In the right foreground of the painting, a black page wearing a plumed turban points to a figurine with human body and horned animal head—a reference to the fact that the young viscount in being cuckolded by the lawyer who wrote up the marriage contract. Hogarth's connection of the opulent scene with the black servants further attests to the close relationship between slavery and the luxury of the upper classes.

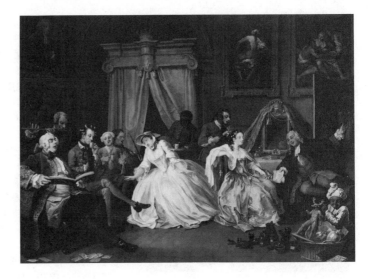

Scene 5 shows the reunited count and countess, with the dying count on one side, and the fleeing lawyer, his murderer; the last plate shows the dying countess flanked by her baby, who has inherited the father's venereal disease, and her father, who removes from her finger the wedding ring before rigor mortis sets in. Hogarth thus holds up to ridicule both the aristocracy and the middle classes: if the viscount is shown to be degenerate, the merchant and the lawyer are depicted as no less corrupt and venal. While the content of his series was decidedly anti-aristocratic, he also directed his advertisements for the paintings toward an aristocratic audience while the engravings were destined for the middle class. If Hogarth's sordid pictorial chronicles often show a tough-minded critique of society, it is also true that he rarely uses art to depict the values in which he believed. He pointed out the flaws in society but profited from his didacticism; by holding up a distorting mirror to society he earned his fortune.

On occasion Hogarth functioned as a political cartoonist and put his art into the service of direct political intervention. Laws passed early in the century encouraged the consumption of cheap gin through making licensing easy and by putting a very low tax on alcoholic beverages. Reforms were difficult since distilling made use of corn, thereby filling the pockets of the landed interests so well represented among members of Parliament. The effects upon the social and physical health of the poor were disastrous, and the rise of the death rate and increase in

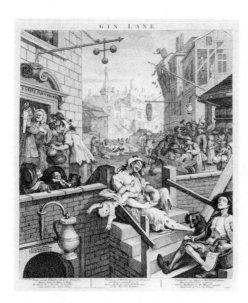

crime during the 1730s and 1740s may in part at least be attributed to excessive gin drinking. Hogarth and Fielding were among those demanding legal reform, and in 1751 Hogarth published two complementary prints as part of this campaign: *Gin Lane* and *Beer Street* (figs. 1.29, 1.30). Hogarth orchestrates a wealth of descriptive detail to point an obvious moral: gin is bad for you and leads to poverty, crime, decay, and illness. Only the pawnbroker, the undertaker, the tavern keeper, and the distiller do good business; all other institutions are debased and fall into ruin. A mother is seated in a stupor on the steps, oblivious to the fact that her child is falling down the embankment. (In this, Hogarth anticipates the modern concern for the effects of excessive alcohol consumption on the offspring.) A sign on the doorway of the tavern below reads: "Drunk for a penny, dead drunk for twopence, straw free"—a motto that actually graced the doorway of a London gin shop.

On the other hand, beer is a healthy and harmless national beverage. Now all institutions are thriving except for the pawnbroker, whose business has fallen into a shambles. Yet if Hogarth's two prints seem to show his concern for the poor, other features connected with them reveal a contradictory attitude. A note in his advertisement for the prints ran: "As the subjects of these Prints are calculated to reform some reigning Vices peculiar to the lower Class of People in hopes to render them of more extensive Use, the Author has published them in the cheapest Manner possible." The engravings, however, sold at one shilling each, which in that period would have been a day's wages for a London laborer, and, second, his reference to "the lower Class of People" whom he "hopes to render . . . of more extensive use" betrays the prejudices of a conservative social position.

Hogarth's two prints were issued a few weeks after the publication of Fielding's phamphlet *An Enquiry into the Causes of the Late Increase of Robbers, etc. with Some Proposals for Remedying This Growing Evil, etc.*[17] Although known to us today mainly as a novelist, Fielding was by profession a police magistrate who sentenced thieves to the same Westminster jail where Tom Jones spent an unhappy week. Fielding's pamphlet is concerned with the poor as a class, their legal status, their proclivity for gin drinking and gambling. As opposed to the novelist's social criticism of fashionable life and the exaltation of unfashionable heroes, Fielding the pamphleteer expresses

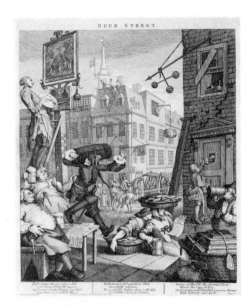

1.30 William Hogarth, *Beer Street*, 1751, engraving. Courtesy Trustees of the British Museum, London.

thoroughgoing aristocratic and conventional socia tudes. Fielding tries to fix the poor in their present p cal and social position, justifying the existing social h archy with its different ranks. Naturally, the assumpti of the inevitability of hierarchy was common among eighteenth-century thinkers, but it was fully taken advantage of by apologists for the status quo. This argument runs throughout Pope's *Essay on Man*: each should try to do one's duty according to God's anointing and accept the lot assigned. Translated into everyday terms, a frugal, industrious laborer obeys the law and accepts low wages in return for feudalistic patronage from social superiors. Any attempt to leave one's place in society subverts the public order.

Fielding's acceptance of the vertical ranking of society is demonstrated by his constant references to the poor as "people . . . of the lower sort," "lower order of people," the "inferior part of mankind." His diatribe against gin drinking, which he blamed for the increase in the death rate and the crime rate, is also rooted in his conservative attitude. Fielding articulates a chauvinistic ideal of a powerful England serviced by the lower classes. The nation's prosperity and military strength depends on recruits from the working classes who man the army and navy and supply the labor for trade and industry. The social hierarchy must be preserved, but the government must institute laws protecting the health of the "meaner" classes to insure its economic and political supremacy.

Hogarth's note in the advertisement suggests that he shared his friend's social attitudes: indeed, the prints almost certainly were executed to complement Fielding's pamphlet. The painter-engraver's obsession with class distinctions and social aspirations also agrees with Fielding's observations. Both thought very much alike: Fielding repeatedly refers to Hogarth in *Tom Jones* as the artist who inspired his characters, and the two were often identified in the critical literature of the time. Hogarth's attitude also may be gleaned from the great portrait of his servants, painted in the mid-1750s (fig. 1.31). In September 1749 Hogarth bought a country villa in Chiswick, set up an impressive coach, and hired six servants who inhabited the top floor of the house. Hogarth paints his servants as a testament to his status as a country squire, and it is curious that he portrays them as a cluster of disembodied heads on a neutral backdrop without a unifying motif. While the heads have their distinct physi-

ognomy, they are divorced from reality and transformed into a kind of still life. Hogarth treats them almost as objects, and in fact they are his possessions.

Despite the inevitable class bias of Hogarth, he represents a progressive influence in the period closely aligned with the moralistic side of the Enlightenment. Enlightenment thought was a rationalization of the specific needs of the middle class, its battle cry. While to a large extent it had won its economic freedom, it aimed philosophic moralism at antiquated political and social institutions. The French *philosophes*, Montesquieu, Voltaire, Rousseau, attacked systems of privilege and idealized new forms of social relationships. The Enlightenment was not based exclusively on theoretical rationalism but comprised the naturalistic philosophies of Rousseau and Diderot who opposed feeling and passion to the artificial manners of polite society. The French term *sensibilité*, a compound of sentimentality and idealism, was related to the literary fashions of the day and reflected middle-class taste. Frequently taken to imply swooning lovers and mawkish moralizing, the term comprised a host of metaphors which became increasingly associated with the nascent Romantic mood: the Ossianic epic, tombs, shipwrecks, churchyards, medievalism, melancholia, the mountains, and the moon. This trend was closely connected with the sensualist philosophy of Locke, the scientific inspiration of Newton, and the anxieties of eigh-

1.31 William Hogarth, *Hogarth's Servants*, mid-1750s. The Tate Gallery, London.

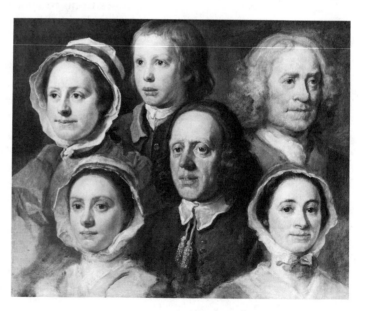

1.32 William Hogarth, plate 1 from *Analysis of Beauty*, 1753.

teenth-century persons abandoning old beliefs about God, the universe, and even absolute monarchy. The liberty to pursue new ideas in the interests of social change depended on the rehabilitation of passion as the stimulus to action. Sensibility and reason were seen not so much as being in conflict as they were considered successive stages in the dynamic leading from thought to execution.

Sensibility's progressive sense finds expression in the masterpieces of the propagandists for social reform, Hogarth in England, Diderot in France. Both demonstrate the reciprocity of France and England in this period: Hogarth traveled to France in 1743 for the purpose of picking up some pointers in the French manner and to secure French engravers for his *Marriage à la Mode* project. His famous "line of beauty"—a serpentine configuration he formulized as the basis for sound design—is remarkably similar to the sinuous rococo decorations he would have seen in France. At the same time, Hogarth's prints were quite popular in France, and his reputation there was secured in 1746 by the publication of a pamphlet by his friend Rouquet, clarifying the artist's themes. Diderot greatly admired Hogarth and drew occasionally for ideas upon the latter's treatise, *Analysis of Beauty* (1753). Hogarth's work follows on the heels of Diderot's first volume of the *Encyclopédie* published in 1751, and his explanatory plates and diagrams bear a remarkable affinity with those of Diderot's work (figs. 1.32, 1.33). Both attempt to demythologize experience, and their carefully

Agriculture Labourage

1.34 Diderot, illustration from *Encyclopédie*, 1751–1765.

designed plates clarify what was normally taken to be miraculous or mysterious.

Diderot's major contribution to the Enlightenment was the *Encyclopédie*, a vast compendium of information published in seventeen volumes between the years 1751 and 1765. The first volume, containing such controversial articles as *Ame* and *Athées*, appeared the same year as Fielding's *Enquiry into the Causes* and Hogarth's *Gin Lane*. Modeled after the *Cyclopaedia* (1728) of Ephraim Chambers, its contributors—who included Montesquieu, Marmontel, Quesnay, Rousseau, and Voltaire—demonstrate that the work was a vehicle for the most advanced ideas of the eighteenth century. Its emphasis on the manual arts and crafts, explained in excellent plates, raised the trades from folklore to science and democratized knowledge in the sense of the modern "do-it-yourself" manuals. The *Encyclopédie* promoted the dignity of labor, the right of the artisan to think for himself based on the knowledge heretofore reserved for the privileged classes. Science was equated with progress, and the plates illustrated a state of industry that foreshadows the development of the industrial revolution (figs. 1.34, 1.35). This explains why, though the enterprise encountered periodic flak from church and government, it was allowed to proceed on its way. The *Encyclopédie* articulated the aspirations of the middle classes upon whom the economic policies of the state depended; it fostered the connections

between free knowledge and free trade and the substitution of merit for privilege.

D'Alembert's preface to the first volume, a survey of the sciences, owed much to the impact of Bacon, Locke, and Newton on French thought and continues the intellectual exchange between England and France. Diderot himself watched closely the progress of English arts and letters; he read thoroughly novelists like Fielding and especially his favorite, Samuel Richardson, and even supported himself for a time translating English authors. His free rendition of Lord Shaftesbury's *An Inquiry Concerning Virtue and Merit* was perhaps the most significant translation in terms of his intellectual development: he published it anonymously in Amsterdam in 1745, since he felt the danger of declaring deistic beliefs like the emphasis of reason over scriptural authority and the existence of a natural morality independent of any particular religion or church. Above all, it was in Shaftesbury that he found the basis for his ideas on art and morality: like the English writer, Diderot linked good taste and good morals, and also turned to Greece and Rome for exemplars in art and morality.

Diderot's aesthetic ideals, however, reveal certain contradictions due to his participation in the transition from the elegant mode of the rococo to a taste for neoclassic forms which occurs in the 1760s and 1770s. While he demanded a moral content in art and wanted the artist to be a moral agent in his work, he nevertheless celebrates passion and verve as the basis of his work. Diderot wrote eloquently on the qualities of the sketch, associating it with freedom, youth, enthusiasm, and sensibility—in short, the qualities most admired by Enlightenment critics. But the personal freedom expressed in the sketch required the self-control and reflection seen in the finished work to convey a serious moral content. While much rococo art made use of virtuoso brushwork, it was identified with a courtly taste, while the more austere classic forms assumed a moral value in its seeming opposition to this taste.

Diderot praised Chardin in his criticism of the Salon exhibitions for Chardin's almost scientific approach to the rendering of objects and for the harmony and order of his designs. But the artist whom he most admired was Jean-Baptiste Greuze (1725–1805), who in his words "gave morality to art."[18] Diderot saw in Greuze the visu-

Architecture, Maçonnerie

1.35 Diderot, illustration from *Encyclopédie*, 1751–1765.

al equivalent of *sensibilité* that he admired in the English novelists. Greuze seemingly dealt with human emotions in simple, often rustic settings, and one can easily understand what attracted Diderot to pictures with such sentimental titles as *L'Accordée de village* (fig. 1.36), *La Mère bien-aimée* (Laborde Collection, Paris), or *Le Père expliquant la bible à ses enfants* (Private Collection, Paris), for these alone tell their own story.

Greuze's *Accordée*, "A Marriage Contract" or "Village Bride," depicting the notarizing of a civil marriage contract, was given a rapturous reception at the Salon of 1761. Diderot and other critics praised the combination of elegance and truth, the ennobling of "an honest rural family" without losing the authenticity of peasant life. Greuze reached an audience partly influenced by Rousseau: calling for the sincere expression of sympathetic and tender feelings, he exalted the simple life of the peasant as the most "natural" and set it up as a model to be imitated. He identified overrefinement with social inequality, and his "primitivism" had a didactic edge. Even members of the court assimilated this idea in their bucolic games where they dressed as shepherds and shepherdesses. It was their way of demonstrating their "enlightened" attitudes.

Similarly, Greuze propagandizes for an elite audience: his idealized peasants were not destined for rural spectators but for aristocrats like the marquis de Marigny who bought the picture. Greuze's conspicuous attention to

lineage and class positions the rural family in a tidy social niche. The suggestion of domestic harmony—and thereby social stability—is expressed through compositional unity, in the rhythmic curve of the figures and central pyramid dominated by the males. There existed for administrators a concept of a type of peasant whom we may consider the "ideal" poor person. Such an individual was noted for industry, thrift, patient resignation in the face of hardship, and especially for acceptance of the social position assigned to him. Such types were immensely grateful to those of their elders and betters who deigned to help them obey the law and were deeply religious. Even if administrators did not believe in the value of religion for themselves, they certainly believed in it for the poor and cited the Bible to reinforce their position. Greuze's picture of pious peasants grows out of Rousseau's primitivism, but it expresses the conservative ideal of the bureaucrats who wanted the rural poor kept in their place. In the painting arrangement of the figures is crucial, as it reflects relationships within a social hierarchy. The father-in-law and the groom are the central figures, indicating a patriarchal dominance. The mother occupies a subordinate space devoted to nurturing and obeisance. Respect for the venerable father means respect for tradition and authority. The somewhat awkward groom has a long way to go before attaining this status, and in fact the betrothed's sister symbolically situated behind the father casts a doubtful glance at the youth, as if to intimate the potential decline from the paternal model.

Greuze's scene has a stagey quality, not only in the self-conscious arrangement but in the way in which all the characters register appropriate emotions. All art of this time was influenced by contemporary theater—especially the *drame bourgeois*—but the figures here appear as actors playing out a role. One can almost envision thought balloons rising over their heads containing expression totally at variance with the external gesture, for example, "How much longer do I have to hold this dumb pose?" This contradiction is rooted in the conflict between the Enlightenment sense of the peasant as a symbol of social progress and the need of the government to maintain rural people in an inferior state.

Greuze's own class confusion relates to this conflict: a social climber from the country town of Tournus, he deliberately altered his father's profession from master tiler to "entrepreneur-architect" in official documents. Essen-

tially, he belonged to the same artisan class as Chardin, but he lacked the court contacts of the latter. At Paris he maneuvered himself into influential circles, including that of Mme. Geoffrin, which included the collaborators of the *Encyclopédie*. He seems to have grasped their cultural ideal, but he managed to couch it in generally acceptable fashion for conservative patrons. Eventually, his benefactors comprised wealthy middle-class persons and aristocrats among whom were a number of clergymen.

Greuze's genre scenes and somber colorations show his debt to the Dutch masters, while the moralizing subject matter stems in good measure from Hogarth. He serialized his themes, as in the case of *The Father's Curse* and *The Son Punished* (figs. 1.37, 1.38), first exhibited in 1765 as sketches, and projected a series of pictures of engravings based on Hogarth's *Idle and Industrious Apprentices*. The *Village Bride* is actually a watered-down positive version of Hogarth's plate 1 of *Marriage à la Mode*. In addition to the theme, the works share a figural grouping oriented around a semi-circular axis, a shallow foreground space, and even a symbolic animal group which complements the scenario. Greuze, however, replaces Hogarth's chained canines with a mother hen feeding her brood—a transformation that signals his distinctive rendition. Whereas Hogarth sets the marriage betrothal in an upper-class setting and it is contracted for gain, Greuze sets his in a humble peasant cottage where the modest

1.38 Jean-Baptiste Greuze, *The Son Punished*, 1778. Musée du Louvre, Paris.

1.39 Jean-Baptiste Greuze, *Morning Prayer*. Musée Fabre, Montpellier. Photo by Claude O'Sughrue.

dowry suggests a marriage of love. Hogarth's sharp satire is softened to meet the exigencies of Greuze's constituency.

In the end, even Diderot grew suspicious, since he could not fail to be struck by the false note in Greuze, whose rural world—far from the realities caught by Ceruti—is one of make-believe and theatrical disguise. Another conspicuous contradiction of Greuze is his need to both preach and titillate: critics observed the narrow waist and healthy bosom of the blushing adolescent bride, and Greuze's fascination for adolescent girls in various states of undress, often on the verge of ecstasy, is barely concealed by the moralizing content. His *Morning Prayer* exploits piety and innocence as a means to heighten the eroticism implied in the exposed shoulder, bare arms and feet, and ecstatic eyes (fig. 1.39). There is in several of his works seemingly suggestive of virtue a suspenseful sort of prurience, a combination that satisfied both the reformers and the epicureans of the wealthy social groups. Not that the licentiousness often associated with the *ancien régime* was alien to the *philosophes*: "taking liberties" had a dual sense then as now, and laissez-faire attitudes in sexual matters could count for as much as in trade.

Many of Greuze's pictures have a filial subject and emphasize the paternal authority: in the *Father's Curse* and *Son Punished* there is a struggle for power between father

and son and the defiance of the latter leads to his ruin. The rebellious son who abandons the family hearth for an army career (much discredited immediately following the Seven Years' War) threatens not only the family unit but the basis of the social hierarchy. This called for severe rebuke. Similarly, the *Return of the Drunken Father* shows what happens when the father relinquishes his responsibilities and undermines domestic unity (fig 1.40). Women in these pictures are shown as passive characters, dependent and often simpering. The masculine emphasis and the themes of devotion to patriarchal authority will become assimilated and cast into a democratic mode by the next generation, but dressed up in classic clothes. Greuze himself incorporated many classicizing features in his work, such as the profiles of the figures in *Drunken Father* and the frieze-like arrangement of the figures. The resulting clarity sets out the divisive impact of the paternal negligence on the constitutive parts of the family structure.

Greuze in many ways is a transitional figure in the shift from the rococo to the neoclassic mode. This is shown in his bitter experience with the academy: Greuze had been accepted at the *agréé* level but kept postponing the execution of his reception piece. The academy had to pressure him to satisfy the conditions of membership. Wanting to be accepted at the highest level and to fulfill Diderot's ideal of a moral theme set in Greece and Rome, Greuze selected his subject from antiquity: *Septi-*

1.41 Jean-Baptiste Greuze, *Septimius Severus Reproaching His Son Caracalla for Having Made an Attempt on His Life in the Defiles of Scotland*, 1769. Musée du Louvre, Paris.

mus Severus Reproaching His Son Caracalla for Having Made an Attempt on His Life in the Defiles of Scotland (fig. 1.41). The subject again is filial impiety and the father's wrath; this time, however, the father is a Roman emperor and the symbolic link to tradition and authority is more apparent. Greuze based the heads of the figures on Roman coins or busts and the general format on Poussin's *Death of Germanicus* (Minneapolis Institute of Arts, Minneapolis), a popular classicizing piece of the previous century. Greuze's remarkable work is much more simplified and powerfully knit, and the austerity of the setting looks forward to the style of the 1780s.

When, however, he completed it in 1769, it was seen by both the academy and Diderot as a fiasco. The academy decided to receive Greuze as an academician on the basis of his past works, but as a genre and not a history painter: "Monsieur, the Academy receives you but as a genre painter; we have taken into account your former productions, which are excellent, and shut our eyes to this one which is worthy neither of the Academy nor of you." Greuze paid the price of those who enjoy prestige in one area and who decided to master another; the envious were delighted to have the opportunity of humiliating him. Even Diderot succumbed to this human weakness, noting that the Septimus Severus is "ignoble" and has "the dark, tanned skin of a gallery slave," while Caracalla "would go wondrous well in a country, domestic scene." The class structure of the period pervades these

1.42 Elisabeth-Louise Vigée-Lebrun, *Queen Marie-Antoinette and Her Children*, 1787. Musée national du château de Versailles.

comments, betraying the ideas of the top layer of the social hierarchy. His failure attests less to the prevailing aesthetic standards than to the class prejudices of the aristocracy and their hangers-on like Diderot. Greuze's need to be accepted as a history painter was part of his desire to improve his social position: but those who judged him wanted him in place exactly like it wanted its peasants in place.

The reaction of his wife, Anne Gabrielle, indicates the crucial nature of the academy's role in a painter's career. A social climber herself, she overwhelmed Greuze with bitter reproaches and sarcastic allusions to his failure. From this point on his domestic life, already made miserable by Anne Gabrielle's infidelities, quarreling, and generally spiteful behavior, became impossible: one night Greuze woke with a start to find her standing over him and threatening to smash his head. Diderot remarked that since Greuze's failure Anne Gabrielle had been "biting her nails with fury," and the incident demonstrates the life-and-death hold of the academy on artists.

Greuze's personal disappointment also related to the loss of a possible professorship at the academy, for these posts were reserved for history painters alone. He was in fact an excellent teacher whose technical precepts were emulated by scores of disciples, including one of the foremost women artists of the late eighteenth century, Elisabeth-Louise Vigée-Lebrun (1755–1842). Vigée-Lebrun was another ambitious member of the middle class whose professional interests motivated her to identify with the aristocracy. Her father was a professional painter and early on encouraged her efforts—a relationship repeated in the lives of several exceptional women in the field who managed to break the sex barrier. Vigée (her maiden name) began her professional career at the age of fifteen and dazzled her clients by her precocity, good looks, and vivacious personality. She read the works of Richardson and Rousseau and reached an upper-class audience now thoroughly steeped in the idea of sensibility. In 1776 she married the influential art dealer and promoter, Jean-Baptiste-Pierre Lebrun, and while they were temperamentally incompatible he faciiitated her entrance into high society. Vigée-Lebrun ably exploited her combination of natural talent and remarkable flow of energy in social situations, attracting a large aristocratic patronage which included Mme. Geoffrin, comte de Vaudreuil, comte d'Artois (Louis XVI's younger brother), and M.

1.43 Elisabeth-Louise Vigée-Lebrun, *Self-Portrait with Her Daughter*, c. 1789. Musée du Louvre, Paris.

1.44 Elisabeth-Louise Vigée-Lebrun, *Self-Portrait*, 1790. Firenze, galleria degli Uffizi, inv. 1890/1905. Foto Gabinetto fotografico della Soprintendenza per i beni Artistici e Storici di Firenze.

de Calonne (finance minister from 1783 to 1787)—relationships that proved disastrous after 1789. Her parties were as celebrated as her portraits, where in both cases she confronted her sitters as a conversing equal. In 1783 she was admitted to the academy, which did not then in principle discriminate against women (although she was opposed by a powerful faction and required the court's intervention to overcome it); in the next century the academy restricted its membership to "males only."

She became Queen Marie-Antoinette's favorite painter; starting in 1779 she represented her over twenty times. Perhaps the most famous of these portraits shows the queen surrounded by her children (fig. 1.42). Here Vigée-Lebrun captures the luxurious textures and materials of the royal chambers, the queen's plumed hat, the velvet covers, thick carpets, cushions, and tassels. Marie-Antoinette is idealized with the oval face and precious features of contemporary porcelain. But most important of all is the fact that Vigée-Lebrun reveals her in the guise of motherhood—a perspective rarely glimpsed of the individual who personified the *ancien régime*. History tends to reduce people to stereotypes, and although it is true that the "Austrian bitch," as the queen was called, was accused of every corruption and formed an excellent focus for antimonarchical sentiment, it is essential to guard the "humanity" of so-called evil types so as not to distort their historical role. Vigée-Lebrun observed her from a feminine perspective and as an equal: they discussed motherhood together (each lost a child in 1786), sang duets, and gossiped about their mutual friends. Certainly, this picture propagandizes in the queen's favor, but it also touches on a side of history that has been lost to us.

Politically, Vigée-Lebrun was a royalist and identified with the court; when the Revolution broke out she took refuge in Italy and thereafter lived more or less in exile until the Bourbon Restoration. She gained her living painting the portraits of Europe's aristocracy. These portraits are unique for their active compositions: several have a breathless quality as if the sitter were suddenly caught in the midst of play or on the verge of speaking. Her portraits of herself and her daughter look as if she just swept up the child in her arms (fig. 1.43), a feeling enhanced by the flow of draping shawls and lively expressions. She loved to work with draperies and had the habit of twisting a muslin scarf around her head in the form of a turban—a feature observed in her *Self-Portrait*

of 1790 (fig. 1.44). Here she catches herself in the act of painting and entertaining her sitter (again Marie-Antoinette). Generally her portraits express the spontaneity and verve of the sitters but rarely go beyond a superficial glimpse of the sitter. Both in her visual examples and written characterizations she invariably fixes on outward display, fashion, and style—the decorum that fixed one's place in the social hierarchy. But at the same time her pictorial movement embodied an ideal of freedom and a sense of spontaneity associated with Enlightenment ideals. It is clear that the aristocracy, bound by courtly artificialities, admired her own spontaneous personality, and she in turn flattered them by projecting it onto their pictures.

We may conclude this chapter with Jean-Honoré Fragonard (1732–1806), a student of both Chardin and Boucher, who sums up all the contradictions of this period.

1.45 Jean-Honoré Fragonard, *The Swing*, 1766–1767. Reproduced by permission of the Trustees of the Wallace Collection, London.

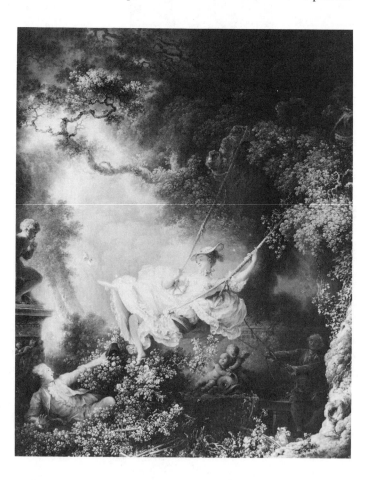

Prolific and versatile, he was as much at home doing allegories for the court as he was doing boudoir and genre scenes for the affluent middle class. His academic credentials were solid but incomplete: he earned the *Grand Prix* in 1752 and was *agréé* in 1765, but he failed to present a reception piece and never became an *académicien*. Nevertheless, an early Salon success and close contact with Boucher guaranteed him an influential clientele which extended to Louis XV and his mistress Mme. du Barry. Fragonard's father had been a "glover's assistant" who listed himself on occasion as "merchant," and finally moved to Paris after an investment failure to work as a clerk to a haberdasher. This unstable class situation made Fragonard less secure than Chardin, for example, and while he was proud of having risen through the ranks this social insecurity probably lay behind his desire to please.

Fragonard, a contemporary of Beaumarchais, Restif de Bretonne, Casanova, Laclos, and de Sade—writers obsessed with female sexuality—recorded in his pictures the voluptuous side of the eighteenth century. Many of his works border on the pornographic and speak to the sexual promiscuity of Parisian high society, which aroused the condemnation of the *philosophes*. Fragonard's famous *Swing* was commissioned by the Baron de Saint-Julien, a rich tax collector representing the clergy (fig. 1.45).[19] Saint-Julien originally requested (first of Doyen who refused the offer and then of Fragonard who accepted it) that his mistress be shown on a swing pushed by a bishop and that he himself be strategically located in the picture "to see the legs of this charming girl, and more, if you want to enliven your picture still further . . ."[20] (In the definitive work the artist replaced the bishop with the woman's husband, who innocently pushes the swing to the delight of Saint-Julien hidden in the foliage.) Saint-Julien, the possessor of both woman and painting, is the spectator in both the visual and actual sense. Undressed women in art—especially nudes—are traditionally displayed for a male audience. Fragonard's picture is designed to appeal to Saint-Julien's sexuality and that of his envious guests whom he must have invited to see it. Even the garden in which the scene takes place belongs to the patron, and in this sense the entire commission is a glorification of the baron's property.

Fragonard imagined himself a kind of gentleman of leisure, and this is manifested in his attitude toward work.

He early adopted a virtuoso technique and rapid execution to satisfy the demands of the rich financiers, farmers-general, aristocratic amateurs, and celebrities who supported him. They provided him a steady stream of commissions for scenes of leisure, romps in parks, swings, outdoor fetes, lively haystack encounters, and erotic nudes in unmade beds. These gave him a quick source of income at a minimum of effort.

One seeming exception to his general repertoire is the *Washerwomen*, an image of two female workers executed after his return to Paris from Italy in 1761 (fig. 1.46). The influence of his Italian trip is clearly felt in the setting for the picture, which is based on sketches of one of the ancient villas in Tivoli, a town just east of Rome. During his stay in Italy he enjoyed the patronage of the abbé de Saint-Non, a wealthy amateur who held both a purchased government office (reserved for nobles) and an ecclesiastical sinecure.[21] He could afford to devote almost all of his time to leisurely pursuits, including traveling, drawing and etching, and subsidizing the efforts of young artists. He professed sympathy with the ideals of the Enlightenment and the *Encyclopédie*, voyaging through England, Holland, and Italy in search of a "simpler" way of life. In Rome he met Fragonard and thereafter subsidized his career. They went on sketching tours together, with some of the results entering the lavish folio volumes documenting the Italian excursions that Saint-Non published. The abbé hoped to cover in this way the whole of Italy, a vast enterprise impossible to

1.46 Jean-Honoré Fragonard, *Washerwomen*, c. 1761–1762. Musée de Picardie, Amiens. © Patrick Joly.

complete. But the project incarnates the outlook of the man-of-leisure on the Grand Tour, and it is no coincidence that the published works include examples of his protege Fragonard. The picture of the *Washerwomen* is treated in the style of the voyeuristic tourist searching for piquant contrasts: the anonymously portrayed women hang out their linen on lines strung between the ancient statuary in the garden. They are robust, uninhibited in their gestures, and joyful while at work. Even the statue of the crouching lion wears a smile on his face. The artist perceives them with a certain irony, as sexually attractive primitives in a high-class milieu, whose individual humanity counts for less than the entertaining spectacle they present for the strolling gentleman.

Another depiction of work as delightful is his *Annête et Lubin*, a favorite theme based on one of the *Contes moraux* (1762) by J. F. Marmontel (fig. 1.47). Marmontel was the son of a village tailor who worked his way to the court and the Académie Française; he wrote for the *Encyclopédie* and knew Mme. Geoffrin intimately, but he made his success primarily by regaling the aristocracy. His sentimental fables express in garbled form the critical views of the *philosophes* as well as the ideals of the privileged elite. The story of *Annête et Lubin* is a typical example: the protagonists are first cousins and adolescent lovers sharing a rude hut in the woods. They tend sheep on the estate of a benevolent squire, innocent of all artifi-

1.48 Jean-Honoré Fragonard, *Women Bathing*, c. 1765–1770. Musée du Louvre, Paris.

cial social restrictions and living in tune with "the simple laws of nature." They pity the miserable aristocrats and bourgeois forced to live in elegant mansions which they term "magnificent prisons," and glory in their humble dwelling surrounded by the pure air and light of the countryside. But the innocence of their idyllic existence comes to an abrupt end when the local magistrate discovers that Annête is pregnant. The poor girl is in turn condemned by the magistrate and the village priest who spell out to her the consequences of an incestuous relationship. In desperation, the two youths plead their case before the squire who obtains for them special papal permission to marry.

Fragonard's treatment of the subject recalls Gainsborough's *Landscape with a Woodcutter Courting a Milkmaid*; rural laborers are shown enjoying a playful interlude while tending to their chores. (Fragonard and Gainsborough have more in common than similar subjects and clientele; the Englishman's teacher, Gravelot, illustrated Marmontel's *Contes* and was a favorite of the *philosophes*.) As Annête and Lubin romp through the fields they move in line with the descending cows and sheep, so that work and play are skillfully woven into the narrative and formal structure. The conspicuous windmill on the horizon suggests cyclical renewal of the seasons, of work and love. Marmontel's blend of bucolic innocence, virginal love, and incest was the literary analogue to rococo erotic imagery, and both he and Fragonard appealed to the

same audience. Here the pastoral fantasies and sexual license of the upper classes are projected onto the incestuous but "chaste" rural lovers. Seeking thrills among a rural populace whose marginal existence freed them in part from artificial social constraints, the dominant elite demanded images that masked the character of its actual hardship. The aristocratic pursuit of sexual pleasure meant total freedom from labor—the implicit meaning of the pastoral fantasy in which the privileged acted out the roles of shepherd and shepherdess. It is no coincidence that in Marmontel's tale it is the country squire who solves the dilemma of the protagonists beyond the confines of conventional social morality. In the end, it was the aristocracy that functioned outside society through its claims for unlimited privilege.

Aristocratic women of the period internalized the male-dominant attitude, worried about how they should appear to men, and turned themselves into objects of vision. They subordinated their personal sense of self to the sense of being appreciated by others. Fragonard's *Women Bathing*, painted for Mme. du Barry, probably served a purpose similar to Boucher's *Venus* by displaying in intimate chambers images that can only be construed as a form of male flattery (fig. 1.48). The female bathers splash exuberantly in a "state of nature"—with nature here invoked as a refinement for titillating the

1.49 Jean-Honoré Fragonard, *The Happy Lovers*, c. 1765–1770. Collection Arthur Veil-Picard, Paris. Photographie Bulloz.

1.50 Jean-Antoine Houdon, *Portrait of Benjamin Franklin*, 1778, sepia ink drawing. Charles Netcher II Memorial Collection. © The Art Institute of Chicago. All rights reserved.

1.51 Jean-Honoré Fragonard and Marguerite Gérard, *The Genius of Franklin*, 1778, engraving. Bibliothèque Nationale, Paris.

royal voluptuary. Mme. du Barry was the possession of the king and all that she possessed in turn attested to his ownership. The protagonists of Fragonard's painting orient themselves frontally and provocatively to address the spectator-owner looking at them. Even on other occasions when Fragonard shows a couple making love, it is always the woman's body that is fully exposed and emphasized along the frontal plane (fig. 1.49).

The image, however, of a frivolous *ancien régime*, with Boucher and Fragonard its visual mouthpieces, is too simplistic to accept without some qualification. The sexuality of this period also relates to the desire of progressive-minded types to seek alike immediate pleasures and fundamental truths. As in Rousseau's *La Nouvelle Héloïse* (1761), sexual passion could be a source of heroic energy, of freedom from the constraints of an unjust, unnatural society. Art reflected this dual tendency, now being viewed as a source of pleasurable sensation, now as a medium for moral improvement. The most representative people of this era wanted to give sense full rein to gain clearer awareness of the world and their place in it. This is perhaps best demonstrated in the life and career of Benjamin Franklin, who spent the years 1777–1785 as United States representative at the Court of France. Franklin was the living embodiment of all the values extolled by the *philosophes*, and the homespun morality of *Poor Richard's Almanack* ("Early to bed and early to rise / Makes a man healthy, wealthy and wise") had a wide following at Versailles and Paris. When he was presented to the king in 1779 to officially request financial aid for the American Revolution, he was one of the most popular persons in France. Painters and sculptors vied for his sittings: Jean-Antoine Houdon (1741–1828) executed his memorable bust of Franklin (1778) (fig. 1.50), while Fragonard sketched him in preparation for his print (done in collaboration with his sister-in-law, Marguerite Gérard) entitled *The Genius of Franklin* (fig. 1.51). Fragonard's print depicts Franklin in heaven with Minerva whose shield protects the figure of America from a bolt of lightning, while the foes of freedom, Avarice and Tyranny, lie writing at his feet—a piece of pure propaganda aimed at undermining England in revenge for the French defeat in the Seven Years' War. Franklin participated in the campaign, posing as a simple frontiersman for those who looked to America as a symbol of Rousseau's "state of nature." He was lionized in high society and caught

up in the social whirl of Mme. Helvétius's Salon, another gathering place for the authors of the *Encyclopédie*. He also capitalized on his position to approach women, and his amorous intrigues became the talk of the town. While these have no doubt been exaggerated (he was in his seventies at the time), many French contemporaries viewed him as a womanizer equal to the foremost French libertines. Thus it is not merely a case of virtue versus immorality in this period, but rather it is a turbulent time of change when all traditions and institutions were open to question.

2.1 Pompeo Batoni, *The Triumph of Venice*,
1737. The North Carolina Museum of Art,
Raleigh.

2 The Seven Years' War and Its Aftermath (1756–c. 1783)

In contrast to the first half of the century, the three decades preceding the French Revolution of 1789 were a period of widespread political and economic tension. Rulers and their peoples found it increasingly hard to maintain a tolerable social contract. The absolute kings of France, Austria, Russia, and Prussia were essentially the executive agents for their feudal aristocracies. Many conflicts arose at this time from the struggle between autocrats who were trying to innovate in the interest of efficiency, and privileged nobles who resisted bureaucratic encroachments upon their traditional social prerogatives. Beneath the aristocratic class were educated and socially ambitious commoners who had reforming ideas of their own but who, as yet, were mostly disregarded by the aristocracy. They were carried along by the wave of economic prosperity which heightened their self-consciousness.

These sources of friction attained a sharper edge after the end of the Seven Years' War in 1763 when several top-heavy European states outgrew their economic resources and found themselves short of cash. As these states looked anxiously for new sources of revenue, they imposed taxes on the nobility and those communities hitherto protected by traditional immunities. The British search for additional sources of taxation set off the revolt of the American colonies. When France—already in poor fiscal shape since the end of the Seven Years' War—ruined itself in the American conflict, Calonne's desperate effort to rescue the bankrupt government provoked the revolt of the privileged orders, which in turn sparked the Revolution.

The duel for world empire between England and

France reached a decisive stage in the Seven Years' War (1756–1763), known in American history as the French and Indian War. Originally, it was solely a conflict over colonial questions, but the network of shifting European alliances and enemies broadened the struggle to the widest possible arena. The treaty ending the War of the Austrian Succession, between Prussia and Austria, had left Maria Theresa, the Austrian ruler who lost her precious Silesian territory, thirsting for revenge against Frederick II ("The Great") of Prussia. She turned to her country's hereditary enemy, France, and convinced Louis XV that the two countries should form an alliance against Frederick of Prussia. Meanwhile, England had already made an alliance with its recent foe, Prussia.

When the alliance between France and Austria was signed in the spring of 1756, Frederick concluded that his only chance of survival was to move against Austria first and forestall any effort to recover Silesia. His plan of campaign led him to attack neutral Saxony. Maria Theresa now built up a great coalition against Prussia consisting of Austria, Russia, Sweden, and France. On the other side, the English with their German allies in Hanover (the British kings in this period descended from the House of Hanover and were automatically head of this state as well) managed to take some of the pressure off Frederick by keeping French armies occupied.

The English, however, suffered initial losses before turning the tide of the war in their favor. This period of crisis brought about a reorganization of the government in England and resulted in assigning William Pitt to take charge of the war effort. His strategy was to provide large subsidies of money to Prussia, destroy French sea power and prevent personnel and supplies from reaching the French possessions overseas, and to dispatch well-equipped and highly trained English forces to the colonies to conquer the isolated French armies.

Behind Pitt's war strategy lay the mercantilist conception of the static nature of commerce, the notion that the world could support only a limited volume of commerce and shipping. In this view a nation that wished to increase its commerce could do so only at the expense of another. This doctrine of the finite market rested on the theoretical basis of exclusive exploitation rather than mutual advantage; it is summed up by William Beckford, a great colonial merchant, who said of France: "Our trade will improve by the total extinction of theirs." Thus

power politics and economic policy during the Seven Years' War became interchangeable terms.

England succeeded in inflicting crushing defeats upon France and dictating the terms of peace. The Treaty of Paris of 10 February 1763, concluded between England-Hanover and France-Spain, represented an overwhelming victory for Great Britain. France ceded all the mainland of North America east of the Mississippi, certain islands in the West Indies, and all French conquests made since 1749 in India and the East Indies. While some English critics expected even more (on the whole, Great Britain was remarkably moderate in the peace terms), George III, who ascended the throne in 1760, was anxious to secure termination of hostilities and promote himself as a benevolent ruler. This was done in opposition to the policies of Pitt, leader of the Whig Party which George hoped to weaken and thereby to establish a more autocratic control of government. His mentor and confidante, Lord Bute, was appointed prime minister in 1762 and became leader of the Tory Party. It was he who negotiated the Treaty of Paris. Lord Bute had instructed the young king to govern more as an autocratic monarch than as a constitutional sovereign and advised an end to the war in favor of establishing a popular image at the outset of his reign. By this agreement Great Britain emerged as the greatest colonial, commercial, and naval power in the world. The English ruling classes now identified with earlier empires, an identification that coincided with George III's assertive kingship. As one contemporary Englishman put it: "I shall burn my Greek and Latin books. They are the histories of little people. We subdue the globe in three campaigns, and a globe as big again as it was in their days."

Meanwhile the French foreign minister who negotiated the treaty, the duc de Choiseul, gained some islands in the West Indies and Goree (Senegal) in Africa due to the moderate terms. But he was anxious to rebuild the French military machine and prepare for a future invasion of England. The demoralized army needed drastic reorganization and redisciplining, a theme that assumes increased urgency in the ensuing years. His wife was the granddaughter of the rich financier and war contractor, Antoine Crozat, marquis de Châtel, who realized vast profits from Choiseul's policies. Choiseul also enjoyed the patronage of the marquise de Pompadour who secured his first diplomatic assignments. As ambassador to

Rome, he enjoyed the luxury of collecting antiquities and mingling with antiquarians. His taste for the antique predisposed him to fantasies about Empire and autocracy, but in the wake of 1763 he was faced with a devasted French army, an exhausted treasury, and a humiliated society smarting for revenge.

The political climate of the period was agitated by the conflict between the two European powers dominating the Holy Roman Empire, the Hapsburgs, rulers of the Austrian dominions, and the Hohenzollerns, rulers of Prussia. The rivalry of these powers, who had fought each other for possession of Silesia from 1740 to 1748 and again from 1756 to 1763, determined policies in Central Europe.

Eastern Europe was dominated by the rising power of Russia. From the 1760s onward, the threat of Russian armies was a growing preoccupation of European chancelleries. Catherine, the Russian ruler from 1762 to 1796, used the rivalry between Austria and Prussia to expand her territory enormously to the west and south. In Poland, religious dissent, the lack of centralized government, and rivalries between Polish magnates enabled Russia, Prussia, and Austria to partition the country in 1772. From here Catherine was encouraged to penetrate the Balkans, which were still held for the most part by the Ottoman Turks. This confrontation between Russia and Turkey—heightened by Greek and Slav resistance—continued to influence international politics in the next century.

Several religious issues in the 1760s further contributed to the general tension. States exploited the Enlightenment demand for religious tolerance by levying new taxes on the Church. In the Hapsburg dominions a stringent tax policy was initiated in this period, with the monastic orders feeling its brunt. The Society of Jesus—the most powerful and rich of the Roman Catholic organizations—was especially taxed at this time because its political and commercial control was envied by aristocracies as well as by absolute monarchs. One source of its wealth were missions to American colonies. The French Jesuits, for example, plied a wealthy and prosperous trading company in the West Indies before it was ruined by the Seven Years' War. They were now attacked by their bitter enemies, the *parlements* or venal law courts. The French law courts were essentially an instrument of aristocratic power which protected feudal privileges. Since

all the members of the bar and the bench of the *parlements* had acquired their offices by private purchase or inheritance from the government, the crown had created a rival power that shackled its reform initiative and impeded its freedom of administrative action. The *parlements* even claimed a supervisory authority over religion in the name of the monarchy but used this issue as a springboard for extending their authority. To extricate France from the war and take the steps necessary to restore French power, the duc de Choiseul had to appease the *parlements*, and he did so by attacking the Jesuits. In 1764–1765 the society was dissolved and its members expelled.

Another situation involving the *parlements* and a religious issue developed around the case of Calas, a prosperous Huguenot citizen of Toulouse whose son hanged himself in 1761. It was alleged that the son was murdered by his family because he converted to Catholicism. The *parlement* of Toulouse condemned Calas, after trying the case in an atmosphere heated by the defeats of the Seven Years' War (Huguenots were often accused of being spies for Great Britain), and characterized by religious fanaticism and judicial incompetence. Voltaire's impassioned efforts in behalf of the family ultimately reversed the sentence but not before Calas had been broken on the wheel and his family pauperized and exiled. Such an outrage was not new, but now the indignation aroused by the *parlement* reached as high as Louis XV's court.

These decades were also a period of struggle for the Jews. Even Enlightenment philosophers like Diderot and Voltaire were notoriously anti-Semitic. Until the eighteenth century, most Jews lived as they did in the medieval days, locked off in a hermetic and backward ghetto world. Although the French poll tax on Jews was removed in 1784, Jews were still subject to financial exploitation and murderous attacks by Alsatians who even tried to block full Jewish emancipation during the French Revolution. Eventually, however, anti-Semitism could not be condoned as an official policy in the incipient age of capitalism. Many Jews understood commerce and were uninhibited by feudal ties and ecclesiastical traditions. During the second half of the century, Jews were treated positively when governments seeking fresh ways of obtaining revenues recognized their economic usefulness.

Despite the economic, political, and social tensions of the period, the dominant artistic style that emerges at this time seems restrained, cool and formal, concerned with archeological exactitude and moralistic themes. Patrons and practitioners look for inspiration to classical antiquity, surrounding themselves with the actual artifacts and commissioning decorations based on motifs culled from them. Artists now become obsessed with "style" independent of other concerns. In the sense that this style was achieved intellectually and self-consciously through an application of theory, it assumes a wholly modern character. Of course the *philosophes*, and later the political revolutionaries, looked most often to Greece and Rome for models of morality and virtue, and the new style— which was not actually labeled "neoclassicism"until the nineteenth century—was in part a reaction to the French rococo and its courtly, frivolous associations. While the motivations for rejecting rococo could vary from country to country (nationalist rivalries made this inevitable), the nascent style soon acquired an international character. The commercial competition, political alliances, and national conflicts were culturally absorbed in a seemingly universal style springing from the matrix of Western tradition.[1]

Neoclassicism was sanctioned, stimulated, and disseminated by the nobility of Western Europe. They and the international group of scholars and artists they recruited from the middle and artisanal classes to carry out the material and practical aspects of diffusing the new style knew one another, corresponded with one another, informed one another, and competed with one another. They were quite aware of their role in the spread of neoclassicism and deliberately created an audience for it. It was the first art movement in history to be packaged, advertised, and sold on the market as a profitable investment. Except in the case of George III and a few independently wealthy types who perceived themselves as pacesetters, most of the participants were motivated by monetary considerations. As we shall see, there was a small core of influential individuals promoting the new style whose interests, both commercial and political, intertwined. Yet their authority and backing made it possible for neoclassicism to become the style of the dual revolution.

Where and in what climate of opinion and activity did

neoclassicism emerge? Many of the leaders of the new style were expatriates who were living in Rome or who had gravitated there for shorter periods to establish artistic, business, and social contacts. Some came from unorthodox religious, cultural, and sexual perspectives, uprooted by the events in Europe and making a living from the tourist industry in Italy. Ambitious and opportunistic, they formed relationships with the cultural elite. As in the past, various nationalities established colonies in Rome with their native class structure intact. During the Seven Years' War governments recruited spies from these colonies to gather news and intelligence about rival nations through social and diplomatic channels. Here the shared cultural interests of the upper classes cut across national rivalries: although ostensibly at war, French, English, Prussian, Russian, Polish, and Austrian fraternized in the salons of socialites residing in Rome or in the villas of prominent Italians. The central topic of conversation was their common interest in collecting antique objects.

Italy in general, and Rome in particular, had become the principal hunting ground for antiquities for obvious reasons but especially since the excavations of Herculaneum (begun in 1737) and at Pompeii (begun in 1748). The unearthing of whole societies almost intact with their homes, furnishings, and even personal toiletries piqued the fascination of European aristocrats seeking the cultural complement of their idealized self-image. La Font de Saint-Yenne, an aristocratic French art critic who did much to encourage a revival of neoclassical history painting, did not hesitate in 1754 to use language identifying the magistrates of the *parlements* with the ancients in their support of a sage monarchy and the laws of the state. All the qualities associated with antiquity—simplicity, elegance, order, and patriotic virtue—were picked up by certain nobles as an index of their authentic self-worth and social status. In addition, influential middle-class members of the Enlightenment supported this association in their denunciation of despotism and corruption and praise for liberty. The blandness of the early neoclassical works allowed for the ambiguity implicit in the nobles' attack against royal prerogatives (when in fact monarchies were striving for a more just application of law) in defense of their own privileges. In the end, however, both sides appropriated the language of neoclassical ideals

to dissociate themselves from charges of corruption, frivolity, licentiousness, and to project a public image of patriotic duty and defense of liberty.

Wartime pressures and the need to mobilize broad support and collect revenues accelerated the spread of the new artistic direction. This taste now stimulated the growth of tourism with Rome as its center and gave rise to the conditions that made participation a profitable enterprise. First, there was increased trade in the works of antiquity; second, there was mass production of views of Rome and its ruins by view specialists who provided on demand real and imaginary scenes of the ancient city; third, there was increased exploration, discovery, and evaluation of architectural, sculptural, pictorial, and other evidences of classical civilization in the Mediterranean world; and fourth, there began the publication of these discoveries by antiquarians who, in the eighteenth century, enjoyed a position of esteem comparable to that of archeologists today.

The Grand Tour

The tourist industry developed out of the concept of the Grand Tour, which at this time was regarded as an indispensable ingredient in the education and culture of a young gentleman. After leaving university, aristocratic and well-to-do middle-class youths would make a pilgrimage to Rome. They gathered, in addition to souvenirs of places seen and visited, antique objects to decorate their future town and country residences. Great Britain's colonial trade and wartime demand for agricultural products generated much of the moneys for this voyage. The British nobility in this period became in reality a wealthier middle class as they increased the scale of their expenditures. They were dependent on trade and speculation; when an English nobleman found the income from his rent rolls inadequate, he could and did invest in the great joint-stock enterprises to earn profits without the stigma of trade. Whigs and Tories alike combined their landowning role with membership in the privileged mercantile companies and directed foreign policy to support and enlarge their trading interests. During the 1760s and 1770s their ever-increasing wealth disposed them to demand town residences in addition to country places, and this stimulated the need for the kind of furnishings and decorations the Grand Tour could provide.

English lords tended to reside in the area around the Piazza di Spagna in Rome which became notorious as the English "colony." They attracted artists and bohemians who settled in the area, supplying the bulk of their patronage for those who pioneered in neoclassicism. The mania for collecting works of antiquity, sculptures, cameos, and pottery gave rise to an illegal supply trade.[2] Many of the fabulous objects pawned off on English *milords* are now considered fakes. Well-known sculptors and painters boasted of their share in it, often earning enough money from their shady practices to retire to more legitimate pursuits after returning home. The extensive manufacture in this period of intaglios and cameos and the restoration of antique marbles for visitors demonstrates the importance attached to the possession of ancient objects as a sign of advanced taste and culture.

One prominent local painter who exploited the English colony and lay bare the dynamics of the Grand Tour was Pompeo Batoni (1708–1787).[3] A generation older than the neoclassicists, he nevertheless prepared the ground for several of them including the painters Mengs, West, Kauffmann, David and Gavin Hamilton, and the antiquarians Winckelmann and Cardinal Albani. Batoni worked for powerful patrons who encouraged his classicizing tendency to embody their political and social views. For example, Marco Foscarini, Venetian ambassador to Rome (1736–1740), commissioned the painter to do a *Triumph of Venice* according to Foscari's own scenario (fig. 2.1).[4] The subject is the state of Venice in the aftermath of the wars incited by the League of the Cambrai, when the climate of peace and the sponsorship of Doge (head of the Venetian state) Lionardo Loredano permitted the fine arts to flourish (1501–1521).

The details of the allegory are easily interpreted: Venice, born of the sea and thus seated on a shell-backed throne, is drawn forward by a team of winged lions, symbols of the Evangelist Mark, patron saint of Venice. She is accompanied by Doge Loredano who calls her attention to harvest offerings brought by child messengers from the earth goddess Ceres. At the left Minerva proudly presents the flourishing arts, while Neptune points out to Mars a panorama of the city of Venice. Leaning on a shield bearing the image of Romulus and Remus suckled by a she-wolf, Mars personifies the martial spirit of ancient Rome. On the clouds above float Fame and History, while at the right Mercury presents a

2.2 Pompeo Batoni, *Charles Cecil Roberts*, 1778. Museo Nacional del Prado, Madrid.

book of the Republic's achievements to the ancient sages.

Foscarini clearly intended the work as propaganda for the Venetian state during his tour of duty at Rome. Ironically, at that time the ailing Venetian economy signaled to several observers the beginning of the state's decline. This was announced by the steady withdrawal of international trade from Venice and its shifts to the ports of Genoa, Trieste, Ancona, and Leghorn. Both as ambassador to Rome and later as doge for a short time, Foscarini lamented the calamities befalling his beloved city. His pictorial program compared the current economic picture to the political situation created by the League of Cambrai, an alliance of Venice's enemies comprising France, the papacy (for a short time), the dukes of Savoy, Ferrara and Mantua who wanted to carve up the envied Venetian hegemony. Batoni's painting exalts Venice in a state of recovery, contrasting its vast domestic and cultural achievements attained through peaceable objectives with those attained by bellicose states like ancient Rome. The several allusions to recorded deeds point to Foscarini's previous position as official historiographer of the Venetian Republic. Thus the picture projects a mood of national self-confidence and the sense of personal patriotism, the ideal advertisement for the ambassador's residence in the Palazzo Venezia in Rome.

Stylistically, Batoni's *Triumph* is a mixed bag containing classical motifs as well as scenic views of modern Venice. This combination appealed to English aristocrats who wanted their Grand Tour recorded by a history painter sensitive to classical culture. The Italian painter discovered in the English colony a fruitful source of patronage. During their continental tour it became fashionable for the young men to sit for Batoni when in Rome. They naturally loved references to antiquity, and Batoni hit upon a formula for satisfying this taste and even stimulating the rage for the antique. He collected a few stock properties which he used over and over again as a setting for his portraits of noble tourists. Behind the sitter Batoni would often paint a false set of an ancient building like the Colosseum or Temple of Vesta, adding a well-known statue of a seated figure like the Ludovisi Mars and an arrangement of antique sculptured fragments (generally in the foreground) such as an upturned Corinthian capital and a bust of Minerva. One example of the English Grand Tourist shows the sitter leaning on a pedestal carved in a classical bas-relief; in the background is

2.3 Pompeo Batoni, *Thomas William Coke, First Earl of Leicester*, 1774. Courtesy Viscount Coke and the Trustees of the Holkham Estate. © Coke Estates Ltd.

2.4 Pompeo Batoni, *Duke Wilhelm Ferdinand of Brunswick*, 1767. Herzog Anton Ulrich-Museum, Braunschweig. Photo by B. P. Keiser.

a view of St. Peter's and the Castle St. Angelo and in the foreground the typical assortment of antique motifs (fig. 2.2). The cultivated Englishman also holds a map of Rome and its environs—the aristocratic precedent for later tourists recorded in all their glory by the polaroid camera.

Batoni's portraits of English travelers formed a very large part of his professional activity. Significantly, his clients and contacts comprised those collectors and dealers who did most to foster the growth of neoclassicism. He painted a group portrait including Sir Watkin Williams-Wynn and Thomas Apperley—major patrons of the new style—against a backdrop of an ancient circular colonnade; the earl of Leicester who collected objects excavated by Gavin Hamilton and Thomas Jenkins (fig. 2.3); William Weddell, who visited Rome in the years 1765–1766 and brought back to England a famous assembly of antique sculpture; and James Adam, the brother of Robert, the neoclassical architect often commissioned by the young collectors to design interiors for their collections.

Batoni's clientele was not confined exclusively to the English colony. In 1767 he painted *Duke Wilhelm Ferdinand of Brunswick*, a nephew of Frederick the Great who distinguished himself as a Prussian general in the Seven Years' War and later led the Austrian-Prussian coalition against revolutionary France (fig. 2.4). This time Batoni added a new feature to the stock backdrop, a group of Greek vases that were in the collection of Anton Raphael Mengs, the German leader of the neoclassical movement. Two of these vases were published by the famous German antiquarian Johann Joachim Winckelmann in 1767 in his *Monumenti antichi inediti, spiegati et illustrati* which reproduced over 200 engravings of antique vases, wall paintings, reliefs, sarcophagi, and gems. Both Mengs and Winckelmann were attached to the circle of Cardinal Alessandro Albani, the nephew of Pope Clement XI and the leading Roman patron and collector of antiquities of the day. Albani built a famous villa on the Via Salaria to display his vast collection of antiquities. Mengs was commissioned to decorate the main ceiling and produced one of the pioneering neoclassical works. Winckelmann worked for Albani as his librarian and cataloger, and his own seminal publications on classical art used as case studies objects from Albani's collection. The *Monumenti*, for example, reproduced several items belonging to Al-

bani and was even written in Italian as a gesture to the patron. Thus Batoni's portrait of the Duke of Brunswick puts us in touch with the German colony and its central importance in the formation of the neoclassical movement.

Mengs

Anton Raphael Mengs (1728–1779) is often erroneously credited with the invention of the new style. But if this exaggerates his role it does give us a sense of his real contribution to its development. His father, Ismael Israel Mengs, was German by birth, Danish by residence, and a converted Jew who learned early how to make the sacrifices necessary for worldly success.[5] Advancing himself to court painter in Saxony, he commanded his children to follow in his footsteps, and he pushed them relentlessly into precocious virtuosity. His calculated choice of the names Anton (from Antonio Allegri da Correggio) and Raphael already bestowed the heavy burden of destiny on his son. Mengs grew up espousing an eclectic synthesis of Raphael's drawing and Correggio's color steeped in the classicizing qualities of the ancients. Later, he preached his synthesis as aesthetic dogma, viewing taste as the capacity to choose from these artists and from antique examples and the natural world that which is most noble and universal. Underlying this grand philosophy, however, was a successful career launched by his association with Cardinal Albani.

The French rococo influence was entrenched in Dresden, capital of Saxony, at mid-century, and Mengs's early pastel portraits reveal the prevailing taste. Mengs was appointed court painter of portraiture to Augustus III, king of Poland and elector of Saxony, who envisioned himself as the very incarnation of the "benevolent despot." The spread of humane ideas in the Age of Enlightenment encouraged the production of history painting which emphasized noble virtues, and Mengs was encouraged to work at this type of representation. To help develop his skills and advance his career, his father took the entire family for their second trip to Rome to immerse them in the grand tradition. There they also converted from Lutheranism to Catholicism, thus smoothing the way to Mengs's later success in Rome and Spain. Indeed, Mengs's shifting back and forth between Dresden and Rome, and later between Rome and Spain, reflected a

restlessness born of ambition, the lack of a strong national identity, and the political turmoil in Europe. He returned to Dresden in 1749 and was appointed chief court painter, but on the pretext of wanting to paint an altar piece commissioned by Augustus III for the Hofkirche in the style of Raphael he begged leave for yet another trip to Rome. Permission was granted, but Mengs never saw Dresden again.

Once in Rome he lost no time in securing his position: he applied for, and received, membership in the Accademia di S. Luca—a necessary step for foreign artists who wanted commissions in Rome. The Roman Academy of St. Luke was the most prestigious art institution in all Italy and enjoyed papal sponsorship. Benedict XIV's desire to update Italian art predisposed him to the foundation of the Accademia Capitolina in 1754, a public life-drawing school taught by the members of the Academy of St. Luke. Mengs was one of the first appointments to the new school. His preoccupation with a predominantly classical style that subordinated color to line emerges at this time and may be attributed to the artistic ferment in Rome and his friendship with Cardinal Albani and Winckelmann (both honorary members of the academy) whom he met in this period. It was through them that he met the dealer-banker Thomas Jenkins, who brought him to the attention of notable members of the English colony.

The outbreak of the Seven Years' War also may have reinforced his stylistic shift; the new alliance between France and Austria against England and Prussia made German rejection of the rococo inevitable. Although Prussia had invaded Saxony to forestall an Austrian seizure of Silesia (located between Poland and Saxony), the Saxon army was absorbed into the Prussian forces and fought against the Hapsburg coalition for the duration of the war. Early in 1756 Mengs had undertaken a major commission from Frederick II of Prussia, but after the outbreak of hostilities he seemed to have canceled it out of deference to Augustus III. Mengs certainly felt this crisis in his pocketbook: his pension from the Dresden court was suspended shortly after the war began. Nevertheless, his close relationship with Winckelmann—a violent Francophobe—may have encouraged him to finally espouse the Prussian cause. Certainly in Rome he would have been treated more as a "German" than as a "Saxon."

His personal fortune was now at its lowest ebb, but on the advice of Cardinal Albani and Winckelmann he began systematically to collect Greek and Roman vases and amass a large collection of antiquities and plaster casts of ancient marbles.[6] Jenkins served as Mengs's agent for the collection of casts which formed the basis of his study but which he also must have occasionally bought and sold to supplement his income. Like Batoni, Mengs earned his bread and butter by tapping the English colony; he painted several portraits of British nobility. Through Jenkins and Albani Mengs received his first major commission in Rome from an English patron, a copy of Raphael's *School of Athens* which he completed around 1755 for the earl of Northumberland. The earl was then decorating his great gallery at Northumberland House with specimens of work of the more classicizing members of the Academy of St. Luke—Batoni, Agostino Masucci, Placido Costanzi, and Mengs. In January 1757 Mengs was busy on a *Judgment of Paris* for the duke of Bridgewater, and in 1760 he completed the *Visit of Augustus to Cleopatra* for the banker-collector Henry Hoare to decorate his villa in Wiltshire. (This last commission was handled through Jenkins who apparently supervised the painter at work.) Later, Mengs executed a picture for one of the foremost patrons of the new style, Sir Watkin Williams-Wynn, but on its way to England the ship which carried it was captured and looted by a French privateer.

The individual most responsible for Mengs's rise was Cardinal Albani, his enormously wealthy and influential backer.[7] He appeared to be a legitimate art collector and patron, maintaining a posh residence in the center of the city and his awesome villa just outside the Porta Salaria on the northeast side of Rome where he housed his collection of antique marbles, busts, sarcophagi, intaglios, cameos, vases, and urns. The Villa Albani became a "must" for any English traveler making the Grand Tour. Behind this wall of apparent legitimacy, however, lay a shrewd and cunning mind that manipulated the international art market. Albani was in fact a dealer-collector who profited both legally and illegally from the vogue for classical antiquity. He sold many of his antiquities to Augustus the Strong of Poland (the father of Augustus III) and to Pope Clement XII who made his purchases the nucleus of a new museum on the Capitol. But he also trafficked much more marginally, endorsing fakes, taking

2.5 Anton Raphael Mengs, *Parnassus Ceiling*, 1761. Villa Albani, Rome. Courtesy Alinari/ Art Resource New York.

fragments and renovating them for resale, and making a huge profit from the fabulously rich English. He hired the sculptor Bartolommeo Cavaceppi to restore pieces for this purpose and was in fact as much concerned with selling as with buying.[8]

Albani is an endlessly fascinating character: he was not only connected with the underground market in antiquities (it was illegal to export certain works) but he also gained English clientele by spying for the British government on the exiled Stuarts and supplying intelligence on papal intentions. Naturally, he was more valuable in times of political crisis, and his activities stepped up during the Seven Years' War. He was on intimate terms with Horace Mann, the English representative in Florence during the years 1744–1772.[9] Mann served as an agent between Albani and English patrons in search of antiquities in Rome, including notable dealers like Jenkins—also both dealer and spy—Gavin Hamilton, and James Byres. Albani also maintained contact with the abbé Peter Grant, the Jacobite head of the Scottish mission in Rome, who similarly dealt in antiquities and played the dual game of art agent and spy. Through his connections, Albani managed to install himself at the center of the neoclassical movement, gaining a monopoly in the market for antiquities and promoting the revival of classicism.

In 1760 Cardinal Albani commissioned Mengs to paint the work that signals the new style, the *Parnassus* ceiling for the great gallery—the principal room of the Albani's splendid new villa (fig. 2.5). It was destined for the Grand Tourist's eye and advertised neoclassical taste. The work was completed in 1761, the same year that Greuze's *Village Bride* showed at the Paris Salon. Mengs's

composition centers on a nude Apollo standing beside a Doric column, holding in one hand a laurel branch and in the other a lyre. He is surrounded by the nine muses and their mother, Mnemosyne. The theme alludes to Cardinal Albani in his role as patron of the arts, and it appears that Apollo's head is an idealized portrait of the cardinal himself. It was also known to contemporaries that the muses were based on actual portraits of the women in Albani's life. The face of Mnemosyne, the seated figure immediately to Apollo's right, is that of Vittoria Cheroffini, Albani's illegitimate daughter with his mistress the Contessa Francesca Cheroffini.[10] The contessa held a famous salon in her palace in the Piazza Pilotta which was much frequented by Albani's artist protégés as well as by the rank and fashion. In addition to the allusions to Albani's friends, the work also assimilated motifs from his collection such as the *Sarcophagus of the Muses*, now in the Louvre. That the entire composition is a monument to Albani is further shown in Mengs's roundels (circular decorations) flanking the central Parnassus, one displaying an allegorical personification of Rome and the other a glimpse of the Villa Albani behind an allegory of the arts. The Villa Albani, with its vast assemblage of ancient relics and its role in the dissemination of the new style, is shown to be at the center of both the ancient and the modern worlds.

Albani's desire to promote his collection and his leadership in the new movement was certainly related to his financial involvements. His aesthetic sense had little to do with it, since he had suffered from poor eyesight most of his adult life and, according to the painter Benjamin West, was nearly blind in 1760. Moreover, his villa was clearly not constructed for long-term dwelling, with tiny subdivisions and rooms of odd proportions. It was not a comfortable place, and it seems that Albani himself only spent a few days of the year there and could not have put up anyone overnight. The villa was clearly designed as a showcase for prospective clients, with the great gallery serving as a reception room. In short, the fabulous Villa Albani was probably nothing more than a glorified commercial art gallery. Jenkins, whose practices were as shady as Albani's, used him as a model when he moved into the splendid villa at Castel Gandolfo, a country retreat designed—according to one contemporary—as a "sort of trap" for rich young Englishmen who wanted to spend large sums on antiquities.

Winckelmann

One way that Albani gave his dealing activities academic respectability was through his secretary and librarian, Winckelmann. As the foremost theoretician of neoclassicism, Winckelmann stands as a key figure in the reinterpretation of the classical past and in the creation of the new style. He was born the gifted son of a poor cobbler of Stendal in Prussia, and dogged early in life by poverty he hoped to amass a fortune through culture. Many anecdotes about his youth attest to his round-the-clock studies and omnivorous reading habits. He obtained work as a librarian in and around Dresden and developed contacts with the Saxon court. This gave him accessibility to the antique sculpture in the royal collections in Dresden. In 1755 he published a pamphlet, *Thoughts on the Imitation of Greek Works in Painting and Sculpture*, an attack on the rococo that echoes Rousseau and Shaftesbury in its evocation of a harmonious arcadian world of natural virtue. He dedicated the work to Augustus III, and it is filled with chauvinistic sentiments, such as "The only way for us[Germans] to become great is to imitate antiquity." His theme was that present-day artists should model their efforts after ancient works, especially those of ancient Greece. The temperate climate and inevitable love of outdoor sport gave Grecian artists opportunity to see beautiful nude bodies, and from this observation created an ideal of noble calm and simplicity.

Winckelmann's pamphlet created much controversy in rococo Dresden and spread his reputation to Roman circles. He had previously converted to Catholicism in the hope that the church would facilitate a journey to Italy and secure him a scholarly appointment. He now requested support for a trip to Rome, and Augustus III, flattered by the dedication of the pamphlet, granted him a pension. Almost immediately after his arrival in Rome at the end of 1755, Winckelmann sought out Mengs and they became intimate friends. Winckelmann was full of gratitude for this friendship and always praised Mengs's knowledge of antiquity. This relationship was reciprocal, and Winckelmann furnished Mengs advice on the iconography of ancient art. Together they visited the major monuments of antique Rome, studying objects in the galleries, vaults, and gardens of Roman palaces, at the new excavations, and even combed ancient sources to

gather material for a projected joint treatise on the subject of ancient Greek taste.

Winckelmann's adoption of Rome as his new home was made complete in 1756 by the Seven Years' War which cut off his pension. He sided with Prussia and rallied against French decadence as manifested in rococo art. Winckelmann responded with ecstasy to the unveiling of the Parnassus ceiling. He called Mengs a "German Raphael" in his discussion of the Albani ceiling in his famous *History of Ancient Art*, published in 1763–1764 and dedicated to Mengs. Here again Winckelmann betrays his chauvinistic disposition, declaring Mengs "the greatest artist of his time and perhaps of all time," whose art incarnated the classical beauty defined in his treatise and who earned the pride of the German nation.

This book is often considered as the first modern example of art-historical writing. It is the contribution on which Winckelmann's reputation rests. In it he proposed principles for the scholarly investigation of a nation's art. He provided a chronological account of antique art, analyzing successive stylistic phases until reaching the highest level of excellence in Greek sculpture. He considered the influence of political, environmental, and religious conditions on the development of that art as well as the art objects themselves. Yet despite his pioneering claims to scientific objectivity, Winckelmann in fact advanced the ideology and the commercial aims of his employer, Cardinal Albani. In this sense as well he set the style for modern art historians.

Albani hired Winckelmann in 1758, and the scholar moved into Albani's urban residence as intimate friend, librarian, antiquary, and trusted consultant in all matters pertaining to his collection. Possessed with devouring ambition, Winckelmann boasted to his friends of his new sinecure and its privileges as well as the opportunities it offered to mingle with the highest Roman society. But the association with Albani also worked to the latter's financial advantage: by cataloging and analyzing the cardinal's collection Winckelmann substantially added to its value. In 1760 Albani requested Winckelmann to write a catalog of the engraved gem collection of his friend Baron Philipp von Stosch, in the hopes of finding a purchaser for the collection. The catalog was dedicated to Albani, which gave it maximum publicity. Baron Stosch had been similarly engaged in illicit trafficking of antiquities, passing off fakes as newly excavated objects and hir-

ing sculptors to carry out this work. He, too, was a part-time spy for the British government, observing the activities of the Catholic Pretender to the throne, James III.[11] (Britain had no representative at the papal court, which recognized the Stuarts as rightful British rulers). But this was only a minor example of the way Winckelmann's talents were exploited for gain: throughout his major works there are numerous references to the objects in Albani's collection. Winckelmann actually used Albani's objects to demonstrate his theories of high art; this despite the fact that many of them later turned out to be copies. The same is true of his *Monumenti antichi inediti spiegati et illustrati*, which included in addition to works belonging to Mengs many reliefs, scarcophagi, and gems at the Villa Albani. The book was even published in Italian to please his patron.

Thus it is not surprising to find that Winckelmann advertised not only the ancient works in the collection of his sponsor but also the new style stimulated by these very antiquities. Just as Mengs's ceiling decoration makes a double reference to the past and present through Albani's taste, so Winckelmann reinforces this in his scholarly writings. Winckelmann thus established the precedent for the modern art historian who serves the rich by glorifying their possessions. Modern art historians continue to authenticate purchases, survey new areas of investment, revive neglected artists, and encourage contemporary artists whose work demonstrates an affiliation with the rediscovered artists and styles.

Certainly, Winckelmann, who was gay, was motivated toward the appreciation of Greek and Roman art for private reasons. It enabled him to sublimate his homoerotic preference, allowing him to openly express his admiration for the male nude body in a sexually repressive period. In a letter of 1763 he laments the transitory beauty in young men and adds: "You are safer with the lasting beauty of marble figures." His notorious description of the *Apollo Belvedere* (fig. 2.6) sounds almost perverse in its emotionally charged statements. In one revealing passage, he intimates that Apollo has become real and plays Pygmalion to Winckelmann's Galatea. In Apollo-Pygmalion's presence "I feel myself transported to Delos and into the Lycaean groves—places which Apollo honored by his presence—for my image seems to receive life and motion, like the beautiful creation of Pygmalion." Winckelmann fantasizes about himself as the passive fe-

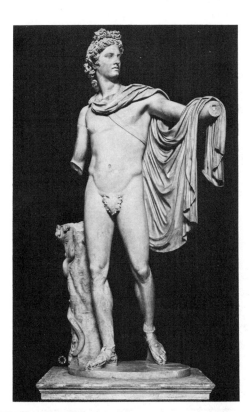

2.6 *Apollo Belvedere*, 2d century A.D., marble. Vatican Museums, Rome. Courtesy Alinari/Art Resource New York.

2.7 Plate 17 of *Le pitture antiche d'Ercolano e contorni*, vol. 1, 1757.

2.8 Frontispiece and title page of *Le pitture antiche d'Ercolano e contorni*, vol. 1, 1757.

male statue and the Apollo as the living male sculptor—an inversion operating on multiple levels. But what is significant in the career of Winckelmann is not simply his subjective preferences but the fact that he could maximize his profitable use of them in the wheeling and dealing circles of Cardinal Albani and Company.

Mengs's ceiling of Parnassus reflects the contribution of the antiquary in the service of mercantile pursuits. The work differs from rococo art in its combination of classical theme and classical style: Apollo and the Muses are painted in partial imitation of Greek and Roman sculpture and the Herculaneum wall paintings. They are worked out in clearly defined forms and the perspective has been flattened, as though done for a wall decoration rather than for a conventional ceiling. In this period, painted ceilings tended to be highly illusionistic; figures seemed to surmount the walls and rise into the clouds.

We know that Mengs assimilated into this work the impressions of Herculaneum and Pompeii which he recorded on a trip to Naples during the years 1758–1759. The two dancing muses in the lower left corner of the Parnassus, as well as some of the positions and costumes of the others, were suggested by the recently discovered wall paintings (fig. 2.7). These were illustrated in the first volume of *Le pitture antiche d'Ercolano e contorni* (1757), one of a series published by the Royal Herculaneum Academy which was founded for the express purpose of supervising the production of the lavish folios (fig. 2.8). The Neapolitan government was concerned about

2.9 Plate 14 of *Le pitture antiche d'Ercolano e contorni*, vol. 1, 1757.

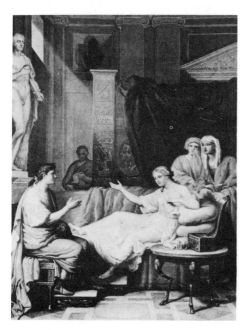

2.10 Anton Raphael Mengs, *Augustus and Cleopatra*, c. 1760. Gallery Czernin, Vienna.

the smuggling going on of the excavated objects into Rome, London, and Paris and wanted to publish the discoveries as rapidly as possible. These volumes were not sold but graciously bestowed by Carlos VII (the future Carlos III of Spain), the king of the Two Sicilies, on his diplomats, connoisseurs, and political allies. The plates of these volumes were the chief means through which everybody became acquainted with the ancient paintings of Herculaneum and contributed to the market for antiquities in general. Both Mengs and Greuze combed these plates in search of antique furnishings to give their scenes the look of authenticity (figs 2.9, 2.10. See also 1.41). Ironically, the enthusiasm they aroused encouraged forgeries which were sold for the most part to unsuspecting Englishmen. They also became one of the most widely used sources for motifs in the applied arts designed for the upper classes throughout Europe. Mengs's *Parnassus* is among the earliest examples of neoclassical painting in which there is conspicuous use of material drawn from Herculaneum. It demonstrates his proximity to the leaders of the new movement.

Another aspect of the classicizing style of Albani's ceiling is the sculptural look, hard and intellectual as opposed to the warmth and energy of painterly rococo. The drapery, for example, seems almost metallic in the sharpness of its ridges and folds, while the composition itself is solidly constructed. This is reinforced by the attitudes of the Muses, who appear as self-contained statues rather than participants in a drama. The effect is that of a collection of marbles in a gallery, perhaps the intent of this pictorial complement to Albani's overblown warehouse.

At the same time, the work owes a conspicuous debt to Raphael and is in other ways totally unlike the art of antiquity. One major difference is the curvilinear character of the compositional movement: while both Winckelmann and Mengs proclaimed an emphatic linear style, here it has a fluid quality more akin to that of Greuze and Hogarth whose "line of beauty" had a similar serpentine intricacy. While later in the century this line assumes a more geometrical orientation, in the *Parnassus* Mengs is unable to entirely shake off the decorative qualities of the rococo still predominant in aristocratic interiors.

Yet Mengs's approach must have appeared in its day as the incarnation of the classical mind, and he was in de-

2.11 Gavin Hamilton, *Andromache Weeping over the Body of Hector*, engraving after the painting of c. 1761. Courtauld Institute of Art, London.

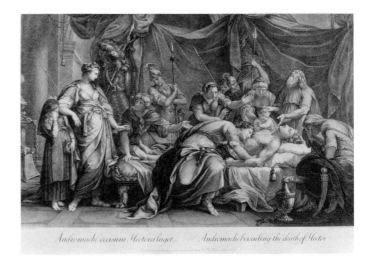

Andromache evexum Hectora luget *Andromache bewailing the death of Hector*

mand for the decoration of the town and country residences of the new breed of English collector. His English counterpart, Gavin Hamilton, who enjoyed all the privileged contacts in the Albani circle, was equally instrumental in the dissemination of the new style through his pictures for country-house and town-house collections and his dealing in antiquities.[12] Both his involvement in archeological excavations and paintings of classical subjects made him a leading arbiter of neoclassical taste. He became a major dealer in antiquities, selling important pieces to ruling-class types like Lord Shelburne and Charles Towneley.

Hamilton

Hamilton was five years older than Mengs and descended from minor gentry in Scotland. His career manifests the vibrant energy of Scottish people following the last attempt of the House of Stuart to regain the British throne. While the nationalist aspirations of the Scots continued unabated, they were now expressed through commercial, industrial, and cultural rivalry. Prosperity lay in adherence to the Union, and the greater opportunities that England afforded induced Scotspeople to cross the border and break down the social and political barrier. After mid-century, we find Scottish participants in the forefront of all new directions: in economy (Adam Smith), philosophy (David Hume), industry (James Watt), geology (James Hutton), literature (James McPherson), and architecture (Robert Adam). At the

same time, George III, embarking on a fresh political program, needed a new constituency, and he found it among the Scottish representatives in Parliament. This was facilitated by his mentor and for a time prime minister, Lord Bute, and his Lord Chief Justice, Lord Mansfield, both from old Scottish nobility. Their presence in the new government gave energy and inspiration to the younger generation of Scots.

After graduating from the University of Glasgow, Hamilton went to Rome and studied under Agostino Masucci at the Academy of St. Luke. He completed a six-week tour of Naples in 1748 with his Scottish friends James ("Athenian") Stuart (1713–1788) and Nicholas Revett (1720–1804) who that year projected a book on the ancient buildings in Greece. The first volume of this publication, *The Antiquities of Athens*, was published in 1762 and became one of the influential works of neoclassicism for its scientific methodology. By 1758 Hamilton was painting classical histories of his own, but the earliest that we can date is the *Andromache Weeping over the Body of Hector* of 1762 (fig. 2.11). It was certainly planned and begun before Mengs carried out the *Parnassus* for the Villa Albani, and Winckelmann noted that the heads were "very close to the Grecian form" and that the general treatment captured the calm of the ancients. Another of his important paintings of the period was the *Oath of Brutus* (c. 1763, fig. 2.12), commissioned by the earl of Hopetoun for his country mansion recently com-

2.12 Gavin Hamilton, *Oath of Brutus*, c. 1763. Drury Lane Theater, London.

pleted by Robert Adam. The subject is the death of Lucretia, when Brutus joins in an oath against the tyrant Tarquinius. These works had a significant impact on Greuze's reception piece and the work of the young David. The frieze-like arrangement of the compositions owe a profound debt to classical reliefs, but akin to Mengs the pictures retain qualities of the rococo in their artful and sinuous poses and exaggerated air of sensibility. As Hamilton made most of his living as a dealer and collector's agent, he painted pictures for the dilettante-clients whose taste he helped form.

One of these was certainly Lord Shelburne, later the marquis of Lansdowne, who distinguished himself in Prussia during the Seven Years' War and was appointed colonel and aide-de-camp to George III in 1760. He enjoyed a distinguished career as a statesman, serving in the House of Lords as secretary of state and prime minister. While he opposed the king's policies on the American colonies, he was long his trusted adviser. He possessed vast land holdings and overseas investments and was a partisan of Free Trade. His interests lay with the new breed of entrepreneurs moving beyond mercantilism to a laissez-faire policy, hence his position on the colonies. He perceived himself in the advance guard of fashion and ideas, and in culture he took to neoclassicism, assembling a major collection of ancient sculpture and commissioning Robert Adam to design his interiors.

Gavin Hamilton acted as his agent and adviser, planning his collection with a view to the layout of his mansions in both town and country. Shelburne had met Hamilton on a trip to Italy in 1771, although his taste for the antique dates from the previous decade. Hamilton's letters to Shelburne project a scheme for housing the collection in his new gallery, library, and gardens at the Lansdowne House in Berkeley Square, together with a scheme for classical history and landscape paintings (based on the Trojan War) to be painted by Hamilton himself. As in the case of Albani and Mengs, Hamilton intended to devise a scheme that would embrace a neoclassical setting for the display and arrangement of antiquities. His letters explicitly demonstrate how acutely conscious both agent and patron were of the meaning of what they were doing: at one point Hamilton claimed he was creating "a collection that will make Shelburne House famous not only in England but all over Europe." In another place he writes that a group of statues that he

has just shipped "are the best that ever were put in any garden in England." Still later, in reference to a piece Hamilton tries to sell Shelburne, he justifies his transaction with the observation that his "principal motive is to increase your collection with something entirely new and uncommon." And projecting the look of the final gallery, he exults that neither the pope himself "nor any prince in Europe can boast of such a collection." Finally, he takes the liberty of sending a piece "so rare and valuable that the Cardinal Albano [sic] alone in Rome can boast of having a piece in his possession, and I may safely venture to say that this is the first that has ever been sent to England."[13] These statements reveal to what extent Hamilton could profit from the vogue he helped to promote by exploiting the need of the British ruling classes to be at the center of fashion and culture. It is clear also that both dealer and client were concerned about the investment value of the relics of antiquity, and Hamilton regularly notes the worth and scarcity of the objects he ships.

Hamilton was also instrumental in the formation of the outstanding collection of Charles Towneley. When Towneley first took possession of his country seat near Burnely, Lancashire, he lived the life of a country gentleman. Like other forward-looking nobility of the time, he improved the estate through crop rotation and hardy grasses for his livestock. He earned sufficient profit from his land and investments during the time of the Seven Years' War to purchase a London town house at 7 Park Street, Westminster. He next visited Rome for the purpose of furnishing the house with ancient art objects, and in 1765 he met and made an alliance with Hamilton and Jenkins who supplied him with works for the most part recently restored. An ardent Jacobite, Towneley found all doors open to him in Rome and began to see himself as the successor to Albani.[14] While later much of the collection was declared counterfeit or made up of Roman copies, Towneley's contemporaries considered it an outstanding example of classical Greek sculpture and one of the great sights of London. He certainly lived up to Hamilton's advice to "never forget that the most valuable acquisition a man of refined taste can make, is a piece of fine Greek sculpture."

Many of the prize works had been sold through Hamilton and Jenkins and restored by the English sculptor Joseph Nollekens. Nollekens left England for Rome in

1760, when the rage for classical antiquities was fast gaining momentum. In addition to his renovations, he also purchased ancient Roman terra-cottas for a trifle and sold them to Towneley for a handsome profit. Towneley became one of his principal customers for antiques, some of which could be classified as pure hoaxes. Nollekens would dexterously piece together fragments and stain the final results with tobacco juice. He and Jenkins would often combine fragments from different excavations to compose a new piece, including heads and torsos. Hamilton was aware of these practices and willingly sold the "restored" works, but he was more discreet than Jenkins, who gained a notorious reputation as a dealer.

In addition to Shelburne and Towneley, several other great landed proprietors (including some collectors of rococo art) with money to invest formed or enlarged their collections of antiquities with objects excavated by Hamilton and Jenkins or acquired through their agency. These included the duke of Bedford (Woburn Abbey), the earl of Egremont (Pentworth Castle), William Weddell (Newby Hall), the earl of Leicester (Holkham Hall), the earl of Lonsdale (Lowther Castle), and Sir Richard Worsley (Brocklesby Park). Hamilton and Jenkins would purchase or lease a site (*cava*) for exploration, then refurbish their discoveries, or purchase relics outright from others for resale. They excavated together in Etruria in 1761; Hamilton dug on the Palatine and elsewhere in Rome, and also at sites in Ostia, Gabi, Monte Cagnolo, and Hadrian's Villa, and Jenkins at Centocelle and in the Muti vineyard near San Vitale. Hamilton's excavations at Hadrian's villa between 1769 and 1771 were particularly fruitful, and he sold his findings to Towneley and Shelburne among others. One of these was an important *Hermes* purchased by Lord Shelburne. Another work he sold Lord Shelburne from his discoveries at Ostia was actually an important copy of Myron's *Discobolos*, which was restored with other fragments by Cavaceppi as *Diomedes with the Palladion*. This gives an indication of the questionable procedures that the rage for antiquity unleashed.

This is even more pointedly demonstrated in the two notable statues of *Venus* uncovered by Hamilton, one of which was sold to William Weddell and the other to Towneley. The Weddell example (still in Newby Hall, the seat of Weddell) provides a clinical case study of the "restoration" process. Hamilton found a headless *Venus*

in the cellars of the Barberini Palace, and traded it to Jenkins who had a head fragment he owned added to it by Cavaceppi. Jenkins brought it to light in 1764, apparently claiming he had found it intact (fooling even Winckelmann), and then sold it to Weddell for an enormously high sum. Nollekens later chided Jenkins for charging what he called "a preposterously high figure" and claimed that it not only had a new head but also arms, one thigh, and a leg. Nollekens further confessed that he sold Weddell a *Minerva* for 600 pounds, which he found headless in a vineyard and purchased for fifteen pounds, but justified his huge return by having to join a head to the original trunk obtained from Jenkins with whom he shared the profits.[15] The Towneley *Venus*, excavated at Ostia, was ranked by contemporaries as a precious relic of fifth-century Greece, but it turned out to be a Roman copy and recently "mended" in several places. Towneley himself seemed to have acquiesced and even encouraged these "restorations"; he once asked Nollekens to make up a pair of arms for another *Venus* in his collection and encouraged him to experiment with a variety of positions. Evidently, the cultured collector of antiquities and benefactor of neoclassicism believed he could fuse the two without impairing the validity of either.

Hamilton, Jenkins, and Nollekens all began their careers as serious artists, but their contacts with Grand Tourists pointed them in the direction of more lucrative pursuits. They also happened to be Catholics—as were most of those who "made it" in Rome during this time—and this facilitated their contact with Roman high society. They gained a fortune from the promotion, sale, and distribution of antique objects. Nollekens was able to retire to London as early as 1770, establishing a successful workshop whose clientele included George III and several other members of the court. He became a well-known speculator on the Stock Exchange and possessed several valuable properties in London. Jenkins fared even better: he became the principal English banker in Rome and the most influential figure in the English colony.[16] His fabulous collection of sculpture, coins, and glass drew visitors from around the world and earned the admiration of Winckelmann. Despite the scandalous activities attached to his name (including a modern factory for turning out "antiques"), his wealth overcame all and he was appointed papal adviser to what would become the Vatican Collections. Almost every individual seeking

high culture in Rome had to go through Jenkins at some point or another. This enabled him to serve as an effective spy for the British government, reporting on the Jacobite activities in Rome.

Nollekens later summed up their activity as a critique of a fellow sculptor who failed to follow in their footsteps:

He ought to have made money by sending over some antiques from Rome. I told him I'd sell 'em for him, and so might many of 'em; but the sculptors now-a-days never care for bringing home anything. They're all so stupid and conceited of their own abilities. Why, do you know, I got all the first, and the best of my money, by putting antiques together? Hamilton, and I, and Jenkins, generally used to go shares in what we bought; and as I had to match the pieces as well as I could and clean 'em, I had the best part of the profits. Gavin Hamilton was a good fellow, but as for Jenkins, he followed the trade of supplying foreign visitors with Intaglios and Cameos made by his own people, that he kept in a part of the ruins of the Coliseum, fitted up for 'em to work in slyly by themselves . . . Bless your heart! he sold 'em as fast as he made 'em.[17]

But if the means of Gavin Hamilton, Jenkins, and Nollekens cast a shadow on the rise of neoclassicism, others who worked for similar ends could give it the cachet of highest nobility. Foremost among these was Sir William Hamilton, Envoy Extraordinary of His Britannic Majesty at Naples. Like his namesake Gavin, he descended from Scottish nobility; but while they had close artistic and business ties they were not directly related. After having seen active service during the Seven Years' War and serving in Parliament, he received his diplomatic assignment in 1764 and held it through the end of the century. Sir William Hamilton was a versatile type, combining the several skills of a diplomatic and social historian, a natural scientist specializing in volcanology, and an authority on Greek and Roman antiquities. His embassy at the court of the king of the Two Sicilies became the hub of artistic and cultural life in a cosmopolitan center thriving in the wake of the discoveries at Herculaneum and Pompeii. Hamilton took advantage of the opportunities offered by his environment, participating in the excavations and organizing expeditions to the crater of Mt. Vesuvius. His archeological and scientific studies secured his election as Fellow of the Royal Society, and his great collection of Greek and Roman vases made him the model of aristocratic collectors. His unique position at

the court of Ferdinand IV and Maria Carolina of Naples and his high place in cosmopolitan European society provided him with impeccable credentials for helping to launch the new classicism.

Hamilton's sinecure derived from his connection with the new English king. His mother had been mistress to George III's father—Frederick, Prince of Wales—and her favored position at court insured that young Hamilton would be raised close to the royal family. Although he was several years older than the future king, the two boys established an intimate childhood relationship. They embarked on classical studies together, always encouraged by Frederick who loved the culture of antiquity. The English translation of Bernard de Montfaucon's encyclopedic work, *Antiquity Explained*—the pioneering eighteenth-century reference book for ancient art—was dedicated to Frederick. In this ambience Hamilton and the young George III grew up sharing identical cultural and political ideals. When the new king wanted to form a Court Party in Parliament, he enlisted the services of his faithful boyhood friend.

However, Hamilton may have had position, rank, and friends in high places but he had little real wealth. He belonged to the ruling aristocratic class whose authority was still impregnable but which often lacked a regular income and settled inheritance. He set his mind early to find a lucrative place and marry an heiress, both of which he achieved; but his life-style required the trappings of wealth as well, and he used culture as a springboard to make his fortune. He did this through collecting and dealing in antiquities. Even as a youth he acquired the habit of selling art objects to pay his debts, and in this way learned about the nature of art investment. In Italy he made contact with neoclassical circles in Rome and commissioned works from people like Gavin Hamilton, Mengs, Batoni, and Angelica Kauffmann. He soon perceived the growing cult of antiquity, and almost immediately after assuming the post at Naples he systematically began to collect Greek and Etruscan vases and other antiques like bronzes, glass, terra-cottas, coins, ivories, gems, and gold ornaments. As a scholar of antiquity, he pioneered in the discussion of its formal qualities—in the shapes and imagery of antique objects. In this way he discovered the value of these works "for forming and ennobling modern art-taste."

In the years 1766–1767 William Hamilton brought out

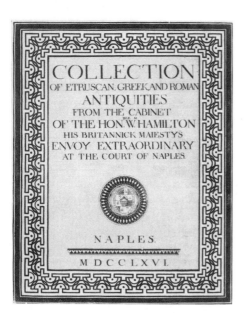

2.13 Title page in English for Sir William Hamilton's *Collection of Etruscan, Greek and Roman Antiquities*.

2.14 Title page in French for Sir William Hamilton's *Collection of Etruscan, Greek and Roman Antiquities*.

four sumptuous folio volumes illustrating his collection, *Collection of Etruscan, Greek and Roman Antiquities from the Cabinet of the Honourable William Hamilton*. This work was destined to have an enormous impact on the diffusion of neoclassicism: Wedgwood, Flaxman, Fuseli, David, and Ingres came directly under its influence. The text was written by Pierre-François Hugues, a French adventurer and amateur archeologist better known under his pen name of d'Hancarville. D'Hancarville was the son of a cloth merchant who posed as a gentleman for most of his adult life and wrote licentious books. He also found time to become a classical scholar and develop close connections to Winckelmann and Albani. He accompanied Hamilton to Naples as scholar-in-residence, and it was he who orchestrated the production and publication of the vase collection.

The volumes were printed in both French and English, thus addressing the widest possible audience at the time (figs. 2.13, 2.14). The plates were engraved and hand-painted, their form usually consisting of a drawing of the vase in perspective, a sectional plan giving detailed measurements, and a reproduction of its imagery at the bottom of the plate. The first volume carries a grandiose dedication to George III on a stele (an ancient slab or pillar of stone bearing an inscription), against which leans a *fasces*, Roman symbol of unity (fig. 2.15). A Greek vase stands in the foreground of the dedicatory plate which is linked pictorially with the *fasces*. Hamilton here clearly establishes a common bond between his taste and that of the king.

The purpose of the work was set out in the preface:

Our end has certainly been to shew a considerable selection of exquisite Models, but we likewise have proposed to ourselves to hasten the progress of the Arts, by discussing their true and first principles. It is in this respect that the nature of the work may be considered as absolutely new, for no one has yet undertaken to search out what sistem (sic) the Ancients followed, to give their vases that elegance which all the world acknowledges to be in them, to discover rules the observation of which conduct infallibly to their imitation . . . in order that the artist who would *invent* in the same stile, or only *copy* the monuments . . . may do so with as much truth and precision, as if he had the Originals themselves in his possession.[18]

D'Hancarville and Hamilton emphasize that their aim in producing the series was not simply to display objects for "fruitless admiration" but to "revive an Ancient Art"

2.15 Dedicatory page for Sir William Hamilton's *Collection of Etruscan, Greek and Roman Antiquities*.

to some purpose. And they conclude with the hope that their models will excite the imagination of artists and craftspeople and give rise to a new artistic direction.

While on the face of it they seemed to be motivated by the noblest concerns, further analysis suggests a simple commercial motive for the production of this lavish series. Hamilton sunk most of his personal fortune into the publishing venture, wishing it to rival the imposing *Le pitture antiche* in importance and impact. The fact that he launched it barely two years after arriving at Naples, and that during this short interval amassed over 700 vases, indicates a deliberate plan of action. He definitely saw antiques as a form of investment, prompting a French contemporary to note that it was not so much that Sir William Hamilton supported the arts but that the arts supported Sir William. He publicized the book well in advance of publication by sending galleys to leading connoisseurs in Britain. His diplomatic status and the dedication of the catalog to George III gave it the royal imprimatur, and it established his reputation as a leading connoisseur himself. The very preface of his book, with its plea for a revival of ancient art, bestowed upon him the role of pacesetter. Sir Joshua Reynolds, newly elected president of the Royal Academy of Arts, publicly praised Hamilton's contribution. Having carefully prepared his campaign, Sir William took a leave of absence in 1771–1772 to return to England for the purpose of selling his now famous collection. He set up an advance exhibition for the owners of his catalog, and then with their help the collection was bought by the trustees of the British Museum with a parliamentary grant. Ten years later, Hamilton took another leave of absence, this time to sell the famous Portland vase, a Roman cameo glass vase dating from the Age of Augustus which he had purchased from James Byres, a close associate of Gavin Hamilton and Jenkins. With the help of go-betweens, Hamilton negotiated in secret with the duchess of Portland who bought the vase and other antiquities at almost double his original investment.

Meanwhile, he had begun collecting actively again, working through agents like the Abbé Peter Grant and Jenkins. He also published this collection in four folio volumes, *Collection of Engravings from Ancient Vases*, which appeared during the years 1791–1795. This time he had the collaboration of the German engraver and painter, Wilhelm Tischbein, who had visited Hamilton in the

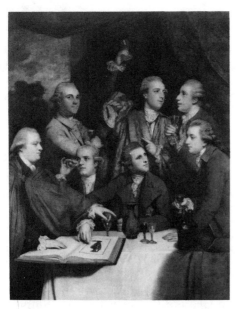

2.16 Sir Joshua Reynolds, *The Dilettanti Society Toasting Hamilton in 1777*, 1777–1779. The Society of Dilettanti, London.

2.17 Plate 60 from Sir William Hamilton's *Collection of Etruscan, Greek and Roman Antiquities*.

company of Goethe in 1787 and remained as part of the diplomat's entourage. Tischbein's sharp linear style influenced the formal look of later neoclassicism, especially the work of the English artists Flaxman and Fuseli, and the German Runge. Thus it may be said that just as Albani employed Winckelmann to add scholarly validity to his mercantile pursuits, Hamilton employed d'Hancarville and Tischbein to further his own commercial ends.

Hamilton's distinguished position enables us to catch a glimpse of the social milieu from which sprang the initiative for neoclassicism. For example, in 1777 he was elected a member of the exclusive Dilettanti Society which consisted of noblemen and gentlemen who had made the Grand Tour and whose interest was in the promotion and patronage of ancient art.[19] They financed expeditions to Greece and Asia Minor and published the results in costly publications like that of Hamilton's. The meeting in which Hamilton was introduced as a new member was painted by Reynolds, and it shows the society drinking his health (fig. 2.16). Hamilton is shown seated, pointing to a volume illustrating one of the vases from his collection (fig. 2.17). At the left (in fig 2.16, in scarlet toga as president of the evening) is Sir Watkin Williams Wynn, to name only one of this elite Tory group collecting antiquities from Gavin Hamilton, Nollekens, and Jenkins, Inc. Hamilton's presence is symbolic of the way in which the economics of collecting antiquities could be "laundered" by noble privilege and authority.

Another example in contemporary painting is the group portrait by Johann Zoffany (1734–1810) of *Charles Towneley in His Gallery* (fig. 2.18).[20] It is a clinical study of the collector of antiquities and his mania for accumulating busts, casts, cameos, intaglios of every description. Zoffany, of German descent, studied under Mengs in Rome for about seven years. He made his way to London in 1760, and his reputation for his imitative skills brought him to the attention of Lord Bute. Through Lord Bute's influence the king appointed him to the Royal Academy, a privileged nomination which placed him on an equal footing with the founder academicians. Zoffany was commissioned by Towneley to paint his gallery at 7 Park Street, Westminster, in 1782. He was instructed to include the famous *Venus* found at Ostia by Gavin Hamilton as well as a number of other prominent pieces in Towneley's collection. Nollekens tells us that these pieces were arranged not as they were generally

2.18 Johann Zoffany, *Charles Towneley in His Gallery*, 1790, Royal Academy Exhibition. Towneley Hall Art Gallery and Museums, Burnley Borough Council, England.

found in the gallery but in a manner that best showed off the well-known pieces in the collection. It is a work flattering the aristocratic collector, both in terms of the objects portrayed and in the people present.

The interrelationships among the various promoters of the new movement are documented in this picture. Towneley is shown seated at the right in the middle of the picture, and facing him from the table at the left is the antiquary and adventurer, d'Hancarville. Towneley was a good friend of Hamilton and fellow member of the Dilettanti Society, and it was through him that he made the acquaintance of d'Hancarville. Standing next to the table are Sir Thomas Astle, a trustee of the British Museum, and Charles Greville, the nephew of Sir William Hamilton. Greville was introduced to collecting by his uncle, and on his advice began speculating in antiquities for profit.

Towneley had invited d'Hancarville to reside in Park Street to catalog his collection, and while there the author composed the better part of his celebrated *Recherches sur l'origine, l'espirit et les progrès des arts de la grèce* (1785). D'Hancarville not only dedicates and addresses the entire work to his patron but he holds up Towneley's collection as the outstanding example of its kind in England. He then declares that it was this collection that made his present book possible, that furnished him with the material to spin out his fanciful mythological theories.[21] D'Hancarville certainly attests to this throughout the three volumes that make repeated reference to the objects in Towneley's gallery. Whenever he wishes to illustrate an esoteric point he invariably asserts, "There exists in Mr. Towneley's collection an example . . ." Thus d'Hancarville does for both Hamilton and Towneley what Winckelmann did for Albani, promoting and aggrandizing their personal possessions but also disseminating their taste and preference to the wider community. The sumptuous publications functioned as both reference text and sales catalog, and while they are now perceived rightly as progenitors of the new style their original motivation has been overlooked.

Wedgwood

These publications profoundly affected the decorative arts of the period. Those who collected antiquities commissioned architects, craftspeople, and interior designers to

enlarge their stately residences and render them appropriate for the objects. Their models of decoration were the engravings published in the sumptuous volumes of the leading collectors and their scholarly retainers. Of all those who profited from this vogue, the most prominent was Josiah Wedgwood (1730–1795). While we shall discuss Wedgwood at length in the next chapter, his role in the diffusion of neoclassicism must be considered here as well. He became an independent potter in 1759 at the height of the Seven Years' War and seems to have caught on early to the growing rage for the antique. In November 1766 he opened his first London showrooms in Charles Street, Grosvenor Square, and the same year he was confirmed as "Potter to Her Majesty." He thereupon renamed his special creamware "Queen's ware." Also that year he purchased nearly 350 acres situated between Burslem, Hanley, and Newcastle, and there he built a factory he called "Etruria" after the ancient civilization in central Italy.

Wedgwood, with his partner Bentley, became the preeminent potter in the neoclassical style. He used his talents as engineer, chemist, salesman, organizer, reformer, and industrialist to prune away rococo extravagance of his contemporary porcelain makers and the chinoiseries of the delftware. He aimed at an ideal that denied most of the cherished ceramic virtues and sought a model of simplicity and elegance in line with the taste of the reigning aristocracy. In Italy ceramic and bronze manufactories turned out reproductions of statuettes, intaglios, and cameos, and the enthusiasm of the English for all things ancient gave rise to the profitable business of forgery. The only objects other than forgeries which could satisfy the colossal demand for antiquities were good copies honestly made and sold as such. First, these were in exact imitation of the original; then they could be reproduced in various other materials that served to bring out the design—for example, plaster for statues, reliefs, and urns; painted plaques for wall paintings; painted earthenware for highly glazed vases; glass paste, sulphur, and, finally, pottery for gems. There was assembled a huge fund of classical designs from which single motifs or parts of motifs were taken. Divorced from their original contexts (sarcophagus, urn, altar, wall painting, gem, coin, vase, etc.) the individual motifs, figures, and shapes could be used in a variety of formats.

Wedgwood depended to a large extent for ideas on the

sumptuously illustrated publications of the neoclassical collectors and on their originals. The names of Sir William Hamilton, Lord Cathcart, Lord Shelburne, Sir Watkin Williams-Wynn, and James Stuart recur often in his letters not only as customers but as consultants for the enlargement of his classical art vocabulary. They suggested designs based on their originals and thus established a symbiotic relationship, all tending to promote the new style and its major patrons. Early in the 1770s Lord Shelburne gave Wedgwood permission to copy some bas-reliefs that had been made to his order from wall paintings in the Villa dei Papyri in Herculaneum.

Wedgwood did so well not because he undersold his rivals or produced unique designs but because he knew how to manipulate the world of fashion. He aimed his productions at the monarchy, the nobility, and the art connoisseurs who were in the forefront of the new style. He understood that to make pots or tea services for the Queen of England was invaluable advertising. Eventually, "Queen's ware"—common earthenware, in fact—made this line a profit-making enterprise on the world market. By 1768 he was advertising his royal patronage in the *St. James's Chronicle*, "that morning paper which is mostly taken by the people of fashion."[22] He undertook many special commissions for Catherine the Great strictly for their advertising potential, to win the patronage of the court and the favor of the fashionable aristocracy and gentry.

By appealing to the fashionable vogue for antiquities, by pandering to the requirements of the ruling classes but asking their advice and accepting their smallest orders, by flattery and attention, and by using their originals as models for his productions, Wedgwood hoped to monopolize the aristocratic market and win for his wares a special social distinction which would eventually filter through to all social classes. He perceived the link between the new vogue and the taste for purity and simplicity, and he did everything possible to promote and to serve the new fashion. In estimating the appeal of his rivals, Wedgwood declared that their clientele were fond of "show & glitter," while "all who could feel the effects of a fine outline & had any veneration for Antiquity would be with us." He knew how to juggle his classical originals so they could better suit the taste of the eighteenth-century market. For instance, he often clothed naked statues (he draped the herm of Priapus so that the

2.19 Josiah Wedgwood, *First Day's Vase*, black basalt, 1769. Trustees of the Wedgwood Museum, Barlaston, Staffordshire, England.

god no longer lived up to his name) to achieve salable goods that would not offend the decorum of the English gentry. He never copied the antique slavishly but attempted to preserve "the elegant simplicity of antique forms." And he had the assurance of Sir William Hamilton that this was the proper way to copy the antique.

Wedgwood's borrowings from Hamilton's collections and publications have been amply documented. He received proof pages of the first Hamilton catalogue from Lord Cathcart, Hamilton's brother-in-law, and Sir Watkin Williams-Wynn subsequently presented Wedgwood with the volumes themselves.[23] For the official opening of his new factory at Etruria which was commemorated on 13 June 1769, Wedgwood celebrated by turning and throwing six black basalt vases with figures copied from Attic red-figured vase published as plate 129 in d'Hancarville's catalog (figs. 2.19, 2.20). Wedgwood's popular *Apotheosis of Homer* vase was also based on an example in Hamilton's collection sold to the British Museum in 1772 (figs. 2.21, 2.22). But perhaps the most spectacular example of this connection is the rare Wedgwood vase of black basalt of a type known as a *krater* (an ancient vessel for mixing wine and water). The model for this *krater* and its imagery also formed part of Hamilton's collection, but we know that Wedgwood made his copy not from the classical original but from engravings in d'Hancarville's catalogue (vol. 1, plates 52–56), since he repeated the errors of design reversal in plates 55 and 56 (figs. 2.23, 2.24).[24]

Later, after they became acquainted, Hamilton lent original vases to Wedgwood for copying, and Wedgwood in turn executed interior decorations for Hamilton's residence in Naples. Wedgwood could claim that he had brought into England, by the sale of his imitations

2.20 Attic red-figure vase published as plate 129 in Sir William Hamilton's *Collection of Etruscan, Greek and Roman Antiquities.*

2.21 Josiah Wedgwood, *Apotheosis of Homer* vase. Trustees of the Wedgwood Museum Barlaston, Staffordshire, England.

2.22 Plate 31 of Sir William Hamilton's *Collection of Etruscan, Greek and Roman Antiquities.* Courtesy Trustees of the British Museum, London.

of the Hamilton vases, three times as much as the 8,400 pounds paid for the collection by Parliament. Indeed, as Wedgwood confided to his "good friend" Hamilton: "The whole nation, as well as I, have long spoken with gratitude of the patronage you have afforded, and the assistance you have given, to the arts in this country by the introduction of so many of the valuable relics of antiquity."[25] Despite the high-sounding phrases, however, Wedgwood was clearly communicating to Hamilton the happy fact that they had helped to make each other's fortune.

Hamilton was not the only source of Wedgwood's ideas. He maintained a library of reference works including the ubiquitous *Le pitture antiche d'Ercolano* (an English translation of the first part appeared in 1773), the comte de Caylus's seven-volume opus, *Recueil d'antiquités*, Montfaucon's *Antiquity Explained*, and he regularly subscribed to the publications sponsored by the Dilettanti Society. His patrons also furnished him with originals, such as Sir Watkin Williams-Wynn, who allowed him to copy no less than 245 cameos and intaglios in his collection. As in the case of Hamilton, Sir Watkin was also an important client who purchased Wedgwood's wares in large quantity and variety, including an encaustic (painting in wax) painted tablet made for the chimney piece designed by Robert Adam for Sir Watkin's residence on 20 St. James's Square.

Wedgwood's use of *Le pitture antiche d'Ercolano* is seen in a series of oval plaques of *Herculaneum Dancing Nymphs* based on Roman wall paintings discovered at

2.23 Josiah Wedgwood, black basalt *krater*. Courtesy of the Board of Trustees of the Victoria and Albert Museum.

2.24 Plate 55 of Sir William Hamilton's *Collection of Etruscan, Greek and Roman Antiquities*.

Pompeii and published in the first volume of *Le pitture* in 1757. (These were related to the same figures Mengs used for his *Parnassus* ceiling.) Wedgwood also took molds from a set of casts of Lord Shelburne's bas-reliefs made in Italy after the frescoes. The *Herculaneum Nymphs* were among Wedgwood's most popular designs, and he produced them in sets of either oval or round plaques (figs. 2.25, 2.26). As with all his large reliefs, they were intended for schemes of interior decoration.

Wedgwood also relied on the publications and contacts emanating from Albani's circle. He used casts of ancient monuments from dealers and sculptors coming through the agency of Thomas Jenkins, who handled Wedgwood's business in Rome. Local Italian artists like Pacetti and Dalmazzoni were hired to execute these casts, many of which were modeled from examples in Albani's collection and also from the Vatican and Capitoline Museums. Wedgwood borrowed freely from the illustrations in Winckelmann's *Monumenti antichi inediti*, which reproduced a number of objects in Albani's antique storehouse.

By his manufactures and modern sales techniques, Wedgwood became the popularizer of the neoclassical style in England and overseas. By his commercial gifts and his enterprise as a manufacturer, Wedgwood played a major part in the diffusion of neoclassical culture. His factory organization, his manufacturing techniques, his products, and his marks were copied everywhere. Wedgwood's imitators could be found in France, Spain, Sweden, Germany, and Italy. He early realized that fame and wealth could be achieved by harnessing industry and industrial design to an art style backed by the wealth and self-interest of the British ruling classes. He certainly could not have predicted that the style would accommodate itself to the history of Europe during the next fifty years, but there can be no doubt that his commercial sense and lobbying efforts did much to bring it about.

Up to this point we have seen a remarkable pattern of common aims and motivations among those members of the English aristocracy and middle-class entrepreneurs in the rise, development, and spread of neoclassicism. Yet this dramatic interlocking of aspirations can be even more tightly assembled within the burgeoning architectural developments. The English patron's mania for collecting antiques was part of a larger enthusiasm for building and embellishing great country and town

2.25 Josiah Wedgwood, *Herculaneum Dancer*, black basalt. Courtesy of the Trustees of the National Museums and Galleries on Merseyside (Lady Lever Art Gallery, Port Sunlight), Liverpool.

2.26 Plate 21 of *Le pitture antiche d'Ercolano e contorni*, vol. 1.

houses. This provided an opportunity for the new decorative style to evolve and gain acceptance. It was in this context that the owners of wealth could amply display their taste and ultimately the power that made it possible. This mood of cultural pomp and imperialism was given a significant and influential direction by the efforts of the architect Robert Adam and his family firm. Adam's activities in the second half of the century pull together the diverse strains and aspirations of neoclassical ideals and stimulate its spiraling growth. He became the leader and vigorous exponent of a classical revival in architecture and decoration.

Adam

Adam descended from minor landed gentry in Scotland; his father was a successful architect and businessman, with extensive coal-mining interests, a brewry, and other investments, and who enjoyed government contracts for constructing forts in the Highlands. Adam was able to make his Grand Tour in grand style, and hobnobbed at the various Salons in Italy while he was there during the years 1754–1758.[26] Before leaving for Rome in 1754 he met Gavin Hamilton in London, and Gavin gave him introductions to art dealers, connoisseurs, and the leading lights of the Albani circle. Through Gavin Hamilton's contacts he was also to meet Charles-Louis Clérisseau, an architect and draftsperson who figured prominently in the neoclassical revival and exerted a major influence on Adam's thought. Clérisseau had been a pensioner at the French Academy at Rome but was expelled for insubordination. He studied architectural drawing under Gian Paolo Panini, the famous painter of scenic views for English Grand Tourists. Clérisseau followed somewhat in his footsteps, seeking patrons to sustain him. Attached to the Albani circle, Clérisseau linked up with Adam, whom he taught elements of drawing, perspective, and antiquarianism in exchange for a per diem allowance.

Hamilton's introduction also brought him in touch with the abbé Grant who acted as an agent for aristocratic English youth. He also met Mengs and Cardinal Albani; Adam became one of the regulars at the famous Salon conducted by Contessa Francesca Cheroffini, where Albani's artist protégés and business contacts were entertained. Later, Albani sold James Adam—Robert's brother—his famous collection of drawings originally owned

by Cassiano de Pozzo, mainly at the instigation of Contessa Cheroffini who wanted the cash for her daughter's dowry. Adam could write in 1755 that he and Albani were on close terms "as he had discovered my hidden talents for the hidden treasures of antiquity."[27] Albani also allowed him to make casts of original objects in his collections to send home. In fact, Adam began collecting antiquities to sell on his homecoming and to employ in his decorations.

His trip to Rome was actuated primarily by business concerns. He had planned to open an architectural firm when he returned, and the trip to Italy was written off as a necessary business expense since he already had a sense of his future clientele. At the same time, he undertook original research in the hopes of publishing a lavish folio of ancient architecture to fulfill the firm's carefully prepared publicity campaign. Hence his expedition to Spalatro and his subsequent publication of the *Ruins of the Palace of the Emperor Diocletian at Spalatro* (1764).

When Adam returned from Rome he set up practice in London. He proved to be another of the daring Scotsmen who grabbed the advantages England offered to entice its neighbors away from a bellicose position to one of mutual cooperation. His position was considerably enhanced when George III ascended the throne still dominated by his mentor, Lord Bute. Through his influence Adam was appointed in November 1761 Joint Architect (with William Chambers) of His Majesty's Works. Before the reign of George III, the dominant architectural trend in England was monopolized by the wealthy Whig aristocracy and was notably influenced by Renaissance, Mannerist, and Baroque architecture. Adam criticized its inherent stodginess and heaviness, the massive and deeply carved entablatures and pediments, its elaborate and pompous door frames. He argued that it had all been reduced to the level of a cliché and was no longer a vital style. The Adam style on the other hand, as it developed in the early 1760s, constituted a return to the purity of the artistic expression of the classical, pre-Christian world. He advocated a lighter, more elegant, almost feminized mode, and in this sense he came close to the style of Mengs, Hamilton, and Wedgwood. His decoration was flat and linear, with delicate pilaster strips in place of bulging half-columns, and stressed simple rectangular planes as opposed to profuse ornamentation. Adam's new approach perfectly suited the new regime,

which threw off the Whig connections as well as the once revered neo-Palladian pomposity.

The emergence of neoclassicism coincides with the emergence of the new regime which required its own style to mark the transition. Lord Bute exercised a notable influence on this direction; a contemporary claimed that Lord Bute "had all the disposition of a Maecenas and fondly hoped he would be the auspicious instrument for opening an Augustan reign." Lord Bute's classical taste was well known and Adam once referred to him as "the bold Scipio." George III's ambitions, stimulated by the vast extent of Britain's colonial possessions, gave rise to thoughts of colossal civic undertakings, as in the ancient empires of the past which commemorated for all time the power of their reign.

It is not coincidental that Adam began his career at the height of the Seven Years' War. Some of his first commissions were from aristocrats engaged in the British armed forces. The most important of these was for Admiral Edward Boscawen of Hatchlands, Surrey, who commanded the British navy and army during its decisive victory over the French at Louisburg (West Indies) in 1758.[28] The following year he gave Adam one of his first houses to decorate, for which the architect supplied the important plastered interiors. Adam used classical images alluding to the admiral's maritime activities. In addition, the library ceiling at Hatchlands displays battle

2.27 Robert Adam, library ceiling at Hatchlands. Courtesy of the National Trust Photo Library, London.

2.28 Robert Adam, *Admiralty Screen*, Admiralty House, London, 1760. Courtesy of the Department of the Environment, Hannibal House, Elephant and Castle.

trophies and cannons in commemoration of the recent military engagements (fig. 2.27). Hence Adam's early use of classical decoration referred to British imperialism and makes a conscious identification between contemporary English and ancient empire. Ironically, Boscawen, who earned the high service pay of 3,000 pounds per year, claimed that he was able to complete his house "at the expense of the enemies of his country."[29]

Other early commissions included the extension to General Humphrey Bland's house in Isleworth in 1758 (although Bland had not fought in the Seven Years' War his *Treatise on Discipline* was the mainstay of the British army's drill); in 1759 he executed designs for the monu-

2.29 Robert Adam, dining room ceiling at Hatchlands, 1759–1761. Courtesy of the National Trust Photo Library, London.

2.30 Robert Adam, *Admiralty Screen*, detail, Admiralty House, London, 1760. Courtesy of the Department of the Environment, Hannibal House, Elephant and Castle.

ment to General Wolfe in Westminister Abbey and also received the commission, probably through Boscawen who had been Lord of the Admiralty, to do the famous Admiralty Screen in Whitehall (fig. 2.28). One possible link to Boscawen is the repetition of ornamental motifs in the dining room ceiling of Hatchlands on the Admiralty gate (figs. 2.29, 2.30). The screen is essentially a classic gateway to the British department of state having charge of naval affairs. But the surest clue to the connection between the new classicism and the Tories' claim to empire is Adam's publication of the ruins of Diocletian's palace at Spalatro. Adam dedicated this work to George III and presented a specially bound copy to George III. In his dedication to the king Adam wrote the following lines:

All the Arts flourish under Princes who are endowed with Genius, as well as possessed with Power. Architecture in a particular Manner depends upon Patronage of the Great, as they alone are able to execute the Artist's plans . . . At this happy Period, when Great Britain enjoys in Peace the Reputation and Power she has acquired by Arms, Your Majesty's singular Attention to the Arts of Elegance, promises an Age of Perfection that will complete the Glories of your Reign, and fix an Aera no less remarkable than that of Pericles, Augustus, or the Medicis.[30]

Adam holds out a vast future for the new king which includes the royal architect as the linchpin of the utopian enterprise. All this is modeled upon the ideal of antiquity and encourages George III to think like a Roman emperor rather than a constitutional monarch. Adam's dedication makes unmistakable reference to this identification:

2.31 Dedicatory page of Robert Adam, *Ruins of the Palace of the Emperor Diocletian.*

"I beg leave to lay before Your Majesty the Ruins of Spalatro, once the favorite Residence of a great Emperor, who, by his Munificence and Example, revived the Study of Architecture, and excited the Masters of that Art to emulate in their Works the Elegance and Purity of a better Age" (fig. 2.31). In brief, George III now has the opportunity to emulate Diocletian by reviving a style superior to the conventional fashions of the day and has at his beck and call an able "master" to carry out his orders. Certainly Lord Bute got the message: he ordered ten copies of Adam's book, more than any other single subscriber.

Like Wedgwood, Adam knew the importance of royal sponsorship in promoting his product. He wrote to Lord Kames on 31 March 1763:

I flatter myself, that the arts in general are in a progressive state in England. If the King builds a palace in a magnificent and pure style of architecture, it will give a great push at once to the taste of this country; as it will not only furnish ideas for lesser buildings, but show effects both of external and internal composition which this country as yet is entirely ignorant of . . . Painting and sculpture depend more upon good architecture than one would imagine. They are the necessary accompaniments of the great style of architecture.[31]

Adam projected plans for a vast synthesis of all the arts predicated on his leadership.

Politically, Adam was a Tory who attached himself to the Scottish contingent of the king's party. As a member of Parliament for Kinross-shire in 1768, he followed the lead of Lord Bute and Lord Mansfield. They in turn encouraged his architectural fantasies, including the ambitious scheme for the Adelphi, a vast complex of commercial and institutional houses and apartments, underground vaults, and terraces, based on his desire to erect a monumental building on the order of antiquity. While it all but bankrupted the firm due to the government's refusal to lease the vaults as storehouses, George III did use his influence to push through bills facilitating the construction of the Adelphi. The final result was seen as worthy of the old Romans, and it was compared to the palace at Spalatro.

This was as close as Adam ever got to realizing his plans for a large-scale revival of antique architecture, but over the years he designed and refurbished most of the major country and town houses of the ruling elite. Lord

Bute commissioned Adam to do a town house in Berkeley Square in 1761, including the interior decorations and furnishings. As it was underway at the time Lord Bute was negotiating the Peace of Paris, the opposition party linked the two events and intimated some sort of bribe. But Lord Bute, who possessed a fortune from coal-mining interests, needed no incentive to project a new order for the reign of George III. Before the house was completed, however, Lord Bute sold it to Lord Shelburne, who finished it to Adam's designs. Adam designed the interiors with niches to hold classical statuary, and later Lord Shelburne contracted with Gavin Hamilton for the formation of a collection of sculpture and antiques for his library and gallery. Lord Shelburne also commissioned Adam to design a Roman portico and new interiors for his country seat at Bowood, Wiltshire.

In 1767 Adam undertook the refurbishing of Lord Mansfield's country seat at Kenwood, Middlesex, including the entrance portico in a restrained Doric mode and the celebrated reception room and library. As Lord Chief Justice and loyal supporter of George III, Lord Mansfield revamped the old feudal laws to meet the rising needs of manufacture and commerce. His decorative scheme for the ceiling of the reception room (the "Adam Room," as it is now called) included an allegorical cycle of "Justice" which embraced Peace, Commerce, Navigation, and Agriculture. While the inspiration of Roman antiquity is acknowledged throughout the decorative scheme, Adam modified classical precedent in the alteration of a Roman frieze to accommodate the coat-of-arms of his patron. The same year as his work at Kenwood, Adam did decorations for Luton House, one of the country seats of Lord Bute, a person Adam described as "so justly esteemed for his great taste and discerning judgment in the celebrated works of the ancients." In his *Works of Architecture* Adam describes the Luton House and exults: "We are happy in having this opportunity of expressing to the world that gratitude which we never ceased to feel, for the protection, favour, and friendship with which we have always been honoured by his Lordship."[32]

In addition to his work for George III's closest advisers, Adam designed the homes of the aristocratic collectors of antiquities. William Weddell, whose seat was Newby Hall, Yorkshire, brought back from Italy a major cache of antique sculptures as a result of his dealing with Gavin Hamilton, Nollekens, and Jenkins. He en-

2.32 Robert Adam, view of gallery with Barberini, *Venus*, 1767–1772, Newby Hall, Yorkshire, England. Courtesy of the National Trust Photo Library, London.

gaged the services of Adam to design a gallery for these objects, and in this context the architect was allowed free scope for an appropriate classical decor (1767–1772). He conceived of the gallery in three spaces, the central one of which was domed. Within these spaces, alcoves, and niches for statuary, neoclassical friezes and bas-reliefs create a solemn classical sanctuary. In one view of the gallery we see the notorious Barberini *Venus* acquired through the wily machinations of Gavin Hamilton and Thomas Jenkins (fig. 2.32).

Adam also designed the town house of the opulent baronet Sir Watkin Williams-Wynn at 20 St. James's Square. Sir Watkin, whose presence pervades the development of English neoclassicism, was a close personal friend of Adam.[33] The rich and seemingly boundless estates owned by Sir Watkin almost amounted to a principality, and the income from them was habitually spent by him to amass whatever architects, painters, sculptors, and manufacturers of neoclassical products offered. Wedgwood wrote his partner Bentley in 1769 that Sir Watkin was prepared to buy the potter's first edition of Etruscan-style vases, no matter what they cost. Wedgwood also collaborated with Adam in the decoration of Sir Watkin's house, supplying painted basalt tablets to the architect's design for the chimney piece. Sir Watkin was a self-conscious pacesetter and used his position to augment his already considerable fortune: he looked upon his antiquities as investments and fully cooperated

with Wedgwood in supplying models from his collection for neoclassical designs, thereby increasing the value of the originals and spreading the taste of their owner.

Adam's facade for Sir Watkin's residence suppressed dramatic projections and reliefs in favor of an austere look, while the interiors stress flat planes and rectilinear patterns of garlands, festoons, swags, and other foliage designs. This was typical of the neoclassical addicts, who required that their drive for wealth be masked with a culture that projected dominance but in a restrained, harmonious mode. Another important commission of the 1770s incarnating Adam's linear and geometric scheme was Lady Home's mansion at 20 Portman Square (now the University of London, Courtauld Institute of Art). The countess of Home was the heiress of a Jamaica sugar magnate, with whom her husband, Lord Home, had enjoyed extensive business connections. Adam's interiors for the Harewood House, Yorkshire, were done for Edwin Lascelles (later Lord Harewood), whose father had made the family fortune as a collector of customs at Barbados and as a director of the East India Company. Adam also did the portico in the inner courtyard and interior decorations for Osterley Park, Middlesex, whose owner (Robert Child) was the head of one of England's largest banks with major overseas investments.

In 1762 the duke of Northumberland approached Adam with the idea of refurbishing his Syon House "entirely in the antique style." The duke of Northumberland was yet another of the large landowners who modernized their estates with scientific methods, and at the peak of the Seven Years' War earned an astonishing 50,000 pounds annually from his estates.[34] He then began investing this fabulous fortune in neoclassicism and gave Adam carte blanche in the decorations: Adam went wild in ordering copies of ancient statues and columns, designing pedestals, medallions, plaques, urns, trophies, an unimaginable variety of motifs for the spacious interiors of this country estate. As in previous commissions, he fused his patron's insignia with ancient motifs; he added lion's claws to the pilasters of the gateway screen in homage to the duchess's family heraldry. Here again he symbolized the transference of ancient rule to contemporary leadership.

Adam the Tory took a great deal of interest in the physical space of social life, designing original vestibules, anterooms, and special access for servants and tradespeo-

ple. These often were as lavish in antique decoration and sculpture as galleries and libraries; the anterooms for servants in attendance at Syon House are remarkable examples of this concern. He declared, for example, that the hall (of vast dimensions at Syon House) should be a spacious apartment intended as the room of access for servants in the livery. "It is here a room of great dimension, it is finished with stucco, as halls always are, and is formed with a recess at each end, one square and the other circular, which have a noble effect and increase the variety." We get yet another hint of his hierarchical arrangements in his distinction between French and English dining habits. He notes that French dining rooms tend to be poorly decorated because the emphasis is on the show of the table, and conversation is enjoyed in other rooms; whereas in England people like to linger at the table much longer and use the dining room as a place of discussion. English dining rooms, moreover, should be fitted up in a masculine mode:

Every person of rank here is either a member of the legislation, or entitled by his condition to take part in the political arrangements of his country . . . These circumstances lead men to live more with one another, and more detached from the society of ladies. The eating rooms are considered as the apartments of conversation, in which we are to pass a great part of our time. This renders it desirable to have them fitted up with elegance and splendour, but in a style different from that of other apartments. Instead of being hung with damask, tapestry, etc., they are always finished with stucco, and adorned with statues and paintings, that they may not retain the smell of the victuals.[35]

These statements demonstrate the ideology of neoclassicism in architecture and its accessory paintings and sculptural decorations. The cool, restrained, and imposing style, its materials of marble, plaster and stucco (which could never reek of garlic), was admirably suited for the privileged classes and spoke to their patriarchal ideal of authority and power and their devaluation of feminine space. Adam's great halls and galleries transport the inhabitants, including the intimidated domestics, to a visionary antique realm of absolute dominion, but at the same time suggest through the lightness and delicacy of the decoration a sense of temperate restraint and moderation. Of course, Adam shrewdly turned all to his own advantage: his repeated references to stucco—which he used so abundantly that his detractors could sneeringly

point to his "white" surfaces—implied a source of huge profit. His firm had purchased the patents for the most improved type of stucco composition and marketed their manufacture, which they called "Adam's new invented patent stucco." As M.P., Adam obtained a special Act of Parliament vesting in his firm the exclusive right to make and vend his composition.

Adam attributed the "profusion and magnificence" of Italian art to "the bigoted zeal and superstitious pomp of the Roman Catholic religion," whereas "the decent simplicity" of the Anglican Church—despite the "acquired power and opulence" of the English nation—forbade the marshaling of abilities and talents to the same degree. While there is a note of regret in Adam's comparison, he rationalizes the consequences as the hallmark of a "free and flourishing people."[36] Thus Adam's classical revival, with its flat harmonious geometries and light colorations, aimed at conveying both the "simplicity" of British government and church, but also the "elegance" (Adam's codeword for privileged taste) associated with their "power and opulence."

The fashion that Adam had introduced into the smart world of George III's subjects was a cult of the antique. Yet his energetic architectural program and organizational skills stimulated English manufactures in general and contributed to the Industrial Revolution. He literally embraced the entire household, designing chairs, tables, carpets, lamps, candelabras, and mirrors right down to the smallest fixtures. Major manufacturers who experienced the impulse of the neoclassical shift in taste included Matthew Boulton, Josiah Wedgwood, and Thomas Chippendale, all of whom collaborated with Robert Adam and were in turn influenced by him. Boulton owed his initial success to Adam for whom he supplied ormolu (a gold-colored alloy of copper, zinc, and tin) mounts, frames, and outlines which added lightness to interior decors, as well as the nuts, bolts, knobs, latches, and metal escutcheons for doors and gates. Wedgwood furnished Adam with jasper tablets, plaques, medallions and chimney piece ornaments, and always maintained "a genial intercourse" with the master because he respected the scale of his demands and the extent of his prestige. Chippendale's association with Adam began soon after the latter's return from Italy in 1758, designing furniture for him in the "antique manner." The stimulus Chippendale received from working alongside the leading expo-

nent of neoclassical fashion proved to be of critical importance for his development.[37]

Adam hired a vast army of laborers, artists, and artisans to execute his plans, including well-known decorative painters like Angelica Kauffmann and her second husband, Antonio Zucchi. He subcontracted work to silversmiths, cabinetmakers, plasterers, upholsterers, and sculptors. At one point his labor force numbered nearly 3,000. He paid well for his top craftspeople but exploited the unskilled: for the Adelphi project he imported laborers from Scotland who worked at home for less than London wages, but when they learned of the discrepancy they struck for equal pay. Adam thereupon sacked the whole lot and replaced them with Irish workers who had fewer options.

Adam's autocratic methods are revealed in his attempt to establish a synthesis in which every detail bore the impress of a single mind within an all-embracing style. In this he modeled himself after the perceived tradition of the ancients. In addition to their own stucco manufactory, Adam and his brothers owned a timber business, a brickworks, a stone and paving business, and owned shares in granite quarries and a builder's supply house. Not least of their vertical business organization was an extensive trade in antiquities and replicas which were worked into their decorative schemes and which their clients could not refuse.

Adam's synthesis was abetted by the formation of the Royal Academy in 1768. This institution was soon training skilled artists and artisans in regimented fashion. The curriculum of the new academy manifested the outlook of George III and the ruling elite. The first president of the academy, Sir Joshua Reynolds, preached an indigenous neoclassical approach in his *Discourses* (dedicated to George III) which satisfied the taste of the leading English patrons. As he said in his First Discourse in 1769, it was his wish and hope "that this institution may answer the expectation of its Royal founder . . . that *the dignity of the dying art* (to make use of an expression of Pliny) may be revived under the reign of George the Third." And in his Third Discourse he set out his method for shortcutting the painful process of learning the transcendental ideal:

I know of but one method of shortening the road; that is, by a careful study of the works of the ancient sculptors; who, being

indefatigable in the school of nature, have left models of that perfect form behind them, which an artist would prefer as supremely beautiful, who had spent his whole life in that single contemplation.

One Adam artisan, the sculptor-plasterer Joseph Rose junior, went through the Royal Academy curriculum and had close contact with Nollekens. He carried out much of the modeling of the decorative patterns, trophies, medallions, and plaques on the walls and ceilings of Adam's residences. It may be said, then, that the academy produced a work force trained to follow the dictates of the leaders of the neoclassical revival.

Rose owned a major library in which figured several of the folio publications previously discussed: these include Montfaucon's *Antiquity Explained*, Stuart and Revett's *Antiquities of Athens*, and an album of views of Rome engraved from the drawings of Clérisseau. Adam's designs demonstrate that he and his collaborators were alert to all the developments, both at home and on the Continent, affecting the circulation of neoclassicism. He modeled several of his decorations after Hamilton's vase engravings (often reproduced as plaster reliefs on walls) as well as after the work of Montfaucon and the comte de Caylus. Some of the designs at the Syon House derived from Caylus, included a tripod used as a water stand, and for Croome Court, Worcestershire, he used a similar precedent for his mahogany flower stand (figs. 2.33, 2.34).

Adam's contact with French developments were facilitated by his friendship and business connections with Clérisseau.[38] Subsequent to his rupture with the director of the French Academy at Rome, Clérisseau was forced to find work among foreign tourists. He acted as tour guide, consultant on archeological matters for dealers and scholars, and recorded views of Rome for collectors. He rapidly grasped the potentialities of the new movement and acquired a clientele among the English visitors in the circle of Gavin Hamilton and Thomas Jenkins. He developed a specialty in drawing architectural ruins for their clients, thus laying the groundwork for his fortune.

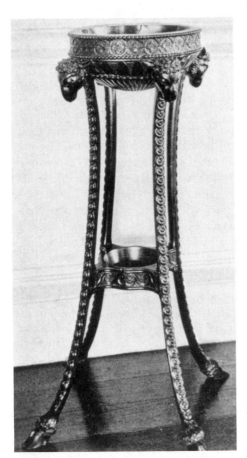

2.34 Robert Adam, mahogany flower stand, c. 1760, Croome Court, Worcestershire, England. Courtesy of the National Trust Photo Library, London.

Clérisseau

Clérisseau claimed credit for introducing Robert and James Adam (both of whom he accompanied on their

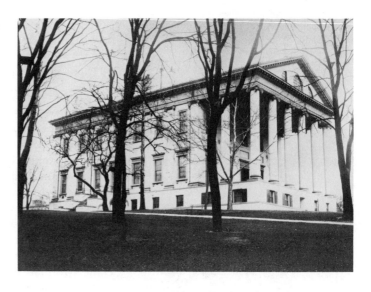

Grand Tours) to Cardinal Albani whom he had met through Horace Mann, the English representative in Florence. Also an art dealer and agent, Mann brought Clérisseau and Albani together in 1755. Albani employed him to decorate his villa with landscapes of antique ruins. Clérisseau now made the acquaintance of Winckelmann whom he advised on archeological matters, and the two carried on a correspondence after Clérisseau left Italy in 1766. When Adam met Clérisseau, the latter was living at the house of Ignazio Hugford, a Florentine dealer in antiquities who was a business associate of Mann and Albani. Adam's encounter with Clérisseau is vividly described in the following passage:

> I found out Clérisseau, a Nathaniel in whom tho' there is no guile, yet there is the utmost knowledge of architecture, of perspective, and of designing and colouring I ever saw or had any conception of. He rais'd my ideas. He created emulation and fire in my breast. I wish'd above all things to learn his manner, to have him with me at Rome, to study close with him and to purchase of his works.[39]

In short, Clérisseau initiated Adam in the profit-making possibilities of neoclassical practice. Adam employed him as supervisor and leading draftsperson on various publishing projects such as the recording of Hadrian's villa, Tivoli, and, in particular, Diocletian's palace at Spalatro which established Adam's reputation.

Before leaving Italy for good, Clérisseau carried out an

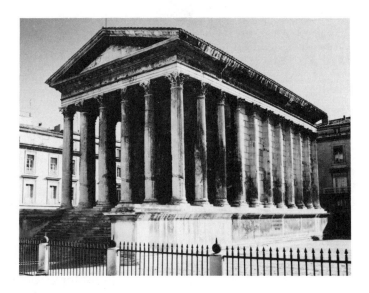

audacious decorative scheme of a "Ruin Room" commissioned by the mathematician-priests Père Le Sueur and Père Jacquier for their room at the convent of St. Trinità dei Monti in Rome.[40] The decoration was a virtuoso performance, comprising an illusionistic setting of ruinous architecture and actual antique fragments. It was an expression of *anticomanie*, a neoclassical fantasy in which even the furniture was formed of antique or antique-looking fragments. While the rationale for such a commission in a religious environment might be thematically implied in the decay of the old order, it also demonstrated that in their enthusiasm for the neoclassic vogue sophisticated clerics could overlook its roots in the pagan past. The earliest mention of this room occurs in a laudatory letter of 1767 to the artist from Winckelmann who was probably instrumental in obtaining the commission as well as a related one for the abbé Farsetti.

In addition to the Rome crowd, Clérisseau affected the taste of several important tastemakers including Catherine the Great, whom he indoctrinated in the theory of neoclassicism, and Thomas Jefferson. Clérisseau was consulted by Jefferson for the design of the Virginia State capitol at Richmond, the first major attempt to give an administrative building the external form of a classical temple. The Richmond capitol was based on the Maison Carée, an ancient Roman temple at Nîmes (figs. 2.35, 2.36). Clérisseau, who published a book on the classical monuments of this town in 1778, furnished Jefferson

2.37 Angelica Kauffmann, ceiling of back drawing room, Chandos House, London. Courtesy of the National Trust Photo Library, London.

with a plaster model of the building and made some suggestions in the details which Jefferson followed in his plans for Richmond. The Richmond capitol became a landmark in American architecture, and in this way Clérisseau contributed to Jefferson's taste for the neoclassical and the formation of the dominant U.S. style. Jefferson, together with Washington, had the most important role in planning the style of America's capitol, and he adopted the neoclassical mode for the new federal buildings. Ironically, while George III used it to express his sense of modern Empire, American leaders chose the style as a mark of national self-importance in the wake of the War of Independence. But both derived their inspiration from the same source—a brilliant group of adventurers bent on the commercial exploitation of the new taste.

Kauffmann

If Clérisseau provided the stimulus for Adam's decorative schemes, Angelica Kauffmann aided him substantially in their execution.[41] Clérisseau in fact influenced her work and that of her second husband, Antonio Zucchi, with whom he traveled as co-guide to James Adams in 1760. Kauffmann became an integral member of the Adam team, and although few of her decorations for Adam residences have been documented it is certain that she was one of his most prolific collaborators. She either did the decorations herself or provided models for mechanical reproduction (as in the case of the Boulton ceilings) and designs for other artists to execute (including Zucchi). Among the Adam buildings, her original or copied work may be found at the Home House, the

2.38 Piano decoration, in the style of Angelica Kauffmann. The Metropolitan Museum of Art.

2.39 Angelica Kauffmann, *Cleopatra Adorning the Tomb of Mark Antony*, engraving.

Montague House, the Harwood House, the Chandos House, and 20 St. James's Square, the mansion of Sir Watkin Williams-Wynn. Adam emphasized that painting and sculpture were accessory to architecture, and this is exemplified in Kauffmann's signed roundels and medallions for the back drawing room of the Chandos House which are masterfully incorporated into the circular patterns of the ceiling (fig. 2.37).

Few painters of either sex could have been more commercially successful than Kauffmann; her classical compositions and portraits were eagerly sought after by the English aristocracy and could be found in most of the major collections including those of George III and other members of the royal family. Kauffmann's work was engraved and reproduced in every conceivable medium including fans, furniture, flower vases, snuffboxes, wine coolers, tea sets, porcelain groups, ceiling and interior decorations (fig. 2.38). Her *Cleopatra Adorning the Tomb of Mark Antony* was engraved twice, showing the demand for her work, and was reproduced in such varied media as a watchcase and a tea wagon (fig. 2.39). Another indication of her popularity was the patronage of the industrialist Matthew Boulton, who developed a secret method for the mechanical reproduction of pictures at his Soho firm around 1780.[42] Through his transfer process (a variation of aquatint engraving) he planned to "mass produce" neoclassical ceiling decorations for Adam's burgeoning market. While he employed several designers, his favorite was Angelica Kauffmann, who executed nearly thirty pictures for the project. Indeed, it is likely

that her decorations for the Montague House at 22 Portman Square were carried out with Boulton's process. During her fifteen years in England (1766–1781), she earned 14,000 pounds—no small sum in that period for a female artist. Her career attests to the vast market for neoclassicism and her ability to satisfy demands of her elite clientele.

Like Vigée-Lebrun, Kauffmann was the daughter of a painter, the Tyrolese Johann Josef Kauffmann. Ambitious and always eager to improve his circumstances, he moved from the small town of Schwarzenberg to the town of Chur in the Swiss Grisons. Chur was a key center on the Rhine route north to the Alps and enjoyed great prosperity. Johann managed to secure several church commissions from the local clergy and to do portraits of prominent Chur citizens. Switzerland was already becoming the neutral land where industries flourished, and its relative religious tolerance induced such distinguished writers and scientists as Rousseau, Voltaire, Gibbon, and Lavater to make their home there.

Angelica Kauffmann was born at Chur in 1741. As she was the only child of his two marriages, Josef centered all his interest on her, and she developed precociously. Less tyrannical than the father of Mengs, Josef was nevertheless a strict master and drove her to the utmost of her unusual abilities. As a result of his program, she became a practicing professional at eleven years of age. Hoping to exploit her talents for profit, he looked for more urban prospects and took her first to Como, then Milan, and finally they made their way to Rome in 1763. They then sought out Mengs who was out of town at the moment, but his wife introduced them to Winckelmann. The antiquarian informed them of the great prospects in Rome and stimulated her participation in the neoclassical movement. Winckelmann commissioned her to do his portrait, an important document of the year in which he published his *History of Ancient Art* (fig. 2.40). Kauffmann presents him at work inventorizing an ancient bas-relief of the *Three Graces* in Albani's collection. His collar is unbuttoned and he wears coarse clothes; Kauffmann sees him as a working employee, not as a refined aesthete or dilettantish scholar. As both a female and a breadwinner, Kauffmann was exceedingly class and status conscious and painted a dignified image of the cobbler's son in the employ of high Roman society.

2.40 Angelica Kauffmann, *Portrait of Winckelmann*, 1764. Kunsthaus, Zurich.

Winckelmann was quite proud of this portrait and mentioned it in several letters to his friends.

Kauffmann's first compositions show the influence of Batoni, Mengs, and Gavin Hamilton. She established a close association with the circle of Hamilton, Clérisseau, the abbé Peter Grant (whose portrait she also painted), and Thomas Jenkins who acted as her banker when she returned to Rome in 1782. Kauffmann soon attached herself to the English community and became an instant hit among the Grand Tourists. Gifted linguistically, she spoke English fluently and received her most profitable commissions from British visitors in Rome, Naples, and Venice where she traveled. Winckelmann noted in a letter to a friend that "she paints all the English who visit Rome."[43] Their orders for portraits and classical subjects encouraged her to move to England and set up shop.

On her trip to Venice in 1765 she met the wife of His Majesty's Resident, John Murray, who styled herself Lady Wentworth (in courtesy to her first husband, Sir Butler Cavendish Wentworth, who died in 1741). Lady Wentworth had high cultural aspirations and liked playing the hostess for talented individuals. She offered to sponsor Angelica's trip to London, projecting a glowing picture of the possibilities available in the Metropolis. Kauffmann needed little prompting in this regard and moved with Lady Wentworth to London in 1766. Through Lady Wentworth she met members of the nobility who befriended her, such as Lord and Lady Spencer and Lord Exeter and the neoclassical leaders Robert Adam, Charles Towneley, and Joseph Nollekens.

Her arrival in England coincided with a period of peace and relative prosperity. The war had brought England vast possessions both in the East and in the West, and the heady sense of Empire sought expression in the "classicalities" (as contemporaries called Kauffmann's works) offered by enterprising architects, painters, and sculptors. Symptomatic are her decorations for the Home House and Harewood House, whose owners derived their wealth from colonial investments. Within six months of her arrival, Kauffmann was well established. She took a large house in Golden Square in 1767 where she received her aristocratic sitters. Even her previous apartments were located in a fashionable area of London and run by a servant; she claimed this was necessary because she could not receive persons of rank in a mean

2.41 Angelica Kauffmann, *The Last Interview of Hector and Andromache*, 1769 Royal Academy exhibition. Courtesy of the National Trust Photo Library, London.

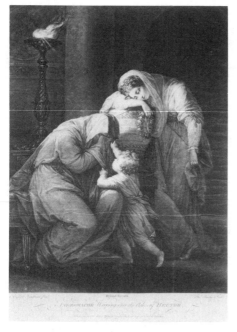

2.42 Angelica Kauffmann, *Andromache and Hecuba Weeping over the Ashes of Hector*, 1772 Royal Academy Exhibition, print.

place and under mean conditions. During her first year of independent activity, she received visits from Lord Baltimore, the Princess of Wales, and Princess Augusta of Brunswick (the king's sister), and she was introduced to Queen Charlotte who became a close friend. The next year (1768) she was elected as one of the founding members of the new Royal Academy—an astonishing record for the twenty-seven-year-old painter! (Until 1936 only one other woman, Mary Moser, who was also a founding artist, had been elected a full member.)

Her meteoric career may be understood only in the context of her patrons' demands. At the first exhibition of the Royal Academy in 1769 she exhibited four pictures, all of them Homeric and Virgilian subjects: *The Last Interview of Hector and Andromache, Achilles Discovered by Ulysses amongst the Attendants of Deidamia. Venus Showing Aeneas and Achates the Way to Carthage*, and *Penelope Taking Down the Bow of Ulysses for the Trial of Her Wooers*. The aristocracy, many of them just returned from service in the Seven Years' War, now looked upon the Trojan War as its ancient counterpart and identified with the heroes of the *Iliad* and the *Odyssey*.[44] This series had been commissioned by John Parker (later Lord Boringdon), a staunch member of the king's party in Parliament, to decorate Saltram House. The *Hector and Andromache* depicts graciously poised figures without drama and emotional tension, a style akin to Mengs and Gavin Hamilton (fig. 2.41). One of the most pathetic scenes in

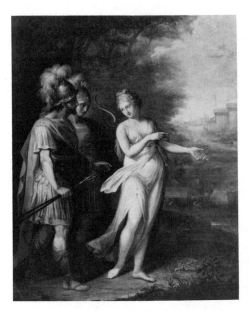

the *Iliad* is reduced to a restrained image of wifely and maternal solicitude. But Kauffmann reveals her personal point of view in the transformation of Hector from the stalwart hero who rejects the entreaties of his wife to a wistful juvenile who wears his helmet uneasily. Kauffmann's emphasis is on Andromache's tender gesture and the nurse who cradles the child in her arms. The picture tells less about masculine courage than about domestic concerns which Hector repudiates. The following year Kauffmann painted *Andromache and Hecuba Weeping over the Ashes of Hector*, which was exhibited in 1772 (fig. 2.42), Andromache leans listlessly upon the funeral urn, while young Astyanax tries to comfort the inconsolable Hecuba, Hector's mother. As opposed to Gavin Hamilton's scene of male sacrifice, the emphasis here is on feminine grief and mourning. Following the Seven Years' War there were many images in England and France of grieving widows, but Kauffmann's commitment to a feminist position is consistent throughout her career. This pleased her aristocratic patrons who wanted to decorate their houses with Greco-Roman allusions to a heroic age but not in a heavy-handed Spartan or tragic mode.

2.43 Angelica Kauffmann, *Venus Showing Aeneas and Achates the Way to Carthage*, 1769 Royal Academy Exhibition, Vorarlberger Handelskammer, Feldkirch.

Women occupy the central place in Kauffmann's work, if not always the formal center. Her *Venus Showing Aeneas and Achates the Way to Carthage* relegates the two male protagonists to the far left and in shadowy profile, while Venus is shown frontally, brightly illuminated, and totally in command of the pictorial field (fig. 2.43). General-

2.44 Angelica Kauffmann, *Zeuxis Selecting Models for His Picture of Helen of Troy*. Annmary Brown Memorial, Brown University, Providence, Rhode Island.

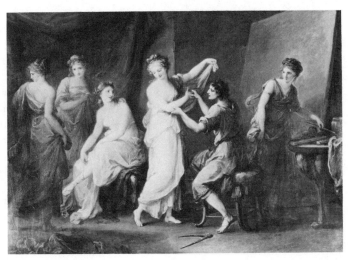

ly, her male figures resemble the Hector and appear weaker than the female, with a boyish face and demeanor. The masculine hero of *Zeuxis Selecting Models for His Picture of Helen of Troy* is located centrally and strategically, but his stiff presence is overwhelmed by the sharply lit and lively women he inspects for his grand synthesis (fig. 2.44). Curiously, at the far right is a woman grasping a brush before the canvas as if on the verge of painting; her head is modeled upon Kauffmann's own features.

Kauffmann expressed in her neoclassical works fundamental feelings about sexual relationships and male-female roles, but her peculiar approach satisfied the taste of her English patrons. Her friend Dr. John Wolcot, a satirist who wrote under the name of Peter Pindar, parodied this approach in his *Lyric Odes to Royal Academicians*:

Angelica my plaudits gains—
Her art so sweetly canvas stains!—
Her Dames so Grecian! give me such a delight!
But were she married to such gentle Males
As figure in her painted tales—
I fear she'd find a stupid wedding night.[45]

Indeed, her love relationships with men were unsuccessful, and while wild rumors perpetually plagued her she seems not to have had an active sex life. Her first husband turned out to be a swindler, and her second marriage to Zucchi, a much older man, was one of convenience. Their nuptial settlement stipulated that her assets were not to be touched by him and that he was responsible for his own debts. Nevertheless, they worked well as a team for Robert Adam and other contemporary architects.

Kauffmann veiled her classical women and never painted entirely nude people except for children, perfectly appropriate for the boudoir ceilings of the homes she and Zucchi decorated. Her effeminate males and gracefully poised women fit the pattern of the pioneer neoclassicists and underscore their primarily decorative function. Here she had no peer and was much more in demand than they as an interior designer. Her style was admirably suited for Adam's light, somewhat playful, and delicate interiors. Like him, she also drew her inspiration from the classical repertoires published by Sir William Hamilton, the comte de Caylus, and the Royal Herculaneum Academy.

Sir William Hamilton commissioned several pictures from Kauffmann, including a *Penelope* for which she waived her customary fee. Their relationship clarifies her appeal to the aristocracy. In 1782 William Beckford (another heir to a Jamaican fortune) wrote Sir William: "As for Angelica, she is my Idol; so say everything that can be said in my name and tell her how I long to see Telemachus's Papa and all the noble Family."[46] Beckford here refers to her stock of subjects centering on Ulysses, king of Ithaca, the hero of Homer's *Odyssey* (including the *Penelope* she did for Sir William). As mentioned earlier, her patrons evidently identified with the Greek chiefs returning to their families after the end of the Trojan War. Beckford's comment about the "noble Family" shows to what extent Kauffmann managed to create an appealing environment of domesticated, playful, erotic deities for lords and ladies who looked upon then as their antique counterparts.

This was typically achieved indirectly through allusion but was often done directly through portraiture. The quest for the life-style of antiquity did not always cease with souvenir fragments or mock environments. For example, Sir William Hamilton's mistress Emma Hart (soon to become the notorious Lady Hamilton) performed for Sir William and his guests a series of classical poses while dressed in antique fashions. Goethe, a guest at Sir William's villa in 1787, was profoundly impressed by Hart's performance. He wrote in his journal that Sir William "thinks he can see in her a likeness to all the most famous antiques, to the beautiful profiles on Sicilian coins—yes, to the Apollo Belvedere itself!" Sir William's erotic fantasies occurred in the context of antiquity, predisposing him to transform his human companion into an object of display like one of his vases. Hart herself knew intimately the neoclassical mind-set: she had been the mistress of Sir Williams' nephew Charles Greville, a prominent figure in Zoffany's painting of the Towneley Gallery, and was a close friend of Gavin Hamilton who accompanied her part of the way to Naples in 1786. At the same time, Sir William commissioned several painters to portray Hart in the guise of a mythological deity, thus making neoclassicism the vehicle for his fantasies.

Angelica Kauffmann numbered among this group, doing a portrait of Lady Hamilton as the character of Comedy garbed "in classical style in thin and light material." This was one of several instances where Kauffmann flat-

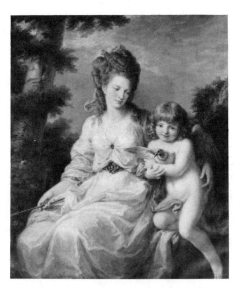

2.45 Angelica Kauffmann, *The Marchioness Townshend and Her Eldest Son, Lord William Townshend as Cupid.* The Burghley House Collection, Stamford, Lincolnshire.

tered the vanity of the ruling classes with mythological identification. She executed a family portrait of Sir John and Lady Webb and their children in classical costume making an offer to Ceres, Goddess of Agriculture and Civilization. The scene actually takes place on the family estate, thus pointing to the bountiful income from Sir John's land. Kauffmann also produced an allegorical image of Hibernia for the seal of the Bank of Ireland, using as her model the daughter of an engineer in the Bank Printing Office.

One of her major patrons was George, the first Marquis Townshend, who commissioned a portrait of his second wife, Anne, Marchioness Townshend, in a playful mythology (fig. 2.45). The marchioness is shown holding an arrow in her right hand and in the other her eldest son, Lord William Townshend, depicted as Cupid cradling a dove. Townshend was perhaps the archetypical Kauffmann patron: he served under General Wolfe during the Seven Years' War and in 1767 was appointed Lord-Lieutenant of Ireland. His mission was to break the parliamentary power of a small knot of Irish landowners and borough proprietors and form a party in the Irish Parliament dependent on the English crown. He established a splendid court at Dublin which became renowned for its revels and cultural events. He was very much attracted by Kauffmann's work and invited her to Dublin to paint portraits of his family and those of his potential allies in government.

Kauffmann's career attests to her alertness to the new trend and her ability to tap it for profit. At the same time, she proved to be a necessary adjunct to patrons like Lady Wentworth and Lord Townshend who required cultural trappings appropriate to their station in the aftermath of the Seven Years' War. Her story constitutes a clinical case study of the way in which artists of one social class identify themselves with the interests of another social class, while yet imagining that they are acting independently.

West

The dazzling career of the American painter Benjamin West offers further testimony to the co-optation of talent by the patrons of neoclassicism.[47] Like Mengs and Kauffmann, West was a child prodigy driven by ambition inculcated in him by his family and reinforced by

social success. His life reads like the first Horatio Alger epic in the history of American art, filled with elements of spectacular fortune and early success more suited to the romantic novel than documented biography. Born in Springfield, an obscure Quaker village in eastern Pennsylvania, he rose to become Historical Painter to George III and practically a member of the royal household. His rise, however, had less to do with talent than with the power and aspirations of his early backers. In 1753 he was a precocious fifteen-year-old painting portraits of local citizens for a guinea or two; seven years later he was the first American-born art student in Italy and a favorite of worldly Roman society. Before he was thirty he became one of England's most popular painters, a founder of the Royal Academy and friend and companion to the reigning monarch.

Years later, West approved a highly romanticized biography of himself by his friend John Galt, which established an almost legendary account of his childhood, his artistic development, and his Quaker affiliations.[48] Actually, West came out of a rather shaky Quaker background: he was born in a Quaker community near Philadelphia but could not have been a practicing Quaker. His father, although a birthright Quaker, moved to Pennsylvania from England around 1725 without a "certificate of transfer," indicating that he was not in good standing with the Society of Friends. Benjamin's mother, Sarah, also a birthright Quaker, was "disowned" or read out of meeting as early as 1717 for "fornication," showing that the marriage was not in order and that the children could not have been recorded as Quakers.[49] This is important to state because West allowed many people to think he was a Quaker, a benign fraud he practiced early in his career to gain the attention of European socialites. Cosmopolitans either viewed him as a somewhat exotic creature of the New World or as a breath of "primitive" fresh air in the hothouse stuffiness of the Continent. Nowhere, however, is this more strikingly contradicted than in West's painting of his family in 1772, where his visiting father (newly reentered in the Society of Friends) and half-brother wear modest Quaker-style garb while he—now an established painter—his wife, and children wear the fashionable costume of an aristocratic elite (fig. 2.46). His desire late in life to be associated again with the Society of Friends relates to the international reputation they then enjoyed from their abolitionist activities:

West told Galt a somewhat fanciful story about how his father freed a slave he inherited and after hiring him for wages helped launch the abolitionist movement. In reality, West identified with the king's party and joined the Anglican church, the ruling elite that propelled him to international success. While he may have professed sympathy for the American Revolution, his intimate links with the Loyalists prevented him from shifting to the other side.

West's first compositional attempt—the *Death of Socrates*—was done during the time he was painting portraits in Lancaster in 1756 (fig. 2.47). The picture was based on a frontispiece for Charles Rollin's *Ancient History*, volume 4, by Hubert-François Gravelot, the ubiquitous French illustrator discussed earlier in connection with Gainsborough and Fragonard (fig. 2.48). West's *Socrates*, however, with its grimacing faces, awkward anatomy, and claustrophobic interior is a crude translation of Gravelot's elegant rococo poses and lofty prison setting. While due in part to West's immaturity, the work's very crudeness embodied those qualities of simplicity and severity that Europeans of the Enlightenment would identify with the emerging American society and hail as the answer to the decadence and luxury of the Old World.

The patron who commissioned this work, Colonel William Henry, was a master gunsmith and large-scale entrepreneur who supplied the weaponry for the Pennsylvania forces during the French and Indian War. An

2.47 Benjamin West, *Death of Socrates*, 1756.
Collection Mrs. Thomas H. A. Stites, Naza-
reth, Pennsylvania.

2.48 Hubert-Francois Gravelot, *Death of Soc-
rates*, frontispiece to Charles Rollin, *Ancient
History*, vol. 4.

amateur scientist and engineer as well, Henry devised la-
bor-saving machinery and experimented with a steam
engine to propel a vessel through water. He comple-
mented his scientific experiments with study of the clas-
sics, both related to his desire to improve society. He
himself suggested the subject of Socrates as a moral les-
son for modern life. It is certain that in this period the
pacifist Quakers would have opposed his manufacture of
arms, and the theme of commitment to the principle of
the state may have represented Henry's defensive re-
sponse. The finished work attracted the attention of Hen-
ry's friend, the Reverend William Smith, provost of the
College of Philadelphia (later the University of Pennsyl-
vania), who was then in Lancaster to advise the towns-
people on setting up a grammar school. Smith was an
ordained Anglican priest who hoped to become the first
archbishop in America. He linked his fortunes to the
Tory Proprietors of Pennsylvania (the descendants of
William Penn) and ran afoul of the Quakers and local
groups represented by Benjamin Franklin. Smith tried to
establish a reputation by generating a cultural boom in
America, and he offered to give West a crash course in
the classics. Smith introduced the young artist to several
of his protégés including Francis Hopkinson, who later
distinguished himself as statesman, poet, musician, and
composer. Smith's periodical, *American Magazine*, which
favored Tory policies and attacked the opinions of Frank-
lin, was a cultural platform for his protégés. The Febru-

ary 1758 issue published a poem praising a portrait by West.

Through Smith West met William Allen, the richest man in Philadelphia. A merchant in his middle fifties, Allen had been educated at Cambridge, in England, and trained in the law in London. He amassed his fortune in the commodities market, owned vast landholdings in New Jersey, Delaware, and Pennsylvania (a part of which became Allentown), ships, a wharf, and large warehouses. He served as a member of the Provincial Assembly, two times as mayor of Philadelphia, and was then chief justice of Pennsylvania, member of the American Philosophical Society, and a trustee of the College of Philadelphia. Like Smith, Allen identified himself closely with Thomas Penn and the Proprietary claims against Quakers, Native Americans, and other groups of dissident Pennsylvania settlers. Allen immediately took to West and introduced him to his circle, including his brother-in-law, James Hamilton, the governor of Pennsylvania, who possessed an important art collection.

When Allen's cousin, Colonel Joseph Shippen, recently retired from military service following the British victory over the French and Indians, embarked on a mercantile expedition to the Italian port of Leghorn, Allen invested in the venture on the condition that Shippen guide his son on a tour of Europe. Reverend Smith then suggested that West go on this trip in exchange for copies of the old masters for Philadelphia collectors. West's voyage was subsidized by several merchants who also provided letters of recommendation for notable officials, connoisseurs, and dealers in Florence, Rome, and London, including Horace Mann, whom Allen had known at Cambridge. When the expedition embarked for Leghorn in 1760 the Seven Years' War was in its fourth year, and the ship was menaced on the high seas by French privateers and British seamen who embargoed certain goods bound for Italy where merchants smuggled them into enemy hands. But the credentials of the party earned for them distinguished treatment, and a British convoy was organized to see the vessel safely into Leghorn.

Allen's business agents in Leghorn, the shipping partners Jackson and Rutherford, furnished West with more letters of credit to prominent people in Rome including their customer Cardinal Alessandro Albani. West's initial encounter with Albani is now legendary: the artist's host,

an Englishman on the Grand Tour, introduced him to Albani as an American Quaker, and the nearly blind connoisseur inquired, "Is he black or white?" He then ran his hands over West's face and head and asked him questions about life on the frontier. West exploited to the full his mystique as a kind of Noble Savage newly emerged from the wilderness and all but clinched this masquerade later in the presence of Albani, Jenkins, and others when viewing the Apollo Belvedere. He exclaimed before a shocked audience of nobility and connoisseurs: "My God, how like it is to a young Mohawk warrior!"

West's host was surprised to learn that the American's letters of introduction were addressed to everyone he knew personally in the circles of Albani, Gavin Hamilton, and Jenkins, including abbé Grant, Batoni, Mengs, and Winckelmann. West eventually embarked on a course of study under Mengs at the Capitoline Academy. He met Angelica Kauffmann in Florence, and the two sketched each other's portrait. He also contacted Horace Mann (whom he would get to know well while recuperating from a surgical operation in Florence), and other members of the English nobility, thus laying the groundwork for his career in Great Britain. Gavin Hamilton especially befriended him, taking him out on the town and furnishing him with helpful advice. He made West aware of the rage for neoclassicism, and described how he planned to profit from it by executing a series of large pictures illustrating the *Iliad* and the *Odyssey* for English patrons and then circulating engravings of the works for a wider audience. Hamilton was one of the first to understand the full possibilities of producing engravings from his work and using them as both a source of income and a means of extending his reputation. West was to use that approach himself in England and turn it to spectacular advantage.

West's participation in the economic and imperialist expansion of Great Britain overspreads his entire career. He volunteered in the Pennsylvania militia during the French and Indian War following the defeat of General Braddock at Fort Duquesne; he rejoiced with his family on hearing the news of England's triumph in 1763; and he decided to move from Rome to London the same year when he recognized the favorable circumstances in England for neoclassical wares. An incident that occurred during his trip underlined the impact of the war on his career: just across the French border his party stopped in

a manufacturing town whose trade had been ruined by the British fleet, and they were suddenly menaced by a turbulent crowd. They just managed to escape through the intervention of the town magistrate. West's rise paralleled the economic growth of England; in 1791 he exhibited an allegory of *British Manufactures* commissioned by George III for a ceiling in the Queen's Lodge at Windsor, and he stressed in his inaugural address as president of the Royal Academy the following year the academy's contribution to the high quality of English commercial products which "stand pre-eminent over the production of other nations."

Shortly after arriving in London in August 1763 West was introduced into London high society, and though only in his mid-twenties he could afford a manservant to free him for full-time painting. He began doing the portraits of celebrated individuals like General Robert Monckton, a hero of the Battle of Quebec and commander of the army that wrested the island of Martinique from the French in 1762. Allen noted West's growing popularity in January 1764 and claimed that "he will make money very fast."[50]

West was given every opportunity to advance his career: Jenkins provided him with letters of introduction to collectors and artists like Richard Wilson, the esteemed landscapist and organizer of the Society of Arts, and his influential Philadelphia patrons Smith, Allen, and Powel, and the Pennsylvania governor James Hamilton were on hand to welcome him with a magnificent reception.[51] Smith was then in London to raise funds for the College of Philadelphia, and the others came to confer with Thomas Penn in an effort to resist attempts to make Pennsylvania a royal colony and wrest it from Penn's proprietorship. They sent a signal to English high society that the New World could now boast an artistic genius and contained the seeds for a potential Renaissance. Even their enemy Benjamin Franklin could write proudly to his English friends about "some of our young geniuses" emerging from frontier existence, and he listed West as an example.[52]

When the classical compositions West exhibited at the Society of Artists of Great Britain in 1764 received enthusiastic praise from critics, he decided to settle permanently in England. His colonial backers opened doors for him to make a substantial contribution to the new vogue. Reverend Smith facilitated West's easy and rapid

association with the English Anglican bishops, including Archbishop Robert Hay Drummond of York who himself promoted the neoclassical revival. Archbishop Drummond enjoyed solid relations with the court; he preached the sermon at George III's coronation and was the royal distributor of alms. Sophisticated, wealthy, and powerful, Drummond looked upon artistic patronage as a means of bringing great prestige to oneself, family, and country.

During this period, there was a fierce religious struggle involving dominant Anglicanism, John Wesley's Methodism, and Deism. The Anglican church felt threatened by Methodists, and some prelates wanted to soften Anglican formalism with visual images that in many ways emulated the flashy baroque style. At the same time, they feared charges of "popery," and permitted only the gradual reintroduction of art into the churches. In this context they perceived that neoclassicism had the advantage of furnishing moral themes of patriotic and conjugal devotion without conventional religious trappings. Naturally, this demand arose only at the highest levels of English society, and West arrived at the appropriate time to satisfy it.

He was championed as a "homegrown" rival of the Roman neoclassicists, capable of meeting domestic needs without the expense and effort involved in importing works from the Continent. The king's chapel master and professor of Greek and Roman history at the Royal Academy, Dr. Thomas Franklin, expressed this position in a poetic tribute to the new institution:

Behold! a brighter train of years,
A new Augustian age appears;
 The time, nor distant far, shall come,
When England's tasteful youth no more
Shall wander to Italia's classic shore;
 No more to foreign climes shall roam
In search of models, better found at home.[53]

In 1766 Archbishop Drummond engaged West to paint a theme from Roman history, *Agrippina Landing at Brundisium with the Ashes of Germanicus*—a subject treated previously by Gavin Hamilton (fig. 2.49). Recounted in the *Annals* of Tacitus, the story concerns the bereaved widow of the popular Roman general Germanicus whose military achievements threatened his uncle and foster father, the Emperor Tiberius. Fearing him as a possible rival, Tiberius recalled Germanicus to Rome from Germa-

2.49 Benjamin West, *Agrippina Landing at Brundisium with the Ashes of Germanicus*, 1766. Yale University Art Gallery, New Haven. Gift of Louis M. Rabinowitz.

ny and transferred him to a remote Syrian post where he was poisoned. Agrippina, who often accompanied Germanicus on his military campaigns, made her way to Rome with the cremated remains of her husband, intending to obtain retribution. She returned by sea, arriving first at Brundisium on the Adriatic coast (now the port of Brindisi). The news of Germanicus's death preceded her arrival, and a large contingent of sympathizers thronged to the port to greet her. Tacitus's description of the event emphasized the unanimity of the crowd: it seemed impossible to distinguish kinsfolk from strangers, men from women in their plaintive lament. West built up his picture with figural and architectural allusions to classical monuments familiar to Grand Tourists, including the Ara Pacis frieze—an altar of peace and harmony and thus appropriate to his theme—which he had seen in Rome, and the palace of the Emperor Diocletian at Spalatro which he knew from Robert Adam's recently published book (fig. 2.50).[54]

West's division of the crowd of mourners into sex and age groups that respond with one accord to the event answers to Drummond's specific proposal. He had in mind

2.50 Robert Adam, *Geometrical Elevation of the Crypto Porticus*, reproduced in his *Ruins of the Palace of Emperor Diocletian*.

a theme implying the melting of factional disputes in a higher unity, no doubt containing a reference to the schisms within the Anglican church. For George III as well, it was important to establish that his policies went beyond partisan politics as he worked to loosen the hold of Whigs on Parliament and restore more authority to the throne. Other high prelates of the Church of England perceived this example of courage, conjugal devotion, and noble behavior in the face of injustice and tyranny as excellent propaganda. The archbishop was so impressed with West's conception that he set up a campaign to raise 3,000 guineas to enable the artist to devote his full energies to history painting. Earlier, Lord Rockingham offered the artist a similar enticement on the condition that the works produced be used to decorate his mansion in Yorkshire. West declined the latter offer, and the other plan failed for want of adequate support from private benefactors. Several others did follow Drummond's example, but their encouragement was superseded by the patronage of the highest Anglican of all, George III.

The king shared Drummond's taste for history paintings that inculcated in the viewer conservative values such as respect for virtue and morality and a deeper love of country—especially in the late 1760s when John Wilkes was writing libels against him and the American colonies began to challenge his authority. Drummond mediated a private meeting between the king and West, the dream of every aspiring person in the kingdom and a rare privilege for any subject. West took great pains to find and wear an appropriate sword for the occasion, because, as he explained to his American pupil Charles Willson Peale, it was absolutely essential that he appear "to belong to the higher orders of society."[55] West could no longer afford the risk of playing the simple backwoodsman.

George III responded positively to the *Agrippina*, which West brought with him, and immediately commissioned what he felt to be its natural complement, *The Departure of Regulus* (fig. 2.51). The king identified with the exploits of the ancient heroes and suggested the theme as "another noble Roman subject." Regulus's inflexible fortitude and courage in the face of the pleadings of family and friends hinted at abstract principles beyond self-interest and party affiliation. Marcus Atilius Regulus was a Roman general whose patriotism made him a national hero. Sent on a mission to invade Africa during

2.51 Benjamin West, *The Departure of Regulus*, 1769. Kensington Palace, London. Copyright reserved to Her Majesty Queen Elizabeth II.

the First Punic War, he at first won several battles before being decisively defeated in 255 B.C. and taken prisoner. In 249 the Carthaginians sent him to Rome on parole with an offer of peace, but he loyally advised the Romans to reject the terms and prepared to return to Carthage—the moment of the picture—and face inevitable death. He rejected the pleas of family, friends, and senators to break his parole and stay in Rome. West used the Doric order for his setting, partly to add a note of gravity to the tragic scene but also with the knowledge that the king was fully initiated in neoclassic doctrine. As George III exclaimed when he saw the finished picture: "Ah West, I see you have chosen the Doric Order for the

2.52 Benjamin West, *Hamilcar Making His Son Hannibal Swear Implacable Enmity against the Romans*, 1770. Kensington Palace, London. Copyright reserved to Her Majesty Queen Elizabeth II.

buildings. That is my favorite order of architecture."[56] He instructed West to show the *Regulus* at the first exhibition of the Royal Academy in 1769, and he paid the fabulous amount of 420 pounds for it.

Rome and Carthage, the great imperial rivals of antiquity, were certainly fit symbols for Great Britain and France in this period. The *Regulus* and the king's next commission from West, *Hamilcar Making His Son Hannibal Swear Implacable Enmity against the Romans*, were destined for the decoration of the Warm Room at Buckingham Palace (fig. 2.52). *Regulus* shows ships in the harbor beyond the colonnade just as one might expect to find them in the backgrounds of contemporary royal portraiture, while the paternal influence emphasized in the *Hamilcar* shows up in pictures of the royal children. West's later example of *Prince Octavius* depicts the child drawing his father's sword from its scabbard. Both works stress the example of the elder for the younger and a commitment to a noble sense of obligation. George III himself had to take an oath when he became Prince of Wales at age thirteen to protect his country against its enemies.[57] The morality, however, is communicated though the means furnished by the mercantile-minded patrons of the new movement: the trophies and other accessories in the *Hamilcar* derive from the publications of Caylus and Sir William Hamilton.

West suggested the theme of *Segestes and His Daughter Thusnelda Brought before Germanicus*, which deeply appealed to King George (fig. 2.53). The episode illustrated

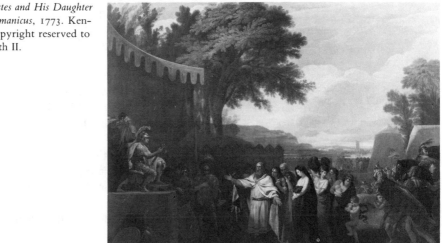

2.53 Benjamin West, *Segestes and His Daughter Thusnelda Brought before Germanicus*, 1773. Kensington Palace, London. Copyright reserved to Her Majesty Queen Elizabeth II.

occurred during one of the campaigns of Germanicus in Germany. In A.D. 15 Arminius, chief of the Cheruschi attempting to expel the invading Romans, had to fight on a second front against Segestes, a rival chieftain who led a pro-Roman faction among the old German tribes. Germanicus came to his defense, and Thusnelda, wife of Arminius and daughter of Segestes, was captured. Segestes presented himself before Germanicus as the only "fit mediator for a German people" and interceded in behalf of his pregnant daughter. The Roman leader promised safety to Segestes's kinsfolk and people.

What made this theme of divided loyalties and devotion beyond national boundaries particularly appealing to George III was the family tradition that made Thusnelda an ancestor of the Hanoverian dynasty.[58] The king's children were raised in Hanover as his father had been and he maintained the dynastic concerns for his German dominions.[59] The relationship of the Georgian dynasty to Hanover affected English involvement in the Seven Years' War, dictating the strategic alliance with the Prussians who pledged to defend Hanover against the French. The last-minute Anglo-Hanoverian link to Prussia in opposition to the French and Austrians created a complicated situation which cut across traditional family and political ties; on the eve of the war France was still allied with Prussia against the historic coalition of Great Britain, Holland, and Austria, and England had to worry about defending Hanover against Prussia and France. Thus the security of Hanover was a dominant factor in the reversal of the old alliances. West's painting also affirms the loyalty of the Hanoverians to England (allegorized by Rome), an ongoing preoccupation especially of opponents who charged the House of Hanover with foreign partialities.

The king actively commissioned art from West, who became his confidante; they were the same age, and their cultural differences allowed for a more casual relationship than George could have permitted himself with others. Their friendship remained firm until the end of the century, when political setbacks, court intrigues, and the king's mental instability pushed a wedge between them. West was promoted to Historical Painter to the King in 1772 with an annual stipend of 1,000 pounds. During the height of the American Revolution, George used West to appease his colonial constituency and domestic supporters by pointing to his early recognition of American "ge-

nius." West in turn, despite some low-keyed approval of the rebellion, remained a loyal partisan of the crown like the heroes of his compositions. One clue to his unyielding commitment is his painting of the *Battle of la Hogue*, painted in 1778 at the height of the Revolution. It marked the victory of the British over the naval forces of Louis XIV in 1692. While West could not depict clashes between Americans and British, he could do the next best thing—show the English defeating America's principal ally. This unswerving loyalty is understood in the context of West's early dependence on Tory patrons and his understanding of this relationship. In one of his presidential discourses before the assembled academy, West declared that "it is the wealthy and the great . . . commonly trained by their situations to the perception of what is elegant and refined," who alone are entitled to the distinction conferred upon them by artists capable of meeting their standards. This naturally worked to his own financial advantage; by 1769 West could have houses in the town and the country and a team of servants to staff them. And at one time he expected a hereditary title instead of a simple knighthood that could not be transmitted to his heirs.

West's best-known work is the *Death of General Wolfe*, painted in 1770 and exhibited at the Royal Academy the following year (fig. 2.54). It depicts the episode of the Seven Years' War when Wolfe died having just received news that the French were in retreat at the Battle of Quebec in 1759. This victory gave North America to England, broke the power of France in the New World,

2.54 Benjamin West, *Death of General Wolfe*, 1770. National Gallery of Canada, Ottawa.

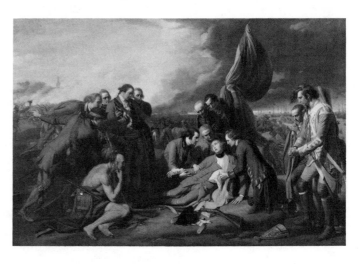

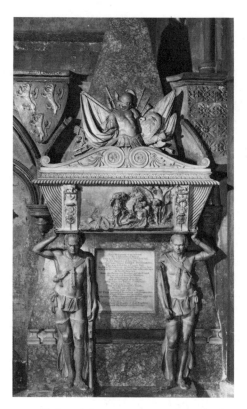

2.55 Robert Adam, *Monument to Townshend*, 1761. By Courtesy of the Dean and Chapter of Westminster.

and established the reformed religion on the North American continent. While the picture flatters the British nation, it also reflects the confidence of an American artist making his mark among the contemporary ruling class. West let it be known in advance that he was preparing a highly controversial picture that would depict the protagonists in modern military costume rather than in ancient togas. West, however, succeeded despite objections by people like Reynolds, who believed that the work of art should not conform to the "law of the historian" but to the conventions of history painting requiring heroic nudity.

On one level, West reversed the increasingly conventional approach of linking neoclassical subjects and style with topical attitudes by depicting a recent historical event in the mode of ancient and old master models. *Wolfe* contains obvious allusions to the Lamentation and Deposition motifs from the Passion, and the Cherokee Indian in the foreground—looking on as an admiring and contemplative spectator rather than as a participant—derives from Robert Adam's Townshend monument of 1761 in Westminster Abbey commemorating the British officer killed while reconnoitering the French lines around Fort Ticonderoga (fig. 2.55). Adam's sarcophagus, ornamented with neoclassical scrolling and Roman trophies, is supported by two Native Americans substituted for the classical caryatid figures of antiquity. Carved on the face of the sarcophagus is a relief of the *Death of Epaminondas*, the Boeotian general who died of wounds after his victory over Sparta. Although lying outside the main action as in the *Wolfe*, the semi-nude Indians complement the partially clad heroes of antiquity.

The theme of Epaminondas also supplied the obvious ancient analogue to Wolfe's military martyrdom. The famous Greek warrior was mortally wounded in the chest by a spear in an inconclusive victory over the Spartans at Martinea in 362 B.C. The broken spear actually halted the flow of blood; once his officers confirmed that his shield has been preserved—the sign of triumph—he directed them to withdraw the spear fragment, which assured his death. The parallel with the *Wolfe* is striking and was in everyone's mind at the time. In 1759 the government sponsored a competition for a monument to Wolfe to be installed in Westminster Abbey. Robert Adam was among those invited to participate and made

2.56 Robert Adam, sketch for projected relief *Epaminondas Expiring before His Tent*, 1759. By courtesy of the Trustees of Sir John Soane's Museum, London.

2.57 Benjamin West, *Epaminondas*, c. 1770–1771. Kensington Palace, London. Copyright reserved to Her Majesty Queen Elizabeth II.

several sketches for the project, one of which demonstrates that he intended to display a relief, similar to that of the Townshend monument, of Epaminondas expiring before his tent (fig. 2.56). West, who suggested to the king that the subject of Epaminondas would make a suitable "classic" and "Grecian" counterpart to the *Wolfe* (whose modern treatment initially disturbed George), based his version on Adam's sketch for the monument as well as on another Gravelot frontispiece, this one for the fifth volume of Rollin's *Ancient History* (fig. 2.57).

West's *Wolfe* and *Epaminondas* have much in common, with their expiring general located right of center and surrounded by mourning warriors and officers. In each instance a figure at the left leans forward to present evidence that the battle has been won, thus allowing the protagonists to die in peace. Here the portrayal of an event of the Seven Years' War is lifted to an abstract plane by the allusions to antiquity which makes death a consequence of patriotic commitment rather than the outcome of imperialist and colonialist ambitions. By linking the modern and ancient scenes, attention was shifted from the tarnished political reality to a train of inspiring classical associations. Despite the modern dress and uniforms, the *Wolfe*, no less than the *Agrippina* or the *Regulus*, points to the intersection of neoclassicism with contemporary ideology.

Although West invoked the example of the historian to justify his use of modern dress, the group around Wolfe is entirely imaginary and inaccurate. When Wolfe fell on the Plains of Abraham on 13 September 1759, only three or four people were present, not the thirteen West depicted. The surgeon holding a hankerchief to Wolfe's heart is Robert Adair who arrived on the scene long after Wolfe's death; General Monckton, the officer clutching his chest in the group at the left, and another officer shown were actually lying severely wounded on the battlefield, while still another was in the rear lines. One officer refused to allow West to include him in the composition as he had not been near Wolfe at the time of his death; another, General Hale, was actually present but eliminated from the picture because (according to Hale's daughter) he would not give the engraver Woollett the sum of 100 pounds, West's price for a place in the composition. Everyone concerned in the production of the engraving earned a fortune: John Boydell, the print publisher, gained 15,000 pounds, Woollett made nearly 7,000

pounds, and West received a sum in royalties never before equaled.

The artist pitched his picture to the ruling elite: "The subject I have to represent is the conquest of a great province of America by the British troops . . . I want to mark the date, the place, and the parties engaged in the event." Such a theme could not fail to win over the English aristocracy: Lord Grosvenor bought the original, the king (after his initial hesitation) ordered a copy, and replicas were made for Lord Bristol, General Monckton, and the Prussian Prince of Waldeck. West could write to Peale on 21 June 1770 that the picture of *Wolfe* "has procured me *great* honor."

Another of his famous works, purportedly based on an actual event but largely fictional, is *William Penn's Treaty with the Indians* (fig. 2.58).[60] Like the *Wolfe*, it projects the ideology of British colonialism with its standard justifications: the deliverance of indigenous peoples from a tyrant, conversion of heathen, the bringing of superior civilization to an inferior culture. West claimed that the object of the picture "was to express savages brought into harmony and peace by justice and benevolence, by not witholding from them what was their right and giving them what they were in want of, and as well as a wish to give by that art a conquest that was made over native people without sword or dagger." Like the *Wolfe*, it was immediately acclaimed; the subject and figures were novel to Europeans, and the engraving enjoyed a spectacular popular success. It was also widely reproduced on ceramic ware and fabrics. Time and folklore have long since veiled the work with a romantic haze, but in point of fact it constituted an apology for the reigning aristocracy in Penn's day.

Penn's Treaty with the Indians recalls the event in American history when William Penn, after disembarking on to his new American territory in 1682, met with the chiefs of the Delaware tribes under the Great Elm at Shackamaxon to sign a treaty of mutual recognition and peace. The Quaker leader and his merchant friends exchanged gifts in return for the sale of Indian land—the first agreement of mutual consent between Europeans and Native Americans. Quakers cherished it as the model for all future negotiations with the indigenous peoples, while later exploiters and speculators searched for its loopholes. To link his ancestry to the legendary episode, West painted his father and half-brother among the arriv-

2.58 Benjamin West, *William Penn's Treaty with the Indians*, 1771. Courtesy of the Pennsylvania Academy of the Fine Arts, Philadelphia.

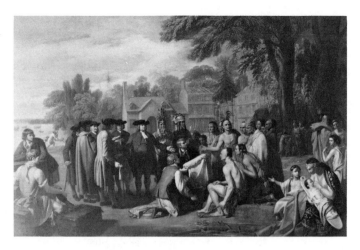

ing Quakers—a total fiction in the familial sense since only his grandfather could be associated with Penn and that during Penn's second voyage to America in 1699.

When West painted the picture in 1771, moreover, all of the ideals implied in it would have been entirely contradicted by the historical realities. While Penn did maintain fair relations with the Indians and kept his promise never to cheat them or seize their land without compensation, he himself profited immensely from the resale of the lands and kept extending his original possessions ceded to him by the English government. He was a feudal landlord with vast private estates and possessed the choicest land in a given tract held jointly by him and his descendants. Moreover, he could not control his land-hungry children who stimulated white outrages against Native Americans and provoked vengeful Indian wars. William Penn's son Thomas was much more exacting in collecting quit rents and feudal dues than his father, and while Quakers and other settlers prospered in the new province they resented the son's sharp business practices and tax-exempt status. He made them shoulder the burden of taxation for the defense of *his* territory.

It was this same Thomas Penn, then the business head of the Penn family and one of the proprietors of Pennsylvania, who commissioned West's picture. The proprietors were generally absentee landlords who exerted power through the governors they appointed. Thomas Penn was a Tory married to an English noblewoman; he had made the Grand Tour and totally identified himself with the aristocracy. He was represented in America by his powerful allies, the Reverend William Smith and Wil-

liam Allen, West's major patrons. While Thomas proba-
bly served as the model for West's William Penn (the
portly portrayal hardly matches the historical description
of the slender, thirty-seven-year-old at the time of his
meeting with the Indian delegates), he was then entirely
unsympathetic to the patriarch's utopian ideals.

West makes conspicuous in his work the Quaker cos-
tume (which actually came some seventy years after the
treaty), but in actuality Thomas Penn and his allies had
moved closer to royal authority and Anglicanism.[61] And
while the Native Americans are shown peacefully negoti-
ating with William, Thomas's desire to extend his con-
trol over the wild lands stimulated many members of the
Six Nations to joint the French during the French and
Indian Wars. During the son's proprietorship, Indian
skirmishes became a fact of everyday life, and Quakers
blamed Penn's greed and aristocratic pretensions for this
development.

Thomas's allies provided the rationale for his rule; he
amply rewarded them as in the case of the Reverend
Smith, who was also the butt of Quaker and Native
American criticism. Smith's views were typically colo-
nialist: Europeans had a Christian obligation to save Indi-
an barbarians through conversion and education. For this
he found a parallel in antiquity, the example of the Ro-
mans taming the wild Germanic tribes. In this sense,
West's scene of recent costume could, as in the case of
the *Wolfe*, sustain neoclassical composition and interpre-
tation. The arrangement of the figures certainly resem-
bles a classical frieze, and individual motifs like the
standing chief extending his arm was modeled after the
Apollo Belvedere ("how like it is to a young Mohawk
warrior!"), and the Indian seated at the edge of the circle
at the right was based on the *Seated Mercury*, one of the
most famous objects discovered at Herculaneum and
Pompeii and published in volume 6 of *Le pitture antiche
d'Ercolano* the year West painted his picture (fig. 2.59).

Such idealization in colonial relations predisposed Penn
to reinterpret the old treaties in the belief that he was act-
ing in everyone's best interest. One case was the notori-
ous "walking purchase" (a clause in a 1686 treaty) which
provided that at some future time the extent of the pur-
chase could be defined by a walk of a day and a half.
Penn hired the three best runners in the province to cov-
er as much ground as possible and came up with an un-
expectedly large area.[62] Leading Quakers seized the op-

2.59 Plate 29 of *Le pitture antiche d'Ercolano e contorni*, vol. 6, 1771.

portunity to embarrass Penn by siding with the Indians, and later the Delaware chief Teedyuscung, in collaboration with Franklin, charged the proprietors with fraud and forgery. At the peace conference at Fort Stanwix in 1768, agents for the Penns and British government attempted to expand the Pennsylvania border and ran into stiff bargaining on the part of the Native Americans no longer content with yard goods and glass beads. Again, Penn was charged with cheating and manipulating the Indians for personal gain.

Another discrepancy between the ideality of figure 2.58 and the contemporary reality is in the area of trade relations. Merchants and their agents occupy a critical role in the picture, shown separately at the left and in the center where they bridge the Quaker and Indian delegations with their merchandise. While Penn initially received his royal grant of 28,000,000 acres in the framework of English mercantile aspirations, English trade with Pennsylvania had reached a state of crisis in 1771 when the work was commissioned. During the early 1770s, Philadelphia merchants protested the import duties exacted by the Townshend Acts for forming an association and declaring a nonimportation policy.[63] They turned back British ships or stored goods unloaded in warehouses without paying for them, even if they had been ordered before the policy was declared. William Allen and William Smith, under the influence of the proprietors, urged moderation since they believed that commercial prosperity depended on close trade ties with the British government.

The strain of nonimportation on both sides began to tell early in 1770. Dry-goods dealers especially suffered as their stock dwindled, and they had to be pressured from breaking the pact in July 1770. Many found it difficult to hold the line on prices, as stipulated in their agreement. On the other hand, those who dealt with the West Indies reaped substantial profits, and goods smuggled in from other countries under the direction of merchants like John Hancock of Boston curtailed the need for some English imports. During the year and a half of the ban, a number of Pennsylvanians made enough to pay off outstanding debts to British merchants, and with no goods coming from England the province as a whole showed a favorable balance of trade. All the participating colonies now looked to their own resources and engaged in more intercolonial trade. Meanwhile, Parliament was pressured

into waiving all duties save that on tea, setting the stage for the exclusive boycott of this product and the dramatic episode known as the Boston Tea Party.

West's picture thus presents a totally idealized set of relations between the proprietary government, Native Americans, Quakers, and merchants, projected back on an event of 1682 but actually referring to the working ideology of the contemporary British ruling class. The presence of proprietary authority is embodied in the figure of William Penn, and the neoclassical formality expresses the harmonious interaction of all the parties. The topical meaning of this work is reinforced by West's thorough identification with proprietary interests. Just as he used false Quaker credentials to enhance his American mystique in the Old World, he now exploited it to enhance the prestige of his patrons in the New World. But this elaborate structure of illusions would utterly collapse five years later in 1776, when Pennsylvania radicals terminated proprietary rule following the Declaration of Independence.

Neoclassicism was the king's preferred style when he ascended the throne; images of heroic virtue in a classical context stimulated ideals of loyalty and morality in a seemingly nonpartisan context and flattered his personal historical and political position. Around 1780, however, events pushed him toward a grandiose scheme of religious pictures which he wanted to install in his private chapel at Windsor. The aborted Chapel of the History of Revealed Religion—as it came to be called—remains one of the most ambitious programs of its kind and identified West with religious narrative for the rest of his life.

The greatest stimulus to its conception was probably the religious riots of June 1780 (the so-called Gordon Riots, named for their instigator Lord Gordon), when several Protestant groups under the heat of the American Revolution rioted against the Catholic Relief Act by pillaging Roman Catholic homes (including those of Lord Mansfield and Charles Towneley), setting fire to Newgate Prison and releasing prisoners, attacking the Bank of England and other public buildings, and targeting the residences of magistrates, lawyers, and bishops. The crowds ruled the streets for several days, and the court was frantic. Eventually, the uprising was ruthlessly suppressed, leaving 450 persons dead. While the riot seemed to have been motivated by narrow religious concerns, in fact it expressed wrath toward the management of war

against the rebellious Americans. It was suspected that Catholics were receiving special dispensation to lure them into the armies fighting in America and otherwise get their support for King George's tyranny.

The cycle of religious pictures demonstrates an attempt to promote a religiously based morality to replace that of neoclassicism. The moral virtue emphasized in the latter had since been preempted by the American patriots ("Give me liberty or give me death!" "I only regret that I have but one life to live for my country"), and the republican ideals uttered by the insurrectionists probably soured the king on the neoclassical style as a vehicle for his intimate beliefs. Indeed, West was ultimately requested to quit work on the chapel due to suspicions about his loyalty. Despite his vast expenditure of time, money, and effort on the enterprise, events transpiring in America and revolutionary France forever altered the relationship of West and George III.

The Second Generation of Neoclassicists

Thus far we have tried to demonstrate the close relationships of patrons and artists in the formation of the neoclassical style. These alliances were not accidental or conspiratorial but based on a set of converging aims and needs. It is necessary to emphasize the pattern of linkages to get at the purposeful, calculating contributions to the emergence of the new style. The practical interests and political aims of the participants did not hinder the creation of significant works, but the genesis of these works was directly owing to the demands of a self-interested elite.

The next generation of neoclassicists modeled themselves after the example of the first, but the immediate network of correspondences became diffused. The overtly mercantile and one-sided political potential of neoclassicism gradually recedes, leaving a thematic and visual vocabulary capable of relaying fresh and multiple messages. What began as the province of an aristocratic elite now enters the wider public domain as a primary means of visual communication. Naturally, this "public" contains the more privileged members of the bourgeoisie, and their use of this imagery constitutes a kind of emulation of the aristocracy. But as the discrepancy between the declaration of abstract principles like justice, liberty, and patriotism and real life practice widens, the neoclassical style becomes increasingly co-opted by the progressives.

Canova

One of the youngest artists directly linked with the first
generation and who bridges the second is the Italian
sculptor Antonio Canova. Canova arrived in Rome in
1779 as a twenty-one-year-old prodigy and four years
later obtained the most important commission available
to a sculptor in Rome, the Pope Clement XIV monu-
ment for the church of the SS. Apostoli. By 1792, when
his second papal monument was unveiled, Canova had
acquired a European reputation such as no Italian sculp-
tor had enjoyed since the seventeenth century. His mer-
curial rise to fame occurred within a little more than a
decade, but it seems less astonishing when we learn that
he had the backing of abbé Filippo Farsetti—a member
of the Albani circle—and Gavin Hamilton.

Canova was born at Possagno in the province of Tre-
viso, then one of the Venetian mainland dominions
known as the *Terraferma*. Possagno possessed rich farm-
lands and was famous for its wool industry and stone
quarries. Canova descended from a long line of stonecut-
ters employed in the local building trade. His father died
while Canova was still an infant, and the child grew up
under the tutelage of his paternal grandparents. While as-
sisting his grandfather in the refurbishing of country resi-
dences, Canova—already revealing precocious gifts—
drew the attention of their patrician client, Giovanni Fa-
lier.[64] A member of the old Venetian aristocracy, Falier
owned a country estate at Asolo near Possagno and a
palace in Venice and wanted a kind of live-in decorator
for his residences. He took on the young Canova as his
protégé and apprenticed him out to a local sculptor
named Torretti who had previously worked on Falier's
estates. When Torretti moved his studio to Venice in
1768, Falier requested that he take Canova with him for
advanced training. Torretti died soon after, but Canova
remained in Venice studying under Torretti's nephew
and at the Venetian Academy.

In Venice Canova also studied at the Palazzo Farsetti,
which contained an immense collection of casts and an-
cient masterpieces in Rome. The abbé Filippo Farsetti
was aided in assembling his collection by his cousin Car-
lo Rezzonico, who became Pope Clement XIII in 1758.
Falier knew both Farsetti and the nephews of Rezzonico
who provided young Canova with several commissions

2.60 Antonio Canova, *Daedalus and Icarus*, 1777–1779. Museo Correr, Venice.

including the monument to their uncle. Equally significant, Farsetti dealt with antiquities and had been closely allied with Cardinal Albani, Winckelmann, Gavin Hamilton, and Jenkins. He was also in touch with Robert and James Hamilton, and around 1765 he commissioned Clérisseau to design a landscape of Roman ruins for the garden of his family estate at S. Maria di Sala near Padua. Farsetti was certainly the leading figure behind neoclassicism in Venice, and Canova studied assiduously at his palace during the years 1768–1779. His first independent works, two baskets of fruits and flowers, were commissioned by Farsetti to decorate the staircase of his Venetian residence.

Farsetti and Falier thus constituted the moving force behind Canova's rise to success. His first notable sculptures, figures of *Euridice* and *Orpheus*, were done for Falier, and the Venetian senator also obtained for him the commission to do the *Daedalus and Icarus* for Falier's friend, Pietro Vettor Pisani (fig. 2.60). These works of the late 1770s stand out for their realism: *Euridice* and *Orpheus* reveal the despair of loss and abandonment, while the *Daedalus* evokes the human side of a father-son relationship. Daedalus is shown attaching a wing to Icarus's shoulder in preparation for their flight from Crete, where they have been imprisoned in a labyrinth they themselves designed for the tyrant Minos to guard his Minotaur. Canova focused on Daedalus's paternal concern for the irrepressible youth and took as their models his patron Giovanni Falier and his son Giuseppe with whom Canova had established a close relationship.

Falier now promoted Canova as a national genius and put him in touch with other leading patricians including Girolamo Zulian, Venice's ambassador to the Holy See.[65] Like Falier, Zulian was anxious to demonstrate that Venetian culture was still capable of producing outstanding talent, and he seized the opportunity to bring the young sculptor to Rome. He invited Canova to Rome as his personal guest in 1779, and for the next year Canova shifted between Rome and Naples and back to Venice again briefly before settling permanently in Rome at the end of 1780. During the interim, Canova studied with Batoni and made a pilgrimage to Gavin Hamilton's studio, still the *doyen* of neoclassicism.

Zulian now sought the best means of employing Canova in the interests of Venice, contemplating a scheme for the wholesale replication of major works in Rome to

be shipped to the Serene Republic. At the same time, he had shipped to Rome the plaster cast of the *Daedalus and Icarus* in order to get feedback from local neoclassicists and their sponsors. Among those visiting the exhibition were Batoni, Gavin Hamilton, and Giuseppe Angelini, a former assistant of Nollekens and Cavaceppi who had also carried out restorations for Hamilton and Jenkins. Hamilton responded enthusiastically to the group but advised Canova to temper his realism with the Greco-Roman ideal. Hamilton soon won Canova's confidence, becoming a close friend and trusted adviser—exactly as he had done with Benjamin West twenty years earlier. While Hamilton now acted the part of the elder statesman rather than the recruiting agent, he remained instrumental in mediating between gifted artists and Anglo-Roman patrons. Canova's long-standing links with the English aristocracy was a critical factor in the spreading of his reputation, and it was also Hamilton who helped Canova obtain the coveted commission for the monument to Pope Clement XIV which launched his international success.

Hamilton made Zulian see the importance of giving effective assistance to Canova, and the latter promptly purchased a block of marble for the young sculptor without stipulating the choice of subject. Canova chose as his theme *Theseus and the Minotaur*, a story related to the myth of Daedalus and Icarus. When Theseus arrived in Athens after a long journey, he heard the unexpected sound of weeping and mourning throughout the city. He learned that the price of the recent Athenian defeat at the hands of the Cretans was an annual tribute of fourteen victims to feed the monstrous Minotaur. The Minotaur belonged to the tyrant King Minos, who kept the beast in the elaborate labyrinth designed by Daedalus. Theseus determined to rid the world of this monster, and it is the hero's moment of triumph that Canova intended to portray (fig. 2.61).

Canova's friend and biographer, the Countess Isabella Teotochi Albrizzi, claimed that the *Theseus* contained a patriotic message; his deed did not merely destroy "a private foe, but his country's" and thereby freed it "from a cruel and degrading tribute."[66] This didactic meaning is reinforced by the realism of the hybrid Minotaur whose immediacy disturbed some of Canova's contemporaries. He even began with the idea of representing the antagonists in violent combat, but Gavin Hamilton recom-

2.61 Antonio Canova, *Theseus and the Minotaur*, 1782. Courtesy of the Trustees of the Victoria and Albert Museum.

2.62 Plate 5 of *Le pitture antiche d'Ercolano e contorni*, vol. 1.

mended that he show Theseus seated triumphantly on the body of the dead monster, thus making it conform more closely to the Greco-Roman ideal of calmness. Hamilton's impact is also shown in the influence of the older painter's *Achilles Dragging the Dead Body of Hector* on the work, while Canova also turned to a popular wall painting at Pompeii for his image of the Minotaur (fig. 2.62). Canova completed a sketch of the composition by 2 June 1781 and completed the sculpture by April 1783. During this time, Falier and Zulian persuaded the Venetian senate to award an annual pension to Canova, certainly an unusually generous gesture for the financially strapped government.

Thus it would seem that Canova's *Theseus* did indeed embody patriotic feelings. Now at the time of its execution it could only have referred to the ongoing conflict between Venice and the Ottoman Empire, the country still exacting "a cruel and degrading tribute." It may be recalled that Venice's colonies once comprised the islands of Cyprus and Crete, both eventually conquered by the Turks in 1571 and 1669, respectively. Crete was the oldest and last remaining of Venice's Eastern Mediterranean possessions, and its loss remained a bitter memory. The Ottoman government, moreover, continued to encroach on Venetian territories right through the eighteenth century which substantially contributed to its economic plight. Its last remaining stronghold on Crete was seized in 1715, and three years later Venice ceded the Morea (Peloponnesus) to the Turks. Algerian and Tunisian pirates of the Barbary Coast regularly raided Venetian merchant ships, and tension between the Serene Republic and Constantinople increased in the last quarter of Venice's existence as an independent state. Meanwhile, as late as 1770, a revolt on Crete against Turkish rule was ruthlessly suppressed. Canova's choice of the Theseus theme, carried out in Rome under the auspices of the Venetian state (Crete had been a possession of ancient Rome as well), could not have been coincidental. And Albrizzi, born on Corfu and a member of the flourishing Greek community traditionally harbored at Venice, well understood its implications.

Zulian, due to be transferred to Constantinople in 1783, did not have to choose the subject to have influenced the work. He and Falier were close friends of Admiral Angelo Emo, considered the last of Venice's great naval heroes in its struggles against the Turks. Emo had

2.63 Antonio Canova, *Memorial to Admiral Angelo Emo*, 1794. Museo Storico Navale, Venice.

distinguished himself by his attacks on the pirates of Algeria and Tunisia and had humbled the dey of Algeria by a treaty highly favorable to Venice. He also made expeditions against Tripoli and other North African territories under the Ottoman hegemony. After serving in the government where he represented a voice of reform, he resumed his naval functions in the mid-1780s against the pirates to clear the Adriatic Sea for Venetian ships. During this time his command was overwhelmed by a severe storm, and he lost two of his vessels. The government, plagued by economic woes, demanded compensation for the losses, and Emo retired in bitterness to his native Malta where he died in 1792. After his death a surge of nostalgia swept over the senate, and Zulian and Falier exploited the opportunity to propose a monument to their friend to be executed by Canova (fig. 2.63). The sculptor refused payment out of patriotic duty for the memorial, but the government awarded him a lifetime stipend for his contribution. Albrizzi noted that the monument glorified one of Venice's "true heroes, who, although their hands are bathed in blood, were actuated solely by the sacred love of an insulted and oppressed country."[67]

Given his patronage and the lack of a progressive middle class in Venice, the generalized patriotic allusions of the *Theseus* constituted the only kind of positive political statement possible for Canova at the time. It was bolstered by a domestic reform movement that provided a glimmer of hope for social change and renewal in Venice's rigidified political structure. The force behind the movement was a group of poor nobility inhabiting the parish of S. Barnaba, known as the *Barnabotti*. They were essentially self-serving but driven by the logic of their position to attack the rich and reactionary cliques in Venice's governing bodies, especially the Council of Ten and the State Inquisition. They invoked patriotic virtues and displayed classical emblems of liberty and justice.

The chief troublemakers among the ruling caste were Angelo Querini and Giorgio Pisani who called for a return to strict constitutional legality. Querini first achieved notoriety during the political crisis of 1761 centering on the powers of the State Inquisition which he wanted to curtail. He was opposed by arch conservatives like Marco Foscarini and wound up in a prison fortress for a couple of years. Thereafter he devoted most of his attention to his art collection but remained a vocal participant in the

struggles of the next decade. His successor was Giorgio Pisani, a member of the *Barnabotti* wanting to halt the decline of the caste system, raise the stipends of certain magistrates, and get ample dowries for patrician women of the poorer nobility when their families could not afford them. In 1780 he was unexpectedly elected procurator of St. Mark, an honorary position of great prestige, and his supporters waved banners proclaiming the ancient virtues. Pisani had a taste for classical allegories with topical references like the ones displaying a cap of liberty on his calling card. All this proved too much for Venice's governing elite, and he was arrested for spreading subversive propaganda the same year as his election.

Canova and his patrons were closely connected to these events. Pisani, distantly related to the patron who commissioned *Daedalus and Icarus*, collected neoclassical images for their propaganda potential. Querini had been an intimate friend of Farsetti and enjoyed a reputation as an antiquarian and patron in his own right. He commissioned young Canova in 1776 to do a bust of his then fellow-reformer, Paolo Renier, three years before he was elected doge in a corrupt campaign of bribery. When Renier compromised with the groups he once attacked, Querini relegated the bust to the servant's quarters.

Canova's *Theseus*, moderate in tone and substance, projected the liberal and patriotic sentiment of the *Barnabotti* and their sympathizers like Zulian and Emo in the aristocratic visual language of the period. With the exhaustion of the *Barnabotti* in the mid-1780s and the increasingly reactionary climate in Venice, Canova's work became conservative and idealized. This could only be exacerbated by the fall of Venice brought about by Napoleon in 1797. He soon became identified with sensuous and erotic forms, as in the *Psyche* and *Psyche and Cupid*. These excited the interest of the first generation of collectors like Henry Blundell, Sir William Hamilton, Charles Towneley, Lord Cawdon, and Lord Bristol. His monuments to patriots like Vittorio Alfieri and George Washington reflect his ongoing commitment to constitutional principles, but like them he recoiled in horror to the progress of the French Revolution. For this reason he felt a love-hate relationship to Napoleon, often using neoclassic ideals to glorify the emperor and members of his family but also repeating the message of his *Theseus* in his *Perseus Triumphant* where Bonaparte becomes the ob-

vious tyrant. The best example of his political flip-flopping, however, is his response to a political interpretation of his *Hercules and Lichas*, his most violent work, which corresponds to the revolutionary upheavals of the period in which it was conceived and developed (1795–1815). Some French visitors to his studio in Rome (occupied by the French since 1798) in 1799 understood the work to show the French Hercules casting the monarchy to the winds, but Canova preferred to see Lichas not as the tyrant but as "licentious liberty."

Late in life, the internationally recognized sculptor was asked to present his views on the Elgin marbles (the Parthenon sculptures), then the center of controversy between the second generation neoclassicists and the first whose financial investments were jeopardized by the presence of authentic and unrestored Greek sculptures of the fifth century. To their credit, several artists of the first generation, including West and Nollekens (although they had nothing to risk), joined the ranks of second-generation artists like Flaxman to acclaim the Elgin marbles. The realism of the Elgin marbles clearly contradicted the Greco-Roman examples of calmness, beauty, and perfection, gradually being perceived as late Roman copies or paraphrases. Towneley's collection (recently acquired by the British Museum) was taken as a test case, but Flaxman and Nollekens upheld the evident superiority of the Elgin marbles over Towneley's concoctions. Opposing them and Lord Elgin was R. Payne Knight, a leader in the Dilettanti Society, who had invested heavily into Greco-Roman antiquities and now tried to block the acquisition (and thus legitimation) of the Parthenon sculptures by the British government.

The Selection Committee of the House of Commons which conducted the hearings did recommend the purchase of the Elgin marbles, thus closing the chapter on the Age of the Grand Tourists and their hangers-on. This was already heralded in 1815 by a dinner given for Canova at the Royal Academy over which Benjamin West presided. Both West and Canova agreed on the value of the Elgin collection, but Canova had said he wished he could start all over again with their example before him. Undoubtedly, they recalled for him his early realist works when he was in touch with reformist and national ideals. The Elgin marbles were themselves victims of the struggle between Venice and Turkey; in 1687 the Venetians attacked Athens, and one of the bombs struck the

Parthenon which the Turks were using as a powder magazine. But by 1815 neoclassicism had run its course in England and elsewhere, and neither the expanding industrial societies nor the conservative governments of the post-Napoleonic period could rely on it to satisfy their ideological needs.

One of Canova's lifelong friends was the French neoclassical theorist Quatremère de Quincy, who similarly underwent a transformation with the discovery of the Elgin marbles. Quatremère and his circle in France demonstrate most vividly the expanding possibilities of neoclassicism among the second generation. He was Canova's exact contemporary (b. 1755), and they formed their friendship after Quatremère came upon the *Theseus and the Minotaur* in 1783 during a long pilgrimage to Italy. Quatremère himself had planned to become a sculptor-architect, and he knew intimately the works of Montfaucon, Hamilton, Adam, and especially Caylus. While in Rome he made the acquaintance of Mengs and Batoni, and in 1779 he met the young Prix de Rome painter Jacques-Louis David during a trip to Naples. David likened this encounter to St. Paul's epiphany on the way to Damascus. Both he and Quatremère sided with the radicals during the French Revolution, participating in the abolition of the old academy and drastically transforming the Beaux-Arts institutions in France. Thus Quatremère—a disciple of Winckelmann and intimate friend of Canova and David—bridged the gap between the first- and second-generation neoclassicists. Although after 1815 he became reactionary in his dogmatic assertion of neoclassical doctrine, his was a progressive voice in the interval between the Seven Years' War and the French Revolution.

La Font de Saint-Yenne

In France the Seven Years' War shaped the national art and moved it in the direction of the new style. Despite the adversarial relationship of France and England, there were many exchanges among their painters, sculptors, architects, and craftspeople (Clérisseau and Adam are only one dramatic example). In 1754 the critic La Font de Saint-Yenne expressed the hope that history painting would attain the high place it enjoyed during the days of Poussin and Lebrun. He wanted a regeneration of "A School of Morality," depicting the virtuous and heroic deeds of great persons from the past. He longed for the

order and authority of Louis XIV and wanted the cultural trappings that accompanied it. As early as 1747 he praised a work by Collin de Vermont which cast Louis XV in the guise of the Emperor Augustus and generously excused its historical errors and anachronisms.[68] La Font's writings were didactic, a plan for the younger generation to follow. He even listed the proper subjects for would-be painters of history to portray: Epaminondas expiring before his tent, Regulus departing for Carthage, Socrates taking the hemlock, and Hannibal swearing enmity against Rome—practically the entire classical repertoire of Benjamin West!

By the 1750s, however, La Font's preoccupation with law and order shifted from its emphasis on the court to the nobility maintaining the nation's institutions through the *parlements*. La Font identified his interests with the aristocracy seeking to maintain its privileges but manipulating the language of the Enlightenment to make it sound as if its interests were those of the country at large. He used terms like patriotism, justice, and sacrifice to describe the actions of the magistrates and ministers of justice who were the principal political adversaries of the court in their struggle to maintain their privileges, and even regain some previously yielded to Louis XIV in his bid for centralization. They succeeded in winning the support of middle-class persons who imagined they were speaking in their behalf against the forces of "despotism." Indeed, the court's gradual sponsorship of neoclassical imagery was in good measure a response to the pressures exerted by the rhetoric and propaganda of their noble and middle-class opponents.

Caylus

La Font's association of order and authority with classical imagery found support in the views of his antiquarian friends like Gros de Boze, keeper of the king's Cabinet de Médailles, and the comte de Caylus whose *Recueil d'antiquités* we have already mentioned. Both Gros de Boze and Caylus were passionate collectors of antiquities but died too soon to see their fondest hopes for a classical revival materialized. Caylus, who had the greater impact, lived at Versailles as a child and could vividly recall the splendor of Louis XIV's reign all his life. Of ancient nobility, he held the honorary title of "Conseiller" of the *parlement* in Toulouse. He was more suspicious than La

2.64 Vignette from title page of comte de Caylus's *Recueil d'antiquités*, vol. 1, 1752.

Font of the parliamentarians: once reflecting on the concern of Roman senators for the public good, he asked, "Are our magistrates motivated by the same zeal for the public good?"[69] After a short military career, he made an extensive tour of Asia Minor, Greece, Turkey, and Italy. This trip inculcated in him his fascination with archeology and also a mad passion for collecting; he spent four-fifths of his large income on antiquities, filling two houses several times over and periodically donating them to the royal collections. Caylus also spent a major part of his income on sculptors and painters who embodied his classical bent. He wanted the reign of Louis XV to be surrounded with the glory of the ancient past and wanted to be remembered as the individual who helped make it happen.[70]

He published a vast number of monuments in his seven-volume production, *Recueil d'antiquités* (1752–1767), and stated at the outset that he intended to publish only the works in his collection or those which once belonged to it. While in subsequent volumes he included the objects of other collectors, his attitude is significant: he tried to embrace the whole of antiquity in both his collection and his *Recueil* which is nothing more than the catalog or inventory of this personal mania. He proudly displayed a vignette on the title page of his first volume of his actual collection which gave "an idea of the disposition of my small gallery" (fig. 2.64).[71] That "small" gallery extended to two houses and as many uncrated boxes as his storehouses could hold. Thus Caylus foreshadowed Winckelmann-Albani and Sir William Hamilton in presenting the catalog of his collection as if it were an objective study of ancient art.

Unlike Hamilton and Albani, however, who let others do their dirty work, Caylus involved himself in every phase of the work's production. As a trained engraver, writer, editor, and lecturer with seemingly boundless energy, he supervised the most detailed features of the series. His intense commitment, unusual for an aristocrat of his ancient lineage, was sparked in part by his contact with the Salon of Mme. Geoffrin and the encyclopedists and in part by his desire to single-handedly initiate a French renaissance. He detested the rococo as a sign of decadence and French weakness and wanted to reinstate antiquity into the royal household. He exercised a profound influence on the academy at mid-century, moving it toward a more intense study of antique forms. He con-

tributed to the foundation of the *Ecole Royal des Eléves Protégés* where—as he and La Font advocated—a group of select students were immersed in the study of classic literature and casts of ancient statues.

Caylus did not need to sell his work to make a living, although he bought and sold regularly for a profit. He often sold off his fakes and forgeries to English and German collectors whom he felt were the least perspicacious of connoisseurs. Nevertheless, he greatly stimulated the market for antiquities, raising the prices by his large-scale purchases and tipping the market in favor of antiquity. There is irony but factual truth in his statement, "Ce commerce d'antiquités est un objet très-advantageux pour moi."[72] And he recognized that knowledge of his publishing venture had given rise to the sale of fakes to meet his insatiable demands.

But with Caylus profit could not be the sole motive since he had inherited a large fortune. At one point, his desperation for antique objects disposed him to consider seriously hiring thieves to steal from Herculaneum since this was being increasingly policed by the Neapolitan government. He was the natural rival of Albani, striving for a collection that would outshine all his competition, and by 1760 he could boast that there was no other collection comparable to his. The same year he noted that his contemporaries had not fully developed a taste for antiquity but that this would come in time.[73] In other words, he was conscious of himself as being part of a new wave and of bringing about a change of taste.

Thus the power and prestige associated with the traditional ideal of the antique fed into the collectomania of Caylus. In the course of his researches at Avignon, Caylus came upon a corpus of drawings after the ancient monuments in Southern France commissioned by Colbert from Mignard, a major project left unfinished. Caylus resolved to complete the task himself and dedicate the folio to the memory of Colbert, Louis XIV's efficacious minister. Colbert wanted to make Versailles a repository of antiques equal to Rome: he wrote the director of the academy at Rome in 1672: "Make the painters copy everything beautiful in Rome; and when they have finished, if possible, make them do it again."[74] The original academy at Rome was thus founded on the royal need for Roman models of luxury and elegance, a kind of factory for the reproduction of Renaissance masterpieces and classical statuary to adorn the parks and gardens of

Versailles. Both Caylus and La Font invoked the shade of Colbert in their desire to revive the pomp of Louis XIV.

There can be no doubt that their sense of national honor was at stake in the quest for the classical revival. Their work assumed a tone of urgency during the Seven Years' War. Caylus carried on a regular correspondence with his agent in Rome, the monk Père Paciaudi, and interspersed allusions to the war among his frequent commands to buy antiques from the dealer Alfani.

On 14 May 1759 he hoped that the French would invade the English to punish forever "their insolence and perfidy."[75] He is angry at the end of the year that the war is preventing him from obtaining objects from Greece since British vessels are patroling the Mediterranean. Caylus's collaborator, the abbé Barthélemy, wrote Paciaudi happily on 17 October 1757 that General Montcalm just captured Fort George, near Albany, from the English. Above all, Caylus supplemented his later volumes with a section of Gallo-Roman antiquities which he felt as an almost patriotic obligation. Shortly after the war ended he referred to the artifacts from "notre pauvre Gaule"—an allusion to France sacked and defeated (19 September 1763).[76]

Caylus and his collaborators developed their own network in France but were well informed on the activities of neoclassical circles in Rome. His friend the abbé Jean-Jacques Barthélemy, who edited and translated classical texts for the *Recueil*, lived in Rome at the height of the Seven Years' War as a guest of the French ambassador, the future duc de Choiseul. Barthélemy had been trained by the antiquarian Gros de Boze whom he eventually succeeded as keeper of the royal Cabinet des Médailles. While in Rome he established links with the Albani circle through Paciaudi. Albani expressed interest in Caylus's research, and the many references to Albani in the *Recueil* testifies to an exchange. Privately, however, Caylus sniped about Albani's participation in illicit art traffic and the manufacturing of fakes. Caylus was closer to Baron von Stosch who sold him several engraved gems, and while he cast aspersions on Winckelmann's integrity he commissioned translations of his work.

Caylus perceived himself as the rival of Roman and English collectors but in the chronological, not the qualitative, sense. At the same time, he urged all antiquarians to follow his example in publishing their collection to establish a line of communication among them and to form

a type of data bank of antiquity for the benefit of the wider public. Ultimately, he wanted to develop a broad base of information on which to found a history of everyday life in the ancient world. He even organized a laboratory to discover the technical recipes of the Greeks, especially encaustic techniques (painting with wax), so that moderns could paint like the ancients. Like the modern connoisseur, Caylus wanted to discover principal stylistic traits, but he also hoped to isolate even the temporary tastes and fashions of antiquity as a means of revivifying everyday life under Louis XV. In fact, his fantasy was incarnated in the abbé Barthélemy's visionary book, *Voyage de jeune Anacharsis en Grèce*, which exploited observations of Herculaneum and Pompeii to reconstruct the private life of ancient Greece. Begun in the late 1750s, but only published in 1788, it contributed to the rage for the antique prophesied by Caylus.

J.-F. Mariette was another of Caylus's collaborators, a wealthy print dealer and collector who started his career by classifying the collections of others. He retired from business in 1752 and purchased the state office of contrôleur de la grand chancellerie, devoting most of his leisure time to enlarging his fabulous collection of ancient engraved gems. Two years earlier he had published several of his precious objects in his *Traité des pierres antiques gravées*, and in the same year gained royal favor for his second publication entitled *Recueil des pierres antiques gravées du cabinet du roi*. Mariette also worked with Caylus on his *Recueil*, and Caylus repaid him by publishing several of his antiquities in the series. His range of contacts were as wide as those of Caylus and Barthélemy with whom he also worked, comprising friendships with Clérisseau and the baron von Stosch. Mariette also kept close tabs on English developments, especially the publishing venture of Sir William Hamilton.

Herculaneum particularly fascinated Caylus and his partners. Thanks to the munificence of the king of the Two Sicilies, they owned copies of the *Le pitture antiche d'Ercolano*. Caylus treasured the handful of examples from the excavations he had (or thought he had), including a fragment of a fresco brought back to him by the neoclassical architect J.-G. Soufflot from his trip to Italy (1750–1751) in the company of C.-N. Cochin and the marquis de Marigny. All three made substantial contributions to the rise of French neoclassicism, and Caylus (despite a later falling out with Cochin over personality differences and petty jealou-

sies) could refer to the group in October 1761 as "my friends." Cochin later published an account of their trip to Herculaneum in the *Observations sur les antiquités de la ville d'Herculaneum*, an excerpt of his much larger work *Voyage d'Italie*, published two years later in 1756. This included a section on the painting and sculpture, and while naively critical the book did illustrate a number of the paintings and artifacts that excited the curiosity of French and English readers (it was speedily translated). While Cochin was then too steeped in the facility of eighteenth-century French painting to appreciate the severe style of Herculaneum, he recognized its importance in the wake of the Seven Years' War when he felt a sense of rage against rococo luxury and waste.

Cochin and his coauthor Bellicard dedicated in the most unctuous terms the *Observations* as well as the *Voyage* to the marquis de Marigny (then known as M. de Vandières), who replaced his uncle, Lenormant de Tournehem, as director des Bâtiments in 1751. In 1749 Lenormant and Mme. de Pompadour (Marigny's sister), intending that their relative should be the next directeur, recommended that he take a "Grand Tour" to prepare him for the job. Cochin, Soufflot, and the abbé Le Blanc were selected to accompany him, and Cochin summed up the goal of their journey: "To acquire the knowledge necessary to guide with dignity a great king in the direction of monuments which must immortalize the glory of his reign." This was precisely the aim of Caylus who was not exactly a bystander to all this: he had the complete confidence of Lenormant and through him transmitted his ideas to Marigny. Marigny used his authority to facilitate Caylus's importation of antiquities from Italy and elsewhere.

This trip did push Marigny in the direction of history painting; while as directeur he allowed rococo painting to continue, he increased the budgetary allocation for moralizing classical and historical subjects. He entrusted Soufflot with the design of the new church dedicated to the revered Sainte Geneviève in an experimental classical style, encouraged a younger generation of neoclassicists, and appointed Cochin as the influential *secrétaire perpétuel* of the Académie Royale, Engraver to the King and Keeper of his Majesty's Drawings. Cochin allied himself with the *encyclopédistes*, executing the famous frontispiece for the first volume of illustrations which showed the personification of Truth emerging from a heavenly

Ionic temple to receive the accolades of the Arts and Sciences. Caylus, upset that he was not invited to participate in the Encyclopedia project, developed a profound animosity toward the editors of this enterprise. At the same time, it is doubtful that he could have subscribed to their democratizing attitude; he and his collaborators drew closer to the king as the middle-class philosophes took up the crudgels against "intolerance" and "despotism." Yet both groups were encouraged by Marigny in their shared admiration for the patriotic virtue and Spartan simplicity exemplified in classical images and texts.

Caylus and his friends also had the support of the Duc de Choiseul, the French foreign minister who negotiated the Treaty of Paris ending the Seven Years' War. Prior to this appointment he served as French ambassador to Rome between the years 1753–1757, and through his protégé the abbé Barthélemy (whom he liberally subsidized) met members of the neoclassical circles. Choiseul actually served as intermediary for the correspondence between Caylus and his agent Paciaudi, thus getting firsthand information on both the Rome and Paris groups. He certainly assimilated their taste: in 1756 he commissioned the Italian painter, Gian Paolo Panini, to paint an imaginary palatial gallery stocked with the greatest treasures of ancient Rome (fig. 2.65). This was a condensed and miniaturized version of Caylus's *Recueil*, done by the painter who made his living depicting real monuments in a fictional time-space realm for Grand Tourists. This ob-

sessiveness with the totality of antiquity hints at the perceived relationship between the exercise of political power and the cultural trappings of classical antiquity. Caylus rejoiced when the duc de Choiseul expelled the Jesuits; he opposed any power that threatened the authority of a centralized monarchy.

Caylus's preoccupation with the interior furnishings of antiquity is bound up with his wish for a stylistic uniformity emanating from on high. The *Recueil* consistently spells out the original function of the objects as if to inform the production of contemporary applied arts. Together with the *Le pitture antiche* it did indeed affect the interior decoration of the fashionable upper classes. Among Caylus's precious finds from Herculaneum were bronze braziers resting on three legs resembling those of a goat, which were destined to have a major impact on neoclassical decoration (fig. 2.66). These tripods show up in an endless variety in the decorative work of Robert Adam, who noted in 1767 that his tripod for Lord Coventry was based on "a French design for a Water Stand." Adam used the form for pedestals, perfume burners, flower and water stands, all standard features in his decorative schemes. Caylus's tripods inspired cabinet makers like Georges Jacob and the entrepreneurs like Jean Henri Eberts who designed a variation known as the *Athénienne*, which did service as a table, perfume burner, and dish warmer like those of Robert Adam.[77]

Eberts, a banker and print publisher, was a figure of some notoriety in the Parisian art world during the period 1760–1780. He regularly entertained connoisseurs, and artists and their patrons, and among the guests at his banquet on 12 February 1765 was the painter Joseph-Marie Vien (1716–1809). It was a painting by Vien which gave the name *Athénienne* to Eberts's tripod (fig. 2.67). Not coincidentally, Vien is considered the forerunner of French neoclassicism and he dominated the French art scene from around 1770 to the end of the century.

Vien, like so many outstanding eighteenth-century French painters, descended from an artisan milieu; his father was a master locksmith known for his ingenious designs.[78] As a gifted prodigy, Vien began sketching remarkable maps and decorating porcelain in his preteens. His talent was quickly spotted by the local painters and gentry of his native Montpellier who sent Vien to Paris armed with letters of introduction to several farmers-general and the comte de Caylus.

2.67 Joseph-Marie Vien, *The Virtuous Athenian Woman*, replica of original shown in 1761 Salon. Musée des Beaux-Arts, Strasbourg.

2.68 Joseph-Marie Vien, *The Young Corinthian Woman*, engraving dated 1762 of original exhibited in 1763 Salon. Bibliothèque Nationale, Paris.

Caylus soon became his mentor and protector, and Vien joined Caylus's famous team of collaborators. Vien won the Prix de Rome in 1743 and studied at the French Academy at Rome from 1744 to 1750. After returning to Paris his first visit was to Caylus who was pleased to have a trained disciple to translate his fantasies into high art. Caylus obtained for Vien his first commissions, including the decoration of the Hôtel Lambert in 1752 which belonged to the farmer-general Delahaye. But there was a trade-off for this patronage: Vien was at Caylus's beck and call for almost everything, including Vien's marriage which the antiquarian arranged for him against his will. Caylus, who tried to resurrect the ancient encaustic techniques he read about in Pliny, engaged Vien to prepare a painting of the *Head of Minerva* in the ancient process he thought he discovered. Caylus used the picture as evidence to support a paper he read on the subject before the assembled Académie des Inscriptions. Vien also exhibited this work at the Salon of 1755 along with several other classical subjects.

The year before Vien was formally admitted to the Académie Royale on the basis of his *Daedalus and Icarus*. He became an adjunct professor in the art school, teaching the ideal of Greek serenity as taught him by Caylus. This ideal he incarnated himself in two works exhibited at the Salons of 1761 and 1763, respectively; the first depicted a *Young Greek Girl Decorating a Bronze Vase with a Garland of Flowers* (later called *Young Corinthian Woman*), (fig. 2.68), and the second a *Priestess Burning Incense in a Tripod*, which was later popularized in an engraving known as the *Virtuous Athenian Woman* and inspired the creation of Eberts (fig. 2.69). Both were done in the style of the paintings of Herculaneum and Pompeii and incorporated objects owned by Caylus. The *Young Greek Girl* displays a vase with its handles at the top, a type especially admired by Caylus who owned several examples and reproduced them in his *Recueil* (fig. 2.70). In the same period Vien designed a series of vases "in the antique mode" for use in contemporary decoration, further contributing to Caylus's goal to initiate a new fashion. This is particularly evident in the exhibit at the 1763 Salon, where Vien illustrated a variant of Caylus's tripod reproduced in plate 38 of volume 3 of *Recueil* (1759). Both of the Vien paintings were engraved by Flipart who exhibited the prints at the Salon of 1765, the year Eberts hosted Vien at his banquet. Not surprisingly, Eberts

2.69 Joseph-Marie Vien, *The Virtuous Athenian Woman*, engraving dated 1762 of original exhibited in 1761 Salon. Bibliothèque Nationale, Paris.

2.70 Illustration of vase with handles on top from comte de Caylus, *Recueil d'antiquités*, vol. 3, 1759.

2.71 Jacques-Louis David, *The Love of Paris and Helen*, 1788. Musée du Louvre, Paris.

himself had commissioned the engravings which were dedicated by him on the plates, one to Prince Christian of Denmark, the other to Prince Gustave of Sweden. Each print carried this legend: "The painting is in the gallery of Monsieur Eberts."

Thus Vien, universally recognized as the seminal exponent of the neoclassical revival in France, received his dominant impulse from the collectors Caylus and Eberts, a wealthy scion of an ancient family and a nouveau riche banker. Caylus had the authority to set the new trend, while Eberts, in emulating the aristocracy, spread the taste among those on the next rung of the social ladder. Here in microcosm is the way a change in fashion occurs, and the way artists—who often erroneously get the credit—function primarily as channels of communication for their patrons.

Precursor of David, Second-Generation Neoclassicist

Now we must take a dramatic leap forward in time to see how these conditions affected Vien's star pupil David, who has come to epitomize our notion of French neoclassicism. In 1787 the king's younger brother, the comte d'Artois, commissioned David to paint the Homeric theme of *The Love of Paris and Helen* (fig. 2.71). David was well prepared for this project; during the period 1775–1781 Vien, then director of the French Academy in

2.72 François-Anne David, engraving of vase in collection of Sir William Hamilton, published in French version, 1785, vol. 2, plate 5.

2.73 Plate 68 of Sir William Hamilton's *Collection.*

Rome with David as one of his pensioners, completed several large paintings for the king representing scenes from the history of Troy. The comte d'Artois's taste for antiquity followed the kind of decorative classicism done by Angelica Kauffmann for the English aristocracy. Previously, he commissioned Vigée-Lebrun to paint *Juno Putting on Venus's Girdle* which was exhibited at the Salon of 1782. The libertine d'Artois loved the erotic titillation and luxury conjured up by the *Iliad* and surrounded himself with antiquities and paintings reflecting this taste. David tried to satisfy his client's demand by reconstructing an ancient bedroom based on motifs from sculptures and bas-reliefs in Rome collections and from ancient medals in the Cabinet des Médailles. His central motif, however, he took from the engravings of Sir William Hamilton's vase collection probably published in the French version of 1785 by the engraver François-Anne David (fig. 2.72).[79] David made systematic tracings of Sir William's vases, and more than one detail in his picture seems to have been inspired by them (fig. 2.73). Additionally, David commissioned the cabinetmaker Georges Jacob to construct ancient furniture for him to reproduce, some of which seems to have been inspired by Robert Adam's designs such as the tripetal base of female griffons supporting the column at the far left. Finally, David did not fail to include in his composition the inevitable tripod which had become an indispensable feature of neoclassical decor. Moreover, it was directly inspired by Caylus's plate 38, except that David replaced the winged griffons resting on the goat legs with the fanciful birds of the tripod published by Cochin and Bellicard (fig. 2.74). Thus at the dawn of the French Revolution David's neoclassicism was still energized by the contributions of Sir William Hamilton and the comte de Caylus which he transmuted into high art for the benefit of a royal patron.

Retracing this line of development, we see the same impulse even more dramatically conveyed in Vien's famous *Seller of Cupids*, exhibited in 1763 (fig. 2.75). This work was based on an engraving in the *Antichità d'Ercolano*, volume 3, plate 7, published the year before (fig. 2.76). Caylus owned this volume, being one of the fortunate amateurs upon whom the king of the Two Sicilies bestowed a copy. Vien translated the original into an elegant neoclassical interior, complete with elegant accessories like the lion-footed table, perfume burner, and a

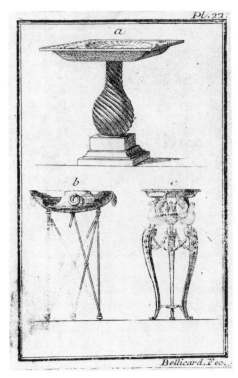

2.74 Plate 22 of Bellicard and Cochin, *Observations upon the Antiquities of the Town of Herculaneum.*

2.75 Joseph-Marie Vien, *Seller of Cupids*, Salon of 1763. Musée national du château de Fontainebleau, Fontainebleau.

chair decorated by a pair of birds. Akin to Angelica Kauffmann, Vien exploited the cult of antiquity for decorative rather than for narrative ends. Here he celebrated the taste of his patron the duc de Brissac, a friend of Caylus. Caylus's presence is strongly felt in Vien's picture: the vase on the marble pedestal repeats Caylus's favorite shape, while the perfume burner with goat legs and the chair seem to have been inspired by objects from Herculaneum in Caylus's collection and reproduced in volume 3, plate 39, of the *Recueil* (fig. 2.77). Vien modified the original by replacing the handles of the perfume burner with rams's heads, but these too were pervasive motifs in Caylus's series and used repeatedly by decorators like Robert Adam to give their objects an "antique" look. Adam used them for his designs of soup tureens for Sir Watkin Williams Wynn in 1773 which closely resemble Vien's censer (fig. 2.78). The *Seller of Cupids* was one of Vien's most popular works, reflecting and promoting his sponsor's taste. The upper classes increasingly decorated their residences "à la Grecque," with costume, hairstyles, textiles, jewelry, and furniture manifesting the marks of the new style. The same year Vien's picture showed at the Salon Soufflot produced furniture in the "antique" mode for the apartments of the marquis de Marigny.

Vien's pictorial source further exemplifies the ideological and commercial ties of neoclassicists across national

2.76 *Seller of Cupids*, engraving, in *Le pitture antiche d'Ercolano*, vol. 3, 1762, plate 7.

2.77 Finds from Herculaneum, *Recueil*, vol. 3, plate 39.

boundaries and the overlapping interests of their sponsors. The *Seller of Cupids* became a pervasive image in the applied arts including German Meissen ware and Wedgwood pottery. There was a great demand for this motif from Wedgwood; he used it in teapot and sugar bowl sets, cameos, and box tops (figs. 2.79, 2.80). While the dates of these objects are uncertain, this dissemination of the motif showed that both neoclassic fine and applied arts were merely part of the decorative ensemble of privileged groups.

Vien's work, however, could still fit neatly in a rococo setting, indicating its transitional role in mediating between the frothiness of Boucher and the new approach. For all of its clean rectilinear divisions, frieze-like aspect, and static poses it still retains playful features of the royal style. The theme of selling loves to patrician ladies could satisfy patrons of Boucher and Fragonard now sensitive to the changing mood and fantasizing about the erotic possibilities of antiquity. Even the obscene gesture of the suspended Cupid—the intention of which was well understood by contemporaries—betrayed the work's affiliation with the sexual promiscuity of Parisian high society. Caylus himself revealed the contradictions of the time in his dedicated labors in behalf of antiquity and his less-publicized pornographic writings for fellow voluptuaries. He was most open in his delight with the obscenities of ancient images where his fascination could be partially sublimated in the historian's task. It is no coincidence that the duc de Brissac presented this work and its com-

2.78 Robert Adam, soup tureens for Sir Watkin William-Wynn, 1773.

2.79 Josiah Wedgwood, *Seller of Cupids*, motif on cameo. Courtesy of the Trustees of the National Museums and Galleries on Merseyside (Lady Lever Art Gallery, Port Sunlight), Liverpool.

panion piece, *Love Freeing Slavery*, to Mme. du Barry, the official mistress of Louis XV and a notorious adventurer who displaced the Pompadour. Du Barry certified the taste "à la Grecque" when she promoted Vien over Fragonard as her favorite painter. She preferred Vien's classically veiled sexuality to Fragonard's *Progress of Love* series which she commissioned but ultimately refused, considering the references in such an example from the series as the *Storming of the Citadel* as much too explicit. By the early 1770s the assertion of middle-class values against the depraved aristocracy had a telling effect, and new forms were required to meet the challenge.

The aftermath of the Seven Years' War profoundly affected the national art and moved it in the direction of the new style. The court's gradual assimilation of neoclassic imagery as its official style indicates concessions to their noble as well as middle-class critics, and this was intensified at war's end when it needed the support of both groups to promote its economic growth. The decoration of the royal Château de Choisy, just then being refurbished, became the focus of the new artistic style. Until then, the royal house was decorated with landscapes, hunting scenes, and erotic myths, but in 1764 Cochin persuaded Marigny, now director-general of the King's Buildings, to adopt a fresh program. It was directly inspired by the political circumstances; with the war over and Europe at peace, Cochin perceived the occasion as an opportunity to express humanitarian sentiments instead of glorifying war and combat. This was analogous to Lord Bute and George III's position, except that they had won the war and could afford to be generous. Naturally, since the French lost, it would have been out of place to display battle scenes, but Cochin ingeniously presented his project as a way of depicting the king as generous benefactor at the moment of the ruler's lowest ebb in popularity. Thus Cochin suggested incidents from Roman history illustrating a ruler's pacific and virtuous deeds, as, for example, *Augustus Closing the Gates of the Temple of Janus*, *Titus Freeing Prisoners Taken at Jerusalem*, *Trajan Interrupting His Military Expedition to Render Justice to a Pleading Woman*, and *Marcus Aurelius Supplying Bread and Medicine to His People in a Time of Plague and Famine*. These subjects would stress the generosity and humanitarian actions of ancient rulers but be linked to contemporary history by way of flattering allusion: "Nothing could be dearer to the heart of our mon-

arch than the subject of *Augustus Closing the Gates of the Temple of Janus*"—an ancient ritual signifying peace. And Cochin also noted that the subject of Titus freeing prisoners was analogous to the benevolent disposition of Louis XV after the Battle of Fontenoy when the French defeated the Anglo-Hanoverian army.[80]

Here was a definite turning point in the style of commissions emanating from the direction of the King's Buildings. The emphasis on serious, philosophic, and

2.81 Joseph-Marie Vien, *Marcus Aurelius Supplying Bread and Medicine to His People in a Time of Plague and Famine*, Salon of 1765. Musée de Picardie, Amiens. © Patrick Joly.

2.82 Joseph-Marie Vien, *Saint Louis and Marguerite de Provence*, 1774. Musée national du château de Versailles, Versailles.

humanitarian pictures became closely tied to the official propaganda designed to offset criticism from opponents within and without. Vien was designated to execute the *Marcus Aurelius*, and his classical erudition was exploited to praise Bourbon charity in the guise of a Roman emperor dispensing alms (fig. 2.81). Ironically, after two years the king found the results either so disturbing or so boring that he ordered them removed. Cochin, disappointed, now requested Boucher—whom he had originally attempted to press in the program of history painting—to do his typical decoration in place of the four pictures. But the original conception was not entirely lost: Boucher died in 1770 without having executed his commission, and the following year Marigny went ahead with four new subjects drawn from antiquity expressing virtuous acts. This time the king was consulted on the choice of themes beforehand and approved them.

At the same time, Vien's efforts to develop a naturalistic classicism smoothed the way for more progressive applications of this style. The propaganda value of works like the *Marcus Aurelius* and his later *Saint Louis and Marguerite de Provence*, showing Saint Thibault bestowing a gift on the founders of the Bourbon dynasty, had an inestimable influence on younger painters (fig. 2.82). The theme of Saint Louis was officially recognized as "flattering to the House of Bourbon, and particularly appropriate to the King's pleasure."[81] Tradition held that France was indebted to his prayers for the descendants of Saint Louis. The fact that the work was commissioned in 1767 shows that art still functioned to provide the king with a positive self-image in the wake of France's losses in North America and India. While the subject in this instance is medieval, Vien treated the composition classically, with a framing right angle formed by the cross at the right and the spade in the foreground.

Vien's pendant to the *Seller of Cupids*, *Love Freeing Slavery*, was exhibited at the Salon of 1789 just after the fall of the Bastille and reflects an entirely different mood (fig. 2.83). While several of the same elements are present (including the elaborate censer at the left), it no longer is a sweetly erotic charade but a frenzied drama embodying the political turbulence of the moment. Love escapes from imprisonment, and the Roman lady and her attendants reach out desperately to retrieve the liberated Cupid who flies out toward the upper left-hand edge of the composition. The pained expressions and wild ges-

tures manifest the drama of second-generation neoclassicism in France brought to perfection by Vien's student David. Despite the fact that they came to espouse opposing political viewpoints, David could refer to the master as "the father of us all" when he delivered the funeral oration for Vien in 1809.

David

Jacques-Louis David (1748–1825) incarnates in his career the progress of the bourgeoisie toward the revolution, spanning their most extreme manifestation in the Jacobins and then final capitulation in the support of Napoleon. Like many other gifted members of his class, he felt a check to his social aspirations and came to identify the academy with the privileged groups who monopolized the important places and closed the doors to advancement based on merit. His progressive radicalization is inseparable from his opportunism; he understood the way bureaucracy functions, and he knew when he had sufficient strength to overcome it.

David was born at Paris into an upwardly mobile middle-class family. His father, a metal tradesman, descended from a long line of merchants, and his mother, who came from a well-placed family of master masons and building contractors, owned a property at Bagnolet where David spent much of his childhood. David's father

was killed in a duel on 2 December 1757, when the boy was only nine years old, a loss that instilled in him a need for alternative forms of authority which ultimately he invested in the state. The trauma of this event may be observed in several of his pictures where the theme involves sacrifice of the father (or of children by the father) and its implications for the rest of the family.

Shortly afterward, David was sent to a boarding school where he studied Latin and classical literature. He now came under the tutelage of his mother's family, including his uncle Desmaisons, *architecte du roi*, who was a member of the Academy of Architecture and knighted by the king in 1769. They made sure that he received the classical education necessary for aspiring members of the middle class. Desmaisons projected for the boy a career in architecture; David, however, wanted to follow his bent as a painter which he had manifested at the Collège de Beauvais and the Collège des Quatre Nations (now the Palais de l'Institute). This desire increased in direct proportion to the resistance of his relatives. He began to visit the public drawing school of the Académie de Saint-Luc, an arm of the contemporary artisan guilds which stressed applied design. This school posed a threat to the elitist academy and its wish to monopolize art instruction, and when it had the audacity to exhibit pictures it was violently attacked by the academy and abolished in 1776. This coincided with the finance minister's abolition of the guilds in the name of free enterprise, but the event probably impressed upon David the privileged position held by the academy in the contemporary art world.

David then lived with an aunt and uncle who planned to support him if he exhibited special talent. Ironically, Boucher was a cousin of David on his mother's side, and David appeared before the master for an interview. Boucher enjoyed the fact that the family continued his artistic precedent but felt that he was too old to undertake David's instruction. He recommended that David study with Vien, whom he felt was on the verge of renovating French art. Boucher's generous instincts are revealed in this statement because his archenemy, Diderot, had proclaimed Vien "the first painter" of the new school. David began to study under Vien in 1765, the year Vien exhibited his *Marcus Aurelius* at the Salon.

David followed the traditional course of the studio art school which fell into distinct categories: copying from prints of classical sculptures and old masters, copying

casts, and, finally, sketching the live model. David's official entrance into the academy program occurred in 1766. The academy itself ran only a drawing school where a rota of teachers corrected drawings from the live model for an advanced group. It conducted competitions for advanced students leading up to the Prix de Rome. There were two preliminary trials for the Rome prize: first a painted or drawn compositional sketch, then an *académie* or painted image of the half-length model, and if the student survived these he then entered into closed cubicles for almost three months to paint the masterpiece. David failed in competition in 1770, 1771, 1772—at which time he was driven to the point of suicide—and again in 1773 before finally winning the coveted prize in 1774. The memory of the failures and the academy's politics left a bitter imprint on his mind.

The following year he accompanied Vien to Rome when the master assumed the directorship of the French Academy. Vien was probably the most powerful figure in the academic system at the time, and David's relationship to Vien was instrumental in his rise to success. Both the Comte d'Angiviller, the new director of the King's Buildings, and his First Painter to the King, Pierre, were close friends of Vien who knew how to flatter their vanity and manipulate them. Vien was indeed fortunate—Louis XVI ascended the throne in 1774, and during his reign history painters enjoyed larger subsidies than ever before. Far more puritanical and reform-minded than his grandfather, Louis XVI regarded Boucher's pictures for Mme. de Pompadour as indecent and wholeheartedly supported the new tendency. In December 1774, d'Angiviller presided over the academy and announced that he and the king intended to step up and systematize the commissioning of history painting. He confirmed this the following month when he issued an official declaration of intent to carry on the tradition initiated at the Château de Choisy. Every year, gifted artists would be assigned four or five history pictures illustrating both ancient and French history, ultimately comprising a series retracing "action and deeds honorable to the nation." D'Angiviller hoped to project images of French history in the same grand style heretofore reserved for classical antiquity. The new surintendant wanted every corner of the reign to reflect the new tendency, even ordering classical models for the Sèvres factory to counteract "the bad influence on porcelain forms under the previous reign."

Clearly, Vien promoted this intensive program and groomed his disciples—who monopolized the Prix de Rome in these years—for its accomplishment.

Vien's correspondence with d'Angiviller confirms that his selection as director was part of a comprehensive policy governing the art complex. Vien was charged to change the academy's regulations in the interests of a tighter work schedule for the students, to systematically expose them to ancient examples, to send them to Naples to view the excavations, to introduce them to scholars, dealers, and officials at Rome who study and buy and sell antiquities. Through Vien and others David came into contact with Mengs, with whom he studied briefly, and others of his circle including old-timers like Hamilton and newcomers like Canova.

The program at the French Academy at Rome was a rigorous one; in the summer students were awakened at five in the morning and drew from the live model during the hours six to eight, and in winter the model posed in the evening. After eight, the students took off to study and copy in the various churches or palaces and museums. Many of these copies were earmarked for the royal houses, so that the function of the students at Rome was to provide decorations for the king's residences and institutions. Students also had to do certain prescribed exercises to be shipped to Paris as a tangible sign of progress and which were carefully evaluated by members of the academy. David's large painted sketch of the *Funeral of Patrocles* of 1779 (Dublin, National Gallery of Ireland) falls into this category and was perhaps the most ambitious project of his five-year stay in Italy. The work is the result of an inexperienced painter trying to say everything at once and impress his mentors. He even inserted a variety of vases and urns to please the antiquarians. The painting's panoramic view and seemingly endless rows of figures convey the effect of a comic opera. The academy certainly perceived it in this way, for it admonished David to tighten up his composition, and to sharpen the light and dark contrasts which would impart more energy and allow the spectator to grasp the whole in a single glance. David evidently heeded this sound advice, for one of the hallmarks of his mature work is compositional focus and clarity.

Studies of antiques, reliefs, busts, and sarcophagi were mandatory, often executed in the museums or from *Recueils*: David made copies after Sir William Hamilton's

collection, the *Antichità d'Ercolano*, Montfaucon, and Caylus.[82] He also went on sketching trips to recently excavated sites; in 1779 he made the pilgrimage to Naples where he stayed for three weeks. He visited Sir William Hamilton and also the residence of the French ambassador to Naples, Vivant-Denon, who followed in Hamilton's footsteps in the collecting of ancient vases. There he also met Quatremère de Quincy who expounded to him the theories of Winckelmann (who had died in 1768).

His pictures of the next few years betray an unorthodox attitude and intimate a growing social consciousness. One unusual subject is the *St. Roch Interceding for the Plague-Stricken of Marseilles* (fig. 2.84). As part of an ongoing public relations campaign, the Bureau of Public Health of Marseilles wanted to commemorate the plague that ravaged the city in 1720 when 40,000 victims—almost half the population—perished. Not more than a thousand of those were above the rank of worker or artisan. The role of the bureau in halting the spread of the disease was dubious, and the bureau was later charged with corruption and negligence. In time, however, it became vital to the maintenance of the port's levant trade, in quarantining ships, inspecting imports, and safeguarding the food supply. Marseilles had weathered an economic crisis in the mid-1770s. In the wake of its recovery the bureau's activity was meant as a show of public spirit. In 1779 its director wrote Vien in Rome to recommend one of his disciples for the job, and Vien chose David. Exhibited in 1781 after much hesitation and delay, the *St. Roch* is best remembered for the furious and disgusted expression of the victim in the foreground whose striking presence overshadows the main protagonists. Diderot dared the spectator in his review of the Salon: "Try to look for a long time, if you are able, at this diseased youth who has lost his mind and seems to have become enraged; you will soon flee from this picture of horror."[83] On the other hand, the Virgin and Child engage in playful exchange and seem to be utterly oblivious to the efforts of St. Roch to intercede on behalf of the writhing, screaming, tormented victims below. David's concern to show the saint's pilgrim staff and knapsack, we well as the sore on his bare leg, suggests a division between the stricken poor and the immunized rich. As a painting of religious devotion it fails miserably, and it even appears as a veiled attack on the church. As a Jaco-

2.84 Jacques-Louis David, *St. Roch Interceding for the Plague-Stricken of Marseilles*, 1781 Salon. Musée des Beaux-Arts, Marseilles.

2.85 Jacques-Louis David, *Portrait of Count Stanislas Potocki*, 1781. National Museum, Warsaw.

bin David rejected the church, but even his pre–French revolutionary religious works (including a commission for a *Crucifixion* for Mme. de Noailles) show his ambivalence on the subject.

David's *Portrait of Count Stanislas Potocki* in shirtsleeves, also exhibited in the Salon of 1781, betrays contradictory attitudes toward the nobility (fig. 2.85).[84] The Polish aristocrat who commissioned this work belonged to a family with over a million acres in the Ukraine. He became a liberal statesman at the time of Napoleon and later under the new kingdom of Poland. A connoisseur of art and literature and collector of antiquities, Potocki eventually translated Winckelmann's *History of Ancient Art* into Polish. He represented the type of person that Vien and d'Angiviller were eager to seek out to keep abreast of the latest developments of the new style. David and Potocki probably first met at Rome, although the picture itself was painted on order at Paris. At the time of their encounter, Potocki was making his Grand Tour and wanted a souvenir of this trip. David, familiar with the approach of their mutual friend Batoni (who admired the *St. Roch* and encouraged the young painter to remain in Rome), wanted to modify the formula with an image of active energy and heroism. His only concession to Batoni's convention is the glimpse of the base of a classical column at the top of the picture. David depicts Potocki in shirt-sleeves, having broken the spirit of a wild horse through bravery and skill, as if noble action rather than noble rank is important. There is a certain stateliness in the composition achieved through the glimpse of the classical detail, the above-eye level view, and the dazzling colors of the Count's *cordon bleu* and costume. David's aggrandizement of Potocki, however, is countered by the fact that he signed his name on the collar of the Dalmatian hound who barks at the feet of the prancing horse and retards its action. David pokes fun at himself as a lackey who projects his potential to both aid and impede the forces of reaction and privilege. But at least one of his contemporaries—the critic for the *Mercure de France*—viewed the work as strictly an income-producing venture: "Painter destined for immortality, do not allow yourself to be seduced by the allurement of lucre! Glory awaits you, and the delights that it procures are much superior to those that you can obtain with gold."[85]

This hint from the aristocratic journal that David's am-

bitions were leading him astray ignores the drive behind them. Most aspiring eighteenth-century liberals like the young David still accepted the idea that nobility was the highest expression of social superiority and virtue. Non-noble elements could believe in the intrinsic value of nobility and of noble standards since it was a system of privilege in which they participated or could reasonably aspire to participate. The pursuit of ennoblement remained a realistic enterprise for the wealthy bourgeoisie of the period. Venal offices which carried nobility could be purchased throughout the century; David's own father began the climb to social promotion by buying a minor administrative post, and his uncle had been recently ennobled.

Naturally, there was the debate as to whether nobility was in the blood or in the mind. But as the century wore on, the new notion of virtue associated with the neoclassical revival changed the nature of the debate by supplying the Roman Republican definition of virtue as civic virtue. This was interpreted to mean that nobility belonged only to those capable of, and desiring to, serve the public good. David's portrait of Count Potocki conveys the contradictory attitude of the upwardly mobile non-noble elements: it celebrates the wealth, gallantry, courage, and personal merits of the nobility but balances this apotheosis with a statement of commitment to universal rights and liberties.

The *Belisarius*

It is especially David's *Belisarius* that puts into proper perspective David's combination of opportunism and early progressivism (fig. 2.86).[86] The work created a sensation at the Salon of 1781 and evoked this marvelous response from Diderot: "I see it everyday and always believe I am seeing it for the first time." David's choice of theme and time of presentation were calculated to arouse this response. *Belisarius* had been his submission for entrance into the academy just prior to the opening of the Salon when he became *agréé*. Indeed, he left Rome the previous year for the express purpose of entering the academy with his *St. Roch*, but when he learned that only a painting done at Paris could be accepted for *agrément* he promptly began the execution of his *Belisarius*. David's return to Paris, his acceptance into the academy

and his Salon debut were part of a well-orchestrated timetable.

His choice of subject was no less calculated to achieve success. Belisarius, whose life is recorded mainly in the histories of Procopius and Tzetges, was then a favorite antique model for the social and religious stands of liberals, moderate conservatives, and conservatives masquerading as moderates. Belisarius (c. 505–564) was a Byzantine general under Justinian who served loyally and won major victories all over the ancient world, but envious courtiers, manipulating his need for adulation, enveloped Belisarius in conspiratorial intrigues and brought about his fall. Deeply disturbed by the popular enthusiasm his general aroused, Justinian sustained the accusations and ordered Belisarius punished by blinding and disgraced. But the attributes of unswerving loyalty and patriotism assigned to him and the lesson of royal ingratitude exemplified by his career made Belisarius an ideal vehicle for social and political propaganda in the second half of the eighteenth century. Both Montesquieu and Gibbon contributed to the popularity of the Byzantine hero by celebrating his military capabilities and devotion to an undeserving emperor. Above all, David's *Belisarius* points to the new emphasis on *art militaire* encouraged by Choiseul and his successors who still anticipated an invasion of

2.86 Jacques-Louis David, *Belisarius*, 1781. Musée des Beaux-Arts, Lille.

England. The military reforms of the 1770 stressed drill and obedience, looking to the heroic actions of ancient heroes for models of regimentation, and sacrifice. David's increasing use of such subjects reveal the preoccupation with military discipline in response to the French defeats during the Seven Years' War.[87]

Belisarius attained the highest degree of renown as the deist hero of Marmontel's moralizing novel published in 1767. After the publication of Marmontel's novel, Belisarius is transformed from a competent general to a cult hero of the *philosophes*—the direct result of Marmontel's exploitation of material drawn from antiquity for the propagation of his own ideas and convictions. Marmontel's hero becomes a greatly wronged philosopher in the mode of Socrates who expressed attributes of humaneness, consideration, and leniency toward his enemies. Marmontel fabricated an image of a persecuted innocent person which was very appealing to the liberal eighteenth-century mind, one already prepared by the author's popular *Contes moraux*. Marmontel's shift from the sentimental bourgeois tales, however, to the moralizing theme of ancient virtue, coincides with the developments in art after the Seven Years' War.

Marmontel's Belisarius and his presentation of the emperor was deliberately designed to evoke parallels with the contemporary historical situation. Marmontel wrote his novel in the aftermath of the Seven Years' War, when France's bitter humiliation—as expressed through the reactionary *parlements*—was often vented in vicious scapegoating and various forms of civil and religious intolerance. The advice offered by Belisarius to Justinian and his son Tiberius actually applied to Louis XV and the Dauphin (the father of Louis XVI) and was deliberately propagandistic in intent. The novel opens on the waning years of Justinian's reign, when the state revealed "every symptom of decline," when administration was weak in all departments, the masses of people unfairly carrying the burden of taxation, and the public moneys serving the interest of private enterprise. Fatigued by a series of wars, the emperor was reduced to purchase peace by surrendering his coveted territories. It is in this context that Belisarius serves as the spokesperson for enlightened authority, religious tolerance, and social reform. Justinian, who does not reveal himself to Belisarius until the end of the novel, employs his former general to advise him and his son Tiberius in the proper affairs of state, and it is in

Belisarius's role as counselor that Marmontel voices his views to Louis XV and the Dauphin. Belisarius attacks civil intolerance, privilege, favoritism, luxury, and a parasitical nobility as detrimental to the state. Furthermore, Belisarius–Marmontel advances ideas gleaned from the Physiocrats and their disciples, including new forms of raising taxes, elimination of arbitrary taxation and venal offices, and special consideration for the agricultural laborer and farmer.

While the parts on taxation spoke to one of the most urgent problems of the nation following the exhaustion of its finances in the Seven Years' War, the most controversial section of the novel was chapter 15 and its heretical views on religion. Belisarius stressed the need for religious tolerance with special emphasis on the salvation of virtuous pagans and pagan heroes: Belisarius declares that Heaven is open to all persons of virtue in all times and places. These preachments gravely offended the traditional piety and religious attitudes of the Catholic Church, and many French clerics accused Marmontel of sedition as well. It is clear that the high-placed clergy, stemming from the nobility, were threatened by the suggested reforms in taxation and cloaked their anxieties in the religious argument. In any event, orthodoxy affected a scandalized tone and compared the novel to Rousseau's *Emile* which it censured five years earlier. Belisarius's pleas for religious and civil tolerance clearly pertained to contemporary persecution of Protestants and probably of Jews as well.

The condemnation by the Faculty of Theology now aroused the community of *philosophes*, including Diderot and Voltaire, who defended several victims of civil and religious intolerance in this period. While the published polemics lasted little over a year, the controversy would stand as one of the most complex and intriguing battles to be fought for toleration in the second half of the century. It further insured that Marmontel would be remembered, along with his fellow *encyclopédistes*, as one of the champions of religious freedom.

David's depiction of the Byzantine hero immediately identifies Belisarius in Marmontel's drama. The novel had already inspired at least four painted versions in France; three appeared at almost regular intervals at the Salon before David's rendition: Jollain (1767), Durameau (1775), Vincent (1777), and Peyron (1779). Peyron's work was commissioned at Rome by the Cardinal de

Bernis, French ambassador to Rome since 1769, and former associate of Marmontel in courtly circles. Peyron was a fellow pensioner and rival of David at the French Academy at Rome, and the success of Peyron's work when it was exhibited at the ambassadorial palace could not have been lost on David. Durameau's painting, depicting the moment in chapter 6 when Belisarius returns home to his family after his long exile, was owned by d'Angiviller who also requested a sketch of Peyron's work, indicating the profound interest of the director-general in this theme. In a sense, d'Angiviller wanted to do in painting what Marmontel accomplished in the *Belisarius*, a book he knew very well. Indeed, Marmontel and d'Angiviller were close friends from around the mid-1760s through the outbreak of the Revolution. D'Angiviller became dependent on Marmontel for many of his ideas on art and literature, and it was through him that d'Angiviller established contact with the *encyclopédistes*. Marmontel wrote several articles for Diderot's project and lived in the house of Mme. Geoffrin where the *philosophes* regularly met. The close association of the two men is shown in d'Angiviller's appointment of Marmontel to the exceptionally prestigious position of Historiographer of France—a post once occupied by Voltaire. Later, d'Angiviller wrote an extensive commentary on the *Mémoires* of Marmontel which touched upon numerous facets of his own career. At the time David painted the picture, Marmontel was secretary of the Académie Française and still a good friend of d'Angiviller who clearly had a special predilection for the *Belisarius* theme.

D'Angiviller

As the directeur and ordonnateur-général des Bâtimens, d'Angiviller affected every area of the beaux arts, including the royal commissions, Salons, academies, choice of faculty and administrators, the private collectors, and the designation of the *Premier peintre du roi*. D'Angiviller's name appeared on the title page of the Salon catalogs as organizer, and it was he who commissioned David's first major neoclassical works. The comte d'Angiviller occupied his position from 1774 to 1791—the period when sober, philosophical history painting received its greatest support in the eighteenth century. He was less a fashionable liberal like Marmontel than an intelligent conservative who understood the need to give his king the look

of enlightened absolutism. He followed Marigny and Cochin in using art to suggest support of liberal ideals and encouraged the emphasis on civic virtue and heroism in scenes from both antiquity and more recent French history.

Following Louis XVI's succession in 1774, the king appointed d'Angiviller to his powerful post, and together they charted the course of the fine arts under the new regime. On 3 December of that year d'Angiviller announced the royal plan for history paintings from outstanding French artists, a declaration confirmed the following month in a letter to Pierre, d'Angiviller's choice for *Premier peintre du roi*. D'Angiviller and Pierre enjoyed the close friendship of Vien who exerted an enormous influence on their work through the authority he derived from his past relationship with Caylus. Vien's own success in this period and the spread of his ideas are tied to these contacts; d'Angiviller appointed him director of the French Academy at Rome just one year after he himself took office. And in the fateful year of 1789 Vien replaced Pierre as *Premier peintre*.

It cannot be fortuitous that all the painters of the Belisarius theme emanated from the schools of Pierre and Vien. Jollain and Durameau studied with Pierre, and Durameau was in fact a favorite of d'Angiviller who commissioned him in 1775 to execute a set of tapestry models for the Gobelins representing "celebrated events and virtuous action from our history." Durameau received one choice appointment after another, including *Peintre du Cabinet du Roi* in 1778 and professor at the Académie Royal in 1781. Vincent was a student of Vien and executed his *Belisarius* after returning from Rome in 1776. While Peyron had studied at Paris under Lagrenée the elder, he executed his *Belisarius* as a pensioner under Vien. Vien's protection brought him to the attention of d'Angiviller, who wrote the master in 1779 regarding the success of Peyron's *Belisarius* that the artist "is one of those on whom I am counting to re-establish our painting."

Peyron's other benefactor, the cardinal de Bernis, used subjects like the *Belisarius* in his ambassadorial residence like Giralamo Zulian used Canova's *Theseus and the Minotaur* in roughly the same period. They exploited such works to signify their enlightened viewpoint and to promote their native culture abroad. Both Bernis and Zulian threw their personal energies and material re-

sources into making their ambassadorships memorable and their embassies glittering attractions to high society. David himself paid court to Bernis during his trips to the Eternal City, and the cardinal visited the exhibition of the *St. Roch*. Bernis is mentioned frequently in the correspondence of the directors of the academy at Rome, and his involvement in the whole network of fine arts attests to his understanding of art as an ideological tool in projecting the king as a benevolent despot and as means of impressing visiting heads of state or their delegates. Inside the embassy, a square room was specially designed for the commemoration of the coronation of Louis XVI whose walls were lined with mirrors divided by painted bas-reliefs alluding to France's prosperity under the king. At the same time, he could parade himself as enlightened for his participation in the suppression of the Society of Jesus ten years earlier.[88]

David was in Rome to witness the development of Peyron's picture and executed a small painting of Belisarius in half-length as well as the highly finished drawing upon which he based his definitive work before embarking for France in July 1780. Having learned toward the end of the year that only a painting done in Paris could be eligible as submission for membership in the academy, David produced the *Belisarius* which was accepted on 24 August 1781. While this work eventually entered the collection of d'Angiviller's friend, Duke Albert of Saxe-Teschen, David executed a replica of the work for d'Angiviller. There can be little doubt that the original was done to ingratiate himself with d'Angiviller who presided over the academy when the artist was *agréé*. David wrote his mother on 27 August 1781 that his acceptance by the academy was unusual in its unanimity. He observed further that d'Angiviller had given him every encouragement and reminded his mother: "You know, of course, that the Comte d'Angiviller is Minister and Surintendant-Général of Buildings." D'Angiviller's protection of David was mischievously commented upon by one jealous critic: "Happy is he with talent when one has d'Angiviller." David also boasted about the crowd of Salon visitors pressing him after the opening on 25 August and in closing stated: "Right now I am rich only in glory, certainly less so in hard cash, but I trust that this too will not be long in coming."[89]

David's identification with the liberalism of Marmontel's *Belisarius* is bound up with his perception of the

chain of relationships which ultimately guaranteed his rise. At the same time, there can be no doubt that he personally espoused this philosophical position; this is especially evident when his painting is compared to the other versions. David chose a motif—the discovery of Belisarius in straitened circumstances by a former officer—which pervaded Marmontel's novel. Every one of the first seven chapters contains a scene of encounter and recognition of the old general's descent from a once glorious height. In chapter 2, for example, Belisarius, guided by a child, is recognized by the ex-King of the Vandals who had been brought to Constantinople after his defeat by Belisarius and reduced to a humble station. Gelimer reacts with the melodramatic start we find in the David: "What do you say? What, Belisarius? . . . O just heaven . . . Belisarius in his old age, Belisarius, blind and abandoned!" David's choice of moment paraphrases the literary source, but, as repeated throughout the novel, the motif stresses the injustice of the punishment and its inhumane application to an unselfish patriot.

Once again the ubiquitous Gravelot enters into the picture. Indeed, David guaranteed the connection between his painting and Marmontel's work by basing his composition on Gravelot's illustrations for the novel (figs. 2.87, 2.88). The main source for David is the engraving

2.87 Hubert-François Gravelot, illustration for Marmontel's *Belisarius.*

2.88 Hubert-François Gravelot, illustration for Marmontel's *Belisarius*.

showing the moment when Justinian sees Belisarius for the first time since the punishment and recoils in horror; in the painting David substitutes an ex-officer for Justinian, and borrowed the motif of the walking stick leaning against the cubic rock in one corner. David chose the moment when Belisarius, blinded and destitute, is reduced to begging in the plazas of Constantinople. Yet the hero remains physically muscular and capable, extending a large, powerful hand. He is aided by a child

2.89 François-André Vincent, *Belisarius*, 1776. Musée Fabre, Montpellier.

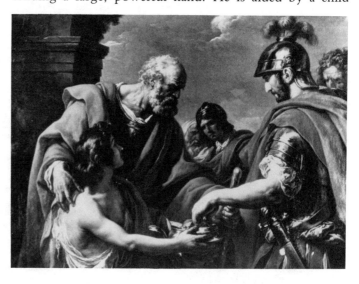

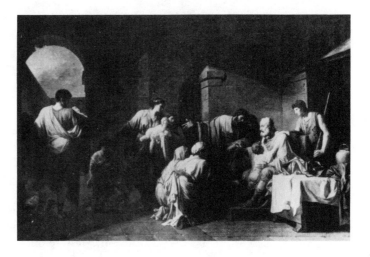

who holds out the warrior's helmet to receive the alms. A woman, almost in tears and trying to shield her face from the sight, proffers a coin while the old officer who fought with Belisarius raises his arms in exaggerated astonishment at the sight of his once-glorious general. David has stripped down the composition to a few essential characters who are united and dignified by the severe classical backdrop. The tightly knit grouping and gestural drama foreshadows the *Oath of the Horatii*—his most famous picture—but the work's effectiveness is tempered by a touch of sentimentality reminiscent of Greuze in the presentation of the histrionic soldier and begging patriarch.

The other versions of *Belisarius* are even more blatantly sentimental; Vincent's painting, which brings the spectator up close to the figures, portrays a similar moment, but his soldier giving alms expresses pity, not shock (fig. 2.89). Peyron's picture shows the scene in chapter 4 when the father of one of Belisarius's ex-soldiers invites him into his household, and centers on the old man in a domestic ambiance surrounded by children like a Santa Claus (fig. 2.90). This emasculated image fit well the taste of Cardinal de Bernis, who passed for "enlightened" under Louis XV and for "reactionary" during the Revolution. Here the injustice and ingratitude of the ruler is played down in favor of an image emphasizing the victim's institutionalization in a sympathetic environment.

David's conscious identification with the novel attests to his liberal religious, political, and social position.

While it is true that the original theological controversy it had aroused had long since subsided, both the religious and the political message were still relevant for Louis XVI. The problem of toleration marked the beginning of the new regime, centering around the Sacre. Turgot, the king's progressive controller-general, wanted to transfer the coronation ceremony from Rheims to Paris to cut expenses, to divest the new regime of outworn medieval associations, and purge it from the sanction of intolerance given in the king's vows to exterminate heretics. But the higher clergy wished to take advantage of the occasion to impress upon the monarch and the nation the claims of the church; they hoped that lavish ceremonies and pomp would supply an antidote to the impieties of the last reign. Many of the prelates were determined to abolish heresy and tried to stimulate the government to launch an attack on Protestant communities. The power of the clergy proved to be decisive and the ceremony was conducted on the old lines at Rheims on 15 June 1775. The king took the oath to exterminate all heretics condemned by the Church—although it was said that he was plainly embarrassed and delivered these passages in an almost inaudible tone.

Shortly afterward, Turgot addressed a memoir to the king, "On Intolerance," encouraging him to treat the oath as a dead letter and advising him not to interfere with the beliefs of his subjects. Turgot's main argument for toleration was stated elsewhere: he had collected statistics to demonstrate the disastrous economic consequences of the revocation of the Edict of Nantes. Throughout his tenure (1774–1776) he spoke frequently for toleration and worked hard to vindicate the reputation of Calas. Not surprisingly, Turgot had been one of the staunchest defenders of Marmontel's novel when it came under attack by the Sorbonne. Turgot's struggle to end intolerance and rationalize the tax structure united the *parlements* with the clergy and brought about his dismissal. When he died on 20 March 1781, there was a revival of interest in his career—the very moment when David was conceiving the Belisarius. And in this decade David and his liberal patrons like Lavoisier and Trudaine espoused the economic and social reforms projected by Turgot.

David's *Belisarius* and its theme of royal injustice took on a special meaning in the light of a specific contemporary event. In addition to the religious issues which

brought Marmontel's novel up-to-date, a political controversy directly related to the Seven Years' War bridged the time of its writing and David's picture. Marmontel's book bears in part the outrage of the *philosophes* against the unfairly tried case of Lally-Tolendal who was executed for treason in May 1766. A hero at the Battle of Fontenoy, Lally-Tolendal had been appointed commander-in-chief of a military expedition to India to protect French interests against the British at the outset of the Seven Years' War. Eventually, however, his caprices and incompetence led to his defeat, and he was sent to London as a prisoner. The loss of French colonial prospects in India in the wake of capitulation in Canada created a climate of hysteria at Paris. Both military and civilian officers involved cast blame on Lally for the loss of Pondichéry, and the general demand for a scapegoat facilitated their aims. He was accused of sedition and conspiring against the interests of the king, of the state, and of the India Company. His years of devoted service were ignored, and he was condemned to the executioner's axe on 9 May 1766, a few months before Marmontel's novel appeared.

Following the execution a more sober appraisal of events took place, and, while it emerged that Lally-Tolendal was involved in all sorts of improprieties, the capital charges of public extortion and sedition were unfounded. Lally-Tolendal's son worked in the ensuing years to vindicate his father's name, and he enlisted the aid of Voltaire—who had come out early against the verdict—to support his cause. The son often invoked the Calas affair as a parallel case of legal injustice and intolerance. Lally-Tolendal's name almost immediately conjured up historical analogies in antiquity: as early as 1768 he was identified with Gaius Manilius, a Roman tribune who vested in Pompey unlimited authority to wage war against Mithridates and Tigranes in Asia Minor, but who was condemned for treason by Pompey's enemies. Both he and Pompey were destroyed by an "ungrateful" Rome. Young Lally-Tolendal himself made frequent comparisons of his father to such classical heroes as Cato, Coriolanus, and Socrates.

The combined actions of Voltaire and young Lally-Tolendal proved effective in the changed political climate of the 1770s when the government's attempt at a more equitable taxation forced a confrontation with the aristocratic *parlements*. In 1778 the Conseil d'état du Roi

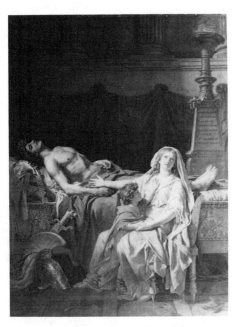

2.91 Jacques-Louis David, *The Mourning of Andromache over the Body of Hector*, 1783. E.N.S.B.A., Paris.

quashed the decree of 6 May 1766, and the case was referred first to the *parlement* of Rouen and later to that of Dijon for a retrial. Although the *parlements* ultimately ruled against Lally-Tolendal, the Conseil du Roi quashed their verdict and restored his reputation. And it was especially during the years 1779–1781 when the flurry of pamphlets, the defense of Lally-Tolendal by the liberals (Turgot among them), and the widespread sympathy for the dashing son made the trial a cause célèbre of the period. D'Eprémesnil, prosecuting attorney for the *parlement* of Rouen, was a hostile adversary: he stood for the interests of the law court against the king, and his family had been involved with the India Company and the administration of Pondichéry which the elder Lally-Tolendal accused of conspiracy and corruption. He was a brilliant orator who polarized the public for a time, but the son's position eventually captivated public opinion.

Louis XVI's administrators naturally favored a revision, and the interest in the Belisarius theme in this period is related to the development of the Lally-Tolendal case. Many of the patrons were linked directly or through descent to events at Fontenoy where the elder Lally-Tolendal distinguished himself. D'Angiviller had been decorated there; the great uncle of Albert de Saxe-Teschen was commander of the French armies at Fontenoy (and was a close friend of Marmontel). David's replica, first owned by d'Angiviller, later entered the collection of the maréchal de Noailles who shared command of the French army at Fontenoy.

Still another close friend of Marmontel, the abbé Raynal, contributed to the growing controversy. Raynal's groundbreaking and very popular *Histoire philosophique et politique des établissements et du commerce des Européens dans les deux Indes*, which condemned the colonial policies of the *ancien régime* including the slave trade, had a profound impact on radical thought of the 1770s. Forced to publish in Holland and Switzerland, Raynal came under the censorship of the Sorbonne for his attacks on the superstition and the tyranny of the church. His essential point of view was that the various conquests of the East by the West were no glorious enterprises conducted by dauntless heroes for God and Country, but mere money-grubbing schemes exploited by unscrupulous financiers supported by Throne and Altar. His work went through several editions starting in 1770, but the lavish ten-volume edition of 1780 created a storm

2.92 Plate 64 of comte de Caylus, *Recueil*, vol. 3.

2.93 Plate 45 of comte de Caylus, *Recueil*, vol. 1.

and exerted a deep influence on progressive individuals throughout the decade. Among his various accounts was a strong indictment of the trial and execution of Lally whom he in no way admired.

Belisarius is considered the first mature "neoclassical" work by David, the emerging leader of the second generation. It brought to bear on the art world not only his liberal ideals but also his carefully cultivated connections with the people who ran the bureaucracy. They are inseparable phenomena and made him the perfect spokesman for those pressing the social and political claims of the Third Estate against privilege. Before this occurred he had entered into the official hierarchy of the Académie Royale with his reception piece of 1783, *The Mourning of Andromache over the Body of Hector* (fig. 2.91). Based on the famous passage in the *Iliad*, David's treatment expresses virtues reminiscent of the *Belisarius*. The wife of the heroic Hector slain by Achilles represents conjugal fidelity and patriotic self-sacrifice. David reached out to the first generation neoclassicists for visual ideas: from Gavin Hamilton's *Andromache and Hector* he borrowed the treatment of the corpse with its head thrown back and chest expanded, and from Kauffmann's *Adromache and Hecuba Weeping over the Ashes of Hector* he took the pose of young Astyanax and the burning candelabrum. David was bent on archaeological exactitude, as is evident in the carefully designed accessories. The details of the candelabrum with the usual rams' heads at the corners were probably based on the second-century type in the Vatican Museum. For others he turned to Caylus and Montfaucon. The feline insignia at the end of the sword handle recalls the plate of Roman pike terminals published by Caylus in volume 3 (fig. 2.92), and even the helmet with its thick plume may owe something to the antiquarian (fig. 2.93).[90]

David, however, breathed into this neoclassic standby some fresh air; he kept the composition simple and rigorously horizontal as a foil for the clutter of antique furniture. The effect comes closer than either Gavin Hamilton or Kauffmann to antirococo sobriety, and even the emotional anguish of Andromache seems contained rather than gushing as in Greuze or even in David's *Belisarius*. Unlike his predecessors, David makes his Andromache turn toward the viewers to plead for their participation in the tragedy. She thus universalizes her plight and in a sense politicizes her act. In the language of young Lally-

Tolendal, she pleads her case before the "Tribunal of the Universe."

Andromache thus symbolizes *La Patrie* mourning the loss of one of its heroes. David's brilliant use of gesture is seen in the juxtaposition of Andromache's open hand and Hector's closed hand—depicting both the contrast between life and death and their union. The hero-martyr is analogous to Belisarius and extends the analogy between ancient soldiership and the Seven Years' War. It is perhaps not coincidental that Andromache assumes the same position as the Byzantine general; whereas Belisarius pleads for alms with his outstretched arm, Andromache pleads for recognition and points an example. Even the child Astyanax occupies a position analogous to the youth aiding Belisarius, demonstrating a certain codification of classical-topical symbols in David's repertoire. At the same time, the child mourning the father anticipates his later works and recalls David's personal loss.

David had now achieved mastery of the neoclassical idiom which had spread across the continent and stood for both enlightened despotism and assertive bourgeoisie. Encouraged by a flagging monarchy and weakened economy, this style in France answered to the aspirations of the merchants, artisans, and professionals whose newly gained status was threatened or who otherwise felt blocked by a system which awarded positions on the basis of birth rather than merit and were increasingly favored by the historical process. The revolutionary generation attended school during the period 1763–1788, beginning immediately with the termination of the Seven Years' War, when the curricula of the *collèges* stressed the Roman classics and looked to the early Republic as a model to emulate.[91] As developed by David, the combination of visual motifs and ancient themes assumed the character of protest against the style and outlook of the Old Regime. His work takes on an almost martial bias, especially as it is expressed in his most significant example of prerevolutionary radicalism, the *Oath of the Horatii* of 1785 which will be discussed in the concluding chapter.

By the mid-1780s the self-interested and purely pecuniary motives of the progenitors of neoclassicism were almost entirely sublimated in a set of visual symbols that could address a wide public in political terms. This public had grown accustomed to seeing in ancient history metaphors for contemporary politics. Revolutionaries

could appropriate this language for themselves once they managed to convince their audience that true heroic self-sacrifice and civic virtue meant toppling the existing structure of privilege. In this way David's neoclassicism became in 1789 the style of the French Revolution and the embodiment of republican ideals.

This does not mean that the leaders of the new French school acted out of purely altruistic motives but that their worldly success was inseparable from their alignment with progressive forces. While their art no longer served necessarily to glorify their material possessions or those of their patrons, they could still profit from it in terms of their newfound status and monetary rewards. This was less true for the second-generation neoclassicists in England, who were still closely identified politically and socially with the first. Members of the older generation, like Wedgwood, now became the patrons of the younger, although the latter no longer saw themselves as protégés but as independent manipulators of the neoclassic sign system. At the same time, Wedgwood's neoclassical vases and utilitarian earthenware now embodied the aims of the Industrial Revolution, which his manufactures and commercial practices did so much to bring about. He understood neoclassicism as representative of free enterprise and progressive industrial, scientific, and social ideals: Wedgwood himself supported the abolition movement, the American Revolution, and the early stages of the French Revolution. Thus neoclassicism became the visual language of the dual revolution, a development considered in the next three chapters.

3.1 Jacques de Lajoue, *The Scientific Cabinet of M. Bonnier de la Mosson*. Beit Collection, Blessington, Ireland.

3 The Industrial Revolution: Pre–American Independence Phase

Neoclassicism ultimately became the preferred style of both the English Industrial Revolution and the French social and political Revolution. An entire world economy centered on England which rose to a position of unprecedented global influence and power. Its naval dominance and massive import–export business exerted a world monopoly of trade and production which could not have failed to influence culture. In the second half of the eighteenth century neoclassical art and industrial enterprise were linked under the banner of science, and the commercial ambitions of both artist and entrepreneur could not be dissociated from their enthusiasm for new forms, inventiveness, ingenuity, shortcut processes, and general spirit of inquiry. They perceived no technical or theoretical barriers to an alliance between art, science, and manufactures. Neither the arts nor the sciences were rigidly compartmentalized into "pure" and "applied" categories, and their practitioners could devote themselves to solving productive problems in the most economical way for the nation's prosperity.

Naturally, the artists most closely identified with the Industrial Revolution could not manifest the pristine style of the first generation of neoclassicists and their immediate successors. Patronage of the painters responding most warmly to the impact of the economic transformation tended to encourage more audacious and visionary forms. The dissenters who participated in the industrial developments asserted themselves as much against strict neoclassical doctrine as they did against political and social authority. Neoclassical style was as artificial as class barriers, and the dislocations of society predisposed its members to question barriers, and the dislocations of so-

ciety predisposed its members to question old assumptions. The commoner Burke introduced anticlassical notions, stretching neoclassical forms to accommodate the rising social force. The dominant event in this period for the English is the American Revolution, which undermined the confidence of those busily refurbishing their country and town houses. Their money no longer went solely into antiquities and property. It was also invested in large-scale industrial enterprise. The upheavals of this period affected first-generation neoclassicism which began to be used more adventurously and sometimes even shockingly. Formal and spatial distortions were often complemented by bizarre effects of light and color. These formal innovations were tied to the progress of science and industry as well as to the violent social convulsions of the late years of the century, mediating between the large-scale developments and the individual contributions.

At the beginning of the eighteenth century, science was very much a gentleman's hobby, and scientific curios were considered collectibles like objets d'art. Collectors of engraved stones and gems like Baron von Stosch and Mariette would also own unusual minerals and geological rarities. A painting from the first decades of the century, showing part of the collection of a rich scientific dilettante, Bonnier de la Mosson, displays tiered cases of optical instruments, mechanical models, measuring instruments, and models of crystals mingled with sculpture and exhibited like other art objects (fig. 3.1). The rich collector displayed his erudition and culture through rarefied objects: on one level this simply meant that then, as now, collectors placed less importance on what was collected than on the value the dominant class attributed to certain objects, whether it be art, antiquities, scientific instruments, or comic books. The eighteenth-century upper classes emphasized the diffusion of general knowledge, and a taste for science reflected the fascination for rational government in politics and historical sense of culture. In the end, state patronage of scientific research was based on the idea that such research could prove useful for trade or the military.

Of course eighteenth-century intellectuals felt themselves on the brink of every imaginable discovery, with science becoming a panacea for all ills. In *Gulliver's Travels* Swift ridicules this outlook in the absurd academy on Laputa where scientists and professors labor to convert

feces back into food or try to distill sunlight from cucumbers. While Swift satirizes the contradiction of speculative theories in this period, he nevertheless attested to the fundamental aim of scientific thought to solve practical problems in the real world. Science was essentially *applied science*. Concern for lighting streets, for harnessing water and steam power, for constructing roads, bridges, and aqueducts were necessarily tied to developments in trade and industry. Electricity offered endless possibilities, and some, like Erasmus Darwin, wanted to apply it to medicine. Franklin's reputation in Europe rested on his discovery of electrical phenomena in the atmosphere, and his role as scientist was vastly exaggerated.

The Royal Society, established in 1662, was actively concerned with the practical applications of science. Its original purpose aimed especially at improving the "mechanick arts," such as building, smith's work, chemical processes, shipbuilding, and agriculture. It advanced the manufacture of tapestry, of silkweaving, and testing soils for the perfecting of pottery and for the fabrication of bricks and tiles. Naturally, the king encouraged these practical interests with a view to developing English industry and trade.

The average member of the Royal Society was an aristocratic virtuoso, but he had his bourgeois counterpart in the new type of professional civil servant. An example was Joseph Moxon, well known in the late seventeenth century for popularizing study of maps, geography, navigation, astronomy, mathematics, architecture, and printing.[1] He was expert in smithing, founding, drawing, joinery, turning, engraving, printing books and pictures, globe and mapmaking, and mathematical principles. This blend of art, science, and craft show how slight were the boundaries between them and that it was normal to practice them all in common—a tradition that would extend more exceptionally in the next centuries in the person of a William Shipley, a Robert Fulton, a John Martin, and a Samuel Morse.

Drawing was absolutely indispensable to the self-education in science which was the hallmark of the late eighteenth as well as early nineteenth century. Michael Faraday, for example, spent long hours drawing and copying from magazines in order to be proficient in sketching blueprints and diagrams. He sketched electrical machines from dictionaries of arts and sciences and compulsively

drew machinery and unusual mineral and plant forma-
tions. Boulton and Watt were very concerned that their
sons learn drawing, both ornamental and practical, not
only to understand good design but to be able to read
prints of machines. In Birmingham drawing schools
were established to improve the designs of artisans—a
development that could be observed also in many large
cities on the continent.

The famous potter, Josiah Wedgwood, was greatly in-
terested in experimental research into clays, glazes, color-
ing, and temperature control. Together with Watt, Boul-
ton, and other industrialists, he associated with scientists
such as Erasmus Darwin, Priestley, and Withering, and
was elected a Fellow of the Royal Society. Moreover, in
his factory at Etruria, he introduced people who could
apply scientific knowledge to pottery manufacture, in-
cluding chemistry, design, modeling, and painting. His
friends Watt, Boulton, Keir, and other industrialists also
became Fellows of the Royal Society.

On the whole, the classical physical sciences were not
revolutionized in this period. They remained substantial-
ly within the terms of reference established by Newton,
either continuing lines of research laid down in the previ-
ous century or extending earlier fragmentary discoveries
and incorporating them into wider theoretical systems.
Electricity and electromagnetism were probably the most
important of the new fields opened. Two main dates in
the late eighteenth century mark its decisive progress:
1786, when Galvani discovered the electric current; 1799,
when Volta constructed his pile battery. But both were
working earlier, and many books and pamphlets on the
subject were published in the 1760s and 1770s as well.

Developments in chemistry advanced rapidly during
the second half of the century, most notably represented
by Priestley in England (also a pioneer in electricity who
first published Franklin's experiments) and Lavoisier in
France. Of all the sciences this was the most closely re-
lated to industry and trade, especially in connection with
the bleaching and dyeing processes of the textile indus-
try. Chemists were also actively engaged in sugar and
rum manufacture in the West Indies. Biology excited the
contemporary imagination when it was discovered that
the chemical elements in living things were the same as
those in inorganic nature, but the main stimulus to its
development came through the practical applications of
botany. The Swedish botanist Linnaeus published his

Systema Naturae between 1735 and 1758, classifying plants, animals, and minerals under Class, Order, Genus, and Species. The development of botanical gardens in this period was widespread, contributing to the economics of trade and medicine. Linnaeus's first important job was as caretaker of the botanic garden of the director of the Dutch East India company who maintained a large herbarium of commercial and medicinal plants from trading outposts. In botanical gardens products from overseas were acclimatized, and industrial scientists and doctors were trained. At the French Jardin des Plantes the potentialities of the coffee and cocoa beans were explored, and chairs relating to dyeing and porcelain were established. Colonial plantations and domestic advances in agriculture further stimulated botanical experiments.

Geological knowledge also expanded during this period and profoundly excited the artists. The increase in road and canal construction, the progress of the pottery industries, and especially mining enterprises promoted the investigation of the distribution of land and water, the well-defined strata (together with the fossil record), the origin of the mountains, and mineralogy. Two rival schools emerged at the end of the century, the Volcanists and the Neptunists.[2] The first believed that rocks and mountains resulted from volcanic processes and heat; the second that the rocks composing the earth were precipitated from mineral deposits in the ocean. The Neptunists had the edge in public opinion since they were supported by the biblical account of the flood.

The leaders of the rival schools, James Hutton, representing the Volcanist position, and Abraham Gottlob Werner, representing the Neptunist, both came to their fields through industry and for industry. Werner, who proclaimed the aqueous origin of rocks, worked for his father, an inspector at Count Solon's ironworks at Wehrau and Lorzendorf. He was groomed to replace him one day. In 1769 he entered the famous mining school at Freiberg, and six years later received an appointment as a teacher there. He did major work on geological formations for the mining industry, especially on the strata and their defined order. Many important German thinkers of the next generation—both scientists and artists—were indirectly inspired by Werner's teaching, including Alexander von Humboldt, Gotthilf von Schubert, and Novalis.

Hutton made a fortune manufacturing sal ammoniac from coal soot or culm; with his profits he devoted him-

self to agriculture and farming on his inherited land in Berwickshire. This in turn stimulated his interest in rocks and the action of running water on soil and rocks. His *Theory of the Earth,* first presented as a paper before the Royal Society of Edinburgh in 1785, established the famous uniformitarian principle that natural processes now at work on or below the earth's surface have been operating much the same way throughout geological time. When his ideas were attacked by the Irish chemist and mineralogist Richard Kirwan, who favored Werner's precipitation theory, Hutton published his landmark book in 1795. Kirwan was himself closely linked to the dyeing and mining industries. He made substantial contributions to the applied sciences and influenced popular opinion. He was also a recognized mineralogist, holding appointment as His Majesty's Inspector of Mines in Ireland. Whatever their differences, Kirwan and Hutton shared a practical outlook, summed up in Hutton's article on the nature of coal and culm, published in 1777. Hutton made great use of culm, both for fertilizer and for the production of sal ammoniac, and opposed what he considered unfair tax distinctions between culm and coal. Culm was necessary for fertilizer and for making brick for houses and industry, and he advocated that the taxes should be lifted for the good of Great Britain's commerce and agriculture. Hutton calculated that the loss in coal revenue would be more than compensated by the flourishing state of the countryside.[3]

One of those who supported Hutton's theories was Sir William Hamilton, whose studies of the activities of Vesuvius were helpful to Hutton's formulation of the volcanic origins of rocks. Horace Walpole called Hamilton "the Professor of Earthquakes," characterizing the obsession of Sir William with eruptions and lava flows. Indeed, Hamilton was almost as absorbed in digging for soil samples of volcanic activity as in excavating for ancient vases. During one eruption, Hamilton heard a subterranean rumbling noise which he suspected had to do with the contact of lava and rainwater. Those who later subscribed to Hutton's theories believed that steam was an active agent in volcanic eruptions, an idea that coincided with the preoccupation with the industrial applications of this power. It is no coincidence that both Hutton and Watt were friends of the chemist Joseph Black whose theory of latent heat informed their scientific and industrial ideas. Hamilton made a major contribution to volca-

nology as well as to neoclassicism, and his meeting with Hutton was a demonstration of the alliance between art, science, and industry.

Like geology, biology also profited from the practical concerns of the scientific and industrial revolution; its concern with the growth of living things from egg, seed, a spore was greatly stimulated by botanical studies of the period, and its interest in the evolution of the species was stimulated by the fossil record disclosed by the mining and canal engineers. An English drainage engineer discovered in the 1790s that the historic succession of strata could be most conveniently dated by their characteristic fossils, thus aiding both geology and biology. Each rock layer contained a particular selection of fossils which was absent in the others. The rudimentary notions of evolution and generation in this period stimulated progressive artists and writers to project a new order of social and family life.

The English advance was not due to scientific and technological superiority alone. In the natural sciences the French were far ahead of the British. But the main technical innovations of the Industrial Revolution were quite modest, not beyond the talents of able carpenters, millwrights, and locksmiths. Further, England owned richer resources of coal and iron, its foreign trade was greatly expanding, enterprise was freer, capital would more easily be mobilized, and the political climate was more favorable to economic development, thus creating more opportunities for applying scientific knowledge.

The right conditions were present in England, especially since private profit and economic investment had been accepted as the objects of government policy. The solution of the agrarian problem was achieved by commercially minded landlords who monopolized the land, which was cultivated by tenant-farmers employing landless laborers and/or smallholders. Much of the ancient collective system based on common land was swept away by Enclosure Acts which began in 1760; this undermined the status of the traditional peasantry as it still existed in other parts of Europe. Enclosure allowed for large-scale production and new crop-rotation schemes which we have touched upon briefly in the first chapter. The old open-field method did not rest on surplus crops or work to supply a market. But with the pressures of the Seven Years' War and the growing empire there was a demand for grain not only to serve the overseas market

but also the home market where there was a growing concentration of people in the cities.

The new farming methods increased the yields which depended on more intense exploitation of the soil. The alternation of corn with other types of crops to prevent the plants from drawing on the same group of chemicals continuously and to give the land a chance to replenish itself was part of the scientific investigation into geology, chemistry, mineralogy, and botany. It was discovered that some grasses, like clover, build up nitrogen in soil and thus obviated the need to let ground lie fallow for part of the time. All crops in a sequence could be used for something; the livestock side of the farmer's operation would benefit, larger numbers of animals could be kept and in turn created more manure for fertilizing the soil.

This practice was impossible with the open-field method since every step had to be done with the permission of neighbors, and animals were let loose to wander on the fields. With enclosure land was redivided and fenced off with hedgerows and trees. Naturally, this aided the big farmers. The Enclosure Acts diminished the intermediate ranks and degrees of wealth in the countryside. The number of farms dwindled, and their average size increased. The aristocracy now became involved in the production of wealth as their farms were converted into profit-making organizations designed to supply an expanding mass market at home and abroad. Much of this wealth was converted into the building or refurbishing of their country estates and town houses in the collections of antiquities and paintings.

This large-scale farming, and the consequent displacement of large segments of the rural populace, also lay at the basis of the Industrial Revolution. The new conditions drastically changed the conditions of transportation; a big market now existed and food had to reach the market quickly and cheaply. Here again the canal system served the needs of the agricultural market and helped the duke of Bridgewater in his efforts. Not only did the canals cut the cost of coal and grain but they expanded to open the link between Liverpool and Manchester and thus opened the way for the shipment of raw cotton from Liverpool (the heart of the slave trade) which could then be finished and returned very cheaply.

The basis for success throughout the economy was higher agricultural productivity, which enabled the non-

agricultural work force to grow and ultimately transfer people from the agricultural to the industrial sector. The enclosures deprived the laborer or smallholder of the use of common land and the opportunity to work a plot of his own. This provided a supply of cheap labor for the cities. Agriculture incomes rose in the eighteenth century as the result of greater efficiency and demand exerted by the growth of population and the colonies. Increased consumption by landowners and farmers led to a related rise in industrial employment, incomes, and investment (town houses, antiquities, fashions, etc.) and contributed to the redeployment of rural population into urban centers.

The rising demand required new transport improvements, which in turn promoted the increased output of goods like iron and cotton. Improved transportation cut industrial costs by feeding raw materials into industry and distributing finished goods more rapidly. Now a number of key industries began thinking of innovation and mass output, which led to changes in organization and production techniques in the areas of cotton, iron, pottery. Large-scale farming gave rise to large-scale industrial production which could now be conceived in global terms. The whole world became one immense market, one that Great Britain dreamed of dominating as it did the battlefield and the high seas.

For 80 percent of the English population who lived in the countryside and made their living by farming, work was a matter of supporting oneself rather than supplying a market. But the population explosion of the period created demand for more food, and this led to a transformation of the system into a market economy of cash incomes and cash sales. Also, many of the industries and manufactures of England were rural, the typical worker being some type of village artisan or smallholder in his cottage, increasingly specializing in the manufacture of some product—mainly cloth, hosiery, and a variety of metal goods—and thus by degrees turning from small peasant or craftsman into wage laborer. Increasingly, villages in which workers spent their spare time weaving, knitting, or mining tended to become industrial villages of full-time weavers, knitters, or miners, and some eventually developed into industrial towns. At the same time, the little market centers where merchants went to buy village products, or to distribute raw material to cottage workers, became towns filled with workshops or primi-

tive manufactories to prepare and perhaps finish the material and goods distributed to, and collected from, the scattered cottage workers. This scattering of industry throughout the countryside gave landlords like Bridgewater a direct interest in the mines under their lands and the manufactures in their villages. The duke of Bridgewater's interest in canals and transport improvements developed from the pressures exerted by the home market and the growing demand from the cities for food and fuel. Food industries competed with textiles as the pacesetters of private-enterprise industrialization. Indeed, flourmilling and beer brewing played a significant role in the coming technological revolution.

Nevertheless, the main impetus for the Industrial Revolution came from cotton. Cotton was the prime pacemaker of industrial change, and it gave rise to a new form of society based on a new form of production, the "factory." Cotton manufacture was stimulated by cotton commerce and domestic demand for cotton prints. The first form of the modern cotton industry, calico printing, was also a major export. Until 1770 over 90 percent of British cotton exports went to colonial markets. The slave plantations of the East Indies provided the raw material until the end of the century when the slave plantations of the southern United States opened up a virtually unlimited source. The new industry localized near the great slave-trading port of Liverpool and grew up around the populous district of Lancashire.

The clue to the incredible expansion of the cotton industry was the adoption of the factory system. The development of machinery was a necessary part of the process leading to the factory system, but in the case of cotton the progress of mechanical invention is dizzying. The technical problem that determined the nature of mechanization in the cotton industry was the imbalance between the efficiency of spinning and weaving. The spinning wheel could not supply the weavers fast enough since the invention of the flying shuttle—which ran on wheels with a pull-on cord casting it from side to side—by John Kay, a weaver and mechanic in the woolen industry.

Arkwright

The next step, therefore, was the mechanization of the spinning process. Enter Richard Arkwright, the prototype of the Captain of Industry and one of the most suc-

cessful of the eighteenth-century cotton pioneers.[4] He began as a barber, but before he died he gained a knighthood, employed 5,000 workers, and could boast capital assets of over half a million pounds. His fortune was founded on a chain of mills, first using water and later steam power to drive cotton-spinning machinery which he called the "water frame." Arkwright took the idea from others, and his legal battles over patent rights were defended by members of the Lunar Society to which he belonged. He was one of the first to make a real success of the factory system in the textile industry; a fierce and unscrupulous competitor, he would take up any project if it facilitated the production and marketing of his cotton.

Arkwright's water frame was patented in 1769; in 1770 James Hargreaves patented another spinning machine known as the "jenny" after his daughter. It had many spindles, allowed for multiple spinning, and could be used in conjunction with the water frame. The spindles were used for the thread of the weft and the water frame for the warp. Hargreaves, like Arkwright, spun yarn for hosiers who were major stimulants of the new industry; Arkwright joined with such innovative hosiers as Need and Strutt.

Cotton masters advanced other areas of activity as well; they bleached and dyed textiles by the most recent inventions of chemistry, a science that came of age in the 1770s and 1780s with the Industrial Revolution. The French scientist Berthollet first suggested to James Watt that chlorine could be used for bleaching, and this gave rise to a chemical industry that flourished in Scotland by the end of the century. The printing of calicoes stimulated the arts; "drawing shops" were organized for designing the patterns on which its fortunes were based. Printers hired young art apprentices trained in the workshops of engravers or industrial art schools. The cotton industry remained a complex of specialized merchants of various kinds, including spinners, weavers, dyers, finishers, bleachers, and printers.

No other industry could compare in importance with cotton in this first phase of English industrialization, but the expansion in the iron and coal industries, and the improvement of the steam engine as a source of industrial power, were indispensable to widespread industrialization. Like cotton, iron was a commodity with immense potential. Iron ore is taken from the ground and burned,

or "smelted," together with limestone to remove the worst of the chemical impurities which it contains. The resulting metal is called "pig iron." If it is poured into a mold, or "cast," it becomes "cast iron." If pig iron is burned further to remove more of the impurities, a more flexible type of iron is produced called "malleable" iron which can be beaten into any shape or size required.

An important ironworks in the eighteenth century was at Coalbrookdale, Shropshire, founded by Abraham Darby. In the vicinity were iron ore, coal, limestone, and wood, and the River Severn, which was one of the main trade routes early in the century. Darby developed coal into coke for smelting the iron which gradually improved the quality and quantity of pig iron. John Wilkinson was a neighbor of the Darby family, with an ironworks at Broseley, a few miles away. He also developed the use of coke, and his chief skill was in the manufacture and boring of cannons. John Roebuck set up the Carron ironworks at Falkirk, Scotland, in 1760 and also specialized in cannon. Later, he worked with Boulton and helped finance Watt's early experiments.

English neoclassicism related to the nation's image as empire, both in the commercial as well as military and diplomatic sense. Its foreign policy was dictated by economic aims, and its wars contributed to technological innovation and industrialization. The tonnage of the navy grew dramatically in 1760, and the rise in iron production also grew substantially. Firms like Wilkinson and the Carron Works in Scotland owed the size of their undertakings partly to government contracts for cannon in the period. Henry Cort, who revolutionized iron manufacture with his "puddling and rolling" process, began in the 1760s as a navy agent responsible for obtaining supplies for Royal Navy ships and dockyards. His discovery during the war of the inferior quality of English wrought iron induced him to try to improve it for the metal parts of a ship.

The interdependence of iron, coal, and steam is one of the hallmarks of the Industrial Revolution. As the fuel for steam engines, coal was essential to the beginnings of industrial development in England. Coal mining was regarded as part of the management of a landed estate. So it was mainly a rural occupation in the hands of a few great landowners. The demand increased very rapidly with the invention of steam power and the closer harnessing of coal to iron production. This use of a com-

mon motive power, and especially of an artificial one, imposed general laws on the development of all industries. The industrial world came to resemble one huge factory producing goods and articles of consumption that could not be provided by nature. Even in its infancy it seemed to be manipulated by belts and transmission wires which regulated the movements and rhythms of both machinery and the human beings operating them. Then, of course, this was not perceived negatively but praised as a source of potential achievement.

Generally, there is a marked correlation between progressive-minded people in science and industry and their initial welcoming of the French Revolution. This includes the artists who were most beholden to the latest scientific and industrial innovations for aspects of their styles. While they were for the most part moderates, during conservative times they were attacked as radicals. Priestley suffered at the hands of a Tory mob for sympathizing with the French Revolution, while Lavoisier was executed for want of good public relations. Lavoisier was both farmer-general and political liberal, but in the eyes of the public he was a tax collector first and foremost. Only Marat, who held a degree in medicine from the University of St. Andrew and wrote abstruse treatises on light, fire, and electricity shifted to extreme radicalism.

The collaboration between scientists and industrialists in societies, such as the Literary and Philosophical Society in Manchester and the Lunar Society in Birmingham, was an important factor in the Industrial Revolution. The Scientific Revolution was largely a provincial movement by the end of the eighteenth century, expressed through the many philosophical and literary societies in Norwich, Northampton, Exeter, Bristol, Bath, Plymouth, Birmingham, Derby, Manchester, Newcastle, and other places. It was no longer confined to London and centered on the Royal Society as it had been in the first half of the century.

Science was popularized and widely diffused through informal, semi-official and official bodies like the Birmingham Lunar Society and the Manchester Literary and Philosophical Society. Coffee houses also encouraged the growth of scientific organizations and "think tanks." The York Coffee House gave birth to a new venture in 1754, when several Fellows of the Royal Society listened to the recommendations of a drawing teacher named Shipley to subsidize inventions and innovative art forms by prizes.

Shipley was very much involved in the industrial arts and wanted to find substitutes for cobalt and madder, both dyes used in the cloth trade and difficult to obtain. From this grew the Society for the Encouragement of Arts, Manufactures, and Commerce, still in existence today under the name of the Royal Society of Arts. The aim of the society was to encourage novel and "curious" inventions that could be useful to the nation. Original ideas were welcomed and rewarded.

The Society for the Encouragement of Arts, Manufactures, and Commerce was closely linked to the growing technology of the period;[5] its members included Joshua Ward, pioneer manufacturer of sulphuric acid; Professor John Robison, Watt's close friend; Peter Shaw, the chemist; Robert Mylne, architect and engineer; John Dollond, the optical instrument maker; Thomas Yeoman, a mechanical engineer who also carried out experiments with electricity. As in the case of the Royal Society, there was overlapping with other organizations; several members of the Lunar Society belonged to both. Altogether, there was hardly a single industry or science in England untouched by the society's endeavors.

This group actually embraced a school of design and foreshadowed the founding of the Royal Academy in 1768. It established a drawing school, the proposal for which was also made by Shipley at the meeting of "Noblemen and Gentlemen, Clergymen and Merchants" on 22 March 1754. All present agreed that drawing was "absolutely necessary in many employments, trades, and manufactures," and wished to encourage young people and promote art by prizes and competitive exhibitions—a practice eventually extended to include mature painters in the arts and crafts. The close connection between this society and the emergence of neoclassicism is seen in the fact that one of its members, the duke of Richmond, recently returned from Italy with a large collection of casts and antique marbles, donated it for the public "advantages of drawing." His gallery in Whitehall provided students with effective training under the joint management of the sculptors Wilton and Cipriani, both of whom had come through the Anglo-Roman network. Shipley's art school served as the training ground for this more advanced instruction and practice.

In 1755 the sculptor Sir Henry Cheere presented a plan for an academy to the society, and five years later it opened its doors to the first public exhibition of contem-

porary British artists to raise funds for a Public Academy. While internal squabbles resulted in the setting up of rival groups known as "The Society of Artists of Great Britain" and the "Free Society of Artists," the hopes for a Royal Academy centered on the original organization and its prestige membership. Most of the founding members of the Royal Academy emerged from the ranks of the Society of Artists. Nor did the Royal Academy, ostensibly set up to foster the spread of history painting, spurn the connections with manufacture and commerce. Although Reynolds warned in his opening discourse at the academy on 2 January 1769 that taste is not formed in manufactures but in higher aims, he acknowledged the king's initiative in the arts "as the head of a great, a learned, and a commercial nation."

Reynolds

The first president of the Royal Academy was certainly in a position to know. He worked closely with manufacturers himself, designing models for entrepreneurs like Boulton and Wedgwood. He painted the portrait of Wedgwood and other Captains of Industry whose drive and ambition he shared (fig. 3.2). Like Hogarth, he was the ambitious son of a schoolmaster and would have preferred more being "an apothecary than an *ordinary* painter." Following an apprenticeship with the most fashionable portrait painter of the day, Thomas Hudson, Reynolds set up an independent practice and took time off for travel, including his own Grand Tour in the early 1750s. Just prior to his journey to Rome, he attached himself to the expedition of a young naval officer, Augustus Keppel, who had been entrusted with a special mission to the dey of Algiers. Reynolds, who devoted his career to depicting the English ruling classes, got his first heady sense of empire during this voyage; Keppel went to warn the dey against his corsairs and their raids upon English ships. On the eve of the French and Indian War Reynolds settled in London where he advertised himself as a painter in the "Great Style."

While Reynolds shared some of the theoretical aims of the neoclassicists and often adopted antique and Renaissance attitudes for his sitters, he rarely executed classical or historical compositions in a classical style. He knew the members of the Dilettanti, he painted Adam's clients Edwin Lascelles (later Lord Harewood) and Sir Watkin

3.2 Sir Joshua Reynolds, *Portrait of Josiah Wedgwood*, 1782 Royal Academy Exhibition. Trustees of the Wedgwood Museum, Barlaston, Staffordshire, England.

3.3 Sir Joshua Reynolds (attributed), *Portrait of George, Admiral Lord Anson*, 1755. National Maritime Museum, London.

3.4 Sir Joshua Reynolds, *Portrait of General John Burgoyne*, 1766 Royal Academy Exhibition. © The Frick Collection, New York.

Williams-Wynn, but his productions exemplified the everyday, immediate side of their status and power. His work glorifies the members of the landowning class entitled to bear arms, including a large number of naval and military heroes who distinguished themselves in battle or in administration during the Seven Years' War. He often painted them in full-dress uniform with a dramatic background vignette attesting to their heroism, as in the case of *George, Lord Anson*, executive of the admiralty and mentor of Keppel, and *General John Burgoyne* (figs. 3.3, 3.4).

Involved in the immediate show of temporal power, Reynolds exploited color and dashing brush strokes and was never rigorously classical, although he often set his modern characters into antique poses and costume akin to Wedgwood. His *Lady Sarah Bunbury Sacrificing to the Graces* was painted in an attitude borrowed from a classical relief (fig. 3.5) and is reminiscent of Vien's *Virtuous Athenian Girl*. It even includes a tripod, but with clawed feet rather than the more familiar goats' hooves. Here the presence of a servant pouring a libation speaks to Lady Sarah's actual social position. Nine years later Reynolds exhibited *The Adorning of a Term of Hymen with Festoons of Flowers*, a work commissioned by Luke Gardiner, M.P., who, soon to marry the daughter of the Scottish jurist Sir William Montgomery, M.P., wanted a representation of his fiancée and her two sisters in the form of "some emblematical or historical subject." Gardiner was so intent on elevating his beloved and her sisters that he flattered Reynolds with the thought of the fame that would accrue to his "conveying to posterity" the distinguished family. Reynolds appreciated the opportunity to introduce "a variety of graceful historical attitudes." In addition, Reynolds managed to stuff the paintings with art objects, furniture, an opulent carpet, and the ubiquitous rams' heads which we have come to associate with the backgrounds of the neoclassicists. The pagan rite of fertility had been transformed into a respectable bridal allegory with the protagonists merely acting a part.

Reynold's approach is seen most clearly in his *Sarah Siddons as the Tragic Muse* (fig. 3.6). Siddons was in actuality a famous actress, and it was appropriate for her to "star" in one of the painter's compositions. He often attended her performances, sitting in the orchestra and visiting her in her dressing room to compliment her. She

3.5 Sir Joshua Reynolds, *Lady Sarah Bunbury Sacrificing to the Graces*, 1765, oil on canvas. W. W. Kimball Collection. © The Art Institute of Chicago. All rights reserved.

herself admitted that she was "an ambitious candidate for fame," and she boasted of attending Reynold's parties at which assembled "all the good, the wise, the talented, the rank and fashion, of the age."[6] Siddons enjoyed royal patronage and read to the king and queen at Buckingham and Windsor Palaces. Reynolds had her pose in the attitude of Michelangelo's Prophets of the Sistine Ceiling, and during one of her sittings he requested her to "ascend your undisputed throne" and give him an idea of the Tragic Muse. Her expression is feigned and calculated, consistent with Reynold's repertoire of ancient pieces and his cast of Old Masters.

Reynolds standardized his approach to the past and painted on a scale and in a volume analogous to his industrialist friends like Wedgwood and the distiller Philip Metcalfe.[7] Already in 1759 he had 150 sitters and was employing considerable studio help to map out the main masses and accessories of his formulized three-quarter-length portraits. By most accounts his assistants were poorly paid and overworked, barely sharing in the high prices he charged. He became the most successful portraitist in the country and purchased the lease on a house in what is now Leicester Square. He later erected a second residence at Richmond. These he staffed with numerous servants and filled with his collection of Old Masters. Reynolds used his position as president of the Royal Academy to advise wealthy collectors and serve as their agent; he also dealt in pictures and statuaries directly. In a letter to his patron the duke of Rutland, dated 7 September 1786, he noted that he purchased from Thomas Jenkins in Rome a work attributed to the Italian sculptor Bernini. Jenkins charged him 700 guineas, but Reynolds added: "I buy it upon speculation, and hope to be able to sell it for a thousand."[8] Reynolds certainly thought of art production and distribution as any other form of business, and he also made use of promotion techniques to enhance his commercial position. He set up an ornate coach which he used as a form of advertising; his sister Frances took it out as often as possible to "give a strong indication of his great success, and by that means tend to increase it."

The Lunar Society

The exchange among the organizations and societies (often royal) devoted to the sciences, manufactures, and the

3.6 Sir Joshua Reynolds, *Sarah Siddons as the Tragic Muse*, 1784. Reproduced by permission of The Huntington Library, San Marino, California.

arts insured that artists participated in shaping the vision of the Industrial Revolution. One of the most important of the informal coteries in this period was the Lunar Society of Birmingham.[9] It may be traced to the 1760s, but it was not until the next decade that the name "Lunar" appears and the meetings recorded. The Lunar Society—so-called because it met on the Monday closest to the full moon to have enough light so that its members could find their way home—embraced a community of provincial manufacturers and professionals who contributed to the transformation of England from a rural society with an agricultural economy to an urban and industrial society. The members of the society, in addition to achieving many individual distinctions, personified the conjunction of three major historical events: the Industrial Revolution, the American Revolution, and the French Revolution.

The original members were Matthew Boulton, Erasmus Darwin, and William Small, Thomas Jefferson's professor of natural history at the College of William and Mary in Virginia. Boulton was the prime mover, quick to see the application of an idea and its profits. One of Birmingham's popular heroes, he early experimented with steam engines and teamed with James Watt to design and sell rotary engines for driving machinery. He was a good friend of Benjamin Franklin who collaborated with him on electrical experiments. His first business was that of silversmith, toy manufacturer, and buckle maker, which he inherited from his father in 1759. He began to build his famous factory in Soho, Birmingham, in 1763; six years later the factory was enlarged and Boulton was granted royal patronage. He produced many small decorative objects such as shoe buckles, brooches, buttons, braclets, and frames for lockets in both silver and cut steel, which were often enhanced by the addition of jasper cameos supplied by Wedgwood. Boulton also made ormolu clock cases and vases and supplied the metallic mounts for much of Adam's projects. By 1770 Boulton was employing 700 workers in his factory, a major contributor to the Industrial Revolution. In 1772 he promoted the Bill of Parliament which set up the Birmingham Assay Office and also started the Birmingham Mint.

For modern historians Boulton's significance in the Industrial Revolution is mainly as Watt's partner, as a pioneer of the steam revolution which was to reach its cli-

max in the nineteenth century. But he was well known long before he even heard of Watt, and would have been a major figure without the steam engine. He certainly incarnated English monopoly and global ambitions in the wake of the Seven Years' War. He boasted to Watt on 7 February 1769: "It would not be worth my while to make for three countries only; but I find it well worth my while to make for all the world."[10] He promoted foreign trade and wanted to compete on the French market with his mass-produced button and steel buckles, the foundation of his wealth.

Boulton worked closely with artists, hiring sculptors and painters like Amos Green, Sir Joshua Reynolds, Angelica Kauffmann, and John Flaxman to supply designs for his various projects.[11] He hired agents to send him cameos, seals, cases as models for his products, including prints and drawings after Sir William Hamilton's collection. Boulton often exchanged designs and prints with Wedgwood; Flaxman supplied various figures from which Boulton's ormolu vases were modeled including the familiar rams' heads. Boulton's patrons included Adam's clients Lord Shelburne and the duke of Northumberland. He brought out his ormolu vases at an auction at Christie's sale room in Pall Mall and widely advertised the event to alert the fashionable world.

Boulton gained a reputation as Maecenas of the Industrial Revolution, establishing close ties to neoclassicism. He contemplated going into business with the Adam brothers, renting a warehouse in the Adelphi complex, but could not find a moneyed partner for the scheme. Adam employed Boulton to produce fittings and art objects for a number of his houses, including Osterley Park, Syon House, and Kenwood. Boulton, in turn, provided work for a host of painters, engravers, and sculptors and did not separate art from trade. He employed Angelica Kauffman in the mass production of mechanical paintings for ceilings, doors, and furniture; she produced nearly thirty works for this project.[12] Oil paintings were reproduced on canvas—a method involving engraved copper plates and a rolling press—and then finished by hand. The most elaborate use of these was in Mrs. Montague's house on Portman Square. He perceived that elegance was good business and that he could improve business through better product design. Boulton commissioned agents to make regular purchases of prints for designs. In addition to Kauffmann, he used works by Reynolds, West, and Joseph

Wright of Derby. In this sense, Boulton, a major contributor to the Industrial Revolution, was also a pioneer of industrial design in the neoclassical mode and innovated mass-produced art.

William Small was born in Scotland and trained at Marischal College in Aberdeen; at the age of twenty-four he went to William and Mary to teach mathematics and then became professor of natural philosophy, expounding Newton's physics. One of his ablest students was Thomas Jefferson who soon became Small's protégé. After several years in the colonies, however, Small's health seems to have suffered, and he returned to Aberdeen to complete his clinical training. Through the help of Franklin and Boulton he took up medical practice in Birmingham. It was Franklin who gave Small a letter of introduction to Boulton, who was just then expanding his business.

Darwin, the third founding member of the society, was a solid, humane, and wealthy physician who had studied medicine at the University of Edinburgh. He was the most creative and versatile of the three—a poet and practical inventor and even an evolutionist long before his grandson Charles published *On the Origins of the Species*. Darwin's famous *Botanical Garden* and *Zoonomia* indicate a rich and fertile mind, eager to embrace all the latest scientific and technological discoveries, but also anxious to share his discoveries with a vast audience. His *Zoonomia*, which shows a profound understanding of the human condition, is also a self-help manual for healing disease and was obviously destined for the masses of people who could not afford high medical fees.[13]

Darwin was an inveterate organizer, and even earlier had founded a botanical society at Lichfield which published a translation of Linnaeus's *Genera Plantarum*. Later, he moved to Derby where he founded his third philosophical society, and extended that Midlands community of scientists and industrialists in which the members corresponded with one another and with the leading scientists of Europe and America. One of the leading members of the Derby Philosophical Society was Robert French, a person who told Sir Joshua Reynolds that he thought Fuseli's *Nightmare* was the best picture in the academy exhibition of 1781. Sir Brooke Boothby, a patron of Fuseli and Joseph Wright of Derby, was a member of both the Lichfield Botanical Society and the Derby Philosophical Society. In addition to art collecting, he

and his fellow members kept fossil cabinets, and all admired Linnaeus.

Darwin's passion for botany and its relationship to natural, scientific, and industrial phenomena is expressed in his long poem, *The Botanic Garden*, published in two parts in 1789 and 1791. Its title and scope is perfectly consistent with the contemporary fascination for botanical gardens. Part I, published last, was *The Economy of Vegetation*—a title itself evoking the industrial use of plants—and Part II, *The Loves of the Plants*, was published first. Written in rhymed couplets, it is nevertheless a monument to his scientific approach. It embraced vast areas of knowledge and their industrial application: his notes, besides treating botanical and biological concepts, contain explanatory comments on meteors, optics, comets, geology, heat, metallurgy and mining technology, meteorology, cotton manufactures, and steam power. Darwin's aim was "to inlist Imagination under the banner of Science; and to lead the votaries from the looser analogies, which dress out the imagery of poetry, to the stricter ones, which form the ratiocination of philosophy."[14] The bulk of the work deals with physical science, technology, botany, and geology in metaphorical and allegorical terms. Like the artist and poet, he wanted to present abstract concepts in concrete images, and he made frequent allusions to contemporary artists in his work. In addition, he also commissioned well-known contemporaries like Henry Fuseli and William Blake—who engraved several plates—to illustrate the poem.

One example illustrates his method as well as exemplifies the Lunar Society's ultimate confidence in English economic and industrial hegemony. After enumerating the scientific discoveries of his friend Joseph Priestley, he singles out his contribution to the diving bell which will "enable adventurers to journey beneath the ocean in large inverted ships, or diving balloons":

Led by the Sage, lo! Britain's sons shall guide
Huge *Sea-Balloons* beneath the tossing tide;
The diving castles, roof'd with spheric glass,
Ribb'd with strong oak, and barr'd with bolts of brass,
Buoy'd with pure air shall endless tracks pursue,
And PRIESTLEY's hand the vital flood renew.
Then shall BRITANNIA rule the wealthy realms,
Which Ocean's wide insatiate wave o'erwhelms; . . . [15]

Darwin's close friend Josiah Wedgwood was another member of the Lunar Society. We have already discussed

Wedgwood's importance in the dissemination of the neo-classical movement, but we have yet to indicate his contributions to the Industrial Revolution. Wedgwood and another member of the Lunar Society, William Withering, carried out research on the significance of oxidation. Wedgwood was well acquainted with the rust-colored clays of domestic crockery. With Withering and other fellow members he set out to find nonferrous clays to use in making pottery of high quality. The clays and minerals Wedgwood came upon in his fieldwork resulted in the development of the famous Wedgwood jasperware and porcelains. Wedgwood later became a Fellow of the Royal Society, not for his work on mineralogy or chemistry but for his invention of the pyrometer, a device for measuring the temperature of kilns. From the first, Wedgwood demonstrated an initiative unique among potters of his time, always jumping to adopt technical aids and improvements. For example, he brought the engine-turning lathe, primarily a metalworking tool, to Staffordshire in 1763 to imitate metalwork in the bronzing of his black basalt ware.

Wedgwood made comparative studies of the breakage of his crockery consignments when they were transported by road and by water. As a result he became a vigorous advocate of the canal system that soon laced England, with the Grand Trunk Canal running from the Mersey through the Wedgwood Potteries to the Trent and thence to London. That Lunar Society members were not the impractical dreamers satirized by Swift is perhaps best seen in their effective agitation on behalf of the canal system. Until the rise of the railroads, water was the easiest and cheapest way to ship freight, and it was the canals that provided the major solution to the problems of industrial transportation. For Wedgwood it insured the safety of his fragile chinaware, and it encouraged him to mechanize in order to standardize the shapes of his pottery for packing and crating. The duke of Bridgewater became close to Wedgwood through their mutual interest in canals; he was also one of his important patrons. Wedgwood joined forces with the duke of Bridgewater to create a large network throughout the Midlands. As early as 1764 Wedgwood participated in a group in Staffordshire to petition Parliament for approval of a canal to connect the Trent and Mersey Rivers. Wedgwood was joined by Darwin, Boulton, and Small, all of whom were active and vocal supporters of the peti-

tion. The bill was passed in 1766. Almost all the Lunar Society members were affected by "canal mania"; from 1767–1773 James Watt was employed in various kinds of canal projects in Scotland, and Boulton, Small, and Keir owned stock in the Birmingham Canal Company.

Wedgwood was certainly one of the pioneers of English factory organization, setting out the modern guidelines for the discipline of workers, the division of labor, and the systematization of production.[16] Etruria became a model for the whole of the pottery industry, ushering in the factory system and the age of industrialization to the potteries. He arranged his various shops so that in the course of its metamorphosis the clay traveled naturally in a circle from the ship house by the canal to the packing house by the canal. Each process remained separate, but there was a smooth progression from one stage to the next. Workers were organized on the same principle, with "fine figure painters" paid higher wages and set to work in a different workshop than the common "flower painters." All were trained to one particular task and compelled to stick to it.

Wedgwood was one of the first scientific industrialists to seek the cooperation of serious artists in large-scale industrial production. He employed Kauffmann, Pacetti, Lady Templeton, Wright of Derby, Stubbs, Blake, and Flaxman to do designs and to oversee other artists; this was the case with Flaxman, his favorite sculptor, who sold work to Wedgwood by the piece.

Wedgwood was a hard taskmaster like his friend Reynolds, imposing punctuality, constant attendance, fixed hours, standards of care and cleanliness, and a drinking ban on people who previously enjoyed a tradition of independence and flexibility. He laid the foundations for a foreman class and introduced the bell and a primitive clocking-in system with tickets to insure prompt and regular attendance. His ambition was to make "such *Machines* of the *Men* as cannot Err."[17] Unlike Blake, Wedgwood did not see this as inhumane: rather it was part of the perfectability of the species that industrialization would bring about.

Wedgwood was patriarchal and autocratic with his workers, believing that he knew what was best for them. He did provide them with better living conditions, for example, homes for them to live in on his estate, schools for their children, and hospitals. He demanded complete obedience in return for better food, better clothes, better

houses, better medical care, better roads, and better transport. His factories appeared as harbingers of a better future; artists painted them, scientists eulogized them, poets were inspired by them. In the pioneer atmosphere of the eighteenth century they could be thought of as the means of escaping the poverty, the backwardness, and the ignorance of the old rural, agricultural society, and pave the way to prosperity, education, and civilization.

One occasional member of the Lunar Society was John Wilkinson, a steel producer, who made possible the engineering success of Boulton and Watt. He started as a cannon maker and received important commissions from the government during the Seven Years' War. He built superior machine tools for boring gun barrels. It was Wilkinson who supplied the means of achieving the required precision in the cylinders of the Boulton and Watt steam engines. Watt himself became a regular member of the Lunar Society, and its input helped him improve on the prototype of the condensing steam engine. Once on his way back to Scotland from giving evidence before the canal commission in London he stopped in Birmingham, where Small showed him around the Soho Works and introduced him to members of the Lunar Society. Later, Watt and Boulton inaugurated their historic association.

Another important member of the group was the scientist Joseph Priestley. A teacher in a religious dissenters' school at Warrington in Cheshire, Priestley had become interested in Franklin's work on electricity. At Franklin's instigation Priestley wrote *The History and Present State of Electricity*, published in 1767.[18] It enjoyed an enormous success and ran into seven editions. Priestley received an appointment as librarian to Lord Shelburne, in whose country house Priestley carried out the experiments that isolated oxygen, which he labeled "dephlogisticated air." He never realized the significance of this discovery for which Lavoisier later got the credit. Another of Priestley's sponsors was Wedgwood, who underwrote the costs of many of his experiments and made laboratory apparatus to Priestley's specifications. Boulton made electric magnets with Priestley's help, and following Franklin's discovery that thunderstorms were caused by electrical discharges from the atmosphere he also began producing lightning conductors. Priestley also wrote on vision, light, and color, but his reputation rests mainly on his work in chemistry, particularly that part dealing

with the nature and composition of gases and his discoveries of nitrous oxide and hydrochloric acid.

Almost all of the members exchanged ideas and helped one another with their expertise: Priestley acknowledged Darwin's contributions to the study of electricity in his *History*; Boulton designed and built a lathe for Wedgwood; Small, an expert mathematician, worked with Watt and Boulton in the steam engine project; while Wedgwood had something for everybody. Not only did the Lunar Society exchange ideas among its members, it had contacts with major scientific thinkers in America and in Europe. Benjamin Franklin, who visited relatives in Birmingham in 1758, was in touch with at least seven of its members. Like Priestley, Boulton's early interest in electricity was stimulated by his contact with Franklin and remained his favorite diversion. In 1760 Franklin and Boulton collaborated in experiments with a Leyden jar. They also carefully observed the developments in France, notably the balloon experiments of Montgolfier and the work of Lavoisier. They had in fact a network of correspondences with foreign scientific societies, including German, Italian, and Swiss. Wedgwood profited from the experiments of Lavoisier, especially the latter's calorimeter for measuring heat, and in 1791 Lavoisier requested information from Wedgwood about refractory clays for a furnace.

Interests of the Lunar Society

The Lunar Society clearly had many absorbing passions, but three which particularly commanded their interest were light, meteorology, and geology. One of the most important domestic inventions of the late eighteenth century was Aimé Argand's oil lamp; the introduction of the tubular wick and glass chimney, producing an upward draught of air on both sides of the burning surface, gave a continuous bright light without the smoke and smell of previous oil lamps. Argand, a Swiss physician and scientist, had to go to London to get his patent—further testimony to the climate of receptivity for technological innovation in England. Later, he opened a manufactory for the lamp in France where he was encouraged by Napoleon. Argand was in London in 1783 where he made contact with William Parker, a London glassmaker and friend of Joseph Priestley. Both referred Argand to Boul-

ton, and they carried on a lively exchange. Boulton shared Argand's interest in new lighting techniques, and it was Boulton who helped Argand patent the lamp in England in 1784 and establish the Argand Lamp Company. Boulton actually manufactured some of the first parts for the lamp. During the years 1784 to late 1786 the correspondence of the Lunar Society is conspicuously filled with ideas about lamps.[19]

William Murdoch, also affiliated with the Lunar Society, worked for Boulton and Watt and was mainly responsible for the addition of gas lighting equipment to the products for which the Soho manufactory became famous. Murdoch's experiments with gas lighting paralleled those of Dundonald and Watt who in the early 1780s investigated the possibility of obtaining light from gas extracted from coal tar. Murdoch did not get much support until Watt's son, Gregory, came back from Paris filled with enthusiasm about Philippe Le Bon's demonstrations in 1801. By 1804 Boulton, Watt and Sons had accepted a contract to light the Manchester Cotton Mill of Phillips and Lee. Murdoch was awarded the Rumford Medal of the Royal Society in 1808 for his contributions to domestic lighting.

The Lunar Society had an obsessive interest in meteorology, in weather observation, and weather instruments like wind and rain gauges. A meteor of 18 August 1783 attracted the attention of a number of English scientists including Edgeworth and Darwin, especially as an example of electrical phenomena. Lightning, meteors, and aurora were then believed to be linked as electrical phenomena occurring in three distinct regions of the atmosphere, each higher than the previous one; in the lower region of dense air, electric fluid accumulated on vapors and was released in lighting; in the uppermost region—almost inflammable air—electricity ignited the air into streams of fire which shot into the vacuum of space. Sometimes, however, streams hurled downward in eddies of waves of fire which combine with the less dense air of the middle region, forming fireballs and meteors. These views corresponded to those held in France by Bertholon (*De l'électricité des météores*, 1787) and Marat (*Recherches physiques sur l'électricité*, 1782), and even to Volta who knew their work, although he disagreed on some of the particulars. The preoccupations of the Lunar Society (and that of Marat as well) predisposed the group

to the theories of Mesmer, for electricity was widely viewed at the time as a therapeutic force.

The interest of the Lunar Society in geology has already been mentioned, but it should be stressed that this was a major topic of scientific discussion in the period and closely related to the Industrial Revolution. On the theoretical plane, the members were involved in the conflicting theories during the decade 1781–1791, especially Withering and Priestley. In the controversy just beginning between Vulcanists (or Plutonists) and Neptunists, that is, between people who insisted on the agency of heat and pressure in the formation of rocks and those who denied it in favor of an aqueous solution based on the biblical flood narrative, Priestley and Withering aligned themselves with the Neptunists while the rest of the Lunar group went with the Vulcanists. Keir and Watt kept abreast of Werner, the great exponent of Neptunism from Germany. Faujas de Saint-Fond, a well-known French geologist and naturalist, student of extinct volcanoes and a firm believer in the volcanic nature of basalt, visited England and Scotland in 1784. He carried with him a letter of introduction from Ben Franklin to Whitehurst (who published a major book on geology in 1778 which he sent to Franklin) and enjoyed frequent visits with Whitehurst, who in turn, sent him on with an introduction to Lunar Society members in Birmingham.

The members of the Lunar Society were clever, politically influential and substantial members of their community. They incarnated the spirit of the entrepreneurs who stimulated the Industrial Revolution: they were not idealists but hardheaded realists who believed that science and industry opened up unlimited possibilities. They were interested in making money from their work; Boulton, Watt, and Wedgwood never allowed sentiment to interfere with their profits. At the same time, their material progress represented breakthroughs in the social sense; they were generally middle-class liberals who espoused laissez-faire economics and could support the American and French Revolutions and agitate against slavery in the colonies. In July 1789 Wedgwood wrote to Darwin: "I know you will rejoice with me in the glorious revolution which has taken place in France," and Darwin wrote to Watt in January 1790: "Do you not congratulate your grandchildren on the dawn of universal liberty? I feel myself becoming all French both in

chemistry & politics."[20] And true to form, Boulton tried in 1791 to get a coinage contract from the revolutionary government. But the Lunar Society's celebration of the anniversary of the Revolution sparked the Tory-inspired Birmingham riots in July 1791 in which Priestley's house, library, and laboratory were destroyed. He fled to America and remained ever after divided in his loyalties. Except for Boulton, perhaps politically the most conservative, the Lunar Society had sympathized as well with the American revolt; Boulton feared competition from the colonies and sustained the prohibition against their producing finished products.

The dissenting manufacturing middle class predominantly favored a number of political, religious, and humanitarian reforms which, however, ran counter to the prevailing climate of conservatism but was consistent with their support of a free and open market, factory labor, and efficient trade. The most significant case is the agitation for the abolition of slave trading which often involved both Whigs and Tories. The Lunar Society was very much opposed to traffic in slaves: Thomas Day's famous poem, *The Dying Negro* (1773), spurred people's consciences, while his later *Letter on the Slavery of Negroes* (written in 1776, published 1784) perceived the American as "signing resolutions of independence with the one hand, and with the other brandishing a whip over his affrighted slaves." To illustrate Day's poem, Wedgwood made a cameo in jasper of a slave in chains with the motto: "Am I not a man and a brother?"[21] By 1788 the abolitionist activities of Clarkson and Wilberforce were generating mass support in England and had the participation of the Lunary Society; but in this case there were too many vested interests and the drive failed. Clarkson, above all, continued the struggle, receiving the financial support and encouragement of Wedgwood.[22]

The Lunar Society thus represents a microcosm of the most progressive thought in England at the time which made substantial contributions to the Industrial Revolution. Culture cannot escape the impact of such a far-reaching development, and it is not coincidental that leading artists and writers were affected by it. Many were directly in touch with the Lunar Society itself or with the work of its members. These artists and writers are often referred to as "romantic," and include Coleridge, who was for a time a pensioner of Wedgwood, a close friend of Watt's son James, and a great admirer of

Priestley. Wedgwood also contributed to the support of Wordsworth, Wright of Derby, Blake, Flaxman, and Stubbs. Years later, a conversation on the work of Darwin inspired Mary Shelley's *Frankenstein*. William Blake, who worked with Darwin on his *Botanical Garden*, could even satirize the Lunar Society with his piece "An Island in the Moon."

The "Proto-Romantic" Artists

The so-called proto-romantic artists of this generation were trained in neoclassic aesthetics, but the influence of science and industry, as well as the turmoil caused by the American and French Revolutions, encouraged an experimentation with unusual light, color, and spatial effects. Before examining individual cases, however, there remains a need to examine two critical literary contributions to the intellectual climate of the period which profoundly affected the artists we are about to discuss. These works are Edmund Burke's *A Philosophical Inquiry into the Origin of Our Ideas of the Sublime and the Beautiful* (1756), and James MacPherson's Ossianic series, beginning with *Erse Fragments* (1760), *Fingal* (1762), and *Temora* (1763). Their dates of publication span the period of the Seven Years' War, and they manifest the quest for empire associated with it. While it would seem that these works escape the effects of the incipient Industrial Revolution, their content and public reception cannot be isolated from it.

Burke

Burke's is an especially interesting case; his essay on the *Sublime and the Beautiful* expanded the common notion of what is acceptable in works of art to embrace the terrifying, the painful, the unknown. He did not write about art in an offhand way; his career attests to a deep commitment to visual culture both as a collector and patron. He owned an extensive collection of classical marbles and Old Master paintings, and subsidized the early career of James Barry whose eccentric style and dramatic effects place him squarely in our group. Burke was also an intimate friend of Sir Joshua Reynolds (much to Barry's chagrin), whose *Discourses* he helped formulate; he was appointed an executor of Sir Joshua's estate.

Burke's notion of the sublime was associated with ac-

tual moments of terror and life-threatening elements, but when such occasions were cast into artistic form they could evoke delight. As he wrote:

The passions which belong to self-preservation turn on pain and danger; they are simply painful when their causes immediately affect us; they are delightful when we have an idea of pain and danger, without being actually in such circumstances; this delight I have not called pleasure, because it turns on pain, and because it is different enough from any idea of positive pleasure. Whatever excites this delight, I call *sublime*.

Here Burke anticipated the success of a number of artists who, invoking his concept of the sublime, managed to appeal to privileged groups by shaping their anxieties and sense of danger into "delightful" configurations.

Burke not only opened the way to new and wider areas of artistic activity but encouraged novel and audacious approaches based on individual observation rather than on exclusive imitation of antique statues, engravings, pictures, and buildings. In his discussion of proportions, for example, he shows how ancient statuary differs widely in proportions, thus debunking the notion that there was fixed canon of so many heads tall. This corresponded to reality which demonstrates that handsome human beings vary widely in their proportions. It is not the compass but "good sense and experience" that should dictate what is to be done in every work of art. Thus Burke rejected orthodox neoclassical theory in favor of a more personal interpretation of the human form. He certainly did not discourage the study of antique works, but he rejected their slavish imitation.

Burke, moreover, set up the example of Milton as a paradigm of sublime expression, and it is no coincidence that artists identifying with the "sublime" like Blake, Fuseli, Wright of Derby, Flaxman, and Barry drew upon Milton for inspiration. Burke in fact claimed that there was no more "sublime description" than Milton's portrait of Satan, a portrait, incidentally, shot through with scientific and industrial images:

> —He above the rest
> In shape and gesture proudly eminent
> Stood like a tower; his form had yet not lost
> All her original brightness, nor appeared
> Less than an archangel ruined, and th' excess
> Of Glory obscured: as when the sun new arisen
> Looks through the horizontal misty air

Shorn of his beams; or from behind the moon
In dim eclipse disastrous twilight sheds
On half the nations; and with fear of change
Perplexes monarchs.—

Burke's section on light made a fundamental contribution to "romantic" formulations:

With regard to light, to make it a cause capable of producing the sublime, it must be attended with some circumstances, besides its bare faculty of showing other objects . . . Such a light as that of the sun, immediately exerted on the eye, as it overpowers the sense, is a very great idea. Light of an inferior strength to this, if it moves with great celerity, has the same power; for lightning is certainly productive of grandeur, which it owes chiefly to the extreme velocity of its motion. A quick transition from light to darkness, or from darkness to light, has yet a greater effect. But darkness is more productive of sublime ideas than light.

Burke's categories thus informed the eccentric, dramatic representations of Wright, Fuseli, Barry, Mortimer, De Loutherburg, Flaxman, and Blake. Like Burke's categories, their daring innovations sprang from scientific and technical interests. Not only did Burke ground his aesthetics firmly in psychology, optics, chemistry, he borrowed his analogies and metaphors from science and industry. His concept of the horrific and the terrible seeks to find aesthetic equivalents for the nascent industrial landscape, the quest for empire and the turmoil of war. Burke, "the prophet of conservatism," energetically supported British empire and trade, and it may be claimed that the expansion of traditional aesthetic categories to embrace the sublime complements his promotion of the expansion of trade. While he supported the American colonies (as a paid agent of the New York Assembly), he did not defend them in terms of the revolutionary principle but in the context of a civil war harmful to empire. It was his repudiation of the French Revolution that underlines his defense of the social hierarchy and unyielding support of privileged interests.

Burke's *Sublime* is related to the intimidation of the individual by a higher power, real or imagined, an authority capable of thwarting the natural passions of society and keeping its members in their "place." Everything he wrote was applied to conservative ends. He believed in an ordered, graded social structure where each class had duties and responsiblities ordained by God. The British

constitution, the Anglican church, and the social structure of England rested upon the pillars of the law and custom of landed nobility. Throughout his life he championed the ranks of privilege, an attitude he had already declared in his *Vindication of Natural Society* which was published the same year as *Sublime and Beautiful*. He rejected liberal theories of human behavior, insisting on the natural evil and sin of human nature which must be repressed by a higher authority and power. *Sublime and Beautiful* deals with issues involving self-preservation, society, and ambition which in one way or the other served the old order. This attitude enabled Burke to gain entrée into bluestocking circles in the late 1750s.

Burke's treatise is also pervaded by scientific and industrial analogies, invoking the authority of Newton as well as his near contemporary, Nicholas Saunderson, professor of mathematics and astronomy at the University of Cambridge. It is clear that preparations for the Seven Years' War influence his concept of the sublime; he noted that the loud "noise of vast cataracts, raging storms, thunder, or artillery, awakes a great and awful sensation in the mind." Few things are more awful than the striking of a great clock in the silence of the night, a single stroke repeated on the drum, and "the successive firing of cannon at a distance."

In his discussion of *uniformity* as a component of the infinite and therefore of the sublime, Burke gave the example of a plantation as a form without seeming boundary. Here he had in mind the vast tracts of fertile land in the West Indies. In April 1757, almost simultaneously with the publication of the *Sublime*, Burke and his cousin William published anonymously a two-volume work entitled *An Account of the European Settlements in America*. The Seven Years' War made the book a timely one and created a receptive market for what proved to be an immensely successful work. It recounted the history and contemporary circumstances of the English, Spanish, French, and Portuguese colonies in the New World. The book is intensely anti-French and empire conscious: the French West Indies "are risen to such as pitch as to be an object of great and just terror to her neighbors." The authors coveted the territory of Louisiana and the French settlements in North America. They also lay great stress on the fact that there is no other part in the world where "great estates" can be made in so short a time as in the West Indies.[23]

Elsewhere in the *Sublime* he notes that "sweetness" is an aspect of the Beautiful, and this stems from the pleasurable association of "sweet bodies" with sugar. Here again Burke had in mind the important sugar trade of the West Indies; in the *Account* Will and Edmund devoted a long section to the cultivation and production of sugar in Jamaica.[24] All his life Burke championed British commerce and as an M.P. consistently defended merchants against taxes and restrictions. He was so well known as a champion of British commercial interests that the merchants of Bristol invited him to become a candidate to represent their city in Parliament. As M.P. from Bristol he supported his shipowning constituency against an act of the Jamaica Assembly levying a tax on imported slaves. Burke condemned the abuses of the slave trade, but he thought regulation and reform both of the trade and of slavery preferable to abolition. He certainly manifested the ideology of his constituents when claiming that Africans were "fitted for the gross slavery they endure." And in his section in the *Sublime* on the terrible as a feature of darkness he gave the example of a blind boy restored to sight recoiling in great horror upon glimpsing a "negro woman."

But where we find Burke's closest analogy to industrial developments is in his choice of categories for describing the sublime. Among these are Power, Vastness, Infinity, Succession and Uniformity, Magnitude in Building, Light, Sound and Loudness, Magnificence, and the Artificial Infinite. All of these are based on experience, such as his example under Infinity of "the beating of forge hammers" which continue to reverberate in the imagination long after the first sounds are past. This in turn leads to a discussion of Succession and Uniformity as examples of the Artificial Infinite which "consists in an uniform succession of great parts" and includes the "successive firing of cannon." Burke's mechanical concepts correspond to the early rise of English industry and commerce as a result of the Seven Years' War. His technical metaphors are necessarily rudimentary, and it remained for thinkers like Erasmus Darwin to build on the connections between the Sublime and modern science and industry. The Industrial Revolution gave impulse to the categories dimly projected by Burke, allowing grandiose visions heretofore unimaginable. There is something poignant in Burke's illustration of Virgil's description of Vulcan's cavern as the grandest passage in the

Aeneid: "Three rays of twisted showers, three of watery clouds, three of fire, and three of the winged south wind; then mixed they in the work terrific lightnings, and sound, and fear, and anger, with pursuing flames." This strange composition, formed and shaped by Cyclops's hammer, anticipates the later descriptions of ironworks. In 1784 the French mineralogist, Faujas de St. Fond, visited the Carron Ironworks, founded in 1759 to supply the British army with "huge guns," and gave this description of the famous workshops:

Amongst these warlike machines, these terrible death-dealing instruments, huge cranes, every kind of windlass, lever and tackle for moving heavy loads, were fixed in suitable places. Their creaking, the piercing noise of the pulleys, the continuous sound of hammering, the ceaseless energy of the men keeping all this machinery in motion, presented a sight as interesting as it was new. There is such a succession of these workshops that the outer air is quite hot; the night is so filled with fire and light that when from a distance we see, here a glowing mass of coal, there darting flames leaping from the blast furnaces, when we hear the heavy hammers striking the echoing anvils and the shrill whistling of the air pumps, we do not know whether we are looking at a volcano in eruption or have been miraculously transported to Vulcan's cave where he and his cyclops are manufacturing lightning.[25]

Clearly, the Industrial Revolution made ancient mythology plausible and provided artists and writers with the means to update the myths with a peculiarly modern twist.

MacPherson

Burke, an Irishman, claimed that the appearance of James MacPherson's Ossianic poems evoked from his fellow citizens the cry that "we have always heard them from our infancy." But when he tested this claim on individuals no one could repeat the original of any one paragraph of the so-called translation. Nevertheless, Irish scholars would claim the bard Ossian as one of their own and add to the controversy surrounding the publication of the Celtic songs by the Scot author.

MacPherson was a writer and journalist, a member of Parliament, an agent for an Indian prince, a government hack, and a prosperous citizen who founded his fortune on the Ossianic poems published at the age of twenty-five.[26] He declared that this youthful work was translat-

ed from Gaelic fragments found in his native Scottish Highlands. Its extraordinary reception brought him an international reputation and continued to exert its appeal on the cultured classes of Europe through the early years of the nineteenth century, exciting the enthusiasm of a Goethe, a Byron, and a Napoleon.

In the late 1750s it was rumored out of Edinburgh that the songs of an ancient bard, as great as Homer, had been discovered in the Highlands. Fragments of an epic were often to be heard in the past, telling in mournful verse of the battles of Fingal, a glorious king, and the woes of Ossian, his son, who was left old and blind, to lament the friends and memories of his youth. He lived late in the third century, a time when the Romans invaded the North. The songs of Ossian spoke of the joys of battle, the glory of the victors, the desolation of the conquered, and of a region enveloped in fog and storm. Later, the chiefs of the various clans maintained bards to keep alive the martial spirit of their ancestors by commemorating their deeds. They looked back to Ossian, the last of the ancients, with reverent affection.

MacPherson gathered fragments of the songs from the district of Badenoch, in Inverness-shire, where he managed a school and heard the fragments commonly recited. His collection was brought to the notice of the dominant elite in Edinburgh who were delighted to find the heroic poems in the unexplored regions of their own country. Ossian became for these conservative Scots a poet who could rank with the great masters of the ancient world, and thus a symbol of Scottish nationalism in particular and of British nationalism in general.

Almost immediately after their enthusiastic reception, however, the authenticity of the poems was suspected; and this gave rise to a raging controversy with which MacPherson's name was forever after associated. The unity he gave the poems, their orderly rhythm and polish, the unification of crude fragments in the form of a regular epic composed by Ossian aroused suspicion, and ultimately it became clear that MacPherson had perpetrated one of the great hoaxes of the eighteenth century by weaving the bits and pieces with figments of his imagination.

But the extent and degree of the attack on MacPherson was politically motivated; it came from the Whig opposition who resented the growing influence of Scotspeople in the government of George III. Indeed, the foremost

patron of MacPherson was Lord Bute, who maintained a profound interest in the poems.[27] Attacks from Whigs induced the Tories to put Ossian on a higher level than Homer; MacPherson was branded as an imposter by some, as a hero by others. But everyone read the poems.

Why the poems should have been so popular during the rise of neoclassicism is a problem that remains to be solved. The Ossianic tales are gloomy and melancholy, hardly the appropriate mood for the victors of the Seven Years' War although consoling for the parents and widows of the wasted youth on Europe's battlefields. But the peculiar melancholy of the Ossianic poems related to nostalgia for the heroic exploits of ancient warriors and was bound up with current interest in the Highlands. The songs resurrected the passions of the Jacobite Rising of 1745 and reinforced the drive of George III and Lord Bute to find support among the Scottish Catholics. The same forces that propelled Robert Adam, Sir William Hamilton, and others operated in behalf of MacPherson.

MacPherson began and ended his career writing in the service of the reigning elite. One of his earliest poems, *On the Death of Marshal Keith*, was about a popular Jacobite refugee who died in the service of Prussia during the Seven Years' War. Deeply admired by Scots, Keith symbolized the absorption of Jacobite passions into support of the House of Hanover and promotion of its economic and cultural agenda. MacPherson also wrote a piece commemorating an officer friend who died in the storming of Quebec. His combination of Scottish nationalism and Tory politics endeared him to the Scottish elite, including John Home, Adam Ferguson, and Hugh Blair, the literary critic and theologian who supervised the publication of MacPherson's first Ossian work, *Fragments of Ancient Poetry*. Adam Smith and David Hume vouched for its authenticity, and it was clear that MacPherson's supporters were Scots who backed George III and were eager to demonstrate to the English their cultural potential as well as their strengths in the realm of politics, science, and industry.

MacPherson's most significant support came from the Tories, especially Lord Bute who took an active interest in the Ossian enterprise and subsidized the publications from the start. *Temora*, brought out in March 1763, was dedicated to Lord Bute who covered its expenses. Considering the closeness of this date to the signing of the Treaty of Paris which Bute negotiated, it is hard to resist

making a connection between George III's policies and the Ossianic lore. Two years later MacPherson published the collected poems under the title, *The Works of Ossian, Son of Fingal*, again dedicating his work to Lord Bute whom he likened to Ossian whose "share of reputation" has been withheld due to "prejudiced times."[28] This was clearly meant to imply that the unpopular prime minister could only be appreciated at a future date in a less-prejudiced climate. Lord Bute could identify with the neglected Celtic hero who now stood for both Scottish nationalism and Tory politics. The passionate melancholy of Ossian's songs evoked the nostalgia of the aristocracy for older hierarchical social structures unthreatened by dissenting voices and republicanism. In addition to Scot aristocrats, Lord North, the abbé Cesarotti— who translated Ossian into Italian—and Chateaubriand represented the kind of conservative mind to whom MacPherson's writings appealed.

Hugh Blair's introduction to the *Works of Ossian* indicates why. He claimed that the ancient Celts enjoyed a government that "was a mixture of aristocracy and monarchy," typical of the form wherever the Druids predominated. The legislative power was entirely in the hands of the Druids, and it "was by their authority that the tribes were united, in times of the greatest danger, under one head." The heroes of the Ossianic songs "carried their notions of martial honour to an extravagant pitch," needing no assist from Gods as in the Homeric sagas.

The Celtic peoples preserved the exploits of their king in song transmitted to posterity by the bards. His heroic actions were magnified, and the populace was dazzled by their propaganda. This led to a process of emulation and formed at last the general character of the English nation, "happily compounded of what is noble in barbarity, and virtuous and generous in a polished people." Moreover,

When virtue in peace, and bravery in war, are the characteristics of a nation, their actions become interesting, and their fame worthy of immortality. A generous spirit is warmed with noble actions, and becomes ambitious of perpetuating them.[29]

Eventually, the exploits were suffused and varnished over with mythical elements, and later generations placed the founders of their families among the heroes. It is this vanity to which contemporaries owed the preservation of what remained of Ossian's work.

Every chief had a bard in the family to record the connection of their patrons with their noble ancestors. These poems were repeated to the whole clan on solemn occasions and thus established and perpetuated the antiquity of the families. The descendants of the Celts, who inhabited the British Isles, could thus be compared with the ancient Greeks who couched their laws in verse and handed them down by oral tradition. Blair observed that it was the historians of ancient Greece and Rome that transmitted "their great actions to posterity." While the great actions of other nations are involved in fables or lost, those of Rome and Greece still enjoyed "unrivaled fame." On the other hand, the Celtic nations are an example of historical omission and neglect. He lamented that "the British, who have carefully traced out the works of genius in other nations, should so long remain strangers to their own." Thus Blair spelled out for us the meaning of Ossian for the cultured elite in the aftermath of the Seven Years' War: Ossian provided the indigenous counterpart to the Homeric epics, a homegrown farrago of heroic ardor and central authority beloved of the Tories who ascended to power with George III. Lord Bute's patronage of MacPherson was not fortuitous: his personal nostalgia for an ancient epoch of warrior directness and aristocratic control found an outlet in his fascination for Ossian.

Ossian would become the Northern equivalent of Homer and thus the English counterpart to the Grecian bard—an epic writer appropriate to the nation's new vision of itself as an empire equal to those in antiquity. In this sense, MacPherson's popularity could be likened to that of Benjamin West who was also looked upon as a homegrown response to European cultural hegemony. MacPherson in fact did a translation of the *Iliad* (1773) in the manner of *Fingal*, and one critic claimed that he paraded "Homer in a plaid and a kilt." It is clear from Blair's introduction to *The Works of Ossian* that the English were excited about the possibilities of this prehistory which gave them an epic akin to the Homeric. A strange pathos surrounded the blind singer in an antique age who bewailed his fate as the last of a race of heroes. In some ways, Ossian spoke to moderns who harked back to ancient Rome in search of ancestral roots. The vague, gloomy scenes of Ossian could fill the historical and imaginative interval between ancient Rome and modern England.

As a political writer working for the government,

MacPherson projected the Tory point of view and provoked the resentment of the Whigs. This was the case of *The History of Great Britain, from the Restoration to the Accession of the House of Hannover* (1775), based on documents collected by Jacobite partisans. At the same time, the court employed him to supervise the newspapers and to use his influence to prevent attacks on the government. In 1776 he wrote the pamphlet *The Rights of Great Britain Asserted against the Claims of America* in which he compared Great Britain to a "Guardian Angel" whose "parental indulgence" had now been spurned by the ungrateful colonies. The work went through many editions and proved to be one of the most popular pamphlets of the war. For his services the government paid him generously; he became wealthy and commissioned Adam to design a handsome villa for his estate on the banks of the Spey near his native village.

While Ossian excited the interest of painters and poets during the late eighteenth and early nineteenth centuries, only two major projects involving this subject occurred near in time to MacPherson's publications.[30] One was a scheme for an exhibition of paintings illustrating the works of Ossian. A new building was to be constructed in central London, and well-known artists were to be commissioned. Elaborate calculations were made to prove that it would be a highly successful investment for surplus capital. Although it never materialized it anticipated similar, entrepreneurial ventures like Boydell's Shakespeare Gallery and Fuseli's Milton Gallery. Another planned cycle of pictures on the theme was carried out by the Scot artist Alexander Runciman for the country seat of Sir James Clerk at Penicuik House (1771–1773) near Edinburgh. The program also included a series of scenes from the Life of St. Margaret, a queen of Scotland in the thirteenth century. The Clerks were a noble family who gained their fortune as merchants, although James's father, Sir John, had been a magistrate and economist of distinction. An ardent Anglophile, he played a leading role in the negotiations for the Union of 1707. His sons became merchants who hoped to launch a Scottish national school of painting, yet at the same time they were royalists loyal to George III.

MacPherson's poems in fact attest to an upsurge of Scottish nationalism as centered in the intellectual and scientific circles of Glasgow and Edinburgh. Interest in Scottish history and in folk songs and legends had been

growing from the time of the Act of Union (1707), which had dealt such a crushing blow to Scottish pride and independence. This concern became more introverted and sentimental after the abortive uprising of 1745 by the Jacobites supported by the French. A wave of nostalgia for the primitive past popularized Ossian's production, and his poems were received with tremendous enthusiasm. Scotland and the subsequent controversy that raged over their authenticity only enhanced their popularity. It became a point of national honor to defend the translations. At the same time, the union had promoted the economy of Scotland which now began to assert itself. Its alkali and textile industries, coal and iron production, and agriculture had grown significantly, and the universities at Glasgow and Edinburgh made remarkable contributions to science and industry. It is in this context that prominent Scottish citizens encouraged MacPherson and financed his tour of the Highlands and the publication of his books. It should be recalled that during this same period James Watt, another Scot, was developing his theories of the steam engine at the University of Glasgow together with his friend, the famous chemist Joseph Black. The same historical forces giving rise to the nationalism expressed in the Ossian poems also encouraged Watt's special talents.

Like Homer Ossian is blind, but his world is gray and lunar as opposed to the sunny climes of Greece. The moon is a recurrent motif in the Ossian poems; in the Northern climes, where the nights are long, people are more aware of the moon. Its regularity in the poems creates the lunar mood which so struck the younger generation of poets and artists. The shield of a warrior is like "the darkened moon when it moves a dun circle through the heavens." The face of a ghost, wan and pale, resembles "the beam of the setting moon." And another ghostly appearance, this time indistinct, is like "the new moon seen through the gathered mist, when the sky pours down its flaky snow, and the world is silent and dark." The soul of the guilty Uthal is "dark as the troubled face of the moon, when it foretells the storm." The moon waxes and wanes with alarming regularity, and allusions to the dark side of the moon suggest more than mere metaphorical application of the lunar orb.

It is not only the moon but clouds, storms, meteors, blinding flashes of lightning, fog, and mist that contrib-

ute to the mood of the poems: meteorological similes are pervasive and are quite sophisticated, like Ossian's comparison of an approaching army to "stormy clouds, when the wings roll them over the heath; their edges . . . tinged with lightning." Warriors follow their chiefs "like the gathering of the rainy clouds behind the red meteors of heaven," while a retreating army is likened to "clouds, that having long threatened rain, retire slowly behind the hills." The first appearance of Fingal is likened by Ossian to a meteor, and elsewhere the "valley gleams with red light." It is clear that MacPherson was as involved in the current investigations of the moon and meteorological phenomena as many of his scientific contemporaries.

Ossian appealed to the "moonstruck" generation of artists and writers concerned with reconciling art and science, art and progress. It is curious to find in the poems no mention of crafts other than navigation and ironworking in which the people of Morven excelled. It is hard to escape the conclusion that trade and industry are here glorified along with recent scientific interest in meteorology. Thus, contrary to conventional notions, the vogue for Ossian had more than aesthetic and primitivizing implications. The sense of melancholy and pessimism pervading the poems blur mundane reality to stimulate imaginative fancy and new conceptual possibilities. The style itself is as spare as Hemingway in a later period, machine-made, rapid, concise, mechanical, and clean-cut. While the outline of content is blurred, the means by which this is achieved—the textual form—is sharply delineated. Here is an example: "Crommaglas, of iron shields! Struthmor, dweller of battle's wing! Cromar, whose ships bound on seas, careless as the course of a meteor, on dark-rolling clouds!" Or again: "Rise, moon, thou daughter of the sky! look from between thy clouds; rise, that I may behold the gleam of his steel on the field of his promise. Or rather let the meteor, that lights our fathers through the night, come with its red beam, to show me the way to my fallen hero." Or again: "Dunthalmo heard the sound of our approach. He gathered the strength of Teutha. He stood on a hill with his host. They were like rocks broken with thunder, when their bent trees are singed and bare, and the streams of their chinks have failed." "The heroes move with their songs. Oscar slowly ascends the hill. The meteors of night set

on the hearth before him. A distant torrent faintly roars. Unfrequent blasts rush through aged oaks. The half-enlightened moon sinks dim and red behind her hill."

MacPherson's work is short on philosophical ideas and presents an array of images set in the lunar landscape. The sentences are short and simple but somewhat confusing by the farrago of names and places without explanatory descriptions. The figures and places lack substance and move like shadowy ghosts through the landscape, appropriate to the mood. The poems are related by Ossian the narrator, singing the saga of his friends and his son Oscar, but especially of his father Fingal, the main protagonist of the cycle. He tells these tales in the company of Malvina, his only companion, the betrothed of his son Oscar. Fingal rules over the kingdom of Morven, and his rival is Starno of Lochlin whose warriors are the traditional enemies of Morven. The stories are about battles and unhappy loves. Some of these themes have a decidedly classical connection; father and son square off in battle, a maid is grief stricken by the fact that her brother and love have killed each other. But very little is given of the warriors' habits or way of life. They lack a family and material existence. Except for the helmet worn by Fingal decorated with an eagle's wing, little description of costume is conveyed. There is no sense of their dwellings or religion. The landscape is bleak and grief is the main emotion; everything points to the instability, the utter futility of life. Ironically Ossian, who incarnates this mood, longs for what seems to him a happier past, when chivalrous, generous sentiments and heroic deeds governed people's actions.

Ossian's warriors are the Northern counterpart of the noble savage. Fingal has all the Boy Scout virtues; maidens are virginal, warriors are noble, enemies implacably villainous. MacPherson elevates emotion over reason, extols the honesty of the primitive person, emphasizes the landscape, and wallows in melancholy. This formula had an incredible appeal to the English artists Flaxman, Blake, Fuseli, Kauffmann; and to the French Gros, Gérard, Girodet, Ingres; and to the German Runge, Carstens, and Friedrich. *Carthon*, one of the poems, was translated into French as early as 1762, and the collected works followed suit in 1777. Diderot and Voltaire loved them. Napoleon became a fervent admirer after he read the poems in the Italian translation by Cesarotti (1763). In Germany and the Scandinavian countries Ossian as-

sumed an added importance as a link to their Nordic heritage. *Fingal* was translated into German in 1764, the collected works in 1768–1769, into Danish in 1790, and into Swedish during the years 1794–1800. Herder, Goethe, Klopstock, Lenz, and Schiller—the heroes of Storm and Stress—as well as the North German poets Claudius and Kosegarten were all influenced by Ossian. Herder praised the Ossianic songs as a magnificent discovery; Klopstock, who considered Ossian German, wrote patriotic odes in MacPherson's style, and Burger turned some of the poems into verse. Goethe attempted a translation of the poems, and their influence is seen in *The Sorrows of Werther*. To illustrate Werther's passionate feelings at the crisis of the tale, Goethe made him turn from the clear healthy world of the Homeric heroes to the cloudy scenes of Ossian's "Songs of Selma."

In England Blake, Coleridge, Byron, and Scott all caught the Ossianic fever, rendered all the more susceptible by Burke's *Sublime and Beautiful*. They incarnate the modern attitude to nature, summed up in Byron's declaration: "High mountains are a feeling." Burke certainly contributed to the success of *Ossian*, which was heralded everywhere as the epitome of the *sublime*. The gloom, the fantastic meteorological effects, the rugged landscape, roaring winds and waves, nocturnal thunder and lightning and moonlit scenes, raging fires and dazzling sunlight seemed to exemplify his categories. The work of MacPherson and Burke provided the conceptual and imaginative framework for the English artists who emerge from the ranks of the neoclassicists but take off on a more eccentric path than their orthodox colleagues. I shall call these the neoclassic *experimentalists*.

Barry

One of them was the Irish James Barry (1741–1806) whose career was subsidized by Burke.[31] Early inspired by the *Sublime and Beautiful*, it is not surprising to find Barry rendering Burke's favorite literary models, Milton and Job. He also drew for inspiration upon the plays of Shakespeare: his striking *King Lear Weeping over the Body of Cordelia* depicts the protagonist as a Nordic collossus suffering the anguish of mortal despair (fig. 3.7). The wind roars through his streaming hair and majestic beard while lightning flashes illuminate the scene. It is not fortuitous that the French painter Girodet turned to Barry's

conception (the work was etched) for his Fingal in the *Death of Comala,* a youthful fantasy steeped in Ossianic gloom and lunar melancholy. Barry deviated from straight neoclassic models in squeezing his heroic figures in a constricted space which heightens their monumentality and psychological tension. He shared this trait with other *experimentalists* like Fuseli, Blake, and Flaxman, whose enormous figures often strain against the confines of the picture space.

Their originality, like that of Burke and MacPherson, was stimulated by the changing economic and industrial picture. Barry, whose father ran a tavern in Cork and carried on a coastal trade between Ireland and England, was forever mindful of the economics of art production. His first public success was a sign for his father's tavern showing a figure of Neptune on one side and a ship of war on the other. Later, he launched his career by exhibiting in the Dublin version of the Society for the Encouragement of Arts, Manufactures, and Commerce. After moving to London in 1764 he attended Shipley's drawing school of the London Society for the Encouragement of Arts, Manufactures, and Commerce, and studied from the casts in the duke of Richmond's gallery.

He was also initiated in neoclassic doctrine at this time; Burke had arranged a job for him with James ("Athenian") Stuart, who, with Nicholas Revett, had published in 1762 the first volume of *The Antiquities of Athens*. Under Stuart's direction, Barry copied in oils several watercolor views of Athens. In addition to sketching casts, he

3.8 James Barry, *The Phoenix or the Resurrection of Freedom*, published December 1776, etching and aquatint. Reproduced by courtesy of the Trustees of the British Museum, London.

also studied compendia of engravings like that of Caylus. In 1765 Burke and his cousin Will financed Barry's Grand Tour, and eventually the young artist gravitated to the English colony in Rome and the circle of Jenkins. Here, however, his dissenting political views and paranoid behavior led to a falling-out with the Anglo-Roman community and ultimately with the mainstream neoclassicists and their patrons.

During the next decade, Barry executed a variety of works including allegorical prints relating to the American Revolution (with which he sympathized) and the decorations for the new location of the Society for the Encouragement of Arts, Manufactures, and Commerce. His etching of *The Phoenix or the Resurrection of Freedom*, published in December 1776, bore a legend that implied that Liberty had made a transatlantic crossing from England to America (fig. 3.8).[32] Mourners assemble around the bier of Britannia while in the background the Three Graces dance before the Temple of Liberty now on America's shore. Among the mourners are Algernon Sidney, who had been executed by Charles II for his republican ideals, a disgusted John Locke brooding over his writings on government, a manacled figure alluding to the government's attempt to suspend the habeas corpus, and Barry himself. This foreground scene is cast in gloomy shadow while the background is bathed in bright sunlight. Typical of the experimentalists, Barry makes darkness—in both its sublime and Ossianic modes—a symbolic opposite of the "enlightened" classical world

and its presumed heritage and points up the political upheavals in the contemporary world. The following year Barry published *Job Reproved by His Friends* which he dedicated to Burke. Here Job stands for the English nation whose acts have brought ruin on its people; in the background a dead victim is carried off like a warrior fallen in battle. The nation's friends, composed of Burke and his companions, admonish the afflicted country to change its ways. Again he manipulates sharp light and dark contrasts to dramatize the event and signify Divine Retribution.

Yet in the same year as the *Job* Barry began work on a historical cycle which openly proclaimed English economic and cultural supremacy and flattered the aristocracy. He could not separate his sense of himself as a historical painter of the sublime from royal and aristocratic patronage. Accordingly, he took it upon himself to decorate the Great Room in the new building of the Society for the Encouragement of Arts, Manufactures, and Commerce constructed by Robert Adam in the Adelphi complex. Originally, the society wanted its scheme executed by a group of mainstream neoclassicists like Kauffmann, West, Cipriani, and Dance, and experimentalists like Barry, Mortimer (a leading graduate of Shipley's art school), and Wright of Derby, but the majority of the artists voted to reject its offer. Barry subsequently proposed his own project, which meant practically working for free—a measure of his ambition. Blake, who admired Barry, pointed to the contradictions of this commission in his annotations to *The Works of Sir Joshua Reynolds* (also one of the original group):[33]

Who will Dare to Say that Polite Art is Encouraged or
Either Wished or Tolerated in a Nation where the
Society for the Encouragement of Art Suffered Barry to
Give them his Labour for Nothing, A Society Composed of
the flower of English Nobility & Gentry—A Society
Suffering an Artist to Starve while he Supported Really
what They under Pretence of Encouraging were
Endeavouring to Depress.—Barry told me that while he
Did that Work, he Lived on Bread & Apples.

Barry's program, which set out to demonstrate that both individual and public happiness "depends upon cultivating the human faculties," charted the triumph of British commerce and civilization beginning with its cultural roots in ancient Greece. By so doing, he hoped also

to personally challenge Winckelmann's claim that the English were incapable of producing works of "genius."[34] Not surprisingly, he managed to work into the series portraits of himself, Shipley, and Burke and a representation of Ossian playing his harp. Two of the pictures related to the specific interests of the Society for the Encouragement of Arts, Manufactures, and Commerce: the first was an allegorical scene of *Commerce, or The Triumph of the Thames*, and the second *The Distribution of Premiums in the Society of Arts*. In *Commerce* Father Thames is represented holding the mariner's compass whose invention was "superior to any thing known in the ancient world." British commerce connects the disparate parts of the globe, bringing together Europe, Asia, Africa, and America who pour their products "into the lap of the Thames." Here Barry drew for inspiration upon the seventeenth-century poet, Sir John Denham, quoting his "Cooper's Hill" which similarly celebrates the Thames. The trade carried on the river "makes both Indies our's," organizes the global environment, and extracts its wealth so that finally "to us, no thing, no place is strange, / While his fair bosom is the world's exchange."[35]

Father Thames is carried along by the English explorers Sir Francis Drake, Sir Walter Raleigh, Sebastien Cabot, and James Cook, while in the rear Nereids bear the products of Manchester and Birmingham to the four colonial centers and in turn receive fruit and wine from Europe, silk and cotton from Asia, furs from America, and slaves from Africa. Barry's dissenting political views did not permit an unqualified adoration of this state of affairs: he supported abolition and showed his "poor African . . . manacled with a halter about his neck, throwing his eyes to heaven for relief." He also depicted some Nereids sporting themselves wantonly to indicate that women have been "cruelly neglected" in English trade and domestic labor. Generally, however, Barry's picture praised the English system including a subsequent addition in 1801 of a naval pillar to honor British maritime victories in the recent wars.

The Distribution of Premiums salutes the society for its patriotic promotion and perfecting of the arts, agriculture, manufactures, and commerce. Barry's written account of the cycle noted that the society had been imitated in France and Spain, again alluding to English superiority. Seen at the far left of this picture is William

Shipley holding the founding instrument of the society, and next to him are the society's officers and members and distinguished visitors awarding the prizes for ingenious inventions and productions. They include the agrarian expert, Arthur Young, Samuel Johnson, the Prince of Wales resting one foot on a bale of cotton, the duchesses of Northumberland, Devonshire, and Rutland, and the earl of Percy. Edmund Burke, Barry's loyal friend and patron, is shown facing the audience at the right of a statue of a mother and child. In the left background may be glimpsed a display of mechanical inventions on desposit at the society, including a crane and loom.

The concluding work in the series, *Elysium, or The State of Final Retribution*, projects a heavenly realm for the "cultivators and benefactors of mankind." Here may be found Barry's selection of the Great Men of History, philosophers, scientists, theologians, statesmen, explorers, writers, and artists. Barry depicted Ossian in center background and near the topmost point of the figural groupings. He took note of the controversies surrounding the Celtic bard, but suggested that simply on the basis of the *Fingal* and the *Tempora* "which the ingenious Mr. MacPherson has published in his name, it is certain he would do honour to any company to which he might introduce him."[36] Barry, however, made one critical change: he portrayed Ossian as an Irish poet with Irish harp and black hair.

Barry's cycle for the society and its inclusion of Shipley, Burke, and Ossian demonstrate the close connections between the neoclassic experimentalist, the literature devoted to the sublime, and the institutional framework for the promotion of science and industry. This pattern holds true for the other experimentalists as well. In his section on the painters shown in the *Elysium*, Barry referred to gifted contemporaries not depicted but nevertheless quite capable of serving the nation should enlightened patronage provide them an opportunity to work on an important historical project. Among this handful he included "the masterly Wright of Derby" whose work is now seen as the very incarnation of the ideology of the nascent Industrial Revolution.[37] His nocturnal scenes and grandiose effects were almost always carried out in the interests of science and technology. Wright aimed for clarity even when depicting lunar scenes. Just as his contemporaries in science and industry

were probing the facts of the physical world, so he aimed at bringing art into alliance with empirical observation. Thus he began as a neoclassicist, sharing with its proponents a clear, linear grasp of subject based on archaeological and scientific findings. He represents another link in the bond between neoclassicism and the Industrial Revolution.

Wright of Derby

Born in Derby, Wright was the son of a solidly middle-class attorney whose ancestors numbered many professional types.[38] He studied under Reynolds's teacher Thomas Hudson, a fashionable portrait painter, and young Wright started his career doing portraits of relations and friends in Derby. He first exhibited at the Society of Artists in 1765 and thereafter regularly until 1776. Wright started on his Grand Tour somewhat belatedly in 1773, arriving in Rome the following year. In a letter dated 4 May 1775, he observed that the Grand Tour had become so fashionable, "and the English cavaliers so profuse with their money, that the artists suffer for their prodigality." He took apartments in the inevitable Piazza di Spagna and devoted much of his time to copying the antique in the galleries and museums. He filled sketchbooks with outline drawings of famous statues, especially in the Capitoline Museum. This was the first public museum of antiquities in Europe, founded in 1734 under Pope Clement XII who had acquired part of the Albani collection.

Wright calculated as shrewdly as Reynolds and kept close accounting of his sales. Once he let a picture go at a lower rate because he needed the money for a mortgage payment, and he requested that the patron never mention the bargain price "as it might much injure me in the future sale of my pictures, and when I send you a receipt for the money I shall acknowledge a greater sum." His career unfolded in the provincial areas of the Midlands, one of the centers of the Industrial Revolution and close to other manufacturing centers in Birmingham and Lancashire. He worked for members of the Lunar Society, and in this capacity his style and content spoke for the broad interests of that group. His patrons comprised scientifically minded nobles as well as the industrial and mercantile classes; a few derived from the country gentry or "squirearchy," especially those of recent origin. He

3.9 Joseph Wright of Derby, *Two Girls with Their Black Servant*, c. 1769–1770. Courtesy of the Heirs of Oliver Vernon Watney.

himself owned property and rented his land to laboring tenants. In the 1770s he was well connected with Liverpool merchants, many of whom were involved in the slave trade. Liverpool would remain his base, supplying him with bread-and-butter commissions from leading merchant dynasties like the Ashtons, the family of a prosperous slave trader and shipowner. Wright painted his daughter-in-law, *Mrs. Nicholas Ashton*, shown reading James Thomson's *Seasons*, with the page open to the section on "Spring." Thomson's poems, which celebrated English patriotism and maritime supremacy, appealed deeply to the ruling classes of the time and provided inspiration for a number of visual artists and writers. Wright's group portrait of *Two Girls with Their Black Servant* points to the Liverpool milieu, identified further by the backdrop vignette of a ship at sea (fig. 3.9). Typically, the black is shown in an inferior position, kneeling before the white children and offering them a basket of flowers. A bond of sympathy clearly exists between the sister at the left and the kneeling servant, but their social differentiation is clearly marked. While Reynolds flattered with classical allusions the aristocratic or wealthy middle-class people of London, Wright's merchants and factory owners are proud of their own achievements: the characteristics of hard work, thrift, and reliability have been appropriately rewarded by prosperity and social respectability. Here there is no need for decorous modesty, and Wright's own outlook—rooted in the same socialization process—is similarly manifested in a style that is spare and carefully worked. Wright kept neat account books and approached his work in a methodical and workman-like manner. *In this sense, Wright would do for the Industrial Revolution what David did for the French Revolution.*

Wright, however, differs in one fundamental formal feature from his neoclassic colleagues and that is his interest in the scientific study of light and especially of artificial light effects. It is the introduction of novel light effects that often conveys the character of the experimentalists, and this is why Wright, with his peculiar combination of hard and polished style and astonishing illumination, is difficult to locate in the traditional stylistic categories. Wright's interest in light reflects his contact with the members of the Lunar Society including Wedgwood, Boulton, Darwin, and other founders of industry in the Midlands like Richard Arkwright, one of the rich-

est cotton manufacturers in England, all of whom sat for Wright. While he knew the candlelight scenes of earlier artists like De La Tour and Honthorst, and certainly the dramatic tenebrism of Caravaggio, his interest is different. Their light is used to heighten a religious experience, and in the case of Caravaggio derives from stage lighting appropriate to the theatrical needs of a counterreformation ideology. Wright's light, both natural and artificial, is deployed consistently in a secular, scientific context.

One of Wright's earliest subject pictures was *Three Persons Viewing the Gladiator by Candlelight* (mid-1760s), which puts into proper perspective his neoclassic experimentalism (fig. 3.10). In a spare setting three men in an art academy view by candlelight a statuette of the *Borghese Gladiator* now in the Louvre. The central figure holds up his sketch of the statue, matching it against the original. The attention of all three is riveted to this action and heightened by the light which picks out their faces in the darkness. In this murky, silent sanctuary the antique appears more alive than the absorbed onlookers. Wright repeated this theme at the end of the decade with his *An Academy by Lamplight* which relegates the *Gladiator* to a minor position in the background while centering on another well-known statue, *Nymph with a Shell* (fig. 3.11). A concealed lamp flashes dramatically on the statue, again blurring the distinction between art and reality in a shadowy interior. This effect may be compared to a fa-

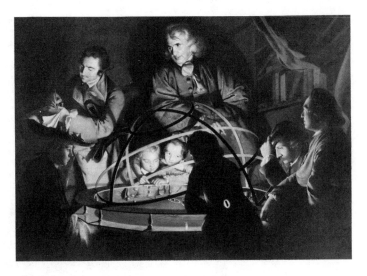

vorite game of Towneley, who located lamps in his gallery to dramatize the marble statuary and create an illusion of the past. Wright's two works demonstrate a scientific approach to antiquity and art (a copy of the *Gladiator* belonged to the duke of Richmond and was highly prized for its anatomical rendering), submitting the objects to prolonged scrutiny under the glare of a relentless spotlight. Their content is not neoclassical but derives from the cult of antiquity which he examines in a pedagogical and scientific context.

During the interval between these two pictures Wright painted *Philosopher Giving a Lecture on the Orrery*, where modern science stood comparison with antiquity in its capacity to enchant and inspire intense commitment (fig. 3.12). The orrery could be compared to a miniature planetarium which represented the relative positions and motions of the moon and planets. Originally designed by a mathematical instrument-maker from Lichfield for Charles Boyle, fourth earl of Orrery, who played the part of patron and encouraged its use, the mechanism was designed to illustrate Copernican principles, the diurnal and annual motions of the earth, the motion of the moon, and the heliocentric orbits of the planets. Later, it became an instrument to popularize the study of astronomy. In Wright's picture children and adults watch in rapt fascination as the demonstrator discusses Newton's principles of the universe. Again, a bright light—here representing the sun in the center of the solar system—intensifies the sense of concentration by illuminating the faces

in the darkness. Perhaps not fortuitously, the various positions of the spectators' heads move in an orbit of their own and appear as phases of the moon. In canto 2 of "The Economy of Vegetation" Darwin versifies the scientific drama enacted pictorially by Wright:

So mark'd on orreries in lucid signs,
Star'd with bright points the mimic zodiac shines;
Borne on fine wires amid the pictured skies
With ivory orbs the planets set and rise:
Round the dwarf earth the pearly moon is roll'd,
And the sun twinkling whirls his rays of gold.[39]

Wright's motif was known as a "grand orrery," a device for teaching astronomy to the uninitiated when this study was no longer the exclusive province of a chosen few. The orrery was rotated with a crank attached to a clockwork mechanism and often surmounted by an armillary hemisphere composed of elliptical bands. The horizontal calendar ring fixed to the base represents the plane of the ecliptic through which the earth moves, and on it are inscribed the zodiacal signs and the months of the year. The elliptical bands represent the Equator, the tropics of Cancer and Capricorn, the solstitial colures intersecting each other at the poles, and an adjustable horizon. All of these components were scrupulously reproduced by the painter.

In Wright's picture the lecturer dictating to the note taker is John Whitehurst, a renowned clockmaker and geologist from Derby. He was a close friend of Darwin and Wedgwood and attended Lunar Society meetings. Wright painted a portrait of him seated next to a window through which we glimpse a smoldering Mt. Vesuvius; on his drawing board is a sketch of a section of rock strata in Derbyshire which he prepared for his book *Inquiry into the Original State and Formation of the Earth.* These accessories allude to his geological interests and identify him as a follower of Hutton. Whitehurst was also an ingenious clockmaker fascinated by orreries, which required a complicated system of escapements, wheels, and gears (fig. 3.13). The person receiving the dictation in the picture was a cartographer named Burdett who often counseled Wright on the scientific features of his work. He was also involved with members of the Lunar Society and once intrigued Wedgwood and Bentley with a method of etching on pottery which would reproduce the tonal range of a one-color wash.

Burdett was also a close friend of the patron who bought the picture, the fifth earl of Ferrers. Lord Ferrers was a Fellow of the Royal Society and an astronomer and mathematician who made pioneering observations on the transit of Venus. A family tradition holds that the enraptured boy at the left was a nephew of Lord Ferrers, indicating that science continued to be an important part of the young noble's education. But the predominantly middle-class milieu of the picture demonstrates that this study was being made available to a wider audience irrespective of social and educational background.

Wright's *Orrery* is more than just a genre composition; it is a sociological document about the role of science and its diffusion through industrial society in the early stages of the Industrial Revolution. Whitehurst, for example, is a classic case of how the traditional skilled craftsperson became an engineer; the clockmaker's skills and tools were turned to cutting gearwheels for the mechanism of early machinery. Whitehurst was consulted in almost every undertaking in Derbyshire and surrounding counties where skill in mechanics, pneumatics, and hydraulics was required. Boulton and Watt consulted him on a plan to mass produce clocks, and he certainly contributed to their development of engineering technique.[40] Eventually he was elected to the Society of Civil Engineers. Wright's painting exemplifies the interplay between science, craft, and industry in the second half of the eighteenth century. At the same time, it points to the progressive character of this interaction in cutting across the class system to encompass the aristocratic scientist, middle-class artisan, and industrialist. While the pictures celebrate the interests of the patron, it magnifies the posi-

3.13 Diagram of an Orrery, from James Ferguson, *Select Mechanical Exercises*, London, 1790, plate 7.

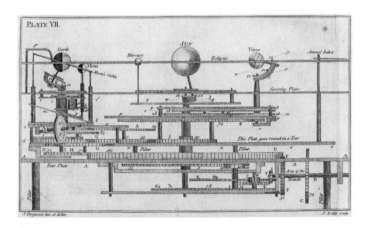

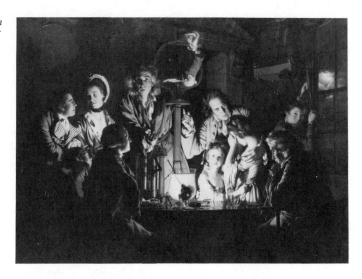

3.14 Joseph Wright of Derby, *Experiment with an Air-Pump*, 1768. Reproduced by courtesy of the Trustees, The National Gallery, London.

tion of the artisan who holds forth in the center like a Belisarius or Socrates.

The interface between science and industry in this period is developed further in Wright's *Experiment with an Air-Pump* of 1768 (fig. 3.14). This work provides a striking instance of how science was diffused throughout the country and made accessible to the larger society. Wright's art promoted this relationship, and he profited from it exactly like the contemporary industrial entrepreneurs. The air pump was one of the most popular scientific instruments of the eighteenth century, and while it was used seriously to study the property of gases it had a high entertainment value. Priestley, for example, claimed he used it for instruction, experimentation, and for the "entertainment" of pupils. Wright also manifests the popularizing tendency of the Lunar Society, making science entertaining and absorbing for a diverse audience.

It was widely recognized, if not fully understood, that air relates to respiration, and various experiments were carried out with the air pump to demonstrate the effect of a near-vacuum on animate and inanimate objects. Air was exhausted from the large glass bowl known as the receiver, and whatever creature—fowl, cat, rat, mouse, or bird—would be inserted inside the bowl would cease to function normally through lack of oxygen. James Ferguson, a well-known public lecturer at the time, noted in his *Lectures on Select Subjects* (2d ed., 1770) that to carry this experiment to its "bitter and cruel" culmination "is too shocking to every spectator who has the least degree

of humanity . . ." At the end of the experiment, however, air could be readmitted by a simple mechanism at the top of the receiver. This is the subject of Wright's *Experiment*: before a mixed audience of adults and children a lecturer is shown on the verge of reintroducing air into the glass receiver so that a bird, seen at the point of expiration, will recover. The risks that the demonstrator has taken in delaying until the last moment has created a climate of unbearable suspense. A father tries to reassure his sorrowful children, while one hides her face in fright. Near the window at the right an apprehensive boy stands by to lower a cage in the event the bird revives. Adding to the atmosphere of anxiety is Wright's inevitable blanket of darkness punctuated by the light of a concealed lamp. Since the standing figures are lit from below, their facial features are etched deeply in shadow, most noticeable in the haggard face of the lecturer. Through the window the appearance of the full moon emerging from behind the clouds contributes another startling effect. As if in empathy with the bird, the central characters hold their breath in anticipation.

Wright has achieved a threshold effect in which all the actors in the picture appear on the brink of discovery. It is as if the air pump—dominantly located in the center and lovingly reproduced from an actual model—is about to yield a scientific breakthrough for each participant. Science and scientific innovation are shown as pressing on the frontier of new knowledge. The religious awe of older painting established through strong chiaroscuro has now been superseded by the awe of unlimited possiblities promised by moonlit science. Wright has deliberately employed the Burkean and Ossianic sublime in behalf of his subject to bathe it in an air of mystery and even of the macabre. It is true that science dispels mystery and superstition, but Wright confines it to the threshold of discovery to promote its appeal. Wright thus functions as a public relations person for new technical knowledge and its dissemination. Like the German Gustavus Katterfelto, who bewildered and entertained London audiences with a bag of magical and scientific tricks, Wright painlessly indoctrinated the public with the virtues of science and technology.[41]

The Itinerant Lecturer

If Katterfelto was more an entertainer (or "windbag" as a contemporary called him) than a scientist, he embodied

the approach of the more serious itinerant lecturer who spread scientific and technical knowledge to the hinterlands. Both the *Orrery* and the *Experiment* focus on the type of itinerant lecturer in natural philosophy who regularly visited the principal towns in the later eighteenth century. One of the most famous itinerant lecturers of the century, Adam Walker (1731–1821), had close connections with Manchester, where he founded a school in January 1762.[42] He and Whitehurst were fellow members of the London science club known as the Chapter Coffee House Society. In 1766 he purchased "the celebrated Philosophic Apparatus" of another lecturer, and thereafter proceeded to travel throughout the north of England, southern Scotland, and Ireland, lecturing on mechanics, hydrostatics, pneumatics, chemistry, optics, astronomy, electricity, and magnetism. His "kit" included not only astronomical equipment like the orrery and globes but also air pumps, telescopes, and electrical machine magnets as well as working models of cranes, water mills, pile drivers, steam engines, windmills, and canals like that of the duke of Bridgewater's. Walker kept abreast of the latest developments in mechanical construction and impressed Boulton with his collection of steam-engine models. He was also a friend of Priestley and other scientists, whose discoveries he publicized.

Another of these lecturers was John Banks, who gave presentations in Birmingham, Bolton, and Manchester.[43] Like Walker, he had an extensive experimental apparatus for illustrating the principles of mechanics. In addition to the usual philosophical and astronomical apparatus, including air pump and orrery, he had working models of various sorts of pumps and engines, so many, in fact, that he required a wagon to carry them from place to place. His *Treatise on Mills*, published in 1775, was subscribed to by many of the English major scientists and industrialists, including John Dalton, Joseph Priestley, Robert Owen, and John Wilkinson.

Closer to home, the itinerant scientist James Ferguson first published his public lectures in 1760, which includes a long section on the use of an air pump and a diagram of the mechanism that greatly resembles the model painted by Wright (fig. 3.15). He frequently used an orrery in his lectures, and it is not surprising to learn that he gave his course in Derby in 1762 and frequently visited Whitehurst with whom he exchanged papers and designs. It is not unlikely that he induced Whitehurst to take up the

3.15 Diagram of air pump mechanism, from the second edition of James Ferguson, *Lectures on Select Subjects*, published in 1770.

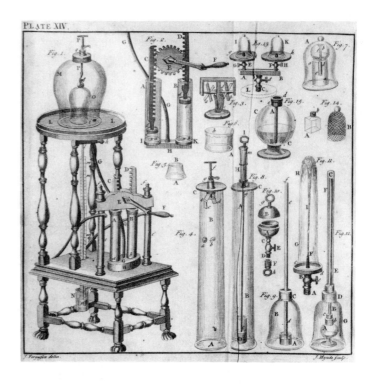

orrery; Ferguson's interest in the mechanism dated from the 1740s, and he not only made several versions but published his findings on the subject.[44] He was also in close touch with Priestley who admired him for his ability to popularize science.[45]

Some of the itinerant lecturers were more local figures, but their importance in the general pattern of scientific education has not been generally recognized. They took with them on their tours quite large collections of working models and scientific apparatus. Like Ferguson, they usually published their lectures in book form or at least printed and sold a synopsis of them. While they did not contribute much to original discovery, they taught the budding inventive and entrepreneurial geniuses of the next generation. Watt's early steam-engine experiments were done on a small model such as that used by the itinerant lecturers. In fact, he was asked to repair a model of a Newcomen engine used for demonstration purposes in natural history classes at the University of Glasgow.

Wright's two pictures thus document a critical stage in the exchange of science and industry in the late eighteenth century. Indeed, his own role as publicist may be likened to the activities of the itinerant lecturers. In this

he served well the interests of his patrons. The owner of *Experiment with the Air Pump* (and also of the *Gladiator*) was a prosperous physician named Dr. Benjamin Bates. Bates stocked his properties with paintings and antiques, including original commissions from neoclassic regulars like Kauffmann and experimentalists like Wright, Flaxman, and John Mortimer. *Gladiator* and *Experiment* spanned his dual taste, with the latter appealing to his scientific interests. Many outstanding scientists and industrialists of the eighteenth century were members of the medical profession, including Drs. Joseph Black, James Hutton, and John Roebuck. Leading physicians taught natural philosophy in the universities; like Darwin, Bates studied medicine at the University of Edinburgh where empirical science was a fundamental component of the curriculum and air pumps were standard equipment. The medical profession was also strongly represented in the scientific clubs, exemplified again by the Lunar Society which included Drs. Erasmus Darwin, William Small, William Withering, and Thomas Beddoes. These physicians identified themselves with progressive scientists and industrialists and thereby validated their own practices. Bates's association with Wright's picture pinpoints an epoch when the practitioners of medicine began to think of themselves as scientists.

The best example of this was the indomitable Dr. Darwin who became Wright's close companion and family physician later in the century. Wright painted two sympathetic portraits of Darwin spanning their friendship and attesting to Wright's intimacy with the inner circle of the Lunar Society. The two friends shared the popularizing bent expressed in terms of the sublime and, on occasion, the ridiculous. Darwin's *Zoonomia* constituted an attempt to summarize his medical experiments in plain talk and make available to the public a handbook on illness and disease with recipes for home remedies and inexpensive cures. He suggests the use of an electrical current to stimulate paralyzed organs and dissolve tumors—at the same time, throughout the work he weaves in literary and artistic allusions, discussing at one point bodily harmony in the context of paintings by Gavin Hamilton and Angelica Kauffmann. But it is the *Botanic Garden*, with its rich blend of mythological, scientific, and industrial allusion, that points up the parallels between the two. Darwin manages to drag into his discussions of plant life the air pump, orrery, the cotton mills

at Cromford, and the iron forge—all subjects of Wright's pictures. It therefore comes as no surprise to discover verses in Part II of *Botanic Garden* directly relating to Wright:

So WRIGHT'S bold pencil from Vesuvio's height
Hurls his red lavas to the troubled night;
From Calpe starts the intolerable flash,
Skies burst in flames, and blazing oceans dash;
Or bids in sweet repose his shades recede,
Winds the still vale, and slopes the velvet mead;
On the pale stream expiring Zephyrs sink,
And Moonlight sleeps upon its hoary brink.[46]

The verses refer to Wright's moonlit landscapes and representations of an active Mount Vesuvius. Like members of the Lunar Society, Wright was absorbed in all aspects of science and industry and their interaction. He explored in landscape studies all kinds of natural and artificial light, mineralogy, geology, botany, meteorological and astronomical phenomena. His interest in the fiery effects illuminating a night sky echo the Lunar Society's fascination with lightning, meteors, "fireballs," aurora, and moonlight. Among Wright's examples the most prominent are the companion images of an erupting Mount Vesuvius and the *Girandola*, the annual fireworks display held at the Castel Sant'Angelo in Rome (figs. 3.16, 3.17). One *Girandola* shows St. Peter's illuminated by the explosions from the castle in the foreground, while several Vesuvius studies play off a moonlit sky against the fiery discharge. Inspired by the events of his

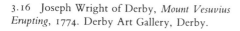
3.16 Joseph Wright of Derby, *Mount Vesuvius Erupting*, 1774. Derby Art Gallery, Derby.

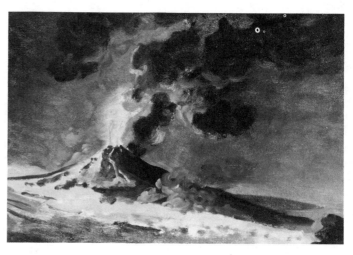

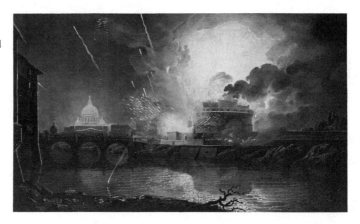

3.17 Joseph Wright of Derby, *Girandola at the Castel Sant'Angelo*, c. 1775–1778. Reproduced by permission of the Birmingham Museum and Art Gallery, Birmingham.

Grand Tour, the two series complement each other as examples of artificial and natural pyrotechnics. While spectacular and memorable in themselves, they imply the preoccupations of Wright's contemporaries with an artificial or humanly ordered natural site capable of unleashing awesome power. Wright rated the Girandola, named for the radiating rockets and rotating wheels which caused a swirling movement of lights in the sky above the Castel Sant'Angelo, as a high example of what humans could achieve in competition with nature. In fact, the experience of both the volcanic eruption and the fireworks were often associated with each other and with technology. Visitors at the display in Rome were reminded of the raging eruption of a volcano, while Sir William Hamilton noted about an eruption of Vesuvius in 1766: "It is impossible to describe the beautiful appearance of these girandoles of red hot stones, far surpassing the most astonishing artificial fire work." At the same time, Hamilton identified volcanic activity with industrial process: "The lava had the appearance of a river of red hot and liquid metal, such as seen in the glass-houses."[47]

Wright made the pilgrimage to Naples and climbed Mount Vesuvius. There can be no doubt that he established contact with Sir William, and evidence suggests that he contributed a sketch to Hamilton's book on volcanoes. During Wright's climb up the mountain, he was reminded of his old Derby friend, John Whitehurst, who was preoccupied with volcanic action and molten material. We may recall that the artist's portrait of the clockmaker and geologist included a glimpse of Vesuvius through the window. If the volcano is unpredictable and cataclysmic, it was also perceived as an example of the

mechanical character of geological activity and ultimately applicable to human endeavor. Whitehurst hypothesized that the action of steam resulting from the interaction of volcanic material and water below the earth's surface generated geologic upheaval.[48] Both Hamilton and Whitehurst inspired Hutton's *Theory of the Earth*, a milestone in eighteenth-century geological thought. Hutton, who personally knew Whitehurst and Sir William, already proposed in 1781 that "the globe of the earth is a machine, constructed upon chemical as well as mechanical principles, by which its different parts are all adapted, in form, in quality, and quantity, to a certain end . . . and an end from which we may perceive wisdom in contemplating the means employed." Hutton, Whitehurst, Darwin, and Wright, followed the Vulcanist position (as opposed to Werner's Neptunists) which corresponded to their perception of the emerging industrial society.

Until Wright visited Italy in the 1770s, nearly all his night scenes were set in interiors; afterward, he attempted a larger-scale presentation expanding into landscapes lighted by fireworks, molten lava, the raging fire, or the moon often reflected in the water of a grotto. Wright's analysis of these effects and their treatment in landscape is again analogous to the attitude of Lunar Society members. The catalog entry for one of his studies of Vesuvius in the posthumous exhibition of 1801 noted that "the Effect is awful beyond Description.—Earth, Air and Water appear as but one Element. It is thus that real Genius can manage Nature at its Will . . ." His attempt to analyze and thus visually "harness" geological and meteorological phenomena and the gradual expansion of his scale and enterprise parallels the development of the industrialists in the Midlands whose conceptual capacity grew incredibly from the 1770s onward. The progress from rudimentary to more complex technological innovation stimulates thinking on a grand scale consistent with the conception of the world as both machine and global market. It is the beginning of mass production and mass consumption and an entrepreneurial sense of unlimited possibilities and magnitude.

The history of iron and textile production is thus a record of the growth of the business unit, the discovery of new sources of raw material, the invention of mechanical and chemical processes, and the expansion of markets. Here again Wright testifies to the major developments of his day. He did a number of scenes of blacksmiths and

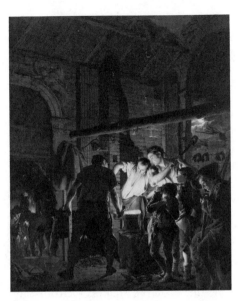

3.18 Joseph Wright of Derby, *The Blacksmith's Shop*, 1771. Yale Center for British Art, Paul Mellon Collection, New Haven.

forge masters, and while they depict instances of minor industry as opposed to large-scale enterprise they touch on functions central to the Industrial Revolution. All the major changes in the iron industry from around 1750 to 1800 were confined chiefly to Great Britain. The use of coke for smelting iron and the increase in the production of wrought iron through Henry Cort's invention of puddling and of the grooved rollers made it possible to produce bar iron more cheaply and in larger masses than with the hearth and hammers of Wright's forgers and blacksmiths, and his repeated use of the motif reflects their historical contribution to this development. Derbyshire, where mining had been known in Roman times, was a center of small-scale metalworking at mid-eighteenth century when the advantages of smelting with coke over charcoal became generally recognized. By 1788 there were seven coke furnaces operating in Derbyshire which helped advance the large-scale enterprises of Boulton and Watt.

It is noticeable that along with the rise of iron founding and machine making there also had been a remarkable increase in the number of smiths and forgers, many of whom would have participated in the evolution of engineering. The extension of cotton manufactures, for example, increased the activity of ironmongers and smithies; the erection of a new mill automatically attracted smiths who would leave their trade for better wages. Carding machines required a blacksmith's assistance, and this in turn increased the demand for wrought iron. By the end of the century, metalworkers of all kinds had been recruited into iron-founding and machine-making firms, which were producing textile machinery, waterwheels, steam engines, and other engineering goods.

Wright's *Blacksmith's Shop* indicates the significant role the tinker and the farrier played in the rising iron industry. It brings us close up to the action of the smithies hammering an incandescent bar of wrought iron which provides the main source of light in this nocturnal scene (fig. 3.18). Wrought iron, with a low carbon content, was malleable, tensile, and able to withstand strain, and was used for making horseshoes, nails, picks and spades, locks and bolts, wire, and tools of all kinds. Wright's smithies are working the bar of iron into a horseshoe for a traveler who is glimpsed in the left background examining with another farrier and his servant his horse's hoof. A candle illuminates their activity, and supple-

menting these two foci of light is the full moon just emerging from behind a bank of clouds. As in the *Orrery* and *Experiment*, spectators of varying age groups assemble around the central action and respond with diverse gestures including drowsy indifference on the part of an old man seated in the right-hand corner. Both in the setting and in the treatment of the chronological and social types Wright constructs an elaborate chronicle about industry and labor in the Midlands in the early 1770s.

In the iron industry the fuel used until well into the eighteenth century was charcoal. Forest therefore determined its location and in turn made the consumption of charcoal expensive. It was the partnership between coal—reduced to coke—and iron which opened the most brilliant prospects to the English metal industry. In the manufacture, as distinct from the production, of iron, it was possible to make full use of mineral fuel, and it was, therefore, on the coalfields that the makers of tools and agriculture implements, chains, locks and bolts, nails, and horseshoes tended to congregate. When seams of coal were located in the Midlands, old corn mills, ruins, and other existing stone structures were converted to metalworking. Wright's picture exemplifies this conversion in showing metalworkers in an old chapel rehabilitated for just this purpose.

3.19 Joseph Wright of Derby, *An Iron Forge*, 1772. The Broadlands Collection, Broadlands, Romsey, Hampshire.

His smithies are portrayed with the gravity of the lecturers in *Orrery* and *Experiment*, while a younger generation watches with fascination and awe, and an older, no longer able to work, turns away sleepily from this sign of progress. Servant and master reveal another set of social relationships, reflecting perhaps the fact that in Derbyshire metalworks were established on the coalbeds of private estates and consequently leased by a wealthy landlord. It was this social class that created simultaneously a demand for implements of war and agriculture. At the same time, the fact that hammering is going on at such a late hour indicates the industriousness of these metalworkers whose sounds reverberate through the night like a realization of Burke's concept of the sublime.

Wright's scene resembles representations of Vulcan's forge prevalent in the previous century and justifies the classical moldings of the chapel. But in Wright there is a change in the type of manufacture: earlier emphasis was on the production of the implements of war, whereas he points up the peacetime pursuits of the metal trade—the conversion of swords into ploughshares in the wake of the Seven Years' War. Nevertheless, Wright's updating of the Vulcan theme is relevant to the Burkean categories and popular explanations which, like the *Botanic Garden* (first conceived in the 1770s although published much later), blended mythology and industry.

If the *Blacksmith's Shop* shows us the manufacture of iron products, Wright's *Iron Forge* shows us the production of the iron itself (fig. 3.19). The forge refined pig iron into malleable iron which was drawn out into bars for the metalworkers. It is as if Wright's forger is producing the iron bar for his blacksmith, thus indicating the interlocking activities of the iron industry in his day. The association of the forgers with the smithies was necessarily close. It was the forge master who supplied the raw materials to the metalworkers, and as coal could be adapted for both smithing and fining it brought the two closer together physically. The earlier dependence on charcoal meant that the smelter and finer had to be located near timber areas and thus created a dispersion of forgemasters. Wright's forge hammer is operated by water power, and hence pointing up Derbyshire with its combination of coal beds and streams from the river Derwent as an ideal location for the metal trades. Those engaged in converting pig into bar iron were known as finers or hammermen, and at each forge there were at

least two men assisted by one boy. In Wright's picture the two men are present but the boy is absent. As in the *Blacksmith's Shop* Wright establishes his scene in nocturnal gloom, giving him not only another opportunity to explore unusual light effects but also to demonstrate that in the iron industry the working day was long. We glimpse the assistant tending the hammer operated by water power and beating the heated metal mass into a rectangular bar. Near him is the master hammerman who is shown as a sturdy figure in control. The master hammerman was among the aristocracy of labor, for his position was closer to that of the small employer than to that of the ordinary wage earner. He usually entered into an engagement for a term of years with a landowner or proprietor of mines and, in practice, the actual operation was under his sole control. While by the end of the century this type evolved into the familiar foreman, he was of vital importance in early ironmaking, since on him devolved the varied functions of industrial leadership, commercial dealing, and technical training.

These dignified and orderly representations of work appealed to the aristocracy: Lord Melbourne (Peniston Lamb, who also owned *Academy by Lamplight*) purchased the *Blacksmith's Shop*, and Lord Palmerston (Henry Temple) bought the *Iron Forge*. Lord Palmerston was a Whig aristocrat who had a seat on the Board of Trade and traveled with William Pars, Shipley's brilliant disciple who together with his older brother Henry took over the management of the industrial drawing school of the Society for the Encouragement of Arts, Manufactures, and Commerce. The possibility of iron making in the hands of landed proprietors was a potential means of increasing their income. Lords Melbourne and Palmerston may not have leased out their lands to smiths and forgers but they could certainly identify with landowners who did. At the same time, it is clear that they felt close to a progressive painter with whom they shared the advanced economic ideals of the time. The Viscount Palmerston shared Wright's keen interests in antiquity, science, and geological exploration and had no reservations about the onset of the Industrial Revolution.[49]

Wright not only depicted metalworkers for aristocratic patrons, he also depicted the new Captains of Industry who stimulated the metal, cotton, and machine manufacture. He did a series of portraits of the leading cotton industrialists of the Midlands, the Oldknows, Strutts, and

3.20 Joseph Wright of Derby, *Richard Arkwright*, 1789–1790. Private Collection. Photograph courtesy of Courtauld Institute of Art, London.

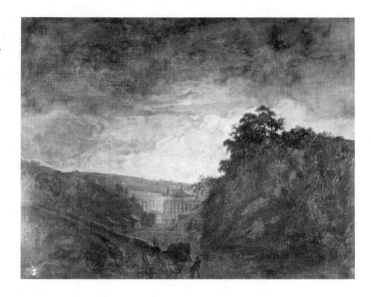

Arkwrights. Among these new Captains of Industry stimulating the iron industry was the flamboyant Richard Arkwright who needed smiths for the metal fixtures of his water frames, carding, and roving engines.[50] Wright painted an energetic portrait of Arkwright with a model of one component of his spinning machine showing the rollers (fig. 3.20). Just as monarchs were once posed with symbols of royal authority, so now the new aristocracy of wealth proudly displays its attributes of conquest and leadership. Curiously, by the time Wright painted the portrait (1789–1790), it had been determined that Arkwright had stolen the invention and his patents were cancelled. Wright's image shows the undaunted self-made entrepreneur, the personification of the new type of the great manufacturer, neither exclusively an engineer or a merchant but the organizer of production and ingenious exploiter of the labor of others.

In addition to getting Wright to record his features and those of his family, Arkwright inspired a series of views of the area where he built up his industrial empire. In 1771 Arkwright moved to the relatively unexploited district of Cromford near Matlock (around fifteen miles from Derby), where he built in partnership with Strutt and Need the nucleus of the Cromford Cotton Mills. By the end of the decade he was giving employment to about 600 workers, many of them children.[51] One of Wright's views of Cromford, painted in the early 1780s, depicts Arkwright's cotton mills under the full moon,

during a night shift (fig. 3.21). This somewhat macabre night scene, with the factory windows ablaze with industrial illumination, catches the dynamic of the Industrial Revolution. Demand for cotton and Arkwright's capacity to satisfy it enabled him to keep the factories going around the clock.

Night and day working was characteristic of the first thirty years of the Arkwright factory system. The machinery ran around the clock (in two twelve-hour shifts with an hour break for meal), with the carding and roving going on during the day and the spinning at night. Spinning, usually done by women and children, was the worst paid of all. Children were especially favored for this process because it was quickly learned, required little strength, and often their small size—as in the case of joining broken threads—made them ideal aids to the machines. Above all, they tended to be docile, were easily reduced to passive obedience, and received a fraction of the adult wage. Most often they started life as paupers and were practically sold as slaves by their parishes. Factories like those of Arkwright at Cromford were built outside towns which made it difficult to recruit laborers from the immediate neighborhood, and parishes were only too delighted to get rid of their paupers and keep expenses down. Children were sent like cattle to a new factory where they remained imprisoned for many years. Those who survived the cruel apprenticeship often bore its brand for life in the form of crooked spines, deformed limbs, and stunted growth. And since they received little training beyond the mechanical routine of their job, they were all but condemned to the factory as serfs had been condemned to the soil. One observer in the later 1770s noted that the Cromford mill employed about 200 persons, chiefly children, but added that "everything wears the face of industry and cheerfulness."[52]

Similarly, Wright manipulates his material to give the scene a positive face. The full moon envelops the industrial site in the glow of its sublime aura, attesting to Wright's faith in Arkwright's intentions and accomplishments (which he shared with Lunar Society members who supported the entrepreneur during his losing patent fight). The association of the moon with the factory trades in on Ossianic convention and scientific progress, legitimizing Arkwright's enterprise and suggesting its aesthetic possibilities. Just as the moon sustains the suspense in *Experiment with the Air Pump,* so now it dots the

"i" of industry and involves it in the promise heralded by contemporary science.

Thus the air of lunar mystery, even of the macabre in Wright's picture, promotes the dissemination and appeal of science and industry. Scientific and technological innovation are seen as pressing on the threshold of exciting new knowledge. The religious awe of earlier painting based on strong chiaroscuro has given way to the awe of unlimited possibilities based on the symbolic and actual light of astronomical science. Central to this is the presence of the moon, whose study had such an enormous impact on modern science. Indeed, Newton's seminal *Principia* (1687) was itself based in large part on his discovery of the gravitational force holding the moon in its orbit and on his computation of the moon's motions and its influence on the tides.

In Wright's day advances in the field were sparked by William Herschel who began making telescopes of unprecedented exactitude in the 1770s. These enabled him to identify a new planet in 1781, now called Uranus. In honor of George III he named it *Georgium Sidus* and was promptly rewarded by being made court astronomer the following year. The Lunar Society—whose own designation links astronomy and innovation—deeply admired Herschel; Wedgwood immortalized him in portrait medallions, while Darwin celebrated his discoveries together with Priestley and Montgolfier in canto 4 of "The Economy of Vegetation." Both Darwin and Whitehurst were preoccupied by lunar phenomena, with Darwin expressing the theory of the moon as a fragment of an exploded earth in his typical blend of science and fantasy:

Gnomes! how you gazed, when from her wounded side.
Where now the South-Sea heaves its waste of tide,
Rose on swift wheels the MOON's refulgent car,
Circling the solar orb, a sister star,
Dimpled with vales, with shining hills emboss'd
And roll'd round earth her airless realms of frost.[53]

This leads to a commentary about the atmosphere of the moon and the surmise that it is presently uninhabited. Darwin further noted that the lunar surface has suffered and continues "to suffer much from volcanos, and this may in time produce an atmosphere capable of sustaining life." Darwin's combination of poetic simile and scientific analysis places into proper perspective the romance "of the silvery moon."

Lunar Theory

Lunar theory had also been stimulated by the search for colonies, especially to meet the need of determining longitude at sea. Navigation required accurate lunar measurements, which were among the main objects of the Greenwich Observatory. James Bradley's observations at Greenwich during the years 1750–1762 made fundamental contributions to meridian astronomy. Since calculation of the moon's position involved a sizeable margin of error, moon mapping and lunar computations were refined throughout the century. Understandably, literature and art of the period absorbed this interest, making moonlight the metaphor for change and fantasy.

The moon would become a pervasive motif in art and literature in the Western World during the eighteenth and nineteenth centuries—another symbol of "romantic" ideals. Between the interval of Beethoven's *Moonlight Sonata* (1801) and Debussy's *Clair de lune* (1895) all the arts incorporated this motif. While the older classical treatment persists—the pining of Endymion for his love, Diana, melancholy, and all the rest—there emerges gradually the new moon of science—an awareness that grows through a more realistic description reflecting the scientific discoveries of the day. Newton's *Principia* of 1687 placed the moon in a rationally ordered system, and this had an effect similar to that caused by the Montgolfier balloon flight in 1783 and the Apollo moon landing in 1969. The most persistent and the most appealing of moon themes were the idea of borrowed light, the influence on the tides, and above all the idea that the moon was not only a world but an inhabitable world. The telescope disclosed it as a sphere geographically like our own, a body that seemed to us as our world must appear to lunar inhabitants.

Attitudes toward the moon assume contrary positions: on the one hand, they extend the aims of the thinkers of the Enlightenment who demystify the world, and, on the other, they run counter to Enlightenment ideology. Young's *Night Thoughts* and MacPherson's Ossianic sagas presuppose in their lunar metaphors darkness, obscurity, mystery, fright. In this sense, the moon becomes the antithesis of the symbolic complement of the Enlightenment, the sun. The sun stood, moreover, for classical antiquity, not only in its Mediterranean reference but in its properties of regularity and clarity. The moon is subver-

sive in presiding over a world of unknown and supernatural events, and it is clear that artists insert it deliberately in their work for its opposition to neoclassical associations. The classical world and the sublunary world become antagonists, especially as society reels under the impact of the dual revolution.

The contradiction of the sublunary motif in implying both the dispelling of old mystery and the ushering in of new fantasy is seen in the poetic effusion of another great English astronomer, Edmond Halley. Halley specialized in moon studies at Greenwich, compiling tables to solve the problem of longitudes. Between the years 1722 and 1739 he made systematic observations of the moon's motions which were published posthumously a decade later. Earlier, Halley helped complete and publish Newton's *Principia* which inspired an ode he dedicated to the discoverer of the law of gravity. Celebrating Newton's clarification of lunar theory, the ode conjures up boundless possibilities:

At last we learn wherefore the silver moon
Once seemed to travel with unequal steps,
As if she scorned to suit her pace to numbers . . .
Till now made clear to no stronomer;
. .
In reason's light, the clouds of ignorance
Dispelled at last by science. Those on whom
Delusion cast its gloomy pall of doubt,
Upborne now on the wings that genius lends,
May penetrate the mansions of the gods
And scale the heights of heaven.[54]

Moonstruck poets were quick to translate this potential into more immediate aims: Thomas Gray, whose *Elegy in a Country Courtyard* echoed the mournful strains of Young's *Night Thoughts*, wrote a poem in Latin entitled *Luna Habitabilis* (1737), which set forth the possibility of an inhabited moon. He predicted commercial treaties between the two worlds and that England, so long mistress of the seas, would in a future time wield sway over the air. It is this promise of unlimited possibilities—its exact configuration still unknown but nevertheless inevitable— that also informed Wright's later work.

Wright catches in paint the mythification of industrial processes typified in the *Botanic Garden*. Darwin's description of Arkwright's cotton mill, while lacking the moon, catches Wright's mood:

So now, where Derwent guides his dusky floods
Through vaulted mountains, and a night of woods,
The Nymph, Gossypia, treads the velvet sod,
And warms with rosy smiles the watery God;
His ponderous oars to slender spindles turns,
And pours o'er massy wheels his foamy urns;
With playful charms her hoary lover wins,
And wields his trident,—while the Monarch spins.[55]

This is the way the Lunar Society helped usher in a new social class and a new economic era. Arkwright certainly shared their boundless hopes for the future: he claimed that, if he were privileged to live long enough, his capital could one day pay off the national debt.

Still, Wright and Darwin had to juggle reality to rationalize the activities of the thrusting and ruthless adventurer.[56] By the time they projected their panegyrics, machine breaking had become a fact of life in the industrial sector comprising Arkwright's factories. There were large-scale riots against machinery in 1779, a depressed year thanks in part to the American Revolution. In Lancashire, where machinery developed most rapidly, riots that year became really alarming. Arkwright's factory in Birkacre, near Chorley, was destroyed, and there was great fear for the Cromford mill.[57] Wedgwood, who happened to be in the district where the riots broke out, wrote an account of them in a letter to Bentley. He encountered on the road a vanguard of striking workers who claimed they intended to destroy "engines" throughout the country. Their professed design was to take Bolton, Manchester, and Stockport on their way to Cromford. In October Arkwright put Cromford in a state of siege, gathering defenders from Derby and neighboring towns and setting up a battery of cannon. But his preparations for defense were unnecessary; government troops sent from Liverpool dispersed the militant workers before they reached the mill. Prompt and severe repression followed; some rioters were tried by the Grand Jury and sentenced to the gallows.

While the rioters never got to Cromford, it is clear that Wright's picture, with its enchanting nocturnal view of the factory operating at maximum capacity, belied the reality of factory life as well as the anxieties of the cotton magnate in the immediate aftermath. Yet this also coincides with the period of Arkwright's greatest expansion; he extended his spinning interests in Manchester, Matlock Bath, Blakewell, and was soon to begin negotiations

in Scotland. The cotton trade in general was beginning an extraordinary period of growth, more rapid than any other industry of the time, and this despite the fall-off of markets due to the American war. Workers returned to their jobs and temporarily reconciled themselves to the new machinery.

These developments would have satisfied the purchaser of *Arkwright's Cotton Mills, by Night*, Daniel Parker Coke, Derby's representative in Parliament until 1780 and thereafter M.P. for Nottingham. A moderate Tory dedicated to "men of property," he advocated the rights of landlords to influence the political judgments of their tenants and believed in a strong protectionist policy for the sake of his cotton-spinning constituents. He supported restrictions on the Irish textile industries which no doubt endeared him to Arkwright. Arkwright owned mills in Nottingham and Derbyshire and would have been one of Coke's ardent supporters. For Coke, Wright's picture probably exemplified the thriving industry of his constituency.

Wright's association with Arkwright is documented in his correspondence with Wedgwood, perhaps his single most important patron among the Lunar Society entrepreneurs. Wedgwood commissioned from Wright three subject pictures and a self-portrait. Like his good friend Arkwright, Wedgwood was a pioneer of English factory organization and discipline, but he went beyond the cotton magnate in joining to his enterprise the operations of the laboratory and artist's studio. Wedgwood was a major art patron in a double sense: he employed sculptors and decorators to design his ornamental ware, and commissioned original works from painters like Wright and George Stubbs (who also shared his desire to fuse art and industry) to aggrandize his social position. Stubb's famous outdoor portrayal of the Wedgwood family shows Josiah and his wife seated next to a tripod table upon which is proudly displayed a Wedgwood black basalt vase (fig. 3.22). Wedgwood wanted his creations to play the part in contemporary art that ancient ceramics played in the recent past. He hoped to celebrate his wares in a modern bourgeois context for which he was then creating an international market. At the same time, by hiring famous painters like Wright and Stubbs to glorify his pottery, he hit upon a sophisticated advertising technique guaranteed to excite attention.

Wedgwood first met Wright around 1773 when he saw

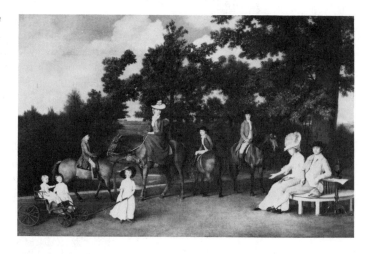

3.22 George Stubbs, *The Wedgwood Family on the Grounds of Etruria Hall*, 1780. Trustees of the Wedgwood Museum, Barlaston, Staffordshire, England.

the artist's painting of *Belshazzar's Feast*, a work that inspired the thought of buying a picture connected with the pottery industry. Later he wrote to Bentley that the subject of *Belshazzar's Feast* presented a situation in which "our Vases might be introduced with the greatest propriety."[58] This idea finally bore fruit in Wright's *Corinthian Maid*, completed around 1784 in a neoclassic mode (fig. 3.23). As recounted by Pliny (and recently popularized by Wright's close friend, the poet William Hayley), the story of the Corinthian Maid tells of the lovesick daughter of a potter named Dibutade. Anxious to keep a record of her lover as he was about to leave the country, she traced the outline of his shadow on the wall as he slept. Her father was so impressed with the accuracy of the outline that he filled it in with clay, made a relief of it, and baked it with the rest of his wares. Here was a subject made to order for Wedgwood and exemplifying the adaptation of neoclassicism to meet the ideological needs of the forerunners of the Industrial Revolution.

Wedgwood wanted allusions to his vases, kilns, and implements introduced into the painting, enjoying the irony of switching from inserting classical motifs into modern products to inserting the same products into a classical scene. In April 1783 Wright visited Wedgwood's factory at Etruria to discuss these details, and later Wedgwood shipped vases to him for use in the picture. While explicit references to Wedgwood's goods were eliminated from the final picture, Wright included two large earthenware vessels and depicted the protagonists in

cameo relief like the designs of his patron's jasperware. In addition, Wright stamped the work with his own innovative light effects.

Wedgwood closely supervised the execution of the picture and at one point criticized the rendering of the Maid for what he felt was too much nudity coming "thro' the drapery." The final rendition is a rather chaste image of the girl consistent with the Wedgwood style. The relationship of Wedgwood and Wright recalls in many ways that of Caylus and Vien, with one important difference: whereas Vien celebrates his patron's aristocratic love of classical luxury and refinement, Wright glorifies the productive activity of the humble craftsperson. The middle-class entrepreneur identifies more with production than with ownership, and in this sense the work hints at the underlying dynamic of the Industrial Revolution.

Two other patrons who offered advice to Wright while he worked on the *Corinthian Maid* were Erasmus Darwin and Brooke Boothby, cofounders of the Lichfield Botanical Society. These scientifically minded patrons he shared with one of the most bizarre painters of the period, the Swiss-born Henry Fuseli.[59] At first glance, Wright and Fuseli appear as polar opposites: the one rational, precise, and generally faithful to empirical reality; the other irrational, distorting, and bent on manipulating nature for the sake of unearthly effects. Yet both had close ties to the Lunar Society, shared many of the same

3.23 Joseph Wright of Derby, *Corinthian Maid*, c. 1783–1784. Paul Mellon Collection, National Gallery of Art, Washington, D.C.

patrons (in addition to Darwin and Boothby there were William Roscoe and John Leigh Philips), incorporated Burkean and Ossianic motifs in their work, and indulged in scientific speculation. Fuseli knew Lavater, Priestley, and the astronomer John Bonnycastle intimately and was himself an amateur entymologist and botanist. Like Wright, he started from neoclassicism but developed from it a unique and eccentric style which appealed to his predominantly aristocratic patrons. Wright's nocturnal depictions of the antique and Fuseli's superhuman compositions heighten the ancient forms and infuse them with unexpected vitality. While the first neoclassic generation emulated antiquity for decorative purposes, the experimentalist wing activated the lifeless forms in tune with the mood of restlessness and anxiety brought on by political and economic upheaval. Fuseli's supernatural beings and effects exerted an enormous influence on "romantic" painters and writers of his own time and those of the next generation, including Blake, Lavater, Wollstonecraft, Goethe, Cowper, Coleridge, Martin, Girodet, and Delacroix.

Fuseli

He was born Johann Heinrich Füssli at Zurich in 1741, the son of an erudite painter and art dealer whose artisanal ancestors included bell founders and goldsmiths. The elder Füssli deeply revered Mengs and Winckelmann, and this love was transmitted to his son who became the first to translate Winckelmann into English. Young Fuseli (who anglicized his name after moving to London) had an incredibly checkered career, beginning with the ministry and followed by a period of writing and translating before his decision to take up art for a living. He was a popular preacher, but his involvement in local politics brought this phase of his career to an abrupt close. In 1762 he and his friends Johann Caspar Lavater and Felix Hess formed a club called "The Patriots," and published a pamphlet attacking a corrupt *Landvogt*, or bailiff, in the Swiss government named Grebel. Unfortunately, political criticism in this period tended to be stifled, and Grebel had familial ties to the burgomaster of Zurich; under these circumstances the families of the "Patriots" thought it prudent that their offspring quietly leave town. This disruption proved traumatic to Fuseli and altered the course of his career. Ever after he found it

painful to recall; it pushed him toward a conservative social and political position and motivated him to seek the protection of the wealthy and powerful. He confessed later that the experience "evinced precipitation on our part, and a want of knowledge of the world."[60]

Fuseli's attitude in 1762 must be considered against the background of profound reaction then prevailing in the Swiss Confederation, the condemnation of his hero Rousseau by the government of Geneva in 1762 and the consequent turmoil among Zurich liberals who founded the Helvetic Society in the same year. Fuseli, who even when a teacher read and admired Rousseau, participated in the circle around the liberal Johann Jacob Bodmer. One of the founders of the Helvetic Society, Bodmer gathered about him a school of devoted scholars bent on the task of modest social reform. Politically, they were more conservative, trying to generate patriotism and calling mainly for greater national unity among the Swiss states. Yet even their combination of piety and politics had to be circumspect in the repressive climate of Zurich, and Bodmer evaded censorship by disguising his ideas in the form of poems and plays.

Bodmer admired English culture and institutions which he upheld during the Seven Years' War. He challenged French authority in literature and in politics with ideas of parliamentary representation and English authors. He translated Milton's *Paradise Lost*, ardently read the works of Shakespeare, Burke, and MacPherson, and as Fuseli's mentor exposed his disciple to the imaginative literature and dramatic expression associated with the sublime. Fuseli acknowledged this debt in his double portrait of himself and Bodmer, shown together with a monstrous bust of a Homer-type sage emerging spectrally from the shadows to preside over their discussion.

Bodmer exerted great influence on German thought and literature, and Zurich became a center for progressive German writers. Klopstock was in close touch with Bodmer, and through him contributed to the formation of the *Sturm und Drang* ("Storm and Stress") movement. While this movement crystallized in Germany around 1770, it derived initial inspiration from Bodmer's circle. Lavater, also Bodmer's disciple, became identified with the movement and enjoyed the collaboration of Goethe, Lenz, and Herder in his celebrated work on physiognomy. While cut off from this group after moving to London, Fuseli maintained links with its founders and shared

their combination of political conservatism and scientific and aesthetic radicalism.

The Sturm und Drang movement was in many ways the Germanic counterpart of the Enlightenment, a middle-class ideological reaction to bureaucratic constraint, political monopoly, courtly conventions, and luxury.[61] Both used suggestions coming from England and Rousseau, and both pretended to judge society against the measure of personal life and merit. But unlike the French and English literary model, Sturm und Drang writings reveal no idealized social class challenging the corrupt world of those holding the monopoly of political power. Lacking the economic base and political consolidation of France and England, the Swiss and Germans suffered from a dearth of public consciousness, and most of their criticism was religious or moralistic in character. They lacked the confidence stimulated in France and England by the widening range of the middle class and a growing belief in its inherent moral worth and energy. Thus they never challenged the functional social divisions as such but believed that certain abuses could be corrected. The pamphlet of Fuseli, Lavater, and Hess did not aim its attack at the oligarchic-conservative government of Zurich on the basis of a political or social principle, but at the greed and moral bankruptcy of a single official whom they felt should be eliminated from the system. Indeed, they even appealed to more honest officials in the bureaucracy to clean their house.

Switzerland was a loose federation of states, with the cantons sovereign and independent. The cantons in turn ruled over subject territories and contiguous rural areas. Some districts were subjects of two or more cantons. In this political complexity and disunity it greatly resembled Germany. While unlike the German states it was not dominated by absolutist and feudal principles (although it did comprise monarchical states like Neuchâtel and the bishopric of Basle), to some degree every canton in eighteenth-century Switzerland was ruled by a self-perpetuating oligarchy which had originally been appointed by a plutocracy. The old feudal class had been displaced by the burgess class, and representative assemblies known as *Landsgemeinden* existed throughout the confederation, but democratic and egalitarian institutions existed in name only and belied the realities of the situation. In every state real power was vested, by right of birth, in a closed class of people, and to a small number of people within

that class. The subject population of Switzerland, though theoretically consisting of free persons, was more limited in its rights before the French Revolution than the vast majority of the French under the *ancien régime*.

Zurich was dominated by one of the most repressive of the administrations based on a corporate oligarchy. The leaders of privileged guilds represented the wealthiest portion of the populace and invariably recruited themselves. They constituted a genuine aristocracy of rank and wealth, monopolizing all political and lucrative offices. Their main concern was to consolidate and increase their riches, to limit the number of citizens with whom they had to share them, and to suppress dissent whenever it appeared. Zurich's guild aristocracy regulated daily life as meanly as any European despot: church attendance was secured by law, and even a dress code was enforced. Artisans and laborers had no political rights; the town systematically exploited the countryside which felt the greatest burden of taxation. Like the other cantons, Zurich ruled over subject lands obtained from conquest, purchase, or treaty. It administered twenty-nine regions of this sort through the *Landvögte* who ruled over their bailiwicks like monarchs. Extortion and corruption in the subject territories was widespread and institutionalized; only Grebel's extreme rapacity singled him out to Bodmer's disciples, and he was eventually removed from office.

Both the Swiss and German members of the Sturm und Drang movement emerged from burgher families and experienced the rigidity of the social divisions and class structure in their respective countries. The middle-class elements excluded from the inner core of power in Switzerland, like those generally in Germany, were traditionalist and subordinate. No one thought of challenging the government but hoped for enlightened authorities to reform the administration, root out corruption, and work for national unity. They conveyed their ideas through literature, the only medium of public discussion. They expressed their sense of frustration by revolting against literary and artistic conventions (especially French), estimating thought primarily in the context of heightened experience and its capacity to relinquish the barriers of bourgeois life. In contradistinction to the rationality of the Enlightenment thinkers, they often exalted the unfamiliar and the terrible to achieve an aesthetic breakthrough. This sprang from an obsession with "ge-

nius" and "originality," as in Fuseli's stated goals to star-
tle and astonish, "to be called Fuseli the daring and the
imaginative." Later, he put it more academically:

Imagination gives, together with history and tradition, material
to invention; epic material astonishes, the dramatic moves one,
and the historical instructs one. The artist has the right to in-
vent, without making use of tradition, poetry or history;
imagination and vision are free invention; to them the artist
flies who is disappointed with reality.

Fuseli based his reputation on his capacity to invent su-
pernatural characters which his English patrons accepted
as proofs of his "genius." Youths were frightened by
him, as in the case of young Benjamin Haydon, who re-
called his trepidation on a visit to the recently elected
Keeper of the Academy:

I followed [the maid] into a gallery or show room, enough to
frighten anybody at twilight. Galvanized devils—malicious
witches brewing their incantations,—Satan bridging Chaos, and
springing upwards like a pyramid of fire—Lady Macbeth—
Paolo and Francesca—Falstaff and Mrs. Quickly—humour, pa-
thos, terror, blood, and murder, met one at every look! I ex-
pected the floor to give away—I fancied Fuseli himself to be a
giant.[62]

But an older, more experienced Haydon perceived Fuseli
as something of a charlatan, exaggerating his effects in
the service of an eccentric "Grand Style.[63]

Burke provided him entry to the English art world,
having set forth the idea that terror was the most exalted
emotion of the sublime, and including ghosts and goblins
among those stimuli that most powerfully affect the
mind. Not fortuitously, Fuseli's patrons—like those of
the Stürmer and Dränger generally—came from the up-
per social echelons, and his work complemented their
self-image of uniqueness and innovative sensibility. Fuse-
li's eccentric genius reflected their feeling of superiority
to, and mastery of, reality.

At the same time, Fuseli shared with the Sturm und
Drang members an interest in science as an alternative in-
terpretation of the dynamic principle of being. Their ex-
altation of the irrational could be justified by the need to
free reason and scientific experiment from dogmatic and
conventional fetters. As in the case of Wright of Derby,
science opened up for Fuseli the vast realm of the imagi-
nation by projecting infinite possibilities. The Sturm und
Drang writers especially loved electrical analogies, in a

period when Franklin and Priestley were carrying out their experiments and the German Lichtenberg was measuring the electric charge in the atmosphere.[64] Lenz wrote to Merck in 1770 about their mutual stimulus to creativity: "We electrify one another to activity, and as a result to happiness! That is inspiration, the wondrous creative power to set souls alive, like the electric spark, perhaps, in blood and sun." Goethe, whose scientific studies included botany, mineralogy, and anatomy, wrote to a female friend: "Happiness of the soul and heroism are as communicable as electricity, and you have as much of them as the electric machine contains sparks of fire." Herder uses the image repeatedly: in his treatise *On Knowledge and Perception in the Human Soul* he uses arguments from modern science including the electric current, gravity, magnetism, and elasticity as expressions of the energy of nature and analogies of the forces within the human soul. Herder was deeply influenced by Priestley's *History . . . of Electricity* which was translated into German in 1772; it gave him the notion to replace the idea of spirit with that of "energies." Electricity is the way the Sturm and Drang link up dynamic principles of matter with the creativeness of spirit. Mind for Herder is not an immaterial abstract substance, but a furnace of glowing forces, "living sparks." It is not by chance that in 1774 Lavater described Fuseli to Herder in meteorological terms: "His spirits are storm-wind, his ministers flames of fire! He goes upon the wings of the wind. His laughter is the mockery of hell and his love—a deadly lightning flash." That same year Fuseli demonstrated the connection between his novel light effects and electrical phenomena in his drawing of a *Seated Youth Observing a Thunderstorm* where a flash of lightning picks out the contours of form otherwise in deep shadow (fig. 3.24). Lavater, Herder, and Fuseli shared the conception of electrical phenomena as a creative force in nature and in art.

England was the gathering place for new ideas in science and in art: like his countryman, Argand, who had to travel there to patent his lamp, Fuseli was encouraged by the receptive climate of Great Britain where more opportunities were offered for scientific and aesthetic experimentation. This mind set is reflected in Darwin's apology at the beginning of the *Botanic Garden* for many conjectural elements in the poem not wholly "supported by accurate investigation or conclusive experiments." He

3.24 Henry Fuseli, *Seated Youth Observing a Thunderstorm*, 1774, pencil and wash drawing. Museum der bildenden Künste zu Leipzig.

suggested, however, that such "extravagant theories" were useful in encouraging and promoting "the execution of laborious experiments, or the investigation of ingenious deductions, to confirm or refute them." Consistent with this attitude, Darwin supported the efforts of his friends Argand and Fuseli.

The Seven Years' War had a decisive impact on the unfolding of Fuseli's art career. The exiled Fuseli and his friends made their way to Berlin, where they arrived on 27 March 1763, right in the middle of the festivites celebrating the victory of England and Prussia in the Seven Years' War. Their way had been facilitated by Johann Georg Sulzer, the Swiss mathematician and scholar who taught mathematics at the Joachimsthaler Gymnasium in Berlin. An associate of Bodmer and protégé of Frederick the Great, Sulzer was in a position to sponsor the trip of the three youths. He arranged for them to stay with Johann Joachim Spalding, the well-known Protestant theologian and philosopher residing in Swedish Pomerania. At this time Fuseli thought of himself as a poet bridging the Swiss and German literary traditions, and he sought out German intellectuals like Klopstock whose poetry he particularly cherished. Klopstock was one of the first German poets to appreciate MacPherson's *Ossian* (who became a hero of the Stürmer und Dränger), the influence of which is strongly felt in the *Hermannschlacht*. A patriotic drama of the late 1760s, it harks back to the ancient fatherland when Arminius and his mighty warriors held the Romans in check. It is shot through with Bardic

and lunar metaphors, blending the Celts and the Germani and ultimately anticipating Klopstock's idea that Ossian was German. Fuseli himself included a verse on Ossian in his *Ode to Bodmer*, written in July 1764. The exchange of ideas between England and Prussia in this period rested largely on their alliance during the Seven Years' War. (We may recall West's painting for George III of Segestes pleading the case of Arminius's wife Thusnelda before Germanicus.) Fuseli's arrival in Berlin coincided with a moment when leading intellectuals of Germany and Switzerland hoped to establish regular channels of literary communication between those countries and England. Fuseli's mentors Bodmer (who earned part of his living from bookselling and subsidized Fuseli's trip to Berlin) and Sulzer took an active part in this project and designated their disciple to execute it. As a starter, Fuseli translated Lady Mary Wortley Montague's *Letters* into German, an example of simultaneous publishing in more than one language since the English edition also appeared in 1763. Sulzer introduced Fuseli to Sir Andrew Mitchell, then British ambassador to the Prussian court; Mitchell in turn invited Fuseli to England under his personal protection to advance the project. The close relations enjoyed between England and Prussia at the close of the war had opened the way for this economic and cultural exchange.

Fuseli left for London early in 1764 and Mitchell facilitated his entry into aristocratic and intellectual circles, putting him in touch with Sir William Forbes, banker and financier, the earl of Waldegrave (who hired Fuseli as tutor to his son), and the publishers Andrew Millar, Thomas Cadell (who issued Priestley's and MacPherson's works), and Joseph Johnson (future publisher of Darwin, Priestley, and other radical authors). But the most important of his introductions was to Thomas Coutts, head of the banking and moneyed interest in London and financial adviser to George III and a large part of the aristocracy. Coutts, who arranged the financing of arms and troops sent to Frederick the Great to wage war against Austria and France, saw his profits quintuple as a result of the Seven Years' War. He had a strong literary bent, had established close relations with the Prussian court, and was probably instrumental in setting up the project. Forbes was a junior partner in the Coutts branch bank in Edinburgh, and the coincidence of the meetings with the publishers and booksellers suggests some type of finan-

cial involvement. In any event, Fuseli received ample employment from these publishers in translating German works into English. In 1765 he translated Winckelmann's *Reflections* for Millar who gave him almost all of the profits.

Fuseli dedicated *Reflections* to his patron Lord Scarsdale to whom he was introduced by Mitchell. His rapid ascent in bluestocking circles and the protection granted him by the wealthiest persons in London may have owed a lot to his brilliance and charm, but they would have been impossible without sanction at the highest diplomatic levels. Fuseli contributed to the cultural exchange between the courts of Frederick and George which was mediated by the commercial publishing arrangements backed by Coutts, who became his special patron. Through Coutts Fuseli managed to build up a steady source of patronage and live in the style of the latest fashion. In letters to Swiss friends he bragged of his meetings with the privileged elite, and henceforth identified his interests with that group. Like Faust he assumed the dress and style of a nobleman to free himself from the confines of bourgeois life. He began his unsigned review of his own book, *Remarks on the Writings and Conduct of J. J. Rousseau* (published by Cadell and Johnson), by declaring that the author "is evidently a gentleman," and he praised a Lawrence painting as "being so refined that no one but a gentleman could have painted it."[65] Certainly some of this was a reaction to his position as a foreigner trying to make his way in smart society, but it also signals his political neutrality and retreat from even the modest reformist ideals of his Zurich days. In a letter to Lavater of 31 March 1768, Fuseli confesses "that the diabolical cry of Wilkes, etc., 'Liberty forever,' stupifies me."

Fuseli's aristocratic protection enabled him to take up painting professionally, a shift motivated in part by his encounter with Reynolds (a friend and client of Coutts) in 1768. The older artist reviewed his sketches and then declared: "Young man, were I the author of these drawings, and were offered ten thousand a year *not* to practice as an artist, I would reject the proposal with contempt." It is probably not fortuitous that Reynolds invoked a mercenary illustration to convey his point; Fuseli must have approached him for an opinion on his chances for earning a living at art. The strong encouragement from Reynolds—then the wealthiest artist in England—and

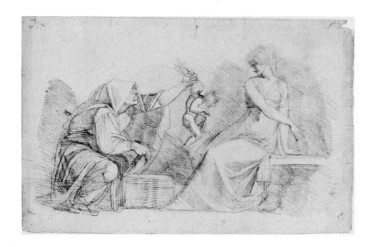

3.26 Henry Fuseli, *The Artist Overwhelmed by the Grandeur of Ancient Ruins*, c. 1778–1780, watercolor and ink drawing. Kunsthaus, Zurich.

Coutts's steadfast support decided Fuseli to abandon his literary career.

He embarked on his Grand Tour in early spring 1770, a trip financed mainly by Coutts who also negotiated a variety of commissions for his protégé abroad from English travelers. Fuseli arrived in Rome in May and remained there for eight years, evolving a unique style and approach to the human figure that laid the groundwork for his mature art. His translation of Winckelmann made him welcome in Albani's circle which now included Alexander Runciman and the Swedish sculptor J. T. Sergel, both of whose nervous drawing line and dramatic chiaroscuro influenced him. He was profoundly affected by his experience of the antique and of Michelangelo, but from the start he used them as the basis for more dramatic and bizarre visual statements. For example, like everyone else he was attracted to the Pompeii *Love Vendor*, but he created his own special paraphrase: the vendor has been transformed into a hag-like procuress who dangles a miniature male adult enticingly before a bewitched patrician lady (fig. 3.25). The shadows on the face of the lustful client and in the background give the sketch a lurid quality. While he retained aspects of the linearity and relief character of neoclassicism, Fuseli charged the scene with an unprecedented drama.

Fuseli's original approach was one way to overcome his late start and conceal technical deficiencies, but more important it related to a sense of rivalry with the magisterial creations of antiquity. A drawing owned by Coutts indicates this mentality, *The Artist Overwhelmed by the Grandeur of Ancient Ruins* (fig. 3.26). Based on the frag-

ments of the colossal statue of Constantine at the Capitoline Museum in Rome, the drawing depicts a diminutive artist despairing over his incapacity to achieve something of their awesome character. While Fuseli arranged the classical fragments in a design analogous to "ruin rooms" by Clérisseau or background accessories by Batoni, their magnified scale puts them beyond the ability of the individual to fit them to a contemporary schema. Fuseli solved the dilemma for himself by projecting in the drawing a sense of the magnitude of Rome through distortion and exaggeration of scale, charging it with contemporary emotion and energy, and through these grandiose effects achieving parity with the greatness of the past.

Perhaps the hallmark of this shift in neoclassic conception is Fuseli's reworking of vase paintings. In 1775 he visited Naples and the excavations at Herculaneum and Pompeii and met Sir William Hamilton, another client of Coutts. Since the late 1760s Fuseli had copied on more than one occasion the vase imagery reproduced in d'Hancarville's catalog and which he now sketched directly from the originals. During the crucial period of his stylistic maturation he was decisively affected by vase painting—clearly revealed in his attenuated figures and their internal muscular delineation. In 1771 a red-figured vase in Hamilton's collection inspired Fuseli's melodramatic theme from Shakespeare, *The King of Denmark Poisoned in His Sleep by His Brother* (figs. 3.27, 3.28). Based on the motif illustrated in d'Hancarville (vol. 2, plate 32), Fuseli

3.27 Henry Fuseli, *The King of Denmark Poisoned in His Sleep by His Brother*, 1771, pen and ink watercolor drawing. Graphic Collection of the Swiss Federal Institute of Technology, Zurich.

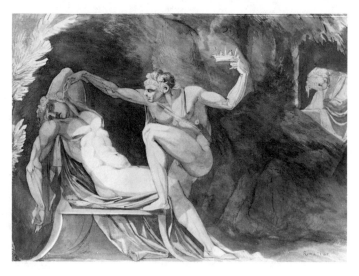

3.28 Plate 32 of Sir William Hamilton, *Collection*.

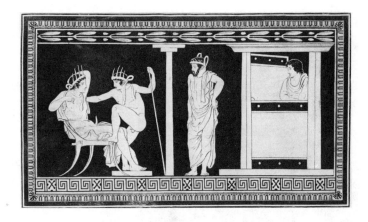

dramatized his version with stark light and dark contrasts, exaggerated postures, and wild grimacing. The work exemplifies the shift from neoclassic fidelity to the "spirit" of the antique to a new departure emphasizing extravagant feelings and gestures. Fuseli's composition illustrates Hamlet's first monologue (scene 1, act 2) in which he says about his father: "So excellent a king: that was to this Hyperion to a Satyr." Hamlet compares his father (upon whom the light falls in a circular shape) to the Sun God and his uncle to the Satyr who embodies the world of shadows—the principle of light snuffed out by the principle of darkness. Here neoclassicism is transformed by the horror of the sublime, and this change signals the impact of scientific exploration. At the same time, Fuseli preserves the classical flatness and lateral movement of vase painting, thus extending the Hamilton-Wedgwood exploitation of the antique in the interests of commerce and industry.

Fuseli's successful adaptation of neoclassicism to the dynamics underlying the Industrial Revolution is shown by the reception he enjoyed in Rome. Thomas Banks, a young sculptor in the British community, wrote in 1773: "Among the students in painting, Fuseli cuts the greatest figure; last season he had pictures bespoke to the amount of £1,300, good encouragement for a student . . . "[66] This is surprising when we consider that he was now working antithetically to Winckelmann's sedate ideal, searching for terrifying, breathtaking scenes at their highest moment of tension in which he could portray the violent passions and dynamic gestures of heroic personalities. In addition to antique themes he illustrated Dante's *Inferno* (including the horrifying *Punishment of Thieves*),

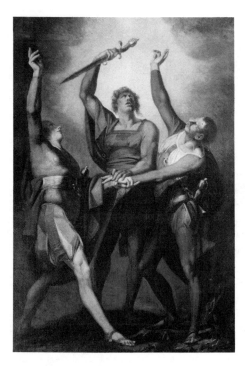

3.29 Henry Fuseli, *The Oath on the Rütli* 1778–1781, dated 1780. Rathaus, Zurich.

Shakespeare's *Macbeth*, Milton's *Paradise Lost*, and Gray's *The Descent of Odin*. These are rendered with eerie lighting effects, ghostly visions, and agitated movements which invoke the Ossianic and sublime categories. While Fuseli never seems to have done explicitly Ossianic themes, his ideas were stimulated by MacPherson's imagery as seen in his *Ode to Bodmer*. His decision to do Gray's ode (based on Nordic legend) and his use of ghostly apparitions and lunar effects attest to this intellectual link. It may also be recalled that his friend Alexander Runciman, with whom he shared the exaggerated style and interest in the macabre, executed his seminal Ossianic cycle for the Penicuik House in 1773. Their success demonstrates that startlingly new interpretations appealed to members of the governing elite. Naturally Coutts, who established banking connections with Jenkins, had much to do with Fuseli's rapid rise; but Coutts himself evidently received ideological feedback from his protégé's work. No wonder that Fuseli could later associate English commercial, scientific, and industrial supremacy with his own exalted imagination: "England is a country dear to fame, whose race nearly peopled one hemisphere, balances the power of both, distributes the wealth of the globe, irradiates science, soars on the wing of fancy, the first in discovery and every useful art."[67]

Fuseli's fresh synthesis is seen in his first major commission, *The Oath on the Rütli* (fig. 3.29). At the end of his Italian sojourn in 1778 he returned briefly to Zurich, at which time he received orders from Swiss patrons including an official commission for the Zurich Town Hall commemorating the advent of the Helvetian Confederation. By then clouded over with popular tradition, the *Oath of the Rütli* was actually the first federal pact signed by representatives of the three cantons, Uri, Schwyz, and Unterwalden, in August 1291. The representative leaders (Walter Furst, Werner Stauffacher, and Arnold von Melchtal, all major landowners, together with a select number of delegates) met at night in the Rütli, a secluded Alpine meadow above the Mytenstein on Lake Uri. Just before dawn, each one raised his right hand toward heaven and swore a solemn alliance which became known as the Eternal Covenant. At that moment, the sun shot its first rays through the clouds and across the top of the Mytenstein mountain. Fuseli's composition concentrates on the three heoric figures who occupy almost all of the space and are cast in a superhuman mold. They are pro-

jected from a low vantage point which further enhances their monumentality. Scale and anatomy have been manipulated to maximize a dramatic impact. The powerful figures raise their right hands and clasp left hands in the vow of unity. The two flanking leaders lift their hands with only three fingers raised, the traditional gesture for the oath of confederacy. The central hero holds aloft a sword dramatically silhouetted by the brilliant flash of light bursting through the dark clouds at the top of the picture.

Despite the dramatic foreshortening and illumination, it seems clear that the work was influenced by vase design. The low horizon, spare background, shallow space, and the exclusive focus upon, and clustering of, the figures all attest to vase-painting prototypes. This is even more conspicuous in his preliminary drawing of 1779 showing the figures nude with schematic interior markings. The poses and gestures are far less rhetorical than in the final work and the figures flatter and more calligraphically executed. As in Rome, the classical prototype was used as the point of departure for the evocation of a supernatural mood.

All three of the canton leaders display exaggerated facial expressions which border on grimace. This is understandable in light of the fact that the commission coincided with the publication of Lavater's major literary effort, the *Physiognomische Fragmente* (*Essays on Physiognomy*), which appeared between the years 1775–1778, and to which Fuseli contributed illustrations. (Fuseli also edited and illustrated the English translation.) Fuseli's illustrations deal for the most part with the horrific, the sublime, and the dynamic characteristics expressed in his contemporary drawings and paintings. He and Lavater certainly thought of physiognomy as a science, a way of discovering the interior of persons by their exterior and evaluating by natural signs "what does not immediately strike the senses." Like Darwin, who believed that physiology and psychology were grounded in the same material substance, Lavater tried to resolve the dichotomy between spirit and matter through physiognomic analysis. He defined his purpose as attempting "to arouse the perception of God in man." He stressed the unearthly, superhuman source and meaning of the positive powers of individuals, hoping thereby to keep his congregation attuned to the soul by reminding them of the connection between their innermost thoughts and the outer form of

head and face. He looked to portraits of great people to find the expression of their inner powers, the working of God, the Divine itself. It was an essentially conservative system rationalizing the position of an intellectual elite and categorizing all the rest more meanly. Similarly, Fuseli's *Oath on the Rütli* relies on physiognomies to suggest the elevation of three heroic personalities over the downward pull of injustice, convention, and reticence.

Fuseli received this commission in 1778 through the influence of a prominent Zurich citizen whose name has not yet been determined exactly. We know that among Fuseli's patrons in this period were members of the Escher family, one of the oldest of Zurich's patrician dynasties. Salomon Escher (1743–1806) commissioned both the double portrait of Fuseli and Bodmer and the bizarre *Ezzelin Bracciaferro Musing over the Dead Meduna*.[68] It is most likely that Salomon, a major silk manufacturer whose family occupied prominent administrative posts in Zurich, was also instrumental in the commission for the Town Hall. All three works were completed in London in the period 1779–1781 and have a common thematic focus in their ideas of unity and loyalty. Fuseli's double portrait depicts an exchange between an older and younger Swiss generation, with Bodmer reaching out to physically touch his disciple as he brings home his point. The ancient tradition, symbolized by the grotesque bust between them, is in turn transmitted by the venerable sage to his respectful disciple. Fuseli is careful, however, to distinguish his fashionable and youthful appearance from the quaint, old-fashioned garb of his mentor, thus emphasizing the bridging of the old and the new generations.

Curiously, the pose of *Ezzelin Bracciaferro* is a tenser version of the one Fuseli gave himself in the double portrait, where he supports his head with the V-shaped position of his fingers. The subject itself is obscure and based on Fuseli's own fiction. In his account Ezzelin was a crusading nobleman from Ravenna who, on returning from battle, learns that his wife had betrayed him in his absence and impulsively kills her. Fuseli shows him brooding over the prostrate body, now uncertain whether she merited this form of retribution for destroying domestic unity. All around the room the Christian symbols like the crucifix and open bible suggesting that his act was one of self-sacrifice and duty. The *Oath on the Rütli* completes this trilogy of unity and self-sacrifice and carries a

highly personal message. Akin to the portrait of Bodmer and Fuseli, it shows the uniting of young and old Swiss generations in the defense of traditional prerogatives. In the letter Fuseli wrote Lavater in October 1781, he declares that the *Oath on the Rütli* is his best work: "I spent a large part of the summer on it and spared nothing to make it worthy of the place where it is to hang, of the men whom it represents, of the impression it is to make and of you and me." It is evident that it contained autobiographical allusions and may specifically refer to the three members of the "Patriots" club—Fuseli, Lavater, and Hess—who had their own moving reunion in 1778. They had attacked the tyrannical bailiff Grebel analogously to Wilhelm Tell attacking Gessner (according to the legend centered on the Rütli episode and popularized in Schiller's play). And it is probably not fortuitous that their notorious pamphlet appeals to enlightened officials to punish Grebel—including one named Escher.

The immediate political circumstances surrounding this commission are related to the Franco-Swiss pact of alliance signed at Solothurn on 28 May 1777. In exchange for certain military and trade advantages France promised to guarantee the union, happiness, and security of the Swiss confederacy.[69] While all the Swiss states eventually signed the pact, opposition to it was noticeable in the Protestant cantons which mingled anti-Catholic feeling and regional rivalry with their hesitation in surrendering part of their independence. At Zurich the leaders of the campaign to form the alliance were the burgomaster Johann Conrad Heidegger (another to whom the "Patriots" appealed in their attack on Grebel) and the Statthalter Heinrich Escher, a relative of Salomon.[70] They shared the preoccupations of the Zurich elite about national unity, independence, and neutrality, but felt that the alliance was the best guarantor of these principles. What is more, they hoped to secure economic advantages for Zurich which was the center of the silk and cotton industries. Swiss silk merchants nearly doubled their exports to France between the years 1775 and 1777 and hoped to extend their commercial privileges through the alliance. Zurich convoked a major diet of Swiss states at Baden in 1776 to discuss the French proposals, with Heidegger presiding and Escher at the head of a delegation of the thirteen cantons receiving the French representative.

The regal ceremony celebrating the oath of the alliance

took place at Solothurn during 24–26 August 1777. On 25 August the deputies, wearing the ancient dress of cloak and sword, gathered at the Town Hall to render the Helvetian three-fingered salute. Escher now headed the Zurich contingent and was the first to pronounce the oath of the alliance in the name of the Swiss Confederation.[71] It is surely this event that informs Fuseli's *Oath on the Rütli*, which, as he himself claimed, honors Zurich and the men who ran it. Since Heinrich Escher died later that year, it is possible that Salomon wanted to commemorate his participation in the alliance with Fuseli's picture. One clue to Escher's role in the commission is the large moth in the lower right of the picture sitting at the feet of the group (fig. 3.30). While a nocturnal complement, it closely resembles the *Bombyx mori* whose larvae produces silk. This image should therefore refer to Salomon, a major silk manufacturer and merchant.[72] Fuseli's interest in entomology served him well here, indicating also how this science contributed to the needs of contemporary industry.

Fuseli's painting connects the heroic pact of the three cantons in 1291 with the French alliance in 1777. It is an affirmation of the will to national unity, a subject of intense debate during preparations for the acceptance of the alliance. Zurichers jealously guarded their presumed autonomy, and Fuseli's image verified it not only for those who defended the French pact but also for those who perceived it as an encroachment on their traditional independence. Ironically, a conservative backlash began to make itself felt around 1780 when further meetings of the

3.30 Henry Fuseli, *The Oath on the Rütli* 1778–1781, detail. Rathaus, Zurich.

Helvetic Society were forbidden and many of its publications ordered to be burnt.

Fuseli's *Oath on the Rütli* is itself a conservative realization of the avowal of alliance, occurring in the remote past and depicted as part of a visionary or religious experience. The figures are ecstatic and fervent and charged with cosmic, rather than specific, significance. Certainly the original covenant of the three cantons was defensive rather than revolutionary: the parties to the treaty were most concerned with judicial procedure and aimed at upholding certain customs and reaffirming old privileges. But even this sense of concrete political justice is stated in the most abstract terms by Fuseli. Swiss patriotic feeling, having neither specific class connection nor reformist guidelines, concentrated on a nostalgic view of the past and on general, romanticized notions of unity. While Fuseli's work is informed by ideas drawn from contemporary science, it is escapist and fantasy-ridden. Akin to his youthful hero Klopstock, his sense of liberty and independence took the form of an Ossianic idealization of the virtues of ancient heroes by which he hoped to instill in his contemporaries a new patriotic pride. And consistent with Fuseli's philosophical (but historically false) approach, the event of the pact is envisioned as the work of a few forceful personalities.

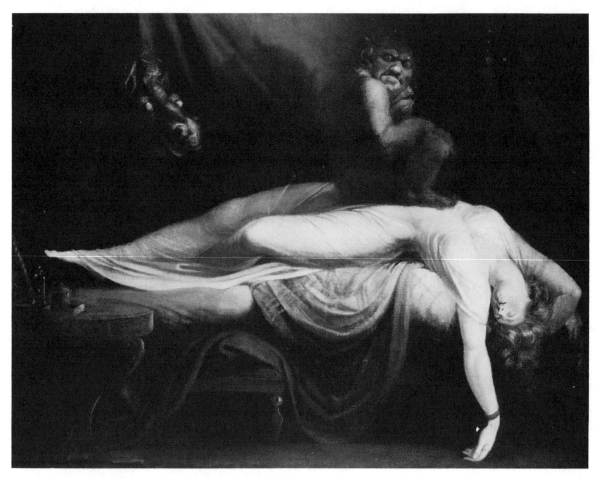

4.1 Henry Fuseli, *The Nightmare*, 1781. Gift of
Mr. and Mrs. Bert L. Smokler and Mr. and
Mrs. Lawrence A. Fleischman, The Detroit In-
stitute of Arts, Detroit.

4 The Industrial Revolution:
Post–American Independence Phase

When Fuseli returned to England in 1779 he experienced the anxiety over the American War of Independence, another dramatic case involving the principles of union and independence. A sense of profound oppression had struck the court and the propertied classes, for the political situation menaced both the domestic and colonial unity. The Gordon Riots of June 1780 demonstrated the widespread working–class discontent with the established order, both secular and ecclesiastical.[1] Edward Gibbon declared: "Our disgrace will be lasting, and the month of June 1780, will ever be marked by a dark and diabolical fanaticism which I had supposed to be extinct." Burke later recalled with horror how close England came to full-scale rebellion. Among the protesting multitude were many "Wilkites"—followers of John Wilkes who opposed the court and its aggressive American policy. Fuseli himself used the term "diabolical" (*teuflisch*) to describe the radical outlook of Wilkes, and it is certain that he shared the sense of alarm that gripped the reigning elite.

The Nightmare

It is not surprising to find that in the same year he applied the finishing touches to the *Oath on the Rütli* (although actually dated the previous year, 1780) he executed his most macabre picture of all, *The Nightmare* (fig. 4.1).[2] The conservative image of political unity was superseded by a terrifying image of chaos and social disorder. The scene shows a woman prostrate in her bed, her head thrown violently over the side with her arms slung lifelessly downward. Her face is twisted in agony, while

a ghastly incubus with a fiendish smirk sits heavily on her chest. From behind the drapes at the right a horse's head with wildly staring globular eyeballs and flying mane thrusts itself into the scene. The interior is steeped in shadow, except for the woman, horse, and incubus which are lit as if by violent streaks of lightning. Moreover, occurring as it does in the bedroom, the horrific vision conveys a sense of flagrant invasion of privacy and random violation of an intimate space.

Probably the most unusual work ever exhibited at the Royal Academy, *Nightmare* created a sensation among the cultured elite (Walpole called it "shocking") and through engravings made Fuseli famous all over Europe. Its success, however, was not founded exclusively on its unusual content but on its capacity to encapsulate the fears and anxieties of the English ruling classes the year Cornwallis surrendered to Washington at Yorktown. Throughout this period Londoners were entranced by violent and melodramatic effects, as seen in the success of the painter Philippe Jacques de Loutherbourg (1740–1812), the principal stage and set designer at Drury Lane Theater. He created a sensation with his *Eidophusikon* which he exhibited for the first time on 26 February 1781.[3] Scenes were painted on sheets of transparent glass, lit from behind by powerful Argand lamps, and complemented by a variety of dazzling visual and sound effects. At first he concluded his performance with a shipwreck and storm at sea, but by December he was ending with the Miltonic theme of *Satan Arraying his Troops on the Banks of the Fiery Lake, with the Raising of the Palace of Pandemonium*. In this finale legions of shrieking demons arose at the signal of their master, and a volcano erupted liquid fire while accompanied by thunder and lightning.

Both dissenter and conservative alike feared the worst in that period and perceived the Empire tottering on the brink of ruin. In his *Facts* (published by Johnson), the radical Horne Tooke characterized the economic and social state of Great Britain in utterly catastrophic terms. This was seconded by Fuseli's lifelong benefactor, Thomas Coutts. Coutts, who had extensive investments in the East India Company and colonial trade, had been extending credit to George III throughout the war and by 1780 feared national bankruptcy. His correspondence throughout the late 1770s and early 1780s attests to a sense of growing alarm for the Empire. He worries constantly about the national debt and the rise and fall of the

stock market as a result of the American involvement. While he remained firmly on the side of privilege and authority, he deplored what he designated the "ruinous conflict." On 1 July 1779 he feared for "an end of the Empire," and added: "The apprehensions of all sensible thinking men are very great indeed . . . This cursed American war, and the obstinacy with which it was begun and continued, has been our ruin." By November he was lamenting the outbreak of "trouble with Ireland" which increased domestic pressure already at the boiling point: "Everybody are of the same mind on these subjects, but none can discover the remedy—so that I fear we must go to the devil." A year later he declared that unless the American conflict was settled nothing could save the country, and following the Gordon Riots in June he worried about "dark and dangerous plots." He wrote on 27 February 1781 of his concern with the imminent threat of French and Dutch naval forces, which, if realized, "shall see the nation in a terrible fright."[4]

Not coincidentally, Fuseli's first sketch for the *Nightmare* carries the inscription "St. Martin's Lane March 1781."[5] Fuseli moved from Broad Street to 100 St. Martin's Lane in 1782, so it could not have been his address at that time. But Coutts then lived in St. Martin's Lane and hosted Fuseli on a regular basis. This still does not demonstrate a direct link; St. Martin's Lane (like Chelsea today) was a fashionable district for the cultured elite and the artists that served them. Nevertheless, what is important is that the time and place of the work's conception was documented by the artist and grounded in a specific historical and social situation. *Nightmare* thus embodies the social tensions of Fuseli and the patrons he represented in that fateful period.

The Irish Crisis

Coutts mentioned the Irish situation as another facet of the Empire's problems: the revolt of the colonies stimulated the eruption of Ireland, which, like America, was neither an independent nation incorporated into a federal system nor absorbed into the general political mass like Scotland. Ireland was subject to Britain but shared neither in its civil liberties nor its wealth. It had no national existence of its own, and Catholics were treated as strangers in their country. The House of Lords, the House of Commons, the courts, all corporate offices in

towns, all military ranks, the whole administration of government were run by the minority Irish Protestants and closed to Catholics. The immense majority of the people of Ireland worked for Protestant masters who regarded themselves as more Scottish or English than "Irish." Nevertheless, even the Protestant body suffered religious and political persecution; the Presbyterians, who formed the bulk of Ulster settlers, were also shut out by law from all civil, military, and municipal offices. The running of the country was in the hands of members of the Anglican church, which meant about one-twelfth of the entire population, and within this group a few great landowners monopolized the government. Irish politics were for these people a means of public plunder, and the only check on their control was the subordination of the Irish Parliament to the English Privy Council. But England had done her best to destroy Irish commerce and ruin Irish agriculture in the interests of its own merchants and farmers.

The bitter memory of the last conquest, however, acted as a check on radical hopes of revolt among the native Irish; and the sporadic outbreaks that arose from the misery and discontent of the poor were mainly social in character and severely repressed by the dominant class. When the threat of political revolt at last menaced English supremacy over Ireland, it came from the dominant class itself at the time of the crisis over the American Revolution. The threat of a French invasion and the want of troops to oppose it compelled the government to call on Ireland to provide for its own defense, and in answer to this call 40,000 volunteers enlisted in 1779. The force was wholly Protestant, staffed by Protestant officers and controlled by the Protestant oligarchy. This group now threatened an armed revolt unless concessions were granted and laws hindering their legislative initiative were repealed. Meanwhile, the Volunteers were forced to get support of native Catholics who in turn demanded concessions in the exercise of religion and economic restrictions.

The problematic character of Irish politics was captured in pigment by the London-born Francis Wheatley (1747–1801) who adopted Ireland as his home country to escape his English creditors in 1779.[6] Trained in Shipley's drawing school, he learned early to attach himself to the dominant elite to advance his career. Immediately after arriving in Ireland, he began painting major works

4.2 Francis Wheatley, *A View of College Green with a Meeting of the Volunteers on the 4th of November 1779*, 1780. National Gallery of Ireland, Dublin.

glorifying the Irish minority rulers, executing in the years 1779–1780 *A View of College Green with a Meeting of the Volunteers on the 4th of November 1779, to Commemorate the Birthday of King William* (fig. 4.2) and *The Irish House of Commons: Henry Grattan Urging the Claim of Irish Rights, 8 June 1780*. Both point to the dynamic character of Irish politics under the impact of the American Revolution.

The first celebrates the social, political, and economic order identified by historians as the Protestant Ascendancy. The Volunteers, organized to fill the vacuum left by the English troops needed in American and to forestall an expected French invasion, assemble to commemorate the birthday of King William III under whose reign the last pockets of Irish resistance were crushed in 1690. The Volunteers gather around the equestrian statue of King William, symbolically occupying the central position, while in the background we catch glimpses of the Irish Parliament House which ratified Protestant minority rule, and Trinity College, whose bar to Catholics in the period maintained the Protestants' exclusive social position. Amid the resplendent pageantry, the figure of the officer who signals the firing of the musketry stands out: he is the second duke of Leinster who supported Wheatley's career and into whose collection the painting passed. His equestrian elegance, however, is upended by the nightmarish implications of Fuseli's beast.

At the time of the meeting, the Irish Parliament was agitating for repeal of the trade restrictions imposed by Great Britain. This agitation was led by Henry Grattan, a Protestant whose steadfast loyalty to the crown did not prevent him from advocating sweeping Irish economic

4.2a J. Dixon, *A Political Lesson*. Mezzotint, 1774. Library of Congress, Washington, D.C.

4.2b *The Horse America, Throwing His Master*, Etching, 1779. Library of Congress, Washington, D.C.

reform and attacking the king's position on the American colonies. When on 19 April 1780 he introduced a resolution calling for legislative independence from the English Privy Council, it gained impact by virtue of the American conflict, and England made the concession of abolishing the embargo on Irish exports to the New World. Wheatley's painting of Grattan in Parliament represents the other side of Irish politics in the time of tension, indicating how the crisis was exploited to gain indigenous reforms and advantages.

England now felt itself caught in a vise of opposing factions at home and abroad, and the need to deal with Ireland and Wilkites became as pressing as the need to solve the American crisis. Only when Lord North and the Tories were voted out in March 1782 and the Whigs assumed control could the problem of satisfying Ireland and ending the war with the United States be met.

Neither Fuseli nor his patrons could be detached from events of such magnitude, and the *Nightmare* may be said to represent a pictorial attempt to work through the actual terror of the historical situation. The confidence of the neoclassicists was shaken and their principles were no longer adequate for the experimentalists of the 1780s; neoclassical style and form was subject to the same deformations as the political and social realms. He articulated anxieties in a form that his patrons could bear. Fuseli consistently embodied his ideas in allegorical form which often touched on political concerns. He himself lauded allegory for its capacity to break "the fetters of time, it unites with boundless sway mythologic, feudal, local incongruities, fleeting modes of societies and fugitive fashions."[7] True to this concept, in *Nightmare* he used classical prototypes such as the Gorgon and the Horsetamers of the Quirinale in Rome, but fused them with the modern decor including rococo table and medicinal vials. Viewed allegorically, the ravished woman on the bed becomes Britannia, the impious incubus (resembling a malevolent leprechaun, and the untamed horse invading the sanctity of the bedroom are Britain's overseas and domestic enemies. Indeed, the popular comic prints *A Political Lesson* (1774) and *The Horse America, Throwing His Master* (1779), distributed in England and the colonies, use the wild horse to signify the rupture between Mother Country and rebellious offspring (figs. 4.2a,b).

That Fuseli could think in these terms is already seen in his frontispiece etching for his book, *Writings and Con-*

4.3 Henry Fuseli, frontispiece etching for his *Writings and Conduct of J. J. Rousseau*, Cadell and Johnson, 1767.

duct of J. J. Rousseau, published by Cadell and Johnson in 1767 (fig. 4.3)[8] Here Fuseli defends his hero Rousseau against Voltaire's attack published in a pamphlet that circulated in London the year before, *Lettre de M. de Voltaire au Docteur Jean-Jacques Pansophe*. The notable passage in the satirical piece is the central character's harangue to the citizens of London, exhorting them to return to nature and eat grass in Hyde Park. In Fuseli's pictorial response Voltaire is represented with a pair of boots and spurs, whip in hand, bestriding a "monster" he has bridled, saddled, and brought to the ground. He has whipped the "natural man" into his view of "humanity." Over his head, hanging on a gibbet, are the personifications of Justice and Liberty, while on the horizontal beam sits the remains of the Temple of Liberty. At the left stands the shrugging Rousseau pointing to the beast and his burden, holding a plumb line in his left hand as if to gauge the real worth and sincerity of the rider.

What is important here is that the frontispiece demonstrates that early in his career Fuseli used the female figure to personify abstract social and political ideas, and metaphorically combined horse and rider to suggest a vicious situation. That the monster-human relationship is seemingly reversed does not alter the conceptual framework which deploys ideas and forces in an allegorical mode. Indeed, the smirking expression of Voltaire may be compared to the malevolent grimace of the incubus, while the suspended figures have the lifeless, abandoned character of the female in *Nightmare*. The monster Voltaire not only is the rider of "Man in a State of Nature" but is also the executioner of the feminine personifications of Justice and Liberty.

Still another example of his use of political allegory is a commission he did for William Roscoe commemorating the unity of England and Ireland which had been made official by Pitt on 1 January 1801 (fig. 4.4).[9] Also a patron of Wright of Derby, Roscoe was an influential banker from Liverpool as well as gifted botanist and author.[10] He founded the Botanic Garden of Liverpool and was also active in promoting Liverpool art associations. He ardently opposed slavery on moral grounds and championed the Irish cause in the name of free enterprise and as a stimulus to Liverpool trade. Fuseli's picture was destined for the Union Society of Liverpool, and depicts the Goddess Concordia reconciling Britannia and Hibernia, while off to the right Minerva chases away the spir-

its of discord. Although painted twenty years after *Nightmare*, this work may be said to celebrate the exorcism of the demons inhabiting the earlier painting.

Shortly after completing this commission he produced a series of illustrations for Joel Barlow's *Columbiad*, the popular American patriotic epic.[11] While his engravings were ultimately rejected in favor of that of another illustrator, they indicate a mind set that had not fundamentally altered since the time of *Nightmare*. His version of *The Inquisition*, or *Religious Fanaticism, Attended by Folly Trampling Upon Trust* shows two demonic personages, one holding a flaming torch and stepping with one foot on the chest of Truth who lies prostrate on the ground, her slung arm manacled at the wrist, one leg bent and the other outstretched like the female (who wears a bracelet) in *Nightmare* (fig. 4.5). Peeking from behind the cloak of Religious Fanaticism is a wild-eyed Folly who recalls the horse in the painting. The passage in Barlow describing "Gaunt Inquisition," for which this engraving was intended, conjures up a nightmarish scene:

Her blood-nursed vulture screaming at her side.
Her priestly train the tools of torment brings,
Racks, wheels and crosses, faggots, stakes and strings;
Scaffolds and cages around her alter stand,
And, tipt with sulphur, waves her flaming brand.
Her imps of inquest round the fiend advance . . .
Jews, Moors and Christians, clank alike their chains,
Read their known sentence in her fiery eyes,
And breathe to heaven their unavailing cries;
Lash'd on the pile their writhing bodies turn,
And, veil'd in doubling smoke, begin to burn.
Where the flames open, lo! their limbs in vain
Reach out for help, distorted by the pain;
Till folded in the fires they disappear,
And not a sound invades the startled ear.[12]

Another of his projected illustrations for Barlow, *Cruelty Presiding over the Prison Ship*, makes use of demons to criticize the practice of impressing seamen. One of these peers at the spectator with a malevolent smirk like Fuseli's incubus. Barlow's references to "brazen eyes" that "cast lightning" and "grinning jaws" were made to order for the creator of the *Nightmare*:

She comes, the fiend! her grinning jaws expand,
Her brazen eyes cast lightning o'er the strand,
Her wings like thunder-clouds the welkin sweep,
Brush the tall spires and shade the shuddering deep;
She gains the deck, displays her wonted store,
Her cords and scourges wet with prisoner's gore . . .
Disease hangs drizzling from her slimy locks,
And hot contagion issues from her box.[13]

A mutual friend of both Barlow and Fuseli, the poet and engraver William Blake, apparently absorbed the allegorical implications of *Nightmare* in his illustrated book *Jerusalem*. This poem was a symbolic effort to overcome all possible human divisions, in individual psychology, in social institutions, in national conflicts, and includes references to the separation of America and the struggles with Ireland. Below the text in plate 94 an image of a clothed female figure lying over the body of a male figure stretched across the page illustrates this passage: "England who is Brittania [sic] awoke from Death on Albion's bosom; / She awoke pale & cold; she fainted seven times on the Body of Albion." Britannia then exclaims in imagery strikingly close in spirit and mood to the *Nightmare*:

O pitious Sleep, O pitious Dream! O God, O God awake! I
 have slain
In Dreams of Chastity & Moral Law; I have Murdered Albion!
 Ah!
. .
 I have slain him in my Sleep with the Knife of the Druid! O
 England!
O all ye Nations of the Earth, behold ye the Jealous Wife!
The Eagle & the Wolf & Monkey & Owl & the King & Priest
 were there![14]

4.5 Henry Fuseli, *The Inquisition* or *Religious Fanaticism, Attended by Folly Trampling Upon Truth*, etched illustration planned for Joel Barlow's *Columbiad*. The Fotomas Index, London (439/F.16515).

Although written in the early years of the nineteenth century, Blake's personifications attest further to the imaginative options available to Fuseli's contemporaries.

But the allegorical interpretation of *Nightmare* is per-

4.6 Robert Adam, *Monument to Major John André*, 1780–1781. By courtesy of the Dean and Chapter of Westminster.

fectly consistent with other types of art produced in the early 1780s. The best example is Robert Adam's monument to Major John André executed and installed in Westminister Abbey in the period 1780–1781 (fig. 4.6). André was the British emissary chosen to deal with General Benedict Arnold, the American traitor who offered to negotiate with the English over the surrender of West Point. André was captured and petitioned for an honorable soldier's death; instead, he was tried by an American court-martial, sentenced as a spy, and hanged. For the English the almost successful treason of Arnold and the tragic loss of André were among the most noteworthy events of 1780. Coutts—also Adam's banker—enjoyed momentary euphoria over the news of the revolt but mourned "the loss of poor André."[15] The fate of the popular officer generated deep sympathy among the English. Adam's monument shows a mournful Britannia seated with her legs extended along the top of the tomb, her left arm slung listlessly over a shield bearing the Union Jack. The composition shares significant features with the *Nightmare*: the flow of Britannia's robe parallels that of the woman in the Fuseli, and the British Lion accompanying Britannia, who tilts her head in her direction, reveals through his flowing mane and muzzle an affinity with the wild horse thrusting in from behind the curtain. Adam's monument helps to recover the background of imaginative perception in the early 1780s and reinforces the idea that Fuseli's picture contains political material.

Critics have rightly observed the important erotic component of *Nightmare* and have tried to connect this with the artist's personal sexual attachments and fantasies. They see the work as the outcome of a frustrated passion for Lavater's niece, Anna Landolt, whose portrait may be the one on the back of the *Nightmare*. Hence this interpretation would make of the picture a personal obsession rather than a response to public events. The point, however, is that these are not incompatible: the woman's position and the grinning imp suggest rape, but this is consistent with a prostrate Britannia. Moreover, Fuseli the man could also have identified with the violated female Mother Country on a sexual level. In a series of erotic—almost pornographic—studies dating from the 1770s Fuseli shows a passive nude male being sexually aroused by a group of women (fig. 4.7).[16] They either squat on or support his reclining body while playing

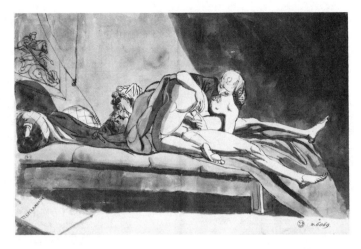

4.7 Henry Fuseli, *Erotic Study*, 1770s, ink drawing. Museo Horne, Florence.

with his genitals. These are unusual for Fuseli since he shows women most often as submissive to powerful males, the obverse projection of sexual insecurity. His projection of the active sexual role for the female must correspond to a deep layer of Fuseli's repressed psychic life which erupted at the surface during the anxiety-ridden events of 1780–1781. Fuseli's powerless Britannia would thus coincide with his fears of sexual immobility and, by inference, of personal political impotence as well.

All this may sound plausible in an age imbued with the teachings of Freud, but it does not sufficiently explain how it was possible for Fuseli to cast his personal and political anxieties in the context of a *nightmare*, complete with eerie lighting effects, claustrophobic interior, and incongruous juxtapositions of animal, human, and supernatural beings. This would have required more than a vivid recollection of a felt experience but also some scientific appreciation and understanding of dream activity and occult experience. Not surprisingly, Fuseli's admirer Erasmus Darwin investigated both in his writings and published an engraving of the *Nightmare* in his 1791 publication of the *Botanic Garden* together with an astonishing poetic and scientific interpretation (fig. 4.8):

So on his NIGHTMARE, through the evening fog,
Flits the squab Fiend o'er fen, and lake, and bog;
Seeks some love-wilder'd Maid with sleep oppress'd,
Alights, and, grinning, sits upon her breast.
—Such as of late, amid the murky sky,
Was mark'd by FUSELI's poetic eye;
Whose daring tints, with SHAKESPEAR'S happiest grace,
Gave to the airy phantom form and place.—

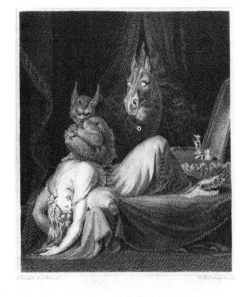

4.8 Henry Fuseli, *Nightmare*, illustration for *Botanic Garden*, 1791 edition.

Back o'er her pillow sinks her blushing head;
Her snow-white limbs hang helpless from the bed;
While with quick sighs, and suffocative breath,
Her interrupted heart-pulse swims in death.
—Then shrieks of captur'd towns, and widows' tears,
Pale lovers stretch'd upon their blood-stain'd biers,
The headlong precipice that thwarts her flight,
The trackless desert, the cold starless night,
And stern-eyed Murderer, with his knife behind,
In dread succession agonize her mind.
O'er her fair limbs convulsive tremors fleet,
Start in her hands, and struggle in her feet;
In vain to scream with quivering lips she tries,
And strains in palsy'd lids her tremulous eyes;
In vain she *wills* to run, fly, swim, walk, creep;
The WILL presides not in the bower of SLEEP.
—On her fair bosom sits the Demon-Ape
Erect, and balances his bloated shape;
Rolls in their marble orbs his Gorgon-eyes,
And drinks with leathern ears her tender cries.[17]

Darwin's poetic description of the work is a compound of the political, scientific, and horrific, locating Fuseli's concept well within the orbit of Lunar Society interests. The supine woman is agonized by the "shrieks of captur'd towns, and widow's tears, / Pale lovers stretch'd upon their blood-stain'd biers"—clear references to the recent war in America. In Part I ("Economy of Vegetation") he had already commented on the war in connection with Benjamin Franklin:

—The patriot-flame with quick contagion ran,
Hill lighted hill, and man electrified man;
Her heroes slain while COLUMBIA mourn'd,
And crown'd with laurels LIBERTY return'd.[18]

While Darwin's sympathies here are more with Columbia than Britannia, he gives us an insight into the contemporary allegorical mind set.

At the same time, he observes somewhat clinically that the woman is unable to confront or nullify the terrifying and irrational images which oppress her: "In vain she *wills* to run, fly, swim, walk, creep; / The WILL presides not in the bower of SLEEP." In a long footnote appended to this last line Darwin restates the nature of sleep and nightmares in scientific terms: sleep consists in the suspension of willpower over both muscular and mental activity though the sensory organs remain alert. Thoughts aroused during waking hours, moreover, continue to

resonate and stimulate dreams. But so long as volition is suspended there can be no active physical or mental challenge to the irrational train of associations. "When there arises in sleep a painful desire to exert the voluntary motions, it is called the Nightmare or Incubus."[19]

Darwin elaborated on his theories of sleep and dreams in his *Zoonomia; or, The Laws of Organic Life* (1794–1796), which attempted to set down a general law for both physiology and psychology. Here he devoted a long section to sleep and classified the nightmare as a form of mental "disease." He supplied a number of clinical case studies, indicating that he had been fascinated by the problem over a long period of time. While his analysis lacks the Freudian idea of the nightmare as a way of working through earlier trauma and repressed material, Darwin's perceptions seem surprisingly modern. Sleep inhibits motor discharge and muscular control; the fear of passivity and inaction in nightmares springs from this lack of volition. He treats the sense of time in dreams, why dreams are often forgotten, the function of the dream in preserving sleep, and the physiology of the body during this state.[20] When Fuseli declares in a much-quoted aphorism, "One of the most unexplored regions of art are dreams," he is in fact acknowledging Darwin's influence on his thought.[21]

Another revealing testimony to their relationship is found in the light dialogue "Interludes" dispersed through the "Loves of the Plants"; in exchanges with his bookseller the poet Darwin discusses the use of personifications in poetry and the plastic arts. Since in the latter they have to be more distinct than in poetry, they often appear as less probable, and only the genius manages to convince the spectator of their probability. Darwin compares this kind of deception to the experience of dreams. The gifted artist induces a state of reverie akin to sleep in which the voluntary, and therefore critical, faculties are suspended. This is achieved by presenting the material in a wholly original form: "The matter must be interesting from its sublimity, beauty, or novelty; this is the scientific part." Darwin expressly associated pictorial originality and sublimity with a progressive and scientific position, while at the same time rejecting the simple reproduction of nature as retrograde:

Nature may be seen in the market-place, or at the card-table; but we expect something more than this in the play-house or

picture-room. The farther the artist recedes from nature, the greater novelty he is likely to produce; if he rises above nature, he produces the sublime.

Here he adduced the example of our painter: "And the daring pencil of Fuseli transports us beyond the boundaries of nature, and ravishes us with the charm of the most interesting novelty."[22]

Darwin thus required premeditated artificiality in visual effects to induce an imaginative state akin to dreaming. Similarly, he was fascinated by mechanical and medicinal techniques which harnessed and controlled nature. He would agree with Burke that the pictorial sublime is a scientific concept based on the artist's ability to render extraordinary phenomena, but would insist that nature be surpassed in the same way that the engineer and the industrialist succeeded in transcending nature and rivaling it in magnitude, scale, and power. Darwin associated his creatures in the *Botanic Garden* with those of Shakespeare and Fuseli, and in the section following the first Interlude he takes up the spinning and weaving processes of Arkwright's cotton mill where "First with nice eye emerging Naiads cull / From Leathery pods the vegetable wool." Interlude 2 centers on the distinction between the Tragic and the Horrid, and the poet again stresses the need of the genius to induce a state of delight or reverie

4.9 Henry Fuseli, *Flora Attired by the Elements*, illustration for *Botanic Garden*, first published in 1791.

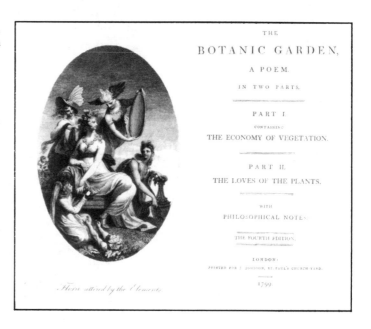

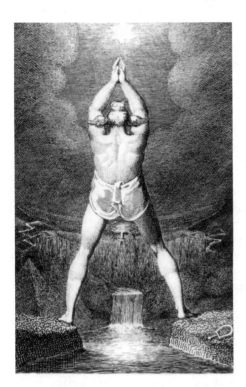

Fertilization of Egypt.

4.10 Henry Fuseli, *Fertilization of Egypt*, illustration for *Botanic Garden*, first published in 1791.

in tragedy to differentiate it from the horrible by mingling it with "sweet consolatory drops." Then follows the remarkable canto 3 which comprises observations on witchcraft, the ancient use of certain plants like the Nightshade to summon devils, toxic herbs, nocturnal creatures like bats, owls, "*two* imps obscene," and the interpretation of Fuseli's *Nightmare*.

Fuseli, Darwin, and other members of the Lunar Society came together under the auspices of the booksellers Cadell and Johnson, Fuseli's first employers and the publishers of Darwin and Priestley. Cadell and Johnson published the *Botanic Garden* for which Fuseli supplied four illustrations: the frontispiece entitled *Flora Attired by the Elements* (fig. 4.9), *Fertilization of Egypt* (fig. 4.10), the *Nightmare* for the 1791 edition, and *Zeus Battling Typhon* for the third edition of 1795.[23] *Fertilization* and *Zeus* depict violent meteorological activity and manifest Fuseli's interest in electrical phenomena: the latter shows the Greek god grasping outsized thunderbolts while struggling with a serpentine sea monster, and the former embodies the cosmic and earthly conditions at the time of the flooding of the Nile. Both works were engraved by William Blake, another artist regularly employed by Cadell and Johnson who frequently collaborated with Fuseli. *Fertilization* depicts a colossal canine-headed deity reaching skyward to the star Sirius (seen through parted clouds in an effect reminiscent of the *Oath of the Rütli*) while near the horizon a bearded deity (added by Blake) issues forth lightning and rain which causes the river to overflow. Darwin's inevitable footnote points out that the Nile flooding coincided with the rise of the dog star, and Egyptian astronomers charted this event to give notice of the approaching inundation at which time they hung effigies of the dog-headed god Anubis on the temples.

Images of electricity and electrical phenomena, both earthly and heavenly, pervade the poetry and commentary of *Botanic Garden*. Darwin's "Additional Notes" reveal that in his time meteors, comets, lightning, rainbows, and aurora were linked as electrical phenomena occurring in three distinct regions of the atmosphere, where electric "fluid" accumulated on vapors and was discharged in various forms. Below the earth's surface electrical forces gave rise to earthquakes and volcanic activity, and closer to home Darwin perceived them at work in fairy rings, will-o'-the-wisps, electric eels, and a

host of phosphorescent objects. He agreed with French natural philosophers that electrified seeds germinate faster and that electrified leaves give off luminosity, and he hoped to see the medical use of electrical charges to stimulate paralyzed organs, cure jaundice, and dissolve tumors.

Darwin's fascination with electrical energy is most markedly revealed in canto I of "Economy of Vegetation" where he enumerated various electrical phenomena and the "electricians" who discovered them: Benjamin Franklin, Abraham Bennet, Jacopo Beccari, and, above all, his close friend Joseph Priestley. He discussed such popular experiments as Beccari's work with phosphorescent light emitted in a dark room, the generation of a current by rotating a glass globe between the hands, and Franklin's application of the Leyden jar which was coated inside and out with tinfoil and could store an electric charge. The American scientist was compared to a saint with "crown electric round his head" and praised for his discovery of the lightning rod which protected houses and ships during thunderstorms.

Electricity was a popular subject in courses taught by itinerant lecturers, and the German K. P. Moritz, traveling through England in 1782, could note: "Electricity is the plaything of the English, and anyone who could puff about it was assured of a smashing success."[24] But if the English made a game of it they also saw it as an important key to unraveling the mysteries of nature. Priestley, who did invent all kinds of electrical toys, also claimed that, like air pumps and orreries, they exhibited the operations of nature, "that is, of the God of nature himself." Electricity thus partook of the Divine and attested to the union of science and religion. So important is this new study that with its progress "the bounds of natural science may possibly be extended, beyond what we can now form an idea of." Indeed, "New worlds may open to our view, and the glory of the great Sir Isaac Newton himself, and all his contemporaries, be eclipsed, by a new set of philosophers, in quite a new field of speculation." Priestley did not separate the purely speculative endeavor from more practical concerns: he urged the wealthy, especially merchants, to support the study of electricity, for from natural philosophy "have flowed all those great inventions, by means of which mankind in general are able to subsist with more ease, and in greater numbers upon the face of the earth."[25]

Fuseli could hardly have escaped the attraction of a field that combined magic, science, and religion in a synthesis which promised to usher in the millennium. His desire to make a stir by the shockingly different, his personal scientific bent, and his close business association with Darwin and Priestley would have made him susceptible to it. Priestley's *The History and Present State of Electricity*, published by Cadell in 1767, and his *Familiar Introduction to the Study of Electricity*, published the following year by Johnson, excited contemporaries like Fuseli's friends in the Sturm und Drang movement who identified electricity with spirituality and lightning with flashes of inspiration.[26] Fuseli's connection to Priestley is even more direct: as early as 1768 he executed the title-page vignette for the scientist's political tract, *Essay on the First Principles of Government*, and in 1783 he painted his portrait at the behest of their mutual benefactor, Joseph Johnson.

Fuseli's *Nightmare* manifests the interest in electricity in its effect of sheet lightning illuminating the darkened interior and in the horse with glowing eyeballs and incandescent mane. Even specific empirical studies of Darwin and Priestley may have contributed to Fuseli's conception. Darwin observed that all animal bodies are conductors of electricity and warned people caught unexpectedly in thunderstorms to lie down "within a few feet" of their horse, since in its more elevated position it will absorb the shock of lightning. Priestley applied electric currents to animals and noted that in one case a dog was struck blind, resulting in a film over the pupils, and corneas that were "throughout white and opaque, like a bit of gristle, and remarkably thick." Finally, among the many contraptions he invented was an "Electrical Horse Race" for public lectures; metallic toy horses were attached to electrified wires which, when terminated in the tail, made it seem "to be all on fire."[27]

The study of electricity went hand in hand with contemporary views of the sublime: Darwin and Priestley compared electric fluid to nervous fluid, suggesting that something akin to electrical impulses lay behind powerful motions and sensations. Priestley could further declare: "Late discoveries show that [electricity's] presence and effects are every where, and that it acts a principal part in the grandest and most interesting scenes of nature." Finally, he observed in clinical applications of electric shock the effects of "terror and surprise."[28] Earlier,

Burke had asserted that lightning flashes and quick transitions from light to dark are "productive of grandeur," and in his section on "Power" he states that normally banal animals like the horse could on occasion attain a state where "the terrible and sublime blaze out together." To prove his point he conflated several passages from *Job* (39:19, 20, 24), where a steed is described "whose neck is clothed with thunder, the glory of whose nostrils is terrible, who swalloweth the ground with fierceness and rage." Is it a coincidence that Darwin's poetic metaphor for electrical phenomena in canto 1 of "Economy of Vegetation" is a "sleepless dragon" whose "eye-balls blazed with ire, / And his wide nostrils breath'd inchanted fire," or that he uses almost the same language in describing the steam engine? Here the elemental forces in nature metamorphose into machinery and art, capable of revivifying the old mythology and generating the new. In the end, Fuseli's unrestrainable stallion is as much a creature of the Industrial Revolution as it is the product of art and mythology.

Priestley sold his electrical toys just as Fuseli sold his "electrified" paintings.[29] Their penchant for discovery and innovation found a receptive audience among an aristocratic and business elite. To the surprise of Fuseli's executors and colleagues, he died a rich man. He possessed sound entrepreneurial instincts and involved himself in a number of successful ventures in connection with book illustrations and engravings. After he observed that printsellers earned a fortune from the sale of the engraved *Nightmare* and other pictures which were widely circulated, he hired his own engraver to move in with him so as not to lose the profits from the reproduction of his imagery and to gain control over distribution.

He also collaborated on two other schemes which combined a publishing venture with an exhibition gallery of paintings. In each case the exhibition, for which admission was charged, was designed to promote the purchase of the engravings through subscription. The first and most extensive undertaking was John Boydell's Shakespeare Gallery which was planned as a permanent exhibition of illustrated scenes from Shakespeare. Boydell was the son of a Shropshire land surveyor and had come to London around mid-century to apprentice himself as an engraver. By 1751 he had earned sufficient profits from the sale of his collected engravings of landscape views in England and Wales to set up an indepen-

dent publishing business. Boydell's prints attained such a huge success (including Woolett's plate of the *Death of Wolfe* by West) that his activities were considered vital to England's export trade. The earl of Suffolk had Boydell in mind when he claimed that the export of prints amounted to some 200,000 pounds per year (c. 1795) and contributed substantially to the wealth of the nation. Thanks to his economic stature Boydell was elected alderman of the City of London in 1782, sheriff in 1785, and Lord Mayor in 1790.

The Shakespeare Gallery which opened in June 1789 with thirty-four paintings eventually grew to over a hundred works, one of the most elaborate schemes of patronage in the history of English art. Almost every recognized English painter and engraver was involved. At the annual dinner of the Royal Academy in 1789 the Prince of Wales proposed a toast, dashed off by Edmond Burke, to "an English tradesman who patronises the art better than the Grand Monarque, Alderman John Boydell, the Commercial Maecenas." In addition to the pictures, Boydell commissioned engravings to be circulated abroad and sold domestically by subscription, and finally assembled into deluxe compendia. Among the artists he commissioned were Reynolds, Kauffmann, Wright of Derby, and, above all, Fuseli, the largest contributor to the initial scheme with nine pictures. Fuseli, was certainly in on the enterprise from the start; he had conceived of such a gallery years before, and his good friends, the artist George Romney and the King's Printer George Nicol, were instrumental in planning and implementing its execution. Perhaps Fuseli's most admired contribution to Boydell's gallery was *Ghost of Hamlet's Father*, depicting an electrically charged apparition with globular eyeballs whose armor emits a phosphorescent glow and is surrounded by a dazzling array of meteoric effects (fig. 4.11).

The money Fuseli earned from the Boydell gallery (roughly 1,350 guineas) enabled him to buy a town house in Queen Ann Street East, complete with gallery and studio and a staff of servants. Inspired by the immediate success of the Boydell scheme he decided to embark on a similar venture, a "Milton Gallery" for which he intended to execute all the paintings and engravings himself. Occupying him almost exclusively during the decade of the 1790s, the idea for the project came to him initially from Johnson who hoped only to emulate Boy-

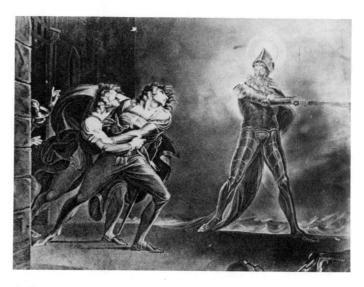

dell's successful edition of the Shakespeare Gallery. He engaged Fuseli to do thirty pictures for engravings to accompany Milton's poetical works, but the publishing idea was abandoned and Johnson encouraged him to use the pictures along the lines of Boydell's exhibition. Fuseli wrote his friend Roscoe in August 1790 that he was tired of "contributing to make the public drop their gold into purses not my own," and invoking the example of West who earned a fortune from prints he now planned "to lay, hatch, and crack an egg for myself too."[30]

Fuseli's scheme required the support of six investors each contributing fifty pounds a year for three years to enable him to work without obligations. Coutts, who owned the lavish edition of Boydell's project, enthusiastically endorsed the Milton Gallery and not only advanced the stipulated sum but made an additional donation of 100 pounds. Five others including Johnson and Roscoe (who also induced his Liverpool associates to buy Fuseli's work in this period) invested in the scheme in return for a percentage of the paid admissions to the exhibition or an exchange in pictures and drawings. He worked devotedly in the ensuing years, and by spring 1799 he managed to set up a temporary exhibition of forty monumental paintings to test public reaction and raise funds for the definitive project. It fared poorly, an ominous portent of the general reception of the Milton Gallery when it opened in March 1800. But if Fuseli's exhibition did not enjoy a popular success, it appealed to the aristocratic elite who protected him and to his colleagues

of the Royal Academy who held a promotional banquet in honor of the new gallery. While Fuseli's hopes for a permanent monument to himself were dashed, his patrons—among whom were Coutts and his daughter, the countess of Guilford, Roscoe, Lock, and John Julius Angerstein—bailed him out financially by purchasing the major pictures in the series.

His benefactors engaged in large-scale business ventures of their own and identified with Fuseli's innovative and speculative approach. The apocalyptic visions complemented their sense of change and scope; his movement and passion went beyond appearances but corresponded to the effects projected by the new entrepreneurs. In the preface to his poem, *Wrongs of Africa* (1787), Roscoe began with a hymn of praise to English scientific progress:

A great aera is opening on the earth, discoveries in science are very rapidly increasing the power, amending the condition, and enlarging the views of mankind; and the close of the eighteenth, like that of the fifteenth century, will probably be marked in future times, as a period in which a sudden accession of light burst on the human mind.[31]

And elsewhere he could claim as England's accomplishments: "An extensive manufacture of almost every article of human accommodation; an unlimited command of markets; an unembarrassed intercourse with all our foreign possessions."[32]

Another patron, John Julius Angerstein, was a wealthy merchant and Lloyd's of London underwriter who streamlined and centralized insurance transactions. He bought the *Satan Rising at the Touch of Ithuriel's Spear* in which Fuseli demonstrated his ability, as an early biographer noted, "above all men of giving aerial motion to his supernatural creations." The work illustrates that section in *Paradise Lost* (Book IV, 810 ff.) where the angels Ithuriel and Zephon come across Satan at the ear of sleeping Eve (fig. 4.12):

Him thus intent Ithuriel with his spear
Touched lightly: for no falsehood can endure
Touch of celestial temper, but returns
Of force to its own likeness. Up he starts,
Discovered and surprised. As, when a spark
Lights on a heap of nitrous powder, laid
Fit for the tun, some magazine to store
Against a rumoured war, the smutty grain,
With sudden blaze diffused, inflames the air;
So started up, in his own shape, the Fiend.

4.12 Henry Fuseli, *Satan Rising at the Touch of Ithuriel's Spear*, 1802. Private collection, Zurich.

Fuseli's flat forms, ultimately derived from vase painting, could be infinitely expanded and contracted beyond the ordinary limits of matter and gravitation. His supernaturally charged nude figures defy their classical heritage, zooming, hovering, soaring, and springing from every possible angle more like mechanical flying objects than live human beings.

One critic of the period wrote that Satan rises "like a pyramid of fire" above the reposing figures of Adam and Eve. The demonic element inherent in forcing nature to submit to the entrepreneurial will and the interference with God's will made Milton's heroic rebel the ideal embodiment of the new scientific and industrial energies in society. While Darwin starts his section on the steam engine with nymphs cavorting on "simmering cauldrons," it is clear that the ingenuity and power involved point to an aggressive rivalry with the Divine Being:

Press'd by the ponderous air the Piston falls
Resistless, sliding through its iron walls;
Quick moves the balanced beam of giant-birth,
Wields his large limbs, and, nodding, shakes the earth.
The Giant-Power from earth's remotest caves
Lifts with strong arm her dark reluctant waves;
Each cavern'd rock, and hidden den explores,
Drags her dark coals, and digs her shining ores.
. .
The imprison'd storms through brazen nostrils roar,
Fan the white flame, and fuse the sparkling ore.
Here high in air the rising stream he pours
To clay-built cisterns, or to lead-lined towers;
Fresh through a thousand pipes the wave distils,
And thirty cities drink the exuberant rills.
There the vast mill-stone, with inebriate whirl,
On trembling floors his forceful fingers twirl.
Whose flinty teeth the golden harvests grind,
Feast without blood! and nourish human-kind.

And a little later:

Soon shall thy arm, *Unconquer'd Stream*! afar
Drag the slow barge, or drive the rapid car;
Or on wide-waving wings expanded bear
The flying-chariot through the fields of air.[33]

The peculiar character of Satan's propulsion in the *Ithuriel*, however, accompanied by a V-shaped jet of hot air and flame, suggests the actions of a hot-air balloon.[34] Lunar Society members were totally caught up in Mont-

4.13 Henry Fuseli, *Uriel Watching Satan Plunge to Earth*, illustration for F. J. De Roveray's 1802 edition, *Paradise Lost*. Reproduced by permission of The Huntington Library, San Marino.

golfier's balloon experiments in the summer of 1783, stimulated in part by Franklin—then American ambassador to France—who imported the balloon mania to England. Darwin celebrates Montgolfier in both parts of the *Botanic Garden*. And his couplets on the French inventor in "Economy of Vegetation" could be read as a contemporary literary analogue to Fuseli's picture:

SYLPHS! your soft voices, whispering from the skies,
Bade from low earth the bold MONTGOLFIER rise;
Outstretch'd his buoyant ball with airy spring,
And bore the Sage on levity of wing;

He returns to the "intrepid Gaul" in "Loves of the Plants" as a symbol of earthly attainment and human mastery of the cosmos:

Rise, great MONTGOLFIER! urge thy venturous flight
High o'er the Moon's pale ice-reflected light;
. .
Leave the red eye of Mars on rapid wing,
Jove's silver guards, and Saturn's crystal ring;
Leave the fair beams, which, issuing from afar,
Play with new lustres round the Georgian star,★
. .
Where headlong Comets, with increasing force,
Thro' other systems bend their blazing course.
For thee Cassiope her chair withdraws,
For thee the Bear retracts his shaggy paws;
High o'er the North thy golden orb shall roll,
And blaze eternal round the wondering pole.[35]

Thus both the rebel Satan and the inventor Montgolfier remain undaunted by the Divine Order and display pride and ingenuity in overcoming it.

Fuseli's fascination with flight in space is also seen in one of his painted studies for the engravings of F. J. Du Roveray's 1802 edition of *Paradise Lost*, the *Uriel Watching Satan Plunge to Earth* (fig. 4.13).[36] Representing the moment when Satan and his rebel angels were ejected from Heaven (Book II, 768 ff.), Fuseli renders the scene from the perspective of a galactic observer. It is actually a glimpse into interplanetary space with Satan—"Hurled headlong flaming from the ethereal sky"—leaving a trail of cosmic dust and fire like a comet orbiting in the boundless universe. Here the expulsion of Satan and the

★A reference to the newly discovered Uranus, then named by William Herschel after George III.

ensuing divisions of Heaven and Hell allegorize the primeval explosion of matter and its separation into the planetary clumps. Such an event could not be projected from a terrestrial viewpoint but from a relative position in outer space.

Fuseli's knowledge of cosmology came not only by way of Darwin and Priestley but through his intimate relationship with the astronomer and mathematician, John Bonnycastle (1750–1821). The two were close friends for over forty years and deeply admired each other's work. Bonnycastle taught at the Royal Military Academy at Woolich and wrote a highly popular *Introduction to Astronomy* which was published by Johnson in 1786. Fuseli designed the frontispiece for the book showing the figures of *Aratus and Urania*, the Greek poet-astronomer whose *Phaenomena* described the constellations and weather signs, and the Muse of Astronomy—a pair often seen in late Roman imagery. In return, Bonnycastle generously shared his knowlege with Fuseli and advised him on such pictorial matters as the appropriate positions of the moon.

Perhaps the most popular work in the Milton Gallery was the horrific *Vision of the Lazar House* which Coutts purchased (fig. 4.14). The passage in *Paradise Lost* (Book XI, 477 ff.) sets out a vast array of afflicted types which the Archangel Michael reveals to the fallen Adam:

4.14 Henry Fuseli, *Vision of the Lazar House*, 1791–1793, sketch. Kunsthaus, Zurich.

A Lazar House it seem'd; wherein were laid
Numbers of all diseased; all maladies
Of ghastly spasm, or racking tortures; qualms
Of heart-sick agony; all feverous kinds;
Convulsions, epilepsies, fierce catarrhs;
Intestine stone and ulcer; colic pangs;
Demoniac phrenzy, moping melancholy;
And moonstruck madness; pining atrophy,
Marasmus, and wide-wasting pestilence;
Dropsies and asthmas, and joint-racking rheums.

Fuseli added to his depiction a frustrated victim who is attempting to escape his condition but is manacled by a ball and chain attached to his left foot. The fleeing figure points frenetically with his right arm to the sky where the specter of "triumphant Death" overshadows the scene with gigantic bat wings. This motif is not found in Milton's text and embodies a protest against death and suffering. Fuseli perceived this movement as a parallel in earthly terms to Satan's rebellion, and, as in the *Ithuriel*, associates this defiance with the new science. Indeed, the taxonomic listing of diseases was geared to the mentality of the good Doctor Darwin, whose *Zoonomia* set out all the known diseases and their cures and was intended for "public utility." He hoped to provide inexpensive recipes for the less privileged groups in society, obviating the need not only for specialists like himself but also for costly pharmaceutical prescriptions. Since the original sense of the term "lazar" referred to a beggar or poor person infected with a contagious disease, it may be said that Darwin's life's work aimed at eliminating the Lazar House—a veritable poorhouse for the sick—and protested against still another aspect of the supposedly eternal "human condition." Of course Darwin, like Fuseli, could afford to entertain "eccentric" views since he profited from millionaire clients like Coutts, the purchaser of *Lazar House*. Darwin treated Coutt's daughter Fanny, who suffered continually from debilitating ailments, and while in Derbyshire in 1796 Coutts wrote William Pitt that he was seeking "the advice of Dr. Darwin whose genius and skill I hold in high esteem."[37]

The example of the Milton Gallery demonstrates to what extent Fuseli was sustained throughout his life by a small but nonetheless influential and generous circle which bought almost everything he did. He was completely at home in Coutt's house and among the members of his family; the banker's eldest daughter Susan,

countess of Guilford, kept up her father's liberality, and it was in her house that Fuseli died. Like West, Fuseli maintained that art was meant for an elite and thus rationalized the privileged position of his faithful patrons. Their patronage promoted him into the highest official art circles as well: he became an Associate (1788) and then a full member of the Royal Academy (1790), Professor of Painting (1799), and finally Keeper for Life (1804). One testimony to his political conservatism is the fact that he became Keeper as a substitute for the proposed Smirke whose election George III refused to confirm on the grounds that Smirke was a democrat. The following year the arch-conservative Flaxman regretted that Fuseli was not lecturing at the academy in place of Opie who taught in "a democratic spirit."

Fuseli grew disillusioned earlier than most with the French Revolution and could be considered one of the most conservative persons in Johnson's entourage and the circle around the Lunar Society. They nevertheless appreciated his eccentricity and wit which corresponded on an intellectual level to their unpopular political views. Blake, far more progressive minded than his friend, could write:

The only Man that e'er I knew
Who did not make me almost spew
Was Fuseli: he was both Turk & Jew—
And so dear Christian Friends, how do you do?

On the other hand, Fuseli was a theological and moral radical who consistently opposed slave trading. Of course, the movement for abolition cut across political parties and was supported by both Whigs and Tories. The evangelical movement was based more on religious humanitarianism than on a sense of political and economic equality, but it was the one liberal idea that could be entertained during the period of the French Revolution and the Napoleonic wars. Abolition, however, could become a political reality only when it could be demonstrated that slavery was no longer economically feasible. Even such wealthy patrons of Fuseli as Roscoe opposed the practice, though he could number among his own clients many Liverpool slavers. Roscoe published *Wrongs of Africa: A Poem* in two parts during the years 1787–1788 when the Society for the Abolition of Slavery was recruiting preachers, writers, and artists for their cause in preparation for upcoming parliamentary debates (1789–

1793) on a bill for abolition. Roscoe felt that slave trading was incompatible with the scientific and industrial progress of Great Britain, developments that would eventually affect political science, inspire brighter views of truth and justice, and so improve the feelings of humanity that it would prevent the crueler side of trade to "degrade the national character." Like the evangelicals and Quakers, he appealed to a higher morality for deliverance from the onus of the "wicked" and "horrid" institution, but he spoke from a lofty pinnacle himself in behalf of the unenlightened "sable children of the sun."[38]

At the same time, Roscoe the banker observed (in *A General View of the African Slave-Trade*) the economic inefficiency and waste of the slave system. He asserted that increasing insurrections, the high price of slaves (brought about by competition), and losses incurred through sickness no longer made it economically profitable. Roscoe claimed that since 1773 twelve out of thirty Liverpool business houses carrying on the trade went bankrupt, and most of the others sustained major losses. Hence not only was the practice "a continual offence against the laws of God," it was simply no longer as productive of wealth as usually imagined. Africa's vast extent and fertile soil could be tapped once the slave trade was abolished and Africans would have to repay with "their natural productions," ultimately far more valuable than the traffic in humans and that could "be had on the most reasonable terms." Roscoe recommended that Parliament pass a bill that would incorporate the idea of "a more extensive trade to Africa, for the commodities of that country, than has hitherto been carried on."[39] The farseeing Roscoe actually heralded the English policy shift in regard to Africa after the abolition of the slave trade in 1807. The new position called for economic exploitation of the vast resources of the African continent which would eventually find itself ringed with English trading posts and military forts.

No wonder that in Roscoe's company Fuseli could feel free to comment during a visit to Liverpool, "Methinks I everywhere smell the blood of slaves."[40] And it should come as no surprise to learn that Fuseli illustrated William Cowper's *The Negro's Complaint*, a topical poem aimed against the slave trade in behalf of the abolitionist cause (fig. 4.15). Fuseli designed the work for the 1806 edition of Cowper's poems published by Johnson. Cowper and Fuseli had been good friends and were brought

4.15 Henry Fuseli, *The Negro Revenged*, illustration to William Cowper's poem, *The Negro's Complaint*, 1806 edition of *Poems*, vol. 1.

together by their mutual friend and publisher who occasionally commissioned them to write anonymous reviews of other authors he printed. Johnson published many of the antislavery tracts of the 1787–1788 period and shared with Roscoe and Cowper their detestation of unpaid servitude.

Cowper was one of the most outspoken poets on the issue of slave traffic and slave ownership and recognized the tremendous pressures that it exerted on the ordinary English citizen. His *Negro's Complaint*, first published in 1788, reflects the moralizing sentiment of the Quaker and evangelical abolitionists. It warns of retribution from on high:

Hark! he answers—Wild tornadoes,
 Strewing yonder sea with wrecks;
Wasting towns, plantations, meadows,
 Are the voice with which he speaks.
He, foreseeing what vexations
 Afric's sons should undergo,
Fix'd their tyrants' habitations
 Where his whirlwinds answer—No.

Fuseli's illustration to these verses emphasizes the cataclysmic punishment the institution brings down upon itself. He magnifies the black slave and his wife on the shore to the superhuman stature he had previously reserved for his mythical heroes. In the distance lightning strikes the slaver's ship tossed by a tornado—clearly an act of Divine Providence. Fuseli's image is ideally suited to the text and the ideology of the first concerted abolitionist movement: in their scenario emancipation of black people does not come in the form of a slave revolt or fundamental political change but in the form of God's punishment. In this way abolitionists could enlist the support of the moderate and even conservative elements in English society.

Cowper's slightly later poem, *Pity for the Poor Africans*, is politically more astute, revealing the nature of slavery's vested interests. The narrator is an ordinary white citizen "shock'd at the purchase of slaves" and pains to "hear of their hardships, their tortures." Then making the connection with commerce and daily consumption of products contributed by slave labor, Cowper gently chides his public:

I pity them greatly, but I must be mum
For how could we do without sugar and rum?

Especially sugar, so needful we see?
What, give up our desserts, our coffee, and tea!

The rest of the poem states the various arguments for the slave trade, including competition for markets overseas and advantages that other nations would enjoy if England quit the trade. Cowper answers with a story of a schoolboy seduced against his scruples to steal apples with his fellows from a poor man's orchard. Reckoning that the apples would be stolen in any case, he thinks he may as well join—which prompts Cowper's sardonic conclusion:

His scruples thus silenced, Tom felt more at ease,
And went with his comrades the apples to seize;
He blamed and protested, but join'd in the plan:
He shared in the plunder, but pitied the man.

As late as 1792, Cowper was giving support to Wilberforce, the parliamentary spokesperson for the abolitionist movement, an unfortunate moment when the French Revolution provided the pretext for Burke and his colleagues to play upon reaction and successfully mute the voices of reform.

But if the first drive for the prohibition of the slave trade failed, it enlisted the support of important backers who would provide the basis for the next, and ultimately successful, push. Among these were members of the predominantly dissenting middle-class manufacturers who argued from Roscoe's position—and they included the majority of the Lunar Society. Priestley published in 1788 *A Sermon on the Subject of the Slave Trade*, while Wedgwood—who poured money into the campaign of abolitionists Wilberforce and Thomas J. Clarkson—created a jasperware cameo of a suppliant slave in chains with the motto, "Am I not a man and a brother?" These he distributed freely by the hundreds, and it rapidly became the symbol of the movement. It was widely used on snuffboxes and bracelets, but most commonly as the title-page vignette for much of the antislavery literature. Darwin reproduced the cameo in canto 2 of "Economy of Vegetation," where he poetizes Wedgwood's achievements (fig. 4.16):

From the poor fetter'd *Slave*, on bended knee,
From Britain's sons imploring to be free;
Or with fair HOPE the brightening scenes improve,
And cheer the dreary wastes at Sydney-Cove;

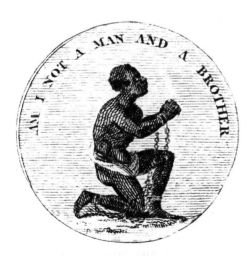

4.16 Josiah Wedgwood's cameo, "Am I not a man and a brother?" from canto 2 of "Economy of Vegetation" in *Botanic Garden*.

Or bid Mortality rejoice and mourn
O'er the fine forms on PORTLAND's mystic urn.

Darwin's commentary reminds the reader that Wedgwood distributed the cameo of the slave in chains "to excite the humane to attend to and assist in the abolition of the detestable traffic in human creatures."[41]

Darwin does not treat the humanitarian drive in isolation but uses it as a springboard to discuss the pressing political problems of the day. Lines 365–375 refer to both the American Revolution and the Irish question; the dual allusion—back to back—to both Columbia and Hibernia leave no doubt as to the connections between them and their mark on English society. Reference then follows to the Bastille and hence to the French Revolution, pointing up the Lunar Society's involvement in the major economic, political, and social issues of the period and their sympathy with reformist struggles both at home and abroad. The slavery issue emerges again in lines 421–430 and essentially closes the section:

Here, Oh BRITANNIA! potent Queen of isles,
On whom fair Art, and meek Religion smiles,
Now AFRIC's coasts thy craftier sons invade,
And Theft and Murder take the garb of Trade!
—The SLAVE, in chains, on supplicating knee,
Spreads his wide arms, and lifts his eyes to Thee;
With hunger pale, with wounds and toil oppress'd,
"ARE WE NOT BRETHREN?" sorrow choaks the rest;
—AIR! bear to heaven upon they azure flood
Their innocent cries!—EARTH! cover not their blood!

William Blake

The one artist of the period who embraced the broad economic, political, religious, and humanitarian spectrum of the Lunar Society was William Blake (1757–1827).[42] Like his close friend Fuseli—his neighbor for several years on Broad Street, Golden Square, and occasional partner on projects for Johnson—Blake both wrote and designed. This dual talent enabled him to communicate a wide range of ideas in the same impassioned way. Blake joined with Fuseli, Johnson, Darwin, and Wedgwood in contribution to the antislavery agitation of the time. His poem *Little Black Boy* appeared during the initial phase of the drive against the trade, and his *Visions of the Daughters of Albion*, which touched on all forms of slavery, came out the year the bill for abolition was defeated in

Parliament (1793). During the interval he began work on a series of illustrations for a book describing the brutal slave conditions in the South American colony of Dutch Guiana. Throughout his writings, moreover, he interspersed allusions to the oppression and liberation of black people, sharing with his friends and employers their deep-seated abolitionist ideals.

Blake incarnates the marriage of neoclassicism and the nascent Industrial Revolution. While his imaginative and visionary mind is often perceived in opposition to the economic transition, and his digs at "dark, Satanic mills" and Newtonian rationalism are paraded endlessly, in fact his art responded to the incipient Machine Age affirmatively and, on occasion, lovingly. He expressed many of the ideas and sentiments of the progressive wing of the British ruling classes and, in particular, those of the Lunar Society for whose members he worked. He engraved at least five plates in addition to those after Fuseli for the *Botanic Garden*, and later designed showcase ads for Wedgwood's catalogs. Blake was in fact a small-scale entrepreneur who developed his own printing techniques and made a living primarily as an engraver.

Blake's father owned a "moderately prosperous" hosiery business (taken over eventually by William's eldest brother, James); thus Blake and his brothers would have been in touch with the most radical industrial developments of the period. It was the great contemporary hosiers, the Strutts, the Oldknows, the Needs, and the Arkwrights who organized the first factories and accelerated the arrival of the Industrial Revolution. At the retail level, the hosier generally purchased stockings, nightcaps, socks, gloves, and other goods directly from the factory, but the larger ones—and this would have included Blake's father—employed their own looms and were themselves stocking weavers.[43] This meant that the senior Blake was involved in all phases of the cotton industry, including printing and dyeing. From his earliest age, therefore, Blake experienced directly the major thrust of English industrial capitalism.

This is confirmed, moreover, by the fact that his father first sent William to an industrial arts school and then apprenticed him out to an engraver. When he was ten years old Blake was enrolled in Henry Pars's drawing school in the Strand, then the best preparatory school for industrial designers. Several of Blake's fellow students went on to work in industry or the crafts. It may be recalled that

4.17 William Pars, textile design, 1756. By permission of the Royal Society of Arts, London.

Pars's school had been founded by William Shipley as an adjunct to the Society for the Encouragement of the Arts, Manufactures, and Commerce. Shipley's school was founded on the principle that drawing was "absolutely necessary in many employments, trades, and manufactures." Shipley's ad for his school in the year Blake was born declared:

As it will be Mr. Shipley's endeavor to introduce Boys and Girls of Genius to Masters and Mistresses in such Manufactures as require Fancy and Ornament, and for which the Knowledge of Drawing is absolutely necessary; Masters or Mistresses who want Boys and Girls well qualified for such manufactures may frequently meet with them at this school; and Parents who have Children of good natural Abilities for Art of Drawing may here meet with Opportunities of having them well instructed and recommended to proper Masters or Mistresses.

Shipley further noted in the ad his commitment to the use of drawing in industry as was intended by the society's prizes "for the most ingenious and best fancied Designs proper for Weavers, Emboiderers and Calico Printers."[44] It is no coincidence that many of his students won premiums for textiles, including Henry Pars's brother William, who won in 1756. His textile design emphasizes a frontal floral pattern interweaving to form a central focus and radiating to the four corners of the page—not unlike Blake's later designs for his *Songs of Innocence* published in 1789 (fig. 4.17).

Blake's friend and admirer, the miniature painter Ozias Humphry, was sent by his parents to Shipley's drawing school on the understanding that he would learn to draw patterns suitable for the family lace business. The young art student wrote home early in October 1757 that the curriculum consists of "Men's Heads, and Plaster Figures, Birds on Trees, Landscapes, all sorts of Beasts, Flowers, foliages and Ornaments," all of which he hoped would give him "a truer idea in Drawing Lace Patterns" which he began copying toward the end of the month.[45]

Shipley enjoyed a spectactular success with his school through its connection with the society. When he retired from active management in 1761 he turned it over to Henry and William Pars. Their advertisement in 1762 indicates that they ran the school along the same lines:

Drawing and Modelling in all branches taught by Henry and William Pars, successors to Mr. Shipley, late Register to the Society for the Encouragement of Arts etc. . . . where Boys of

Genius are frequently recommended to masters in such trades and manufactures as require fancy and ornament, for which the knowledge of drawing is absolutely necessary.[46]

They also indicated that Shipley would recommend enterprising graduates for work in the trades, demonstrating that the founder continued to take an active interest in the school after his retirement. One student in this period, Thomas Jones, wrote that after several months of exertion Shipley introduced him "to the Duke of Richmond's Gallery . . . to draw after those fine copies of the most celebrated Antique Statues."[47]

Jones's statement reminds us of the neoclassic emphasis in Shipley's curriculum. Shipley himself collected antique gems and coins which brought him into contact with Albani's circle. Many of the examples of ancient Roman medals and coins he owned were replicas made by Baron von Stosch from the great continental collections. Shipley in turn made plaster casts of these reproductions covering for the most part the "Roman Commonwealth and Empire," thus following the ideological lead of the wealthy connoisseurs and collectors of the period. The Pars brothers retained Shipley's neoclassic direction: William accompanied the architect Revett to Athens and Ionia to sketch buildings and sculptures, and later Blake made engravings of Pars's sketches for the popular Stuart and Revett portfolios of *The Antiquities of Athens and Ionia*.

At the age of fourteen Blake was apprenticed to James Basire, engraver to the Society of Antiquaries and the Royal Society of the Arts. Blake's father paid in a lump sum the substantial fee of fifty-two pounds and ten shillings for this apprenticeship. As in the case of Pars, it is mostly likely that the senior Blake hoped to reap some benefit from this course of action beyond gratifying his son's ambition to become an artist: an industrial designer and engraver could have served a useful function in the hosiery business. Printers in the textile industry hired young art apprentices trained in the workshops of engravers or industrial art schools. At the same time, the success of entrepreneurs like Boydell and the increasing demands of publishers also may have predisposed the elder Blake to apprenticing William as he did. Blake's first friends suggest his early industrial aspirations: Thomas Trotter did calico prints and introduced Blake to Thomas Stothard who had been apprenticed to a pattern designer

in Spitalfields, Stepney, a major silk-producing center with the most advanced looms of the period.[48] Stothard, who became one of the outstanding book illustrators of his day, also executed designs for Wedgwood and the royal silversmiths Rundell & Bridge. Stothard in turn introduced Blake to Flaxman—"one of the best and firmest friends Blake ever had"—who also worked extensively for Wedgwood and Rundell & Bridge. Blake's fellow student at Basire's and his future business partner, James Parker, did interior design for the architect Thomas Leverton at Woodhall Park, Hertfordshire, and also engraved prints for Boydell.

Basire himself engraved the work of West and Reynolds, and his reproductive facility made him sought after for scientific publications. He illustrated histories, geographies, and encyclopedias, while his engravings of ancient monuments gained him the position of official engraver to both the Royal Society and the Society of Antiquaries. As Basire's apprentice for seven years Blake was steeped in antiquities; many of Basire's commissions consisted of engravings of old coins, vases, and gems for such works as the *Archaeologia*. Blake collaborated with the master on a variety of projects (for which he received no credit) including Jacob Bryant's *New System of Mythology* which Blake later drew upon for his own mythological lore. Basire also sent Blake to make drawings of tomb effigies in Westminister Abbey for Richard Gough's *Sepulchral Monuments in Great Britain* which, although Gothic, reinforced in him a taste for linearism and the decorative ensemble.

At the completion of his apprenticeship, Blake attend-

4.18 William Blake, figures from a Greek vase, after plate 68 of Sir William Hamilton's *Collection of Etruscan, Greek and Roman Antiquities*. Reproduced by courtesy of the Trustees of The British Museum, London.

4.19 Sir William Hamilton's *Collection of Etruscan, Greek and Roman Antiquities*, vol. 2, plate 68.

ed for a short time the Royal Academy where he had the opportunity to draw from life. But he always felt more at home with old prints, plaster casts, and applied art objects. Late in life he claimed: "Natural Objects *always did and do weaken*, deaden and obliterate imagination in me!"[49] He was trained in the mechanical craft of engraving, and this predisposed him to conceptualize in schematic outlines. Indeed, his capacity to create dynamic figural movement and fantastic hybrid creatures emerges from his reduction of the world to a kind of visionary blueprint. As he declared in his marginalia to Reynolds's *Discourses*: "Mechanical Excellence is the Only Vehicle of Genius."[50]

Blake assimilated the technical ideal of industry as expressed through neoclassic outline. The linearism of neoclassicism made this style preeminently suited for the new industrial design, exemplified in the work of Robert Adam, Matthew Boulton, and Josiah Wedgwood. Neoclassical silhouetting adopted itself readily to the contours of applied art objects, could be simplified to the point of abstraction (as in textile patterns), and was easy to reproduce. While still an apprentice, Blake obtained a copy of Fuseli's translation of Winckelmann's *Reflections on the Painting and Sculpture of the Greeks* which exalted the human form and emphasized "precision of Contour, that characteristic distinction of the ancients." And like his friends Fuseli and Flaxman, he early gravitated to the celebrated d'Hancarville catalog of Sir William Hamilton's collection of vases.[51] Among his youthful works are two line drawings after d'Hancarville's illustrations, one of which is the Apotheosis of Bacchus reproduced as plate 68 in volume 2 (figs. 4.18, 4.19). Blake faithfully reproduced the silhouettes of every figure including the seated Silenus with his lyre at the extreme right and Ariadne holding a cornucopia at the extreme left. It may be recalled that the illustrations of Sir William's vases were instrumental in the rise of the linear style and its industrial applications.

Blake's notion of a graphic cutting edge was identified in his mind with craft and industry. He set this out affirmatively in his *Descriptive Catalogue* of 1809 under entry XV ("Ruth.—A Drawing"): "The great and golden rule of art, as well as of life, is this: That the more distinct, sharp, and wiry the bounding line, the more perfect the work of art; and the less keen and sharp, the greater is the evidence of weak imitation, plagiarism, and bun-

gling." Then he shows how this relates to the larger social context:

What is it that builds a house and plants a garden, but the definite and determinate? What is it that distinguishes honesty from knavery, but the hard and wirey line of rectitude and certainty in the actions and intentions? Leave out this line and you leave out life itself; all is chaos again, and the line of the almighty must be drawn out upon it before man or beast can exist.[52]

Blake's obsession with outline informs his life's work, and if it is not always consistently applied in his practice it is of overriding importance to his philosophical ideal. Even his most extravagant visions are subjected to this control; in the *Descriptive Catalogue* he took the opportunity to answer criticism of his method of depicting spirits with solid bodies and firm outlines:

A Spirit and a Vision are not, as the modern philosophy supposes, a cloudy vapour, or a nothing: they are organized and minutely articulated beyond all that the mortal and perishing nature can produce . . . Spirits are organized men. Moderns wish to draw figures without lines, and with great and heavy shadows; are not shadows more unmeaning than lines, and more heavy? O who can doubt this?[53]

This position is analogous to that of Erasmus Darwin who claims in the advertisement to the *Botanic Garden* "to inlist Imagination under the banner of Science; and to lead her votaries from the looser analogies, which dress out the imagery of poetry, to the stricter ones, which form the ratiocination of philosophy."

Blake shared his outlook with the progressive manufacturing and commercial classes of his day—an outlook perhaps most completely embodied in the writings of his friend George Cumberland (1754–1848).[54] Cumberland had worked for many years as a clerk in the Royal Exchange Assurance Company, a job he hated but which permitted him to accumulate some capital through timely investments. After being turned down for a promotion he expected he resigned in 1785, around the time he first met Blake. With his savings and a modest inheritance he acquired in 1792 a small estate at Bishopsgate, near Egham, in Windsor Great Park, and embarked on an artistic and literary career. Cumberland experimented with new methods of engraving that would embrace both image and text on the same copper plate and substitute for conventional printing. At the same time, he en-

joined Blake to collaborate with him on at least two projects, one of which was published in 1796 with the title *Thoughts on Outline*.[55] Blake executed some of the plates in the style of classical gems and taught Cumberland how to etch the others, thus enabling the author to "reduce considerably the price of the book." One Blake example, *Psyche Repents*, was composed by Cumberland and demonstrates to what degree the commercially popular cameo format dictated the design (fig. 4.20).

Cumberland, who identified with the commercial classes, understood the outline method as the only aesthetic approach compatible with British naval, political, and industrial supremacy. In this book and others he revealed an obsession with French competition; he wanted to inspire British industry "so as to rival our neighbors on the Continent." *Thoughts on Outline* opens with the following quote from Sir Williams Jones's *Asiatic Researches*: "Let us not so far undervalue our rival in arts, and in arms, as to deny them their just commendation, or to relax our efforts in that noble struggle, by which alone we can procure our own eminence." He then addressed his tract to the Whig leader Charles James Fox who above all, in the wake of the American and French Revolutions, is capable of guiding "the mismanaged vessel of the British State, stained, indeed, but not quite ruined, shattered, but not, I hope, out of the reach of repair."

Cumberland's contribution to a regenerated Ship of

State is the "chaste outline," the principle of the ancient masterworks. As he stated:

I have treated principally of *Outline*; for until the importance of it be generally admitted, and its perfection as generally sought; till it be understood, *that there can be no art without it*, and that no man deserves to be called an artist, who is defective in this best rudiment; we may continue to model, carve, and paint; but, without it, we shall never have Artists, Sculptors, nor Painters.

He claims that this principle is central to well-being, "without a knowledge of which, all our justly-boasted manual skill can be of little or no utility, either to this country, or its *commerce*, the source of all our wealth, our pride, our folly, and our crimes." His hope in writing is to provide a stable base for the fine arts in England, "which alone can insure our future consequence in Europe, and which, I sometimes flatter myself, will be the means of again extending them over the whole world." This encompassed the industrial arts as well; without outline, products bear sloppy and haphazard forms:

The calico-printer fatigues himself and the public, in inventing patterns without meaning; and religiously believes, that chance alone, and luck, give a print vogue.

The same is true of the potter, founder, engraver, and printer; what alone can insure the success of all is "firm or pure Outline."[56]

Cumberland's position sprang from the neoclassical movement; he appended to his text his own linear designs of "classical subjects invented on the principles recommended in the essay." He perceived his ideal in sculptors like Canova and Flaxman because sculpture by definition "is *all* Outline." And he was certainly inspired by the first catalog of Sir William Hamilton's vase collection. While he disapproved Tischbein's illustrations to the second catalog (and even "the very tasteful Homer and Aeschylus by Mr. Flaxman") for the thick and thin flourishes of the outlines, Cumberland espoused the philosophical attitudes expressed in d'Hancarville's earlier introduction.

Cumberland also boasted that his plans for a public art gallery ("A Plan for the Improvement of the Arts in England") enjoyed the "Hearty and impartial Approbation" of Sir William Hamilton. He further assimilated Sir William's elitist notion of neoclassicism in connection with

"pure" outline, for he felt that a "coarse, thick, and irregular Outline, is, like a coarse mode of expression, fit only for the rabble of mankind."

Blake, who often sympathized with the "rabble," was nevertheless dependent on prosperous patrons for his livelihood. While his social and political perspective contained many dissenting attitudes, his thorough association with Cumberland's tract indicates that he too identified with English supremacy. Like the Lunar Society members, he could support the American and French Revolutions, attack the slave trade at its roots, but at the same time work in the interests of a diplomatically and industrially powerful Great Britain. Blake's immediate cue came from the commercial middle classes advancing themselves through science and technology; their promise he translated into mystical inspiration, divination, and novelty. In his prospectus addressed "To the Public" in October 1793 he declared his "powers of invention," and in the advertisement for his *Descriptive Catalogue* he could repeat in the same breath that his "Original Conceptions on Art" were by "an Original Artist." The earlier public prospectus gave him credit for inventing "a method of Printing both Letter-press and Engraving in a style more ornamental, uniform, and grand, than any before discovered, while it produces works at less than one fourth of the expense." Convinced of his public success, he pointed out that his gifts "very early engaged the attention of many persons of eminence and fortune; by whose means he has been regularly enabled to bring before the Public Works (he is not afraid to say) of equal magnitude and consequence with the productions of any age or country."[57]

Among these projected works are singled out a series of subjects drawn from the Bible and a history of England. Now Blake may have been acting defensively in a year of political repression, but from first to last he appealed to patriotic feelings to sell his work. One of his initial projects as an independent engraver was a series of scenes from English history, one of which was *Edward and Elinor*, engraved and published only in 1793 (and offered for sale in the prospectus) but designed in the late 1770s (fig. 4.21). Blake's subject is that of Elinor's courageous act in sucking the poison from her husband's wound by an assassin, a theme exemplifying both domestic and national fidelity to the crown. The composition itself is an amalgam of neoclassic poses and gestures

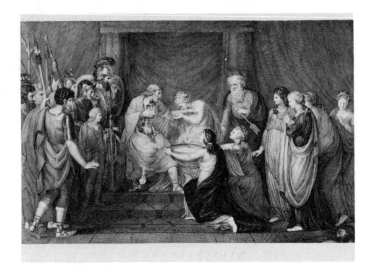

derived from Gavin Hamilton, Benjamin West, and Angelica Kauffmann (who exhibited the same subject at the Royal Academy in 1776).

If Fuseli had his Coutts, Blake had his Butts. One of Blake's most "eminent" and devoted patrons was Thomas Butts, who constantly prodded the painter with cash and encouragement.[58] Butts was the same age as Blake and like Cumberland was a "white-collar" benefactor. He worked as a clerical adjunct of the paymaster in the Commissary General of Musters, an office whose function was to verify that military personnel drawing pay were alive and well, that military hardware was in order, and that enlistments were recorded. By 1788 Butts became the chief clerk and received an excellent salary. Through shrewd investments (and graft) he accumulated a small fortune; he owned quite a bit of property including two houses in fashionable Fitzroy Square, and he invested the bulk of his estate in such rising industrial and financial enterprises as canals, waterworks, mines, banks, and insurance.

Butts met Blake around 1793 and instantly took a liking to the person and his work. Ironically, Butts was both a political and religious conservative and was punctilious in his dress and public behavior. Evidently, Blake's so-called eccentricity did not prevent him from gaining support from sober, pragmatic, and shrewd business types who knew a good thing when they saw it. As in the case of Fuseli, Blake's high-flown images spoke to the adventurous fantasies and exploits of the new breed

of entrepreneurs, complementing their large-scale trans-
actions with grandiose conceptions of the teeming uni-
verse. Butts's mansion in Fitzroy Square became a verita-
ble Blake gallery. For almost thirty years he was a steady
buyer of the artist's work, at one point purchasing a
drawing each week. All told, he must have owned at one
time or another nearly 200 of the artist's pictures, includ-
ing such outstanding pieces as the tempera designs of
God Judging Adam, Nebuchadnezzar, and *Newton*.

Indeed, nearly all of Blake's surviving Bible illustra-
tions, in tempera, drawing, and watercolor, come from
the Butts collection. It is no wonder that Blake could
boast to Butts in November 1802 that the works he had
done for him were equal to those of Carracci and Rapha-
el and that he was "Proud of being their Author and
Grateful to you my Employer & that I look upon you as
the Chief of my Friends, whom I would endeavour to
please, because you, among all men, have enabled me to
produce these things."[59] Blake's letter expresses the clas-
sic artist-patron relationship with one crucial variation:
he perceives his backer as an "employer" rather than as
the traditional Maecenas. This testifies to his self-percep-
tion as artisan-entrepreneur, as someone who works for a
stipulated rate of pay.

Blake was actually in business for himself and took on
a variety of jobs throughout his career. In 1784 he set
himself up next door to the family hosiery business as an
engraver, printseller, and publisher in partnership with
James Parker, a friend and colleague from the studio of
Basire. They hoped to cash in on a market that earned a
fortune for the engravers and publishers of such works as
Nightmare and *Death of General Wolfe*. Blake and Parker
hoped to eliminate the middlemen by combining in their
enterprise the functions of artist, publisher, distributor,
and dealer. They began by engraving the mildly erotic
scenes of their mutual friend, Stothard, wanting to tap a
market beyond the existing institutional network. The
partnership, however, dissolved after only three years; a
rift with Parker ended the relationship and the printsell-
ing. Henceforth, Blake—in alliance with his wife Cather-
ine who worked with him closely on the printing and
coloring processes—acted as a self-employed, free-lance
designer and engraver.

It was widely felt at this time that any method for sim-
plifying the production of books and newspapers would
insure its inventor not only wealth but also unlimited ac-

cess to the public. Like Cumberland and many others, Blake experimented with fresh approaches to stereotyped printing. Movable type was labor intensive, putting the author at the mercy of printer and publisher, and as both artist and writer Blake sought a cheap means of combining both image and text on the same plate. His solution was to write directly on the plate and replace letterpress altogether. The main problem here was the reversal of the lettering, which he resolved by producing a stereotype plate in which the design and the lettering were applied in reverse on the plate. He accomplished this through his skill in mirror-image writing and did everything directly on the plate. Then all the lights were bitten by the acid, and the outline of both image and type were left in relief for making impressions.[60]

Blake mocked his own entrepreneurial schemes in a parody of the Lunar Society entitled "An Island in the Moon," written around the time he opened his shop with Parker. One fragment of the unpublished manuscript contains an exchange between two of the characters on a revolutionary printing process which would guarantee a fortune;

"Then," said he "I would have all the writing Engraved instead of Printed & at every other leaf a high finished print, all in three Volumes folio, & sell them a hundred pounds a piece. They would print off two thousand." "Then," says she, "whoever will not have them will be ignorant fools & will not deserve to live."[61]

The idea of making a killing on the market by creating a cheaply made "luxury edition" was reiterated by Blake more seriously in a later exchange with his brother James in January 1803:

The Profits arising from Publications are immense, & I now have it in my power to commence publication with many very formidable works, which I have finish'd & ready. A Book price half a guinea may be got out at the Expense of Ten pounds & its almost certain profits are 500 G.[62]

Thus from first to last Blake was determined to make money with his art—the primary justification for his life in a professional sense.

Here again Blake's entrepreneurial ventures and inventive head locates him in the orbit of the Lunar Society whose members he knew quite well. As stated earlier, he also shared their involvement in a number of political,

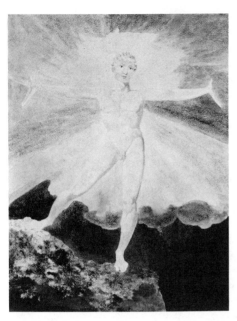

4.22 William Blake, *Glad Day*, color version. Reproduced by Permission of The Huntington Library, San Marino.

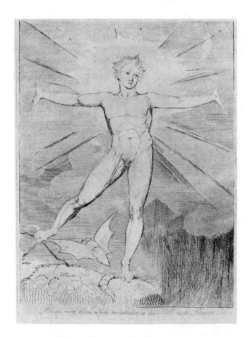

4.23 William Blake, *Glad Day*, 1780, engraving. National Gallery of Art, Rosenwald Collection, Washington, D.C.

religious, and humanitarian reforms. But he was less a political radical than a champion of persecuted peoples and an advocate of self-reformation. In his copy of Lavater's *Aphorisms*, translated by Fuseli and published by Johnson in 1788, Blake underlines and annotated with the single word "Excellent!" the following aphorism: "He, who reforms himself, has done more toward reforming the public than a crowd of noisy, impotent patriots."[63]

Yet in June 1780, when Blake was twenty-three years old, he joined the surging crowd of the Gordon Riots and was swept along "in the very front rank" to witness the burning of the fortress-like Newgate prison. The crowd was composed of thousands of journeymen, apprentices, and servants, demonstrating that the grievances went beyond the religious issue of "No Popery!" Blake and his fellow artisans seized the opportunity to protest the economic burden heaped on the underclasses as a result of the waging of the American war. Their sympathies, inspired by a personal sense of persecution and injustice, went out to the rebels who dared overthrow a tyrant. Similarly, Blake's heart went out to the French patriots who stormed another prison at the end of the decade and ignited the French Revolution.

Blake commemorated his participation in the Gordon Riots with a drawing entitled *Glad Day* or *The Dance of Albion* which documents a connection between that event and the American Revolution.[64] He later engraved this drawing and ran off several color versions which vary slightly from the existing monochrome engraving (fig. 4.22). The only known uncolored state is signed "WB inv 1780" and captioned "Albion Rose from Where He Labourd at the Mill with Slaves Giving himself for the Nations He Danc'd the Dance of Eternal Death" (fig. 4.23). Representing an act of regeneration, it shows a naked human being exulting on a mountain top with outstretched arms and basking in the radiance of a brilliant sunrise. The idea of metamorphosis is contained in the image of a butterfly taking wing just after shedding its chrysalis. Blake's was a positive response to the critical events of the period, exemplifying his contrary position to that of Fuseli whose reaction found expression in the *Nightmare*.

The title *Glad Day*, given to the work by Blake's Victorian biographer, Gilchrist, derives from Psalms (118:24): "This is the day which the Lord hath made; we will rejoice and be glad in it." Typically, Blake fused the his-

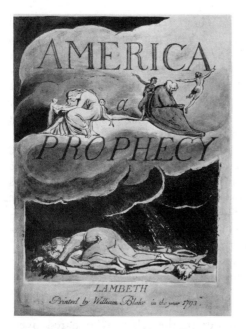

4.24 William Blake, title page from *America, a Prophecy*, 1793. The Pierpont Morgan Library, New York (PML 16134, Copy A).

4.25 William Blake, study for *Glad Day*, pencil. Reproduced by courtesy of the Trustees of The British Museum.

torical moment with biblical prophecy. While he consistently attacked orthodoxy, he was susceptible to religious exaltation of an apocalyptic kind and later gravitated to Swedenborgianism. The biblical character of both his poetic and visual imagery demonstrates that his basic education was grounded on a close study of the Scriptures, and in particular the Book of Revelation. The apocalyptic note was sounded in the engraving's caption, "Albion Rose from Where He Labourd at the Mill with Slaves Giving Himself for the Nations He Danc'd the Dance of Eternal Death," as well as in Blake's illuminated book of 1793, *America, a Prophecy*, which Erdman has linked with the June riots. In plate 17 of *America* Blake traced the spirit of insurrection moving from the colonies to the cities of Great Britain, arousing protests against the war and hastening its end through mass resistance:

The millions sent up a howl of anguish and threw off
 their hammerd mail,
And cast their swords & spears to earth, & stood a
 naked multitude.

And in plate 6 he wrote, "Solemn heave the Atlantic waves between the gloomy nations," suggesting that Albion's act of self-sacrifice in "Giving Himself for the Nations" promoted a sense of independence and regeneration for both adversaries. Burke, who recalled the Gordon Riots with a shudder, observed that, had full-scale rebellion actually taken place, "not France, but England would have had the honour of leading up the death-dance of democratic revolution." Thus Blake's

caption, which similarly equates the death dance with rebellion, underlines the topicality of his allegory.

Glad Day is related pictorially as well as thematically to *America*: on the title page of the work, just beneath the final "A" of *America* a joyful nude figure flies out toward the upper right-hand corner (fig. 4.24). Seen from the rear, this figure is the reverse counterpart of the heroic nude in *Glad Day*. Indeed, Blake's preliminary studies for the engraving were done on both sides of a single sheet, and show on the recto the figure as ultimately depicted, and on the verso the same body viewed from behind— the apparent model for the figure flying off the page in *America*. Both studies were derived from a pair of engravings (fig. 4.25) published in the inevitable *Le pitture antiche*, demonstrating once again the neoclassical foundations of Blake's novel creations (figs. 4.26, 4.27).

Blake writes in *America*, plate 8:

Let the slave grinding at the mill run out into the field;
Let him look up into the heavens & laugh in the bright air;
Let the inchained soul shut up in darkness and in sighing,

. .

Rise and look out, his chains are loose, his dungeon doors are open
And let his wife and children return from the oppressors scourge;
They look behind at every step & believe it is a dream,
Singing, The Sun has left his blackness, & has found a fresher morning
And the fair Moon rejoices in the clear & cloudless night;
For Empire is no more, and now the Lion & Wolf shall cease.

The similarity of these lines to the image and caption of *Glad Day* point unmistakably to their common source in the June Riots and reveal Blake's concurrence with the liberal members of the Lunar Society. Solidarity with the Yankees meant the end of the rule of privilege, civic and parliamentary reform, freedom of the press, and economic justice. A type like Wedgwood was not in the least bit perturbed by the loss of the colonies, knowing that even an independent America would still have to line up for British wares and skills.

Blake saw in the French Revolution a reappearance of the civic patriotism that sparked the Americans to action. Again he shared the attachment to civil and religious liberty of the dissenters, large employers, and Lunar Society members, whose concern for these rights went hand in hand with their attachment to dogmas of free trade. The

warmest welcome to the first stages of the French Revo-
lution came largely from middle-class and dissenting
groups among which Blake's artisanal-entrepreneurial
category could be counted. It may be recalled that in July
1789 Wedgwood wrote Darwin: "I know you will re-
joice with me in the glorious revolution which has taken
place in France."

In 1791 Joseph Johnson printed Book I of Blake's *The
French Revolution: A Poem, in Seven Books* in conventional
typography and without illustrations. The type was set
and proofs made, but the work was not published and
the remaining books have been lost. Early in 1791 John-
son printed Tom Paine's first volume of *The Rights of
Man* (which, among other things, also traced the history
of the French Revolution), but the rising tide of Tory
reaction decided him against publishing it. In July of the
same year, when Lunar Society members were celebrat-
ing the second anniversary of the fall of the Bastille a
well-schooled crowd "rioted" in Birmingham and de-
stroyed Priestley's house, library, and laboratory.[65] Simi-
larly, the project of Blake—who characteristically per-
ceived the French Revolution as ushering in the
millennium and wore the red bonnet of the French Jaco-
bins—fell victim to the mood of prevailing hysteria.

Blake's *French Revolution* resonates with the euphoria
of fundamental change and the boundless optimism of
the French people. It is somewhat free in its presentation
of the facts but nevertheless firmly rooted in history.
Blake compresses the events of two months in summer
1789 into one day, opening with the king of France wilt-
ing on his couch, suffering from a diseased absolutism.
In the towers of the Bastille languish seven manacled po-
litical prisoners who bear witness to the corruption of the
regime, including a dedicated patriot whose only crime
was to send "a letter of advice to a King" and has gone
mad from frustrated hopes for liberty. The king and his
court watch with dread as the National Assembly un-
folds its strategies, and he resigns himself to hiding "in
the dust." But the duke of Burgundy (clearly the comte
d'Artois) advocates a hard line and persuades the king to
banish Necker, the popular finance minister, from the
kingdom and call for war. The scene then shifts to the
National Assembly where the hero, the duke of Orleans,
challenges the call to war and tries to calm the fears of
the nobles who fear that a progressive government spells
the end of their existence: "Can Nobles be bound when

the people are free, or God weep when his children are happy?" And he advises the court "to consider all men as thy equals, / Thy brethren, and not as thy foot or thy hand, unless thou first fearest to hurt them." The book ends with the guardians of false religion chased from the abbeys "by the fiery cloud of Voltaire, and thund'rous rocks of Rousseau," and who in turn inspire Lafayette to assume command as "General of the Nation."

The events covered by Blake's poem embrace the gathering of the Three Estates at Versailles on 4 May 1789, their separate conventions, and the attempt on the part of the Third Estate to induce the nobles and clergy to join them. Buttressed by increasingly popular support and the solidarity of liberal clerics and nobles, the Third Estate declared themselves as "National Assembly" on 17 June. The king, urged on by the queen and his brothers (especially the counterrevolutionary d'Artois), issued orders to close the meeting hall of the Third Estate and prepare it for a Royal Session. The members of the Third Estate then moved to the royal tennis court (*jeu de paume*) where they swore not to separate until they drew up a constitution. The king capitulated one week later, ordering the clergy and nobility to unite with the Third Estate. But in the tense climate of July he severed a link of compromise by dismissing Necker from office and surrounding Paris and Versailles with foreign mercenaries. Rioting broke out on 12 July, and the following day the Parisian middle class, concerned about maintaining order and securing property, established a National Guard. During the morning of Tuesday, 14 July, rumors spread that the royal troops were mounting an attack. The National Guard threw up barricades, and the crowds searched for arms and ammunition. The ancient fortress of the Bastille was raided for muskets and powder, and its defense led to its total destruction. The dungeons were opened and the seven prisoners found in them were released. On the fifteenth the marquis de Lafayette was named chief of the bourgeois militia; after the king confirmed his nomination Lafayette formed the tricolor cockade of the new order with the red and blue colors of Paris and the white of the Bourbon dynasty.

While Blake took liberties with the sequence of events, moved the main site of the action from Versailles to Paris, and confused the royal troops with the bourgeois militia, he was nevertheless quite specific and accurate in terms of names, places, and other historical details.

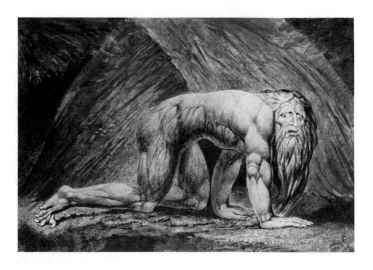

4.28 William Blake, *Nebuchadnezzar*, 1793. The Tate Gallery, London.

Through it all he clearly established his opposition to royal tyranny: if his heroes are the aristocrats Lafayette and the duke of Orleans, they nevertheless have behind them "the voice of the people, arising from valley and hill."

Blake's protest against despotic rulers in the 1790s also took the form of a powerful graphic image entitled *Nebuchadnezzar* (fig. 4.28). The grotesque naked monarch on all fours first appeared in Blake's illuminated book, *The Marriage of Heaven and Hell* (1793), accompanied by the inscription "One Law for the Lion & Ox Is Oppression." As in many of Blake's works, the point of departure is biblical but the reference is topical. The story of Nebuchadnezzar is told in chapter 4 of the Book of Daniel, revealing the king of Babylon at the peak of his power with extensive dominions reaching "to the end of the earth." Forgetful of the divine source of his wealth and possession, he chose to see them as the result of his own intelligence and skills. For this insolence and pride of power God drove him temporarily from his kingdom and all human society. he was reduced to dwelling "with the beasts of the field," and forced to "eat grass as oxen, and his body was wet with dew of heaven, till his hairs were grown like eagles' *feathers*, and his nails like birds' claws."

Blake's monstrous figure has been literally turned inside out, with the musculature and bone structure violently contorted, and the head and neck collapsed into the body. The ungual digits of the right foot are tensed and pushed into the floor of Nebuchadnezzar's cavernous

habitat. His long, flowing beard seems to make his skin "crawl." The low walls of the cavern confine Nebuchadnezzar's movement, the symbol of the limited horizons of his mental vision. Here is the neoclassical nude exploded and reworked into a grotesque being whose visible lineaments give it the character of a mechanical monster.

While the striking color print of 1795 did not indicate the former rank of Nebuchadnezzar, the illustration for *The Marriage of Heaven and Hell* shows unmistakably a crown on his head (fig. 4.29). Nebuchadnezzar's fall corresponds to the actual condition of two monarchs in that fateful decade. In France a king was dethroned and beheaded in January 1793, and in England the king—who had lost his precious American colonies and was now menaced by another revolution—suffered periodically from a debilitating hereditary illness which had the earmarks of madness. That the first version related to contemporary events is shown in the fact that it immediately preceded Blake's "Song of Liberty," which associates a fallen king with his tumbling animals:

Down rushed beating his wings in vain the jealous king; his grey brow'd councellors, thunderous warriors, curl'd veterans among helms, and shields, and chariots, horses, elephants . . . Falling, rushing, ruining! buried in the ruins, on Urthona's dens. All night beneath the ruins, then their sullen flames faded emerge around the gloomy king.

And at the end of the song "the son of fire" spurns the laws promulgated by the king crying, "EMPIRE IS NO MORE! AND NOW THE LION & WOLF SHALL CEASE." This same declaration culminates plate 8 of *America*, at the end of the passage mentioned earlier: "Let the slave grinding at the mill, run out into the field . . . " The reference to the end of "lion & wolf" means that beasts of prey no longer have a reason to exist and the meek inherit the earth.

There is another level of meaning to the work, relating to the scriptural text and contemporary liberal ideology. One law for both the lion and the ox implies that the individuality of these separate animate existences is not considered, hence making the law oppressive. In Blake's unpublished *Tiriel*, following the question "Why is one law given to the lion & the patient Ox?" he deleted a response that came immediately after: "Dost thou not see that men cannot be formed all alike . . . " The idea sug-

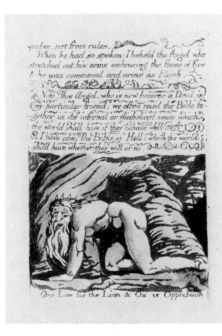

4.29 William Blake, *Nebuchadnezzar*, from *The Marriage of Heaven and Hell*, 1793. The Pierpont Morgan Library, New York (PML 17559, Copy C).

gests a cramped existence, a limited horizon imposed on society by rulers like Nebuchadnezzar whose own outlook had been circumscribed by an inflated opinion of self and an ignorance of godly inspiration. Similarly, the narrow role assigned to large segments of the population in Blake's own time was confining and oppressive; the exclusivity of class and social status weighed heavily on the town and country poor.

The attempt to straitjacket society resulted in the limited vision of contemporary kings. In the *French Revolution* Blake's Louis XVI says:

"I see thro' the darkness, thro' clouds rolling round me, the
 spirits of ancient Kings
Shivering over the bleached bones; round them their
 counsellors look up from the dust.
Crying: 'hide from the living! Our bonds and our prisoners
 shout in the open field,
Hide in the nether earth! Hide in the bones! Sit obscured in the
 hollow skull.
Our flesh is corrupted, and we wear away. We are not
 numbered among the living. Let us hide
In stones, among roots of trees. The prisoners have burst their
 dens,
Let us hide; let us hide in the dust, and plague and wrath and
 tempest shall cease.' "

But this narrow perspective is contradicted by the magnanimous Duke of Orleans who declares that a free people implies an unfettered nobility and advises against stifling, horizon-limited views:

But go, merciless man! enter into the infinite labyrinth of
 another's brain
Ere thou measure the circle that he shall run. Go, thou cold
 recluse, into the fires
Of another's high flaming rich bosom, and return unconsum'd,
 and write laws.
If thou canst not do this, doubt thy theories, learn to consider
 all men as thy equals,
Thy brethren, and not as thy foot or thy hand, unless thou first
 fearest to hurt them.

The result of the revolution is not simply to bring down a tyrant but a movement to open the structure of society to embrace all members as equals.

Unfortunately, the pleas of the people and their representatives have slight effect on the king and his peers. Blake's Louis XVI breaks out into a "chill cold sweat"

but sits unmoved. In the final scene, "The cold newt / And snake, and damp toad, on the kingly foot crawl, or croak on the awful knee, / Shedding their slime, in folds of the robe the crown'd adder builds and hisses / From stony brows; shaken the forests of France, sick the kings of the nations." A similar royal fate is described in *America*, written the year Louis was beheaded. Plate 5, headed by the title "A PROPHECY," starts off with the "Guardian Prince of Albion," burning "in his nightly tent," and by the end of plate 6 "The King of England looking westward trembles at the vision" of revolutionary America. The havoc that he attempts to wreak on the colonies backfires: " . . . then the Pestilence began in streaks of red / Across the limbs of Albions Guardian, the spotted plague smote Bristol." And as the mutinous millions at home "cast their swords & spears to earth, & stood a naked multitude"

Albions Guardian writhed in torment on the eastern sky
Pale quivring toward the brain his glimmering eyes, teeth
 chattering,
Howling & shuddering, his legs quivering; convuls'd each
 muscle & sinew.

The king's episcopal and scribal flunkies are likewise stricken: "Hid in his caves the Bard of Albion felt the enormous plagues, / And a cowl of flesh grew o'er his head & scales on his back & ribs."

The impact of the American revolt now reverberates throughout Europe whose frightened monarchs attempt to close off horizons even more drastically:

Stiff shudderings shook the heav'nly thrones! France, & Italy,
In terror view'd the bands of Albion, and the ancient Guardians
Fainting upon the elements, smitten with their own plagues
They slow advance to shut the five gates of their law-built
 heaven

But the five gates are unable to stem the tide of revolutionary energy and are consumed by fire; the barriers that separate the "law-built heaven" from "the abodes of men" vanish in the flames.

Thus Blake's creeping *Nebuchadnezzar* not only epitomizes an epoch of kings gone mad and dethroned but correlates their fall with the expansion of social and mental horizons. This idea he shared with his friend Tom Paine who while in France in 1791 set down his thoughts on the constitution recently submitted by the National

Assembly. He insisted that the mental breakthrough about monarchy achieved by the French must go beyond seeing kings as individuals and view them "as part of a system of government, and conclude that what is called monarchy is only a superstition and a political fraud." The intimidating factor in the monarchical concept arises from a "slavish habit of mind," the emancipation from which requires a progressive political movement:

Could we draw a circle round a man, and say to him: You cannot get out of this, for beyond is an abyss ready to swallow you up—he will remain there as long as the terror of the impression endures. But if, by a happy chance, he sets one foot outside the magic circle, the other will not be slow to follow.[66]

Blake's and Paine's hatred of royal tyranny and its subtler tools of oppression are echoed in the *Botanic Garden*, published by Johnson in the same year he printed *The French Revolution*. In canto 2 of "Economy of Vegetation" Darwin discusses the land of Franklin where "Tyrant-Power had built his eagle nest," and against whom "The patriot-flame with quick contagion ran, / Hill lighted hill, and man electrified man." Then follows a description of the Bastille, its tortured captives, and its liberation, all of which profoundly affected Blake's poem:

Long had the Giant-form on GALLIA'S plains
Inglorious slept, unconscious of his chains;
Round his large limbs were wound a thousand strings
By the weak hands of Confessors and Kings;
O'er his closed eyes triple veil was bound,
And steely rivets lock'd him to the ground;
While stern Bastile with iron-cage inthralls
His folded limbs, and hems in marble walls.
—Touch'd by the patriot-flame, he rent amazed
The flimsy bonds, and round and round him gazed;
Starts up from earth, above the admiring throng
Lifts his Colossal form, and towers along;
High o'er his foes his hundred arms He rears,
Plowshares his swords, and pruning hooks his spears;
Calls to the Good and Brave with voice, that rolls
Like Heaven's own thunder round the echoing poles;
Gives to the winds his banner broad unfurl'd,
And gathers in its shade the living world!

Darwin's footnote to this section quotes from an eyewitness testimony on the conditions of the Bastille in which "prisoners were fastened by their necks to the walls of

their cells," and skeletons were discovered "with irons still fastened to their decayed bones."[67]

These dramatic images may be compared to Blake's description of the prisoners in the seven towers of the Bastille: in "the den nam'd Horror" was a man "Chain'd hand and foot, round his neck an iron band, bound to the impregnable wall"; in "the tower nam'd Darkness" was a person "Pinion'd down to the stone floor, his strong bones scarce cover'd with sinews, the iron rings / Were forg'd smaller as the flesh decay'd," while in the tower named "Bloody, a skeleton yellow remained in its chains on its couch/ Of stone." A later section, where oppressed French people begin to question their conditions, reads remarkably close to Darwin's closing lines:

Till man raises his darken'd limbs out of the caves of night, his
 eyes and his heart
Expand: where is space! where O Sun is thy dwelling! where
 thy tent, O faint slumb'rous Moon!
Then the valleys of France shall cry to the soldier, throw down
 thy sword and musket,
And run and embrace the meek peasant.

The infinite extension of this process leads to an egalitarian society in which the priest "puts his hand to the plow" and people enjoy heaven on earth.

Blake's involvement with the *Botanic Garden* took place on both a practical and intellectual plane; it may be recalled that Johnson recommended him to Darwin as an engraver and that he engraved at least five of the ten plates in the 1791 edition, including Fuseli's *Fertilization of Egypt* and the four illustrations after Wedgwood's replica of the Portland vase.[68] Blake's own addition to the *Fertilization* of the winged patriarch flinging lightning and rain from his outstretched arms becomes a recurrent depiction in his repertoire including the title page of the *Visions of the Daughters of Albion, The House of Death,* and *The Morning Stars Sang Together*—an illustration for his *Job*. The reproduction of the figures in the compartments of the Portland vase reveal the classical prototypes he used as the point of departure for his more daring imagery (fig. 4.30). The vigorous male figure on the left of the second compartment with his closely cropped curly hair is the other stock character in his repertoire, one whom we have already encountered in *Glad Day*.[69]

Like Darwin and Fuseli, Blake loved botanical and entomological forms, floral blossoms of every type, ten-

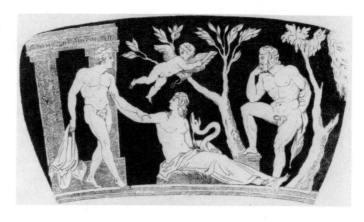

4.30 William Blake, figures from the *Portland Vase*, engraving from Erasmus Darwin, *Botanic Garden*, 1791 edition.

dril, seedling, and sprout, and insects like the worm, bee, spider, caterpillar, chrysalis, and butterfly. His sympathy for the helpless underdog extended from "the little winged fly" to exploited peoples.[70] At the same time, he metaphorically employed these images to exemplify his ideals of political, social, and mental renewal and regeneration. Blake's works, starting with the publication of *Songs of Innocence* and the *Book of Thel* in 1789—the same year that saw the appearance of *Loves of the Plants*—were profoundly affected by Darwin's floral and vegetable metaphors. Mingled among his flowers and insects are the forms of fairies and spiritual beings who dart everywhere in the friendly bowers of the *Botanic Garden*. Akin to Darwin who used his gnomes, nymphs, sylphs, and other creatures to allegorize the operations of nature and industry, Blake often anthropomorphized his leafy and floral forms as in the verses and illustrations to the poem "The Blossom" in *Songs of Innocence*:

Merry Merry Sparrow
Under leaves so green
A happy Blossom
Sees you swift as arrow
Seek your cradle narrow
Near my Bosom.

Surrounding these verses on plate 11 is a burgeoning, flame-like plant on whose leaves cavort naked winged children and an adult winged figure bending over her baby. This may be compared with Darwin's "Quick flies fair TULIPA the loud alarms, / And folds her infant in her arms" in canto 1 of "Loves of the Plants," or in canto 4 his verses:

Spring! with thy own sweet smile and tuneful tongue,
Delighted BELLIS calls her infant throng.
Each on his reed astride, the Cherub-train
Watch her kind looks, and circle o'er the plain; . . .

Or compare Blake's stanza from "A Cradle Song" (also
in *Songs of Innocence*), decorated with flourishing
branches and leaves upon which tiny figures lay,

Sweet sleep with soft down
Weave thy brows an infant crown.
Sweet sleep Angel mild,
Hover o'er my happy child,

with Darwin's

Closed in an azure fig by fairy spells,
Bosom'd in down, fair CAPRI-FICA dwells;

and

So the pleased Linnet in the moss-wove nest,
Wakes into life beneath its parent's breast,
Chirps in the gaping shell, bursts forth erelong,
Shakes its new plumes, and tries its tender song.

Blake's "Infant Joy" shows two enormous blossoms
growing from the bottom right corner, one open above
the text containing a mother and baby in her lap and a
standing sprite with moth wings. But example after ex-
ample can be paraded to demonstrate Blake's use of im-
agery derived from the natural sciences and which he
carefully integrated with his text on the basis of his earli-
er training as an industrial designer.

Blake's floral imagery is one of the most pervasive fea-
tures in both his textual and graphic illustrations. Several
of his title pages carry such motifs, as do his numerous
plates with fairy-like creatures frolicking under flame-like
plants, trees, and vines. Blake was clearly impressed by
Darwin's lively rendition of the sexuality of plants in
mythological terms, exemplified in the description of the
teasel herb:

—With languid step fair DYPSACA retreats,
"Fall, gentle dews!" the fainting nymph repeats,
Seeks the low dell, and in the sultry shade
Invokes in vain the Naiads to her aid.—
Four sylvan youths in crystal goblets bear
The untasted treasure to the grateful fair;
Pleased from their hands with modest grace she sips,
And the cool wave reflects her coral lips.

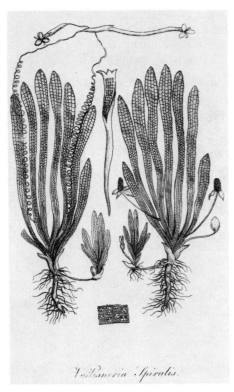

4.31 Illustration of *Vallisneria spiralis*, *The Botanic Garden*, vol. 2, p. 52.

In his *Visions of the Daughters of Albion* Blake ascribes human traits to flowers and, like Darwin, associates them with sexual desire. Oothoon, a virgin, wanders in the valley "seeking flowers to comfort her," and addresses the Marygold:

Art thou a flower! art thou a nymph! I see thee now a
 flower:
Now a nymph! I dare not pluck thee from thy dewy bed!

The Golden nymph replied; "Pluck thou my flower Oothoon
 the mild,
Another flower shall spring, because the soul of sweet delight
Can never pass away." She ceas'd & closd her golden shrine.

Then Oothoon pluck'd the flower saying, "I pluck thee from
 thy bed
Sweet flower, and put thee here to glow between my breasts
And thus I turn my face to where my whole soul seeks."

Whereupon Oothoon soared over the ocean to take the flower (of her virginity) to her lover.

More concretely, Darwin's plate in "Loves of the Plants" of the *Vallisneria Spiralis* (fig. 4.31), with its root structure, long spiral stalk, wandering tendrils, serpentine leaves, and blossoms was used by Blake as a model for his decorative foliage in plate 4 of *America*, plates 4 and 12 of *Europe, A Prophecy* (fig. 4.32), and was probably the source of the large plant at the foot of plate 2 of *The Marriage of Heaven and Hell* (fig. 4.33).[71]

The striking visual and literary correspondences between Blake and Darwin point up their common philosophical approach to the larger issues of their time. Stimulated by the awesome human potential promised by current scientific and industrial innovation, they tried to grasp the broad implications in a humanized cosmography that would be understandable in both contemporary and prophetic terms. In this Blake again showed his affiliation with the Lunar Society members.[72] He establishes this in his satire on the group entitled "An Island in the Moon," written around 1784:

In the moon is a certain Island near by a mighty continent, which small island seems to have some affinity to England, & what is more extraordinary the people are so much alike & their language so much the same that you would think you was among your friends.

One of the main characters is Inflammable Gass the Wind Finder, who is surely a take-off on Priestley. He conducts all sorts of experiments, makes toys and pup-

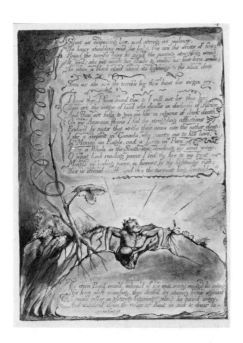

4.32 William Blake, plate 4, *America*. Fitzwilliam Museum, Cambridge, England.

4.33 William Blake, plant from plate 2, *The Marriage of Heaven and Hell*. The Pierpont Morgan Library, New York (PML 17559, Copy C).

pets, and uses an air pump to carry out experiments with the dangerous, plague-bearing "phlogiston."[73] Another character, the mathematician Obtuse Angle, sings a song about John Locke and Isaac Newton, and must be William Small, who had expounded mathematics and Newtonian physics at the College of William and Mary in Virginia before helping found the Lunar Society. Steelyard the Lawgiver hosts the group one evening and is probably Matthew Boulton, the iron magnate at whose house many of the meetings of the Lunar Society took place. Finally, Etruscan Column the Antiquarian is none other than Josiah Wedgwood whose factory Etruria turned out antique objects to order.

Although most of the records of Blake's work for Wedgwood are now lost or destroyed, it is almost certain that Blake engraved illustrations for Wedgwood's *Catalogue of Queen's Ware* assembled in the period 1781–1783. According to a surviving Wedgwood account with John Flaxman (who introduced Blake to the potter), the ceiling painting for the drawing room of Etruria Hall, Wedgwood's residence, was designed by Flaxman and executed by Blake, who was paid three pounds, seventeen shillings. [74] Blake also made the engravings of Wedgwood's replica of the Portland vase for the *Botanic Garden*. Perhaps his most notable commission for the firm came from Josiah Wedgwood the younger in 1815; Blake engraved plates 1–18 for the Queen's Ware Catalogue of 1817; these display cream bowls, butter dishes, soup terrines, salad bowls, and china fruit baskets (figs. 4.34, 4.35). Blake executed these objects with the linear technique associated with neoclassicism; the clear, crisp outlines have now been explicitly deployed in the sale of Wedgwood's products. Blake's systematic turn of mind is exemplified in a note he wrote Wedgwood the younger in 1815 about the commission: "It will be more convenient for me to make all the drawings first, before I begin engraving them, as it will enable me also to regulate a System of working that will be uniform from beginning to end."[75]

In addition to Blake's identification with the commercial aims of the Lunar Society, he shared their desire for the emancipation of persecuted peoples. Listen, for example, to his "Song of Liberty":

Look up! look up! O citizen of London enlarge thy
 countenance;

4.34 William Blake, plate 9 of *Wedgwood's Queen's Ware Catalogue*, 1817. Photo courtesy of Josiah Wedgwood and Sons Ltd.

4.35 William Blake, plate 17 of *Wedgwood's Queen's Ware Catalogue*. Photo courtesy of Josiah Wedgwood and Sons Ltd.

O Jew, leave counting gold! return to thy oil and wine; O
African! black African! (go winged thought, widen his
 forehead.)

Here he sympathizes with the Jew and black forced to
live out stereotyped roles, and urges them to break with
them and get beyond the limits imposed by the King of
this World. Throughout his writings he expresses con-
cern for the oppression of blacks and other persecuted
peoples, starting with his poem "The Little Black Boy"
in *Songs of Experience*.

 This poem contributed to the early stages of the cam-
paign for abolition, going hand in hand with Cowper's
Negro's Complaint and Roscoe's *The Wrongs of Africa*. It
begins

My mother bore me in the southern wild,
And I am black, but O! my soul is white.
White as an angel is the English child:
But I am black as if bereav'd of light.

As on the title page the verbal and visual image focuses
on a teaching mother and her student child: responsibility
for the child's education belongs to the mother. Blake
identifies "light" with enlightenment and takes the con-
ventional association of black with the unenlightened and
uncivilized aspects of human society. The mother directs
the child to look "on the rising sun" which God inhab-
its, thus also making light the metaphor for the spiritual
realm. Blake's black child has a "white soul" so that it is
this spiritual quality that equalizes the races. And the
poem ends:

Thus did my mother say and kissed me,
And thus I say to little English boy:
When I from black and he from white cloud free,
And round the tent of God like lambs we joy:

Ill shade him from the heat till he can bear
To lean in joy upon our father's knee
And then Ill stand and stroke his silver hair
And be like him and he will then love me.

While the last line suggests that full equality can come
about only when the black child shall be like the "little
English boy," a close reading indicates that both need
liberation from stereotyped categories: "When I from
black and he from white cloud free." Nevertheless, Blake
finally demonstrates his moderate position on the racial
issue in making his racial utopia depend on the black

stroking the "silver hair" of the English boy and in his being like him before he can be loved in return.

Blake's poem should be seen in relationship to another in the same series entitled "The Chimney Sweeper"—directed at child labor and oppression:

When my mother died I was very young,
And my father sold me while yet my tongue,
Could scarcely cry "weep weep weep weep,"
So your chimneys I sweep & in soot I sleep.

Although Blake's sweeps are white children, their sooty skin is symbolic of the black skin of African slaves.[76] Blake depicts a youthful sweep in bondage who fantasizes about an escape to freedom. His friend Tom Dacre had a dream in which thousands of sweepers were locked up "in coffins of black," but an angel with a "bright key" sets them free:

Then down a green plain leaping laughing they run
And wash in a river and shine in the sun.

Here again light represents freedom and spiritual enlightenment, as does the revelation of their bodies "naked & white."

Blake's "Chimney Sweeper" indicts English society for subjecting children to slave conditions, and coincides with the passage of the moderate Chimney's Sweeper Act of 1788 when the sweep's circumstances were widely publicized. Blake's sweep was sold by his father while yet his tongue "could scarcely cry 'weep weep weep weep' "; and this corresponds to actuality since the average age of sweeps or apprentices was six or seven and could even include four-or five- year-olds. They were sold for cash to a master sweep who exploited them ruthlessly. The work stunted their developing bodies and permanently discolored their skin, leaving them with twisted kneecaps, and deformed spines and ankles from crawling up chimneys as small as seven or nine inches in diameter. Respiratory ailments and severe eye inflammations among this group were quite common as well as cancer of the scrotum from the constant irritation of soot. They generally lived like animals, rising in the dark and working until noon, sleeping on the bags of soot they collected. When Blake's sweep says "in soot I sleep," the artist was reporting fact.

Blake makes his sweep worse off than "the little black boy" who is able to see beyond his present condition to a

moment when he shall be free of his "black cloud." But the sweeps began as white and have become black, thus giving the term "black" an ironic twist in the two cases. In the case of the Africans white society felt it could enslave and hence dehumanize them because of the blackness of their skin, which then becomes symbolic of their inferiority according to white ideology, and also of their oppression. But Blake could perceive black skin positively: its ability to withstand the sun's heat allows the black child to shade the English boy "till he can bear / To lean in joy upon our father's knee." In the case of the white sweep, however, there is no positive reversal of blackness; the white victims of oppression are turned black and have become permanent outcasts. Although both are black and slaves, the African child envisions a release from his condition thanks to his mother's teaching, while the sweep is locked into a hopeless situation symbolized by the last line of the poem: "So if all do their duty, they need not fear harm."

Blake deals again with black and white oppression together in his *Visions of the Daughters of Albion*, where the main theme is female bondage. The very first words of this illuminated book are: "Enslav'd, the Daughters of Albion weep." They are in fact an adult version of the youthful sweeps. We may recall that the virgin, Oothoon, has plucked the "bright Marygold" of sexual desire and flies to meet her lover, Theotormon. But Bromion, a vicious taskmaster, intercepts and rapes her and makes her his slave. His new possession is then equated with colonial and plantation oppression:

Thy soft American plains are mine, and mine thy north &
 south:
Stampt with my signet are the swarthy children of the sun:
They are obedient, they resist not, they obey the scourge: . . .

Theotormon responds in moral outrage to the act, "And folded his black jealous waters round the adulterate pair," who are depicted bound back to back in Bromion's cave where "terror and meekness dwell." But he sits dejected and conflicted at the mouth of the cave, unable to act, and hears

The voice of slaves beneath the sun, and children bought with
 money,
That shiver in religious caves beneath the burning fires
Of lust, that belch incessant from the summits of the earth.

These verses on plate 5 are complemented by the image of a prone naked black man struggling to get up, while another pictorial allusion to slavery appears on plate 9, where a naked man flourishes a cat-o'-nine-tails at a fleeing naked woman.

Blake's language derives from the abolitionist writings of the period such as Roscoe's *Wrongs of Africa* which refers to "the sable children of the sun, / Whom modern pride disdains, whom avarice dooms," and his even earlier *Mount Pleasant* which attacks the slave trade:

There AFRIC'S swarthy sons their toils repeat,
Beneath the fervors of the noon-tide heat;
Torn from each joy that crown'd their native soil,
No sweet reflections mitigate their toil;
From morn, to eve, by rigorous hands opprest,
Dull fly their hours, of every hope unblest.
Till, broke with labour, helpless, and forlorn,
From their weak grasp the lingering morsel torn; . . . [77]

Blake uses the abolitionist rhetoric as a context for other forms of subjection such as mental bondage which he sees typically as the enclosure of an "infinite brain into a narrow circle," and he makes Bromion say Blake's favorite bromide: "And is there not one law for both the lion and the ox?" Finally, he alludes to female slavery and prostitution.

Blake's own erotic sense of the defiled slave who yields on every point to the master is blended in the text, akin to the harem fantasies conjured up by the *Letters* of Lady Mary Wortley Montagu. Theotormon, however, is inhibited by a moral code that now condemns Oothoon as impure, while Oothoon insists that she is not a fallen woman and that her lover's affection will restore her purity. A discussion of free love and of male and female rights ensues, but Theotormon remains bound by conventional fetters and Oothoon "every morning wails." In the end, emancipation of sexuality and self depends on moral rather than political regeneration, and here Blake reveals himself in the abolitionist camp.

Blake's knowledge of the cruelties of slavery came from numerous sources, but none was as direct as his involvement with the *Botanic Garden*. Around 1791 Johnson sent to Blake a portfolio of sketches for a book about the human and geographical conditions in the South American colony of Dutch Guiana. Blake engraved at least sixteen of the plates—including almost all those

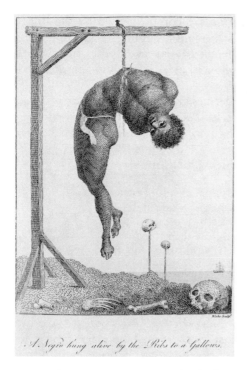

4.36 William Blake, *Negro Hung Alive by the Ribs to a Gallows*, engraved illustration to John Gabriel Stedman's *Narrative of a Five Years' Expedition. . .* , 1796.

dealing with slavery in the colony—for the book by Captain John Gabriel Stedman finally published in 1796.[78] The full title of Stedman's work implies a scope as broad as Darwin's opus: *Narrative of a Five Years' Expedition against the Revolted Negroes of Surinam, in Guiana, on the Wild Coast of South America, from the Year 1772 to 1777: Elucidating the History of That Country, and Describing Its Productions, viz. Quadrupeds, Birds, Fishes, Reptiles, Trees, Shrubs, Fruits and Roots; with an Account of the Indians of Guiana and Negroes of Guinea.* Stedman was an English mercenary sent to Guiana to help suppress rebel slaves. His account, not only of the expedition itself, but also of the prevailing conditions throughout the colony, is both an immensely human document and an authoritative source for the period. Stedman claimed that he set down the account in response to the contemporary "exploring of foreign countries" then in progress, especially intense since the discoveries of "the immortal Captain Cook."

By 1772 the menace of rebel slaves, who attacked and then disappeared into the bush, had become so serious that the Dutch government had to take forceful action to crush the revolts. Stedman was prepared to deal ruthlessly with the slaves, but once he arrived in Surinam he was shocked by their treatment. Slaves went to work on the sugar estates just at dawn and worked until dark, with short breaks for breakfast and lunch. They were housed in long ranges of wooden barracks divided into small compartments. They were branded instead of being baptized and given humiliating classical names at the hands of their owners like Pompey, Caesar, Scipio, Hannibal, Jupiter, Venus, Bacchus, and Apollo. Above all they were mercilessly whipped for the nonperformance of impossible tasks. One female slave was sentenced to 200 lashes, then condemned to drag a chain several yards in length, one end of which was locked around her ankle, and the other affixed to a weight of at least 100 pounds.

Stedman, however, shared the general biases of the time: he saw nothing intrinsically wrong with the ownership of slaves, especially by a kind master who could provide a life infinitely preferable to wage labor in Europe. While he opposed the inhuman tortures he witnessed, he believed that slaves had to be kept in place through severe discipline. Finally, he believed that sudden emancipation could only hurt the slaves who would be lost without European supervision.

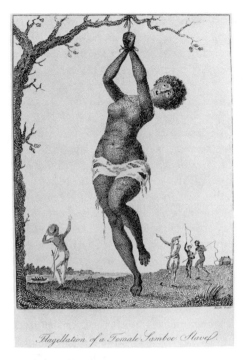

4.37 William Blake, *Flagellation of a Female Samboe Slave,* engraved illustration to John Gabriel Stedman's *Narrative of a Five Years' Expedition. . . ,* 1796.

Stedman, who himself fell in love with a young slave named Joanna, was fascinated by the sexual uses and abuses heaped on female slaves who performed for all European ranks and sexes. He claimed that the young women exulted in living with a colonist whom they served obediently. Even the clergy availed themselves of the privilege. Probably out of jealousy, Stedman was outraged by the type of colonist "who may have been nothing in Europe" living like a monarch and waited on by an army of slaves. Enjoying total power over their bond servants, the male colonist formed intimate relations with the females and indulged his passions freely. The majority lived like "Eastern despots" with a seraglio on every estate. Stedman could remark that if the planter's harem "did not emulate the luxury and pomp of the Turk," it transcended its prototype in coarseness and sensuality.

Blake's plates for Stedman's publication encompassed most of these observations on slave conditions. Stedman appreciated the engravings (they were done after Stedman's own drawings), and eventually he and Blake became good friends. The illustrations catch Stedman's perceptions of the dignity of black men and women under inhuman torture: the pained, knowing look of the *Negro Hung Alive by the Ribs to a Gallows* who never uttered a complaint, the scene of the *Flagellation of a Female Slave* showing a young woman bound by her hands to the branch of a tree, her body lacerated by the stroke of a whip (figs. 4.36, 4.37). Blake's engraving of *A Surinam Planter* satirizes the fashion and arrogance of the colonist (fig. 4.38). Stedman's description of the type stressed the inappropriately showy morning dress in the colony and his daily round of dissipation. His breakfast was served by the most beautiful slaves that could be selected, and afterward, while he napped, he was fanned by attendants. As Stedman put it: "Such absolute power . . . cannot fail to be peculiarly delightful to a man, who, in all probability, was in his own country, Europe, a— nothing."[79] Blake added to the engraving a black female servant, nude from the waist up, pouring the master's drink. She is shown in an inferior position in the background looking up at the planter with an almost worshipful gaze. She yields herself to her master's bodily pleasures, suggested by her nudity and the drink. Like Stedman, Blake has no respect for the planter, but at the same time he shares the fascination for the sexuality of

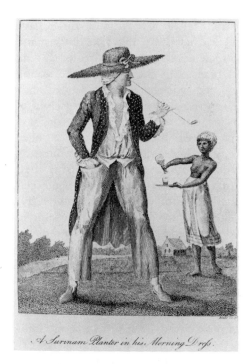

4.38 William Blake, *A Surinam Planter in His Morning Dress*, engraved illustration to John Gabriel Stedman's *Narrative of a Five Years' Expedition. . .* , 1796.

the slave-master relationship, and confines the woman to a subordinate pictorial as well as social position. Blake essentially accepts the traditional view of the black female slave, ignorant and present only for the master's pleasure.

His engraved picture for the book's end is an allegorical depiction of *Europe Supported by Africa and America* (fig. 4.39). The first is represented by a white nude wearing pearls, while the others, symbolized by a Native American and a black woman, wear slave manacles. They are far from equal: Europe in the middle is actually being propped up by her sisters who brace themselves to sustain her nonchalant posture. While Blake and Stedman protested against the cruelest features of slavery, they could not accept the black person (or the Native American) as a full, integrated member of society. Like the abolitionists in general, their outraged cry of protest was articulated in mainly moral rather than political terms.

The fact that Blake's involvement with the Stedman portfolio and manuscript coincides with the execution of the *Visions of the Daughters of Albion* indicates a direct link between them. There are several overlapping connections including images of manacled and tortured women, and the broader issues of female servitude, the taxmaster's sexual violation of the slave, and the colonial mind set. If we imagine Europe as a stand-in for Albion in Blake's finis plate for Stedman, propped up by its colonial empire, then the eternally wailing Oothoon becomes the symbol of the repression of English society and its colonized peoples in 1793. That Blake chose the female symbol to embrace the various forms of institutionalized bondage is probably not fortuitous: in 1791 he illustrated the works of Mary Wollstonecraft for Johnson. Wollstonecraft's pioneering *Vindication of the Rights of Women*, also from that year, often draws comparisons between women and male slaves: for example, both are considered forms of property, and "from the respect paid to property flow, as from a poisoned fountain, most of the evils and vices which render this world such a dreary scene to the contemplative mind." At the same time, the denial of women's political and social rights, as in the case of slavery, degrades both "the master and the abject dependent."

Blake's need and capacity to find symbols embodying dynamic political, social, and economic issues was affected by the experimentalist wing of the neoclassicists

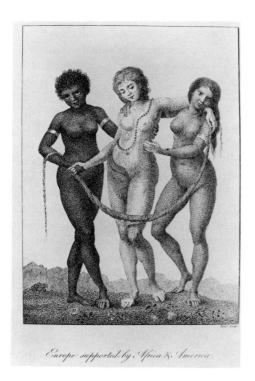

4.39 William Blake, *Europe Supported by Africa and America*, engraved illustration to John Gabriel Stedman's *Narrative of a Five Years' Expedition. . .*, 1796.

among whom he could be counted. He drew upon their same sources and expanded aesthetic frame of reference to exploit neoclassicism on behalf of the expression of new social and political changes. He read Burke's *Sublime* at an early age, and while he claimed to have gained little from it his work belies the claim. His exploration of the full range of human passion, as well as his lifelong preoccupation with Milton and the Book of Job, demonstrate to what extent the background of his imagination was shaped by Burke's treatise. MacPherson he loved openly and dearly; unlike most of his friends he persisted in believing in the truth of the Scot's assertions. In his marginalia to the preface of Wordsworth's poems which criticized MacPherson, Blake wrote that "I Believe both MacPherson & Chatterton that what they say is Ancient Is so," and also admitted that "I own myself an Admirer of Ossian equally with any other Poet whatever."[80]

Blake's debt to the Ossianic songs reveals itself in the unusual nomenclature of his mythical beings and places, in the metrical rhythms of his poetry and the way they build tension, and the capacity to fuse convincingly human action with elemental or cosmic forces. In this sense, MacPherson, Darwin, and Blake share a system in which heroes or plants become mythical creatures acting in consonance with natural phenomena like moon, mist, cloud, fog, shadow, lightning, and meteoric events. In the section entitled *Croma: A Poem*, Malvina laments the death of Oscar by a botanical metaphor: "I was a lovely tree, in thy presence, Oscar, with all my branches round me; but thy death came like a blast from the desert and laid my green head low." MacPherson's political views differed from those of Darwin and Blake, but his experience of the same cataclysmic historical events was channeled through similar formal structures. What varies are the symbolic meanings attached by the various authors to their cast of characters. For example, in his political tract, *The Rights of Great Britain Asserted against the Claims of America*, MacPherson calls Great Britain a "Guardian Angel" who had always stretched "forth her hand" to the aid of the Americans who now display the highest type of ingratitude.[81] Blake's *America*, on the other hand, has "Albions Angel" standing "beside the Stone of Night," perceiving

The terror like a comet, or more like the planet red
That once inclos'd the terrible wandering comets in its sphere.

Blake could use MacPherson's techniques and elemental metaphors to express an opposite political position. Throughout *America* Blake passes in rapid succession red meteors, blazing comets, planetary orbs, and clouds to establish a cosmic (and meteorological) backdrop for a dynamic exchange between England and America. The conjunction of Ossianic imagery and the American Revolution may be easily understood in light of our previous discussion of Fuseli's *Nightmare*, but now is further charged by the events of the French insurrection. The progress of national liberation is equated with the vast possiblities projected by science. Nevertheless, Blake's own position was squeezed by the forces of reaction, and in place of the concrete historical persons and happenings of *The French Revolution* he now had recourse only to aerial beings, celestial phenomena, and hybridized imagery without solid ties to the real world. The bow of promise on the cloud has meaning only in terms of the power implied in the meteorological metaphor.

The Visions of the Daughters of Albion was even more directly affected by MacPherson's Ossianic works. The "Argument" on plate 3 refers to Oothoon's unashamed love for Theotormon to which she adds: "I trembled in my virgin fears / And I hid in Leutha's vale!" In MacPherson's *Croma* the virgins of Lutha (a valley in Morven) see Malvina's tears and ask: "Why art thou sad . . . thou first of the maids of Lutha?" Blake's "Daughters of Albion," like such MacPherson phrases as "maids of Lutha," daughters of Morven" (*Lathmon*), and "sons of Albion" (*Temora*, Book VII), has a distinctly Ossianic ring. Even more significant, the poem preceding *Croma* is entitled *Oithona* and recounts the story of a woman whose husband has been called away on Fingal's expedition to the land of the Britons, and while alone is forcibly seized and raped by Dunrommath, Lord of Uthal, who conceals her in a cave on the desert island of Tromathon. The striking similarity between the names Oothoon and Oithona (which means "virgin of the wave") and Tromathon and Theotormon, as well as the coincidence of major narrative details, demonstrates that Blake delved deeply into MacPherson's Ossianic songs. He would have sympathized with the nationalist feelings of Scotland and Ireland expressed through the Ossianic lore, and its primeval and elemental attachment to ancient Albion also must have appealed to that side of him

4.40 William Blake, *The Spiritual Form of Nelson Guiding Leviathan, in Whose Wreathings Are Infolded the Nations of the Earth*, exhibition and *Descriptive Catalogue*, 1809. The Tate Gallery, London.

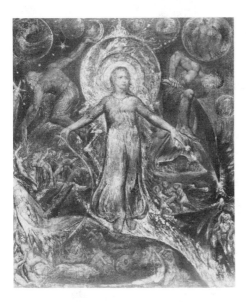

4.41 William Blake, *The Spiritual Form of Pitt, Guiding Behemoth*, exhibition and *Descriptive Catalogue*, 1809. The Tate Gallery, London.

which wished to contribute to an aesthetic, political, and social regeneration of his native land.

By the end of the century, however, Blake's diminishing political energies had evaporated almost entirely. He was pitching his work to an elite group with little revolutionary impulse (*America* was advertised for ten shillings and sixpence, a price affordable only by the wealthy), and trying to make his way quietly in the repressive political climate of the 1790s. After the beheading of Louis XVI the atmosphere of repression intensified; those calling for parliamentary reform in Scotland were harshly sentenced by the chief justice. People could be charged with treason for trivial remarks, and government spies furnished false evidence, as in the case of the leaders of the London Corresponding Society. Blake himself grew increasingly disillusioned after the period of the Terror in France, and his work became esoteric in reaction to censorship. And his need to earn a living made him dependent on conservatives like Butts.

During the Napoleonic period, Blake felt conflicted between his lingering sympathies for the French Revolution and the need to reach a chauvinistic audience. There are contradictory utterances in private and in public, but even these last are mingled with irony and his irrepressible need to break with conventional aspirations. Blake's exhibition and *Descriptive Catalogue* of 1809 promoted his ideas for public works and attempted to reach a larger clientele. He listed for sale a number of works including *The Spiritual Form of Nelson Guiding Leviathan, in Whose Wreathings Are Infolded the Nations of the Earth*, and its companion piece *The Spiritual Form of Pitt, Guiding Behemoth; He Is That Angel Who, Pleased to Perform the Almighty's Orders, Rides on the Whirlwind, Directing the Storms of War: He is Ordering the Reaper to Reap the Vine of the Earth, and the Plowman to Plow Up the Cities and Towers* (figs. 4.40, 4.41). As in the past, clarity and precision of outline are his primary goals as opposed to those who would use technique to "hide form." He compares his two pictures to mythological apotheoses of Persian, Indian, and Egyptian antiquity, modeled upon the imagery of the ancient republics, monarchies, and patriarchies, the progenitors of memorable examples of ancient art like the Farnese Hercules, the Medici Venus, and the Apollo Belvedere. Blake claimed to have attempted the emulation of the grandeur of these ancient

works "and to apply it to modern Heroes, on a smaller scale."

The two works are bizarre but nevertheless of a conservative bent, indicating Blake's public chauvinism during the Napoleonic wars. Not only does he apotheosize England's two great leaders (Nelson had died in the Battle of Trafalgar in 1805, Pitt the following year), but he quotes Nelson's famous Order of the Day to the fleet just before the Battle of Trafalgar: "England expects that every man should do his duty," and then adds, "in Arts, as well as in Arms, or in the Senate."[82] Blake's exploitation of English subjects to appeal to chauvinist sentiment indicates the length to which he was willing to go at this time to sell his paintings.

This is even more dramatically highlighted by the fact that the *Pitt* title invokes the popular patriotic poem by Joseph Addison called *The Campaign* which celebrated the victory of the English over the French at Blenheim in 1704. The title draws on the following couplets:

So when an Angel by divine command
With rising tempests shakes a guilty land,
Such as of late o'er pale *Britannia* past,
Calm and serene he drives the furious blast;
And, pleas'd th'Almighty's orders to perform,
Rides in the whirl-wind, and directs the storm.

Addison was commissioned by a Tory government to write the poem whose jingoistic sentiments anticipates James Thompson's "Rule Britannia, rule the waves!" The poem had made Addison's political fortune, and no doubt Blake thought that the painting would make his. In the *Descriptive Catalogue* he laments the failure of contemporaries to build monuments as they did in antiquity, for if they did "he should not doubt of having a national commission to execute these two pictures on a scale that is suitable to the grandeur of the nation, who is the parents of his heroes."[83]

Blake thus never fully recovered from the repression of the 1790s, ironically orchestrated by Pitt. Pitt had served as prime minister during the years 1783–1801 and 1804–1806. During these ministries he formed three major European coalitions against the French, hence Blake's reference to him as "directing the storms of war." Pitt opposed all domestic dissension in times of war, and it was he who implemented the king's program for suppressing dissent and prosecuting radicals. Thus Blake's

withdrawal to the "underground" was largely the result of the machinations of Pitt whom he now glorifies in his picture. Nevertheless, the *Pitt* and *Nelson* demonstrate his persistent preoccupation with current events and allow him again to make direct historical statements as he did before the repression. Blake comes out of hiding only when he can cover his traces by glorifying the regime. That he pandered deliberately to the public is seen in both his published statements and in his choice of the popular heroes who had only recently died.

Typically, Blake uses biblical metaphors as the point of departure for his themes: Leviathan and Behemoth symbolize the forces of sea and land in Job (chaps. 40–41) which convince the prophet of the omnipotence and omniscience of God. Pitt guides the raging monster Behemoth on land who takes a heavy toll of human victims, while the Giant Reaper reaps the vine of the earth, and his counterpart, the Plowman, deals destruction to cities and towers below. Disruption is pervasive as cannons fire at fleeing victims, Behemoth swallows howling warriors, and buildings are consumed by fire. In the heaven above there are six planetary orbs enclosing figures, stars, and a bright rushing comet. As in Darwin and MacPherson, the hero becomes a kind of cosmological symbol governing the universe. Nelson bestrides the sea monster Leviathan, whose coils grasp struggling, shrieking, and exhausted victims. The hero stands on a coil of the beast writhing over the collapsed body of an African slave identified by a wrist manacle. Next to Nelson, this figure is the most prominent in shape, position, and color, and makes sharp contrast to the hero. The position of the slave is ambigous: he is neither included in the coils of Leviathan nor is he entirely free from danger.

Blake's two pictures express for the public a sense of national heroism and self-sacrifice, but they are hardly exempt from ambiguity and criticism. Nelson is indifferent to the slave who forms part of the base on which he stands, and both he and Pitt are oblivious to the shrieks and sufferings of the victims of the two beasts they ride. Slave traffic was abolished in 1807 although not the possession of slaves, and the law was hardly effective since it continued under various guises for many more years. Moreover, with Hobbes the Leviathan had become the symbol of the tyrannical state or the unwieldy Ship of State. The English Ship of State and its powerful navy rides on the back of Nelson and the slaves, while the ter-

restrial power depends upon the obedient cooperation of the Reaper and the Plowman—the association of the landed aristocracy and "Farmer" George, the nickname for George III and his Model Farm at Windsor. These forces behind Nelson and Pitt control, or unleash, Leviathan and Behemoth.

The vast increase in Great Britain's agricultural trade due to the demand created by the Napoleonic Wars is also symbolized in the *Reaper* and the *Plowman*. During the period Blake worked on his two pictures Napoleon had resorted to economic warfare to undermine English morale, attempting to close the whole of Europe to British goods and at the same time to starve Britain by cutting off all supplies. Britain retaliated with the Orders in Council of 1807, designed to put an end to maritime trade which might aid Napoleon. The effects of the struggle were seen in the severe shortage of food, and though British sea power insured that trade in food was not entirely stopped, it was to some extent disrupted. Grain prices reached crisis levels in the period 1805–1809, due to shortage and monetary inflation. The government discouraged wasteful uses of grain such as milling it into hair powder, perhaps allegorized in the large lock of hair Nelson holds in his right hand. The wealthy farmers flourished and their power and landholdings increased. In order to enjoy maximum returns, they embarked on great improvement schemes; lands previously considered worthless were ploughed—including heavy clay areas fit only for pasture, acid, and chalky soils—and sown with grain. Blake's metaphorical use of Reaper and Plowman in the context of the Napoleonic wars was perfectly in tune with the times.

Summing up, these two works were allegories of English agricultural and naval power, the twin supports of its dominance. But Blake does not hesitate to show that English glory is frightfully blemished: it rests on slavery, domestic oppression, and brute power to achieve its aims. Nelson and Pitt are, as Erdman claims, "aggressive heroes," but they are not the exclusive villains. Their potential for violence emanates from the state in the context of English-French warfare. Nelson and Pitt appear as angelic counterparts to their beastly complement because they cannot be held responsible for the violence resulting from the forces set into motion.

The existence of these two works, albeit rather late and unusual even for Blake, demonstrate the artist's fun-

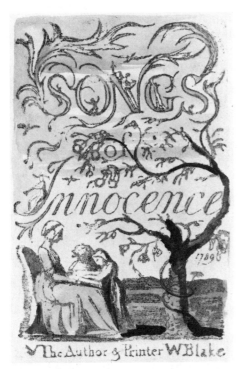

4.42 William Blake, title page of *Songs of Innocence*, 1789. The Library of Congress, Rosenwald Collection, Washington, D.C.

damentally political and economical outlook. He was able to merge his apocalyptic imagination with current events, and this explains as well his abundant use of industrial metaphors. Blake was a child of the Industrial Revolution; the dates of his life correspond to the beginnings of the shift from an agrarian to an industrial economy. We have seen how this affected his choice of career and his training. Now it remains to see more concretely how industrial processes affected his conceptual and stylistic approach.

Blake, Science, and Industry

The influence of Henry Pars's drawing school (originally Shipley's) on Blake's work is evident on his first major illuminated book, *Songs of Innocence*. The title page integrates word and image in a tightly knit design reminiscent of textile patterns (fig. 4.42). The branches of the apple tree on the right are elaborated near the top of the page into plant-like flourishes and form the letters of the word "SONGS." Tiny creatures cavort in and among the letters like playful sprites, consistent with the childhood theme. The "o" of the word "of" lies in the center of the page and is ingeniously encircled by a curving branch bearing apples so that it harmonizes with them like another piece of fruit. The centering of this motif among the intertwined plant flourishes and tree branches distinctly recalls the textile designs produced at the industrial art school (see fig. 4.17), suggesting that Blake's skill in weaving text and image into successful configurations derived from this early training.[84]

Other illustrations for the *Songs of Innocence* show the influence of Shipley's basic curriculum. For example, the design for "The Shepherd"—with the prominent tree along the right-hand margin serving as a foil for the grazing sheep along the line of the horizon—looks back to designs produced by Shipley's students such as the prize-winning *Composition after Nature of Beasts and Birds* of 1759 (figs. 4.43, 4.44). This pictorial formula recurs several times in Blake's work, recalling Ozias Humphry's remark about the "beasts, flowers, foliages and ornaments" sketched in Shipley's school in preparation for lace patterns.

Blake credited himself on the title page of *Songs of Innocence* (and other illuminated books as well) as "The Author & Printer," thus emphasizing his dual role as art-

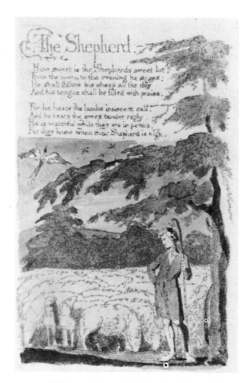

4.43 William Blake, *The Shepherd*, from *Songs of Innocence*, 1789. The Library of Congress, Rosenwald Collection, Washington, D.C.

4.44 Nathaniel Smith, *Composition after Nature of Beasts and Birds*, 1759, drawing. By permission of the Royal Society of Arts, London.

ist and entrepreneur–master artisan. This dual status is literally and symbolically represented by his capacity to combine text and image in a coherent package. Blake's entrepreneurial use of new methods of stereotype printing broke down the distinctions between artist and industrial designer and between type and illustration.[85] It also advanced a pictorial way of materializing imaginative concepts in line with the ideas of the Lunar Society. Blake's imaginative powers consisted of bringing his work into harmony with the new scientific and industrial developments.

An astonishing example of this is the frontispiece (plate 1) to *Jerusalem: The Emanation of the Giant Albion*, dated 1804 on the title page but not completed until around 1820 (fig. 4.45). It shows a type of nightwatchman or caretaker pushing his way through the door of an arched portal in a stone wall. As he enters the profound darkness of the interior he carries with him in his right hand a spherical lantern articulated into concentric circles which give off rays. The lantern is made of a transparent material for the fingers of the caretaker are visible through it, but the globe seems to adhere to his hand rather than be grasped by it. This is especially evident in the color print where the entire scene is illuminated by the curious light (fig. 4.46).

This figure clearly represents Los, the protagonist of *Jerusalem* and the persona of Blake himself. Los stands for

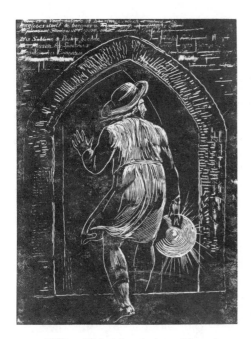

4.45 William Blake, frontispiece of *Jerusalem*, 1804–1820. Fitzwilliam Museum, Cambridge, England.

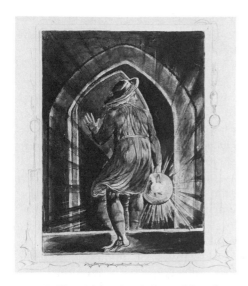

4.46 William Blake, frontispiece of *Jerusalem*, 1804–1820, color print. From the Collection of Mr. and Mrs. Paul Mellon, Upperville, Virginia.

the Imaginative Mind who perceives spiritual truth but is mired in the materialism of the temporal world. But if he is frustrated in his attempts to make his creations capable of grasping "Eternity in an hour," he continually strives to enlighten human vision. On either side of and above the archway of the frontispiece Blake initially engraved eleven lines which were later deleted or obscured in the printing stages. These confirm the identity of the caretaker as "Los / As he entered the Door of Death" and who on plate 31 takes "his globe of fire to search the interiors of Albions / Bosom . . . " Albion, the primordial Human Being, the first inhabitant of England, was separated from Jerusalem—his emanation or feminine counterpart—at the Fall, and Blake's long poem unfolds the history of Albion's redemption and reunion with Jerusalem after having passed through the experience of Eternal Death. It is Los who enters into the darkest recesses of the material realm in order to bring to Albion the secrets of a regenerate existence beyond. Los, the perennial seeker after truth, has the responsibility of finding ways of healing divisions and conflicts in the physical and moral structure of the universe—a fictional charge informed by Blake's actual experiences during the ruinous Napoleonic wars.

Los assumes the role of the blacksmith to construct the city of imagination and form the tools of salvation. His attitude is precisely that of Blake himself:

I must Create a System, or be enslav'd by another Mans.
I will not Reason & Compare: my business is to Create.

But Los–Blake must carry out his work in the temporal realm, and his contradiction lies in the attempt to build a new world from the materials and ideas of this one. It is not surprising, therefore, to find Blake drawing upon the innovations of science and industry to reveal this contradiction, since progressive groups like the Lunar Society heralded these innovations as the foundation of the New Jerusalem.

One of these was certainly electricity. Among other things, Blake shared Darwin's faith in electricity as a curative force.[86] The ball-shaped lantern carried by Los in the frontispiece to *Jerusalem* is actually the image of a rotating glass globe used to generate electricity in contemporary electrical experiments. Several examples of the different kinds of electrostatic devices were reproduced in Priestley's *History and Present State of Electricity* (fig.

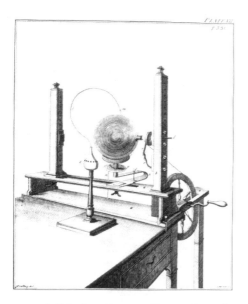

4.47 J. Priestley, *History and Present State of Electricity*, 1747, plate 4, fig. 1.

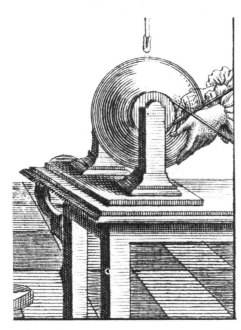

4.48 J.-A. Nollet, *Recherches sur les causes particulières des phénomènes électriques*, plate 2.

4.47).[87] Priestley, who wrote an entire chapter on the construction of "electrical machines," also devotes a major section to his French colleague, the abbé Jean Antoine Nollet, who pioneered in these contraptions (fig. 4.48).[88] As the glass globe was spun, friction was applied to it by the hand or an emory cloth, and the resultant charge was then conveyed by wires to an electrode. These devices were used in primitive electromagnetic experiments, and could also be manipulated to create dazzling light effects in the form of sparking or a more sustained glow when the air around the globe became ionized. Thus Los, Blake's alter ego or the spirit of prophecy, seeks truth in the dark corners of the material universe with an electric light. Blake was clearly a prophet in more ways than one.

Blake's interest in Priestley also revealed itself in his color design of *Newton*, another of the series owned by Butts (fig. 4.49). Priestley wrote a long section on Newton's optics in his *The History and Present State of Discoveries Relating to Vision, Light, and Colours*, published by Johnson in 1772.[89] He centered much of his discussion on the phenomenon of the rainbow, examining ancient and modern theories, as well as analyzing halos, corona, phosphorescence, and a host of luminous effects. He also discussed microscopes and telescopes, "fallacies of vision" like double vision and optical illusions, all of which Blake himself incorporated as metaphors into his writings. Blake's use of the rainbow motif, for example—which he used both graphically and poetically—always follows the Newtonian formula, either moving from top to bottom from red to violet or in the reverse order from violet to red.[90] This last order he employed on the title page of *Visions of the Daughters of Albion*, and the fact that the word "Visions" is seen above the rainbow which arcs across the title suggests a further connection with Priestley.

In asserting that the *Opticks* was Newton's major mathematical achievement, Priestley hinted of an equation between Newton and the Divine by quoting Plato's opinion that "to pry into the mysteries of light was to encroach upon the prerogatives of divinity." Unlike Priestley, Blake opposed the concept of a rational Supreme Being which set limits on the human physical and mental potential, and extended this position to include inductive thinkers like Locke and Newton. His curious image of the nude Newton bent over in close concentration on a geometric diagram testifies to Blake's distrust

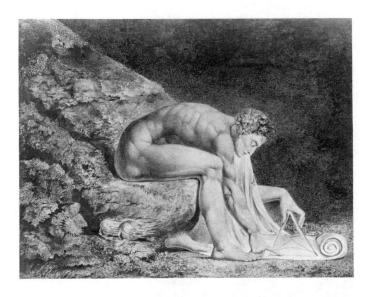

4.49　William Blake, color design of *Newton*. The Tate Gallery, London.

of the Newtonian approach. Newton sits on a rocky mass in what appears as an underwater grotto or underground cave; embedded in the rock or clinging to it are a variety of fossils and marine plants and animals like polyps and squids. This setting lends a touch of absurdity to the sage who manipulates a pair of dividers to form an arc within a triangle on the ocean floor. Newton had modestly compared himself to a boy playing on a seashore "diverting myself in now and then finding a smoother pebble or a prettier shell than ordinary, while the great ocean of truth lay all undiscovered before me."[91] Blake uses Newton's own confession to condemn a narrow focus excluding the larger mental and spiritual issues. Newton signified to most eighteenth-century thinkers the experimental or inductive method, but Blake associated him with materialism and limited mental horizons. Blake generally indicated a hatred of measurement because he saw its rigidity and standardization as analogous to repressive moral and physical laws. We have already seen how often Blake rails against enclosing the infinite in human systems and condemns the mental constraints imposed by religious and political authority. Newton draws an arc inside a triangle on the Sea of Eternity but his geometric arguments prevent him from grasping the discontinuous, nonmathematical reality.

Blake linked Priestley and Newton as doubters and experimenters, but at the same time he could refer to his own work as "experiments." Like Los, Blake may not

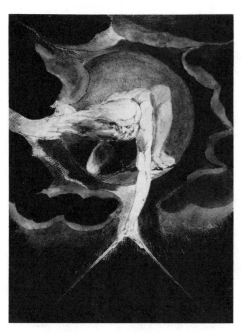

4.50 William Blake, *Ancient of Days* or *Urizen Creating the World*, frontispiece of *Europe, a Prophecy*, 1794.

have liked to "Reason & Compare" in Newtonian terms, but his work demonstrated a need to do so. One of his most striking images—the frontispiece to *Europe, a Prophecy* of 1794—reveals the basic contradiction of his life and thought (fig. 4.50). The frontispiece shows the *Ancient of Days* or *Urizen Creating the World* and takes its literary inspiration from Proverbs 8:27 ("when he set a compass upon the face of the earth") and *Paradise Lost*, Book VII, where God takes "the golden compasses" and circumscribes the universe. Blake uses the same kind of phrasing in his own *First Book of Urizen*, 1794, where, on plate 20, Urizen "form'd a line & plummet / to divide the Abyss beneath," and with "golden compasses" explored the Abyss. Here the Creator is equated with Urizen whose rational boundaries preclude the imaginative life.

Despite the negative connotations of Urizen (Your Reason), it remained one of Blake's favorites, synthesizing as it did the Bible, the inevitable Milton, Ossianic metaphors, and his idol Michelangelo whose *God Creating Adam* on the Sistine Ceiling furnished the inspiration for Blake's bearded deity. J. T. Smith, Nolleken's biographer and Blake's friend, claimed that the design was mainly inspired by a vision Blake had in which he saw a figure hovering over his head at the top of the staircase in the cottage at Lambeth:

He has frequently been heard to say, that it made a more powerful impression upon his mind than all he had ever been visited by. The subject was such a favorite with him, that he always bestowed more time and enjoyed greater pleasure when colouring the print, than on any thing he ever produced.[92]

Europe exudes the air of pessimism and reflects the repressive climate of 1794: it was the year of the Reign of Terror in France when Blake's sympathies for the French Revolution came to an end. The deity Enitharmon, earth-mother, has a dream in which 1,800 years unfold, the interval between the Birth of Christ and the American and French Revolutions. Again the familiar themes of religious and political tyranny are woven into the narrative. Enitharmon is awakened from her sleep by "A mighty Spirit . . . Nam'd Newton: he seiz'd the Trump, & blow'd the enormous blast!" She now makes the mistake of welcoming into her midst Orc, the spirit of insurrection champing at the bit and howling in captivity. Orc's release allows him to unleash a bloodbath "in the vineyards of red France":

The sun glow'd fiery red!
The furious terrors flew around!
On golden chariots raging, with red wheels dropping
 with blood;
The Lions lash their wrathful tails!
The tigers couch upon the prey & suck the ruddy tide;
And Enitharmon groans & cries in anguish and dismay.

Blake here refers to the wave of reaction and panic abroad as well as at home which resulted in the suspension of the Habeas Corpus Act, a bill against public meetings labeled as seditious assemblies, and a wider interpretation given to the Statute of Treasons. The press was censored, sermons of dissenting ministers were indicted as seditious, and conventions of French sympathizers were roughly broken up.[93] The worst excesses of this panic showed up in Scotland where young Whigs, advocating only parliamentary reform, were sentenced to deportation. This period of repression left in its wake a bitter conservative mood which halted attempts at social reform for many years afterward.

In this illuminated book, the juxtaposition of Newton and Urizen as constituents of oppressive authority clarifies the symbolic meaning of the compasses which relates his two designs. The connection is reinforced by Blake's dependence for this design on the frontispiece to Andrew Motte's 1729 translation of Newton's *Principia* (fig. 4.51). Blake's scientific source and his linear design again testify to the paradox that haunts his work. His cosmic scheme employs the standard compass used by geometers and natural philosophers of the period, and the design itself with its brilliant orb which encloses the figure and the triangular-shaped dividers creates a formal pattern closely resembling Newton's diagrams for the *Principia*. Urizen's arm extends downward like a power-driven mechanical appendage to create the rational universe. Blake thus becomes a kind of Urizen himself, imposing on formless chaos the hard, precise geometric delineation which he professed to condemn in Newton and Locke.

In Blake's personal myth of Creation, as set out in *The First Book of Urizen*, Los—Blake's alter ego—gives birth to the form of Urizen who usurps Los's power and all but enslaves him. Blake consistently struggled against the social and aesthetic contradictions of his time, but he got caught in the concentricity of existence, "the Net of Urizen." A recurring Blake theme is that error must be given form before it can be rooted out, but the more he at-

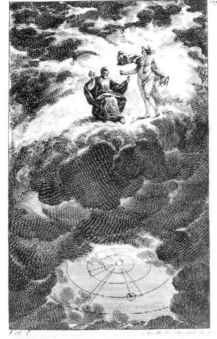

4.51 Design for frontispiece of Andrew Motte's translation of Newton's *Principia*, 1729.

tempts to materialize the more deeply Blake becomes enmeshed in error's web. Los, suffering the anguish and pain of Urizen's separation, and trying to get a handle on the cosmic transmutations of his creation, has recourse only to the ironworks:

The Eternal Prophet heavd the dark bellows,
And turn'd restless the tongs, and the hammer
Incessant beat; forging chains new & new,
Numb'ring with links, hours days & years.

Los himself becomes entangled in his workings:

Forgetfulness, dumbness, necessity!
In chains of the mind locked up,
Like fetters of ice shrinking together,
Disorganiz'd, rent from Eternity.
Los beat on his fetters of iron:
And heated his furnaces & pour'd
Iron sodor and sodor of brass.

Los is finally overwhelmed with his task, confounded by his imprisonment with Urizen in the created world. In his struggle to bind Urizen, he enters into the nature of Urizen and becomes what he sees and grapples with:

Shudd'ring, the Eternal Prophet smote
With a stroke, from his north to south region.
The bellows & hammer are silent now;
A nerveless silence, his prophetic voice
Siez'd; a cold solitude & dark void
The Eternal Prophet & Urizen clos'd.

Thus Blake clearly reveals a recognition of his own limitations in transcending the economic and political circumstances which dominated the period in which he lived. In the end, Blake is the product of Empire as much as a prophet against it. His visions are tied to the global network and industrial progress of late eighteenth-century England. In his marginal comments to Sir Joshua Reynold's *Works* he noted: "The Foundation of Empire Is Art & Science. Remove them or Degrade them & the Empire is No more."[94]

Almost all of Blake's friends accepted the idea of a mechanistic design of the cosmos, a concept indispensable to the Industrial Revolution. The image of the mechanical universe provided the philosophical foundation for harnessing nature through machines. Tom Paine, for example, envisioned God as the archetype of mechanical genius:

The Almighty is the great mechanic of the creation . . . Had we, at this day, no knowledge of machinery, and were it possible that man could have a view . . . of the structure of the machinery of the universe, he would soon conceive the idea of constructing some at least of the mechanical works we now have.

This is similar to the Lunar Society's benign view of the mechanical world, one that does not contradict contemporary visionary and religious experience so much as reinterpret it. There is no doubt that for many people the actual sight of real machinery in the English environment evoked awestricken and sublime ideas about God's creation. This was certainly the case for Paine who was a civil engineer with new and ingenious solutions for building metal bridges.[95]

Blake's mechanistic beings, with their diagrammatic appearance and aerodynamic movements, derive from this point of view. His famous color print (also belonging to Butts) of *God Judging Adam*, although couched in biblical trappings, perfectly supports this conclusion (fig. 4.52). The obvious narrative of *God Judging Adam* marks the advent of the Fall, symbolized by the serpent entwined around Adam's leg. It also reveals Blake's condemnation of the Old Testament Jehovah-Urizen during the severe repression and misuse of the legal system in the mid-1790s. The book of laws lies open on God's lap and Adam's body swings forward abruptly in response

4.52 William Blake, *God Judging Adam*, 1795, color print finished in pen and watercolor. The Tate Gallery, London.

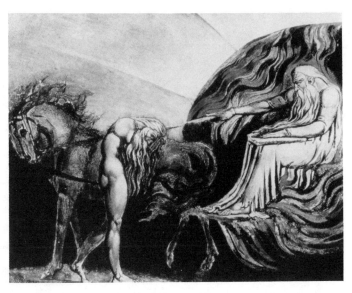

to the severity of the chastisement. The law declared here is the same as pronounced in the *Marriage of Heaven and Hell*: "One Law for the Lion & Ox is Oppression."

Significantly, the structure of the work depends on an industrial image. The entire composition follows the model of Watt's double-acting rotative steam engine, with the reprimanding arm of Jehovah substituting for the driving arm and piston, and the orbital "fiery chariot" replacing the flywheel and furnace (fig. 4.53). There is biblical precedent for the latter motif in 2 Kings 2:11, where "a chariot of fire, and horses of fire" separated the prophet Elisha from Elijah who was taken "up by a whirlwind into heaven." But the term itself was commonly used in Blake's time to characterize steam engines, as in the case of Darwin who referred to the "fiery chariots" of the future which would soar into the heavens powered by steam.[96] Moreover, in this period the term "horsepower" was not used, but people spoke of engines "of three or four horses." Blake's flaming creatures clearly depend on the current metaphors for the new technology.

The first London factory to use steam power was the Albion Mills Company erected in the years 1783–1784.[97] This firm was a flour mill erected on the Surrey side of the Thames near Blackfriars Bridge and was the best equipped of the period. But in 1791 it was burnt down (possibly by unemployed workers displaced by the new machinery) and the company never recovered. Watt and Boulton constructed the steam engines, the first of which began operation in 1786, and the second with its set of

4.53 Rotative steam engine made by James Watt and Matthew Boulton, 1784. Trustees of the Science Museum, London.

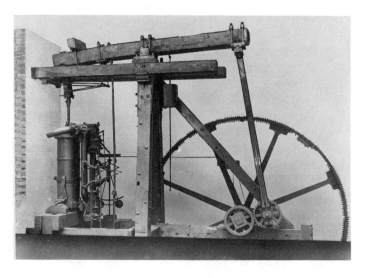

4.54 Robert Fulton, drawing of Boulton and Watt's steam engine adopted for steam boat, 1809. The American Society of Mechanical Engineers, New York.

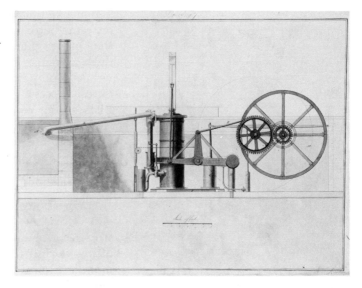

millstones was installed in 1789. This last was one of the earliest double-acting engines with rotary motion in which the steam pressed alternatively on opposite sides of a piston, enabling the engine to make a power stroke in both directions. Blake could have seen the Watt-Boulton rotary steam engine at work, with its large flywheel and connecting rod. While the engine at the Albion Mills had the boiler on the opposite side of the flywheel, Blake's design compresses the complicated mechanism into a compact shape.

Blake's work further resembles the horizontal disposition of Robert Fulton's design for a steamboat mechanism which he submitted to Watt and Boulton for consideration (fig. 4.54). While the drawing reproduced here dates from 1809, Fulton had first developed the concept in the 1790s when still a disciple of Benjamin West and exhibitor at the Royal Academy exhibitions which he looked upon as a means "to create a name that may hereafter produce business." As early as 1793 Fulton drew up a scheme for moving ships and barges by steam, and in November of the following year requested from Watt and Boulton an estimate of the expenses needed for "a Steam Engine with a Rotative movement . . . designed to be placed in a Boat."[98] Fulton and Blake had mutual friends who moved in the social circles of Johnson, such as Joel Barlow and the poet William Hayley, who later became an important patron of Blake.[99] Barlow, who protected Fulton and joined with him in many literary,

graphic, and technical projects, dedicated his *Columbiad*—the same book for which Fuseli projected a series of illustrations—to the steamboat pioneer. But we do not have to demonstrate a direct link between Fulton and Blake; we need only show their participation in the same historical process. A comparison of the Fulton sketch with Blake's print reveals astonishing formal parallels, starting with Blake's fiery orb at the right and Fulton's flywheel, moving to the deity whose lower garments are segmented like a gear, his extended arm echoing the connecting rod, and thence to Adam with his legs outstretched, receiving the action akin to Fulton's triangular mechanism.

Adam's body has been impersonalized and transformed into a machine-like object by the concealment of his arms beneath his beard and the geometric configuration of his vertical torso, legs, and the seemingly automatic motion of head and neck which spring forward to meet the staff of Jehovah. It is instructive to juxtapose with Blake's picture the following description of the utopian Age of Steam by Andrew Ure, its foremost apologist in the early years of the nineteenth century:

> The benignant power of steam summons around him his myriads of willing menials, and assigns to each the regulated task, substituting for painful muscular effort on their part, the energies of his own gigantic arm, and demanding in return only attention and dexterity to correct such little aberrations as casually occur in his workmanship.[100]

Could the creation of the first human be considered one of those little aberrations that needed to be adjusted to the demands of the new technology? Here the Machine no longer models itself after the universe but usurps the functions of the Supreme Being.

Blake's design identifies industry with the severe punishment of God and the dehumanization of Creation.[101] When the state is oppressive, technology enslaves people rather than aids them. Blake did not condemn industry in itself, but only its pernicious application in the forging of weapons of war and the enslavement of the people for the sake of their production. During intervals of truce or in the New Jerusalem, technology may produce the implements of peace and then people enjoy control over production. Under these conditions industry promises unlimited creative possiblities for humankind.

In the mid-1820s Blake worked on a series of watercolors illustrating Dante's *Divine Comedy* for his friend and patron, John Linnell. Blake actually rejected Dante's

world view, regarding it as resignation to tyranny and the rule of vengeance. For Blake the *Inferno* exemplified the state of cruelty to which Dante acquiesced, and he could denounce the Italian humanist as an "atheist" and "mere politician." Blake's famous illustration from the series, *Whirlwind of Lovers*, based on the *Inferno*, canto 5, employs a mechanical allusion to go beyond Dante's conception and show a beneficial effect on society (fig. 4.55). The picture represents Francesca da Rimini and her lover Paolo in a flame above the prostrate Dante, while a whirlwind draws other couples heavenward. Blake declared that "Dante saw Devils where I see none—I see only good," and use the *Inferno* both to emphasize Dante's fixation on retribution and to suggest that those who overcome certain obstacles may attain to a higher union.

The whirlwind carries the couples (who sinned in their earthly existence) beyond the physical to a spiritual union. In the original narrative lustful sinners are driven relentlessly by furious winds, blown hither and thither only to be dashed against the shore. That Blake transformed the wild gusts of wind into a uniform, cylindrically shaped passage indicates a radical departure from Dante's text. He evidently took as his model for this design hollow tubes or pipes constructed for conveying water, gas, and especially steam which would have been the driving force for most of English industry by the 1820s. Basic to all the steam engines were the suction pipe and air pump.

Blake's sinful lovers rush through the tubes as if into a

4.55 William Blake, *Whirlwind of Lovers*, from Dante's *Divine Comedy*, 1824–1827, pen and watercolor over pencil. By courtesy of Birmingham Museums and Art Gallery, England.

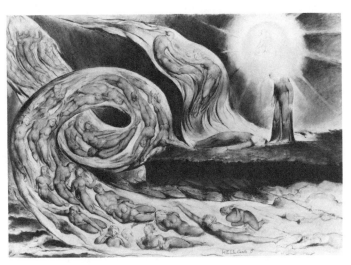

vacuum created by the difference between the air pressure within and without. Thus his transmutation of the Dantesque punishment into an opportunity for spiritual growth required a mechanical model along the lines of Los and his lantern. Here again it would seem that Blake did not view science and industry as inherently evil but rather condemned the ways to which they were often applied. Indeed, Blake could perceive the action of steam and vaporizing as a metaphor for the ascendance of sinners into a more spiritual realm—that is, a less solid state of matter.

Thus there is ample evidence of Blake's dependence upon changes wrought by eighteenth-century science and the Industrial Revolution, keeping in mind that the unprecedented interest in science in this period and its pragmatic applications were inseparable from the economic and industrial developments. Yet critics and historians are fond of repeating Blake's expression of the "dark Satanic Mills" as evidence of his loathing for the new technology. Ironically, this expression appears in the preface of *Milton* (1804), an eschatological work that abounds in scientific and industrial metaphors. Milton's descent is characterized as an "electric flame" and is graphically shown as a rapidly falling star trailing vapor. Los seizes "Hammer & Tongs" to shape on his anvil "a red round Globe hot burning" which separates into the male and female progenitors of creation. The context of the expression "dark Satanic Mills" is itself an account of the positive applications of indutry:

And did the Countenance Divine
Shine forth upon our clouded hills?
And was Jerusalem builded here,
Among these dark Satanic Mills?

Blake calls for weapons to wage a "Mental Fight" against the materialism of his time, but in the end the building of the New Jerusalem shall require all the industrial arts at society's disposal:

Bring me my Bow of burning gold:
Bring me my Arrows of desire:
Bring me my spear: O clouds unfold:
Bring me my Chariot of Fire!

I will not cease from Mental Fight,
Nor shall my Sword sleep in my hand:
Till we have built Jerusalem,
In Englands green & pleasant Land.

Darwin's "chariot of fire" was a locomotive steam engine which he had conceived in the early 1760s, and it is clear that despite Blake's efforts to combat industrialism he wound up "fighting fire with fire."

It is true that the birth of Satan in *Milton* conjures up an industrial world:

O Satan my youngest born, art thou not Prince of the Starry
 Hosts
And of the Wheels of Heaven, to turn the Mills Day & Night?
Art thou not Newtons Pantocrator weaving the Woof of
 Locke?

But this same industrial world coincides with England as a great nation:

Loud sounds the Hammer of Los, & loud his Bellows is heard
Before London to Hamsteads breadths & Highgates heights To
Stratford & old Bow; & across to the Gardens of Kensington
On Tyburns Brook: loud groans Thames beneath the iron
 Forge
Of Rintrah & Palamabron, of Theotormon & Bromion, to
 forge the instruments
Of Hargest: the Plow & Harrow to pass over the Nations.

And this prolific activity continues to reverberate throughout industrial London:

Loud sounds the Hammer of Los, loud turn the Wheels
 of Enitharmon.
Her Looms vibrate with soft affections, weaving the Web of
 Life
Out from the ashes of the Dead; Los lifts his iron Ladles
With molten ore: he heaves the iron cliffs in his rattling chains
From Hyde Park to the Alms-Houses of Mile-end & old Bow.

Much of this corresponds to the rhythms and ideals of Darwin's poetry in the *Botanic Gardens*; the second book of *Milton* abounds in references to gnomes, nymphs, and genii and their cosmological significance. Plate 31 projects a Garden of Eden with an inventory that would rouse the envy of Linnaeus and an anthropomorphic interpretation that would charm Darwin. The latter's praise for industry in the context of his love of plants is tied to a vision of a mechanistic universe. In canto 1 of the "Economy of Vegetation" he takes up the origins of the cosmos as a mechanical operation of Divine Love:

Earths round each sun with quick explosions burst,
And second planets issue from the first;

.

Orbs wheel in orbs, round centres centres roll,
And form, self-balanced, one revolving Whole.
—Onward they move amid their bright abode,
Space without bound, THE BOSOM OF THEIR GOD![102]

This may be compared with Blake's verses in *Jerusalem* which contrasts the mechanized nature of tyrannical institutions with the mechanized operations of his ideal world:

I turn my eyes to the Schools & Universities of Europe
And there behold the Loom of Locke whose Woof rages dire
Washd by the Water-wheels of Newton; black the cloth
In heavy wreathes folds over every Nation; cruel Works
Of many Wheels I view, wheel without wheel, with cogs
 tyrannic
Moving by compulsion each other: not as those in Eden: which
Wheel within Wheel in freedom revolve in harmony & peace.

Hence it is not simply the character of gears and cogwheels that torments Blake, but the ends to which they are applied.

Jerusalem speaks repeatedly to this point throughout its long, ungainly unfoldment. Plate 65, for example, condemns the drudgery of the mechanical age in by now familiar terms:

. . . intricate wheels invented, wheel without wheel:
To perplex youth in their outgoings, & to bind to labours in
 Albion
Of day & night the myriads of eternity that they may grind
And polish brass & iron hour after hour, laborious task:
Kept ignorant of its use, that they might spend the days of
 wisdom
In sorrowful drudgery, to obtain a scanty pittance of bread:

Later, Los, after "Striving with Systems to deliver Individuals from those Systems," throws his creative energies into the building of Golgonooza. Already identified in *Milton* as the city of "Art & Manufacture," Golgonooza is the New Jerusalem of the Imagination which in biblical language "lieth foursquare."[103] It was inspired by St. John's vision described in the Book of Revelation (chap. 21), except that the biblical New Jerusalem points to a spiritual dimension beyond earth while Blake's Golgonooza is surrounded by materialistic science.

Blake's contradiction recurs in the *Vala* or *The Four Zoas,* an unpublished work conceived between the mid-1790s and 1807. This long poem is divided into nine parts called "Nights" which together form a dream-like

vision. Each of the *Zoas* corresponds to a different state of mind or mind power. The various *Zoas* revolt against the cosmic order, fall and divide; humankind disintegrates and wars against itself. Ultimately, however, tyrannical authority is overthrown, Albion rises regenerated and free, and a new order emerges. The key to this cycle is Blake's quote in Greek above the title of the manuscript from the last chapter of Ephesians (6:12): "For we wrestle not against flesh and blood, but against principalities, against powers, against the rulers of the darkness of this world, against spiritual wickedness in high *places*." In this epistle St. Paul exhorts the Ephesians to regenerate themselves, to "put on the new man" and be renewed in the spirit of the mind. Spiritual thought is described as continual warfare against materialism and requires the putting on of the "armour of God." Urizen's attempt to build a world based on science and industry represents a mistaken perception of that warfare—a limited vision which sees the conflict in the narrowest of terms. His redemption comes with his insight into the nature of the struggle in a higher sense, against the innate propensity to do evil, against an impersonal sense of materialism.

Again the biblical narrative was invoked to explain Blake's experience of the political and social upheavals during the time he wrote the manuscript. It dates from the period he and his peers turned against the French Revolution and continues through the Napoleonic wars. *Vala* is anti-authoritarian, but the dominant authority figure, Urizen, is redeemed at the work's end. Albion, the Universal Giant, possesses the four mental qualities or Zoas: Urizen, Luvah, Tharmas, and Urthona—reason, passion, body or sense, and spirit. The whole man, or "new man," contains all four qualities that comprise a total experience. Their integration makes possible the elimination of war, the conversion of industry to peaceful applications, and universal brotherhood. As defined at the start of the work, Blake was concerned with humankind's "fall into Division & his Resurrection to Unity." Blake wrote to his friend Flaxman on 19 October 1801, following the preliminaries for a peace treaty: "I hope that France & England will henceforth be as One Country and their Arts One."[104] The *Vala* or *The Four Zoas* thus unfolds the resolution of discord between nations, the individuals who comprise them, and the internal conflicts in each individual that give rise to strife between

nations. It may be recalled that Pitt had endeavored to meet the French threat by forming successive coalitions with other European powers, but thanks to Napoleon's strategy and military victories they became divided among themselves and subject to dissolution. The upheavals and division of the *Vala* reflect the internal and external conflicts central to English political life during this period.

For Albion the Eternal Man to triumph he must reunite his four *Zoas* or divided self to become One against despotism. The *Zoas* tried to set themselves up as gods instead of recognizing their need for union in the service of the total human being. By encroaching on each other's domains they also fail in the fulfillment of this union and their own functions. They become mere specters and shadows which pervade the poem. The first to feel the fall described in "Night the First" is Tharmas, the sensual self, who is no longer at one with Enion, the Earth Mother and generative force. From their unhappy union are born Los and Enitharmon, who would have been one in Urthona but have to separate due to Urthona's threefold division. Urizen takes advantage of this dissension to proclaim himself god and demands obedience from Los. Thus begins the fall of Albion, as Urizen begins to build the material world as protection against error or nothingness.

Urizen's rule develops the commercial abuses of slavery, child labor, and, finally, war, which is "energy Enslav'd." He builds a world related to science and industry:

Some fix'd the anvil, some the loom erected, some the plow
And harrow formd & framd the harness of silver & ivory,
The golden compasses, the quadrant & the rule & balance.
They erected the furnaces, they formd the anvils of gold beaten
 in mills
Where winter beats incessant, fixing them firm on their base.
The bellows begin to blow & the Lions of Urizen stood round
 the anvil . . .

Untold numbers of builders rise to construct the Golden Hall of Urizen where tyranny rules, and victims are sacrificed on an altar of brass produced by the labor of ten thousand slaves.

The interaction between actuality and imagination is shown in the fact that Blake himself had collaborated in the plans for a similar altar: in 1799 a committee of naval officers and statespersons was formed for raising a public

monument "to perpetuate the Glorious Victories of the British Navy." Flaxman commissioned Blake to engrave a prospectus of the sculptor's designs to submit to this committee for a colossal pillar or memorial which would include a group of Britannia Triumphant and Nelson on the pedestal. Urizen's altar for the sacrifice of war victims may be seen as an ironic metaphor for rampant British nationalism in which Blake himself participated.

In "Night the Seventh" Blake comments on Empire and its exploitation of children:

First Trades & Commerce Ships & armed vessels he builded
 laborious
To swim the deep & on the Land children are sold to trades
Of dire necessity, still labouring day & night till all
Their life extinct they took the spectre form in dark despair
And slaves in myriads in ship loads burden the hoarse
 sounding deep
Rattling with clanking chains, the Universal Empire
 groans . . .

He indicates how quickly the arts of peace are transformed into the arts of war:

Then left the Sons of Urizen the plow & harrow, the loom,
The hammer & the Chisel & the rule & compasses;
They forged the sword, the chariot of war, the battle ax
The trumpet fitted to the battle & the flute of summer
And all the arts of life they changd into the arts of death.

Workers are kept in ignorance about the destination of their labors, while the mechanical nature of their machines, which can be converted so easily to the production of weaponry, is mystified:

And in their stead intricate wheels invented, Wheel without wheel
To perplex youth in their outgoings & to bind to labours
Of day & night the myriads of Eternity that they might file
And polish brass & iron hour after hour laborious workmanship
And ignorant of the use they might spend the days of wisdom
In sorrowful drudgery to obtain a scanty pittance of bread.

By "Night the Eighth" this weaponry becomes capable of awesome devastation:

But Urizen his might rage let loose in the mid deep.
Sparkles of Dire affliction issud round his frozen limbs.
Horrible hooks & nets he formd twisting the cords of iron
And brass & molten metals cast in hollow globes & bor'd
Tubes in petrific steel & rammd combustibles & wheels

And chains & pullies fabricated all round the heavens of Los

. .

To all his Engines of deceit that linked chains might run
Thro ranks of war spontaneous & that hooks and boring screws
Might act according to their forms by innate cruelty.

These then are the fatal consequences of science and industry (logic and reason) carried to their ultimate extreme in the service of the warrior state.

But science and industry in and of themselves may not be harmful and destructive: when subject to the control of the people and converted to peacetime use they are capable of releasing unlimited creative energy. In the New Jerusalem, under the guidance of Enitharmon and Los, we see them put to productive use:

Employing the daughters at her looms & Los employed the
 Sons
In Golgonoozas Furnaces among the Anvils of time & space,
Thus forming a Vast family wondrous in beauty & love . . .

Finally, in "Night the Ninth" Urizen gains in spiritual insight and recognizes the error of trying to limit mental vision:

Urizen Said: "I have Erred & my Error remains with me.
What chain encompasses, in what Lock is the river of light confind

. .

Where shall we take our stand to view the infinite & unbounded
Or where are human feet? for Lo our eyes are in the heavens.

Now the Sons of Urizen resume their peaceful rural labors and throw away their war implements:

They beat the iron engines of destruction into wedges;
They give them to Urthonas Sons; ringing the hammers sound
In dens of death to forge the spade, the mattock & the ax, . . .

As in *America,* slaves are set free and the millennium introduced:

Let the slave grinding at the mill run out into the field;
Let him look up into the heavens & laugh in the bright air;
Let the inchaind shut up in darkness & in sighing

. .

Rise & look out, his chains are loose, his dungeon doors are open
And let his wife & children return from the oppressors scourge;
They look behind at every step & believe it is a dream.

And "All the Slaves from every Earth in the wide Universe / Sing a New song drowning confusion in its

happy notes / . . . Composed by an African Black from the little Earth of Sotha."

Vala or *The Four Zoas* ends in a resounding triumph for science and industry, thus associating redemption and regeneration of both the individual and the nation with the dawning age of the Industrial Revolution:

Then Enion & Ahania & Vala & the wife of Dark Urthona
Rose from the feast in joy ascending to their Golden
 Looms.
There the wingd shuttle Sang, the spindle & the distaff
 & the Reel
Rang sweet the praise of industry.

And the dream ends with these optimistic lines: "The war of swords departed now, / The Dark Religions are departed & sweet Science reigns.

One of Blake's most persistent metaphors is the tiger which in its various states embodies the full range of human experience. In *Vala* the Reign of Harmony is signaled by the conversion of wild animals into pacific symbols:

The noise of rural work resounded thro the heavens of
 heavens;
The horses neigh from the battle, the wild bulls from
 the sultry waste,
The tygers from the forests & the lions from the
 sandy desarts.
They Sing; they seize the instruments of harmony; they
 throw away
The spear, the bow, the gun, the mortar; they level
 the fortifications.

This brings us to a fitting text to end this discussion of the artist: "The Tyger" from *Songs of Experience* (fig. 4.56). Blake's feline has been shaped by a cosmic blacksmith, identified with hammer, anvil, and furnace. If it does not conjure up the Carron Ironworks, it does demonstrate that Blake was not loathe to fuse the creative imagination with an industrial process:

Tyger Tyger, burning bright,
In the forests of the night:
What immortal hand or eye
Could frame thy fearful symmetry?

. .

What the hammer? what the chain,
In what furnace was thy brain?
What the anvil? What dread grasp
Dare its deadly terrors clasp!

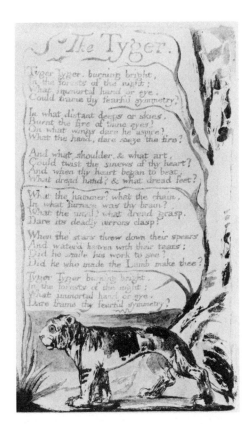

4.56 William Blake, *The Tyger*, from *Songs of Experience*, 1789–1794. British Museum, London.

Thus the tiger "burning bright" is the molten material of the New Age waiting to be shaped into the stuff of art and history.

Blake's graphic image of the tiger shows us a docile and lovable beast, like the felines in "The Little Girl Found" (in *Songs of Innocence*) who symbolize a non-threatening environment. Animals and children romp in the biblical paradise heralded by Isaiah, "and the lion and the kid together, and the little child shall lead them." Blake's tiger, too, conjures up a pastoral realm of the innocent, uncorrupted lamb: "Did he who made the Lamb make thee?" The same stanza in which this line is found begins:

When the stars threw down their spears
And waterd heaven with their tears:
Did he smile his work to see?
Did he who made the Lamb make thee?

For eighteenth-century rationalists stars symbolized cosmic harmony and order, and the throwing down of spears signals an acceptance of peace. As in the *Vala* or *The Four Zoas,* there is an exchange of rule based on war production for a rule based on the peaceful pursuit of those who plant and harvest. Not fortuitously, the original inspiration for Blake's poem came from Burke who wrote that the *sublime* revealed itself "in the gloomy forest, and in the howling wilderness, in the form of the lion, the tiger, the panther, or rhinoceros."[105] Blake begins and ends his poem in the sublime mode, but its development intimates a dialectical exchange with the category of the Beautiful. The result is a benign tiger who restores the lamb. Thus one of Blake's most remarkable poems may be linked to the impact on his thinking of the Industrial Revolution and his perception of its potentialities for social progress.

Flaxman and Wedgwood

John Flaxman (1755–1826), Blake's close friend and occasional collaborator, made considerable contributions to the industrial art of the period, and his enormous influence on the Continent parallels the spread of English technical know-how.[106] He incarnated the nascent Industrial Revolution during his prolific and financially successful career. Flaxman senior owned a shop which produced plaster casts and models, mainly of antique

subjects, for decorators, architects, and manufacturers. Young Flaxman aided in the production of the casts and his precocious gifts drew the attention of his father's customers Matthew Boulton and Josiah Wedgwood. When Flaxman was eleven he won a prize from the Society for the Encouragement of Arts, Manufactures, and Commerce, an astonishing triumph he was to repeat two years later. From 1767 onward he contributed works to exhibitions sponsored by the Free Society of Artists, and in 1769 he enrolled in the recently founded Royal Academy. His earliest works showed the neoclassical influence of the Society for the Encouragement of Arts and were based on themes from ancient Roman history and literature like the *Death of Julius Caesar* (1768) and *Neptune* (1770). His chief companions in his youth were William Blake and Thomas Stothard who shared his dual interest in neoclassicism and the applied arts.

The greatest boon to Flaxman, however, was Josiah Wedgwood. Prior to the sculptor's trip to Italy in 1787, Wedgwood provided him with more work than any other patron. It may be recalled that Wedgwood was dependent on neoclassic sculptors and decorators to translate and adapt ancient motifs for his pottery designs. Wedgwood's union of the applied arts and a breezy, modernized neoclassicism gave him a fashionable edge on his competitors at home and abroad. He gained a large fortune promoting the sale of his earthenware, especially in the ingenious adaptation of highly linear designs which gave his products an elegant and costly look. With the money he earned from this large-scale production he produced a more exclusive line for the wealthier portions of society. Wedgwood and his partner Bentley visited collections of antiquities and set about acquiring a library of antiquarian books and engravings which could be tapped as source material for their factory designs. They then hired Flaxman to adapt and harmonize these motifs for their new line of jasperware, the potter's most important contribution to neoclassic ceramic art.

Adam's interior decorations influenced the decision to produce the new line of two-color jasperware. Prior to this introduction of the jasper body (a white stoneware that, when properly potted and fired, became translucent like porcelain), Wedgwood produced his basalte plaques and medallions which were almost jet black and seemed incongruous amid the light colors of Adam's interiors. The traditional Staffordshire method of "sprigging,"

whereby a small design was formed in a mold and then applied to a background of a different color, probably inspired Wedgwood with the idea of the two-tone jasperware. He experimented in secrecy during the year 1774 and by the following year had all but mastered the technique of combining the two clays. Once ready for production he needed an abundant supply of designs, and for this he looked to Flaxman.

Flaxman was first employed by Wedgwood in 1775 to produce bas-reliefs and cameo heads, and subsequently executed a variety of designs for portrait medallions, vases, figures, chess pieces, chimney pieces, plaques, and teapots. Flaxman's gifts permitted Wedgwood to realize his dream of mass-producing commodities which appeared at first glance like classical artifacts or "objets d'art." Thus the young sculptor entered the marketplace as the author of endlessly reproduced designs for a variety of industrial products. Scholars are not loathe to admit his role in manufacture but tend to separate his industrial designs from his "classical idealism." As we shall see, these were not mutually exclusive categories and in fact were inseparable from the current economic developments. Wedgwood advertised his factory complex not only as a center of commerce but as the New Etruria capable of rivaling the ancient crafts. This blending of economic and cultural ideals is dramatically demonstrated in Benjamin West's *Genius Calling Forth the Fine Arts to*

4.57 Benjamin West, *Etruria* or *Genius Calling Forth the Fine Arts to Adorn Manufactures and Commerce, and Recording the Names of Eminent Men in Those Pursuits,* 1791. Cleveland Museum of Art, Gift of the John Huntington Art and Polytechnic Trust.

Adorn Manufactures and Commerce, and Recording the Names of Eminent Men in Those Pursuits, which was exhibited at the Royal Academy exhibition in 1791 (fig. 4.57). The central motif is Wedgwood's Etruria where vases like the Portland imitation are being decorated. The harmony of the fine and applied arts is brought about by their common participation in British industry and empire, and it is no coincidence that West's study was projected as part of a decorative scheme devoted to art and industry at Queen's Lodge, Windsor.

Flaxman's particular adaptation of neoclassicism, however, with its spare outline and severe planarity, is far removed from the perspectival and more full-bodied work of West or Hamilton. His linear style and lack of modeling was affected by the restrictions necessary to produce wax designs for reproduction in jasper, and this meant subordinating modeling to outline for easy transference by factory workers. Flaxman adopted a planar approach to such designs, modeling down through the wax in successive stages until he reached the base, now barely covered by a thin layer of wax. His highly linear forms pitted against plain backgrounds served the double purpose of providing a smooth even outline for reproduction, and at the same time realizing a conception with the most economical means. Since Wedgwood tried to realize the maximum profit on his wares, and Flaxman had to bid lower than his main rivals, they pooled their talents to achieve a frugal solution.

The relationship between Flaxman and Wedgwood provides an enlightening example of how the working association between artist and patron influences style. Flaxman accepted Wedgwood's criticisms and suggestions, adapting his techniques to reproductive processes and the disciplines imposed by them. The sculptor first submitted his linear design to his employer who then proposed modifications or alterations. Flaxman would then produce the wax model of the design to be modeled at the factory. Just as Wedgwood pioneered in the division of labor within the pottery industry, so he systematized the procedures of his designers. Wedgwood could be very specific, as in the case of his commission for a plaque commemorating the commercial treaty of 1786 between France and England.

As early as 1772 Wedgwood sought to induce English politicians to negotiate a trade treaty with France, and he had even made overtures to the duc de Choiseul, minis-

4.58 John Flaxman, original plaster mold for *Mercury Uniting the Hands of England and France.* Trustees of the Wedgwood Museum, Barlaston, Staffordshire, England.

4.59 John Flaxman, finished plaque of *Mercury Uniting the Hands of England and France*, 1786. Collection of Castle Museum and Art Gallery, Nottingham, England. Courtesy of Josiah Wedgwood and sons Ltd.

ter of Louis XV, in the form of a gift assortment of "urns and Vases in the Antique taste." He finally succeeded through the influence of his friend William Eden, English minister plenipotentiary to France in 1786, who negotiated the treaty. Wedgwood lost no time in capitalizing on the event and rushed to commission two medallions from Flaxman, *Peace Preventing Mars from Bursting Open the Gates of the Temple of Janus* and *Mercury Uniting the Hands of England and France.* This second work is one of the best documented of the sculptor's works for Wedgwood, starting with a pen sketch carefully outlining the figures of Mercury (God of Commerce), Britannia, and France with maximum simplicity, and moving through the plaster model to the final blue and white jasper plaque (figs. 4.58, 4.59). The chilling economy of the definitive form and arrangement was arrived at through Wedgwood's suggestions. He rejected an initial study which had too many figures and accessories and recommended a tight balance in the interest of a nonpartisan look. Akin to our current multi-national mentality, Wedgwood treated the world as a global market free from nationalist sentiment and he required an appropriate image of neutrality:

We must take care not to shew that these representatives were invented by an Englishman; as they are meant to be conciliatory, they should be scrupulously impartial. The figures for instance that represent the two nations, should be equally magnificent & important, in their dress, attitude, character and attributes; and Mercury should not perhaps seem more inclined to one than the other, but shew a full front face between them.[107]

Wedgwood's commercial opportunism was also shown in his medallions celebrating the French Revolution during the years 1789–1790. He warmly welcomed the Revolution, claiming that he had no fears, "as an Englishman, from the French nation obtaining their liberty, but join . . . in the truly liberal sentiments that the diffusion of liberty through any nation will add to the security and happiness of the neighbouring ones." Naturally, he had in mind as well improved trade relationships and a larger market for his wares. He hastily adapted Flaxman's design for the commercial treaty of 1786 to the requirements of the moment, changing the two protagonists into France (who carries a staff surmounted by a Phrygian bonnet) and Athene, goddess of Wisdom, clasping

4.60 Wedgwood's adaptation of Flaxman's design for *France with Athene before Fortuna*, 1789 medallion. Trustees of the Wedgwood Museum, Barlaston, Staffordshire, England.

hands in the presence of Fortuna standing on an altar in replacement of Mercury (fig. 4.60). Thanks to Wedgwood and Flaxman, the neoclassicism of the Industrial Revolution joined hands with the neoclassicism of the French Revolution.

The art of the two revolutions further enjoyed in common the inspiration of d'Hancarville's catalogue of Sir William Hamilton's vase collection. Sir William's wish to see Greek vases serve as the model for contemporary artists was most fully realized in the conceptions of Wedgwood and Flaxman. They used his collection for at least four major designs, including the *Hercules in the Garden of the Hesperides* published in volume 2, plate 129 of d'Hancarville's catalog which served as the model for Wedgwood's first basalte vase produced at Etruria in 1769. Flaxman employed it for a jasperware vase design in 1785 and for a series of plaques and panels (fig. 4.61). But the most important example was the *Apotheosis of Homer* (d'Hancarville, vol. 3, plate 31), originally intended for a jasperware chimney piece in 1778 but adapted to a variety of formats including vases, plaques, and panels (fig. 4.62). Flaxman copied fairly carefully the original composition, retaining the contrast in his model between the light figures and the dark ground. He refined the crude contours, but this was consistent with Wedgwood's rejection of slavish copying and his wish to mainly "preserve the style and spirit, or if you please, the elegant simplicity of the antique forms." Wedgwood took great pride in the *Apotheosis* plaque and sent one as a gift to Sir William Hamilton who gratefully declared that "it is more pure and in a truer antique taste" than the work of artists in Italy who study the originals before them every day. Thus patron and artist achieved a modernized neoclassic style capable of translation into mass-produced art objects while yet losing nothing of the "purity" and the "truth" of antique taste.

In 1787 Flaxman and his wife traveled to Rome, where they remained until 1794. This trip was subsidized in large part by Wedgwood, who needed a supervisor for the designers and modelers he was employing there to copy antique friezes. His employer could note in a letter to Sir William Hamilton on the eve of Flaxman's departure that the artist "promised to employ for me all the time he can spare at Rome, and to superintend a modeller, who I have engaged to accompany him and to employ the whole of his time for me at Rome."[108] Flaxman

worked also for himself, settling in at Rome as a sculptor as well as illustrator of the *Iliad,* the *Odyssey,* the works of Dante, and the tragedies of Aeschylus. The engravings of his illustrations securely established his reputation and were enthusiastically received everywhere on the Continent. These illustrations distill from his experience with Wedgwood essential outlines and pictorial conventions easily adjusted to the demands of commercial artists and manufacturers.

Once in Rome Flaxman settled in the area around the Piazza di Spagna, thus retracing the well-worn pattern of the Grand Tourists. He studied the major collections of antiquities in the Vatican, the Museo Capitolino, and the Villas Albani and Borghese where he was a frequent visitor. His sketchbooks are mainly devoted to drawings of classical antiquity, and it seems clear that he was grooming himself for future Wedgwood commissions which he continued to execute in Rome. He made the acquaintance of Canova, who became his friend and one of his most fervent admirers. He was also in frequent contact with Sir William Hamilton and d'Hancarville and steered several fellow artists to the English envoy in Naples. While in Italy he made copies and original sculptures in an antique mode for Sir William and wealthy collectors such as Thomas Hope, Lord Bristol, Countess Spencer, and Mrs. Hare-Naylor. He returned to London in 1794 with sufficient capital to lease a large house and decorate it with antique artifacts and establish workshops run by a team of assistants. Like Nollekens, Flaxman entered the business of neoclassicism and drew to himself the fash-

4.61 John Flaxman and Josiah Wedgwood, *Hercules in the Garden of the Hesperides*, Vase, 1785. City Museum and Art Gallery, Stoke-on-Trent.

4.62 John Flaxman, and Josiah Wedgwood, blue jasper plaque with "Apotheosis of Homer," c. 1778. Trustees of the Wedgwood Museum, Barlaston, Staffordshire, England.

4.63 John Flaxman, design for colossal statue of Britannia for Greenwich Hill. By courtesy of the Board of Trustees of the Victoria and Albert Museum, London.

ionable and wealthy who wanted to complement their lifestyle with the latest neoclassical designs.

Flaxman executed many tombs and monuments for the nobility and upper-middle-class merchants, war heroes, colonists, and naturalists. He identified with the most conservative political wing in England, moving to the right of his patron Wedgwood (who died in 1795) and friend William Blake. He projected an obelisk, which was never realized, to commemorate British naval victories in 1799, and a colossal 230-foot-high statue of Britannia for Greenwich Hill (fig. 4.63). He also produced sumptuous designs for silverware fabricated by the large firm of royal goldsmiths, Rundell, Bridge & Rundell. These were less appropriate for Republican than for Imperial Rome and suggest the chauvinism of the Napoleonic period.

The later decorative commissions take on a massive

and ornate feeling, as in the case of the silver vase designed to commemorate the Battle of Trafalgar in the years 1805–1806 (fig. 4.64). It was mass-produced and sold or given to naval and military officers who had taken part in the naval encounter or to their widows. Under the influence of John Julius Angerstein, Lloyd's underwriter and friend of the goldsmiths, Lloyd's created a fund to raise sums after each naval victory for just such a purpose. The drive was motivated by the desire to "animate the efforts of our defenders by sea and land." The success and popularity of Flaxman's design of this trophy led to his becoming a chief modeler for Rundell's.

He also produced for the firm an *Achilles Shield,* symbol of military success, which he modeled late in life. It was produced in silvergilt for the first time in 1821 for George IV, who had succeeded to the throne the previous year, and it was prominently displayed at the coronation banquet in July 1821. The shield was soon cast for the duke of York, the duke of Northumberland, and Lord Lonsdale. It appealed to a weakening aristocracy trying to project its links with ancient power and authority, and Flaxman flattered them with his battle scenes around the perimeter of the shield and scenes of agricultural life such as harvest, vintage, and the slaughtering of an ox. The combination of beleaguered city, farm scenes, and a wedding procession recalled the Napoleonic wars, a period during which England maintained its domestic activity in full swing while waging war on the continent and on the seas. In this context the figure of Pallas Athene who leads the troops into battle must be seen as the ancient counterpart of Britannia, and the celestial form of Apollo in the center, surrounded by various constellations and a full moon, should be understood as the king.

Flaxman also continued his father's association with Matthew Boulton, producing designs for all types of medals for the Soho Mint in Birmingham. One of these was the honorary medal for the Royal Society of Arts which carries the inscription "Arts and Commerce Promoted." On one side is the figure of Britannia holding up a figure of Victory and the inscription "Britannia Triumphant," and on the obverse Hercules slaying the hydra with the incription "Britons Strike Home." Here in the proverbial nutshell are shown the intimate connections between industry, politics, and culture, and sums up the story of Flaxman's career.

Flaxman's reputation among an international class of

4.64 John Flaxman, silver vase commemorating the Battle of Trafalgar, 1805–1806. By courtesy of the Board of Trustees of the Victoria and Albert Museum, London.

4.65 Wilhelm Tischbein, plate 27 of second edition of Sir William Hamilton's archeological collection, 1791–1795.

dilettanti rested upon his illustrations to Homer, Dante, and Aeschylus. He was admired by Goethe (who wrote an enthusiastic article on him in 1799) and a host of others, not for his sculptures, which they could not have seen, but for his engraved illustrations. Just as English industry and technology was imported to other countries, so Flaxman's work achieved a reputation based on his connections with that technology. His familiarity with illustrations on classical vases and bas-reliefs, and the industrial style he developed for Wedgwood, were put to use in the outlined illustrations that established his fame.

Here again Sir William Hamilton's collection played a major role. The publication of his second collection in the period 1791–1795 was another pioneering project. The folios were the first major archaeological publication to be illustrated almost entirely by simple line engravings. Wilhelm Tischbein's images were of the utmost conciseness and eliminated the shading used in some of the plates of Hamilton's first collection (fig. 4.65). There can be no doubt that Hamilton's second project reinforced Flaxman's linear style and his predisposition to conceptualize in neat outline for adaptation to the applied arts. Ironically, Sir William admitted that he used simple line drawing to reduce the cost of the book—further testimony to the connection between neoclassic reductionism and simple economics.

Flaxman's *Homer* drawings, commissioned by Georgina Hare-Naylor, the daughter of the bishop of St. Asaph, were published in two volumes in 1793, engraved

by Thomas Piroli. They were not conventional book images since they were not published with a complete text and even replaced the text itself. Ocasionally, there was a short legend placed beneath the image, but they were primarily picture albums and had a profound visual appeal. His style is clearly based on Hamilton's vases and makes generous use of accessories depicted on them. Flaxman knew intimately Hamilton's first collection, and while in Italy got to know the second before it was published. He maintained close contact with the collector and kept abreast of his continuing acquisitions. Akin to the Wedgwood style, the designs are reduced to a small number of figures, the backgrounds are neutral, and all superfluous details and accessories are kept to the minimum (fig. 4.66). The effect is drastically two-dimensional, and preliminary drawings show that he calculatedly suppressed all spatiality. From the Greek vase paintings he absorbed a style that eliminated modeling and spatial depth, pared down settings and accessories to an absolute minimum, and portrayed forms in pure outline.

Like the *Iliad* and *Odyssey* designs, the thirty plates to Aeschylus were commissioned in Italy by the dowager Countess Spencer, a cousin of Georgina Hare-Naylor. Unlike his other volumes, Flaxman retained the copyright to the *Aeschylus* and earned a modest income from its sales. Several foreign editions appeared during his lifetime. At the same time he was working on the sets of drawings for the *Iliad* and the *Odyssey*, Flaxman received a commission from Thomas Hope for a set of 109 illustrations to the *Divine Comedy*. It was intended for private circulation only, to be given to Hope's friends. They

were therefore published as a small private edition in 1793. But the illustrations were pirated, and finally a public English edition came out in 1807 by Longman. Hare-Naylor and Hope both sold their engravings to the publisher who paid them double the original cost.

Under each engraving for the *Divine Comedy* Flaxman quoted from both the original Italian text and from the English translation of Henry Boyd which had appeared in 1785. The date of Boyd's publication indicates how recently Dante had become of interest to English culture. As we have seen, both Fuseli and Blake dealt with Dante's work as an instance of that facet of the sublime stimulated by the rise of industrial England. Boyd dedicated his translation of the *Inferno* to Lord Bristol, showing that it was in the circle of Flaxman's entrepreneurial patrons that the revival had come about. Lord Bristol, who had commissioned Flaxman's monumental sculpture, the *Fury of Athamas,* was involved in road and canal construction, coal mining, and scientific farming methods. His interest in Dante parallels the contemporary mania for Milton and its apocalyptic character. Their awesome imagery corresponded to the sense of the new scientific and industrial forces unleased in society. The identification of Satan with the power of industry had already been made in Blake's *Milton,* and now his friend Flaxman followed suit in his illustrations for the *Inferno.* For example, Flaxman's striking concepton of *Dis, or Lucifer* who devours sinners with his multiple mouths, confronts

4.67 John Flaxman, *Dis, or Lucifer*, from *Inferno*.

4.69 J. Priestley, electrical experiments, *History and Present State of Electricity.*

the spectator with an open, rectangular maw reminiscent of a furnace (fig. 4.67). The top part of Lucifer's head, with its flaming hair, surmounts the rectangular maw and may be compared to the chimney of a furnace, while the mouths on the side resemble the openings in furnaces called "filling places" into which the material for smelting was inserted. Here is an allegory of industrial life where "sinners" may be likened to workers attending the "furnace" and have to be relieved periodically by other teams. Flaxman ironically anticipates Marx who observed about conditions in a match factory: "Dante would find . . . his cruellest fantasies of hell surpassed."

The Beatific Vision (Paradiso) is conceived by Flaxman as a series of concentric circles composed of tiny hatchings radiating outward from the center in a dazzling display of high energy (fig. 4.68). It corresponds to images of electrical experiments performed by Priestley for his *History and Present State of Electricity* (fig. 4.69). Like Blake, Flaxman could only imagine celestial imagery in the light of the most recent developments of science. A deeply religious person, he stated that "art and science are given to man to lead him from destruction and wickedness . . . towards improvement, to reveal to him a feeling for what is noble and to keep alive his higher destiny." Thus Heaven and Science were not mutually exclusive categories but associated with trial and redemption.

Thomas Hope

Thomas Hope, the patron who commissioned the illustrations for the *Divine Comedy,* perceived his role in life as one of raising the standards of English art and industry for the purpose of promoting "a new source of health, wealth, strength, vigour, and patriotism, and nobleness of mind and feeling." His messianic intentions, however, related to his status as a foreigner and his need to make a name for himself in smart English society. The scion of a wealthy Dutch banking family whose ancestors had emigrated from Scotland in the seventeenth century, Hope moved to England permanently when the French annexed Holland in 1795. Through his lavish hospitality he sought to launch himself in fashionable art circles.

Hope had several advantages in addition to money and family connections: the Hopes were well-known collectors of antiquities who created an art setting at Amsterdam reeking of opulence and power. Thomas's older second cousin, Olivier Hope, was a close friend of Cardinal Albani and Winckelmann. Thomas grew up with a love of the antique and made extensive travels throughout Italy, Greece, Turkey, Egypt, and Syria in his search for ancient art objects. He began systematically to purchase antiquities in Rome from Jenkins and Pacetti in the mid-1790s. Already by 1794 his reputation and contacts gained him membership in the London Society of Antiquaries. His financial connections with John Julius Angerstein further facilitated his entrance into the exalted world of connoisseurship, and he soon won important members of the nobility to his side by lavish expenditures on art and entertainment.

In 1799 he acquired the opulent town house built by Robert Adam for General Robert Clerk from the dowager countess of Warwick, the sister of Sir William Hamilton. This mansion was located at Duchess and Mansfield Streets and formed part of the Mansfield Street complex designed by the Adams in the 1770s. In 1800 Hope gained admittance to the exclusive Society of Dilettanti, and for the remainder of his life lay claim to raising the standard of English taste through collecting superior works of art, publicizing his designs and collections, and patronizing artists and craftspersons whose work embodied his sense of elevated taste. The center of his

hopes and fantasies was his mansion which he furnished in the grand style. In addition to painting and sculpture, he decorated the interiors from top to bottom in the antique mode. He hired decorators and applied artists "capable of ennobling, through means of their shape and their accessories, things so humble in their chief purpose and destination as a table and a chair, a footstool and a screen."[109] The enormous task was nearly completed in 1801, and in February 1804 he sent out admission tickets to members of the Royal Academy.

Hope certainly modeled himself upon the first-generation neoclassical patrons Sir William Hamilton, the comte de Caylus and Cardinal Albani. He owned the catalogs of their collections and was familiar with their philosophical rationale for collecting. Hope actually owned a major portion of Hamilton's second collection of vases which he purchased in 1801 for the sum of 4,400 guineas. He displayed them in custom-made interiors resembling those of the comte de Caylus (fig. 4.70). Like Hamilton and Caylus too, he published books such as *Costume of the Ancients* (1809) which were based on works of art in his own collections. He also commissioned neoclassical paintings to decorate his house which incorporated antiquities in his possession. While all this was done, as he claimed in *Costume of the Ancients,* in the interests "of humanising the national manners, exalting the national character, and increasing the national spirit and happiness,"[110] it was not without a profit motive.

4.70 Interior view showing Sir William Hamilton's vases, purchased by Thomas Hope in 1801.

4.71 View of "Aurora Room" in Duchess Street mansion owned by Thomas Hope.

He bought and sold his vases, for example, and kept turning over his collection.

Hope designated Flaxman as the artist to head his campaign of aesthetic rejuvenation and earnings. He first commissioned Flaxman, then in Rome, to undertake a sculptural recreation of a lost classical group, *Hercules and Hebe*. This was based on a suggestion by d'Hancarville, then editing the catalog of Sir William Hamilton's second collection of vases. Later, he commissioned a group of *Aurora and Cephalus* which was to become the centerpiece of a special antique room devoted to the theme of Aurora for the Duchess Street mansion (figs. 4.71). Inspired by Ovid's *Metamorphoses*, it depicts the moment when Aurora descends to kiss a hesitant Cephalus on her daily visit to him on Mount Ida, where Cephalus had been taken after his abduction from his wife Procris. Here Flaxman and Hope reveal a charm and discretion similar to their mutual friend Wedgwood. Hope deeply admired the potter's products and purchased a Wedgwood copy of the Portland Vase in 1793 for his London house. In addition to the *Aurora and Cephalus*, Flaxman would execute a classical-style bust of Hope's brother, Henry, several bas-reliefs, and a number of chimney pieces for the Duchess Street mansion (fig. 4.72).

Hope's commission to Flaxman for 109 illustrations to Dante may have been suggested by an idea of the Comte de Caylus in his work on Homer and Vergil (1757). He recommended Dante as a source for modern painting insofar as Vergil would play a major role. Since Hope saw himself as a modernizing force, as one who could invigorate and update antiquity, the idea of synthesizing differ-

4.72 John Flaxman, chimney pieces for the Duchess Street mansion owned by Thomas Hope.

4.73 Thomas Hope, furniture designs.

ent worldviews like those of Dante and Vergil would have appealed to him. At any rate, this is the period when Flaxman initiated his outline technique which became the hallmark of later neoclassicism. Hope responded enthusiastically to Flaxman's illustrations to the *Iliad* and the *Odyssey* which inspired many of the designs for his elegant town house. For him Flaxman's compositions "offered the finest imitations I know of the elegance and beauty of the ancient Greek attire and furniture, armour and utensils."[111] It is altogether unsurprising, therefore, to find that Flaxman's antique furniture designs—themselves derived from Sir William Hamilton's vases and Pompeii—were used as the basis for Hope's own interior decor (figs. 4.73, 4.74). Indeed, to step into Hope's rooms was to step literally into a three-dimensional recreation of a Flaxman drawing (fig. 4.75).

Hope published line engravings of his classical interiors in the style of Flaxman's illustrations for his book *Household Furniture* (1807). This remarkable work bridges the wildest fantasies of the first generation of neoclassicists with the commercial industrial applications of the second. It is essentially a plea to the privileged classes to join him in a campaign to revitalize English art and industry through everyday applications of neoclassical ideals. In this he not only wanted to revive antiquity but to modernize it and even to create his own version of it. Unlike Hamilton and Caylus, Hope was identified on a basically practical level as "the man of chairs and tables, the gentleman of sofas." He conceived his interiors in a much more specialized way than Adam, tailoring them

ULYSSES WEEPS AT THE SONG OF DEMODOCUS.

4.74 John Flaxman, design for Homer's *Odyssey*.

4.75 Interior view of the room owned by Thomas Hope.

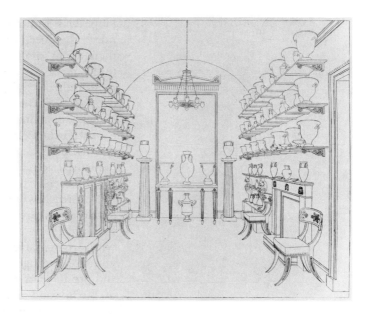

symbolically to suit specific themes geared to the specific function of each.

As mentioned previously, Hope rationalized his efforts with the idea that he was making England a sounder artistic and manufacturing country; by encouraging the fabrication and use of his type of furniture at home England could forgo the "disadvantageous importation" of foreign-made objects and "increase in a considerable degree the internal resources and the external independence of the commonwealth." Written at the height of the Napoleonic wars, Hope was expressing the widespread concern of the time about a lingering reliance on the "repulsive and unpatriotic" luxury products produced by French applied artists. This discouraged local artists and craftspersons and "diminished the balance of trade in our favour."[112]

At the same time, Hope wanted to bring into play not only "the mere mechanic trades" but also those talents allied with the "more liberal arts," the draftsperson, the modeler, the painter, and the sculptor. All this promised to add nourishment to the poor and "new decorum to the expenditure of the rich; not only towards ultimately increasing the welfare and commerce of the nation, but refining the intellectual and sensible enjoyments of the individual." But if he opted for an up-to-date version of antiquity to promote the industrial growth of the nation,

Hope was ambiguous on the issue of machinery. He admired the gifted artisan and designer and hoped to rescue them from the mechanizing process which increasingly threw them out of work. He felt that his contribution lay in stimulating job opportunities for unemployed talents deprived of their livelihood by the substitution of machinery for manual labor. Here his vision was clouded by his entrenched class position which dictated the more traditional patron-artist relationship over the dynamic entrepreneurial activities of the middle classes and an increasing number of the landowning nobility.

Nevertheless, his fundamental opposition to mass production was predicated on his fear of a future world of standardization and bland facsimiles. He was preoccupied with art-manufacture (the term given by his son), and with connecting the beauty of antique forms to the needs and products of everyday life. He supported the attempts of Wedgwood and others to resolve the contradiction of mass production and individual distinction. Hope was a close friend of Matthew Boulton, a fellow member of the Royal Society, and shared with him the desire to improve domestic and commonplace items through mechanization. Boulton, of course, relied on the latest technology at his Soho factory in Birmingham to apply neoclassic designs to steel jewelry, Sheffield and silver plate, and ormolu ornaments and brackets. He sent his gifted protégé, John Phillip, an apprentice die stamper, to Hope's house to make studies of the decorations and furniture. Hope took great pride in this exchange and loved the idea that his forms and ornaments could serve as models for Boulton's manufactures. Indeed, Hope wrote Boulton in 1805 that the industrialist's products exerted a "beneficial influence over a whole country."

Through his patrons Wedgwood, Boulton, and Hope, Flaxman evolved a style of fundamental importance for the history of European art. His ceramic designs and outline illustrations to Dante, Homer, and Aeschylus aroused immediate interest and enthusiasm among artists and collectors. The perceived purity and primitive simplicity of Flaxman's work struck them as a fresh, regenerative approach not simply to antiquity but to basic art production. As a result, his outlines became a basic source book of new ideas and images for artists right through the nineteenth century. His work had an especial appeal to the French painters and their disciples who came of age during the French Revolution. David, for

example, declared when he saw the French edition of Flaxman's illustrations: "Cet ouvrage fera faire des tableaux."[113] He was in a position to know, since he had already used a Flaxman illustration in the mid-1790s for his major work, *The Intervention of the Sabine Women*.

Despite the praise of his artistic innovativeness, in the end Flaxman's "regenerative" simplicity—the sense of blank space circumscribed by mechanical lines—sprang from the economies imposed by Wedgwood and the demands of industrialized production and profit. His minimal visual vocabulary conveys not the sense of high tragedy and heroics of David and West but the charm and elegance of his employer's ceramics. Together they forged a style infinitely adaptable to interior decoration, book illustration, and almost every other branch of the applied arts. In a sense, the team of Wedgwood and Flaxman popularized neoclassic imagery and content in the same way that *Classic Comics* popularized in abbreviated form the great literary works. Flaxman in fact acted as a kind of commercial artist-cartoonist simplifying experience and ideas for the primary purpose of selling a product.

England exported its modernized neoclassicism to the Continent by virtue of its power and authority in the industrial realm. Just as other countries sought British advice and technology, so their artists and art-buying public looked to England for advanced ideas in the visual realm. Even earlier, however, artists in France had seized upon the call for a purified style in art and in life by striving for a boldly revolutionary approach. They represented not merely moral themes but subjects of uncompromising rectitude and Spartan austerity. They, too, subjugated their formal patterns to the exigencies of outline and geometric clarity, but in behalf of an uncompromising commitment to the patriotic ideals of the regenerated nation. They looked to antiquity with fresh eyes, drawing upon the same sources as their English colleagues and searching for a primitive state of society not yet available for the luxury and corruption of civilization. They warmly received Flaxman's outlines because they had been initiated into a similar set of visual symbols which they eventually saw as the embodiment of progressive economic, scientific, and social ideals. The geographical scene now shifts to France as we examine the role of neoclassicism in the service of the other Revolution.

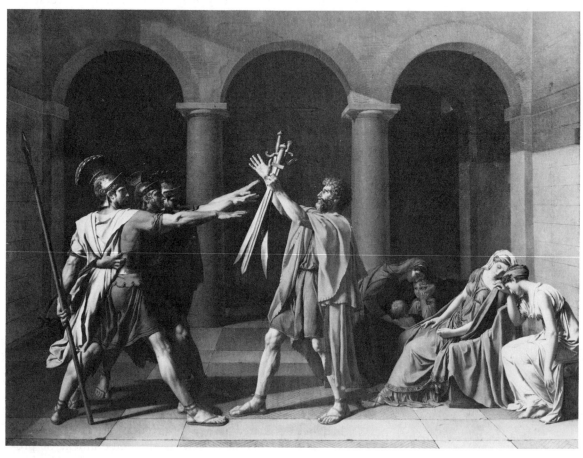

5.1 Jacques-Louis David, *Oath of the Horatii,*
1784. Musée du Louvre, Paris.

5 The French Revolution: (1789–1799)

Neoclassicism thus changed radically under the environmental pressures of the dual revolution. It gradually evolved into the official visual language of the French Revolution, becoming synonymous with the work of Jacques-Louis David and his disciples.[1] David emerged as the "official" painter of the Revolution, committed both politically and visually to its most radical manifestation. We have seen how his earlier work depended upon the sources of the first-generation neoclassicists in England and Rome; gradually he appropriated their visual language in the service of more progressive social ideals. Indeed, the aesthetic discourse of neoclassicism was the visual equivalent of the rational principles declared by the partisans of the Enlightenment. By merging the didactic and emotional characteristics of genre painters like Chardin and Greuze with history painting, this discourse succeeded in providing the Third Estate with a visual language capable of addressing the elite with authority. At first, both the nobles and the rising middle-classes shared the enthusiasm for this style which expressed antique virtue in the highest academic category and implied "enlightened" despotism. Similarly, the two groups imagined that they shared a common understanding of the abuses of royal authority. But as the reformist actions of the government began to take hold of the public imagination, the privileged orders grew increasingly alarmed and desperate. They arranged dazzling fireworks displays, made vociferous appeals in behalf of the rights of the people, the law, and the constitution, and rallied crowds against alleged ministerial tyranny. Not fortuitously, the *parlement* in Paris began its resistance in 1787 by refusing to register a Stamp Act—the quintessential

act of rebellion against royal injustice in the public mind since the American revolt. But the claim of the nobles to represent the people against royal despotism soon sounded hollow as their self-interested objectives were unmasked. Neoclassic imagery then assumed an immediacy and importance for the progressive middle classes who monopolized it. This shift in control of the style is represented by the work of David.

It has already been shown how the *Belisarius* demonstrated David's growing recognition of the contradiction between the nobles' rhetoric and behavior. At the time of its execution, however, David was still striving to ingratiate himself with enlightened authority, and the work remains an important example of his transition. The first work that projects the outlook of the prerevolutionary bourgeoisie is his legendary *Oath of the Horatii* shown at the Salon of 1785 (fig. 5.1).[2] It depicts the three Horatii taking the oath before combat to fight to the death for their nation. More than any of his previous paintings, it captures the rhetorical flavor and ideology of Enlightenment discourse.

If there is a single written document of the eighteenth century to which the *Horatii* most closely relates, it is Rousseau's short treatise on political theory, *Du Contrat social* (1762). Insurrectionists and revolutionaries were to find many useful slogans and terms in its pages. The essence of Rousseau's social contract is the surrendering of unrestricted natural liberty akin to a Hobbesian state of war in favor of a freely negotiated condition beneficial to the interests of society as a whole. It was already the model for some artists in the early 1780s who wished to escape from a "lawless" situation dominated by the powerful into a pool of sovereignty represented by the entire people. *The Social Contract* can be stated in the following words: "Each of us puts his/her person and power in common under the supreme direction of the general will and in return is received as an indivisible part of the whole." The general will (*volonté générale*), roughly the common interest of all, is embodied by the sovereign— meaning here not merely the monarch or the government but the community in its collective and legislative capacity. Individuals participate in the general will by willing for themselves what they will for others, and conversely. The public interest takes precedence over individual convenience and traditional privilege, since the state alone can secure the liberty of its members. Ironi-

cally, though Rousseau's doctrines pay lip service to democratic principles, he never fully worked out the politics, and they may also be read as a justification of the totalitarian state.

David's *Oath of the Horatii* may be read on several levels as a visual analogy of this work even to the point of embodying its contradictions. Its Spartan austerity and theme of civic virtue and self-sacrifice echo similar ideas running throughout Rousseau's book and provide the basis for David's work during the next fifteen years. The oath, which thematically unites the male members of the family and binds them to the state, is also the controlling pictorial motif subordinating the individual figures to the compositional whole. Rousseau's *Social Contract* abounds in reference to Sparta and Rome as models of austere morality and dutiful obeisance to the commonwealth and generally furnishes a flattering picture of the heroes and institutions of Republican and pre-Republican antiquity. Early on Rousseau alludes to Roman military oaths, and later to the city states of Alba and Rome, devoting an entire section to the social structure of the newborn Republic. And just as Rousseau calls the family unit the first model of political societies and likens the father to the ruler, so David makes the patriarch of the *Horatii* the symbol of *la patrie,* the Fatherland. The *Horatii*'s unity of action and engagement further recalls Rousseau's suppression of factions as a condition for the effectiveness of the general will. It is no coincidence that the anonymous reviewer of the 1785 Salon for the *Journal de Paris* could write: "Seeing this picture one experiences a feeling that lifts one's soul—to use J.-J. Rousseau's expression; . . . all the conventions are so well observed that one feels transported to the early days of the Roman Republic."[3]

David's painting builds on the precedent of *Belisarius*—indeed, he exhibited a replica of the latter together with the *Horatii* in 1785—and affirms unequivocally the artist's politically progressive viewpoint. The *Horatii* was commissioned by the king in 1783 through the program organized by d'Angiviller and certainly reflects the administration's attempt to project the king as benevolent ruler committed to Enlightenment goals. Art was one area of royal activity where the king and his ministers felt they could make concessions to public opinion. Thus the fact that this work was ordered by the Royal House does not contradict its radical content, but indicates an alignment

of both patron and producer coming from opposing perspectives. Indeed, in its rigid attitudes and uncompromising sense of obedience, it encodes the militarism spawned by the government since the end of the Seven Years' War.[4]

The subject is drawn from Corneille's drama, *Les Horaces,* written in 1639 and based on Book I of Livy's *History of Rome*. Corneille adds a psychological dimension to the historical account but more or less follows the source. After the death of Numa, war was declared between Rome and its rival neighbor Alba for political supremacy. As the two armies prepared for confrontation, it was recognized that both states were linked by blood ties and marriage, prompting the Alban chief to propose a less destructive approach to the solving of their differences. Coincidentally, there was a set of triplet brothers in each army almost equal in age and strength, the *Horatii* representing Rome and the *Curiatii* representing Alba. The two armies agreed to allow the two families to fight each other alone and to accept the rule of the state whose champions proved victorious. Livy, and Corneille in turn, stress the traits of loyalty, self-sacrifice, and patriotism stimulated by the confrontation. Corneille wrote his drama under the impact of social events occurring just outside his window: in 1639 civil strife in Rouen over unfair taxation spread to the countryside, and the rebels were hung in the Rouen town square near Corneille's apartments. Awareness of civil disorder in his own time and a search for symbolic resolution certainly affected Corneille's presentation.

The play, which David saw performed shortly before he conceived his picture, builds on conflicting allegiances to the state and family. The ultimate victor, young Horatius, elevates the claims of his country above all else, while the Alban champion, Curiatius, does his duty with a torn heart, and he falls in combat with his single-minded opponent. The two women protagonists, Sabina and Camilla, exemplify the family ties that have to be surmounted. Sabina is Alban by birth, at once the sister of the three *Curiatii* and the devoted wife of Horatius, and thus sees no alternatives in prospect but the subjection of her adopted or of her native city, the death of her brothers or of her husband. Horatius's sister, Camilla, is betrothed to Curiatius and openly advocates the importance of familial ties and feeling over abstract principle.

During the contest, Horatius's brothers are slain; but

by an ingenious strategem he separates the three *Curiatii* and kills them in turn. The brother of the Horatius clan is like a machine without feeling: he is welcomed back as a hero, but when Camilla insults him for having destroyed her lover his patriotic delirium makes him kill her on the spot. He is brought to trial but is ardently defended by his father, Old Horatius, and is acquitted on the basis of his previous heroism. David originally planned to base his picture on the fifth act, at the moment when the father defends his son before the people, again attesting to the central importance of this figure for David's conception. His preoccupation with paternal figures meshes with the moralistic attitude of the bourgeoisie but at the same time relates to his own childhood trauma and guilt over the loss of his father. The identification of the father with the state and the sacrifice of either male parent or son(s) was his way of making rational this experience. Thus David's emphasis on the patriarch has a social, intellectual, and deeply personal meaning; his search for a governing principle lost in childhood is now transposed to the social order. Curiously, the frightened children consoled by Julia, confidante of Sabina, are never mentioned in discussions of David's *Horatii,* but like the Astyanax of *Adromache Mourning the Corpse of Hector* they are fundamental to an understanding of his autobiographical projections.

David studied Latin and the classics at a time when the curriculum stressed the work of Sallust, Cicero, Livy, and Plutarch. All referred to an earlier Republican past to which they attributed such virtues as the simple life, frugality, industry, temperance, self-control, courage, integrity, and justice, with Livy and Plutarch adding self-sacrificing love of country and of liberty. These abstract virtues were given flesh in the form of early Roman heroes like the Horatii and Junius Brutus whose love of country impelled him to set the preservation of the state above the life of his two sons. As depicted by these writers and repeated by the *philosophes,* early Rome was a society where revolution, violent or peaceful, was a recurrent thing, and generally resulted in increased liberty for the people; where despotic kings like Tarquin the Magnificent could be eliminated by those rejecting tyranny; where the chief officials, even the early kings, were elected by the people, and, finally, where self-made types like Cicero could, on their merits alone, rise to the highest positons in the state. Robespierre, for one, expressed the

idea in 1784 that in France—as opposed to Republican antiquity—many careers were closed to the most able members of the society. Several future revolutionaries found themselves blocked in their careers by privilege and regulations, and hostile encounters with royal institutions like the Parisian bar and various academies transformed them from conventional liberals with conventional thirst for fame into more radical reformers desiring to change the existing order.

David always perceived himself as one of the professional classes whose aspirations ran counter to the academicians and their system of privileges. He was personally ambitious, a trait well known to his contemporaries, and chose to execute his *Horatii* at Rome both for the influence of the environment and its antiquities and for the kind of publicity he could generate in the heartland of neoclassicism. At first he hesitated to make the trip for want of money, but his father-in-law volunteered to pay all expenses (including those for an entourage of servants and assistants) with the observation: "Work for glory, my friend, I work for the money."[5] Of course, David, like most people, wanted both; it may be recalled that his *Belisarius* was calculated to win official support and wealthy clients, and in a similar spirit he tried to solicit from d'Angiviller an especially advantageous position for the *Horatii* at the Salon of 1785.

The final result unites theme and style in a taut synthesis which yields an effect of great energy controlled. Everything is clear, separate, rational, and understandable, like an eighteenth-century Declaration of Rights. The critic for the *Mercure de France* observed the "rigorously austere" costumes; as against the stereotyped rococo image of grace and fluff, David produces a work seemingly stripped of all superfluity and as austere as Livy's vision of the early Republic. The brothers are shown on a line in incredibly distorted positions, with legs spread out too far beneath them and feet flat on the floor or on tiptoe, with Horatius twisting one arm behind him as he grasps the javelin, and arms straining outward in the oath. This was seen as novel at the time: the *Mercure* critic declared that the picture's composition was "of a new type; it proclaims a brilliant and courageous imagination. Few painters would have dared to line up the three brothers on the same plane, fearing to become dry and hard."[6] The outstretched hands move upward gradually from Horatius's almost horizontal position toward the central-

ly located open hand of the father, an almost cinematic effect reminiscent of stop-action photography. The hands never touch, the slight gaps between the fingertips are like the gaps of a spark plug anticipating the snap of an electric charge. It recalls the gap between the finger of God the Father and that of the lethargic Adam in Michelangelo's Sistine Ceiling where the former summons the latter to life. David makes the sword blades echo the hand positions—"arms" here designating the primitive meaning of weapons as extensions of the body and assuming new meaning four years later with the pervasive cry of "aux armes!" The brother in the middle grasps his elder around the waist in an awkward claw-like embrace; this and the other poses are manipulated to guarantee a straining musculature which in part accounts for the superhuman appearance of the figures. (One can almost imagine an "S" in an inverted triangle on the cape of the father.) The heroic character of the male bodies is idealized in conformity with antique models, but also points to an optimistic vision or faith in the achievement of an "ideal" state. The starkness of the background contributes to the stripped-down look and emphasis on the figures: the unadorned Doric arches and open areas they enclose create an appropriate stringent environment.

All the figural action is pressed along the foreground plane, and the shallow space of the composition and vertical rhythm of the columns simulate the effect of a frieze. But while the picture owes much to Greuze, Hamilton, and Vien, David's rigorous treatment of every detail provides a punch and conviction imperceptible in their work. Hamilton's *Oath of Brutus,* for example, displays a series of elegant poses and gestures still reminiscent of the rococo mode. David's stringent sense of order and clarity corresponds to the qualities praised by the *philosophes* in Chardin and Hogarth and to the virtues described in their social writings. They form an ethical contrast with the luxuriousness and prodigal surface appearance of the rococo painters and the taste of their patrons. The strenuous poses and awkward gestures of the *Horatii* struck many contemporaries as brutal and blunt, a decided shift from what they had been conditioned to expect. That this could be read in political terms is seen in the *Mercure* critic's observation that the father's head bore an expression of "patriotic ferocity which recalled the deadly courage of the first Romans." David's own personal manner tended toward the "rough" and blunt in

contrast to the elegant decorum of the nobility and their middle-class clones. Not surprisingly conservative critics were disturbed by the picture, while the progressives praised David's defiance of conventional practice.

David's picture immediately invites comparison with Fuseli's *Oath on the Rütli,* executed in the early 1780s. There are obvious thematic and pictorial affinities in the focus on a patriotic oath which binds people in the cause of national unity. Both artists show their groups standing with splayed legs and upraised arms, gazing heavenward, and centering on a single figure who carries aloft the symbolic weapon(s). David met Fuseli in Rome in the 1770s and also read Lavater's *Essays on Physiognomy,* the first two volumes of which were translated into French in 1781. It is not unlikely that he knew of the *Rütli:* his friends the Trudaine brothers and the poet André Chénier had traveled to Switzerland in 1784, stopping in Zurich and visiting Lavater whose *Essays* they all knew. Chénier's poem about the trip, dedicated to the Trudaines, refers to the event on the Rutli:

Oh! If only I were a child of that enchanted lake
Where three herdsmen [sic] carried to liberty
All their nephews and Helvetia entirely![7]

Despite their affinities, however, the two works stand in striking contrast with each other; Fuseli's figures are somewhat wild and ecstatic, while David's are concentrated on a single objective with their feet planted firmly on the ground; Fuseli's event is charged with cosmic significance, while David's is rooted concretely in time and space. Their different treatments ultimately reflect their social and political positions. Fuseli identified with an oligarchy of bourgeois and nobles who kept a tight lid on reform and dissent, and the best he could do was depict a nostalgic view of the patriotic past. David, on the other hand, identified with the advancing bourgeois in France who possessed a real program based on enlightenment principles, and his pictorial statement—classical though it may be—intersects fundamentally with present reality.

Several critics observed that the women in David's picture formed a contrasting group to that of the three brothers. Indeed, the father turns his back toward the women and shuts them out of the oath-making ritual; they are also diminutive in scale and seemingly located below the masculine heroes. While the men are rigid, confident, the women are swooning and simpering; male

virility and discipline are here contrasted with female softness and emotionality. This contrast is also demonstrated in the opposition of the sinuous, undulating curves of the women to the angular upright forms of the males. It is as if the females symbolize both the style of the rococo and the traits of emotion and family concerns that have to be overcome under the new order. Here is exemplified the devaluation of feminine space later to be sanctioned officially during the Revolution, the clear compartmentalization of male-female attributes which confined the sexes to specific roles. This was the interpretation given to the dynamic opposition by an Italian reviewer writing in September 1785: "It demonstrates great shrewdness on the part of the painter to represent the warriors as neither mixing with the women nor heeding their weeping, for that is most appropriate for the proud, bellicose nature of the three brothers, one of whom would rather stain his hands in the blood of his sister than suffer those tears, which seem to him an outrage against their land."[8]

Sexuality was increasingly rationalized and categorized from this period onward: in the transition from the Old Regime to the new, it was first of all woman's sexuality that had to undergo this process so that the anarchic and pansexual tendencies associated with the libertine aristocracy could be repressed. It may be said that the French Revolution marked the culmination of a period dominated by feminist energies; to some radicals it seemed that the social and economic liberties allowed women during the Old Regime were dangerous. Women like the Pompadour had great political power, and others like Mme. Geoffrin governed the intellectual life of the country through their Salons. While the French Revolution did spark a militant feminist movement which formulated a Declaration of the Rights of Women analogous to the one proposed by men, feminism was equally suspect to Jacobins and *sans-culottes* (literally, *without breeches*), or the mass of artisans and shopkeepers. David's painting already manifests this suspicion in his depiction of male heroes who, in order to achieve success, must eliminate the feminine in their personality and swear to defend Rome to the death.

This simultaneous rejection of the feminine and exclusive alliance of the males clarifies the dynamic connection between risk-related masculine activities and the notion of *fraternity*.[9] The civil order, as outlined in the *philosophes,* is subject to formalized and duplicitous relation-

ships, expressed often in certain forms of economic exchange and rules of decorum. Competitive societies encourage both the concept of the bargaining process and the polite greeting as a means of maintaining social order. But this in turn generates dishonest relationships and interactions and debases ethical principles. Many actions that involve risk taking, however, bring people together temporarily in a direct way unmediated by the desire to get the upper hand or by the manipulative and stereotyped social interaction. The concept of the duel relates to an attempt to rescue personal honor and integrity through a direct, risk-taking encounter. It may be recalled that David's own father was killed in a duel; he had evidently experienced some challenge to his sense of self-worth which was unresolvable within the bounds of legality. The dueling institution, moreover, through its dependence on "seconds"—those who represent and aid the principals in a duel—also brought friends and relatives closer together in a direct emotional experience. David's *Oath of the Horatii* is actually a representation of a duel between two sets of triplet brothers for the honor of their respective families as well as nations.

Similarly, war was seen as a larger form of duel involving the honor and prestige of entire nations. Traditionalists could perceive war as positive in welding the disparate factions of a community in their struggle against the common enemy. At the same time, it could be considered socially therapeutic and "manly" in forcing participants to put their life on the line for each other and overcoming duplicitous and superficial exchanges common to the marketplace. From this perspective, the threat of external violence and the risk involved in confrontation promotes honesty and intimacy in social relations. Thus violent encounters would be actively sought after as a means of achieving a sense of unity with fellow human beings. This still may be observed in male-dominated activities such as contact sports and military life. Men tend to join with one another primarily under threat of annihilation—whether in reality or symbolically in play—whenever their manhood needs to be reaffirmed. It may be claimed that there exists a historical link between the meaning of the oath ritual in David's picture and the blood oath of secret societies like the Ku Klux Klan.

The brothers stretch out their arms in a salute that has since become associated with tyranny. The "Hail Caesar" of antiquity was transformed into the "Heil Hitler"

of the modern period. The fraternal intimacy brought about by the Horatii's dedication to absolute principles of victory or death is the other side of the coin implied in the *Social Contract*. Its emphasis on the destruction of all intermediate loyalties between citizen and state, and on the abolute sovereignty of state power, is closely related to the establishment of the fraternal order. Rousseau's own sexism is clearly shown in his novel *Emile*, where the woman functions in a subordinate role. A major problem of a society desiring full economic equality is how to engage diverse factions and the sexes without any of the groups lapsing into an exclusivistic position and without provoking violent confrontation. In the total commitment or blind obedience of a single, exclusivistic group lies the potentiality of the authoritarian state.

Nevertheless, like Rousseau's work, David's picture historically manifested the progressive outlook of those who sought social promotion based on talent and a more equitable social order. His pictorial language is radical for this period, and his theme corresponds to the aspirations of the liberal aristocracy and the militant bourgeoisie in the mid-1780s. David used pictorial rhetoric analogously to contemporary lawyers who owed their professional eminence to forensic eloquence. As mentioned earlier in connection with David's education, middle-class training included instruction in classical rhetoric, with Cicero as the revered model of eloquence. In many ways, the generation that became revolutionaries knew more about the history and practices of republican Rome than of monarchical Paris.

At the same time, patriotic movements elsewhere in this period exposed French liberals to topical ideals which coincided with their understanding of ancient republican institutions. From the time of the American Revolution, reformist ideas spread in France, England, and on the Continent. Early in the decade, revolutionary activity occurred in Geneva, but several powers, France among them, initiated a military blockade and the leaders fled, including Clavière, later finance minister of revolutionary France. There was much unrest in Holland as well, although revolution broke out on a wide scale only in 1787. But the Dutch Patriot Associations comprising wealthy bourgeois were already forming in 1785 and by the following year had gained control of most of the provinces. This time the French government supported the rebels because of the ties of the House of Orange to

the English; but France's ruinous financial condition did not permit more than token involvement. Simultaneously, the alliance of France and America throughout this period not only exposed French society to democratic and republican ideas but made them eminently fashionable and respectable.

The *Oath of the Horatii* now appears as a document of one stage in a chain of events leading to the fall of the Bastille in July 1789. The year following its exhibition the French controller-general, Calonne, reached the end of his credit; his solution was to summon an Assembly of Notables, with the idea that they should vote the urgently needed new taxation. Presided over by four princes of the royal blood, it was doomed from its opening in February 1787. Calonne actually requested that the privileged orders—nobles, clergy, members of the *parlements*—voluntarily sacrifice their fiscal privileges and positions of power in the interests of a reforming bureaucratic monarchy. Not surprisingly, Calonne was dismissed, exiled and disgraced, and the Notables, having refused to agree to any new taxes, were dissolved, leaving the royal credit in worse shape than ever. Calonne's successor, Brienne, also tried to introduce economic reforms into the government and was similarly dismissed under aristocratic pressure. Necker took his place in August 1788. Meanwhile, a small party of patriots, drawn from all the higher groups of society and imbued with a democratic ideology learned from their American, Dutch, and Genevan predecessors, began to make their ideas felt openly in print. They picked up on a solution which the *parlements* had rashly put forward to support their tenuous claim to embody the will of the people, the appeal for a meeting of the Estates-General.

David's *Horatii* anticipates the main thrust of the patriots' ideas in its emphasis on the state as an abstract principle vested in the reified General Will rather than in a single, all-powerful king. The oath is taken at the behest of a patriarchal type but in behalf of a Fatherland, not a father. It may be recalled that in this period a new notion of virtue came to challenge the debate over hereditary and mental nobility, reflecting the increasing departure of the elite from old standards. This was the Roman Republican definition of virtue as civil virtue—the defense of the public domain. It was culled by the highly educated professional groups from their reading of the Latin authors like Livy, Cicero, and Tacitus. This radical no-

5.2 Pierre-Alexandre Wille *fils*, *French Patriotism*, c. 1785. Musée National du Blérancourt. Photo courtesy des Musées Nationaux.

tion implied that true nobility belonged to those whose interests coincided with the public weal.[10] David's male protagonists are the "new" nobility who direct their gestures upward in deference to the elevated ideal of *res publica*—the commonwealth. This concept is reinforced by the severe treatment of the composition and the figures, whose rigid profiles and thrusting arms constitute a frontal attack on rococo gentility and decorum associated with courtly extravagance and privilege.

This may be clarified by comparing the *Horatii* with a more conventional painting of around the same time, Pierre-Alexandre Wille *fils*'s *French Patriotism* (fig. 5.2).[11] Like the *Horatii,* it depicts the theme of self-sacrifice and patriotism that is sealed in the form of an oath administered by a father to a son readying for combat. Wille did not neglect the classical allusion to sacrifice, but it has been relegated to accessory status in the form of a frieze on the background urn. Set in the contemporary present, moreover, the patriarch does not point to an abstract principle but gestures significantly with his left hand to a bust of Louis XVI—the central motif in the picture and one that closes the compositional pyramid. The son, newly commissioned as an officer, swears an oath of fidelity to the head of the family and to the head of state, both physically incarnated as symbols of the social and political hierarchy. In exchange, the father hands the youth the patrilinear sword, the emblem of aristocratic presence and authority. This glimpse into the fashionable aristocratic ambience helps us to understand that their patriotism has a specific class bias, referring to unwavering loyalty to the hierarchy with the monarch at its head. Significantly, this transaction spills over into the domestic sector, with the women and a younger brother tearfully pleading with the youth to renounce his pretensions to enter the field of combat. While the adult males resolutely seal their compact despite the anguish of the others, the physical proximity of the women and the child to the main action legitimizes their response. Nevertheless, the scene as a whole lacks closure and conviction and seems more preoccupied with outward display than with inner necessity.

Just as David and his peers gradually appropriated the visual language of neoclassicism, so they invested key words with fresh meaning. Language associated with the *ancien régime* and having to do with privilege and rank was rejected, while words like "nation," "*patrie,*" and

"constitution" signaled devotion to the wider community. Heroism and civic virtue implied the Rousseauistic idea of morality as the self-government of people who acknowledge no law except one they have collectively made. David's oath motif seeks to displace the "charisma of kingship" with a call for national sovereignty. This oath, however, requires the military discipline and obedience exemplifed by the ancients. Their watchword *vaincre ou mourir* (conquer or die) was the formula of both the military manual and the new patriots. What began as the motive force for reorganizing the army ended as the springboard for social change.[12]

Another clue to the progressive nature of David's picture is its rhetorical language, similar to that of the *cahiers de doléances,* the formal complaints and grievances drawn up on the eve of the Revolution to be presented by the deputies of the three social orders of the Estates-General. While these addresses were often influenced by prominent members of a given constituency and reflect regional differences, they represent the views of a broad range of social groups. The sentiments of these *cahiers* are hardly radical and are even somewhat conservative for 1789, but they convey the accumulated feelings suppressed for several years and passionately demand social equality, freedom of opinion, security of property, a career open to talent, a fair assessment of taxes, and a hundred other reversals of the old order of society and government. Above all, the dominant idea was of the sovereignty of the people or nation. Some called for the expression of the General Will of the people in the form of a National Assembly, an idea more fully and eloquently summed up in the brochure by the abbé Sieyès, *Qu'est-ce que le Tiers Etat?* The form of the *cahiers* was typically cast in classical rhetoric, as in the case of one address that indicates how David's work captured a prevailing mood still unarticulated by the masses: "Frenchmen will have one fatherland (*patrie*), and will be one people—a single family, whose elder members use their superior intelligence and powers to increase the happiness of the younger, in which the national character will recover its energy, and patriotism will rule every heart."[13]

No one, of course, dreamed of revolution in this period, but the changing circumstances required a fresh vocabulary, visual and verbal, to articulate new political attitudes. David's *Horatii* rehearses the platform of the liberal nobility and clergy raised on Rousseau's *Social*

Contract, as well as acts out the pressures felt by the bourgeois who did most of the work of government and comprised the professions, but who were kept out of the highest offices by lack of *noblesse* or influence at court, and were humiliated socially by the thought that they belonged to an inferior caste. Toward the manual workers of the towns and the peasantry, of course, the attitude of the bourgeois was very much that of the privileged orders toward themselves: the masses did not exist for them except as supporters. In the end, however, the Revolution could never have succeeded without the independent agitation of the laboring classes.

The Progressiveness of David

David's friendships and patrons generally confirm the liberal context of his ideas. He frequented the circles of the moderate aristocracy and upper middle class who espoused the aims of the early phase of the Revolution. But he became increasingly radical while his liberal friends turned conservative in its later stages. (His growing radicalism may explain why he was not included by d'Angiviller among the king's commissions for 1786.) In the spring of 1786 David was commissioned by Charles-Michel Trudaine de La Sablière and Charles-Louis Trudaine de Montigny to paint the *Death of Socrates,* one of the most arresting pictures of the Salon of 1787 (fig. 5.3). The Trudaines descended from a well-known noble family which in the eighteenth century had produced a number of distinguished scientists and economists.[14] Their

5.3 Jacques-Louis David, *Death of Socrates,* 1787. The Metropolitan Museum of Art, Wolfe Fund, 1931. Catharine Lorillard Wolfe Collection (31.45).

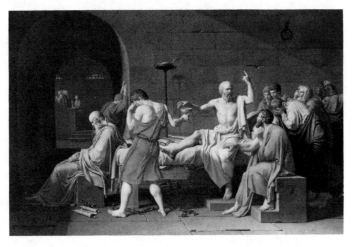

grandfather, Daniel-Charles Trudaine, member of the royal advisory council and an intendent of finance, founded the royal school of civil engineering (Ecole des ponts et chaussées) and built thousands of miles of tree-shaded paved roads that made travel in France the most comfortable and the speediest ever known since Roman times. He passed on his offices and his immense wealth to his son, Jean-Charles-Philibert Trudaine, the father of Michel and Louis, a fortune which included a Paris mansion and his chief country estate, Montigny near Fontainbleau. The estate embraced a number of villages and contained a park of over a thousand acres. Philibert Trudaine was a loyal son of the Enlightenment and helpful associate of the Encylopedists. He created the popular "Trudaine Society"—a regular meeting held at 5:00 P.M. at the Paris town house where he and his wife entertained a large number of philosophers, scientists, historians, literary and art critics, and statespeople. Philibert espoused reform within the government, aiming his ire at the despised *corvée*, a tax on the use of roads shouldered almost entirely by the peasantry. A close friend of Turgot, the progressive controller-general in the mid-1770s, the two carried on an extensive discussion on the question of this road tax which culminated in Turgot's edict of abolition in February 1776. Indeed, this was one of the reforms that earned Turgot the hostility of the aristocracy who pressured the king to dismiss him three months later.

Like Turgot, Trudaine père believed in laissez-faire economics and urged a free market in the commerce of grains which he cultivated on his estate. Both attached themselves to the physiocrats, who represented the most progressive economic thought in France during the period. They believed that value and consequently wealth—the total stock of valued goods—originated with the products obtained from the land and the water. Only the primary activities of agriculture, fishing, and in some instances mineral extraction were considered truly productive activities. The physiocratic class system consisted of farm workers, then artisans and tradespeople who transport, refashion, and exchange the products raised by the first class, and, finally, the landowning class, including the church and the king himself. They postulated a single tax on the net product paid to the landlord who had to bear the main burden of taxation. That Trudaine, a land-

owner with vast holdings, subscribed to this idea is a testimony to his liberal philosophy.

His two sons, Charles-Michel and Charles-Louis Trudaine de Montigny, assimilated his outlook. Charles-Louis, the eldest, supported Necker's attempts at reform (he commissioned a marble bust of the minister for his residence), and Charles-Michel was a close friend of Lafayette and translated the *Federalist Papers* of Hamilton, Madison, and Jay in 1792.[15] Originally published in 1787–1788, these papers aimed at persuading the people of New York to ratify the Constitution. They are couched in classical rhetoric: printed under the pseudonym of "Publius" they make frequent allusions to ancient confederacies as models to emulate. Thus it is understandable that Charles-Michel would support David's neoclassicism and reward him with 1,000 francs more than the artist initially asked for the *Death of Socrates*. Both Trudaine brothers held republican views in 1789 but grew disenchanted with the direction of the Revolution in the period 1793–1794. They were guillotined in 1794 as enemies of the Revolution: David was asked to intervene in their behalf but refused and even threatened the friend who had sought his support.

The *Socrates*

One intimate friend of the Trudaines, the poet André Chénier, also played a significant role in the conceptual development of the *Socrates*. Like David, he stood at the center of eighteenth-century politics and ideas. His work was also committed politically, and he saw no dichotomy between his literature and his politics. But after 1791 he attacked the direction of the Revolution and found himself on the opposite side of his old friend David. Chénier had been close to the Trudaine brothers ever since they were fellow pupils at the Collège de Navarre in the 1770s. Chénier spent his vacations at the Montigny estate, and his early bucolic writings refer to its arcadian environment. The Trudaines supported him in his endeavors, taking him on trips to Switzerland and Italy and paying all expenses.[16]

Chénier, the Trudaines, Lafayette, Lavoisier, and David all shared the liberal outlook of the club they helped form, the Société de 1789. They did not subscribe to revolutionary action but to moderate constitutional reform.

Chénier and David were still close in 1791 when Chénier dedicated his "Ode au jeu de Paume" to the painter in honor of his projected picture of the Tennis Court oath. David, however, threw in with the Jacobins, while Chénier began to attack the direction of the Revolution after 1791. Their falling out was a painful blow to Chénier who had admired the artist since the early 1780s when his mother entertained him along with other young celebrities at her Salon.

They became close mainly through the Trudaines; David in fact initiated them all in the study of the great Italian masters on the eve of their departure to Italy in 1786. Earlier that year all three involved themselves in the progress of the *Socrates* which the Trudaines had commissioned in the spring. It was to be a scene of the death of Socrates as described by Plato in the *Phaedo*. At the Collège de Navarre, the Trudaines and Chénier were exposed to such classical authors as Plato, Cicero, Horace, Tacitus, and Virgil. They were also steeped in classical rhetoric which the Trudaines, both lawyers and members of the regional *parlements,* carried over into actual life. Chénier actually furnished David with the rhetorical gesture of his protagonist. Originally, the artist wanted to show Socrates holding the cup of hemlock, but Chénier advised him to depict the philosopher reaching somewhat absentmindedly for the cup while still speaking—demonstrating his indifference to death and his unyielding commitment to his ideals.

5.4 P. A. Martini, *Exposition at the Salon of the Louvre in 1787*, 1787, engraving.

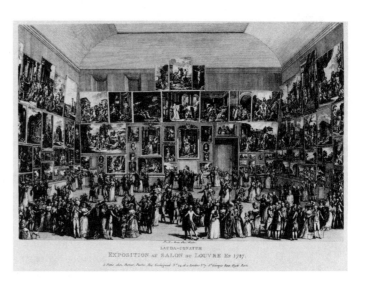

Socrates created a sensation at the Salon of 1787, although one would never guess it from an engraving of the exhibition (showing the *Socrates* on the lowest register just left of center) that depicts the spectators more like a crowd at a fashion show than as participants in a novel aesthetic event (fig. 5.4). The upper-class gathering yields a rich insight into the type of audience addressed by the artists and their critics. Among the ecstatic spectators were Count Potocki, Sir Joshua Reynolds, and Thomas Jefferson, then ambassador to France, who wrote to the American painter John Trumbull on 30 August: "The best thing is the Death of Socrates by David, and a superb one it is."[17] Jefferson, of course, was a friend of the Trudaines and Chénier and may have met the painter in this period. Jefferson and David also had other mutual friends such as Marie Cosway, wife of the English artist Richard Cosway, the well-known miniature painter, and Filippo Mazzei, the Italian patriot. David was thus in touch with an international liberal crowd for whom the *Socrates* must have carried special meaning in 1787.

His painting represents another father figure unjustly condemned but who sacrifices himself for an abstract principle. David transformed a somewhat fashionable motif into an hypnotic image through the contrasting movements of the energetic but firmly controlled Socrates and his swooning disciples, and through the distribution of the light and dark accents which heighten the contrast. Socrates, speaking while reaching for the cup of hemlock, is taut, angular, and starkly lit, while most of his disciples and slaves swirl around him in grief. He alone incarnates firmness, confidence, and power as he prepares to sacrifice himself in defense of the principle of the state.

The dominance of the patriarch (again distinguished by telling rhetorical gesture), the devotion to the governing authority despite its impossible demands, and transcendent patriotism relate the work to the *Horatii*. In this instance, however, the disciple sons betray the weakness of emotionalism, and, except for Plato at the foot of the bed and Crito seated on the stool at the left, their bodies bend and sway like the females in the earlier picture. Women continue to be shown as weak and isolated: an early sketch revealed Socrates's wife fainting at his feet, and in the final version she is all but excluded from the entourage as she is glimpsed leaving the prison, turning

to bid farewell. Her gesture echoes feebly Socrates's upraised arm pointing to the elevated principle on which he bases his action.

The significance of the *Socrates* in this period may be best understood in the context of the major event of that year—the Assembly of Notables which met in February 1787. This ancient institution had been previously convoked only in moment of crisis. It may be recalled that the (then) Controller-General Calonne naively conceived of the council in 1786 in the hopes that the privileged orders would voluntarily sacrifice their fiscal privileges and even positions of power to help resolve the urgent financial crisis facing the country. David's Socratic lesson of self-sacrifice quite naturally sets the standard for this type of virtuous action. The hard line of the 144 participants, however, resulted in the fall of Calonne in April, while his successor, Brienne, would fare little better. The assembly ended in a stalemate with the government at the end of May. Thus the example of the *Socrates* at the Salon in late summer contrasted glaringly with the selfish behavior of the Notables who nevertheless retained a sizable segment of public support in their struggle against royal "despotism."

The scene takes place in a convincing and (for contemporaries) frightening dungeon, reminding the audience of the political prisoners proliferating on the Continent and—closer to home—those languishing in the Bastille. David's friends and patrons were certainly aware of the abuses of justice perpetuated in the state prisons. In the early 1780s Chénier and the Trudaines visited the prison at Vincennes and were horrified by the chilly, depressing cells reserved for those condemned to solitary confinement. They encountered one victim of injustice who explained to them how a corrupt aristocracy wielded power against individuals. It was this same insight that motivated William Blake to make the seven prisoners in the Bastille the symbol of oppression in *The French Revolution*. Ironically, when the Bastille fell the crowd liberated from beneath the towers the political prisoners, one of whom, the comte de Lorge, bore a striking resemblance to David's Socrates.

David certainly had in mind the glorification of patriotic self-sacrifice as a rebuke to cringing souls. A contemporary critic noted that he based his pose of the grief-stricken Crito on the response of Uncle Harlowe to the will of his niece Clarissa, the heroine of Richardson's

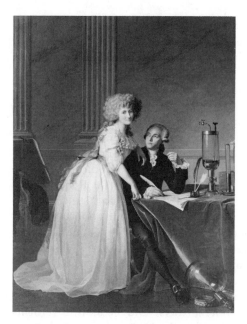

5.5 Jacques-Louis David, *Antoine Laurent Lavoisier and His Wife*, 1788. The Metropolitan Museum of Art. Purchase, Mr. and Mrs. Charles Wrightsman Gift, 1977 (1977.10).

famous novel, *Clarissa*. The work tells about a virtuous martyr whose death shames her unsupportive family and demonstrates her unwavering dedication to the high principles they espoused. Another instance of martyrdom familiar to many of David's friends in the mid-1780s related to the case of Anton Mesmer, the discoverer of animal magnetism. Chénier's friend, Duval d'Eprémesnil—the same jurist who defended the law courts against the attempt to vindicate Lally-Tolendal—assumed the air of a liberal by defending the cures of Mesmer against the attacks of the Academies of Science and Medicine, and harshly rebuked the well-known scientists Franklin, Bailly, and Lavoisier for issuing an official condemnatory report. D'Eprémesnil gained the adherence of many future leaders of the Revolution who rallied around Mesmer for the very reason that they identified with his martyred state: they too felt blocked by the same institutions that quashed all attempts to democratize scientific and literary ideas and professional practices.[18] Not fortuitously, d'Eprémesnil compared Mesmer to Socrates surrounded by his adepts, a thought that may have corresponded to David's vengeful attitude toward the academy that had humiliated him on several occasions in the past.

David also may have identified with the subject on a very personal level: critics noted the way in which he transfigured the legendary ugly face of Socrates through the "noble" action. During this period of politicalization, David's left cheek, wounded some years earlier by a fencing foil, began to swell and deform his face. At the same time, he was beginning to be surrounded by his own disciples and assumed a leadership role among the younger generation of artists. In his dedication to political liberalism, he was prepared to sacrifice himself for his students as his father had sacrificed himself for the family honor.

David's next important work is his portrait of *Lavoisier and his Wife,* painted in 1788 (fig. 5.5). Lavoisier was an intimate friend of the Trudaines, especially close to their father who had been an exceptionally able chemist among his other accomplishments. Lavoisier's scientific innovations dominate the fields of chemistry and physics during the second half of the eighteenth century. Among his most famous experiments were those that demolished the phlogiston theory and demonstrated many of the properties of oxygen, an element he named. In his experiments on combustion, he also discovered the law of

the conservation of matter—that matter cannot be created or destroyed. Lavoisier was an adviser to the French government on almost every scientific problem of the day and managed to combine successfully pure science and practical technology. He analyzed and carried out intensive cultivation of the soil, chemical fumigation of prisons, purification of water, and secured uniformity of weights and measures throughout France—thus embodying the highest ideals of contemporary French science in its concrete application to daily life. (Ironically, Lavoisier's favorite disciple, Eleuthère Irénée du Pont, son of the physiocrat Pierre Samuel du Pont de Nemours, migrated to America to found the Du Pont gunpowder and chemical firm, long since renowned for its manufacture of high explosives, plutonium, and toxic chemicals. From the debunking of phlogiston, one path has led to rampant pollution and mass destruction.)

Lavoisier was himself a bundle of contradictions: he actively supported liberal social and economic reforms and counted among his friends the Trudaines, Lafayette, Franklin, and the physiocrats Du Pont de Nemours and Turgot. He assumed a leading role in the constitutional club, Society of 1789, which included David. At the same time, however, to free himself for scientific work, he had become a farmer-general, an agent of the hated department of internal revenue responsible for collecting taxes. This was to cost him dearly as the Revolution moved increasingly leftward. He was scrupulous in his scientific experiments, but he never gave credit for his inspiration to the English chemist, Joseph Priestley, whose ideas greatly stimulated his researches. Like Franklin, Lavoisier maintained close ties to the Lunar Society.

In 1775 his appointment by Turgot as controller of munitions further endangered his reputation. While he supervised the changeover of the manufacture of gunpowder from a private monopoly to a government operation, its long history of corruption and graft, which many held responsible for France's defeat in the Seven Years' War, clung to the new administration. When in 1789 powder was transferred from the Paris arsenal to storehouses at Rouen and Metz, rumors spread that traitors were shipping it out of the country, and a riot broke out in which Lavoisier was nearly killed. His self-righteous attitude also made many enemies, including Jean-Paul Marat, whose attacks on the chemist in *L'Ami du*

peuple in 1791 as royal lackey and farmer-general ultimately led to his execution by a revolutionary tribunal three years later. Marat—a scientist himself—was being vindictive: he had been denied admission to the Academy of Science due to Lavoisier's denunciation of his experiments on combustion, and he also resented Lavoisier's condemnation of Mesmer's theory of animal magnetism, which he and other future revolutionaries regarded as socially beneficial.

When David painted Lavoisier's portrait, however, there was no hint of the turbulence to come. David depicted him in a tranquil domestic setting, suggesting his love for Lavoisier as a friend and an equal. The scientist is shown pausing from his labors to acknowledge his wife's entrance into the study. David emphasized the momentary interruption as Lavoisier shifts from an attitude of deep concentration in which he releases the hand supporting a heavy head to one of temporary relaxation as he turns to admire Madame Lavoisier. Every detail in the picture has been carefully rendered; both Lavoisier and David acquired reputations for their capacity for sustained work, painstaking regard for detail and logical thought, and the painter's meticulous re-creation of the scientific instruments used to measure gases demonstrates his own empirical outlook. Both persons discredited sloppy and virtuoso approaches in their respective fields and attempted to ground their disciplines on the solid rock of exact science. Their mutual friend Chénier, who dedicated a poem to Lavoisier's close colleague, the astronomer Bailly, believed like Erasmus Darwin that modern science constituted the basis for new poetic inspiration. Similarly, David wished to establish his art with archaeological precision, structural validity, and strict execution. Often he worked out his figures from a skeletal foundation, next adding the musculature and finally the clothing.

On a deeper level, Lavoisier, Chénier, and David believed that the scientific model could serve as the basis of the new society dispensing laws through a representative assembly. Their emphasis on clarity and rationality, their shared political views—especially their trust in constitutional reform within the monarchical system—made David and Lavoisier ideal partners in this undertaking.

David placed Lavoisier's wife, née Marie-Anne-Pierette Paulze, in the compositional center. She leans somewhat casually on her husband's shoulder with her left arm and

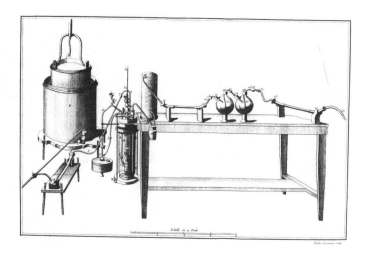

5.6 Marie-Paulze Lavoisier, plate for *Traité élémentaire de Chimie*, 1789.

braces herself on the worktable with the right. David directs our attention to her through an ingenious manipulation of the pictorial ingredients: the glass globe in the lower right-hand corner initiates a strong diagonal movement which is picked up by the sharply illumined fold in the velvet table cloth, is reinforced by her husband's extended right leg, and leads straight to Madame Lavoisier's bent right arm. She represents a stable force in the composition as well as in her husband's life, forming a buttress which in turn is extended upward by the fluted wall pilaster. She presides over Lavoisier's work with a powerful presence akin to an inspirational muse. Her dominant position in this work suggests a rise in status for women in David's pictures, but she is nevertheless shown at leisure in fashionable attire while her husband is shown hard at work. Since servants did the domestic chores, women in her social class were free to pursue "pastimes"—to play at time-filling activities practiced seriously by males. Indeed, she studied drawing with David, and this is indicated by her portfolio thrown with her cape on the chair in the left background. Thus her work is relegated to a subsidiary area of the painting, and she is pictured mainly as a decorative adjunct to the scientific world of her husband.

Here David grossly falsified her actual social role. Marie Lavoisier was a staunch liberal who actively participated in the political discussions of the Trudaine circle. She inherited a progressive philosophical position from her father, Jacques Paulze, another liberal farmer-general who collected taxes from the sale of tobacco. He gath-

ered much source material for his friend the abbé Raynal who incorporated this research into his *Philosophical and Political History of the Establishment and Commerce of Europeans in the Two Indies,* a book that exposed the seamy side of the Old Regime's colonial policies such as the slave trade and the unjust treatment of Lally-Tolendal. It may be recalled that this work exerted an enormous influence on radical thought everywhere in the decade of the 1780s.

Marie Lavoisier studied drawing under David in order to illustrate her husband's treatises, just as she undertook the mastery of English to translate the work of British scientists such as Priestley for her husband's research. She engraved the plates for her husband's seminal treatise on chemistry, joining her own name to her husband's for her signature "Paulze Lavoisier sculpsit."[19] The plates are carefully executed, and it is likely that her drawings served David for his painting of the lab instruments (fig. 5.6). She also assisted him by taking notes during experiments and recording their results. An engraving based on her own drawing of an experiment conducted by Lavoisier concerning the changes in the composition of air during respiration shows Madame Lavoisier sitting at her desk at the far right diligently recording the results (fig. 5.7).[20] Thus while David made her visually prominent in his portrait he hardly did justice to her real-life contributions.

The portrait was destined to be exhibited at the Salon of 1789, which took place after the fall of the Bastille in a

5.7 Marie-Paulze Lavoisier, *Lavoisier Conducting an Experiment, Mme. Lavoisier Recording It,* engraving.

Lavoisier dans son laboratoire
Expériences sur la respiration de l'homme au repos

searing political climate. This was also the period of the riot at the arsenal which nearly took Lavoisier's life, and it was mutually decided by the aristocratic scientist and d'Angiviller's staff not to exhibit the work. (Paintings generally took on fresh meaning in the light of events: the administration hesitated to exhibit a portrait of *Lally-Tolendal Unveiling the Bust of his Father,* showing the son holding his initial petition to the king ["My father was not guilty"] and symbolically restoring his father to honor, but ultimately acquiesced to young Lally's insistent demand.) At the same Salon, David showed the *Paris and Helen,* another potentially controversial piece, not because of its subject but because it was commissioned by the king's brother, the comte d'Artois. The comte d'Artois represented the extreme forces of reaction and remained throughout his life a diehard counterrevolutionary. Worried about the response this patronage might have, the official organizers of the Salon opted to suppress the proprietor's name. It seems difficult to reconcile David's progressive position with his relationship to comte d'Artois (although Marat had once served as his physician), but it may be recalled that David did not figure among the king's artists for 1786 and probably felt it expedient to make concessions to retain communication with the court. It would certainly have been impolitic for him to turn down an offer from the comte d'Artois, who evidently noticed David after his success with the *Socrates.* Painted in 1788 and roughly repeating the intimate

5.8 Jacques-Louis David, *Lictors Returning to Brutus the Bodies of His Sons,* 1789. Musée du Louvre, Paris

pose of the Lavoisiers, David's *Paris and Helen* flatters the Homeric interests and erotic fancies of the libertine d'Artois. As discussed in Chapter 2, it was a throwback to the first-generation neoclassical pieces by Mengs, Hamilton, and Vien; the lavish interest in accessories corresponds to the patron's personal collecting mania. Above all, the lack of the clear narrative action seen in his previous history pictures is perhaps the best testimony to David's submission to the patron's conservative taste.

Meanwhile, however, David continued to develop the radical potential of neoclassicism. In 1788 he also began a new commission ordered by the Crown in the wake of his popular success with *Socrates* and possibly brought about by his ties with the king's brother. This time the painter determined to make his most revolutionary statement to date, and to accomplish this went "underground" and concealed his subject from the royal commissioners. Originally commissioned to paint the subject of Coriolanus, David substituted that of the *Lictors Returning to Brutus the Bodies of His Sons*—a distinctly Republican theme showing the first consul seated in his house when lictors return the sons whom he himself condemned to death for treason (fig. 5.8).[21] The story of Lucius Junius Brutus (not to be confused with Caesar's assassin) begins with the demise of the last king of Rome in the sixth century B.C., Tarquin the Proud. Tarquin had ruled autocratically, systematically eliminating his rivals including Brutus's brothers, both nephews of the previous king. The corrupt monarchy collapsed when Tarquin's son Sextus raped the virtuous Lucretia, the wife of the hero Collatinus who proudly boasted of her honor. In a dramatic exit, Lucretia assembled her father and her husband and their trusted friends Valerius and Brutus, and after explaining what occurred, committed suicide. Brutus—who until then had feigned stupidity to save himself—drew the dagger from the wound and swore on Lucretia's blood to banish Tarquin and his family. The others swore the same oath and together they sparked an uprising which deposed the king. The first Roman Republic was established, with Brutus and Collatinus elected joint consuls and committed to the principle that "the rule of laws [are] more powerful than men." Following these events, Brutus performed an act that supported this principle: his two sons, Titus and Tiberius, were seduced into a royalist conspiracy to restore the exiled king, and when the plot was discovered Bru-

tus was obliged to order and witness their execution. Livy reported that "the natural anguish of a father was apparent on Brutus's face as he performed his duty as public executioner."

David thus chose again the excruciating moment when stoic patriotism is tested by family ties, when the father-son relationship is subordinated to the laws of state, and when the feeble character of women is contrasted with the stern duty of the male. (In Voltaire's *Brutus*—one source of inspiration for David—Titus allows himself to be guided by Tullia, Tarquin's daughter, and thus corrupted by the effeminate side of his nature.) The composition struck the contemporaries as even more bizarre than the *Horatii;* while the canvas is sharply partitioned into male-female domains, there is no starting or culminating point. Brutus is seated brooding in full shadow at the extreme left clutching the document attesting to his sons' betrayal; the returning lictors trigger a violent response from the wife and daughters which in turn causes Brutus to momentarily start, pulling his head forward mechanically from the bent arm upon which it rested like a stiff Lavoisier. Brutus's feet are turned inward and pressed closely together, with even the toes curled in stress as he attempts to repress his paternal feelings. He has been meditating silently in the shade of an Etruscan statue of ROMA decorated with the fasces, symbol of unity, a figure of Liberty, and a relief of the fabled She-Wolf suckling Romulus and Remus. He has made the ultimate commitment to the principle of the state and the sovereignty of the people. ROMA screens out the bodies on their stretchers, emphasizing the idea of the free state above all. Brutus has essentially cut himself off from his earthly family, and in his "exile" can find solace only in the umbrage of the "higher" family to which he has now submitted himself. Brutus's almost mechanical and controlled gestures contrast strikingly with the explosive movements of his wife and daughters wracked with emotional spasms, a contrast all the more heightened by the bright light in their area and separation by a column and empty chair.[22] A sewing basket and iron shears lie on a table in the otherwise spare background, further emphasizing the women's domestic role and separate realm of existence. Only a lictor glances at the grief-stricken women, barely acknowledging their familial pain.

Although Vien and David took opposite political sides,

the *Brutus* may be compared with the former's *Love Free-ing Slavery* which was also displayed at the Salon of 1789. The narrative chaos and discontinuities in the formal arrangement of the two works point to a shared response to the disorder of civil life. The gesture of Brutus's wife is remarkably close to that of the servant in Vien's picture who holds open the cage and reaches desperately outward with a flat, open hand. Except for Vien's more sumptuous interior, various accessories and the general movement further suggest a commonality of pictorial inspiration. Above all, the eye is unable to find a resting place in either work: in the David the wife gestures toward the sons at the extremity of the picture, while in the Vien the servant grabs for the cupid flying out at the same edge. Both generations of neoclassicists—although coming from opposite political perspectives—convey a dissonant image wrought out of the anxiety of the moment.

During 1788–1789 when David worked on the *Brutus,* new political attitudes were developing that were catastrophic in their suddenness: the convocation of the Estates-General was proclaimed, and memorials and petitions poured out demanding the sovereignty of the people through double representation for the Third Estate and the voting by head instead of by Order. The Third Estate, which had previously seconded the privileged classes in their so-called struggle against royal despotism, suddenly discovered that its supposed allies were its enemies. The abbé Sieyès published his popular pamphlet *What is the Third Estate?* in February 1789, summarizing the case of the middle-class against privilege. The establishment of the delegations and the formulation of the grievances generated intense public excitement which was carried to fever pitch by the food riots caused by the disastrous harvest of 1788. The wild proceedings of the Estates in May and June 1789 pitted the Third Estate and their liberal aristocratic allies against the nobility with the former finally arrogating to itself the title of National Assembly, implying that it was, as Sieyès claimed, everything, and the other two Orders (clergy and nobility) nothing. After the oath on 20 June not to disband until joined by the other two Orders, the Third Estate suffered threats to disperse, but when joined by 170 clergy and fifty nobles the king reversed policy and on 27 June ordered the other two Orders to join them. But after this victory, the Third Estate began to grow uneasy: the min-

ister Necker, whose financial policies the bourgeoisie and artisans regarded as essential to reform, was dismissed on 11 July, and the concentration of troops near Paris intimated an impending military coup. Orators at the Palais Royal called the people to arms, and crowds surged daily in Paris, gathering around most public buildings and especially before the Bastille. The assault of the Bastille on 14 July, the general collapse of the royal administration, the lynchings, the frequent uprisings, and the chronic food shortages precipitated the Great Fear—panic fright of foreign intervention, scarcity, and anarchy. These events stimulated wholesale emigration of the nobility, which in turn fueled the fears of counterrevolutionary plots.

Thus by the time David applied the final touches to the *Brutus* town and country disturbances were endemic and society seemed ungovernable. David wrote to a student in June that he was busy with the Brutus despite his wretched personal state, and then noted that he felt "in this poor country like a dog thrown into a river against his will, and who struggles to reach the shore in order to survive."[23] David moved with the crowds in the storming of the Bastille, met and made a sketch of Robespierre, and by the time the work was exhibited (much to the disappointment of the royal commissioners who hoped it would not be done in time) his progressive position coincided with those who assumed power. He could not have missed the numerous implications of his theme for the contemporary events: even Sieyès's words echo those of Livy: "The Nation exists before all things and is the origin of all. Its will is always legal, it is the law itself," posing a national sovereignty in the form of a representative assembly over and against the monarchical sovereignty of the Old Regime. In the same letter to his student, David mentions his treatment of Brutus as "man and father," a recurrent motif now given a fresh slant by the circumstances of his own life: he was surrounded by disciples and was also the father of two sons. His favorite student, Drouais, toward whom he felt very protective, died in Rome in 1788. This aroused a sense of guilt, and with the breakdown of law and order in the public realm he feared for the safety of his own children. Whereas previously the father sacrificed himself for the sons, now the father sacrifices the sons to uphold the state—a psychological reversal due to the change in David's genera-

tional position and the want of protection from the public authority.

Brutus was the last picture David painted for the Old Regime, but it was the one that made him the artist of the Revolution. Voltaire's drama of the same subject (1730) was revived during this period, and the effigy of Brutus becomes synonymous with the most radical faction of the Revolution. When Voltaire's *Brutus* was performed in November 1790, the audience was polarized, with the royalists applauding Tarquin and the radicals cheering the lines favoring Brutus and the Republic. The republicans easily outshouted their adversaries, and the applause and cries were deafening when Brutus proclaimed: "Gods! Give us death rather than slavery!" On the second night, David appeared and placed on opposite sides of the stage busts of Brutus and Voltaire. At the end of the play, his picture of *Brutus* was re-created as a *tableau-vivant*.

David and Contemporary Theater

As we have seen, David knew many people in the theater and his works—the *Horatii* and *Brutus,* for examples—felt the influence of the great French playwrights. He shared further the aims of contemporary tragedians who wished to address the major political issues of the time. Among these was André Chénier's brother, Marie-Joseph, whose play *Charles IX, ou l'école des rois* enjoyed the same popular response as David's *Brutus* when it first opened in November 1789. Although clothed outwardly in the story of the infamous massacre of Protestants on St. Bartholomew's Day, it baptized the French stage in the name of the nation, the law, and the constitution. Chénier dedicated his play to the "French Nation," declaring that his aim was to transform the stage from "a school of flattery, mawkishness and libertinism" into " a school of virtue and liberty." He addressed Louis XVI as a monarch "full of justice and kindness," but warned him against duplicitous courtiers who threw up a wall between the king and his people. He called Louis XVI to his duty as patriot-king, appealing to his sense of equity beyond private interests.

There is hardly a scene in Chénier's play that does not condemn tyranny, fanaticism, and treachery as crimes of the court and exalt the cause of liberty, justice, and the rights of the people. In act 3, scene 1 the chancelier de

l'hôpital, taken by most contemporaries to be the persona of Necker, prophesies the time when

> to the grandeur of the throne
> There shall succeed the grandeur of the state,
> The people suddenly glorious again,
> Shall banish every prejudice and lie,
> And repossess themselves of their Natural Right.
> .
> Then shall these living tombs, these dread Bastilles,
> Crumble to dust beneath their generous hands
> Which impose on the Prince his duty
> And fix forever the limits of his power.
> Then shall our heirs, prouder than their ancestors,
> Recognize leaders but never masters,
> Happy beneath a justice-loving king
> Who restores their laws and liberty.

Charles IX, however, is portrayed as the dupe of court intriguers and the high clergy who ultimately sanction the massacre. The end of the play shows him struck with remorse, and the moral needed little emphasis:

> I have betrayed my country, its honor and its laws:
> In striking me, Heaven gives an example to other kings.

Not surprisingly, *Charles IX* played for over three weeks to an overflowing crowd; it proved to be the most effective revolutionary propaganda of the year.

Chénier's drama had been written in 1788 and underwent a similar kind of reinterpretation as the paintings in the 1789 Salon. Originally, the royal censor declared it too provocative and forbade its presentation. Just before the fall of the Bastille, Chénier began demanding the right to present his play but was again rebuffed by the royalists. He now embarked on a public campaign spearheaded by his pamphlet, *On the Liberty of Theater in France,* that was widely publicized in the press. It spoke out against censorship because those who can articulate their thoughts in print are the most effective enemies of "tyranny and fanaticism." Chénier declared that the morality of a country dictated the character of its stage, and, conversely, the stage affected the evolution of that morality. Having been grounded in the severe classicism of Tacitus and Sophocles, Chénier wished to embody his sense of patriotism in the form of "national tragedy" which could draw attention to the historic facts that threaten or ennoble the ideal national life.

In this he was noticeably affected by the Italian patriot-

dramatist, Vittorio Alfieri, who resided in Paris during the years 1787–1791 supervising the publication of his collected tragedies. Both Chénier brothers had met Alfieri and were exposed to his latest production, *Del Principe et delle Lettere* (The Prince and Letters), a defense of the thesis that where rulers exercise the right of censorship no authentic literature is possible. Alfieri's views influenced both Marie-Joseph's *On the Liberty of Theater* and André's *Essay on the Causes and the Effects of the Perfection and Decadence of Letters*. Alfieri and André especially became close friends, acknowledging each other in their work and carrying on an affectionate exchange of correspondence.

It was probably through the Chéniers that David met Alfieri, although they had several friends in common including Thomas Jefferson and Filippo Mazzei. Alfieri and David were almost exact contemporaries (David was a year older), shared identical political positions in the late 1780s, and both spread the cult of classicism in the service of a brighter national future for their respective homelands. For them the notion of ancient patriotic virtue encompassed the wider and modern conception of nationalism. Both read deeply into the same classical sources for inspiration—Livy, Plutarch, and Seneca—and looked for their model society to Rome of the Republic.

David encountered Alfieri at the home of the Italian author's mistress, the countess of Albany.[24] She was then legally separated from her husband, Charles Edward Stuart, the "Young Pretender" to the British throne. Some Catholic nations still recognized him, and the countess of Albany profited from this by receiving a pension from the treasuries of France and the papal states. Since this was her sole income she took care not to jeopardize it by dwelling separately from Alfieri while in Paris. She conducted a regular Salon which celebrities like the Chéniers, Jefferson, Mazzei, and David often frequented.

It was no coincidence that Alfieri had written plays about the two Brutuses in 1785. While in France he versified the first one (*Bruto Primo*)—based on the account in Livy used by David—in preparation for the publication of his collected tragedies in late 1788 and early 1789. Alfieri's dedication (signed and dated "Paris, 21 December 1788") was "to the most illustrious and free citizen, General Washington," whom he identified with the hero of his play: "The name of the deliverer of America alone can stand on the title-page of the tragedy of the deliverer of Rome."[25] The drama opens shortly after the suicide of

Lucretia as Brutus consoles Collatinus with the hope that the catastrophe may prove the signal for the establishment of Roman liberty. It then unfolds the plot in which Brutus's two sons are duped into subscribing to the conspiracy against the newly founded Republic. In the final scene Brutus sinks into his seat and averts his eyes from the execution of his sons. The curtain falls at the point where Brutus faces the audience and the lictors stand ready to strike the conspirators.[26] Thus it may be concluded that the topical meaning Alfieri attached to his drama in the dedication and the stoical gesture of Brutus in response to the outcome of his harsh decision significantly influenced David's conception.

The Brutus of both Alfieri and David embodied their liberal views based on the example of the American Revolution and support of fundamental constitutional reform. Descended from ancient Piedmontese nobility, Alfieri could be numbered among David's liberal aristocratic friends who comprised the Society of 1789. But as the Revolution progressed, Alfieri grew alarmed over the violent uprisings of the "rabble." While the politicalization of the work of David and Marie-Joseph Chénier predisposed them to a more radical position, Alfieri and André Chénier retreated to a more conservative one. But Alfieri's later professed disgust over the outcome was economically motivated: his fortune, which had been tied up in French securities, was lost during the course of the rebellion which also cost the countess of Albany her precious pension.

The Oath of the Tennis Court

The next major event in David's development as artist and revolutionary occurred in the spring of 1790.[27] On 20 June 1790, the first anniversary of the Tennis Court Oath, a popular society founded expressly to solemnize the event, opened a national subscription with the idea of subsidizing David who had already begun work on a commemorative picture. But Dubois-Crancé, a Jacobin deputy who participated in the oath, did not want credit for the initiative to go to a private group and induced the Jacobin Club—then only a group of constitutional liberals meeting to caucus on motions coming up before the National Assembly—to sponsor the picture for the government on 28 October 1790. The colossal work was to be financed through a subscription for an engraving of

the composition—an idea inspired by the successes of Gavin Hamilton and Benjamin West. (This project failed, however, and eventually the government stepped in to subsidize the commission.) Dubois-Crancé heralded the prospective monument as more significant than the erection of the pyramids, and wanted for its realization an artist who was "the author of *Brutus* and the *Horatii,* this French patriot whose genius foreshadowed the Revolution." And in words that recalled the motif of the *Horatii,* Dubois-Crancé noted that the people's representatives took refuge in the Tennis Court, and there "arms outstretched toward the Eternal One . . . made the oath to die rather than to separate before France was free."[28] Dubois-Crancé and David surely shared the insight that the *Oath of the Tennis Court* was a realization in actuality of the *Oath of the Horatii.*

Significantly, the careers of the two men incarnate the progress of classicism from a royal plaything to the ideological manifestation of the Third Estate. They were approximately the same age, and their fathers belonged to the upwardly mobile middle class. Dubois-Crancé's father had been intendent of police and finances attached to the army of the duc de Richelieu during the Seven Years' War. Dubois-Crancé himself spent thirteen years of his youth in the royal musketeers at Versailles, an experience that turned him into an ardent rebel. As deputy of the Third Estate from 1789, he always voted with the extreme left. Just as Dubois-Crancé broke the family tradition of serving the monarchy to throw in with the Jacobins, so David threw off the shackles of first-generation neoclassicism to impress it in the service of radical politics. It is not surprising that in his sketch of the *Oath of the Tennis Court* David gave Dubois-Crancé—who together with Barère enthusiastically supported his project—a prominent position: it is he who stands on the chair behind Robespierre dominating the right foreground with his forthright gesture (fig. 5.9).

The Estates-General and the Oath

While we have already reviewed the history of this event, it is necessary to recapitulate it as background to the picture. The financial crisis of the monarchy brought matters to a head. All attempts at fiscal reform since the Seven Years' War had been blocked by the vested interests led by the *parlements,* who covered their aims by at-

5.9 Jacques-Louis David, *Oath of the Tennis Court*, 1791, pen drawing with sepia wash. Musée du Louvre, Paris.

tacking a "despotic" king in the name of all the people. Then France became involved in the American War of Independence. We have already seen the consequence of this in the spread of democratic and republican ideas in France, but by far the worst consequence was final bankruptcy, and thus the American Revolution can claim to be the direct cause of the French.

Fundamental reform was now imperative. But the crisis gave the aristocracy and the *parlements* their chance: they refused to cooperate without an extension of their privileges. The first breach in the monarchy came when the controller-general, Calonne, summoned the Assembly of Notables in February 1787 to accept a new tax reform plan. They rejected his plan and that of his successor, Brienne. The privileged classes, now knowing that some reform was inevitable, requested the convoking of the Estates-General—the old feudal assembly of the realm akin to King Arthur's Knights of the Round Table—suppressed since 1614. The *parlements* now began to invoke Rousseau's concept of the "general will" and saw in the revival of the Estates-General the chance to retake the liberties lost to them by administrative centralization. Before this nationwide revolution of the privileged classes the king capitulated and summoned the Estates-General to meet on 1 May 1789. The Revolution thus began as an aristocratic attempt to recapture the state, for the calling of the Estates-General meant abdication of absolute monarchy.

But the *parlements,* who up until this moment had the

support of the wider public, made a fatal miscalculation. They underestimated the independent intentions of the Third Estate dominated by the middle class and over-looked the authentic nature of the economic crisis. The *parlements* wanted the Estates-General to be composed in the manner observed the last time they met, which meant that the representatives voted as Orders, and thus the Third Estate would always be in a minority of one to two when the three Orders voted. The interests of the privileged classes were instantly revealed and the Third Estate now came to the front, fighting to win a representation as large as that of the nobility and clergy combined, and for the right to exploit their potential majority votes by turning the Estates-General into an assembly of individual deputies voting by head rather than by Order. This reorientation of the Estates is seen in a contemporary engraving where the artist designated by a crisp vertical line the confrontation between the commoners shown at the extreme right and the other two Orders (fig. 5.10).[29] The Third Estate succeeded against the combined resistance of the king and the reactionary nobility because it represented not merely the interests of an educated and militant minority but those of the surging working-class poor of the cities and the rebellious peasantry. For what transformed mild agitation for reform into a revolution was the fact that the revival of the Estates-General coincided with a profound economic and

5.10 *Opening of the Estates-General at Versailles, 5 May 1789,* 1789 engraving. Vizille, Musée de la Révolution françoise.

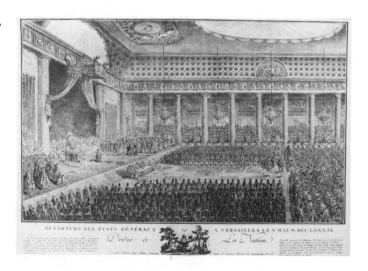

OUVERTURE DES ETATS GÉNÉRAUX A VERSAILLES LE V MAI M.DCC.LXXXIX.
Dedié à *La Nation*

social crisis. The disastrous harvest of 1788 especially made the situation acute, and disturbances over food shortages spread all over France in the spring of 1789. Bad harvests involved a general slackening of economic activity and led to a general decline in the demand for industrial goods. Hungry country laborers migrated to the towns to swell the ranks of the urban unemployed—evidence suggests that unemployment in industry reached a peak of 50 percent. The flood of pamphlets and propaganda circulating in this period gave these people a political perspective emphasizing liberty from privileged minorities and oppression. A mutinous people backed the deputies of the Third Estate.

By 17 June the members of the Third Estate had sufficient confidence to perceive themselves as embodying the "general will"; they boldly assumed the title of National Assembly, the representative assembly of the nation. Their defiance prompted the king, urged on by the comte d'Artois, to close the Parliament house on 20 June against the deputies and to prepare it for a royal session. Determined to resist what they perceived as a first step toward their dissolution, the deputies moved on to the royal tennis court *(jeu de paume),* whose large bare space more than adequately housed the group. Bailly, the president of the Third Estate, accepted a suggestion to swear an oath that was destined to become a charter of French liberty. The National Assembly now resolved to "take a solemn oath never to disband" until the constitution of the realm was set up on firm foundations.

This is the event that the Society of Friends of the Constitution (the nascent Jacobin Society) commissioned David to immortalize in 1790. David set out, like West in the *Death of Wolfe,* to transform the contemporary happening into a major historical picture free from the trappings—if not the allusions—of allegory and classicism. He had tentatively garbed the figures in Roman costumes, but reality had caught up with ideality, had become as compelling and exciting as antiquity, and now required a different approach. His intimate contact with daily events profoundly affected his art and his politics; while his liberal friends grew increasingly alienated by the direction of developments David continued to shift leftward and identify with the Jacobins. The intersecting of real life with David's neoclassicism is demonstrated by the fact that this composition springs directly from the

Horatii; the gestures of the Horatii brothers are repeated in the motions of the deputies as they take their oath, but are now multiplied and extended as if the representatives of the people reenacted the scene for the whole of society. As in the earlier picture, David signifies the unity of minds and bodies in the service of a patriotic ideal; this time, however, the union reaches across family ties to envelop more realistically different class, religious, and philosophical opinions. The outpouring of fraternalism, the embracing and loving gestures by members of all three Orders, further clarifies the nature of such events for a male-dominated world. It is altogether consistent with his artistic and political development that he joined the *Horatii* to his drawing of the *Oath of the Tennis Court* in the Salon exhibition of 1791.

The political message of the *Oath of the Tennis Court,* however, was even more visually pointed than in the *Horatii;* whereas the Horatii consecrated their action to an abstract ideal (one still unattainable in the real world—hence "ideal"), the deputies of the Third Estate and their aristocratic allies swear to fulfill a concrete objective. This specificity further reveals itself in the material presence of the forces arrayed against them. In the upper-left-hand corner of the lofty interior space a sudden gust of wind drives the billowing curtains of the window inside, disclosing a glimpse of the royal chapel of Versailles in the distant background. The effect resembles an explosion surrounding the royal house which seems to shake it to its very foundations. While historically the oath did indeed take place during a storm—we see one spectator struggling with his umbrella against the wind and rain—David seized the opportunity to both dramatize the event and drive home his political message.

David projected the work on a gargantuan scale (more than 20 × 30 feet) with the key protagonists looming life-size in the foreground, but the commission proved too overwhelming for him to complete in the context of his manifold political obligations. His official functions both as artist and revolutionary prevented him from immediately finishing the ambitious project. In the long run, however, the changing political circumstances rendered it a stillborn child of the Revolution. As the insurrection progressed, the shifting political alignments transformed many of the deputies David would have immortalized as deliverers into victims of the scaffold—

condemned as traitors to the Revolution. Under these circumstances, his initial inspiration must have dissipated and finally turned to loathing. How could David have confronted in later years a work depicting heroic self-sacrifice when its central figure was cruelly executed for entertaining the same views he held at the moment of the oath?

What remains therefore are fragments, scattered portrait studies, and the large colored drawing of 1790–1791 which was exhibited in the open (nonjuried) Salon of 1791 together with his major prerevolutionary pictures—*Horatii, Socrates,* and *Brutus.* Clearly, he wanted to establish a link between the *Tennis Court* and his neoclassical masterpieces. The large unfinished study at Versailles demonstrates that he began building each figure from the nude before adding clothing, that he essentially established a classical base for his contemporary superstructure (fig. 5.11).

The deputies themselves act with the gestures of classical drama. The central figure, Bailly—president of the assembly, dear friend of Lavoisier and André Chénier, astronomer, mayor of Paris, who would be executed during the Terror—stands on a table administering the oath, his right hand raised to heaven. From all sides carefully balanced groups of deputies stretch out their arms toward him. Sieyès sits unmoved at the table, as if pondering the event; old Gérard at the right, the peasant deputy, is clasping his hands in prayer; Barère, a journalist, is reporting the scene, pen in hand; Robespierre strikes a dramatic attitude near Gérard, his head thrown back, and both hands upon his breast, as though (according to David) he had two hearts beating for liberty. Near

5.11 Jacques-Louis David, *Ebauche of Oath of the Tennis Court*, begun 1791. Musée national du château de Versailles, Versailles.

him, his body concealed by the crowd, is Dupont de Nemours, one of the many liberals soon to be outflanked by the rush of events. Standing on the chair, Dubois-Crancé strikes the attitude of the "noblest Roman of them all," while Mirabeau, wearing black, his legs splayed like the Horatii, gestures melodramatically. In the foreground a monk (Dom Gerle, who was not there), a priest (Grégoire, who actively campaigned on behalf of Jewish emancipation), and a Protestant pastor (Rabaut Saint-Etienne) embrace one another in a sign of unity and religious tolerance. Despite the compositional and narrative coherence, however, David manages to communicate the tumult and exuberance of the mutinous decision to assume "all authority in the Kingdom."

David's great project inspired his friend André Chénier to compose an ode entitled *The Tennis Court: to Louis David, Painter*. It was composed and published during the winter of 1790–1791 when the two men were still closely associated. (The Trudaines probably covered the cost of the printing.) It was an important milestone in Chénier's career because he made his public debut as a poet with *The Tennis Court*. Chénier establishes David's link with the antiquity from the outset by identifying the work and its patriotic message with the poet's own "ancient discourses." He recapitulates David's pictorial development in alluding to the *Belisarius, Socrates,* and *Brutus,* and then relates the "virile oath" of the *Horatii* to the "more noble oath" of the *Tennis Court.*

Chénier suggests that the events leading to the Tennis Court Oath resulted from conditions that were not only conducive to political growth but to artistic growth as well. The choice of words here: "Virile liberty is the contented genius of the arts . . . No talent is born of royal favor," echoed the ideas of Chénier's brother Marie-Joseph and their friend Alfieri who stressed that genius could only flourish in an atmosphere of freedom. The same application of rational principles which would form the foundation of a workable constitutional government also guarantees the exalted example of David's picture.

The first two-thirds of Chénier's ode glorify such revolutionary events as the oath to provide France with a constitution, the storming of the Bastille, the shift of the government from Versailles to Paris, and the acts of the National Assembly in eradicating the Old Regime and laying the groundwork for the new. Yet, if in this part

he celebrated the progressive movement which underlay the events surrounding the Tennis Court Oath and gave rise to David's painting, in the last third he anticipated his falling out with the artist in warning the people against the abuse of power in the name of liberty. He lashed out against demagogues who incite the people to commit atrocities, and called upon the "sovereign people" to shun the "avid courtesans." He stated that those who oppress others abdicate their own freedom. Considering fanaticism as one of the worst enemies of justice, Chénier spoke out in favor of moderation and reason, stressing that it is better that those guilty of crime go free than to commit outrages against the innocent in a fit of overzealous and misguided patriotism.

The concluding lines of the ode apotheosize the eternal values of freedom and therefore move beyond the specific events of the Tennis Court Oath to the lasting Order which can arise only when liberty is seen as the driving force of all historical action. As the poem ends, the heroes and the villains, the rich and the poor, the politically powerful and the politically oppressed are all swallowed up in the sea of destiny:

Necessity lingers, inflexible and powerful,
To this sovereign tribunal
Your tottering majesty:
There the cries of the human species will be gathered;
There incorruptible judge, and the hand on the thunderbolt,
Will disappear, reduced to powder.[30]

Thus in the last section Chénier became the prophetic bard, estimating the dangers that will threaten the realm, and vaguely implying that David will never finish the great canvas and that before long those whom the artist hoped to glorify as heroes will die on the scaffold as traitors.

The American and French Revolutions Compared

The first stage of the French Revolution may be compared to the American War of Independence; neither of these was a popular uprising in the modern sense, although they attempted to redistribute power on a broader basis. Their aims were moderate, conservative, and sober—qualities embodied for the later eighteenth century in the almost archetypal figure of George Washington. For him, however, and for most of his peers, liberty was

not a moral abstraction, still less a slogan of social up-heaval; its invocation was simply the most expedient means of insuring the hegemony of America's ruling class. The English had to stand for tyranny, the rebels for freedom. The result, enshrined in the Declaration of Independence, ironically became the manifesto of almost every later democratic movement. It is no coincidence that the French Declaration of the Rights of Man was modeled on the American declaration, or that Jefferson—then American minister to France—was consulted in drawing up the drafts.

The second stage of the French Revolution, however—the one that frightened Chénier—was more radical and violent than the first. It abolished the monarchy, institut-ed the Republic, and fundamentally altered social rela-tionships. The American Revolution had been more po-litical than social; there was no aristocracy to overthrow, and in fact one group of Tories replaced another—most of whom abhorred the second stage of the French Revo-lution. As Hobsbawn has written, the distinctive feature of the French Revolution was that one faction of the lib-eral bourgeoisie remained revolutionary up to and even beyond the brink of conservative withdrawal on the part of the others: this group was the Jacobins that commis-sioned the *Oath of the Tennis Court*. David's rip-roaring presentation of the event was thus conditioned by his identification with the radicals who moved the rebellion to its most advanced position.

Trumbull and David

The differences between the extreme stage of the French Revolution and the moderate American Revolution were commemorated by their respective official artists, seen most vividly in a comparison of David's *Oath of the Ten-nis Court* with John Trumbull's *Declaration of Indepen-dence*—perhaps America's best-known painting (fig. 5.12).[31] The two situations involved the same high stakes and were equally tumultuous, but while David's picture bristles with energy and commotion, Trumbull's is gro-tesquely inert and dull. David animates the original event with all the excitement of a true believer; Trumbull con-geals his scene into a waxworks display totally devoid of the stormy passions it aroused. The explanation of their dissimilar approaches lies in their opposing political alle-giances.

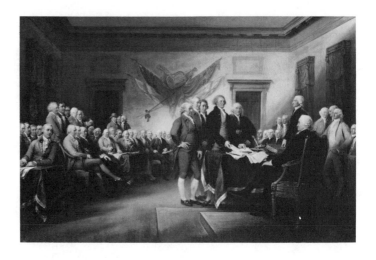

Trumbull was born in a conservative, privileged milieu of prominent merchants and shipbuilders; the Trumbulls had their own family coat of arms, and John's father rose to become governor of their native Connecticut in 1769. Trumbull graduated from Harvard, the first American artist to receive a college degree. At the height of the American Revolution, Trumbull went to study art in London where he admired the well-ordered, cultivated life-style of the upper classes. He settled there for several years, and it is not surprising that many contemporaries perceived distinctly pro-British attitudes beneath's the patriot's facade.

Trumbull went to work under Benjamin West and was early indoctrinated in the political application of neoclassicism. His first major work (now lost), *The Deputation from the Senate Presenting to Cincinnatus the Command of the Roman Armies* of 1784, gave the protagonist the features of George Washington—Trumbull's vision of the "American Cincinnatus." The following year Trumbull began *The Death of General Warren at the Battle of Bunker Hill*, inaugurating a series of pictures devoted to the American Revolution (fig. 5.13). He painted it under the watchful eye of his mentor whose *Death of General Wolfe* provided the main source of inspiration. As in West's epic picture, *The Death of General Warren*—composed in the form of an ancient frieze—raises contemporary warfare to the heights of classical tragedy.

West and his aristocratic friends and patrons acclaimed it as "the best picture of a modern battle that has been painted." This would seem to contradict attempts to

5.13 John Trumbull, *The Death of General Warren at the Battle of Bunker Hill, 17 June 1775,* 1786. © Yale University Art Gallery, New Haven.

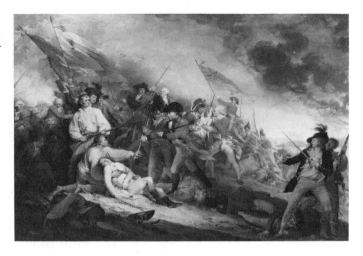

classify the work as an example of American patriotic painting and square more with Trumbull's political outlook at the time. Although centered on the martyrdom of the physician-leader of the Massachusetts militia, the work apotheosizes the pyrrhic victory of the British at Breed's Hill (an incident notoriously misnamed). The British are shown routing the Americans, with the central motif highlighting the action of the English major John Small in preventing a grenadier from bayoneting the expiring Warren. Small enjoyed a reputation as an example of British humanity and kindness to American prisoners. Another English officer in the picture, Major General John Pitcairn, falls mortally wounded into the arms of his son, while in the center middleground Lieutenant General Sir Henry Clinton raises his sword in victory. In stressing the sacrifices endured on both sides, Trumbull pitched the painting to a pro-British audience. He viewed the War of Independence as a tragic civil war rather than as a revolution, the position of the American Loyalists who fled to England shortly after the Revolution erupted.

In the spring of 1786 Trumbull fell in with Jefferson who was visiting London from Paris on diplomatic business. They hit it off immediately and Trumbull became Jefferson's protégé and confidant. He visited Jefferson in Paris later the same year and again during the winter of 1787–1788, when he arrived armed with letters of introduction to leading French collectors and dealers such as Jean-Pierre Lebrun, Vigée-Lebrun's husband. Trumbull also met d'Hancarville at this time, no doubt feeling very

much at home with the French adventurer, hustler, and promoter of neoclassicism. Equally significant, Trumbull was introduced to David in this period "who became and continued my warm and efficient friend.[32] Trumbull shared Jefferson's ardent admiration for David whose *Socrates* the minister considered one of the great masterpieces of the era. Trumbull saw the *Belisarius* and the *Oath of the Horatii*, and even found time to dash off a copy of David's *Andromache Mourning over the Body of Hector* while visiting the academy's gallery at the Louvre. Through Jefferson and David, Trumbull came into contact with the Trudaines and others from aristocratic liberal social circles. His encounter with Maria Cosway sparked a close friendship, and later he acted as go-between for Jefferson and Cosway, transmitting the undercover correspondence of the two lovers.

During this visit, Trumbull stayed with Jefferson at the American minister's mansion working out the initial scheme of the *Declaration of Independence* that they had jointly conceived the year before. Jefferson's information and advice was instrumental in the realization of the project. But though begun in 1787, the work advanced most rapidly in the years 1790–1793 when Trumbull had returned to the United States. Due to the critical demands of the portraiture, the execution of the work extended until 1820, during which time the artist enlarged his composition to accommodate life-size figures for his version in the rotunda of the United States Capitol.

Given the relationship between David and Trumbull, it is not surprising to find a correspondence between the *Tennis Court Oath* and the *Declaration*. David must have been informed about Trumbull's work in its early stages, and the impression of a body of patriots proclaiming their independence from royal tyranny must have been in his mind at the time he conceived the *Oath*. Conversely, the pictorial evidence indicates that Trumbull owed a major debt to David's scheme in his separate clusters of figures, individual poses, and the frontal, box-like space. Trumbull's initial sketches depicted the interior from an oblique angle, and only much later did he introduce the frontal arrangement. Additionally, two of David's figures are repeated in almost identical location in the Trumbull: the seated Barère at the left, legs crossed and quill in hand, is analogous to Trumbull's Richard Henry Lee, while David's Barnave, standing at the right just behind Mirabeau, furnished the pose for Edward Rutledge,

delegate from South Carolina, closing off the composition at the far right. Trumbull could have known David's work in both etched and engraved versions, or he could have seen the original during trips to Paris in the 1790s.

Like David, Trumbull deployed his personages with the dignity of ancient sculpture. The central group of Jefferson, Adams, and Franklin are derived from classical prototypes; the grouping and gestures of the other figures are executed with the gravity bestowed on rulers and military heroes in typical Roman classical relief. Yet, as mentioned previously, the two works are as dissimilar as night and day. David's sense of total commitment and the fervor of the moment is completely absent in the Trumbull. In this respect, Trumbull's presentation is inaccurate: the members of Congress assumed as great a risk as did the deputies of the Third Estate, and in both cases there was sharp disagreement, excitement and tension. John Dickinson, who alone wears a hat in Trumbull's *Declaration*, refused to sign the document as too drastic and as a step toward war—a statement of dissent echoed in the *Oath* by the lone deputy, Martin d'Auch, who opposed the oath and kept his hands to his chest. Nevertheless, Trumbull's figures stand stiff and formal, fossilized into a mythologized state more appropriate to the late date of its completion than to the date of its conception. Here the moment of insurrection is shown as orderly, as if the reins of authority have been exchanged in an entirely business-like manner. Indeed, the effect of the whole is rather like the declaration of a dividend at an annual meeting of corporate shareholders.

Trumbull cast the event into an image perfectly consistent with the ideology of the class to which he belonged. Most of the signers of the Declaration of Independence were wealthy landowners and slaveholders, a veritable middle-class "aristocracy" in their own right. With the possible exception of Jefferson and a few others, they were less concerned with overthrowing the monarchical system than with the prospect of paying burdensome taxes. Several of the Northerners were among the wealthiest people in the colonies, and over half of the Southerners belonged to the planter class and owned slaves. Franklin had a considerable fortune earned in part from investments and land speculation in the Ohio River Valley, while John Hancock, seated prominently up front in Trumbull's picture, was the wealthiest person in New

England and in the forefront of the protest against the Stamp Act. There is no mention in the Declaration of Independence of disenfranchised groups like slaves, indentured servants, women (which bothered Abigail Adams), or of social groups like small farmers and the debtor class excluded from the electoral process by property qualifications. The members of Congress who adopted the Declaration perceived the State as a reflection and a bulwark of the dominant class. They did not see themselves as unruly revolutionaries but as those who rightfully possessed the effective power.

Trumbull himself hustled as both artist and businessman, ending up as a person of considerable property and social prestige. He made regular voyages to Europe to negotiate business with diplomatic transactions, buying French brandy for a group of British investors on one occasion, speculating in tobacco with a partner in Paris on another, and making timely investments in French bonds during the period of the Directory. Art and trade he considered interchangeable terms, and at one point speculated in the dealing of Old Master paintings which were acquired from French families impoverished by the Revolution. West taught him all about the profitable use of engravings, and he earned a good deal of money from the sale of prints of his revolutionary pictures. He went to great lengths to promote a subscription for the projected engraving of the *Declaration*, engaging in flag-waving rhetoric that by now has a familiar ring.

It is not surprising to find that Trumbull joined the Federalist Party. Under the sway of Alexander Hamilton, the Federalists embraced a conservative wealthy elite, advocated a strong central government, and wanted to maintain strict neutrality, if not outright opposition, toward the revolutionary government in France. Ironically, this meant that Trumbull threw in with the bitter foes of his old friend Jefferson who headed the opposing Republican faction favoring yeoman farmers, a loose confederation of states, and support of the French Revolution. (Indeed, it may be argued that the split and definition of the two parties were catalyzed by the second stage of the French Revolution.) This falling-out with Jefferson certainly contributed to Trumbull's loss of nerve in the handling of the *Declaration*; analogous to David's motive for abandoning the *Tennis Court Oath* project, changing political circumstances in the United States

made inevitable partisan interpretations of the Declaration of Independence.

Significantly, during the critical period 1794–1800 Trumbull neglected work on the picture in favor of diplomatic errands for the Federalists and his business speculations. As against the Republicans, he welcomed the Jay Treaty which promoted trade relations with Great Britain but alienated the French. France was at war with England and felt betrayed by the young nation it had supported in its own struggle against their common enemy. Eventually, the Jay Treaty spawned the nasty *XYZ* Affair in which the French tried to exploit the American government's desire to patch up their differences. When Jay became special envoy to Great Britain he chose as his secretary the loyal Trumbull who accompanied him in 1794 to work out the details of the treaty. Jay sent Trumbull to Paris in March 1795 to inform James Monroe, then American minister in Paris, of the terms of the treaty. But Jay wanted Monroe to keep the details secret, while the minister, a Republican sympathizer, thought it his duty to inform the French government. When Monroe insisted on keeping his pledge to the French, Trumbull withheld the communication of the details, which hardly endeared him to the French. Later, Trumbull acted as a mediator for Rufus King, American minister to Great Britain, and became embroiled as a go-between for American and French agents in the bribery attempt known as the *XYZ* Affair (named by President John Adams as *X*, *Y*, and *Z*).

His involvement in Federalist policies, his shady business dealings, and his undercover activities placed his position in jeopardy in France in October 1797. All his attempts at securing a passport to leave Paris had failed, and in desperation he called upon the one person he thought might be able to influence the local authorities: Jacques-Louis David. During this encounter, they had an exchange that revealed the political gap between them. Trumbull reflected on the violent turn of the French Revolution, and while David admitted this he also concluded that "it would have been well for the Republic, if five hundred thousand more heads had passed under the guillotine." Trumbull then experienced a cold shudder, but years later he could see David from a larger perspective:

David was naturally a kind and warm-hearted man, but ardent, sometimes even violent, in his feelings; an enthusiastic admirer of the Roman republic . . . he most admired the elder Brutus, who had sacrificed his two sons for the good of his country. He had painted a fine picture of this subject, and had wrought up his own feelings to the belief that all which was otherwise dear must be sacrificed to our country. When the Revolution commenced in France, he took the popular side, devoted all the energy of his character to the establishment of a republic, (that favorite phantom of the age) . . .[33]

Here Trumbull testifies in his own *Autobiography* to a certain disillusionment over the hopes and ideals of 1776, and this too is manifested in his presentation of the *Declaration*.

David's Role in the New Government

Like Trumbull, David was a political activist but in the service of the Revolution; in 1792 he was elected deputy to the National Convention, and that same year he assumed the position of propaganda minister and pageant director, organizing and planning the public festivals and ceremonies, floats, parades, banners, and theatrical backdrops.[34] He did almost every professional chore the new government demanded of him, including erecting or painting memorials of its martyrs, inventorying national art treasures, supervising new commissions and competitions, and even producing political cartoons attacking England. He was the official supervisor of state ceremonies and designed celebrations on such a scale that virtually the entire population of Paris was directed to participate in them. These were inspired by the festivals of antiquity, and eighteenth-century heroes like Voltaire were joined to ancient idols like Brutus. David designed special revolutionary cards eliminating the king, queen, and knave; he designed costumes reflecting the influence of Roman garb and thus the new spirit. Hence just as there was an ideological shift in neoclassic painting, so the applied arts also underwent a radicalization in the service of the Revolution. An outstanding illustration of the new approach in the applied arts is seen in David's unfinished project for an opera curtain, dating from the period 1793–1794 (fig. 5.14). David conceived the scheme as a popular procession in which the chariot of the people crushes under its wheels the symbolic attributes of kingship, church, and feudalism. Seated atop the chariot is a

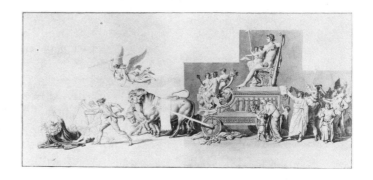

monumental Hercules, while a parade of ancient and modern heroes—Marat and Brutus included—accompanies its triumphal march. Ahead of the procession two *sans-culottes* (those who wore proletarian trousers in preference to aristocratic breeches, hence by extension all working-class republicans from the Paris slums) are applying the *coup de grâce* to fallen kings, and crowning their act is the allegorical figure of Victory hovering overhead.

The propaganda processions of the Revolution invoked the contemporary mania for antique institutions. In July 1791 the remains of Voltaire were transferred to the Pantheon in a festival of anticlericalism marked by groups wearing Roman costume and marching with imitation Roman standards and medallions. The sarcophagus lay between four antique candelabra which could have come straight out of Caylus or Adam. Indeed, many of David's careful tracings of the engraved plates of the antiquarians served as models for the decor of the festival. The following year David organized a public festival of Liberty in honor of the Swiss guards of Châteauvieux who mutinied against a contingent of loyalists. A controversial event which signaled the rupture between David and André Chénier, David glorified the recently freed Swiss survivors through neoclassic allusions. A huge triumphal chariot bearing a seated statue of Liberty and adorned with patriotic reliefs dominated the pageant. But perhaps the greatest of David's enterprises was the Festival of the Supreme Being held at the height of the Terror on 8 June 1794. He directed the festival in conjunction with Robespierre to celebrate the deistic religion calculated to weld together the disparate (and severely frayed) strands of the Revolution. Rousseau, Voltaire, and Brutus figure prominently, and among the antique rites and

observances was a civic oath in which sons draw their swords from the hands of their venerable fathers, "swearing to make equality and liberty triumph over the oppression of tyrants."

As deputy of Paris to the National Convention, David campaigned in favor of the arts for propaganda purposes and mobilized artists behind the new regime. His presence was felt in all the major art commissions, competitions, and artist unions. He headed a group of dissidents who wrested power from the academicians and projected sweeping reforms of the academy's statutes, and, finally, in 1793 aided substantially in abolishing all the academies as bastions of privilege and abuse. For his loyalty the Jacobins elected him president of their club and appointed him to the powerful Committee for Public Safety (designed to curb counterrevolutionary activities within and without France), in which capacity he signed the warrant of arrest for many people later guillotined. At the trial of Louis XVI, David voted for death without delay or appeal. All these activities undermined his family life and separated him from his wife, indicating his total involvement with the extreme radical faction of the Revolution.

We may now try to recapitulate briefly the sequence of historical events to better establish David's relationship to them. It may be recalled that between 1789 and 1791 it was the victorious moderate bourgeoisie who set about the reform of France. The major institutional achievements of the Revolution date from this period, as do its most impressive international contributions such as the metric system and the pioneer emancipation of Jews. The social and economic outlook of this group was entirely liberal: its policy for the peasantry was the enclosure of common lands for redistribution to individuals and the encouragement of rural entrepreneurs; for the working class, the abolition of artisan guilds. The 1791 constitution set up a parliamentary system based on property qualifications. It did help the common people in the secularization and sale of church lands (as well as those of the emigrant nobility) which were parceled out as a kind of return for revolutionary activity.

But the outbreak of war led to the second revolution of 1792, the Jacobin Republic of the year 2 and eventually to Napoleon. Two sectors of French society forced France into a general war: the extreme right and the moderate left. For the king, the French nobility, and the horde of aristocratic and ecclesiastical emigrants, only

foreign intervention could restore the Old Regime. This received the endorsement of nobles and monarchs elsewhere who felt that the restoration of Louis XVI's power was not merely an act of class solidarity but an important shield against the growing threat of the dangerous ideas coming out of France.

At the same time, many moderate liberals—especially those rallying round the deputies from the mercantile Gironde department and known as the Girondists—assumed a bellicose tone. They had a missionary feeling about the revolution, proclaiming the liberation of France as only the beginning of a universal march toward liberty. This was tied to their laissez-faire economic policy which viewed the market in global terms. More pragmatically, they also believed that war would help solve the problems on the home front. It was tempting then, as now, to try and weld various factions together by blaming the difficulties of the new regime on plots of emigrants and foreign tyrants, and to divert popular discontents against these. Businessmen further argued that the unstable economic conditions could be resolved if the threat of invasion could be eliminated. Finally, most of the Girondists were merchants or represented big business and thought of war as an opportunity to outdo England in commercial rivalry.

War was declared against Austria and Prussia in April 1792. Early defeats, which the public blamed on royal sabotage and treason, radicalized French society. In August-September the king was dethroned, the Republic established, and a new age in human history proclaimed with the retroactive institution of the year 1 as the start of the French Revolution. The second phase of the Revolution unfolded with the September massacres of the political prisoners, the elections to the new constituent assembly, designated the National Convention, and the call for total resistance to the invaders. During the ongoing crisis, the new government learned how to mobilize the entire nation's resources through the abolition of the distinction between soldier and civilian, rationing, and a tightly controlled war economy. And it managed to succeed in halting the foreign invasion at Valmy.

It was mainly the threat of foreign intervention that gave rise to the bloodier and more radical stage of the Revolution. Until then the most that was envisaged was a constitutional monarchy. After the Prussians declared war in the summer of 1792, the French Assembly an-

nounced a state of national emergency. The proclamation on 11 July, "La Patrie en danger!" (The Country in Danger!), was issued throughout France, and represented a call to arms. As there was no standing army, every eligible male became an instant soldier, and enrollment booths were set up everywhere for volunteers. Fears of conspiracy from within and the war without agitated the populace. News of the Prussian commander's aim in behalf of the Austrian and Prussian rulers to end the prevailing anarchy in France and restore royal authority only exacerbated the tension. Popular anger now concentrated upon the court, the emigrants, and the foreign foes. A vociferous segment of the people now advocated the overthrow of the monarchy and also the impeachment of Lafayette whose moderate stand now appeared as retrograde. But the Legislative Assembly refused to take drastic action, and in frustration Parisians attacked the Tuileries Palace on 10 August 1792.

This event was commemorated by the painter Jacques Bertaux, whose *Attack on the Tuileries, 10 August 1792* was exhibited at the Salon of 1793 (fig. 5.15). Bertaux captured the frenzied rioting and shooting in which more than a thousand persons were killed, shot, or trampled underfoot in panic. While the king's palace was defended by gendarmes, National Guards, and royalist volunteers, Bertaux's work emphasized the struggle between the popular classes and the Swiss mercenaries, thus underscoring the king's reliance on external aid. The artist shows a late phase of the fighting when the attackers, reinforced, pushed the king's defenders into the royal

5.15 Jacques Bertaux, *Attack on the Tuileries, 10 August* 1792, Salon of 1793. Musée national du château de Versailles, Versailles.

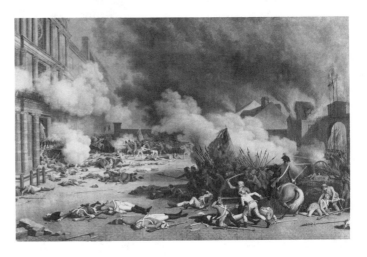

courtyard of the palace for the final showdown. In the right middleground a group armed with pikes and wearing the red liberty bonnet (actually modeled on the Phrygian cap of antiquity worn by enfranchised slaves) prepares to charge the Swiss defenders in the entrance of the palace. In the foreground two *sans-culottes* savage a fallen Swiss guard—a group that probably influenced David's motif in the opera curtain project. Bertaux's picture accurately depicted the outcome as a people's victory; among the dead insurgents were carpenters, house painters, tailors, hatters, boot makers, locksmiths, hairdressers, and harness makers—over sixty occupations represented in all. Two of the many women combatants were among the wounded, reflecting the participation of a wide range of ordinary citizens who had been thought too insignificant to have a vote or a voice in the Revolution.

Gérard

Before the fighting had begun the royal family retreated across the gardens to the door of the assembly house. There the king and queen, the king's sister, and his two children sat in one of the press boxes (*loge de logographe*) while the deputies discussed their fate. Thunderstruck by the turn of events, the deputies deprived the king of his powers and decided on elections to save the country. David's student, François Gérard, executed a sketch of this situation revealing the aggressiveness of the popular classes, the consternation of the deputies, and the fear of the royal family glimpsed behind in the press box at the right (fig. 5.16). Gérard gives the male and female *sans-culottes* the pose of the Horatii, although in this instance it is less an oath of commitment than an accusatory gesture. They form a solid front moving belligerently toward the deputies who retreat, rear backward in indignation, or collapse into tears. In the galleries overhead the people clamor with wild gesticulations for appropriate action. Beneath a placard that reads "No more king" a wife supports her husband wounded earlier in the fighting, while a mother puts one arm around her son armed with a sword and with the other holds up a liberty bonnet. Above the crowd one sees a banner with the inscription "Fatherland, Equality, Liberty," thus making it clear that 10 August was the radical and popular stage of the French Revolution. As if to underscore this dramatic shift, a deputy seated at the far right—noticeably resem-

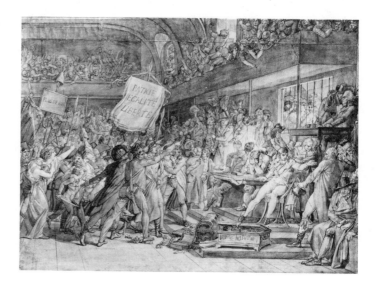

5.16 François Gérard, *The 10th August 1792*, 1792, pen and ink drawing Musée du Louvre, Paris.

bling the abbé Sieyès in David's *Tennis Court Oath*—recoils in horror at the turn of events that has transpired since the Third Estate first seized the initiative in June 1789.

Gérard's *sans-culottes* are not as sympathetically drawn as the deputies, lacking their range of expression and character differentiation. Despite the pictorial recognition of the people's achievement, they are depicted as the "mob"—the terrifying horde that sent the emigrants scurrying across the border. Gérard was much more conservative than David; he was born to a cultivated family in Rome where his father organized the household of cardinal de Bernis, French ambassador to the Holy See. When the family returned to France in 1780 his father worked for the reactionary Breteuil, a minister of the royal household who left in the first wave of émigrés. Through Breteuil's influence Gérard received special art training subsidized by the king. *The 10th August 1792* is exceptional in his work and done to ingratiate himself with David. Thanks to the master he received all kinds of favors including exemption from military duty.

Girodet

Gérard's pretense comes out in correspondence with his close friend Anne-Louis Girodet-Trioson, a fellow pupil of David who spent the critical revolutionary years in Italy. Girodet ridiculed David and made Gérard privy to

his cynical, hypocritical letters to the master.[35] Girodet had especially high social pretensions, grounded in part by the curious circumstances of his childhood. His father and mother both came from privileged backgrounds, and the elder Girodet had charge of the estates of the duc d'Orleans. Girodet's parents were strongly attached to the monarchy and hoped to see their son become an officer of the king's army like his brother had. But both parents died while he was still young, leaving him emotionally deprived and hungry for love. He was adopted by a close family friend named Dr. Trioson, an official physician of the king's army who later served in the royal household. Despite Girodet's financial security, however, he had an inordinate need for fame and adulation and sought out the company of the rich and influential. He was keenly competitive to the point of cheating in the Prix de Rome contests. Although caught and excluded in 1787, he got away with the same unorthodox method in 1789 and won the prize. He left for Italy in 1790 where he remained for the next five years, experiencing from afar the tensions of his native France.

During his Italian sojourn, Dr. Trioson was forced to surrender Girodet's feudal rights, and the good physician's important role in the circle of the king's family made him particularly vulnerable to Jacobin suspicions. He incurred losses of property and at one point was arrested. Girodet's own ambivalent position subjected him to pressures from both the right and the left: in Italy he was exposed to the attacks against all French persons not officially classified as emigrants. He tried to avoid the label of "revolutionary" by changing his hairstyle (unpowdered short hair was the sign of "Jacobin opinions"), shunned acquaintances known for radical convictions, and never challenged Italian tirades against the Revolution. Nevertheless, he was still subject to scrutiny by the Italian police and harassed and even arrested on several occasions on suspicion of espionage.

But this high-voltage situation only underscored the reactionary milieu in Rome which extended a warm welcome to the fleeing émigrés. At best a moderate conservative in the first stage of the Revolution, Girodet was nevertheless open to criticism instigated by his aristocratic countrymen. Pressure from the other side was shown in an experience that occurred on his way to Rome: he stopped in a small French village near Lyons to sketch old monuments, but since his dress and demeanor were

aristocratic the local inhabitants supposed him to be a spy in the pay of nobles gathering data for an enemy invasion. He and his party were almost lynched—attesting to the tense conditions under which he made his departure.[36]

His pictorial reaction to his shaky position in Rome was the *Sleep of Endymion*, begun in the spring of 1791 (fig. 5.17). In a letter to his foster father, dated 19 April, he refers both to his work on the picture (its effect "is purely ideal") and to the arrival of the *émigrés* enthusiastically received by the pope and Roman aristocracy. It is clear that concern over the political events and the development of his painting fused in his immediate experience. *Endymion*, however, seems far removed in both style and content from the actual anxieties reflected in Girodet's life and thought. It shows the nude Endymion reclining under a tree while Eros—in the guise of Zephyr—pulls aside the foliage to allow the rays of the moonlight to fall on his face. Girodet's dramatic juxtaposition of light and shade is highly evocative, catching the erotic character of the myth in which Diana, Goddess of the Moon, caresses her loved one with the moon's soft light. Her nightly pause to gaze upon Endymion's beauty before kissing him is represented by the focusing of moonbeams on his countenance. Girodet's response to his crisis takes the form of erotic escapism.

According to the myth, Diana, who could not bear the thought of Endymion's beauty marred by want, worry,

5.17 Anne-Louis Girodet-Trioson, *Sleep of Endymion*, 1793. Musée du Louvre, Paris.

age, and exposure, caused an eternal sleep to fall upon him and carried him off to Mount Latmos, where she concealed him in a site accessible henceforth only to her. It is curious that Diana, however, is represented only by the moonlight and that Girodet had to insist more than once that the picture's title was not *Diana and Endymion* but the *Sleep of Endymion*. Thus the work emphasizes a type of hibernation, a period of dormant activity untouched by the vicissitudes of time. The protagonist assumes a state of total passivity, marking time while yet enjoying the balmy caresses of sensual pleasure. Evidence that Girodet identified with the character is shown by the fact that he signed some of his letters to Gérard as "Endymion."[37] Girodet's work is in this sense no less political than David's *Brutus*; it is a deeply felt response to the insecurities of the moment by someone not wholly supportive of the progress of the Revolution. Girodet preferred to bury his head in the sand, ostrich-like, until it was all over.

The picture was a great success at the Salon of 1793, proving that others shared his Rip van Winkle fantasy in that bloody year. They found the picture "dreamy," "poetic," and "unreal" by virtue of the novel lighting. Here they divined Girodet's passionate ambition to distinguish himself from the Davidian school, or as he put it himself, "to move as far from [David's] genre as possible." He rejoiced because "everyone agreed that I do not resemble in any way M. David."[38] Girodet's search for originality in this case was predicated on an antirevolutionary, anti-Davidian approach. The lunar mood and indolent feminine pose of the *Endymion* oppose the Enlightenment clarity and masculine vigor of the master's radical neoclassicism.

Hence Girodet's picture is not a simple case of escapism; the sexually ambiguous Endymion posed in a position conventionally assigned to the female nude, his attenuated proportions and marmoreal flesh, contradicts not only the doctrinaire maleness of David's imagery but the dynamic underlying his visualization of the Revolution. While Girodet's contemporaries hinted at homosexual affairs, this is less important than his capacity at this moment to image forth an androgynous ideal. The very struggle of French people opened the way to social experimentation and utopian visions, ironically extending the thrust of the Enlightenment challenge to received ideas and dogmatic assertions. Girodet's quest for origi-

nality, with all its economic and political implications, was encouraged by the Revolution. His geographical dislocation, and his sense of a collapsing social and moral structure, permitted him to explore a wide range of sexual feelings and manifest them in paint.

The other unusual feature of the work is the nocturnal effect which we have previously discussed as a characteristic strain in the art affected by the Industrial Revolution. The presence of the moon signals a loss of confidence in rational philosophy, but this is compensated for by a profound interest in science which also challenged traditional assumptions. The night lighting, the detailed study of the moth wings of Eros, the botanical accuracy of the oak, acanthus, laurel, and evening glory all testify to Girodet's absorption in contemporary scientific investigation. A student of mineralogy and electricity, he counted among his friends well-known scientists and naturalists such as Alexander von Humboldt. At the same time, it is certain that his lunar motif was influenced by the English since in this period he read Young's *Night Thoughts* and MacPherson's *Ossian*. Moonlit scenes began to enter the Salon in the early years of the Revolution, and critics generally identified them with English literature and art. This phenomenon should be seen as a development analogous to that which occurred in England during the American Revolution. While *Endymion* lacks the violence of Fuseli's *Nightmare*, it nevertheless appeared as unexpected and disturbing to French audiences in its day. Girodet certainly knew Fuseli's work from reading Lavater's *Essays on Physiognomy* in the early 1790s, and in general he considered the English school (perhaps again in reaction to David) as the most advanced of the day. In any case, nocturnal scenes and Ossianic subjects become a persistent feature of his mature production.

Girodet's *Endymion* is conspicuous for its smooth, almost-uninterrupted contours. In the course of the picture's execution, the artist examined ancient reliefs and Greek vase painting which form the "classical" basis of his unique conception. During this period he met Flaxman who decisively affected his work. Girodet's style of outline illustration owed much to the English sculptor and to the reproductions in the catalogs of Sir William Hamilton's collections. While Flaxman's engravings had not yet been published, he began the sketches in 1792 when Girodet may have seen them. They certainly knew

one another at the time Girodet was painting the *Endymion*, since many years later the French artist sent Flaxman a recently made engraving of the work as a souvenir of their first encounter.[39]

Girodet's *Endymion* and its relation to Davidian neoclassicism may be understood as a parallel to the transformation of neoclassicism in England during the American War of Independence and the onset of the Industrial Revolution. Using the English example and ideas inspired by contemporary science, he broke up and transformed the dominant style as a protest against its identification with the Revolution. It would not be the first or the last time that a radical innovation in art grew out of a fundamentally conservative instinct.

Girodet's example encouraged the aspirations of a refractory group of David's students later in the decade. They professed a loathing for his heavy-handed authority and his increasingly mannered style. Their disposition also reflected their reaction to Jacobinism in the aftermath of the Terror, and took the form of wildly eccentric dress and behavior. Known variously as *Les Barbus* ("Bearded Ones") and *Primitifs*, they painted homoerotic themes, androgynous types, moonlit scenes, and sought an archaicizing, pre-Phidian look embodied in the linear patterns of Etruscan vases and Flaxman's designs.[40] In reaction to the political events and the authority of David they advocated a return to the primitive civilizations exemplified in the work of Homer and Ossian. Ossian was their first and most passionate love: the leader of the sect, Maurice Quay, once contrasted Homer and Ossian through their respective symbols of sun and moon, and then declared himself firmly on the side of the moon because it was "simpler, grander, and more *primitive!*"[41]

The reaction of the *Primitifs* in the late 1790s must be seen in the context of the direction taken by the Revolution subsequent to the attack on the Tuileries. The moderate members who still dominated the Assembly hesitated to recognize that *10 August* was as much an attack on them as on the palace. The Girondists, for example, took the lead in attempting to preserve the fiction that the attack was an extension of the liberal first stage. Their moderate position became increasingly untenable in the current state of crisis. The tragic episode later known as the "September Massacres" was evidence of this. The relatives of those who had fallen on 10 August clamored for vengeance, and the deputies grudgingly set up a spe-

cial court to try the prisoners. But the slow process left the public dissatisfied; they continued to cry for revenge on "traitors and tyrants." Their anger was exacerbated by the news of the advancing Prussian troops and rumors that political prisoners were planning a break to join the enemy and its armed consort of *émigrés*. The result was the systematic lynching of over a thousand prisoners during the period 2–5 September 1792.

The Later French Revolution

All hopes of the country were now placed in the elections for the National Convention which coincided with the Prussian advance and the massacre in the prisons. Supposedly representing the restitution of the power of the sovereign people, the convention shaped up as the representation of mature age and social standing. It was dominated by lawyers, with only a handful of working persons representing the popular classes. The early months of the convention were taken up by the struggle between the Girondists, representing mainly commercial constituencies, and the Jacobins, who derived their support from a large segment of the popular classes and disaffected intellectuals. Of this last group, the most extreme faction was "The Mountain" (with whom David sat), so-called from the higher seats it took at the rear of the convention hall.

Their first major confrontation came over the question of the king's fate; the Girondists did not want to try or execute Louis while the Jacobins did. The discovery in November of the king's secret safe, containing documents outlining conspiratorial plots and projects for the king's flight, heightened the demand for the king's punishment and greatly reinforced the case against him. The Jacobins completely monopolized the issue and pushed for the king's execution, feeling that the act would permanently radicalize the public. When the case was called to a vote, the Jacobin deputy Barère noted that each member of the convention must vote his conscience "before the statue of Brutus, before your country, before the whole world." The fateful vote was taken on 14, 16, and 17 January 1793, and the barest majority elected the death of the king, with David voting with the winners.

By March 1793 France was at war with most of Europe, and counterrevolts against the revolution broke out internally when the Vendée region rose in arms against

the attempt to enforce conscription for the army. But the expansion of the war strengthened the hands of the Jacobins, which alone demonstrated the will to win it. Forced on the defensive, the Girondists were finally driven to intemperate attacks against the left, which were soon to turn into an organized insurrection to seize the key positions in Paris. A rapid coup by the *sans-culottes* halted it on 2 June 1793; twenty-nine Girondist deputies were suspended and interned. The Jacobins now controlled the convention and held it until July 1794. While the Revolution has for the most part been associated with the Jacobin reign of terror, for the masses of French people who stood behind the terror it was neither cruel nor vengeful but seemingly the only efficient means to save their country. In June 1793 sixty of the eighty departments in France were in revolt against Paris; the Prussian and Austrian armies were invading France from the north and east; the British from the south and west. The country was helpless and bankrupt. Fourteen months later all France was under the centralized control of the Jacobins, the invaders had been expelled, the French armies in turn occupied Belgium and were about to enter on twenty years of almost unbroken military triumph. The Jacobins unified the country during the crisis, mobilizing mass support against internal dissidents and the foreign invaders. They proclaimed a new constitution in which the people were offered universal suffrage, the right of insurrection, and the incredible notion that the happiness of all was the responsibility of the government. They abolished all remaining feudal rights without indemnity (which cost Girodet a chunk of his income), improved the small buyer's chances to purchase the forfeited land of the *émigrés*, and later abolished slavery in the French colonies to encourage the blacks of San Domingo to fight for the Republic against the English. The center of the new government shifted perceptibly to the left, reflected in the reconstructed Committee of Public Safety (a term borrowed from Rousseau), which rapidly became the effective war cabinet of France. Maximilien Robespierre became its most influential member, a lawyer raised on the ideas of his hero Jean-Jacques Rousseau. His aim was to unify French people by emphasizing the mission of the Revolution.

The work of David in this period coincides with these developments, and he contributed to them both as a political activist and as an artist. His artistic activity and his

political activity cannot be separated. David's idealized abstractions were now translated into concrete action, and his imagery reaches the peak of its naturalism. He was finishing his month as president of the Jacobin Club when news reached him on 13 July 1793 of the assassination of his dear friend Jean-Paul Marat. David had visited the Jacobin deputy the day before and observed him writing on a makeshift desk on the tub in which he daily soaked in a solution to ease the pain of his eruptive skin condition. David was ordered by the convention to paint a commemorative image of the dead Marat—and the result is a moving testimony to what can be achieved when an artist's political convictions are directly manifested in his work (fig. 5.18).

Marat and Corday

The incredible background to the meeting of Marat and his unlikely assassin, Charlotte Corday, demonstrates to what extent the symbols of antiquity could motivate people during the Revolution. Marat was a genuinely gifted mind whose disrespect for accepted opinions pushed him in the direction of highly original but often impractical solutions to problems.[42] His idea of creating a new order based on universal brotherhood was to totally demolish the old; this could be achieved only by a kind of democratic dictatorship. His life, like his mind, was full of contradictions. He was born in Switzerland of a Swiss mother and a Spanish father who fled his native land after converting to Calvinism. The elder Marat, trained as a physician, suffered a loss of status by this act since in Switzerland he was unable to legally practice his profession. Jean-Paul planned to become a doctor as well, but lack of finances forced him into a vagabond existence, picking up here and there what then passed for medical science. He studied medicine at the University of Bordeaux and later in Paris, finally receiving the equivalent of an honorary medical degree from St. Andrew's University in Scotland (which in those days was purchased).[43] In the early 1770s he was a well-known foreigner in the coffeehouses of Soho, London, including among his friends Angelica Kauffman and her future husband Antonio Zucchi. Through them he established contact with neoclassical circles, although his checkered background made him a misfit and English class bias predisposed him to attack established institutions and

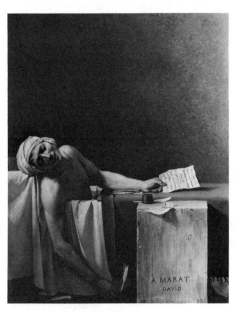

5.18 Jacques-Louis David, *Death of Marat*, 1793. Musée Royal des Beaux-Arts, Brussels.

ideas. He considered himself a follower of John Wilkes, and expressed his hatred of tyranny and love of liberty in a book entitled *The Chains of Slavery* which he published in English in 1774.[44] His political views made him a celebrity among liberals in London, Newcastle, and Edinburgh.

Science in the second half of the eighteenth century had opened limitless vistas of human progress, permitting gifted people like Marat to merge liberal political views with new ideas on the invisible forces of gravity, electricity, and gases. It was possible to conceive of an ideal society founded on control of these forces. Several important future leaders of the Revolution championed speculative scientific theories broadcast by Priestley, Nollet, and Mesmer. Before 1789 Marat devoted much of his energy to writing fantastic treatises on light, heat, electricity, and even techniques of balloon flight.[45] Jacques-Pierre Brissot, who became a major Girondist leader, studied science under Marat and came away with both an optimistic forecast of society and a hatred of academies which he felt stifled the new truths of science and philosophy.

During the years before the Revolution Marat continued to develop a reputation as a fashionable practitioner, working remarkable cures by means of various concoctions which sometimes contained little else but chalk and water. He also wrote a *Memoir on Medical Electricity* which anticipated some of the ideas of Erasmus Darwin.[46] Since Franklin expressed interest in Marat's electrical experiments it is possible that he mediated between the two physicians. Marat also praised Priestley's *History and Present State of Electricity*, and it is probable that during his years in England he established contact with some future members of the Lunar Society. He certainly shared their desire to democratize the medical field by making inexpensive cures available to the wider community, and like them he ultimately turned to politics to promote his views of the good society.

Ironically, however, Marat reappeared in Paris in 1777 as a doctor attached to the household guard of the reactionary comte d'Artois, a job he held for ten years. It is certain that he took the position to enhance his chances of getting accepted at the Academy of Sciences; he took care to print in bold type on the title pages of his scientific pamphlets, "Médecin de garde du corps de Monseigneur le comte d'Artois." But even this patronage failed

to help him: he became known in learned circles as an ambitious and cantankerous candidate for a place in the Academy of Sciences. The academicians opposed him as an upstart and in many ways treated him unjustly. Lavoisier paid dearly for his disapproval of Marat's ideas; others dealt with him more mischievously, such as delaying the academy's official report of his experiments on light to allow his adversaries to publish a refutation. Later, he was a candidate for director of the Academy of Sciences in Spain, but members of the French Academy wrote nasty letters to Floridablanca, the Spanish ambassador to France, and wrecked his chances. There is no doubt that Marat touched a raw nerve of the academicians, and their treatment of him did much to radicalize his thought. He clearly was a scientist of more than amateur standing; the Academy of Rouen honored two of his treatises, and even Goethe quoted him with appreciation in his study on color.

The outbreak of the Revolution found Marat in a state of mind akin to David's, a rebellious temperament enfranchised by the political events. News of the fall of the Bastille converted him; he abandoned his medical practice and scientific research and became a radical journalist. A candid friend of the people—he named his popular newspaper *L'Ami du peuple*—he preached his sermon to the populace. He labored prodigiously despite a painful skin condition, sleeping but two hours a night; in addition to his editing, his duties as deputy to the National Convention, and committee functions, he patiently listened to the grievances of the poor, wrote petitions for the oppressed, received denunciations, and delivered speeches in public squares. His indefatigable work for the underclasses made him one of the most popular members of the Jacobin party.

When André Chénier wrote of demagogues stirring the masses to violent action he undoubtedly had Marat in mind. Marat figured prominently on the Vigilance Committee which had jurisdiction over the police and prisons during the fateful week in September 1792. While he denied overt complicity in the massacres of the prison inmates, he certainly incited the populace to defend themselves in every way possible against the threatened uprising. Many of the groups of citizens he organized later participated in the executions of the prisoners. His denunciations and organization work contributed significantly to the lynchings of priests, aristocrats, and even

ordinary criminals who were unfortunately in the place at the wrong time.

Marat also played a major role in the struggle premacy between the Girondists and the Jacobins. The Mountain made use of its growing power to obtain the adoption of a law for the creation of an extraordinary criminal court, to judge without appeal conspirators against the state. The Girondists opposed the measure but lost; and thus arose the opportunity for Marat and Robespierre to strike at those who had for some time menaced them. As president of the Jacobin Club for the month of April 1793, Marat issued an inflammatory address warning of a Girondist counterrevolution. The Girondists demanded his impeachment and carried a motion for Marat's indictment, but he was acquitted unanimously by the new criminal court. The decision overjoyed a crowd of his supporters who carried him in triumph through the halls of the Palace of Justice.

This event was depicted by the painter Louis-Léopold Boilly who specialized in scenes of Parisian life (fig. 5.19). Entitled *The Triumph of Marat*, it shows the Friend of the People carried aloft by the surging crowd. Boilly's detailed analysis of costume enables us to see the class makeup of the crowd which comprises many working-class women and *sans-culottes* who push forward to greet their idol. Marat, wearing an almost saintly smile on his face, raises his right arm as if bestowing a benediction on his followers. No other image so aptly communicates the almost idolatrous attachment that many segments of the popular classes felt toward Marat. At the same time, it

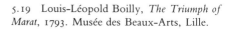

5.19 Louis-Léopold Boilly, *The Triumph of Marat*, 1793. Musée des Beaux-Arts, Lille.

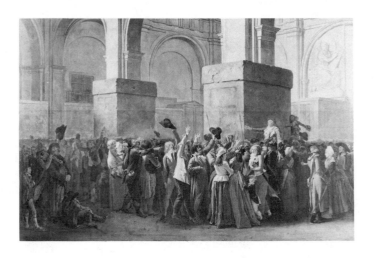

should be noted that Boilly painted this work to ingratiate himself with the Jacobins who had expressed their displeasure at what they perceived as the artist's "indecent" subjects. He was accused by a favorite student of David's, thus attesting to the puritanical outlook that the master shared with his other Jacobin colleagues.[47] Boilly, however, won his way to their hearts by ingeniously selecting a highlight of the party's rise to leadership in the convention.

Two days after his acquittal Marat orchestrated the indictment of twenty-two Girondist deputies "guilty of the crime of felony against the sovereign people." He also stepped up his accusations of the Girondists in his journal and included them in the general proscription he urged on the public. The Girondists were accused of having sold out to the court, of fomenting civil war, and of plotting to destroy the unity of the Republic by making the departments independent of the capital. This paved the way for the events of 2 June when thousands of insurgents flooded the convention chamber demanding the arrest of the Girondin leaders who were ultimately expelled and ordered under house arrest.

Although the Girondists had few supporters at Paris, they had partisans in the departments, especially in northwest cities like Rennes and Caen and in the southwest Bordeaux. Thus the warning that the danger of general insurrection loomed great had substance; in addition to the supporters of the Girondists, royalists were in open rebellion in Lyons, Toulon, and in La Vendée. While there was no danger of these groups joining, they were lumped together by Jacobin propaganda. Among those who had placed faith in the Girondists and their ideals was a young woman from Caen in Normandy, Charlotte Corday. Owing to Marat's persistent denunciations of the Girondists, she and her friends accounted him exclusively responsible for the September massacres, the expulsion of the Girondists, and for what she perceived as a growing dictatorship by the Jacobins. Unable to grasp the entire situation which had brought about the fall of the Girondists, Corday imagined that by killing Marat she could also put an end to the system of government that he advocated.

Corday was noble by birth but lived in modest circumstances. She was a descendent of Corneille, the dramatist who wrote the *Horatii*. As a child she voraciously read books of ancient history—especially Plutarch's

Lives—and grew up full of admiration for the stern manners and customs of Rome and Sparta.[48] She imaginatively relived the pages of history and tragedy exemplified in the *Horatii* of her ancestor Corneille. Her friends teased her for continually quoting the ancients. But she persisted throughout her adolescence in extolling heroes of antiquity who were ever ready to kill or be killed in a great cause. She admired both Brutuses but personally identified with the later Brutus who sacrificed his benefactor and perhaps his father to the principle of liberty.[49] She also knew whole passages of Voltaire's *Brutus* by heart and thus shared the general interest in the early Roman hero.

Corday also admired contemporaries whom she felt embodied her social ideals based on the model of antiquity. She felt a close kinship to the Girondist leader Mme. Manon Roland, one of the few females to have risen in the ranks of the two major factions. Manon Roland exercised a profound influence on her husband, Jean-Marie Roland, who served as minister of interior during the first phase of the Revolution. Mme. Roland was also raised in the cult of antiquity and longed to emulate the matrons of Sparta; she cursed her sex and the time for not allowing her the opportunity to use her talents as fully as women did in antiquity. As she declared: "I was meant to be born a Spartan or a Roman woman, or at least a French man."[50] Ultimately she went to martyrdom before a statue of Liberty, and possibly recognizing the deception of her classical daydreams she uttered: "Liberty, what crimes are committed in thy name!"

Corday also idolized the intimate friend and spokesperson for Mme. Roland, the Girondist François Buzot. His self-portrait could stand as a frontispiece for almost every biography of the members of the National Convention:

My head and heart were filled with Greek and Roman history, and with the great figures which, in those old republics, were the honor of the human race . . . With what pleasure I can still recall that happy period of my life . . . when I wandered silent across the mountains and woods of my native place, reading with delight something of Plutarch or Rousseau, or reminding myself of the most precious features of their moral and philosophical teaching!"[51]

Such was the childhood origin of Girondist and Jacobin ideals, if not of their means of achieving them.

Marat had in common with Corday, Roland, and Buzot the love of Rousseau (he actually read the *Social Contract* on street corners as early as 1788) and of antiquity. He too identified with ancient heroes, now seeing himself as Cato, now as Lucius Junius Brutus. He published a short-lived paper called *Le Junius français*, referring to the English "Junius" who published a series of letters attacking the Tory ministries in the late 1760s and early 1770s, but also invoking the shade of one of his favorite heroes. David's painting demonstrates Marat's own Spartan existence, depicting him as a Homeric warrior fallen in single-minded devotedness to a great cause. All the actors of the Revolution were inspired and to a degree governed by the symbols of antiquity.

It was the power of antiquity as communicated by neoclassicism that impelled Corday and Marat to their fateful encounter. She would sacrifice herself in the name of liberty by ridding the world of another Tarquinius. Corday actually carried with her to Paris a volume of Plutarch's *Lives* when she made up her mind to assassinate Marat. Not everything went according to the text, however. When she arrived in Paris, she learned to her dismay that for the last month Marat had not been seen at the convention where she originally planned to act out her fantasy. He was ill, suffering from an eruptive skin disease, which he treated by spending long hours in a warm tub. The Jacobin deputation (including David) that saw him the day before his death found him, as Charlotte Corday would, "in his bath, with a table, an inkpot, some papers and books by his side, working as hard as ever at public business."

Early on 13 July 1793 Corday bought a butcher's knife at a shop in the Palais Royal and drove in a cab to Marat's lodgings. She was refused admittance. She left a note requesting a brief meeting and hinting that she had information on the insurrectionary activity of the Girondins in Normandy and that they had a common interest in preserving the fatherland. She also prepared another letter in the event the first failed to catch Marat's attention; this was never delivered but discovered on her person. It mentioned the first letter and again requested an interview, but this time Corday claimed she had "secrets" to reveal for the "salvation of the Republic." And she concluded: "I am persecuted in the cause of liberty; I am miserable, and I am sufficiently unhappy to have a right to your protection." There is a touch of pathos in

the fact that, in a last-ditch attempt to gain his ear, she took advantage of his well-known compassion for the downtrodden and persecuted. At the same time, David exploited this motif to point up the contradictions in Corday's act.

Corday returned again that evening and was again refused admission. But this time Marat heard the exchange and called for her to come in. He questioned her about the Girondist deputies at Caen and took down the names of the rebel administrators of Calvados at Evreux. At this point, she drew her knife and stabbed him in the breast. She made no attempt to escape and went to her death four days later. Marat's last article for *L'Ami du peuple* appeared the morning of his murder in which he invoked "Brutus's dagger" against the king of Prussia—almost to the moment when his own assassin was identifying with the same ancient hero.[52] Even more ironic, Marat described himself despondently in the last words he printed as "the Cassandra of the Revolution." At the moment of their catastrophic encounter, she pictured herself as a male hero of antiquity, he as a female. Such was the awesome hold on their imaginative lives by the symbols of antiquity. Both were immediately apostrophized in verse as classical heroes: he by the Jacobin deputy P. J. Audouin who lauded his civic virtue, she by André Chénier who wrote that Greece, admiring her courage, had enshrined her with their own.

The drama of their confrontation is captured in an engraving of the moment Marat's corpse is being taken from the tub and Corday is arrested (fig. 5.20).[53] The two principal actors are garbed in white and stand out from among the crowd, rivaling for our attention and enjoining us to take sides. The invasion of Marat's bedroom recalls Fuseli's *Nightmare*, except that in this instance it is a male who has been violated by a female. This repeated depiction of the invasion of private space in late eighteenth-century painting is symptomatic of the breakdown of society's barriers. The penetration of violence into the quiet sanctity of one's own bedroom signals the dissolution of social order and heralds the rupture of the boundaries between the classes, between domestic and civil strife, between war and civil war.

Whatever her psychological motivation, Corday was swept along to her act by her idealism; she felt that she could end the civil war by destroying a single individual. No more dramatic incident demonstrates the flaws of the

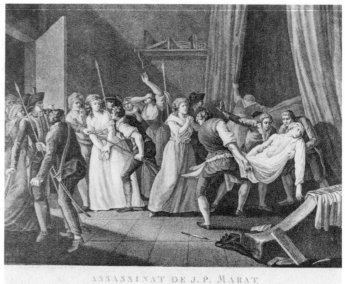

ASSASSINAT DE J. P. MARAT.

N'ayant pu me Corrompre, ils m'ont assassiné.

theory of the significant individual's role in history. In general, it makes more sense to accept the argument of Plekhanov that the major forces in history will always find someone to embody and advance them, and the same claim may be made for the history of art. David, more than others, traced in images the progress of the French Revolution, but it was the Revolution that made his work meaningful both to himself and the public. Similarly, it was the Revolution that shaped the roles of Marat and Corday who in turn helped make the Revolution. Corday's act was the prelude, not to a Girondist peace but to a Jacobin vendetta.

The Jacobins lost no time in exploiting Marat's prestige and his murder in the interests of the party. With their complete control over the print and visual media they turned to their advantage the assassination of a popular idol. The Jacobins commissioned David to do a painting treating Marat as a martyr of the Revolution; he also prepared the display of the body for a public funeral, organizing a fanatical cult to his memory highlighted by torchlight ceremonies. Within a few weeks of the funeral, the Committee of Public Safety launched more active measures against their Girondist opponents; police control in the provinces was secured; steps were taken to arrest suspicious foreigners and to round up counterrevolu-

tionaries in the Vendée. Girondist leaders were in flight all over the country, and the moderates in the National Convention were all but muzzled. Now the Terror commenced: from October 1793 through July 1794 dozens of the Girondin party were either executed or took their own lives.

Jacobin centralization and dictatorship called for the propagandizing ministrations of Robespierre and David. The press, visual images, and pageants were ingeniously manipulated in the interests of Jacobin ideology. David's moving memorial to his friend Marat, however, underscores the artist's faith in that ideology. David no longer had need to look to ancient Rome for examples of virtue, although his conception treats Marat with the dignity and sobriety reserved for classical heroes. The nudity of Marat's exposed upper torso and even the wet towels on his head recall the Hector of David's reception piece; there the figure wears a laurel wreath, the head is similarly thrust back, and the arm positions are roughly comparable. Even the coverings of Hector's lower body are echoed by the towels insulating Marat's bathtub. Equally striking is the contrast between the elaborate sword beneath Hector's right elbow and the ignominious butcher knife smattered with blood below Marat's. Marat, however, holds in his limp right hand the quill pen with which he was correcting the proofs of his latest edition. Tilted at an angle like Hector's weapon, David suggests that Marat's pen was mightier than the sword. David demonstrates in the opposition between the simplicity of Marat's life-style and the sumptuous setting of the *Hector* a personal recognition of the ideological differences between first- and second-generation neoclassicism and between the first and second stages of the French Revolution.

The real Spartans and martyrs for liberty existed in the present. The wooden crate that serves as a table is as rectilinear and noble as the Doric order,[54] the ink pot and quill pens more suggestive of classical restraint than a bronze candelabrum. David guards in the *Marat* the horizontal composition and geometry of the Hector but eliminates all superfluous details. Gone are the extravagant accessories once meant to dazzle collectors of antiquities, and in their place is an environment reduced to the bare essentials. Once David would have felt compelled to add a classical column in the background, now all is shadow and emptiness behind Marat.

While the Jacobins would have avoided overt Christian imagery, David draws an unmistakable parallel between Marat and the dead Christ.[55] Marat's right arm is slung over the side of the tub exactly as in the image of the *Pietà*, while the radiant expression on his face highlighted by the bright illumination in the foreground plane suggests a state of transfiguration. David's unusual handling of the composition, in pushing the central motif as far as possible to the frontal picture plane while blanking out the background, also gives the scene the look of a sepulchral monument for a pope or saint. This effect is enhanced by the frontality of the wooden crate and its inscription which appears as if carved into the box: "A Marat, David. L'an deux." In addition to the formal means he used to make the parallel between Marat and a Christian martyr, David also manipulated for his purpose the narrative circumstances of Marat's assassination. He not only shows Marat holding in his left hand the undelivered second letter Corday wrote in the event the first failed to reach its destination, but he altered the phrase, "I am sufficiently unhappy to have the right to your protection" to read "I am sufficiently unhappy to have the right to your benevolence"—thus pointing up the fact that the murderer took advantage of Marat's sympathy for the underprivileged and meek of this earth.[56]

Despite the manipulation of the actual facts and the unique technical approach, David has rendered the figure and the narrative details with an astonishing realism. A moment ago it was noted that this corresponded to the supplanting of the past with heroic events of the present, but it also must be emphasized that with this replacement comes a loss of the earlier revolutionary idealism. The bloodshed so starkly represented in the Marat signals a pessimism and pragmatism identified with the second stage of the Revolution. The blood of friends cannot be romanticized but must be translated into sober reality. Civil war, internal and external chaos can only be rendered with a sense of hope for the future when they are safely in the past. The tragic power of the *Marat* lies in the overall progress of the Revolution as recorded by David, passing from zeal and idealism to violence and disillusion.

Something of the change in David's attitude, even a touch of cynicism, may be perceived in his next important work for the Jacobins, *The Death of Barra* (fig. 5.21). Near the end of the year, Robespierre asked the National

Convention to accord full honors to Joseph Barra, whom he claimed was killed at the age of thirteen by royalist partisans in the Vendée for having refused to cry "Vive le roi" and shouting instead "Vive la république!" It became legend that Barra was a valiant drummer boy: Jacques Richard's later poem dedicated to his memory includes the line, "To the sound of the bugle, to the beat of the drum." Once again David was called upon to depict a martyr of the Revolution, and this time he fabricated an image of the fallen adolescent clutching a tricolor cockade to his heart with his dying gasp.

The whole story, however, was an invention to whip up revolutionary fervor. According to Barra's patron, the youth "preferred to die rather than surrender himself and hand over the two horses which he was leading." One may still admire his courage, but it was clear that Barra was more concerned about his horses than his political convictions. The incident occurred earlier in 1793, a time of general crisis and one particularly poor for recruitments. The enthusiasm of 1792 had evaporated, and desertions were common. Robespierre, who knew the truth about Barra, saw in the event a potential symbol to rekindle the spirit of patriotism among the nation's youth. In this same period, shiny new drums were offered to all youngsters who volunteered for active duty. The convention enthusiastically adopted Robespierre's motion, and Barra became an eponymous title for Jacobin patriots. Barra's body, said Robespierre, would be

buried in the Pantheon with the honors given to Rousseau and Voltaire, and a picture of his martyrdom, promised Barère, would be hung in every schoolroom in the country.[57]

David was not only asked to design this picture but to organize the commemorative procession to take place in the following year. His program stressed the need for French youths to emulate Barra's courage in defense of the Republic. His visual counterpart to the myth created by Robespierre shows the fallen youth nude and almost smiling, with an expression akin to rapture as he presses his badge of patriotism to his breast. What is most curious about the figure is its effeminate character; both the face and the figure resemble more a pubescent female than an adolescent male. The heady fraternalism of the Jacobins may have had erotic associations that surfaced in a more open sexual expression—part of the search for a new symbolic language already found in the work of David's student Girodet. Since the work is incomplete we cannot know for certain whether David intended to clothe Barra or not; but the present effect further suggests that David tried to encode signs for rape and murder. This kind of sensational emotional appeal is alien to the spirit of the *Marat* and attests to a certain dishonesty on David's part. It is certain that he knew the facts in the case, and it would seem that on this occasion he engaged in false rhetoric for the first time. In any event, the fall of Robespierre in July 1794 led to a postponement of the Barra festival, and David never finished his painting.

Yet David's picture is significant for giving us insight into an image that would become a pervasive vehicle for propaganda in the next century. One major example is Archibald M. Willard's *Spirit of '76*—America's most popular patriotic image (fig. 5.22). Willard typically focused on the inspired drummer boy as a metaphor for devotion to the fatherland. A veteran of the Civil War in which thousands of drummer boys served, Willard was thinking more about that experience than about the American Revolution which is the actual historical backdrop for his picture. But the work exemplifies the persistent cogency of the image for propaganda purposes; the drummer boy was often used during the Civil War as an advertisement for recruitment purposes. Not surprisingly, the subject proliferated in a period when both sides were desperate for new enlistments. In the end, youth marched off to war in fulfillment of fantasies stimulated

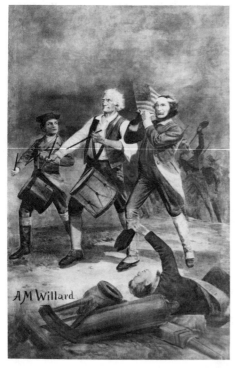

5.22 Archibald M. Willard, *Spirit of '76*, 1876. The Western Reserve Historical Society, Cleveland.

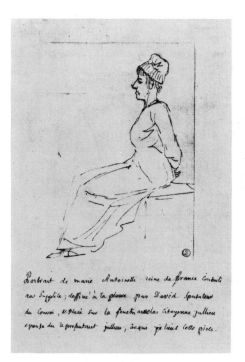

5.23 Jacques-Louis David, sketch of Marie-Antoinette on the way to her execution, 1793, pen drawing. Musée du Louvre, Paris.

by painters working in the "best interests" of their country. While the artists may or may not have derived creative inspiration from the image, the drummer boys died for it.[58]

David and Revolutionary Feminism

On 17 October 1793, three days after David completed his *Death of Marat*, Marie-Antoinette was executed. David watched the procession taking the queen to the scaffold from the window of a friend's apartment and dashed off a cruel sketch of her in the cart (fig. 5.23). The severe profile silhouette is the view he would have seen as the cart passed down the street on the way to the site of execution (now the Place de la Concorde). He caught her defying death and the hostile crowd with total disdain. But the haughty look contrasts singularly with her simple mobcap and straggly hair. In trying to emphasize her anachronistic presence, David took his realism to the borderline of caricature. His study of the now prematurely aged and haggard queen tells us how far French society has traveled since the time Vigée-Lebrun painted her glorious portraits just ten years earlier!

Marie-Antoinette showed little understanding of the popular classes, and little sympathy with their troubles. Yet she was a wife and mother who could be touched by demonstrations of goodwill, and it is all too easy to blame her, as Jefferson did, for the fall of the French throne. David's own particular hatred of her may be seen in the context of his general attitude toward women. The day after the women's raid on Versailles David dined at the home of the countess of Albany; when the conversation turned to the queen he commented bitterly: "It is a great misfortune that that vile bitch was not strangled or torn to pieces by those women mobsters, for so long as she is alive there will be no peace in the kingdom."[59]

David clearly did not do justice to militant women either on the Right or the Left, reflecting in this the sex-biased position of the Jacobin Society which restricted its membership to males. Yet women of all classes, both demographically and politically, represented a major force in bringing about, and advancing, the Revolution. They encompassed all shades of the political spectrum, and militant feminists among them such as Olympe de Gouges inspired the writings of the English Mary Wollstonecraft. While their early demands sprang from the

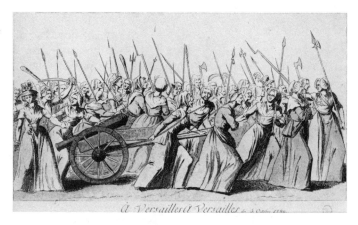

immediate economic and social conditions, they gradually learned to translate their protests into effective revolutionary activities. They began to identify themselves by class rather than sex, an identification indicating their stand on policies other than bread and butter issues. They exercised their power through elaborate and well-organized tactics which included meetings, popular societies, boycotts, petitions, strikes, and participation in mass demonstrations at the National Assembly, festivals, and even raids as in the case of the Tuileries where Théroigne de Méricourt, Reine Audu, and Claire Lacombe distinguished themselves and were later awarded a "civic crown" for their courage.[60]

There is, however, an astonishing dearth of pictorial documentation of concerted women's action in the Revolution. One exception is the March on Versailles which has come to us in the form of popular prints (fig. 5.24). The occasion would be immense significance for the realization of the notion of popular sovereignty during the first stage of the Revolution. On 5 October 1789 working-class women gathered at the Hôtel de Ville demanding that Lafayette escort them to Versailles to get bread and request that there be more control over the distribution and price of grain. When he waivered, the crowd enlisted the aid of sympathetic National Guardsmen and set off for Versailles. Along the way they picked up many middle-class women and even some ladies of fashion. At Versailles, delegations were formed to pressure the members of the National Assembly and approach the king. In the end the women achieved two astonishing results: the king promised their deputation that Paris would have bread and informed them of his intention to

shift the seat of government to the city. The women returned in triumph to Paris the following day, having made a stunning contribution to the struggle for political control of the Revolution.

Among the participants in the Versailles march was Marie Gonze—better known under her pen name, Olympe de Gouges—whose Declaration of the Rights of Women helped define and formulate women's rights during the Revolution. Published as a rejoinder to the liberal constitution of September 1791, her declaration aimed at full social and economic equality for women. She emphasized that while women aided in realizing the Revolution, they were now being excluded from its benefits. De Gouges pioneered in the formation of women's societies early in 1793, and by February the common women of Paris established their own institutional base, the Society of Revolutionary Republican Women. Its leaders were Pauline Léon, a chocolate manufacturer whose trade had been undermined by sugar shortages and the flight of aristocrats, and Claire Lacombe, an actress from the provinces. This group profoundly affected the power struggle between Girondists and Jacobins, siding with the latter in the critical days of May–June to oust the former from the National Convention.

Once the Jacobins gained full control of the revolutionary political machinery, they clamped down on further reform and began revealing their deep-seated gender bias. The Society of Revolutionary Republican Women continued to grow and advance the interests of the common people, pointing to the Jacobins' failures and unfulfilled promises. By September their demands constituted a real threat to the Mountain and a wave of antifeminism swept the National Convention. At the end of October, just two weeks after Marie-Antoinette was guillotined, the convention prohibited all women's societies and virtually brought their organized struggle to an end. On 3 November Olympe de Gouges, identified as a counterrevolutionary, was condemned to death.

The Jacobins now began rationalizing their actions by trotting out the traditional stereotypes assigned to women. Their aim was to undermine women's growing challenge to the accepted opinions regarding the inferiority of the female sex, and the laws and social customs that reinforced those views. The Jacobins revived the ideals of their hero Rousseau, whose *Emile* set forth male hegemony and the confinement of women to well-defined do-

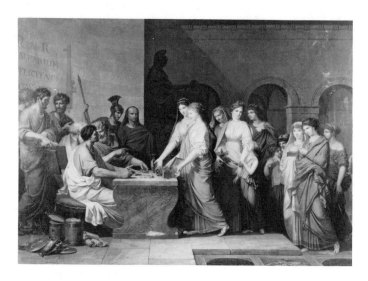

mestic roles. Young girls, according to Rousseau, were to be trained from the earliest age how to be helpmates and companions to their husbands. Similarly, the Jacobins exhorted women to return to their household duties and refrain from acting as men. Here is an example by the radical journalist Louis-Marie Prudhomme:

Women citizens, be honest and diligent girls, tender and modest wives, wise mothers, and you will be good patriots. True patriotism consists of fulfilling one's duties and valuing only rights appropriate to each according to sex and age, and of not wearing the liberty bonnet and pantaloons and not carrying pike and pistol. Leave those to men who are born to protect you and make you happy.[61]

These gender-biased denunciations and the emphasis on domestic responsibilities indicate that the Jacobins were threatened by politicized women. It is probable that their firm control of the print and visual media insured that women's contributions to the Revolution would be not only deprecated but suppressed. Except for a handful of prints of certain female types, idealized female allegories of the nurturing or Amazonian Republic, or the larger body of material showing women functioning as auxiliaries to male actions, there is little pictorial souvenir of women's organized revolutionary activities.

There is, however, an important series of paintings from the period which celebrates one such event and seems to contradict this assertion. In September 1789 a group of eleven wives and daughters of artists organized

by Madame Moitte, including Mesdames David and Vien, dressed themselves in white, stuck tricolor cockades in their hair, and publicly donated their jewelry to the National Assembly. The occasion was immediately recorded in prints and paintings and carried an immediate appeal for neoclassicists who knew of its prototype in Roman Republican history. As recounted in Plutarch's story of Marcus Furius Camillus, patrician women in Rome offered their gold and jewelry to the Senate to pay for a golden urn which Camillus had pledged to Apollo for a victory over the Etruscan city of Veii. Inevitably, the patriotic Frenchwomen were equated with their ancient Roman counterparts. At the Salon of 1791, Louis Gauffier exhibited his *Generosity of Roman Women* which essentially translated the contemporary incident into neoclassic terms (fig. 5.25). The women are shown lined up before a table of senators receiving the gifts, analogous to the popular prints of fashionable ladies donating their objects to members of the National Assembly (fig. 5.26). We have come a long way from Boucher—women here sacrifice their luxuries for the state—but the work still consigns women's role to a matronly function. Both in antiquity and in the modern period the donation was perceived as a way to bolster male authority and patriarchal dominance.

Related to this was another work done by Gauffier for the Salon of 1792, *Cornelia, Mother of the Gracchi, Solicited by Roman Women to Donate Jewels to the Fatherland.* In this

5.26 *Patriotic Women Donating Jewels to the National Assembly*, 1789, engraving. Vizille, Musée de la Révolution française.

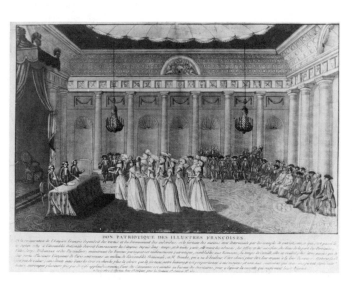

story, taken from Valerius Maximus, Cornelia was visited by a patrician lady who asked to see her jewels, and in response Cornelia introduced her children as her "jewels." Gauffier's synthesis of the two themes is not fortuitous: his work suggests that the woman's most important contribution to her country are the male sons she brings forth in the world. It was certainly a popular theme of the period since it also appeared at the Salon of 1793 and three times at the Salon of 1795. This last Salon was held during the time of the Thermidorian reaction which, while bringing about the fall of Robespierre, nevertheless sustained the conservative view of women. The new government dismantled national workshops for women established in 1790 and proclaimed that domestic responsibilities make for better wives and mothers.

We shall see in a moment how this attitude influenced David's last major work of the Revolution which closed his revolutionary career. Under the stress of circumstances, bitter divisions broke out among the Jacobins. Now that the armies of France had driven back the invaders beyond their own frontiers, the internal bloodbath no longer seemed necessary. When Robespierre called for one final purge, he alienated many members of his own party. On 27 July 1794 (9 Thermidor in the new revolutionary calendar) he was prevented from speaking at the convention. He and several of his colleagues were arrested and executed the next day. Shortly afterward, David was summoned before the convention as an accomplice of Robespierre and ardently defended himself as a "dupe" of the Jacobin leader. He called his former friend a hypocrite who had abused the trust of the people. The deputies doubted David's sincerity but spared his life. He was arrested on 2 August and imprisoned in the Hôtel de Fermes, where he encountered members of the convention earlier arrested on the order of Robespierre now exiting.

David—a Change in Attitude

Here and later at the Luxembourg Palace where he was transferred David underwent a period of deep soul-searching. He became reconciled with his family who visited him during his imprisonment—his mother, his children and their governess, and, ultimately his wife, who had divorced him in March 1794. His thoughts now turned to his previously neglected responsibilities as son,

5.27 Jacques-Louis David, *View of Luxembourg Gardens*, 1794. Musée du Louvre, Paris.

father, and husband, shown in part by his portraits of his mother, the children's governess, and his wife, Marie-Geneviève. David was profoundly moved by Marie-Geneviève's spirit of devotion and forgiveness, and the couple remarried shortly after the painter's release from prison.

David's change in attitude is expressed in a modest landscape sketch he executed during his confinement at the Luxembourg Palace in the summer of 1795 (fig. 5.27). From his window he gazed wistfully at the rolling terrain below, then caught a fragment of it in his uncharacteristic scene of a casually fenced-off yard and a park beyond. The view is surely a reaction to his incarceration—treating a pastoral glimpse of the natural environment like a private garden. It is no coincidence that in this period he dreamed of retiring to a country residence with his family, which he actually accomplished through the public exhibition of a monumental painting he planned in the same period as the landscape sketch.

In this David identified with the types who came to power in the wake of the Terror and subsequently comprised the Directory, for the most part people of newly acquired wealth and office. They were not the cultured upper bourgeoisie of the Old Regime such as the farmers-general but the purchasers of nationalized property, war contractors, speculators, profiteers, and professional

politicians. Barras, later one of the five Directors, acquired five estates. Others like Marlin de Thionville and Legendre, people of power and influence in the new regime, had lavishly feathered their nest with the secularized and nationalized lands of the church and the old nobility who had emigrated. They celebrated the ownership of wealth and property, profiting from the wild inflation that followed the end of the tight Jacobin economic controls.

Those who dismantled the Mountain's machinery now had no choice but to provide the Republic with a new constitution. Its chief author, Boissy d'Anglas—the person who ultimately signed David's order of release—favored and rationalized the position of the newly rich. His constitution was based on a dual fear of democracy and dictatorship, steering a middle course between popular sovereignty and authoritarian control which he experienced at first hand. After coming close to execution by the Jacobins, Boissy-d'Anglas almost became the victim of the crowd. This occurred on 20 May 1795 (1 Prairial, year 3 of the revolutionary calendar), a famous day in the final stage of the Revolution. The new coalition embarked on a series of reactionary moves against the remnant of the Left, which it blamed for the widespread misery, evoking the worst days of 1789. The prices of staples increased so rapidly in this period that the National Convention doubled the daily allowance of the deputies. Crowds thronged the bar of the convention crying "Du pain!" On 1 April 1795 the distribution of bread took place later than usual and was reduced by one-half. The popular classes became exasperated, and a furious throng composed mainly of women and children invaded the National Convention. Barras, and other members of the Right, restored order by promising a change and then turned around and indicted deputies of the Mountain such as Barère and Collot d'Herbois. The famine was used as a pretext to systematically eliminate the remnants of the Jacobins.

But on 19 May only two ounces of bread were bestowed on the members of the popular classes, and the following day an enraged crowd again rushed on the convention. The common people now demanded bread, the restoration of the Jacobin constitution of 1793, and amnesty for citizens arrested for their protests against the government's handling of the economic crisis. When a deputy named Féraud tried to physically resist the onrush

5.28 Charles Monnet, *Crowd Bearing Head of Deputy Féraud* the Day of 1 Prairial of Year 3 (20 may 1795), popular engraving, 1796–1797.

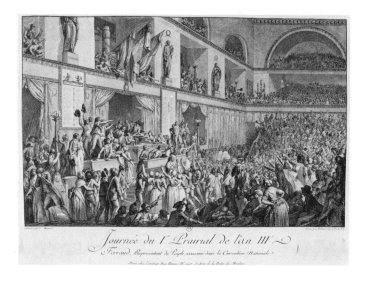

Journée du 1.^{er} Prairial de l'an III.
Ferraud, Représentant du Peuple assassiné dans la Convention Nationale.

of the crowd, he was shot, decapitated, and his head paraded at the end of a pike. Meanwhile, the president of the convention withdrew, and Boissy d'Anglas, secretary of the convention, replaced him. Thus on 20 May 1795 Boissy d'Anglas found himself surrounded on all sides by a furious crowd waving before his face a threatening pike bearing the severed head of the deputy Féraud. This event was sketched and printed in the form of popular engravings; one by the well-known painter and illustrator, Charles Monnet, conveys the tumult of that moment as well as the significant role of women in pressing the deputies for the people's rights (fig. 5.28).[62] Having little else to do in the face of this threatening gesture, Boissy d'Anglas remained impassive and then saluted the head of his colleague. While later he was revered as the new savior, one who averted a second Terror, in point of fact the convention owed its stability to the lingering leftists who promised measures that calmed the crowd. They were later guillotined or deported when the danger had passed.

But the experience certainly demonstrated to Boissy d'Anglas the need to repress popular sovereignty and return to the moderate system of 1791. The new constitution, proclaimed on 23 September 1795, abolished universal suffrage and instituted indirect elections. A restricted franchise restored political power to the propertied classes. Boissy d'Anglas believed that the best leaders were those who possessed property. To prevent con-

centration of power, the executive and legislative powers were separated, and the latter was entrusted to a Directory of five. The Directory depended on the army both for the suppression of the periodic coups and plots and for its conquests and loot to fill the government's treasury. It was during this regime that Napoleon Bonaparte rose to prominence; the victor at Toulon during the Revolution, he temporarily lost favor because of his association with the Mountain. Then he was called upon to suppress a royalist revolt in October 1795 and a leftist organization known as the Society of the Pantheon.

Babeuf

Since the Society of the Pantheon included supporters of what one may consider the first socialist movement of modern times we must consider it before taking up David's major picture of the period. The leader of this movement was François-Noel Babeuf, who took the name of Gracchus in 1793 after the most famous protagonist of agrarian reform in the ancient world. In October 1794 he changed the name of his newspaper, *Journal of the Liberty of the Press*, to *Tribune of the People*, thus evoking the Roman office held by Gracchus. His choice of the name Gracchus is bound up with his carefully thought-out concept of property—the core of his doctrine and the preoccupation of the Thermidorians.

The son of an employee of a corporation of farmers-general, Babeuf began his career as a *feudiste*, one who kept account of the property on an estate and exacted dues from tenants. He witnessed at first-hand the penurious condition of the peasantry and the abuses of the aristocrats who cheated him more than once on his services. At the time of the assembling of the Estates-General, he helped prepare the *cahier* for the town of Roye in Picardy. It showed the influence of the physiocrats in advocating a single tax on the land and calling for the abolition of feudal tenures. Babeuf became active in rural politics, encouraging the peasants of Picardy, his native region, to get involved in the political struggles of the period.

Babeuf was especially concerned about the concentration of land in the hands of the bigger farmers, a problem articulated repeatedly in the *cahiers* of 1789. Babeuf sympathized with the sufferings of the struggling small peasants and the landless, displaced by circumstances in which a few main cultivators held in their hands the ex-

ploitation of an entire territory and could manage everything with the aid of a few hired laborers. He was outraged by this system of inequality and called for radical agrarian reform, advocating the redistribution of land and abolition of private property.

It is here that Babeuf's choice of the name Gracchus becomes relevant. In Plutarch's *Lives* Tiberius and Caius Gracchus are associated with drastic agrarian reform. Tiberius Sempronius Gracchus, the elder of the two brothers by nine years, was elected tribune in 133 B.C. His principal action was to pass a law distributing the lands conquered by the armies of Rome among the poor. Originally intended for commoners, these lands had been diverted from their rightful owners by various intrigues and bribes favoring the rich. His plan was to reclaim the state land and redistribute it in small holdings. Since the effect of concentration had been to displace laborers who went elsewhere for work, Tiberius hoped by his reforms to encourage Romans back on the land (and who could also be recruited for his legions). Eventually, however, the rich proprietors conspired to alienate the people from Tiberius's support, and a small band of them clubbed Tiberius to death.

Caius Sempronius Gracchus was elected tribune in 123 B.C., although the opposition of the patricians prevented him from obtaining the first position. He proposed the reinstitution of his brother's agrarian reform, warning against the continued absorption of independent small holdings into the vast estates and wanting to guarantee each Roman householder a monthly grain ration at a modest price. Additionally, he wanted the price of corn stabilized, suffrage extended, and the reduction of power of senators over the courts of justice. As in the case of his brother, the patrician senators—large landowners themselves—opposed his reforms and conspired to bring about his ruin. When Caius's followers were routed, he hid himself in a little grove where he ordered his servant to slay him and then commit suicide.

The Gracchi became heroes of the Revolution with the performance of Marie-Joseph Chénier's play *Caius Gracchus* in February 1792. David designed the scenery and costumes which excited much critical attention. As in Chénier's *Charles IX*, the play attacked privilege, but it also referred specifically to the usurpation of conquered lands by the large proprietors and to political and agrarian reform. That Babeuf assumed the name of Gracchus

in 1793 (when the play was also published) must be seen in the context of Chénier's play and its topical associations with Babeuf's own plans for social change.

While Babeuf protested the Jacobin Terror and welcomed the Thermidorian reaction, he soon recognized the basically conservative disposition of the new regime and attacked the growing social inequality and the rapid increase of economic and political concentration. He accused the Thermidorians of the same kind of tyranny as their predecessors which led to his arrest at the end of 1794. He now believed that only violent change could usher in his ideal society, and after his second imprisonment in 1795 he began to lay plans for the famous conspiracy of 1796. Known as the Conspiracy of Equals, he and his fellow conspirators (including several women attracted by his belief in equal status for the sexes) planned a *coup d'état* which would set up a temporary dictatorship to restore the constitution of 1793, and then attempt to reorganize society along collectivist lines.

Babeuf's attempt to establish a society based on full economic, social, and political equality and whose precondition was the abolition of private property naturally met with the severest reprisal on the part of the Directory. The government was terrified by the speed with which the movement grew; through their espionage network they arrested Babeuf and his key followers on 10 May 1796 and indicted him for his agrarian revolution dedicated to the "confiscation of private property." The government's swift action in ending the conspiracy and the harsh punishment meted out (he was executed in the spring of 1797) indicates the extent to which this re-

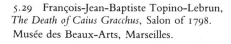

5.29 François-Jean-Baptiste Topino-Lebrun, *The Death of Caius Gracchus*, Salon of 1798. Musée des Beaux-Arts, Marseilles.

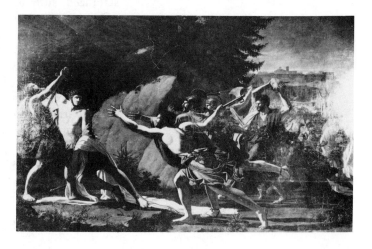

gime—dedicated to the principle of private property and its unlimited annexations—felt itself threatened.

Babeuf's conspiracy embodied the most socially progressive ideals of the French Revolution, but its pictorial representation is confined to a single painting, *The Death of Caius Gracchus* by François-Jean-Baptiste Topino-Lebrun (fig. 5.29).[63] Exhibited at the Salon of 1798, it depicts the moment when Caius's enemies rush upon him in his hiding place, only to see him expiring with stoic unconcern. One critic, apparently sensing the connection with current events, claimed that it "offered many thorns"—alluding here to the martyrdom of Babeuf. That it was certainly meant to be understood in this way becomes clear when we learn that Topino-Lebrun—the most radical student of David—was a follower of Babeuf and destined to assume an important administrative post in the new society after the *coup d'état*.

Like Babeuf, Topino-Lebrun was a Jacobin who opposed the Terror but was nevertheless pursued by the subsequent government. During the time he worked on the picture he was attending the meetings of Babeuf and his followers, a rare example of a David student following in the master's footsteps. Yet *The Death of Caius Gracchus* won a second-class medal at the Salon of 1798, and Topino-Lebrun was one of a small number of artists at the Salon to be singled out for special encouragement by the government which purchased the work for the artist's hometown of Marseilles. While this undoubtedly indicates the diminishing potential of neoclassicism to express a politically progressive position, it also demonstrates its limitations for conveying the aspirations of the politically active individual. Topino-Lebrun actually chose the moment of the demise of Gracchus rather than his victories in the Senate or his realization of practical reforms. Topino-Lebrun's expression of despair over the possibilities of reform in French society in the mid-1790s was amply rewarded by the government. Indeed, the Directory could only have viewed the painting as evidence that the movement had been entirely crushed.

It was not until the advent of the Consulate that Topino-Lebrun was again seen as a political threat. It may be recalled that after Napoleon's campaign in the New East, he returned to France and with an armed guard dismissed the legislative Council of Five Hundred—the *coup d'état* of 9 November 1799 (18 Brumaire) that dissolved the First Republic. The following month the Consulate

was founded, a government of three consuls (modeled after the ancient Roman model) of whom Napoleon himself was the most powerful, or first consul. During his period of consolidation Bonaparte gathered support from various factions, former followers of Robespierre, the Girondists, and even of Babeuf like his ruthless minister of police, Joseph Fouché. Fouché's favorite tactic was to feign terrorist threats as a pretext for rounding up dissidents and insuring the new regime's stability. At the beginning of October 1800, the police learned of a conspiracy against the life of the First Consul. Trumped-up evidence and false testimony was used to implicate Topino-Lebrun, whose republican integrity probably threatened most of the turncoats who went over to Napoleon's side. This included David himself who was called upon as a witness during the trial of his student in January 1800. David's lukewarm and guarded testimony did little to help and demonstrated his involvement with the new regime. Topino-Lebrun was guillotined on 30 January 1801, one month after David agreed to paint the propagandizing image of *Napoleon Crossing the Alps at Saint Bernard*.

The *Sabines*

The Consulate was established by the constitution of 24 December 1799, and three days later David opened his exhibition of the *Intervention of the Sabine Women* (fig. 5.30). It is a picture heralding his change of image from fanatic radical to bourgeois proprietor. We have already seen to what extent he tried to separate himself from the old associations and pursue a policy of reconciliation with the ruling regime. He withdrew increasingly into his family life and the activity of his studio. He now dressed conservatively and welcomed into his workshop returning *émigrés* who represented a body of prospective patrons of the arts. David's exhibition of his picture in the Louvre enjoyed a phenomenal success, and on the proceeds he purchased a major piece of country real estate in the Seine-et-Marne region. His success shows his alignment with the ideas of the reigning elite in the closing days of the Directory and the opening phase of Napoleon's regime.

From the time of David's brief detention through the end of the Directory and the rise of Bonaparte in 1799, David worked almost exclusively on the *Sabines*. As in

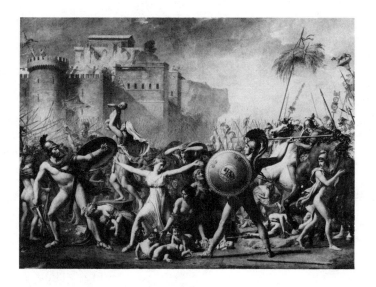

his early works, David drew for inspiration from antiquity to make a cogent statement about the present. Unlike the *Horatii,* however, the *Sabines* projects a conservative message rooted in the desire to efface his revolutionary past. Based on a story told by Livy about pre-Republican Rome, the *Sabines* concerns the primitive society organized by Romulus consisting mainly of shepherds from neighboring countries, fugitive slaves, and a variety of types closely resembling the more modern French Foreign Legion. While they constituted a formidable warrior army, it was a male-dominated state with a scarcity of women. Romulus's plans for the creation of a state and promulgation of a new people called for marriage with women of neighboring tribes, and he and his troops turned their attention to the daughters of the Sabines, a group living in the vicinity of Rome. The Sabines, however, rebuffed their overtures for alliances and intermarriages which led to bitter resentment among Romulus and his followers. Romulus now schemed to trick the Sabines by inviting all the neighboring tribes and their families to a sumptuous celebration. Strangers flocked to the festival, the Sabines in particular, who were led to believe that the celebration was being held in honor of a god they venerated. When all were assembled, the soldiers of Romulus suddenly seized the daughters of the Sabines and carried them off, while the Sabine men were permitted to flee without pursuit.

Romulus assured the women that they would be mar-

ried in solemn ceremonies and be treated with the utmost consideration. They were soon reconciled to their new status, but their parents donned mourning clothes and contemplated revenge. Several attempts by the Sabine warriors against the Romans resulted in bitter failure. Finally, at the end of three years, the Sabine king, Tatius, assembled his most courageous soldiers and penetrated the Roman outposts by a daring surprise attack. The two armies, the one led by Tatius, the other by Romulus, now faced one another at the site of the Roman Forum. The two chiefs made ready for the single combat which would initiate a full-scale battle, but at this juncture the unexpected occurred. During the interval between the kidnapping and the latest confrontation, the intermarriage of the Sabines and the Romans had settled into normal domestic existence and produced numerous offspring. Thus at the moment of imminent warfare between the two peoples the captive Sabine women suddenly threw themselves into the scene of battle, some carrying their children in their arms. They parted the hostile groups and implored their fathers, their brothers, and their husbands—Romans and Sabines together—not to shed the blood of those who were now relatives and commit parricide. Hersilia, the wife of Romulus, came forward between the two chiefs and pleaded with tears for an end to the combat. There was a sudden hush; then the leaders stepped forward to negotiate terms not only for peace but for combining the two states into one.

David chose the moment when Hersilia mediates between Tatius on the left and Romulus on the right who stand poised for violent confrontation. These three figures, however, are frozen into immobility and constitute a point of stability in a field of chaos and action. Behind Hersilia another female, arms shielding her head, comes rushing forward, an old woman bares her breast, another mounts a pedestal and holds up her child to the javelins, while in the foreground a group of three infants and their bare-breasted mother huddle in fear. (Some of these motifs derived from David's pageants: in the Festival of the Supreme Being of 1794 he arranged at the climactic moment for mothers to "raise their infants to the sky.") At the right, an elderly Roman patriarch has received the message before the others and restores his sword to the scabbard.

Once again David employed a theme which centers on the conflicting loyalties of wives to their husbands who

are at war with other members of their families. This time, however, a dramatic shift has occurred in regard to the protagonists which totally negates the fundamental dynamic of the earlier *Horatii* and *Brutus*. Here the women dominate the theme and action, reversing the male-female relationships in the previous pictures. Hersilia, for example, commands the center while the male heroes are pushed to the peripheries. The virile warriors appear almost as mannequins as Hersilia and her sisters enjoin them to refrain from battle. But the women do not engage the males as courageous equals as they did in actuality during the raid on the Tuileries on 10 August 1792: instead they cry, plead, and otherwise engage in blatant emotionalism to achieve their point. Hersilia tilts her head disarmingly toward Romulus, her woeful eyes and open mouth attempting to excite pity rather than understanding. At the same time, the skimpy costumes and bare-breasted types in the picture indicate also that she and her sisters are not above using their sexuality to manipulate males. If David switches his usual male-female roles, he nevertheless maintains the stereotypical qualities with which they were associated in his earlier paintings.

What David seems to have suggested in this picture is that the present epoch called for the feminine virtues celebrated by the gender-biased Jacobins and their more conservative successors. The iron and heroic age of the Revolution was over and the times required the spirit of reconciliation based on women's "natural" functions as wife and mother. And to this could be added the role of "sex object," since the Directory's ruling class indulged in a licentious life-style in the aftermath of Jacobin puritanism and moral rigidity. Gathering places like the foyer of the Montansier Theater were famous for their daringly dressed women who awaited admirers and customers.

Hersilia incarnates the demand on the part of the bourgeoisie for conciliation, mediating between warring parties in the civil conflict that tore the country in the aftermath of the Terror and its excessive bloodletting. One contemporary made the claim, which was confirmed by David, that the work symbolizes "Frenchmen of opposing parties ready to slaughter one another, with Mother Country rising up and rushing between them, crying stop!"[64] It is essentially a conservative plea for the kind of unity that would eventually center in the dictatorial powers of the Consulate and finally in the one person believed capable of maintaining order, Napoleon.

Conceived in prison, David's picture undoubtedly reflected the state of his exhaustion and the loss of the heroic aspirations of his fellow male revolutionaries. But it is also a sign of a certain cynicism and conservatism that he shared with the dominant members of his class.

David was now dependent on the domestic cares and organization of his wife, who restored a sense of balance to his life. She also took over fundamental practical concerns which belied his male-biased outlook. When he decided to have a special exhibition of the *Sabines,* Mme. David approached the administration for their support and for the assigning of security guards. The administration's official report recorded her efforts and indicated that they were not without influence on the decision to aid David. Several female friends of the family posed for the picture, and the old woman baring her breast was modeled after his children's nursemaid.

The *Sabine*'s theme of reconciliation also proved timely in signaling the increasing middle-class sympathy for the *émigrés,* many of whom left female members of their families behind. They began to trickle back during the Directory which allowed the laws against them to lapse and gradually returned in numbers toward the end of the century. David welcomed many into his studio which became a kind of meeting place for the fashionable who wanted to see the *Sabines* in progress. David was not the

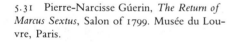

5.31 Pierre-Narcisse Gúerin, *The Return of Marcus Sextus*, Salon of 1799. Musée du Louvre, Paris.

only artist to allude to them in a major work: the same year he showed the *Sabines* privately, Pierre-Narcisse Guérin exhibited his *Return of Marcus Sextus* at the Salon, where it excited the admiration of the Parisian elite (fig. 5.31). Originally Guérin planned to paint a Belisarius returning home, but he adopted the suggestion of a friend to transform the protagonist into a political refugee returning home after a long exile.[65] The hero, however, has arrived only to learn that his wife has perished during his absence. Guérin shows Marcus Sextus standing transfixed in grief before the corpse of his wife while his prostrate daughter embraces his leg. Both the *Sabines* of David and the *Marcus Sextus* of Guérin attest to the need of the ruling elite to make a place for the returning *émigrés* in their grand scheme of reconciliation.

But this homecoming had to be on the terms of the Directors who were bent on preserving two major achievements of the Revolution: the abolition of feudal rights and distinctions, which opened the way for so-called men of talent to assume political power, and the redistribution of property made possible by the nationalization and sale of land formerly belonging to the monarchy, the church, and the emigrated nobility. The fledgling government wanted to reinforce and rationalize its new sphere of control, and the tacit acceptance of the changed state on the part of the returning *émigrés* gave it an aura of legitimacy. This ideological position also insured the appeal of David's picture, for in preaching the message of reconciliation it also implied accepting a state of society founded on the usurpation and illegal seizure of property.[66] The *Sabines* essentially calls for reconciliation to a situation springing from illegal conditions—the primary ideological demand of the new regime whose own shaky origins constantly required reinforcement.

David's painting is an expression of his thorough identification with the new regime. Even its exhibition inaugurates an entrepreneurial attitude in keeping with the commercial proclivities of the Directory. Whereas he painted the *Horatii* for "glory," he painted the *Sabines* for the money. He charged admission to see it, a practice that had been forbidden by the academy. Here he recognized the changing nature of the marketplace; his old patronage had been eliminated and now he needed to reach out to the more anonymous bourgeois public. As in the case of the Salon, however, mainly the fashionable elite flocked to see his picture. David handed each visitor a

5.32 John Flaxman, *The Fight for the Body of Patrocles*, illustration to Homer's *Iliad*.

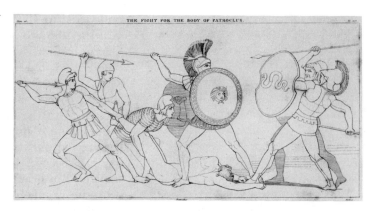

5.32 John Flaxman, *The Fight for the Body of Patrocles*, illustration to Homer's *Iliad*.

printed statement defending the admission charge. He invoked the example of Benjamin West whose *General Wolfe* earned a fortune for the artist through public exhibitions and engraving.

David's reference to West underscores one other feature of his new conservatism, a return to the commercial outlook and sources of the first-generation neoclassicists. During the execution of the *Sabines,* he declared his intentions to return to the purity of Greek art ("This picture will be more Greek"), and accordingly reexamined the catalogs of Sir William Hamilton and the engravings of the Herculaneum excavations. Significantly, he also based his composition on two of Flaxman's illustrations to Homer, *The Fight for the Body of Patrocles* and *Diomed Casting his Spear against Mars* (figs. 5.32, 5.33). The *Sabines* bears a strong resemblance to Flaxman's battle scene, especially evident in the poses of Tatius and Romulus. David originally conceived of these figures in costume as seen in a preliminary drawing, bringing the original concept even closer to Flaxman's outline illustration.

5.33 John Flaxman, *Diomed Casting His Spear against Mars*, illustration to Homer's *Iliad*, 1793.

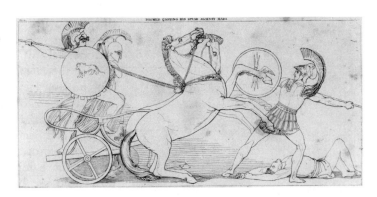

David drew upon another English source for his composition, James Gillray's satirical print *Sin, Death, and the Devil* which is dated 9 June 1792 (fig. 5.34). Gillray's cartoon shows the struggle between British Prime Minister Pitt and his Lord High Chancellor Thurlow, with the queen throwing herself between them to shelter Pitt from the fallen Thurlow's vengeance. The striking similarity between the three figures and the protagonists of the *Sabines* leaves no doubt that David used Gillray's cartoon in formulating his picture. Even the distressed expression on Hersilia's face seems derived from that of Gillray's queen. Moreover, since Flaxman's illustrations were not published until 1793, it is possible that even his composition derived from the work of the humble caricaturist. David's partial dependence on Gillray's print suggests that he conceived his picture in the topical spirit of a political cartoon.

David's return to the outline quality of the Greek vases and Flaxman's illustration exemplifies the influence of the group of students known as the *Barbus*. While at first they responded affirmatively to the master's desire to restore the primitive vitality of the ancient Greeks, they soon grew disillusioned with the mannered style of the *Sabines*. They associated the highly self-conscious approach with David's new conservative life-style, against which they revolted. Under the leadership of Maurice Quay, this group exhibited bizarre dress and behavior

5.34 James Gillray, *Sin, Death, and the Devil*, satirical print, 9 June 1792, engraving. Yale Center for British Art, Paul Mellon Collection, New Haven.

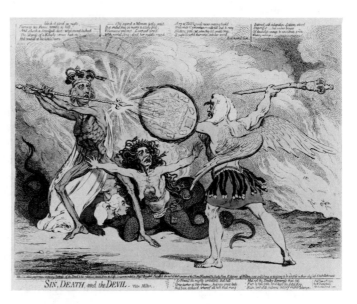

SIN, DEATH, and the DEVIL. *Vide Milton.*

and affected admiration for Ossian, Homer, and Flax-man. They wore their hair long and grew full beards and wore sheet-like cloaks and white pantaloons. Their eccentric behavior and exotic theories represented a protest against Jacobin constraint and David's cynicism. The appearance of this group within the ranks of the master's studio underscores the shifting social layers at the end of the Revolution. When Napoleon, interviewing Quay as a prospective drawing teacher for his nieces, asked him why he wore a type of clothing that separated him from the world, Quay retorted: ". . . in order to separate myself from the world." Ironically, however, the group's bohemian withdrawal derived motivation from the commercialized reproductions of Flaxman and the Ossianic hoax. In the end, it was Wedgwood and the Industrial Revolution that most profoundly affected the *Sabines* and the revolt of the *Barbus*.

Mme. Tussaud

One final feature of the *Sabines* may be considered here: of all David's pictures, it exhibits the most melodramatic character. The poses of the male figures appear staged and frozen; the style has become somewhat precious and mannered. It is perhaps no coincidence that David's friends included the woman who later founded the famous Waxworks Exhibition, Madame Tussaud. Marie Grossholtz, who later became Madame Tussaud, was one of the most interesting artists of the revolutionary period.[67] Her father died of wounds inflicted during the Seven Years' War, and as a child she moved to Paris to live with her uncle, Philip Curtius, a physician-sculptor who treated her as his daughter. Curtius was another of the "survivalists" of the epoch; having established intimate contact with the court he could later gain the confidence of the Jacobins, including David who was a frequent visitor to Curtius's residence. Curtius bought and sold paintings and also opened the first exhibition devoted to wax portraiture, all of which earned him a considerable fortune. Before the Revolution his quasi-pornographic figurines appealed greatly to the taste of the Old Regime, and later he earned his living modeling the heads of those guillotined. He died by poison while on a mission for the Republican government.

Like the other women artists mentioned, Marie grew up precociously and followed the bent of her adopted fa-

ther. She lived on close terms with Louis XVI and Marie-Antoinette, but it was she who modeled their guillotined heads for her uncle. Later, she performed the same office for the revolutionary governments, doing the heads of Danton and Robespierre. Both she and her uncle designed and executed figures for David's processions and festival floats, and David actually commissioned Marie to make a cast of the head of the dead Marat for his painting.[68] She had known Marat quite well; her uncle had given him asylum during the early stage of the Revolution. Apparently she executed a waxwork of his death scene which was on view to the public. David's own painting, has overhead lighting and a stage-like character suggestive of a waxwork display. The work that later made Tussaud an international celebrity was thus launched during the French Revolution. Her morbid and melodramatic style appealed to an age suffering from disillusionment and cynicism. She cultivated the leading personalities of the period, including Napoleon whose effigy she also executed in wax. The painted "statues" of both Madame Tussaud and David's *Sabines* are similar in spirit and spring from the same social conditions.

Thus the work of David and his disciples incarnated the progress of middle-class society from the prerevolutionary period through its most radical phase, only to capitulate in the wake of the Terror and withdraw to a conservative position during the Directory. While the poor lacked employment and were again disenfranchised, conservatism became the ideology of the Directors and their constituents. They wanted no more than that their personal gains remain safeguarded and perpetuated. But the Directory became increasingly incapable of coping with France's problems; the finances of the country had yet to be placed on a firm basis, and invasion by another coalition of France's enemies appeared imminent in 1799. Faced with possible economic ruin and invasion the French turned to the one person they thought capable of preserving the middle class, Napoleon. The forces released by the dual revolution and embodied in neoclassical art now gave rise to the authority of Napoleon. Perhaps more than anyone else of the period, he was attuned to the effects of the dual revolution and tried in his own way to take charge of both. That is the subject of the next volume, *Art in an Age of Bonapartism*.

Notes

Preface

1. E. J. Hobsbawm, *The Age of Revolution 1789–1848* (New York, 1962), xv.

2. N. Hadjinicolaou, *Art History and Class Struggle* (London, 1978), 11–17.

3. The literature on the subject is enormous, but see for starters G. Lichtheim, "The Concept of Ideology," *The Concept of Ideology and Other Essays* (New York, 1967), 3–46; T. Eagleton, *Criticism and Ideology* (London, 1976). E. Kennedy, " 'Ideology' from Destutt de Tracy to Marx," *Journal of the History of Ideas* 40 (1979), 353–368; M. Ferber, *The Social Vision of William Blake* (Princeton, 1985), 3–12.

4. For an excellent discussion of Hauser's historical role see M. R. Orwicz, "Critical Discourse in the formation of a Social History of Art: Anglo-American Response to Arnold Hauser," *Oxford Art Journal* 8, no. 2 (1985), 52–62. Also central to my thinking was F. Antal, *Classicism & Romanticism*, New York, 1973, pp. 1–45. For a history of the practice of social art history and its sometimes equivocal relationship to Marxism see N. Hadjinicolaou, "L'histoire sociale de l'art: Un alibi?" a talk given at the colloquium "Théories et applications de l'histoire sociale de l'art," Musée des Beaux-Arts, Chartres, 10–11 December 1983.

Chapter One

1. N. R. Bell, *Thomas Gainsborough* (London, 1897), 7 ff.

2. G. S. Thomson, *The Russells in Bloomsbury, 1669–1777* (London, 1940), 191.

3. G. Testori, *Giacomo Ceruti* (Milan, 1966), v ff.

4. One of his patrons was Johann Matthias von Schulenberg, a retired professional soldier from Saxony living in Venice, and something of an obsessive about his aristocratic status. He owned several of Ceruti's peasant pictures and also a painting of a beggar by Piazetta. See F. Haskell, *Patrons and Painters* (London, 1963), 110 ff.

5. Bell, p. 118.

6. P. Jean-Richard, *L'oeuvre gravé de François Boucher* (Paris, 1978), 15. Although Boucher *père* often passed himself off as a "master painter," he made his living in fact as a *dessinateur de broderies*.

7. T. D. Kaufmann, "Remarks on the Collections of Rudolf II: The *Kunstkammer* as a Form of *Representatio*," *Art Journal* 38 (Fall 1978), 22–28.

8. For a cogent account of the development of the eighteenth-century salon see T. Crow, *Painters and Public Life in Eighteenth-Century Paris* (New Haven and London, 1985), chaps 1–4; Hôtel de la Monnaie, *Diderot & l'art de Boucher à David, Les Salons: 1759–1781* (Paris, 1984), 79–83.

9. An excellent example of how academic practice served royal interests is seen in the first *Grand Prix* subjects: *Fame Proclaiming to the Four Quarters of the Globe the Marvels of the Reign of Louis XIV and Presenting to Them His Portrait* (1665); *The King Granting Peace to Europe* (1671); *The Crossing of the Rhine* (1673).

10. W. G. Kalnein and Michael Levey, *Art and Architecture of the Eighteenth Century in France* (Harmondsworth, 1972), 113–114.

11. G. Wildenstein, *Lancret* (Paris, 1924), 15.

12. A. Reichwein, *China and Europe: Intellectual and Artistic Contacts in the Eighteenth Century* (Taipei, 1967), 101 ff.; H. Honour, *Chinoiserie* (London, 1961), 101.

13. See E. Fox-Genovese, *The Origins of Physiocracy: Economic Revolution and Social Order in Eighteenth-Century France* (Ithaca, N.Y., 1976).

14. P. Rosenberg, *Chardin, 1699–1779* (Cleveland, 1979).

15. See D. Carritt, "Mr. Fauquier's Chardins," *Burlington Magazine* 116 (September 1974), 502–509; M. Fried, *Absorption and Theatricality: Painting and Beholder in the Age of Diderot* (Berkeley and Los Angeles, 1980), 48–51.

16. R. Paulson, *Hogarth, His Life, Art, and Times,* 2 vols. (New Haven and London, 1971); D. Kunzle, "William Hogarth: The Ravaged Child in the Corrupt City," in *Changing Images of the Family,* ed. V. Tufte and B. Myerhoff (New Haven and London, 1979), 99–140.

17. M. R. Zirker, Jr., *Fielding's Social Pamphlets* (Berkeley and Los Angeles, 1966), 33.

18. A. Brookner, *Greuze: The Rise and Fall of an Eighteenth-Century Phenomenon* (Greenwich, Conn., 1972); E. Munhall, *Jean Baptiste Greuze, 1725–1805* (Hartford, 1976); N. Bryson, *Word and Image: French Painting of the Ancien Régime* (Cambridge, 1981), 122–153.

19. D. Posner, "The Swinging Women of Watteau and Fragonard," *Art Bulletin* 64 (1982), 82–84.

20. R. Portalis, *Honoré Fragonard: sa vie et son oeuvre* (Paris 1889), 57.

21. D. Wakefield, *Fragonard* (London, 1976), 7.

Chapter Two

1. See R. Rosenblum, *Transformations in Late Eighteenth-Century Art* (Princeton, 1967); H. Honour, *Neo-classicism* (Harmondsworth, 1968).

2. S. Howard, "The Antiquarian Market in Rome and the Rise of Neo-Classicism: A Basis for Canova's New Classics," *Studies on Voltaire* 153 (1976), 1057–1068.

3. A. M. Clark and E. P. Bowron, *Pompeo Batoni* (New York, 1985), 18–19.

4. F. Haskell, *Patrons and Painters* (London, 1963), 258–259.

5. Mengs's Jewish ancestry is the subject of debate, but it was already an accepted fact in the nineteenth century. See F. Landsberger, "The Jewish Artist before the Time of Emancipation," *Hebrew Union College Annual* 16 (1941), 321–322, 402. Various Jewish encyclopedias claim him (*Grosse jüdische National-Biographie, Jüdisches Lexicon,* and *The Jewish Encyclopedia*) and are affirmed by Thieme-Becker and Cecil Roth (*Jewish Art* [New York, 1961], 535). Mengs's recent biographer, Thomas Pelzel, however, rejects this idea (*Anton Raphael Mengs and Neoclassicism* [New York and London, 1979], 9, 268 n. 6). But the existing documents are inconclusive either way. My own investigations tend to support the traditional view: Mengs's grandparents established themselves at Hamburg and then at Copenhagen, two sanctuaries for Jews in the late seventeenth and early eighteenth centuries, and it was in Hamburg's merchant community (where Jews played a prominent role) that Ismael launched his career as a portraitist. I also find it difficult to believe that the traditional acceptance of Mengs's Jewish background sprang from the name Ismael Israel alone, as Pelzel suggests. Either the insider's folklore or the outsider's prejudice maintained that tradition into our own time.

6. S. Röttgen, "Zum Antikenbesitz des Anton Raphael Mengs und zur Geschichte und Wirkung seiner Abguss-und Formensammlung," *Antikensammlungen im 18. Jahrhundert,* ed. H. Beck, P. C. Bol, and H. von Steuben (Berlin, 1981), 129–148.

7. G. Gorani, *Mémoirs secrets et critiques des cours, des gouvernemens, et des moeurs des principaux états de l'Italie,* 3 vols. (Paris, 1794), 175–180. Albani could not bear the thought of an anonymous bust and casually bestowed names on unknown heads akin to the art dealer whose clients demand identification for market value. In fact, he restored and christened so many works that he gained the title of *réparateur en chef de l'antiquité* (repairer-in-chief of antiquity). See A. Michaelis, *Ancient Marbles in Great Britain* (Cambridge, 1882), 43, 68.

8. S. Howard, *Bartolomeo Cavaceppi, Eighteenth-Century Restorer* (New York and London, 1982), 155 ff.

9. L. Lewis, *Connoisseurs and Secret Agents in Eighteenth-Century Rome* (London, 1961), 151.

10. Pelzel, p. 109.

11. Lewis, pp. 61–62, 193 ff.

12. D. Irwin, "Gavin Hamilton: Archaeologist, Painter, and Dealer," *Art Bulletin* 44 (1962), 87–102.

13. E. Maurice, "Letters of Gavin Hamilton, edited from the mss. at Lansdowne House," *The Academy* 14 (1878), 142, 168, 243.

14. Michaelis, p. 97.

15. We get a sense of Jenkins's manipulations in Hamilton's letter to Lord Shelburne dated 6 August 1772: "I have sold to Jenkins a torso of a Meleager little inferior to that of your Lordship, but without head, arms or legs. I gave him at the same time a fine head of a young Hercules, which he appropriates to the above torso, and in place of a Meleager he makes a Hercules of it."

16. Gorani, pp. 26–28.

17. J. T. Smith, *Nollekens and his Times*, 2 vols. (London, 1828), 1:250–251.

18. *Collection of Etruscan, Greek and Roman Antiquities from the Cabinet of the Hon.^{ble} W.^m Hamilton, His Britannick Majesty's Envoy Extraordinary at the Court of Naples*, 2 VOLS 1766–1767 IVI

19. G. Harcourt-Smith, *The Society of Dilettanti: Its Regalia and Pictures* (London, 1932), 69 ff.

20. M. Webster, "Zoffany's Painting of Charles Towneley's Library in Park Street," *Burlington Magazine* 106 (1964), 316–323.

21. P. d'Hancarville, *Recherches sur l'origine, l'esprit et les progrès des arts de la grèce*, 3 vols. (London, 1785), 1:xxv ff., 57, 136, 183–184, 188, et passim.

22. N. McKendrick, "Josiah Wedgwood: Eighteenth-Century Salesman," *Proceedings of the Wedgwood Society,* no. 4 (1961), 166.

23. E. Meteyard, *The Wedgwood Handbook* (Ann Arbor, 1971; reprint of the 1875 ed.), 256.

24. C. Zeitlin, "Wedgwood Copies of a Vase in the Hamilton Collection," *Proceedings of the Wedgwood Society, no.* 7 (1968), 147 ff.

25. B. Fothergill, *Sir William Hamilton, Envoy Extraordinary* (London, 1969), 118; A. Finer and G. Savage, *Selected Letters of Josiah Wedgwood* (London, 1965), 307.

26. R. Fleming, *Robert Adam and his Circle* (London, 1962), chaps. 4 and 5.

27. Ibid., p. 165.

28. A. T. Bolton, *The Architecture of Robert & James Adam,* 2 vols. (London, 1922), 1:133 ff.

29. J. K. L., "Edward Boscawen," *The Dictionary of National Biography* (London, 1937), 2:880.

30. J. Swarbrick, *Robert Adam and His Brothers* (London, 1915), 152.

31. Bolton, p. 51.

32. R. and J. Adam, *Works in Architecture,* 2 vols. (London, 1778–1779), 1:53.

33. D. H. Solkin discusses Sir Watkin's patronage of the landscap-

ist Richard Wilson who celebrated his country property: *Richard Wilson: The Landscape of Reaction* (London, 1982), 130–132.

34. Bolton, p. 253.

35. R. and J. Adam, p. 48.

36. Ibid., p. 54.

37. C. Gilbert, *The Life and Work of Thomas Chippendale,* 2 vols. (New York, 1978), 1:120–122.

38. Fleming, pp. 137–141, 157 ff., 159 ff., 237–240, 242, 294 ff.

39. D. Stillman, *The Decorative Work of Robert Adam* (London and New York, 1973), 10.

40. T. J. McCormick and J. Fleming, "A Ruin Room by Clérisseau," *Connoisseur* 144 (1962), 239–243.

41. V. Manners and G. C. Williamson, *Angelica Kauffmann* (London, 1924), 129 ff.; P. S. Walch, "Angelica Kauffmann" (Ph.D. diss., Princeton University, 1968), 71 ff.

42. E. Robinson and K. R. Thompson, "Matthew Boulton's Mechanical Paintings," *Burlington Magazine,* 112 (1970), 504.

43. Manners and Williamson, p. 14.

44. For the quantum leap in Homeric subjects after mid-eighteenth century see D. Wiebenson, "Subjects from Homer's Iliad in Neoclassical Art," *Art Bulletin* 46 (1964), 23–37. The comte de Caylus recommended a series on the subject in 1757: *Tableaux tirés de l'Iliad, de l'Odyssée d'Homère et de l'Enéide de Virgile, avec des observations générales sur le costume* (Paris, 1757).

45. J. Wolcot, *The Works of Peter Pindar, Esquire,* 2 vols. (London, 1794), 1:45.

46. L. Melville, *The Life and Letters of William Beckford of Fonthill* (London, 1910), 163, 113–114, 122.

47. See H. von Erffa and A. Staley, *The Paintings of Benjamin West* (New Haven and London, 1986).

48. A. U. Abrams, *The Valiant Hero: Benjamin West and Grand-Style History Painting* (Washington, D.C., 1985), 31–43.

49. J. Dillenberger, *Benjamin West: The Context of His Life's Work with Particular Attention to Paintings with Religious Subject Matter* (San Antonio, 1977), 1–2; Abrams, p. 37.

50. R. C. Alberts, *Benjamin West: A Biography* (Boston, 1978), 61.

51. For West's powerful backers see G. B. Nash, *The Urban Crucible* (Cambridge, Mass., 1979), 180, 257, 267.

52. Ibid., p. 40.

53. J. Northcote, *Memoirs of Sir Joshua Reynolds, KNT* (London, 1813), 108.

54. Staley (p. 46) points out that Drummond had been one of the subscribers.

55. Alberts, p. 87.

56. Ibid., p. 89.

57. Abrams, p. 158.

58. O. Millar, *The Later Georgian Pictures in the Collection of Her Majesty the Queen,* 2 vols. (London, 1969), 1:131–132; J. Galt, *The Life, Studies, and Works of Benjamin West, Esq.* (London, 1820), 50–51.

59. A. W. Ward, *Great Britain and Hanover: Some Aspects of Their Personal Union* (Oxford, 1899), 34, 47, 181, 196, 199.

60. A. U. Abrams, "Benjamin West's Documentation of Colonial History: *William Penn's Treaty with the Indians*," *Art Bulletin* 64 (1982), 59–75.

61. A. Pound, *The Penns of Pennsylvania and England* (New York, 1912), 278–279.

62. Ibid., pp. 287 ff.

63. J. J. Kelley, Jr., *Pennsylvania: The Colonial Years 1681–1776* (New York, 1980), 642–661.

64. G. Dandolo, *La Caduta della Repubblica di Venezia* (Venice, 1855), 114–115.

65. Ibid., pp. 208 ff.

66. I. T. Albrizzi, *Opere di scultura e di plastica di Antonio Canova*, 4 vols. (Pisa, 1821–1824), 1:62.

67. Ibid., p. 5.

68. La Font de Saint-Yenne, *Réflexions sur quelques causes de l'état present de la peinture en France* (The Hague, 1757), 80 ff.

69. A. C. P. de Caylus, *Recueil d'antiquités egyptiennes, etrusques, grecques, et romaines,* 7 vols. (Paris, 1752–1767), 3:254.

70. See J. Babelon, *Choix de bronzes de la collection Caylus donnée au roi en 1762* (Paris and Brussels, 1928), 5–6; T. W. Gaehtgens, "Archaeology and Enlightenment: The Comte de Caylus and French Neo-Classicism," in *The First Painters to the King,* ed. C. B. Bailey (New York, 1985), 37–45.

71. Caylus, 1:xv.

72. C. Nisard, *Correspondance inédite du Comte de Caylus avec le P. Paciaudi, théatin (1757–1765),* 2 vols. (Paris, 1877), 1:84.

73. Ibid., p. 144.

74. A. de Montaiglon, ed., *Correspondance des directeurs de l'Académie de France à Rome,* 21 vols. (Paris, 1887), et seq., 1:226.

75. Nisard, p. 72.

76. Ibid., p. 350.

77. E. Dacier, "L'Athénienne et son inventeur," *Gazette des Beaux-Arts,* 6e pér., vol. 8 (1932), 112–122. See also S. Eriksen and F. J. Watson, "The 'Athénienne' and the Revival of the Classical Tripod," *Burlington Magazine* 105 (March 1963), 108–112.

78. F. Aubert, "Joseph-Marie Vien," *Gazette des Beaux-Arts* 22 (1867), 180–190, 282–294, 493–507; 23, (1868), 275–287, 297–310, 470–482.

79. *Antiquités etrusques, grecques et romaines gravées par F. A. David avec leurs explications par d'Hancarville,* 5 vols. (Paris, 1785).

80. J. Locquin, *La peinture d'histoire en France de 1747 à 1785* (Paris, 1912), 23 ff.

81. J. Seznec and J. Adhémar, *Salons de Diderot,* 4 vols. (Oxford, 1957–1967), 4:242.

82. S. Howard, *Sacrifice of the Hero: The Roman Years, a Classical Frieze by Jacques-Louis David* (Sacramento, 1975), 24, 38–39, 47 et passim.

83. Seznec and Adhémar, p. 377.

84. For a history of the picture see N. Hadjinicolaou, *Art History and Class Struggle* (London, 1978), 110–111.

85. *Mercure de France*, no. 40, 6 October 1781, 38.

86. A. Boime, "Marmontel's *Bélisaire* and the Pre-Revolutionary Progressivism of David," *Art History* 3 (1980), 81–101. For other interpretations see M. Fried, *Absorption and Theatricality: Painting & Beholder in the Age of Diderot* (Berkeley and Los Angeles, 1980), 145–160; C. Duncan, "Fallen Fathers: Images of Authority in Pre-Revolutionary French Art," *Art History* 4, no. 2 (June 1981), 195–196; E. Stolpe, *Klassizismus und Krieg* (Frankfurt-am-Main, 1985), 45–47; T. Crow, *Painters and Public Life in Eighteenth-Century Paris* (New Haven and London, 1985), 198–209; N. Bryson, *Tradition and Desire: From David to Delacroix* (Cambridge, 1984), 54–62.

87. Stolpe, 28–29, 38–44.

88. Gorani, 189–194.

89. D. and G. Wildenstein, *Documents complémentaires au catalogue de Louis David* (Paris, 1973), no. 87.

90. This is especially evident in the drawing for the work: Académie de France à Rome, *David e Roma* (Rome, 1981), no. 31, 129–130.

91. H. T. Parker, *The Cult of Antiquity and the French Revolutionaries* (Chicago, 1937), 8–36.

Chapter Three

1. A. E. Musson and E. H. Robinson, *Science and Technology in the Industrial Revolution* (London, 1969), 22.

2. C. C. Gillispie, *Genesis and Geology* (Cambridge, 1951), chaps. 2 and 3.

3. J. Hutton, *Considerations on the Nature, Quality, and Distinctions of Coal and Culm, with Inquiries, Philosophical and Political into the Present State of the Laws, and the Questions Now in Agitation Relative to the Taxes upon These Commodities* (Edinburgh, 1777), 37.

4. R. S. Fitton and A. P. Wadsworth, *The Strutts and the Arkwrights 1758–1830* (Manchester, 1958), chap. 4.

5. D. G. C. Allan, *William Shipley, Founder of the Royal Society of the Arts*, (London, 1979), 50–57.

6. S. K. Siddons, *Reminiscences 1773–1785*, ed. W. van Lennep, (Cambridge, 1942), 17.

7. Northcote quoted Reynolds as saying that "no man ever acquired a fortune by the work of his own hands alone." See J. Northcote, *The Life of Sir Joshua Reynolds*, 2 vols. (London, 1819), 1:84–85.

8. F. W. Hilles, ed., *Letters of Sir Joshua Reynolds* (Cambridge, 1929), 161–162.

9. R. E. Schofield, *The Lunar Society of Brimingham: A Social History of Provincial Science and Industry in Eighteenth-Century England* (Oxford, 1963).

10. E. Robinson, "Eighteenth-Century Commerce and Fashion:

Matthew Boulton's Marketing Techniques," *Economic History Review,* 2d ser., vol. 16 (1963–1964), 40.

11. E. Robinson, "Matthew Boulton, Patron of the Arts," *Annals of Science* 9 (1953), 368–376.

12. E. Robinson and K. R. Thompson, "Matthew Boulton's Mechanical Paintings," *Burlington Magazine* 112 (August 1970), 497–508.

13. E. Darwin, *Zoonomia; or, The Laws of Organic Life,* 4 vols. (London, 1801).

14. F. D. Klingender, *Art and the Industrial Revolution* (London, 1972), 29 ff.

15. E. Darwin, *The Botanic Garden, a Poem in Two Parts,* 4th ed., 2 vols. (London, 1799), 1:200–201.

16. N. McKendrick, "Josiah Wedgwood and Factory Discipline," *Proceedings of the Wedgwood Society,* no. 5 (1963), 1–29.

17. Ibid., p. 6.

18. J. Priestley, *The History and Present State of Electricity* (London, 1767), vii.

19. Schofield, pp. 347 ff.

20. K. E. Farrer, ed., *Correspondence of Josiah Wedgwood 1781–1794* (London, 1906), 92–93; Schofield, p. 358.

21. This was reproduced in Darwin's *Botanic Garden:* see Farrer, pp. 88–89.

22. Ibid., p. 220 ff.

23. E. and W. Burke, *An Account of the European Settlements in America,* 2 vols. (London, 1757), 2:22–73, 38, 46–47, 100, 128. The authors could say: "We have been engaged for above a century with France in a noble contention for the superiority in arms, in politics, in learning, and in commerce; and there never was a time, perhaps, when this struggle was more critical."

24. Ibid., pp. 95 ff.

25. P. Mantoux, *The Industrial Revolution in the Eighteenth Century* (New York, n.d.), 313.

26. T. B. Saunders, *The Life and Letters of James MacPherson* (London, 1894).

27. Ibid., p. 189.

28. J. MacPherson, *The Works of Ossian, the Son of Fingal,* 2 vols. (London, 1765), 1:nonpaginated "Dedication."

29. Ibid., p. xvi.

30. H. Okun, "Ossian in Painting," *Journal of the Warburg and Courtauld Institutes* 30 (1967), 327–356; H. Hohl and H. Toussaint, *Ossian,* Réunion des musées nationaux, Paris, 1974; *Ossian und die Kunst um 1800,* Hamburger Kunsthalle (Hamberg, 1974).

31. E. Fryer, ed., *The Works of James Barry,* 2 vols. (London, 1809), 1:6–7, 9 ff., et passim.

32. W. L. Pressly, *The Life and Art of James Barry* (New Haven and London, 1981), 77 ff.

33. G. E. Bentley, Jr., ed., *William Blake's Writings,* 2 vols. (Ox-

ford, 1978), 2:1451. Blake also wrote (ibid., p. 1450): "While Sr Joshua was rolling in riches Barry was Poor & Unemployed except by his own Energy."

34. E. Fryer, 2:305.
35. Ibid., pp. 332–333.
36. Ibid., p. 371.
37. Ibid., p. 388.
38. B. Nicolson, *Joseph Wright of Derby*, 2 vols. (London, 1968), 1:1 ff.; W. Bemrose, *The Life and Works of Joseph Wright, A.R.A., Commonly Called "Wright of Darby"* (London, 1885).
39. Darwin, *The Botanic Garden*, 1:117. In *The History and Present State of Electricity*, Priestley describes the orrery as one of the means by which "ingenious men have hit upon to explain their own conceptions of things to others." For a history of the orrery see H. C. King, *Geared to the Stars: The Evolution of Planetariums, Orreries, and Astronomical Clocks* (Toronto, 1978), 150–167.
40. Musson and Robinson, p. 143.
41. K. P. Moritz, *Reisen eines Deutschen in England im Jahr 1782* (Berlin, 1903), 51.
42. Musson and Robinson, pp. 104 ff.
43. Ibid., pp. 107 ff.
44. J. Ferguson, *The Use of a New Orrery, Made and Described* (London, 1746); *A Dissertation upon the Phenomenon of the Harvest Moon. Also, the Description and Use of a New Four-Wheſl'd Orrery* (London, 1747); *Select Mechanical Exercises: Shewing How to Construct Different Clocks, Orreries, and Sun-Dials, on Plain and Easy Principles* (London, 1773).
45. Ibid., pp. 102–103; Nicolson, p. 113.
46. Darwin, *The Botanic Garden*, 2:24–25.
47. B. Fothergill, *Sir William Hamilton* (New York, 1969), 87–88. Elsewhere (ibid., p. 276), Hamilton observed that the eruption of Vesuvius brought to mind "that noise which is produced by the action of the enormous bellows on the furnace of the Carron iron foundry in Scotland, and which it perfectly resembled."
48. J. Whitehurst, *An Inquiry into the Original State and Formation of the Earth* (London, 1778), 94–95.
49. B. Connell, *Portrait of a Whig Peer* (London, 1957), 26, 168, 176–177.
50. Musson and Robinson, pp. 434–435, 438.
51. R. S. Fitton and A. P. Wadsworth, *The Strutts and the Arkwrights 1758–1830* (Manchester, 1958), chap. 9.
52. Ibid., p. 99.
53. Darwin, *Botanic Garden*, 1:76–77.
54. E. F. MacPike, *Correspondence and Papers of Edmond Halley* (Oxford, 1932), 205 ff.
55. Darwin, *Botanic Garden*, 2:82–83.
56. In this same period Arkwright brought suit against nine com-

petitors who were infringing on his patent rights, and he lost his case. He refused to be beaten and in February 1782 addressed a petition to Parliament asking for an extension of his rights. It was a period in which he exalted his merit and Wright's painting was meant to further his effort. See Mantoux, pp. 232–233.

57. Ibid., p. 231.

58. Nicolson, 1:143.

59. J. Knowles, *The Life and Writings of Henry Fuseli,* 3 vols. (London, 1831); F. Antal, *Fuseli Studies* (London, 1956); P. Tomory, *The Life and Art of Henry Fuseli* (New York, 1972); G. Schiff, *Johann Heinrich Fuseli,* 2 vols. (Zurich, 1973).

60. Knowles, 1:21.

61. R. Pascal, *The German Sturm und Drang* (London, 1953); H. Brunschwig, *Enlightenment and Romanticism in Eighteenth-Century Prussia* (Chicago and London, 1974).

62. T. Taylor, *Life of Benjamin Robert Haydon, Historical Painter,* 3 vols. (London, 1853) 1:27–28.

63. Ibid., 2:100 ff. He expresses his change of attitude even more forcibly in his diary. To a rather flattering entry of 1808 he added a footnote seven years later: "I have since found Fuzeli a Traitor—mean, malicious, cowardly & debauched—November 27, 1818." See W. B. Pope, ed., *The Diary of Benjamin Robert Haydon,* 5 vols. (Cambridge, Mass., 1963), 1:37–38.

64. Pascal, pp. 181 ff.

65. J. Fuseli, *Remarks on the Writings and Conduct of J. J. Rousseau,* ed. E. C. Mason (Zurich, 1962); J. Fuseli, "Remarks on the Writings and Conduct of J. J. Rousseau, published by Cadell," *Critical Review* 23 (1767), 374 ff.

66. J. T. Smith, *Nollekens and his Times,* 2 vols. (London, 1828), 2:191.

67. E. C. Mason, *The Mind of Henry Fuseli* (London, 1951), 114–115.

68. Knowles, 1:66; Tomory, pp. 50, 92. Salomon (whose nickname was "Henry") was also related to Bodmer, and he named one of his sons after the scholar. Another son, Heinrich, donated the double portrait to the *Künstlergesellschaft* (Artists' Society) which founded the Zurich Kunsthaus. See Fuseli's interesting letter to his patron reproduced in *Neujahrsblatt der Künstlergesellschaft in Zürich für 1848,* no. 8 (1848), 14.

69. P. Gern, *Aspects des relations Franco-Suisses au temps de Louis XVI* (Neuchâtel, 1970), chaps. 6 and 7.

70. Ibid., pp. 89, 117, 127 ff.

71. Ibid., p. 128.

72. For the geneology of this side of the family and its international connections in France and Germany see C. Keller-Escher, *Fünfhundert und sechzig Jahre aus der Geschichte der Familie Escher vom Glas, 1320–1885,* 2 vols. (Zurich, 1885), 1:50–54.

Chapter Four

1. E. P. Thompson, *The Making of the English Working Class* (New York, 1964), 71–72.

2. The basic study is N. Powell, *Fuseli: The Nightmare* (New York, 1973).

3. F. D. Klingender, *Art and the Industrial Revolution* (London, 1972), 85–90.

4. E. H. Coleridge, *The Life of Thomas Coutts, Banker,* 2 vols. (London, 1920), 1:74, 79, 83–84, 102, 110–114, 117, 119, 121, 127, 130–131, 134, 136.

5. J. Knowles, *The Life and Writings of Henry Fuseli,* 3 vols. (London, 1831), 1:64; G. Schiff, *Johann Heinrich Füssli,* 2 vols. (Zurich, 1973), 1:508, cat. no. 841.

6. M. Webster, *Francis Wheatley* (London, 1970), 29 ff., 126–127; P. McGuinn, "The *Volunteers* and Repression in Ireland," (unpublished research paper, UCLA, 1983).

7. Knowles, 2:197 note.

8. E. C. Mason, *The Mind of Henry Fuseli* (London, 1951), 136; J. Fuseli, *Remarks on the Writings and Conduct of J. J. Rousseau,* ed. E. C. Mason (Zurich, 1962), 5; J. Fuseli, "Remarks on the Writings and Conduct of J. J. Rousseau, published by Cadell," *Critical Review* 23 (1767), 374 ff.

9. Schiff, pp. 593–594, cat. no. 1424.

10. G. Chandler, *William Roscoe of Liverpool* (London, 1953), xxx, 83 and note, 88, 275 ff.

11. Schiff, 1:580, cat. nos. 1342a–1342b, 1343a–1343b; J. Barlow, *The Columbiad: A Poem* (Philadelphia, 1807).

12. Barlow, pp. 144–145.

13. Ibid., p. 211.

14. G. E. Bentley, Jr., ed., *William Blake's Writings,* 2 vols. (Oxford, 1978), 1:627–628.

15. Coleridge, 1:132, letter to the Earl of Stair, 15 November 1780.

16. For examples, see Schiff, 2 (nos. 538):540–541.

17. I am using the fourth edition: E. Darwin, *The Botanic Garden, a Poem,* 2 vols. (London, 1799), 2:126–128.

18. Ibid., 1:105.

19. Ibid., 2:127–128n.

20. E. Darwin, *Zoonomia; or The Laws of Organic Life,* 3 vols. (London, 1801), 1:284–316.

21. Knowles, 3:145.

22. Darwin, *The Botanic Garden,* 2:72–73.

23. Schiff, 1:533, nos. 973–976.

24. K. P. Moritz, *Reisen eines Deutschen in England im Jahr 1782* (Berlin, 1903), 51: "Die Elektricität ist das Puppenspiel der Engländer, Wer damit Wind machen kann, ist eines glücklichen Erfolgs gewiss."

25. J. Priestley, *The History and Present State of Electricity* (London, 1767), xi–xiii. 26. We get a sense of the historical context from the fact that Fuseli's review of his own book on Rousseau and

summary of Priestley's *Electricity* appeared in the same issue of *Critical Review* see n. 7 above, pp. 329 ff., 374 ff.). Not surprisingly, both works were printed by the same publisher, Cadell.

27. Priestley, pp. 556 ff., 656.

28. Ibid., p. 83.

29. J. Priestley, *A Familiar Introduction to the Study of Electricity* (London, 1768), advertisement before title page, "Electrical machines to be sold."

30. Knowles, 1:174–175.

31. W. Roscoe, *Wrongs of Africa, a Poem* (London, 1787), iii ff.

32. W. Roscoe, *Thoughts on the Causes of the Present Failures* (London, 1793), 5. Still later, Roscoe would write: "There is no country under heaven which can derive such benefit from peace as Great Britain. Possessed of a marine superior to that of all the rest of the world; sovereign of the most extensive colonial territories that ever acknowledged obedience to a parent state, superior in capital, in ingenuity, in industry, and in mercantile probity, to every nation upon earth . . ." (*Considerations on the Causes, Objects and Consequences of the Present War, and on the Expediency, or the Danger of Peace with France* [London, 1808], 105.)

33. Darwin, *Botanic Garden,* 1:31–32, 34.

34. The connection between the hot-air balloon and floating supernatural beings in paintings had already been established by French Salon pamphleteers in 1783: see T. Crow, *Painters and Public Life in Eighteenth-Century Paris* (New Haven and London, 1985), 94–95.

35. Darwin, *Botanic Garden,* 1:193–194, 2:79–80.

36. Schiff, p. 564, cat. no. 1211.

37. Coleridge, 2:82.

38. Chandler, pp. 343–378.

39. Roscoe, *A General View of the African Slave-Trade, Demonstrating Its Injustice and Impolicy: With Hints towards a Bill for Its Abolition* (London, 1788), 16, 24–25, 27, 31.

40. Knowles, 1:376–377.

41. Darwin, *Botanic Garden,* 1:101–102 and note; K. E. Farrer, ed., *Correspondence of Josiah Wedgwood 1781–1794* (London, 1906), 88–89.

42. Every modern Blake scholar must start with D. V. Erdman, *Blake: Prophet against Empire* (Princeton, 1977). I have also made abundant use of M. Schorer, *William Blake: The Politics of Vision* (New York, 1946); J. Bronowski, *William Blake 1757–1827: A Man without a Mask* (New York, 1967); D. Bindman, *Blake as an Artist* (Oxford, 1977); G. E. Bentley, Jr., *William Blake's Writings* (Oxford, 1978); K. Raine, *William Blake* (New York, 1973); M. Butlin, *The Paintings and Drawings of William Blake* (New Haven and London, 1981).

43. *The Book of English Trades, and Library of the Useful Arts* (London, 1824), 373. An advertisement that Blake designed for a hosier depicts a stocking weaver at a loom in the lower right-

hand corner, showing Blake's intimate knowledge of the process. See R. N. Essick, *William Blake Printmaster* (Princeton, 1980), no. 32.

44. D. G. C. Allan, *William Shipley: Founder of the Royal Society of Arts* (London, 1979), 80.

45. Ibid., p. 81.

46. Ibid., p. 87.

47. Ibid., pp. 87–88.

48. W. Sandby, *The History of the Royal Academy of Arts from Its Foundation in 1768 to the Present Time,* 2 vols. (London, 1862), 1:303; S. M. Bennett, "Thomas Stothard, R. A." (Ph.D. diss., University of California, Los Angeles, 1977), 7 ff., 167 ff.

49. D. V. Erdman, ed., *The Complete Poetry and Prose of William Blake* (Berkeley and Los Angeles, 1982), 665.

50. Ibid., p. 643.

51. Bindman, *Blake as an Artist,* p. 17; Butlin, 1(no. 174).

52. Erdman, *Complete Poetry and Prose,* p. 550.

53. Ibid., pp. 541–542.

54. G. Keynes, "Some Uncollected Authors XLIV: George Cumberland 1754–1848," *Book Collector* 19 (1970), 31 ff.

55. G. Cumberland, *Thoughts on Outline, Sculpture, and the System That Guided the Ancient Artists in Composing Their Figures and Groupes* (London, 1796).

56. Ibid., pp. 1 ff., 8, 12–13, 21.

57. Erdman, *Complete Poetry and Prose,* pp. 528, 692 (dated 10 October 1793).

58. G. E. Bentley, Jr., "Thomas Butts, White Collar Maecenas," *PLMA,* vol. 71, part 2, Sept.-Dec. 1956, pp. 1052 ff.

59. Erdman, *Complete Poetry and Prose,* p. 719.

60. Essick, pp. 22–23. Blake's ideas on this were informed by experiments of Cumberland, but he developed his own approach. Ibid., 86–89, 112, 119, for a clarification of Blake's methods.

61. Erdman, *Complete Poetry and Prose,* p. 1465.

62. Ibid., p. 726.

63. Ibid., p. 922.

64. Erdman, *Blake: Prophet against Empire,* pp. 7 ff.

65. R. E. Schofield, *The Lunar Society of Birmingham* (Oxford, 1963), 359.

66. M. D. Conway, ed., *The Writings of Thomas Paine,* 4 vols. (New York and London, 1984–1896), 2:252.

67. Darwin, *Botanic Garden,* 1:105–106 and note.

68. D. Worral, "William Blake and Erasmus Darwin's *Botanic Garden,*" *Bulletin of the New York Public Library* 78 (Summer 1975), 405–406.

69. Raine, p. 31.

70. Ibid., p. 113; Darwin, canto 1 for worms, spiders, beetles; canto 4 for seeds, acorns, bulbs and buds, butterflies, caterpillars, and chrysalis.

71. Worral compares the *Vallisneria* illustration to other plates in Blake, p. 414.

72. Michael Ferber claims that Blake's science differed from that of the Lunar Society and was closer to "Christian Science" than to bourgeois science. I am trying to make clear that upon her understanding of "Christian Science" Lunar Society members would have welcomed into their midst Mary Baker Eddy. See M. Ferber, *The Social Vision of William Blake* (Princeton, 1985), 37–38.

73. Erdman, *Blake, Prophet against Empire,* pp. 93–94nn.13, 13a, recounts the pros and cons about the Priestley identification. Thus far the best alternative suggested has been Gustavus Katterfelto, an itinerant lecturer generally regarded as a "windbag." However, Katterfelto was only one among a number of itinerant lecturers on science and mechanics, as we have seen in the last chapter. Almost all of them took their cue from Priestley, who was perhaps the best-known public lecturer of all. His discoveries concerning "different kinds of airs" were highly publicized. See A. E. Musson and E. Robinson, *Science and Technology in the Industrial Revolution* (Manchester, 1969), 101–102, 106–107. We may recall also Priestley's fondness for games and toys and the fact that his books were published by Joseph Johnson, Blake's friend and occasional client. Finally, no one enjoyed a livelier reputation than Priestley for his popular experiments on air and gases. Darwin wrote: "His various discoveries respecting the analysis of the atmosphere, and the production of variety of new airs or gasses can only be understood by reading his Experiments on Airs." Hence Priestley should be considered the prime candidate for "Inflammable Gass the Wind Finder"—O who can doubt this?

74. R. Reilly and G. Savage, *The Dictionary of Wedgwood* (Woodbridge, Suffolk, 1980), 49.

75. G. Keynes, *Blake Studies* (London, 1949), 67 ff., Bentley, *Blake Records* (Oxford, 1969), 239 ff.

76. R. Pimeau, "Blake's Chimney Sweeper as Afro-American Minstrel," *Bulletin of the New York Public Library* 78 (Summer 1975), 418 ff., M. K. Nurmi, "Fact and Symbol in 'The Chimney Sweeper' of Blake's *Sons of Innocence,*" *Bulletin of the New York Public Library* 68, (1964), 249 ff.

77. Chandler, p. 332.

78. Erdman, "Blake's Vision of Slavery," *Journal of the Warburg and Courtauld Institutes* 15 (1952), 242–252.

79. J. G. Stedman, *Expedition to Surinam*, ed. C. Bryant (London, 1963), 161, 163.

80. Erdman, *Complete Poetry and Prose,* p. 1025.

81. J. MacPherson, *The Rights of Great Britain Asserted against the Claims of America* (London, 1776), p. 12.

82. Erdman, *Complete Poetry and Prose,*. p. 804. In his advertisement for the exhibition (ibid., p. 777), Blake claims that his show is "the greatest of Duties to my Country," and in a related statement on his painting of *The Canterbury Pilgrims* he aimed a barb at Napoleon: "Let us Teach Buonaparte, & whomsoever else it

may concern, That it is not Arts that follow & attend upon Empire, but Empire that attends upon & follows The Arts." (Ibid., p. 815.)

83. Ibid., p. 781.

84. For further analysis of Blake's design in this work and its relationship to the text, see E. Bass, "*Songs of Innocence and of Experience,* the Thrust of Design," in D. V. Erdman and J. E. Grant, eds., *Blake's Visionary Forms Dramatic* (Princeton, 1970), 197–198.

85. Essick, pp. 119–120.

86. Blake submitted his wife to electrical treatments in 1804: see his letter to Hayley, 18 December 1804, in Erdman, *Complete Poetry and Prose,* p. 1111.

87. Priestley, *History and Present State,* plates 4 (p. 525 for explanation), 6, 7.

88. Ibid., pp. 96, 135 ff.; Abbé J. A. Nollet, *Recherches sur les causes particulières des phénomènes électriques* (Paris, 1749).

89. Priestley, *The History of Present State of Discoveries Relating to Vision, Light, and Colours,* 2 vols. (London, 1772), I, 1:238 ff., 280 ff.

90. J. Gage, "Blake's *Newton,*" *Journal of the Warburg and Courtauld Institutes* 34 (1971), 372–376.

91. A. Cobban, ed., *The Eighteenth Century* (London, 1969), 118.

92. J. T. Smith, *Nollekens and his Times,* 2 vols. (London, 1828), 2:478n.

93. Thompson, pp. 197–198.

94. Erdman, *Complete Poetry and Prose,* p. 970.

95. Conway, 2:227 ff., 230 ff.

96. Schofield, p. 29.

97. H. W. Dickinson and R. Jenkins, *James Watt and the Steam Engine* (Oxford, 1927), 164 ff.

98. H. W. Dickinson, *Robert Fulton, Engineer and Artist: His Life and Works* (London, 1913), p. 30.

99. Erdman, *Blake, Prophet against Empire,* pp. 23, 26, 156 ff., 159 n.32, 210n.24.

100. A. Ure, *The Philosophy of Manufactures* (London, 1835), 18.

101. Ironically, Blake's perception reversed that of his contemporaries who saw the steam engine as the means of subduing the earth—the biblical promise of Genesis before Adam's Fall. Here is the definition of the steam engine in an account of Matthew Boulton published in 1803:

The steam engine, approaching to the nature of a perpetuum mobile, or rather than an *animal,* is incapable of lassitude or sensation, produces coals, works metals, moves machines, and is certainly the noblest *drudge* that was ever employed by the hand of art. Thus we "put a hook in the nose of Leviathan;" thus we "play with him as a child, and take him for a servant forever;" . . . thus "we subdue nature, and derive aid and comfort from the elements of earthquakes."

See "Biographical Account of Matthew Boulton, Esq.," *Philosophical Magazine* 15 (February to May 1803), 60. In this con-

text God's chastisement of Adam may be understood also as a metaphor for the abuse of "the new and stupendous power" of steam engines.

102. Darwin, *Botanic Garden,* 1:10–11. Also in "Loves of the Plants." canto 2, line 176, "Tooth urges tooth, and wheel drives wheel along," has the Blakean rhythm.

103. Frye characterized Golgonooza as "a huge machine shop or foundry—a vast crucible into which the whole physical world had to be thrown before the refined gold of the New Jerusalem can emerge from it." See N. Frye, *Fearful Symmetry* (Princeton, 1947), 253.

104. Erdman, *Complete Poetry and Prose,* p. 1059.

105. E. Burke, *A Philosophical Enquiry into the Origin of Our Ideas of the Sublime and Beautiful,* ed. J. T. Boulton (London, 1958), 64; M. D. Paley, *Energy* and *Imagination* (Oxford, 1970), 45.

106. D. Irwin, *John Flaxman 1755–1826* (New York, 1980), D. Bindman, ed., *John Flaxman* (London, 1979); S. Symmons, *Flaxman and Europe: The Outline Illustrations and Their Influence* (New York and London, 1984).

107. Bindman, *Flaxman,* no. 52.

108. A. Finer and G. Savage, *Letters of Wedgwood* (London, 1965), 307.

109. T. Hope, *Household Furniture and Interior Decoration* (London, 1807), 7.

110. Hope, *Costume of the Ancients,* 2d ed., 2 vols. (London, 1812), 1:xi.

111. Hope, *Household Furniture,* p. 57.

112. Ibid., p. 3.

113. L. Hautecoeur, *Louis David* (Paris, 1954), 178.

Chapter Five

1. For David see E. J. Delécluze, *Louis David, son école et son temps* (Paris, 1855); J.-L. Jules David, *Le peintre Louis David, 1748–1825* (Paris, 1880); L. Hautecoeur, *Louis David* (Paris, 1954). Three recent studies should also be noted: A. Brookner, *Jacques-Louis David* (London, 1980); A. Schnapper, *David* (New York, 1982); *David e Roma* (Accademia di Francia a Roma, 1981).

2. An enormous literature has been accumulating on this work: see most recently T. Crow, *Painters and Public Life in Eighteenth-Century Paris* (New Haven and London, 1985), 211–241, an elaboration of his earlier "The Oath of the Horatii in 1785: Painting and Pre-Revolutionary Radicalism in France," *Art History* 1 (1978), 424–471; N. Bryson, *Tradition and Desire: From David to Delacróix* (Cambridge, 1984), 70–80.

3. E. G. Holt, ed., *The Triumph of Art for the Public* (New York, 1979), 29.

4. E. Stolpe, *Klassizismus und Krieg* (Frankfurt-am-Main, 1985), 57–89.

5. David, p. 26.

6. *Mercure de France,* 1 October 1785, 33.

7. P. Dimoff, *La Vie et l'oeuvre d'André Chénier jusqu'à la révolution française,* 2 vols. (Paris, 1936), 1:136–152; A. Chénier, *Oeuvres complètes,* ed. P. Dimhoff, 3 vols. (Paris, 1937), 3:145–146.

8. Holt, p. 25.

9. I owe this concept to my brother, Jerome Philip Boime. In his unpublished manuscript "Violence and Sociality" (1975) he writes: "However various the social manifestations—criminal factions (juvenile and adult), revolutionary unions, and commissioned armies defending the territory or invading another on imperial expedition—these combinations possess, below their salient differences of justification, a common underlying form that depends on the break with, or physical separation from, civil order. And this further implies, absenting the container, that they present their members with the immediate prospect of irrevocable danger as a condition of membership. We shall recognize then that the division of social order into militant sides conserves an alternate affiliation in the breach of civil association: *if the aversion to violent death conserves civil order, the risk of violent death conserves fraternal order.*" I am presently editing Jerry's writings for publication.

10. C. Lucas, "Nobles, Bourgeois and the Origins of the French Revolution," *Past and Present,* no. 60 (August 1973), 100.

11. Stolpe, pp. 63–64.

12. L. Hunt, *Politics, Culture, and Class in the French Revolution* (Berkeley and Los Angeles, 1984), 20–21.

13. Quoted in J. M. Thompson, *The French Revolution* (New York, 1945), 14.

14. E. Choullier, *Les Trudaine* (Arcis-sur-Aube, 1884).

15. Ibid., p. 38; C.-M. Trudaine de La Sablière, tr., *Le Federaliste, ou collection de quelques écrits en faveur de la constitution proposée aux Etats-Unis de l'Amérique . . . publiés . . . par MM. Hamilton, Madisson et Gay* [sic], 2 vols. (Paris, 1792).

16. Dimoff, *La vie,* pp. 52 ff., 133 ff., et passim.

17. I. B. Jaffe, *John Trumbull, Patriot-Artist of the American Revolution* (Boston, 1975), 128; J. P. Boyd, *The Papers of Thomas Jefferson,* 20 vols. (Princeton, 1950), 12:xxxvi, 69, et passim. On 14 March 1789 Jefferson wrote to Mme. de Bréhan: "I do not feel an interest in any pencil but that of David" (Boyd, 14:656); and even years later, in comparing Trumbull to his contemporaries, Jefferson could recall that he thought the American artist "superior to any historical painter of the time except David" (A. A. Lipscomb and A. E. Bergh, eds., *The Writings of Thomas Jefferson,* 20 vols. [Washington, D.C., 1905], 19:243).

18. R. Darnton, *Mesmerism and the End of the Enlightenment in France* (Cambridge, Mass., 1968).

19. A.-L. Lavoisier, *Traité élémentaire de chimie,* 3 vols. (Paris, 1789), 3:plates 1–13 engraved with the signature "Paulze Lavoisier sculpsit."

20. Reproduced in E. Grimaux, *Lavoisier 1743–1794 d'après sa corre-*

spondance, ses manuscrits, ses papiers de famille et d'autres documents inédits (Paris, 1888),opp. p. 128. See also opp. p. 118 for a related sketch. Arthur Young was deeply impressed with Mme. Lavoisier's scientific knowledge: G. E. Mingay, ed., *Arthur Young and His Times* (London, 1975), 100.

21. R. L. Herbert, *David, Voltaire, Brutus and the French Revolution* (New York, 1973).

22. The unusual character of the composition was remarked upon by an early biographer of David: A. Th[ibaudeau], *Vie de David, premier peintre de Napoleon* (Brussels, 1826), 46–47.

23. D. and G. Wildenstein, *Documents complémentaires au catalogue de l'oeuvre de David* (Paris, 1973), 28.

24. M. V. Vaughan, *The Last Stuart Queen: Louise Countess of Albany* (London, 1910), 155.

25. V. Alfieri, "Bruto Primo," in *Opere*, 22 vols. (Pisa, 1805–1815), 14:3–4.

26. Ibid., pp. 80–81. As the crowd addresses him as a chorus, "The father, the god of Rome," Brutus laments: "The most unhappiest of men, I should never have been born."

27. The most complete documentation on this subject is P. Bordes, *Le Serment du jeu de paume de Jacques-Louis David* (Paris, 1983). See also his "Jacques-Louis David's 'serment du jeu de paume': Propaganda without a Cause?" *Oxford Art Journal* 3 (1980), 19–25.

28. David, pp. 88 ff.

29. Musée de la Révolution française, *Premiéres Collections* (Grenoble, 1985), no. 3.

30. Chénier, *Oeuvres complètes*, pp. 230–244.

31. Jaffe, chap. 7; *Trumbull: The Declaration of Independence* (New York, 1976).

32. T. Sizer, ed., *The Autobiography of Colonel John Trumbull* (New Haven, 1953), 93.

33. Ibid., pp. 223–226.

34. D. L. Dowd, *Pageant Master of the Republic: Jacques-Louis David and the French Revolution* (Lincoln, Nebr., 1948).

35. H. A. Gérard, ed., *Lettres adressés au Baron François Gérard, peintre d'histoire*, 2 vols. (Paris, 1888), 1:129–130.

36. P. A. Coupin, *Oeuvres posthumes de Girodet-Trioson*, 2 vols. (Paris, 1829), 2:359 ff., letter to Trioson dated 5 May 1790.

37. Gérard, p. 181. David perceived this connection between the painter and his persona and once wrote him: My dear Girodet, when for heaven's sake will you arouse yourself from this lethargic slumber which heartens your envious rivals and profoundly afflicts your friends?" Coupin, p. 312.

38. Coupin, p. 396, letter to Trioson dated 24 October 1791.

39. A. S. Banles, "Two Letters from Girodet to Flaxman," *Art Bulletin* 61 (1979), 100–101.

40. G. Levitine, *The Dawn of Bohemianism: The Barbu Rebellion and Primitives in Neoclassical France* (University Park, Pennsylvania, and London), 1978.

41. E.-J. Delécluze, *Louis David, son école et son temps* (Paris, 1855), 428.

42. F. Chèvremont, *Jean-Paul Marat*, 2 vols. (Paris, 1880). The most complete statement on David's picture is now J. Traeger, *Der Tod des Marat* (Munich, 1986).

43. Chèvremont, 1:25, 2:365.

44. Ibid., 1:13–14.

45. J.-P. Marat, *Recherches physiques sur le feu* (Paris, 1780); Marat, *Découvertes sur le feu, l'électricité et la lumière* (Paris, 1779); Marat, *Recherches physiques sur l'électricité* (Paris, 1782); Marat, *Mémoires académiques, ou nouvelles découvertes sur la lumière* (Paris, 1788).

46. J.-P. Marat, *Mémoire sur l'électricité médicale* (Paris, 1784), 3, 82–83.

47. M. Marmottan, *Le peintre L. Boilly* (Paris, 1913), 48 ff.

48. H. Sokolnikova, *Nine Women* (New York, 1932), 37–38.

49. C. Vatel, *Charlotte de Corday et les Girondins*, 3 vols. (Paris, 1872), 1:xxvi–xxvii.

50. H. T. Parker, *The Cult of Antiquity and the French Revolutionaries* (Chicago, 1937), p. 55.

51. C. A. Dauban, *Mémoires inédits de Petion et mémoires de Buzot et de Barbaroux* (Paris, 1866), pp. 39–40.

52. Vatel, p. cclxxi.

53. *Premières Collections*, no. 38.

54. It was called "une table rustique" by a critic in 1826. See M. Perignon, ed., *Catalogue des tableaux de galerie et de chevalet, dessins, études, livres de croquis de M. Louis David* (Paris, 1826), 5.

55. K. Herding, "Davids 'Marat' als *Dernier appel à l'unité révolutionnaire*," *Idea: Jahrbuch der Hamburger Kunsthalle* 2 (1983), 89–112.

56. W. Sauerländer "Davids 'Marat à son dernier soupir' oder Malerei und Terreur," *Idea* 2 (1983), pp. 66, 70.

57. G. Bord, "Deux légendes républicaines: Bara et Viala," *Revue des questions historiques* 32 (1882), 233 ff.; J. C. Sloane, "David, Robespierre, and 'The Death of Bara,'" *Gazette des Beaux-Arts* 74, (1969), 143 ff.

58. A. Boime, "Thomas Couture's Drummer Boy Beating a Path to Glory," *Bulletin of the Detroit Institute of Arts* 56, no. 2 (1978), 122 ff.

59. H. R. Marraro, ed., *Memoirs of the Life and Peregrinations of the Florentine Philip Mazzei* (New York, 1942), 326–327. Vaughan (p. 161) has it that David declared in the presence of the countess of Albany that peace could not be restored until Marie-Antoinette had been guillotined. For David's meetings with Mazzei on other business in this period see D. and G. Wildenstein, pp. 30–32.

60. For women's participation in the French Revolution see O. Hufton, "Women in the French Revolution," *Past and Present* 53 (November 1971), 90–98; R. Graham, "Loaves and Liberty: Women in the French Revolution," in *Becoming Visible*, eds. R. Bridenthal and C. Koonz (Boston, 1977), 236–254; D. G. Levy

and H. B. Applewhite, "Women of the Popular Classes in Revolutionary Paris, 1789–1795," in *Women, War, and Revolution,* eds. C. R. Berkin and C. M. Lovett (New York and London, 1980), 1–35.

61. L.-M. Prudhomme, *Révolutions de Paris,* no. 213, 7 Brumaire, year 2, p. 151.

62. L. Blanc, *Histoire de la révolution française,* 12 vols. (Paris, 1870), 12:147 ff.; Graham, p. 251.

63. J. H. Rubin, "J.-L. David's Patriotism, or the Conspiracy of Gracchus Babeuf and the Legacy of Topino-Lebrun," *Art Bulletin* 58 (1976), 547–568; P.-L. Bordes, "Intentions politiques et peinture: le cas de la *Mort de Caius Gracchus,*" in *Guillotine et Peinture,* ed. du Chêne (Paris, 1977), 26–45.

64. P. J. B. P. Chaussard, *Le Pausanias français, état des arts du dessin en France à l'ouverture de XIXe siècle: Salon de 1806* (Paris, 1806), 159–160; Chaussard, *Sur le tableau des Sabines, par David* (Paris, 1800), 46. A popular poem on the picture spoke to its contemporary message for the spectators: "Chaque père est Romain, chaque mère est Sabine!"

65. David, pp. 343–344.

66. J. E. Mitchell, "David's *Intervention of the Sabine Women:* A Reconsideration of Its Subject Matter and Meaning" (unpublished College Art Association talk, 1983).

67. M. Grossholtz (Madame Tussaud), *Memoirs and Reminiscences of France* (London, 1838).

68. Ibid., pp. 199, 340; H. E. Hinman, "Jacques-Louis David and Madame Tussaud," *Gazette des Beaux-Arts* 66, ser. 6 (1965), 331–338. Hinman thinks that the cast was done for a drawing, later engraved, of Marat.

Index

Note: Italicized folios indicate pages on which illustrations appear.

Vien, Joseph-Marie, 153–55, 161–
62, 163–65, 173, 471
View of College Green (Francis
Wheatley), 282–*83*
View of Cromford (Joseph Wright
of Derby), *251*
View of Luxembourg Gardens (Jac-
ques-Louis David), *473*
Vigée-Lebrun, Elisabeth-Louise,
44–46
Vigilance Committee, 456
Vincent, François-André, 171–72,
173, *176*, 177
Vindication of the Rights of Women
(Mary Wollstonecraft), 342
Virginia state capitol. *See* Jeffer-
son, Thomas
Virtue, 402
Virtuous Athenian Woman, The
(Joseph-Marie Vien), *153*,
155
Vision of the Lazar House (Henry
Fuseli), *302*–3
Visions of the Daughters of Albion
(William Blake), 308, 334, 338,
342, 344, 352
Voltaire (François-Marie Arouet),
21, 27, 34, 36, 59, 179, 285,
421, 441

Walker, Adam, 241
Washerwomen (Jean-Honoré Fra-
gonard), *48*, 49
Washington, George, 423, 432–33
Watt, James, 188, 224, *358*
Weddell, William, 65, 99–100
Wedgwood, Josiah, 87–93, 100,

103–4, 188, *199*, 205–8, 335,
336, 371–77, 385, 389, 488
*Wedgwood Family on the Grounds of
Etruria Hall, The* (George
Stubbs), 257–*58*
Wentworth, Lady, 111
Werner, Abraham Gottlob, 189
West, Benjamin, 63, 116–37, 144,
257–59, *372*–73, 434–35, 438,
486, 495n.51
What Is the Third Estate? (Emman-
uel Joseph Sieyès), 419
Wheatley, Francis, 282–83
Whigs, 57, 94, 219–20, 315
Whitehurst, John, 237, 238, 245–
46
Wilberforce, William, 307
Wilkes, John, 279
Wilkinson, John, 208
Willard, Archibald M., *466*–67
Wille, Pierre-Alexander, *fils*, *403*
*William Penn's Treaty with the In-
dians* (Benjamin West), 132–34
Williams-Wynn, Sir Watkin, 65,
86, 89, 90, 91, 100–101, 199–
200; Adam's soup tureens, *159*
Wilson, Richard, 494–95n.33
Winckelmann, Johann Joachim,
63, 65, 67–68, 71–76, 106, 110–
11
Wolfe, James, 129–32
Wollstonecraft, Mary, 342
Women: artistic representations
of, 39, 42, 47, 49, 50, 51–52,
288–89, 338, 398–99, 403, 409–
10, 414–15, 470–72, 481; social
status of, xxi, 10–12, 15, 44,

338–39, 341–42, 401, 418, 459,
467–71, 483
Women Bathing (Jean-Honoré Fra-
gonard), *50*, 51
Work and leisure, 6–7, 9, 24, 47–
48, 234, 250
Working class. *See* Labor and la-
borers; Poor, as a class
Works of Ossian (James MacPher-
son), 218–27, 254, 266–67, 343,
450, 451
Works of Sir Joshua Reynolds, The,
230, 356
Wright, Joseph, of Derby, 232–
40, 242–53, 255–60
Wrongs of Africa (William Roscoe),
304, 339

XYZ Affair, 439

Young, Arthur, 508n.20
Young, Edward, 254, 255
Young Corinthian Woman, The (Jo-
seph-Marie Vien), *154*
Young Porter, The (Giacomo Cer-
uti), *8*

Zeus Battling Typhon (Henry Fu-
seli), 293
*Zeuxis Selecting Models for His Pic-
ture of Helen of Troy* (Angelica
Kauffmann), 114
Zoffany, Johann, 86–87
Zoonomia (Erasmus Darwin), 204,
243, 291, 303
Zucchi, Antonio, 104, 108, 454
Zulian, Girolamo, 139, 141–42